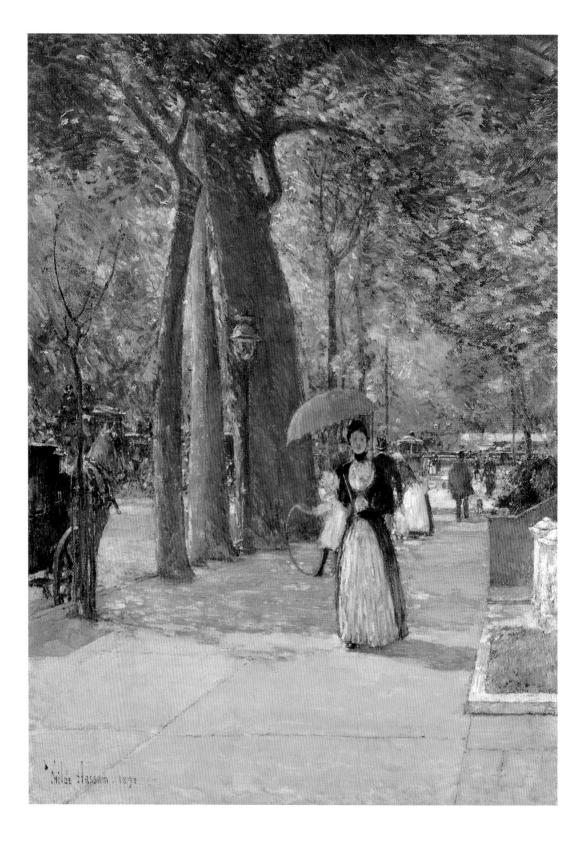

IMPRESSIONIST ART

1860-1920

Edited by Ingo F. Walther

Volume II

IMPRESSIONISM IN EUROPE AND NORTH AMERICA

by

Beatrice von Bismarck, Andreas Blühm, Peter H. Feist,

Jens Peter Munk, Karin Sagner-Düchting and

Ingo F. Walther

Benedikt Taschen

Slipcase: Edouard Manet The Viennese: Portrait of Irma Brunner in a Black Hat (detail), 1880 Paris, Musée du Louvre, Cabinet des Dessins © Photo: R.M.N., Paris cf. p. 213

Front cover: Philip Wilson Steer Young Woman on the Beach, Walberswick (detail), c. 1886–1888 Paris, Musée d'Orsay © Photo: R.M.N., Paris cf. p. 575

Page 402: Childe Hassam Fifth Avenue at Washington Square, 1891 Oil on canvas, 56 x 40.6 cm Lugano, Thyssen-Bornemisza Collection

This book was printed on 100 % chlorine-free bleached paper in accordance with the TCF standard.

© 1996 Benedikt Taschen Verlag GmbH Hohenzollernring 53, D-50672 Köln © 1992 for the reproductions: VG Bild-Kunst, Bonn, and the estates of the artists Edited and produced by Ingo F. Walther, Alling, Munich Editorial assistants: Antje Günther, Matthias Feldbaum English translation: Michael Hulse

> Printed in Germany ISBN 3-8228-8643-2 (Hardback) ISBN 3-8228-8558-4 (Paperback) GB

Contents

10	Painting in the Netherlands and Belgium in the Impressionist Period Tradition and Modernity: The Hague School and the Amsterdam Impressionists Impressionism in Belgium	407 407 419
II	"The light of freedom":	433
	Impressionism in Germany	433
	German and French Impressionism A Brief History of German Impressionism	441
12	The New Reality:	
	Impressionism in Scandinavia	467
	Scandinavian Artists in Paris	467
	The Encounter with Impressionism	468
	Artists' Colonies	475
	Plein-air Painting	475
	Nature and Civilization	477
	Man and Nature	478
	Effects of Light	480
	Plein-airisme and the Interior	483
	Point of View and Composition	487
	The Sense of Movement	492
	"La Vie Moderne"	494
13	Homelands and Europe: East and Southeast European Impressionists	501
		501
	Russia	512
	Poland	515
	Bohemia and Moravia	519
	Hungary	525
	Romania	528
	Bosnia-Herzegovina, Croatia, Serbia, Slovenia	5
14	Impressionism and Italian Painting	500
	in the Latter Half of the 19th Century	533

15	Painting in Spain in the Impressionist Period	553	
16	The British Response to French Impressionism	571	
17	Impressionism in North America	591	
	Origins and Principles of American Impressionism	591	
	The "European" Americans	600	
	The Evolution of a Distinct American Impressionism	607	
	Establishment and Dissemination:		
	The Second Generation of American Impressionists	628	
	The 20th-Century Aftermath of Impressionism	635	
	Appendix		
	Directory of Impressionism	642	
	Acknowledgements and Picture Credits	707	
	Index of Names	708	
	Brief Biographies of the Authors	712	

10 Painting in the Netherlands and Belgium in the Impressionist Period

Tradition and Modernity: The Hague School and the Amsterdam Impressionists

Dutch 17th-century art made its exciting impact not only on the French pre-Impressionist Barbizon painters, who saw the landscapes of a Salomon van Ruysdael (1600–1670) as modern in flavour (compared with the idealized landscapes of academic art) and as expressing a view of Nature in line with their own endeavours. The French Impressionists themselves also recognised those qualities. In addition, the art of Frans Hals (c. 1583–1666) and Jan Vermeer (1632–1675) increasingly attracted their interest in the 1860s. What they valued in Hals was particularly the freedom of his broad brush-strokes, while in Vermeer they admired his colourist virtuosity.

The French artists approached the Dutch old masters they esteemed not only by copying paintings in the Louvre but also through contemporary writings such as those of the critic Théophile Thoré (1824–1869). Furthermore, the personal contacts between French and Dutch artists were many. Thus Monet named the Dutchman Johan Barthold Jongkind (1819–1891) as his most important mentor (beside Boudin), to whom he owed a new and more intense view of Nature. Monet first met Jongkind in 1862, though like many of his contemporaries he had already admired his work – primarily seascapes and beach scenes – at the Paris Salon. Jongkind's highly sensitive use of colour, and his subtle rendering of atmospherics and effects of light on water or snow, were of particular interest. His airy landscapes, flooded with light and established with relatively economical and free brushwork, made Jongkind a significant precursor of Impressionist art.

Jongkind illustrates in a special way the distinctive relations and mutual influences of Dutch and French art, relations that were of such consequence for Impressionism. He first studied in The Hague under the landscape artist Andreas Schelfhout (1787–1870). In Paris, where he continued his studies in 1855 and worked in the studio of Eugène-Gabriel Isabey (1803–1886), the marine artist, Jongkind took a close interest in the art of the Barbizon school, whose view of Nature seemed to tend in the direction he was himself pursuing. That same year, disappointed by his failure to win an award at the Paris World Fair, he

George Hendrik Breitner Portrait of Mrs. Theo Frenkel-Bouwmeester, 1887 Portret van vrouw Theo Frenkel-Bouwmeester Oil on canvas, 217 x 152 cm Amsterdam, Stedelijk Museum

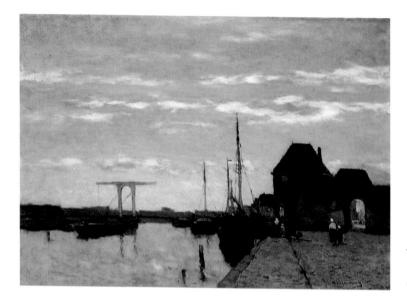

Johannes Hendrik Weissenbruch View of Haarlem Gesicht op Haarlem Oil on canvas, 72 x 102 cm The Hague, Haags Gemeentemuseum

returned to Rotterdam. When he next visited Paris in 1860, with watercolours and wintry or moonlit landscapes he had done in Holland, he was so great a success with his fellow artists and the critics that he decided to concentrate on the sought-after Dutch motifs of his home parts every summer from then on. Paintings such as the *View of Rouen* (p. 409) date from the decade (up to 1870) of his artistic breakthrough. His palette lightened at this time. His brushwork was bold, unconstrained and sketchy, revealing his interest in recording the mood and atmospherics of the moment.

Inspired by Jongkind and the Dutch old masters, several of the French Impressionists travelled at various times to the Netherlands, to study in museums and paint the landscape. It was the paintings of windmills and canals Monet did on his stay in Zaandam in 1871 that prompted Boudin to view him as the future leader of the Impressionist movement. Dutch artists in the later 19th century, in their turn, were led by the Barbizon

Willem Roelofs Summertime, 1862 Zomer Oil on panel, 27 x 49.2 cm Utrecht, Centraal Museum, on loan from the Van Baaren Museum Foundation

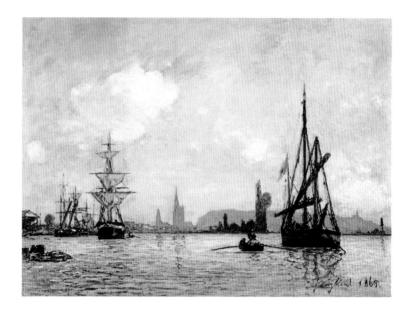

Johan Barthold Jongkind View of Rouen, 1865 Oil on canvas, 41.9 x 56.2 cm Hefting 336. Private collection

school's example to introduce greater tensions into their work. This produced a more searching scrutiny of Nature, and a more comprehensive sense of their own nation's art.

The Hague School was of signal importance in this context. Its heyday ran from the 1860s to the 1880s, and the achievement of those years earned 19th-century Dutch art a new respect and reputation. Johannes Warnardus Bilders (1811–1890) had already withdrawn in the 1850s to Oosterbeek, the "Dutch Barbizon", a wooded region where he painted from Nature; and soon he had attracted a number of pupils, among them Anton Mauve (1838–1888). In the summer months they were joined by the brothers Jacob Hendricus (1837–1899), Matthijs (1837–1917) and Willem Maris (1844–1910), and by Willem Roelofs (1822–1897), Jozef Israëls (1824–1911) and Johannes Hendrik Weissenbruch (1824–1903). Most of these artists had already had first-hand experience of Barbizon art; moreover, Dutch art dealers were frequently offering works by the Barbizon school for sale at that period.

In 1871, a number of these painters settled in the Hague. It was a charming small town then, still largely untouched by industrialization. That move, and their joint exhibition at the academy of art there in 1875, marked the birth of the Hague School. Contemporary critics were quick to highlight their realistic bent, the relatively new ways of seeing and representation, and the grey tonalities of their paintings; the emphasis of tonality over colour sometimes supplied grounds for adverse criticism. The Hague painters, in freeing their brushwork and establishing a more intense relation with Nature, cited their great Dutch predecessors, particularly Rembrandt, Vermeer, Hals and the 17th-century realists; this rather blunted the point of hostile criticism, given that the status of these artists was no longer contested. Nonetheless, the Hague School was not

Johan Barthold Jongkind Dutch Landscape, 1862 *Landschap* Oil on canvas, 34.5 x 56.6 cm Hefting 230. Private collection

Johan Barthold Jongkind

Rue de l'Abbé-de-l'Epée and Church of Saint James, 1872. La rue de l'Abbé-de-l'Epée et l'église Saint-Jacques du Haut-Pas Oil on canvas, 47 x 33.5 cm Hefting, 880. Paris, Musée d'Orsay a unified movement, nor did its coherence last: there were signs that it was breaking up as early as the mid-1880s, when landscape began to change under expanding industrialization. The artists had largely contented themselves with seascapes and views of mills in the idyllic region around The Hague and Scheveningen. They also painted tranquil interiors and genre pieces. Israëls – along with Mauve, the brothers Maris, Roelofs and Weissenbruch – was the foremost representative of this line. During studies in Paris he had met Jongkind and the Barbizon painters, and, beginning with a romantic, historicizing style, had quickly developed an arresting approach that at times owed a palpable debt to the tragic realism of Rembrandt. His subject matter, which earned him success throughout Europe, was mainly the life of ordinary people – peddlers, tailors, fishermen. Among his many admirers were the young Liebermann and van Gogh.

While Weissenbruch's teacher, Schelfhout, had placed little value on painting in the open, for Weissenbruch and other artists of the Hague School, with their knowledge of Dutch 17th-century art and the Barbizon school, *plein-airisme* became fundamental. Taking Daubigny's floating studio, "Le Botin", as their model, Weissenbruch and Roelofs regularly went out in boats. Roelofs' pasture, windmill and canal landscapes – of which *Summertime* (p. 408) is a fine example – use lighting effects that express a painterly freedom comparable with Daubigny's. Weissenbruch's spacious Dutch scenes, such as *View of Haarlem* (p. 408), contrast in their use of bolder and broader brushwork. In their own specific, lyrical way, drawing foremost on the colourist juxtaposition of silvery blues and greens with warmer shades, Weissenbruch's paintings nicely captured the moist atmosphere that lies upon Dutch landscapes.

Jacob Maris, another prominent figure in the Hague School, initially painted figural work, and subsequently landscapes. Six years in Paris gave him ample opportunity to study French art, and he especially admired Courbet and the atmospheric panoramic views of Daubigny. Back home, painting his native Dutch landscapes with a muted palette that registered subtly intimate nuances of light and hue, he evolved a distinctively Dutch style in works such as Allotment Gardens near The Hague (p.413). His brother Matthijs was exposed to various influences during his studies in the Hague, Paris and London. He espoused the sensitive realism of the Hague School in figural work, landscapes (such as Quarry at Montmartre, p. 413) and portraits; but the impact of the later German Romantics and of the English Pre-Raphaelites also produced in Matthijs Maris a strong tendency towards dreamy, fairy-tale realms. Willem Maris in his turn, who was in fact a student under his brothers at The Hague Academy, was more fully Impressionist. He assigned a dominant role to effects of shimmering light, concentrating on the Dutch landscape (Dusk, p. 412) and paintings of animals.

Though they viewed an immediate response to Nature as the essential prerequisite for landscape art, studies painted on the spot, with a fresh and spontaneous air to them, mainly served the Hague artists purely as preparation. The final oil was painted in the studio from the preliminary

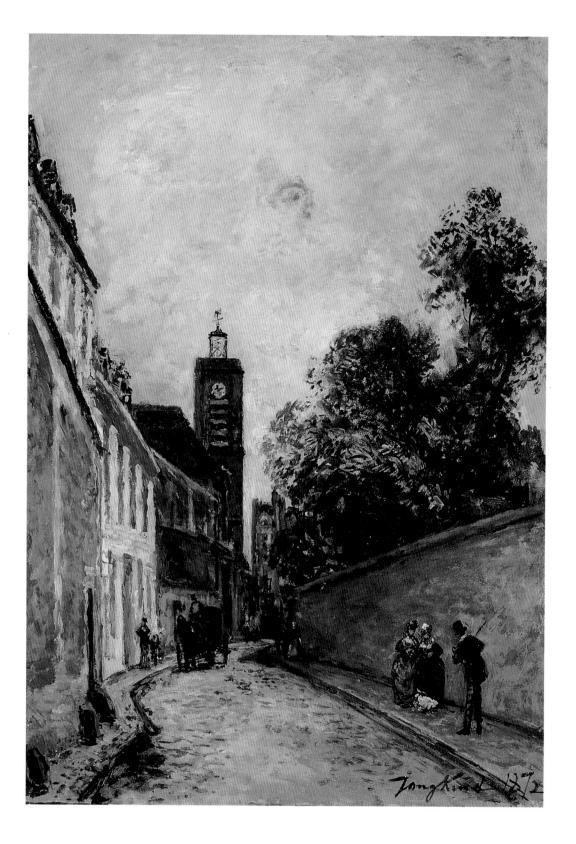

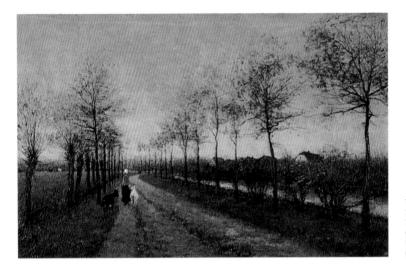

Willem Maris Dusk, c. 1875 *Tegen de avond* Oil on panel, 42 x 66 cm Utrecht, Centraal Museum, on loan from the Van Baaren Museum Foundation

studies. This fact, with their subject matter and their (initially) tonalitydominated palettes, constituted signal differences from the contemporaneous major phase of French Impressionism. The artists of the Hague School are better described as realists of a pre-Impressionist cast than as Impressionists of a distinctive – and distinctively Dutch – kind.

Once The Hague began to lose its appeal for them, Roelofs and Weissenbruch preferred to paint in the polders. Mauve moved to Laren, where Albert Neuhuys (1844–1914), another member of the Hague School, had settled in the meantime. Soon there was talk of a Laren School and a new "Dutch Barbizon", but in fact it was thematically more or less a continuation of the Hague art. Mauve, a cousin of van Gogh (whom he often advised on his art), was primarily drawn to pasture landscapes and street scenes of considerable colourist sophistication. His contemporaries were not slow to admire the wonderfully silvery and

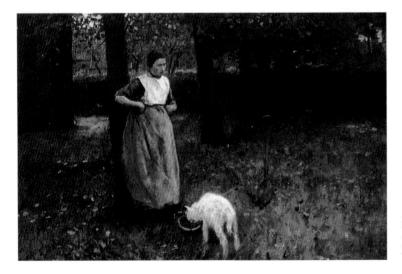

Anton Mauve Laren Woman with Goat, 1885 *Larens vrouwtje met geit* Oil on canvas, 50 x 75 cm The Hague, Haags Gemeentemuseum

diffuse light in his paintings, his relaxed brushwork, and his atmospherics (as in *Laren Woman with Goat*, p. 412).

For younger artists such as George Hendrik Breitner (1857-1923) and Isaac Israëls (1865–1934), son and pupil of Jozef, The Hague soon felt like a backwater. They preferred the city life of Amsterdam, where the 1880s saw a large number of artists working in Impressionist modes and attempting to cut loose from the Hague School. Certainly, the Hague artists were abandoning their grey tonalities during the decade, lightening their palettes, using stronger colours, and relaxing their brushwork. But the major subject for the Amsterdam Impressionists was now city life. Closer to the French Impressionists in their thematic concerns, they painted scenes of modern life, and the simple pleasures of city people, consciously working social components into their art. The Amsterdam group - which included Breitner, as its leader, Israëls, and Floris Hendrik Verster (1861–1927) – took a great interest in Naturalist literature. Indeed, Breitner was nicknamed the "Zola of Amsterdam". After van Gogh, with whom he was in touch in 1882 and 1883, he was assuredly the most important Dutch Impressionist. A pupil of Willem Maris, he studied in Paris in the 80s, and painted Barbizon-inspired work in Cormon's studio. The examples of Manet (whose 1884 retrospective he saw), of Monet, Pissarro and Degas, and of Japanese art, were crucial to his future development.

Even so, Breitner's pastose interiors with their audacious brushwork, and his full-length portraits, retained their visible links with specifically national traditions. Dutch qualities reminiscent of a Rembrandt or Ver-

Matthijs Maris

Quarry at Montmartre, c. 1871 Steengroeve bij Montmartre Oil on canvas, 55 x 46 cm The Hague, Haags Gemeentemuseum

Jacob Hendricus Maris

Allotment Gardens near The Hague, c. 1878 Slatuintjes bij The Hague Oil on canvas, 62.5 x 54 cm The Hague, Haags Gemeentemuseum

Jan Toorop Shell Gathering on the Beach, 1891 *Schelpenvisser op het strand* Oil on canvas, 61.5 x 66 cm Otterlo, Rijksmuseum Kröller-Müller

Jan Toorop The Dunes and the Sea at Zoutlande, 1907 Duinen en zee te Zoutlande Oil on canvas, 47.5 x 61.5 cm The Hague, Haags Gemeentemuseum

Jan Toorop Three Women with Flowers, c. 1885/86 *Trio fleuri* Oil on canvas, 110 x 95 cm The Hague, Haags Gemeentemuseum

> meer are apparent in the loving presentation of fabrics, furniture and tiled floors in his interiors, for instance. *The Earring* (p. 417), painted in Breitner's most prolific period between 1886 and 1901, is characteristic of his reduced and understated palette using only a few colours such as black, white and brown, and done with a spatula. His preference for dark colours earned his idiosyncratic style the sobriquet Black Impressionism. In works such as *The Dam* (p. 416), Breitner successfully drew out the poetry in everyday life. In later work, he had a predilection for scenes of old Amsterdam seen at dusk or on overcast winter days. His range of subjects also included working life in the city; this was an interest he shared with Verster and Israëls, in such works as their pictures of servant girls.

> Verster's Impressionist eye for reflections and for blocks of colour informed not only the landscapes he painted, mainly around Leiden, but also still lifes squarely in the great Dutch tradition. Israëls betrayed a frequent stylistic proximity to Breitner in his Amsterdam years from 1885 to 1903; inspired by Zola, he tackled city subjects such as factory workers, sailors' bars, prostitutes and cabarets. This led him to join the

Emile Schuffenecker A Cove at Concarneau, 1887 *Un coin de plage à Concarneau* Oil on canvas, 38.1 x 55.2 cm Private collection

rival Amsterdam artists' group, the Tachtig. At Scheveningen he met Liebermann. From the mid-80s he worked in the open, painting scenes that make a very spontaneous impact; his tonally harmonic palette and transparent coloured shadows marvellously caught atmospheric phenomena that he had carefully observed. In later years, particularly following his sojourn in Paris from 1903 to 1904, his technique became looser and sketchier. Israëls steadily became a pre-eminent Dutch Impressionist (p. 419).

The generation of Willem Bastiaan Tholen (1860–1931) and Willem de Zwart (1862–1931) combined the Hague School and Amsterdam Impressionist approaches by deliberately rejecting the "grey school" and tackling modern, urban subject matter. Tholen did this in unusual butchers' and slaughterhouse paintings. Willem Witsen (1860–1923)

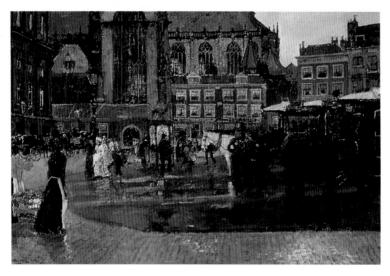

George Hendrik Breitner The Dam, c. 1891–1893 *Gezicht op de Dam* Oil on canvas, 100 x 153 cm Laren, Singer Museum

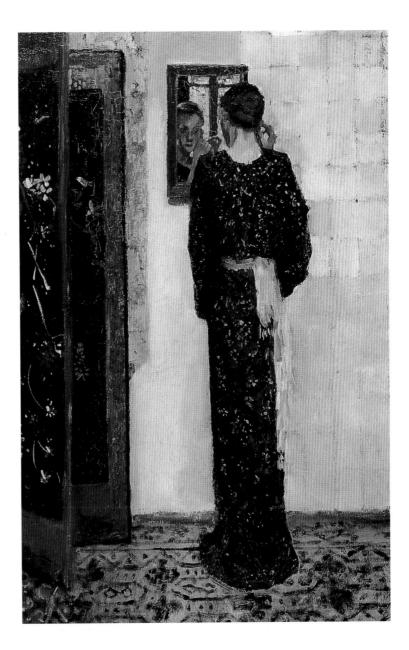

George Hendrik Breitner The Earring, c. 1893 *Het oorringetje* Oil on canvas, 84-5 x 57-5 cm Rotterdam, Museum Boymans-Van Beuningen

struck a more narrative note in pictures of Amsterdam canals in the snow, or the bridges and squares of London in the fog.

The foundation of the Hague Art Circle also reflected the new developments in art. Jan Theodorus Toorop (1858–1928), who ran the painting section, established contact with the internationalist Les Vingt in Belgium, which smoothed the Dutch artists' way to a prompt assimilation of French and Belgian Neo-Impressionism. Toorop studied at the Amsterdam Academy and subsequently in Brussels, where his most important teacher was James Ensor (1860–1949). He and Ensor became friends and visited Paris together, where Toorop's appreciation of French art, and particularly Manet, became substantial. A visit to England left him with a taste for Whistler. In the 1880s, Toorop shared with the Brussels artists an interest in Neo-Impressionism. The work he painted, exhibited with Les Vingt and elsewhere, used muted tonal harmonies influenced by Whistler, as well as a systematic division of brushwork and a pointillist use of colour dots derived from the Neo-Impressionists (pp.414, 415). In the 90s, Toorop turned increasingly to Art Nouveau and to the arts and crafts revival, quickly becoming a major figure in Belgian Art Nouveau. His work of that period was highly stylized in draughtsmanship and thematically prone to symbolist reverie.

Dutch artists such as Hendrik Pieter Bremmer (1871–1956) and, for a while, van Gogh, also followed the pointillist or divisionist line. Nevertheless, the dominance of the Hague School was to remain till the First World War, with even Piet Mondrian (1872–1944) following the example thus set in his early years. In 1892, Mondrian entered the Rijksakademie in Amsterdam, where he met Breitner and, questing for

Piet Mondrian Idyll, c. 1900 *Lente Idylle* Oil on canvas, 73.5 x 62 cm Seuphor 227. Private collection

Isaac Israëls In the Dance Hall, 1893 In het danshuis Oil on canvas, 76 x 100 cm Otterlo, Rijksmuseum Kröller-Müller

new means of expression, showed a growing interest in Impressionism – which thus had an influence on developments that were to go much further (Idyll, p. 418).

Impressionism in Belgium

Belgium became an independent kingdom in 1831 following the nationalist revolt of the previous year. Related feelings of national autonomy were manifest in Belgian art of the time. From 1863 on, the writer Camille Lemonnier (1844–1913) repeatedly insisted on the distinctness of the Belgian nation's art and literature. Belgian art shared the fine traditions of the Low Countries, and in the Flemish painters Peter Paul Rubens (1577–1640) and Pieter Breughel the Elder (1525/30–1569) numbered some of the greatest European artists in its ancestral line. In the second half of the 19th century, though, Belgian art was strongly under the influence of neighbouring France. The art scene there opened up options that seemed already available or adumbrated in local art. History painting, highly esteemed, fitted this pattern most obviously; the leading artists in this genre were Ferdinand Pauwels (1830–1904) and Louis Gallalit (1810–1887).

In the later 19th century, Belgium was economically one of the most advanced countries in Europe. The social problems which this involved were reflected in a committed art that dealt with the world of the poor; and it is scarcely surprising, then, that realism was so successful in 19thcentury Belgium. In Flemish and Dutch art alike, realism had a significant tradition that could look back to a Breughel or an Adriaen Brouwer (1605/06–1638). In the 1860s and early 1870s this background produced an admiration of the new French art, in particular that of Courbet and Millet. One of the foremost Belgian artists in this line was Constantin Meunier (1830–1905), whose landscapes and scenes of everyday life presented the hard life of workers and miners with a true-to-life realism that yet contrived to include symbolist touches. The interest aroused by this style of art was such that in 1867 the Société libre des Beaux-Arts was founded.

French Impressionism met with a warm welcome in Belgium. Among the upper middle classes of Brussels and Ghent there were many affluent collectors of an open-minded, cosmopolitan kind, and the art of Degas

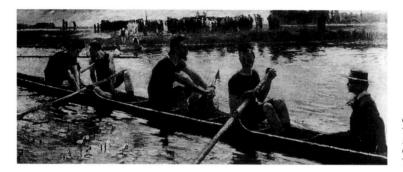

and Manet had its following there at a fairly early stage. Nonetheless, Impressionism made only a gradual impact on Belgian art. The Tervueren School played an important part in gaining its entry. Tervueren, a village in Brabant, had attracted a number of artists who made the first Belgian attempt to deal extensively with the subject matter of the Barbizon artists; and so Tervueren was quickly dubbed "the Flemish Barbizon". One of the most important of these painters was Isidore Verheyden (1846–1905), who combined the Barbizon style (familiar to Flemish artists from their sojourns at Fontainebleau) with an Impressionist interest in fleeting atmospheric effects, an interest that appeared mainly in his landscapes and coastal scenes. Verheyden, who was a founder member of Les Vingt in Brussels in 1884, was sceptical in regard to the ultimate implications of Impressionism, though, and later left the group. Around 1880, his enthusiasm for light and *plein-airisme* was also shared by artists such as Joseph Adrien Heymans (1839-1921), working at Termonde near Ghent, and prompted luminous, brighter, clearer use of colour. One of Verheyden's best known pupils was Anna Boch (1848-1936), who had a perceptive grasp of the problems and currents in modern art. At an early date she bought works by Seurat and Gauguin, among others, as well as the only painting van Gogh sold in his lifetime. Boch too was a member of Les Vingt; the group played a decisive role in the Belgian reception and dissemination of Impressionism.

Les Vingt, like the Indépendants in Paris, existed in order to promote new, innovatory art. The twenty members (either Belgian or resident in

Guillaume van Strydonck The Oarsmen, 1889 *Les canotiers* Oil on canvas, 84.5 x 201.9 cm Tournai, Musée des Beaux-Arts

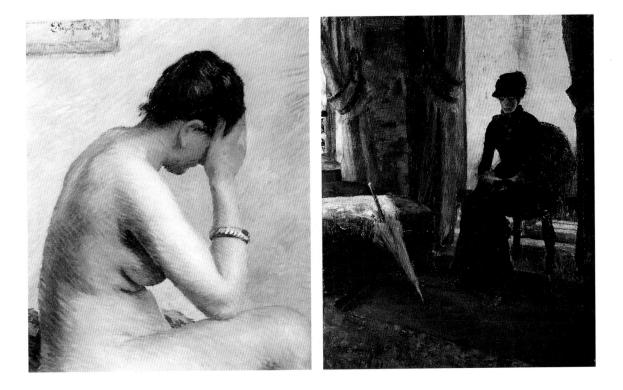

Belgium) included Georges Lemmen (1865-1916), Guillaume Vogels (1836-1896), Alfred William Finch (1854-1930), Théo van Rysselberghe (1862–1926), Fernand Khnopff (1858–1921), Henry van de Velde (1863-1957), Toorop, and Ensor, among others. They planned annual exhibitions at which the twenty members and the same number of invited artists at home and abroad would show work. There were also concerts and poetry readings. The very first exhibitions featured Impressionist art from France and Britain. The secretary and leader of the group was a lawyer, Octave Maus (1856–1919). When Les Vingt was disbanded in 1893, it was Maus who created La Libre Esthétique, an association that provided an internationally recognised forum for modernist aesthetics and ideas up till the First World War, thus assuring Brussels its role as an avant-garde centre around the turn of the century. Together with Edmond Picard (1836-1924) and the writer Emile Verhaeren (1855-1916), Maus used the new weekly magazine "L'Art Moderne" to profile both the aims of Les Vingt and the international art scene in general.

The magazine's Paris correspondent was Fénéon, a writer who (as we have seen in Volume I) was closely associated with Neo-Impressionism in France. Indeed, it was Fénéon who first coined the term Neo-Impressionism in "L'Art Moderne" in 1886, in an article on Signac and Seurat, who were exhibiting for the first time that year at the eighth Impressionist exhibition and were prompting controversy. Interestingly, this new offshoot style was rapidly adopted by Les Vingt: replacing the line by the point or dot was the very kind of liberation from conventional norms Emile Schuffenecker Female Nude Seated on a Bed, 1885 *Femme nue assise sur un lit* Oil on canvas, 65 x 45 cm Private collection

James Ensor

The Dejected Lady, 1881 De sobere dame Oil on canvas, 100 x 81 cm Brussels, Musées Royaux des Beaux-Arts de Belgique

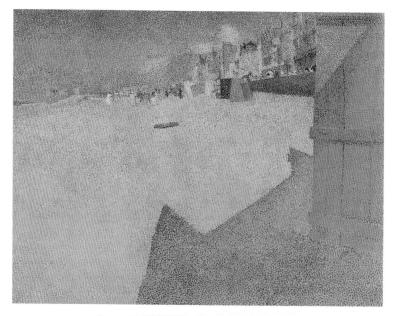

Henry van de Velde: Bathing Huts at Blankenberge, 1888 Strand med badhokjes in Blankenberge Oil on canvas, 71 x 100 cm Billeter/Hammacher 18. Zurich, Kunsthaus Zürich

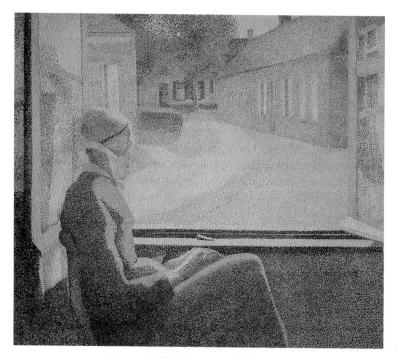

Henry van de Velde: Woman at the Window, 1889 Zittende vrouw voor een venster Oil on canvas, 111 x 125 cm. Billeter/Hammacher 20 Antwerp, Musée Royal des Beaux-Arts

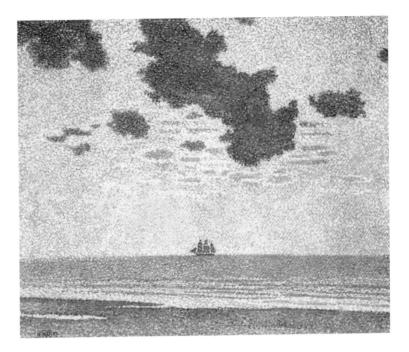

Théo van Rysselberghe Heavy Clouds, Christiania Fjord, 1893 *Grote wolken, Christiania Fjord* Oil on canvas, 50.8 x 63 cm Indianapolis (IN), Indianapolis Museum of Art

that Belgian artists were calling for. Thus Seurat's famous picture A Sunday Afternoon at the Ile de la Grande Jatte (pp. 260/261) – the first work in which the artist applied his new divisionist principles of colourism – was exhibited with Les Vingt as early as 1887. The interchange between French and Belgian artists was constant and active.

Flemish artists, though ready in their reception of Impressionism, adopted the approach in a more structured form; this was apparent in their greater emphasis on draughtsmanship and chiaroscuro features. This resulted in the occasional juxtaposition of native Flemish styles with imported Impressionist styles that derived from the French. The more Flemish version was to be found in the work of Vogels (who began in Tervueren); Albert Baertsoen (1866–1922), one of whose finest paintings was Ghent, Evening (p. 431); Ferdinand Willaert (1861-1922); and the early Ensor. The major exponents of the more French-oriented line were Emile Claus (1849-1924), who painted in the style of Monet; Henri Evenepoel (1872-1899), a friend of Toulouse-Lautrec; and the foremost Belgian Neo-Impressionist, Rysselberghe. Other artists active between 1880 and 1918, who made the Impressionist period in Belgium so notable, included Guillaume van Strydonck (1861-1937); Willy Schlobach (1864–1951), who was inspired by Turner and Monet; Rodolphe (1860– 1927) and Juliette Wytsman (1860-1925), a married couple both of whom were painters; and the self-taught Marcel Jefferys (1872-1924), who was also inspired by Monet.

Claus did not start out as a painter. As a student at Antwerp, he rebelled against the academic instruction of his Romantic tutor, Narcisse de Keyser (1813–1887). A stay in Paris, and the art of Bastien-Lepage,

Alfred William Finch Haystacks, 1889 *Les meules de foin* Oil on canvas, 32 x 50 cm Brussels, Musée d'Ixelles

prompted work that echoed the social concerns of Zola. Claus spent the winters of 1889 to 1892 in Paris and – though draughtsmanship of an academic kind always remained fundamental in his view – he steadily adopted more of the Impressionist techniques and subjects, moving further and further from the earthy tonalities of the Antwerp school. Paintings such as *Sunshine* and *A Corner of my Garden* (p. 427) show how intensely he grappled with the phenomenon of light and different atmospheric conditions. His subjects, frequently landscapes, recall Monet. At his home, "Zonneschijn", near Astène – restructured by van de Velde – Claus entertained numerous artist and writer friends such as Verhaeren, on whom he exerted a considerable influence. His active presence on the Belgian art scene also included membership of Les Vingt and the Libre

Georges Lemmen View of the Thames, 1892 *Vue de la Tamise* Oil on canvas, 61 x 86.7 cm Providence (RI), Museum of Art, Rhode Island School of Design

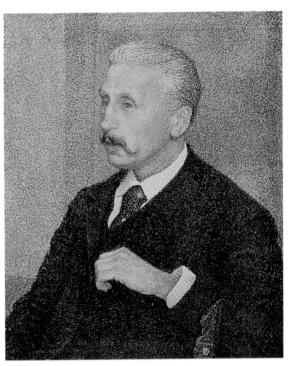

Esthétique. In 1904, with Ensor, Lemmen, Boch and others, he founded the Cercle vie et lumière. Claus was extremely successful, both at home and abroad. His numerous pupils, among them Georges Morren (1868– 1941), constituted a fairly homogeneous group within Belgian Impressionism. Claus's significance was unjustly eclipsed by the rise of Belgian Expressionism.

Evenepoel, resident in Paris from 1892, took an enthusiastic interest in Montmartre life in his paintings, posters and illustrative work. In the late 1890s - his most productive period, brought to an abrupt end by the artist's early death - he painted portraits, street scenes and interiors. Evenepoel studied in Moreau's studio, where (by his own report) he learnt that "every brush-stroke must be guided by feeling", and that colour must be at once thought and dreamt if it is to render Nature imaginatively. This conviction led Evenepoel to a highly personal brand of Impressionism. Sunday in the Bois de Boulogne (p. 428) and Veterans' Festival (p. 429) demonstrate his flair for unusual composition. His Sunday walkers in the Bois de Boulogne seem to be walking out of the canvas to right and left, at different speeds, as in a snapshot. The left edge of the picture is audaciously cropped, and left of centre there is an empty space that seems to be pushing the actual movement out to the sides. Compositionally, this highly idiosyncratic picture recalls Toulouse-Lautrec, while the colours, featuring Evenepoel's preferred ochres, owe more to Moreau. Evenepoel's colourism and expressive brushwork constitute a meeting of Impressionism and Fauvism, and make his art one of the finest Georges Lemmen Self-Portrait, 1890 Zelfportret Oil on canvas, 43 x 38 cm Lausanne, Samuel Josefowitz Collection

Théo van Rysselberghe

Portrait of Auguste Descamps, the Painter's Uncle, 1894 *Portrait d'Auguste Descamps, l'oncle du peintre* Oil on canvas, 64 x 53 cm Geneva, Musée du Petit Palais

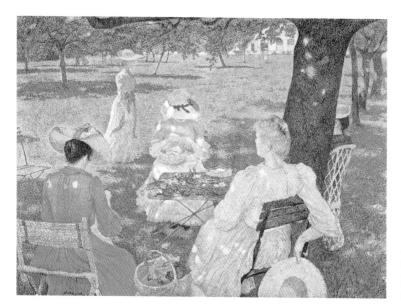

Théo van Rysselberghe Family in an Orchard, 1890 Famille assemblée dans un verger Oil on canvas, 115.5 x 163.5 cm Otterlo, Rijksmuseum Kröller-Müller

achievements in late 19th-century painting. He himself was a friend of both Impressionists and Fauvists; one friend he had made during his apprentice years in Paris was Matisse, who esteemed him highly.

Rysselberghe too was close to Fauvism in his later years. Like his friends Maus and Verhaeren, he was a member of Les Vingt, and played a decisive part in disseminating French and British avant-garde art in Belgium. His earliest work showed a strong interest in portrait painting, and he naturally enough received his first Impressionist influences primarily from the portrait work of Manet, Degas and Whistler. He was also impressed by Spanish art and by Hals. This fascination was reflected in his relaxed but powerful brushwork and his strongly contrastive effects of light. In 1886 Rysselberghe made contact with Seurat and Signac, and his style evolved in a Neo-Impressionist direction. From that time on he regularly exhibited at Neo-Impressionist shows in Paris. His pointillist Heavy Clouds, Christiania Fjord (p. 423), painted in 1893, is largely based on complementary contrasts of blue and orange, and of yellow and violet; the central coupling of blue and yellow establishes the most powerful contrast in terms of light and dark and of warm and cold. This serves to highlight the heaviness of the rainclouds, their irregular shapes making them stand out all the more above the calm line of the watery horizon. This picture is Rysselberghe at his most Seuratian, his technique deploying effects of colour, contour and shape in ways that were squarely in line with the cognitive psychology of the time.

As well as van de Velde, Rysselberghe ventured into the applied arts, which were undergoing a notable international revival at the turn of the century. The Arts and Crafts movement in England had provided the main spur, rejecting modern mass production and calling for a return to cottage ideals of craft. This implied involving art in every area of life

Emile Claus Sunshine, 1899 Zonneschijn Oil on canvas, 80.5 x 116.5 cm Paris, Musée d'Orsay

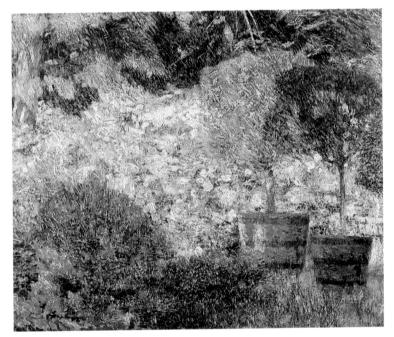

Emile Claus A Corner of my Garden, 1901 *Un coin de mon jardin* Oil on canvas, 60 x 74 cm Private collection

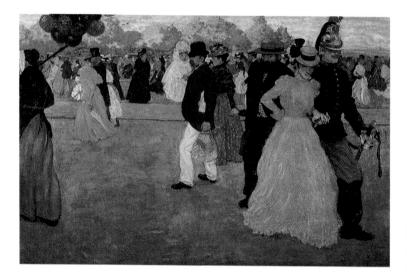

Henri Evenepoel Sunday in the Bois de Boulogne, 1891 Zondag in het Bois de Boulogne Oil on canvas, 59 x 90.2 cm Antwerp, Musée Royal des Beaux-Arts

and experience, and in this respect the ideal resembled that of the "Gesamtkunstwerk". Integration of this kind was widely considered an essential prerequisite if societal conditions were to be radically changed. Les Vingt were quick to espouse these ideas. Rysselberghe did illustrations for literary works (especially those of the Belgian symbolist writers), made posters, and designed catalogues and furniture. His true talent, though, was nevertheless as a painter. His art began to undergo a change after 1898, following a visit to Paris, and he turned increasingly to nudes and open-air scenes, done in relaxed, Impressionist brushwork. About 1908 he abandoned the Neo-Impressionist approach altogether.

Briefly, between 1889 and 1892, Finch also tried his hand at Neo-Impressionist techniques, under the influence of his meetings with Seurat and Pissarro, and works such as *Haystacks* (p. 424) resulted. In 1897 Finch settled in Finland, and after 1900 he was primarily important in the applied arts, into which he tried to import Neo-Impressionist theories of colour and proportion. Like many of his contemporaries, Finch believed art could expand to include other areas of experience and thus effect a fundamental improvement in life; social utopianism of this kind often appeared in aesthetics at that date. In Helsinki he became professor of ceramics and established the Septem group, which successfully introduced Impressionism – and particularly Neo-Impressionism – into Finland. Like his friend Ensor, Finch had studied at the Academy in Brussels; both were founder members of Les Vingt.

Finch's friend Lemmen, a richly talented and unjustly forgotten painter, was also quick to be fired by Impressionist innovations, and published articles on the subject in "L'Art Moderne". He repeatedly criticized Belgium's public exhibition facilities. Influenced by Rysselberghe and his own friendship with Seurat and Signac, Lemmen adopted a Neo-Impressionist technique, locating his own personal, poetic version

of pointillism in such works as his View of the Thames (p. 424). Though he was successful at exhibitions (including the Indépendants in Paris) with his Neo-Impressionist paintings, and particularly with his portraits, Lemmen began to change his position again from 1895 on, tending increasingly towards an espousal of the more traditional views of Claus and Heymans - together with whom he would create the Cercle vie et lumière in 1904. The artists of this circle were known as the Luminists, and included those who had been trying to find suitable ways of presenting light since the Termonde School. Lemmen's intimate works, such as the Self-Portrait (p. 425), which surely best expressed the artist's reticent, introspective nature, now became suggestive of Renoir or Bonnard. But Lemmen also played a significant part in the foundation of the L'Art group, which contributed to the applied arts revival in Belgium. He himself did posters, tapestries, ceramics, and book illustrations, as well as watercolours and drawings; yet to this day he has largely been denied his due recognition.

Van de Velde was also associated with the circle of Claus and Heymans after attending the Antwerp Academy and Carolus-Duran's studio in Paris. He was one of the most important and influential artists at the turn of the century, albeit less in painting than in architecture and the Arts and Crafts movement. Van de Velde's predilection for motifs from farming life was reflected in his high opinion of Millet's and Pissarro's art. In 1887 he first saw Seurat's *Grande Jatte*, which influenced his own style, with the result that in 1889, as one of Les Vingt, he exhibited Neo-Impressionist paintings such as *Bathing Huts at Blankenberge* and *Woman at the Window* (p.422), which are among his best known works. From 1890 van de Velde's attention was increasingly on other artistic fields, and around 1894 he abandoned painting for good. For many artists, Impressionist or Neo-Impressionist styles were simply a transitional phase on the way to Symbolist or Expressionist art of a kind

Henri Evenepoel Veterans' Festival, 1898 La fête aux invalides Oil on canvas, 80 x 120 cm Brussels, Musées Royaux des Beaux-Arts de Belgique

that has often been explained in terms of a "mystical" tendency in Flemish painting.

Symbolism evolved alongside Impressionism. The major Belgian Symbolists were Khnopff and Ensor, but the style was also evident in the mysticism of the first Sint Martens Laten School - the "Flemish Pont-Aven" near Ghent - where Gustaaf van de Woestijne (1881-1947) and others established the link with Flemish Expressionism. The artists of this group had all started out in Impressionism and then moved on to Expressionism. Ensor's work exemplifies the development: from The Dejected Lady (p. 421) he moved on to carnival scenes, ghosts, monsters, and the masks for which he is famous, evolving a highly idiosyncratic realistic-cum-symbolist style that in some ways echoed the fantastic tradition of Hieronymus Bosch (1450-1516) and Breughel - in other words, the great heritage of Flemish and Dutch art. In sum, it can be said that the new, autonomous, individualist approach that distinguished Belgian art between 1884 and 1913 owed a crucial debt to the Impressionist breakthrough - which indeed ultimately made modern art in Belgium possible.

KARIN SAGNER-DÜCHTING

Albert Baertsoen Ghent, Evening, 1903 *Gand, le soir* Oil on canvas, 151 x 155 cm Brussels, Musées Royaux des Beaux-Arts de Belgique

II "The light of freedom": Impressionism in Germany

German and French Impressionism

French Impressionism remains the yardstick by which Impressionism in other countries is judged, and this naturally applies to Germany too. The achievements of forerunners such as Karl Blechen (1798–1840), Carl Gustav Carus (1789–1869), Johann Georg Dillis (1759–1841), Wilhelm Leibl (1844–1900), Adolph von Menzel (1815–1905), Carl Schuch (1846–1903) or Johannes Sperl (1840–1914) were crucial to the subsequent development of *plein-airist* painting. And yet, regardless of the specifically national tradition that lay behind German Impressionism, the fact remains that the younger artists increasingly had to make their way in the international market, judged by international critics. And that meant Paris.

The French capital had superseded Rome as a place of artistic pilgrimage. The academies and private art schools, as well as the world fairs held there since 1855, had only consolidated the position of Paris, and the list of German painters who duly went there resembles a who's who of German Impressionism: Max Liebermann (1874–1935), Gotthard Kuehl (1850–1915), Fritz von Uhde (1848–1911), Lesser Ury (1861– 1931), Lovis Corinth (1858–1925), Heinrich von Zügel (1850–1941), Max Slevogt (1868–1932), Wilhelm Trübner (1851–1917), Leo von König (1871–1944) and Albert Weisgerber (1878–1915). Scholars have justifiably wondered what these artists were looking for in Paris – and what they found. Critics often emphasize that the German artists knew little of the new developments in art. Some point out that the Germans tended no longer to be young, and indeed to be well advanced in their technical grasp, by the time they first encountered French Impressionism. Others deny there was any connection whatsoever.

What the artists themselves said tends to be not very informative. Familiarity with the new French art generally cannot be documented till the 1890s. Since the recorded responses largely dovetail, it is fair to assume that the artists were not merely trying to safeguard their own work's claims to originality. To what extent the legacy of enmity between the Germans and French following the Franco-Prussian War played a part is a moot point. Corinth, whose stinting political view of the world was in line with the prevailing patriotic mood, reported that "The division of colour is all nonsense. I have just seen it once again: Nature is simple and grey." MAX LIEBERMANN

Max Liebermann Munich Beer Garden, 1884 *Münchner Biergarten* Oil on canvas, 95 x 69 cm Munich, Bayerische Staatsgemäldesammlungen, Neue Pinakothek

German artists in France would deny their national origins for fear of local hostility. By the same token, the artist who was perceived in Germany as an imitator of the French was ill-advised, to say the least.

In their own country, the founding fathers of Impressionism had to wait till the close of the century for official approval. Their exhibitions were private in character and did not reach a wider public. The Salon was still seen as the major platform for those who wanted public attention and criticism based on comparison. Leibl was noticed there in 1870, and in 1874 Liebermann exhibited *Plucking Geese* (p. 434), a painting

Adolph von Menzel Departure of King Wilhelm I for the Front, 31 July 1870, 1871 Abreise König Wilhelms I. zur Armee am 31. Juli 1870 Oil on canvas, 63 x 78 cm Berlin, Staatliche Museen zu Berlin – Preußischer Kulturbesitz, Nationalgalerie

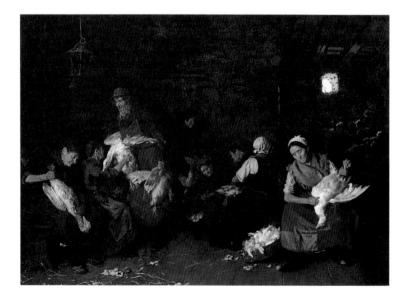

Max Liebermann Plucking Geese, c. 1870/71 Die Gänserupferinnen Oil on canvas, 172 x 118 cm Berlin, Staatliche Museen zu Berlin – Preußischer Kulturbesitz, Nationalgalerie

that used the earthy heaviness of his early work and had been damned two years earlier in Berlin as representing "the absolute in ugliness". Liebermann later owned paintings by Manet, including *Bundle of Asparagus* (p. 198). His own interest was in the Barbizon School; and Courbet, Leibl's friend, still attracted the admiration of German painters of a progressive disposition.

In 1880 Uhde exhibited his *Chanteuse* (Munich, Neue Pinakothek) at the Salon. The painting strongly recalls Franz Defregger (1835–1921). In 1884 Corinth submitted his *Conspiracy* (whereabouts unknown), which had won a bronze medal in London. In this painting and those done in Paris, no influence of French Impressionism is detectable, which is scarcely surprising, given that he was studying at the Académie Julian under Bouguereau, the academic Salon painter. Could it be that the reservations younger French artists had concerning the venerable Salon and its celebrated artists had not yet reached German ears?

Our first evidence of German acquaintance with the Impressionists dates from 1883, when Gurlitt's in Berlin put Carl and Felicie Bernstein's collection on view. The public had no idea what to make of what they saw. The writer and critic Jules Laforgue (1860–1887), one of the early advocates of Impressionism, was at the court in Berlin at that time, em-

Max Liebermann

The Orphanage at Amsterdam, c. 1881/82 Freistunde im Amsterdamer Waisenhaus Oil on canvas, 78.5 x 107.5 cm Frankfurt am Main, Städelsches Kunstinstitut und Städtische Galerie

Fritz von Uhde Fisher Children in Zandvoort, 1882 Fischerkinder in Zandvoort Oil on canvas, 60 x 80 cm Vienna, Neue Galerie in der Stallburg

ployed to read to the German Empress; and the exhibition did not escape his keen notice. "If Berlin acquires even a modicum of insight into art, it will be the doing of Herr Gurlitt", he observed. But the public response did not encourage a repeat show, and the Bernstein collection was to remain an exception for some time.

By the turn of the century, Gauguin and Denis had been exhibited in Germany and French Impressionism, though not yet fully established there, was becoming familiar. The critics set about discovering similarities with modern German art – which provided opponents with a weighty argument, the accusation that the German artists were "aping" the French. This hit the Germans where it hurt; for all their admiration for the French achievement, they did not want their own work dismissed as imitative.

Once it had been levelled, the accusation prompted intense efforts to show how German Impressionism (now thus described) differed stylistically from French. The artists never tired of defining their own autonomy. Liebermann's famous assertion that Nature is grey, quoted at the head of this chapter, was meant programmatically, and illustrates a dilemma that confronts art criticism to this day when it has to label the style of the period in Germany

According to Horst Imiela, the term "Impressionism" was first applied to German painting by the dealer Paul Cassirer (1871–1926). Imiela cites Corinth's wife as his source. But surely the earliest description of a German painting as "Impressionist" came from Laforgue's pen. In his memoirs of Berlin he noted that Menzel's *Coronation of King Wilhelm I at Königsberg* (Hanover, Niedersächsisches Landesmuseum), painted in 1861–1865, featured "an attempt at Realism, indeed at Impressionism, remarkable in official art". Menzel's *Departure of King Wilhelm I* (p. 434) depicted the Berlin street bustle with a virtuoso yet free brushwork, and a disdain for the draughtsman's minutiae, that anticipated later solutions of this thematic problem. Menzel's subject is so displaced from the centre that we do not indeed see it till we look more closely. What matters more to him is the difficult task of conveying a crowd's enthusiastic mood, which he does through the accumulation of details. It is not without irony that, of the relatively few German paintings that deal with contemporary public affairs, there is this one that employs Impressionist technique even before the term was in currency. Though Menzel's colourist method may seem related to that of the Impressionists, his relation to the movement was, however, a tarnished one, and he told the Bernsteins his poor opinion of the French paintings they hung in their home in no uncertain terms.

The formal affinities which the art of Liebermann, Corinth and Slevogt (to name only the three leading figures) bore to French Impressionism naturally obscure the differences which emerge on closer inspection. The most signal criterion in differentiating between German and French Impressionism is the way the paint is applied. Liebermann was not alone in his aversion to the scientific division of appearance into the colours of the spectrum. Juxtaposing almost unmixed colour tonalities was not for the Germans. We can see how the attitudes compare if we consider a subject whose very changeability invites experiment, a subject which is indeed intimately associated with the origins of Impressionism as a

Fritz von Uhde Two Daughters in the Garden, 1892 Zwei Töchter im Garten Oil on canvas, 145.5 x 116.5 cm Munich, Bayerische Staatsgemäldesammlungen, Neue Pinakothek

Fritz von Uhde Big Sister, 1885 *Die große Schwester* Oil on card, 48.5 x 33 cm Munich, Städtische Galerie im Lenbachhaus

term: water – or, to be exact, the surface of moving water with the shifting play of light on it. Monet's revolutionary treatment of sunlight on water in the 1872 landmark painting *Impression: Sunrise* (p. 113) had had so little influence, twenty-two years later, on the well-informed and deliberate artist Leopold von Kalckreuth (1855–1928), that the German artist felt no need to go beyond the linear drawing of waves in his painting *Returning Dockworkers on the Elbe* (Hamburg, Hamburger Kunsthalle).

This comparison shows how representationally fixated on their subject German artists remained during the act of painting. Yet both principles open up new directions. And both options – which could be interpreted as a striving for greater truthfulness in recording what was seen, and thus as a higher objectivity – opened the door to a new subjectivity. Where Monet and his successors liberated colour, the Germans drew their growing strength from an ever more relaxed handling of the line, which was gradually permitted a life independent of the subject, a presence that expressed an individual signature. The development of Corinth's art affords the best example of this.

In their approach to composition there were similarities and differences between the Germans and French. The latter usually gave equal attention to every part of a composition, whereas the Germans might place emphases, as Liebermann's *Woman with Goats* (p. 442) nicely shows. In this picture, the major interest lies in the contrast between the heroic compositional treatment and the everyday nature of the motif.

Fritz von Uhde Walking to Bethlehem, c. 1890 Der Gang nach Bethlehem (Schwerer Gang) Oil on canvas, 117 x 126 cm Munich, Bayerische Staatsgemäldesammlungen, Neue Pinakothek

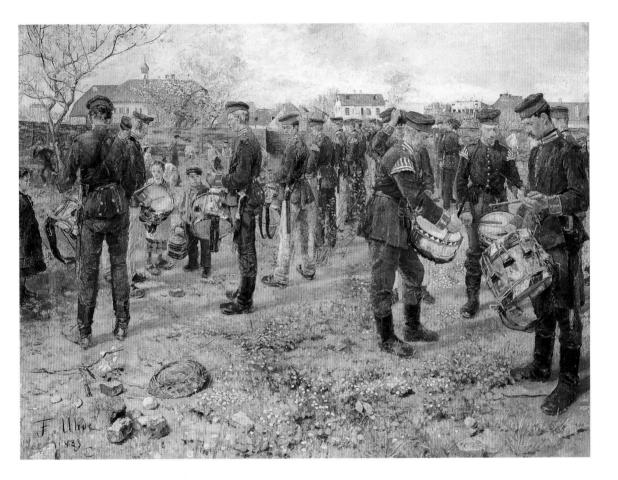

Of greater weight was the contrast between the French and German Impressionists' choices of subjects. Germany abounded in genre paintings of everyday life and leisure, but the German Impressionists' use of their new style for narrative or history paintings would have been unthinkable among the modern French artists. This feature of German Impressionism has often been ignored by critics, or dismissed as a false start, on the grounds that it had nothing in common with Impressionism as conceived by the French.

Turn-of-the-century neo-classicism, and the triumphant achievements of Arnold Böcklin (1827–1901) and Max Klinger (1857–1920), demonstrated that as the 19th century closed it was still usual to treat abstracts such as happiness, love and peace in allegorical fashion. The leaning towards history painting discernible in Corinth and Slevogt, in Trübner, and occasionally even in Liebermann, suggests that the German Modernists were not out to break with academic tradition. Rather, they tried to adapt it to their own preferences. Corinth's history paintings might be described as realistic idealism. At all events, they are far removed from any principle of art for art's sake. Still, Impressionist history painting constituted a more drastic assault on habitual ways of seeing than a focus Fritz von Uhde Bavarian Drummers, 1883 Die Trommelübung (Bayerische Trommler) Oil on panel, 72 x 95 cm Dresden, Gemäldegalerie Neue Meister

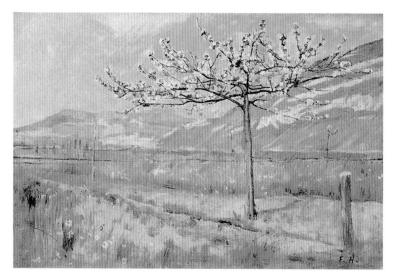

Ferdinand Hodler Apple Tree in Blossom, c. 1890 *Blühender Apfelbaum* Oil on canvas, 26.5 x 40 cm Winterthur, Oskar Reinhart Collection

Ferdinand Hodler Portrait of Louise-Delphine Duchosal, 1885 *Bildnis Louise-Delphine Duchosal* Oil on canvas, 55 x 46 cm Zurich, Kunsthaus Zürich on landscape could have done. The inherent contradiction between grave subjects and light styles could not always be overcome. And only painters prepared to compromise, such as Hugo Vogel (1855–1934) or Ludwig Dettmann (1865–1944), won official commissions and painted murals on public buildings. This might be placed under the heading of what Karl Scheffler (1896–1951) termed "Salon Impressionism".

Of course the label "Impressionism" was not uncontroversial or capable of unambiguous interpretation in France. Whether masters such as Manet or Degas can properly be included in the group is debatable. Scheffler, a leading apologist of German turn-of-the-century Modernism, retrospectively attempted a definition that concentrated on the intellectual background of the style and has a certain across-the-board validity: "When every object is dissolved in an atmosphere, and the aim is to present light, air and motion, the painter can only use means of representation that pass over the detail in favour of the overall impression perceived by the eye and nothing else." If everything is reduced to this common denominator, it is no longer of great moment that Monet and Pissarro render light in juxtaposed, unmixed brush-strokes while Liebermann and Slevogt continue their attempt to capture the specific shade or tonality of an object. Their differing methods of dissection and sketching basically establish a similar effect, that of something visually registered in an instant - an impression.

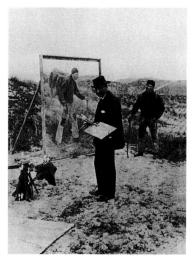

Max Liebermann and his model at work in the open on "Peasant Walking" (destroyed 1945). 1894

A Brief History of German Impressionism

In 1907 art historian Richard Hamann (1879–1961) published his study "Der Impressionismus in Leben und Kunst", in which he attempted a retrospective overview. The title of his book promised to deal with Impressionism in life and art, and implied a programmatic extension of the term across the genre divides, an aim which may not strike us as audacious or indeed questionable. Hamann proposed criteria by which Impressionism could be identified in various areas. In music, it was anti-logical and expressed a neurasthenic awareness; in poetry, it was atmospheric and given to repetition; in philosophy, it was subjective and vivid. Characteristically for his period, he felt that the crux was "a feverish longing for spontaneity, for the free movement of light in open spaces, such as the creative moment offers: in its entire uniqueness, in a constant state of flux within its own laws, yet subject to chance as well."

This view, which seems to suit Expressionism better, may not immediately appear apt to the serious toil that went into German Impressionist works, which often make a less radical impression than works by French contemporaries. But the new stress on the artist's individual achievement was undoubtedly relevant to the Germans too. Realism, and the principle of truth, were the soil that nourished German Impressionism; but they were superseded by the painter's autonomy. It was only through *pleinairisme* that Liebermann's "imagination in painting" became possible.

Max Liebermann Woman with Goats, 1890 *Frau mit Ziegen* Oil on canvas, 127 x 172 cm Munich, Bayerische Staatsgemäldesammlungen, Neue Pinakothek

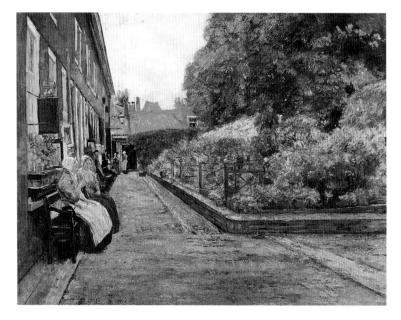

Max Liebermann St. Steven's Foundation, Leyden, 1889 Stevenstift in Leiden Oil on canvas, 78 x 100 cm Berlin, Staatliche Museen zu Berlin – Preußischer Kulturbesitz, Nationalgalerie

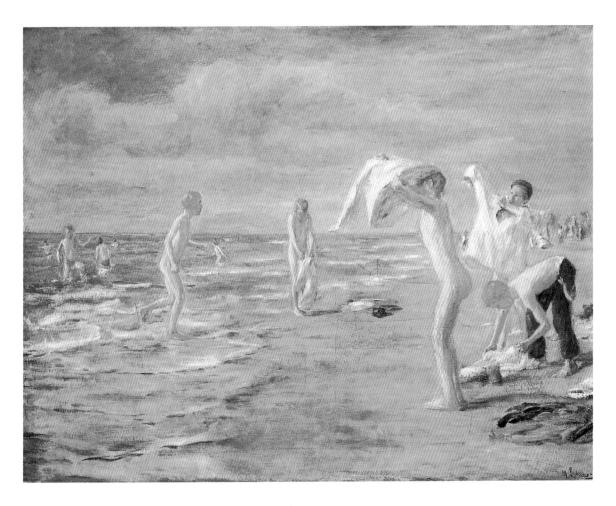

Painting in the open had been established decades before, by various painters. At the great centennial exhibition at the Nationalgalerie in Berlin in 1906, when Impressionism was at its peak, the public was bewildered to find that much that had been supposed a revolutionary innovation was already there in the work of artists long since canonical. The "Impressionist" Menzel was discovered. Names such as Blechen or Christian Morgenstern (1805-1867) were remembered, and the value of the oil study as a genre in its own right was registered. German art, partitioned into schools, had come up with stunning achievements; and work had often been done in parallel, at various places, in mutual ignorance. The art colleges at Karlsruhe, Munich and (from 1860) Weimar had demonstrated a more tolerant flexibility than those at Düsseldorf and Berlin. The struggle for realism, and for a higher estimation of landscape art, had flared up anew in the 1850s and 1860s. In contrast to France, though, the debate did not spread beyond academic circles.

Liebermann, born in 1847, was the eldest of the leading German Impressionists. Like Leibl, he had roots in realism. Like most of his felMax Liebermann Boys Bathing, 1898 *Badende Knaben* Oil on canvas, 122 x 151 cm Munich, Bayerische Staatsgemäldesammlungen, Neue Pinakothek low travellers, he had enjoyed academic training; but even his choice of the new art college at Weimar, modern in outlook, was indicative of his leanings. In 1871 he met Mihály von Munkácsy (1844–1900), and the impact of the Hungarian's art confirmed Liebermann in his wish to paint a scene of everyday life in the earthy brown so prized by the realists. This picture was *Plucking Geese* (p. 434), a meticulous composition for all its vigorous brushwork. Its success was mixed; one critic damned Liebermann as the "apostle of ugliness", and his subject and technique alike bewildered the public, but he did find a purchaser for his first major work, Strousberg, a railway magnate and philanthropist.

We must pass over the factors that decided Liebermann for realism, such as his reading of Ferdinand Lassalles (1825–1864); social progress in Holland, where he travelled for the first time in 1871; or his observation of farm labour, of which Hans Rosenhagen left an account. Lieber-

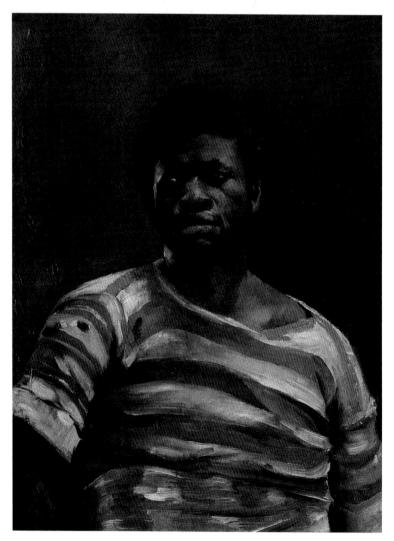

Lovis Corinth "Othello" the Negro, 1884 Neger "Othello" Oil on canvas, 78 x 58.5 cm Berend-Corinth 19 Linz, Neue Galerie der Stadt Linz, Wolfgang-Gurlitt-Museum

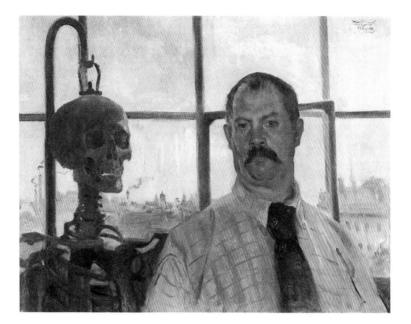

Lovis Corinth Self-Portrait with Skeleton, 1896 Selbsbildnis mit Skelett Oil on canvas, 66 x 86 cm Berend-Corinth 135 Munich, Städtische Galerie im Lenbachhaus

mann's love of the simple life probably derived less from political conviction than from his own well-to-do middle-class background and his childhood in the heart of Berlin. It is important to bear in mind that his use of subjects drawn from working life was not a reflection of the new German Empire's boom years, but rather a reflection of a pre-industrial state.

In 1872, a year after the Franco-Prussian War, Liebermann spent his first fortnight in Paris; other sojourns were to follow. He wanted to see the masterpieces of realist art, and was especially anxious to see Barbizon, the famous home of *plein-air* art, with his own eyes. But of greater moment for German Impressionism were his visits to Holland, which had lost its position as the centre of art over the centuries. In 1871 and subsequently, he repeatedly visited Holland, some of his stays there being lengthy - even before "Les maîtres d'autrefois" by Eugène Fromentin (1820–1876) sparked off a fashion for Holland. It is impossible to say what fascinated Liebermann most - the undramatic landscape with its distinctive colours; Rembrandt, Hals, and other old masters whose painterly liberty he felt kin to; or the works of contemporaries such as Mauve or Jozef Israëls. In a painting on a Dutch subject, The Orphanage at Amsterdam (p. 435), painted in 1881/82, Liebermann began to put the blacker shades of his early realism aside, and to brighten up his palette. For the first time he rendered sunlight falling through trees perfectly. It is a truly Impressionist perception; but it was not the fruit of any spontaneous inspiration, nor a sketch hastily set down. As Günter Busch rightly stresses, this composition - which seems so effortless and undeliberate - was the result of careful thought and months of hard work. What may be even more surprising is that maturer works of this kind

were not done in the open at all, but were studio paintings done in the traditional manner from sketches.

The Dutch period in Liebermann's work was followed by the Menzel period. Adolph von Menzel's virtuoso use of colour inevitably influenced his German Impressionist successors. Liebermann's *Munich Beer Garden* (p. 432) most strikingly reveals his debt to Menzel. This convivial scene of folk life, with its even brushwork, is still far removed from the major form of *Woman with Goats* (p. 442). Despite continuing spiteful criticism, Liebermann was now to score his first successes. His *Old Men's Home in Amsterdam* (private collection), painted in 1881, brought him the first French award made to a German painter since the Franco-Prussian War.

The other modern German painter to enjoy international success was Uhde. Born the year after Liebermann in 1848, he began studies at the Dresden Academy in 1866 but soon broke them off in order to serve as a soldier for the next ten years. In 1877/78 he settled in Munich and became a pupil of Munkácsy, with an interruption when he visited Paris in 1879/80. The pictures of the largely self-taught Uhde drew on the legacy of realism, and their narrative lyricism placed them squarely within the cliché conceptions of sentimental German sensibility in art. His pastose, patchy application attests the formal freedom now won by artists; but Uhde himself would never have embraced the full experimentalism of the French. Rather, the impact of his art derived from the tension between stylistic openness and expressive content – even if this conflict was generally neutralized in some form.

Bavarian Drummers (p. 439), painted in 1883, is set on a Munich parade ground. Uhde stresses the random positioning of his numerous figures – though it required meticulous study and endless preliminary sketching before he was satisfied with the arrangement. Both monumental and as incidental as a snapshot, the painting baffled the public. Uhde was more successful with *Walking to Bethlehem* (p.438), painted around 1890. This

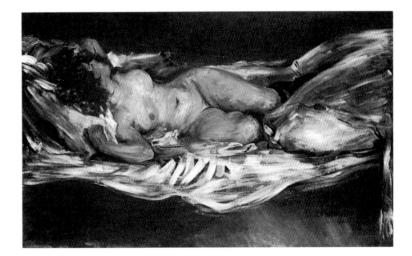

Lovis Corinth Reclining Nude, 1899 *Liegender weiblicher Akt* Oil on canvas, 75 x 120 cm Berend-Corinth 179 Bremen, Kunsthalle Bremen

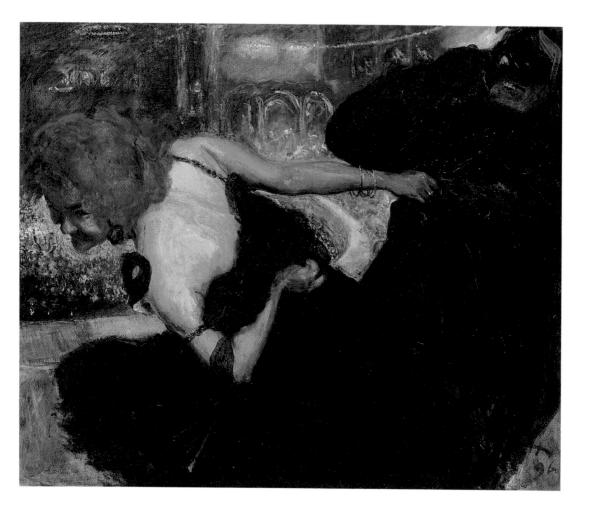

translation of Mary and Joseph's journey to Bethlehem into contemporary costume and a familiar environment was immediately accessible.

More Impressionist in subject and colouring was the 1892 *Two Daughters in the Garden* (p. 437). Though the subject is carefree, the painting is not without melancholy. The Impressionist style – which Uhde has not unreservedly embraced – retains its function of characterizing the girls. Admittedly Uhde has essayed a sense of the random moment and image, such as are essential to the Impressionist style; but his figures do not occupy their space with the disregard and independence of figures in Degas' work.

Trübner, born in 1851, was also of Liebermann's and Uhde's generation. The Munich International Art Exhibition of 1869, and meetings with Leibl, Courbet and Schuch, made a deep impression on him, and he used his new-found freedom to develop a highly individual style in representing the natural world (pp.449, 461). Trübner's brushwork was notable for its deliberation, and he juxtaposed and contraposed colours, albeit without dividing them. Like the German Impressionists generally, he respected the Max Slevogt Dance of Death, 1896 *Totentanz* Oil on canvas, 102 x 123 cm Nuremberg, Germanisches Nationalmuseum, Georg Schäfer Collection

Walter Leistikow

Sundown at Lake Grunewald, 1898 Somenuntergang über dem Grunewaldsee Oil on canvas, 167 x 252 cm Berlin, Staatliche Museen zu Berlin – Preußischer Kulturbesitz, Nationalgalerie

given colours of objects. While the group around Monet and Pissarro established an airy atmosphere by separating brush-strokes, Trübner's landscapes had a tactile three-dimensionality to them. His influence on the next generation in Germany cannot be exaggerated. Many younger artists, including those who did not study under him, admired him unreservedly and gladly acknowledged that they had learnt the most from him.

The most famous of them was Corinth, who met Trübner in Munich. Corinth had already spent several years at the extremely conservative Königsberg Academy, which was under the influence of Berlin, before moving to the Bavarian capital in 1880. There he studied under Defregger and Ludwig von Löfftz (1845-1910). In the early years, Corinth's development as artist was not untypical. His early portraits used the brown shades that had been preferred from Leibl to Franz von Lenbach (1836-1904). In 1884 he went to Paris and studied at the Académie Julian. As a German, he was not particularly popular; but he was proud of the praise of his tutor Bouguereau, the academic painter (p. 188). Like so many others, Corinth was torn between striking out in new directions and striving after official recognition, and he submitted to the Salon; but in 1887, when every one of his paintings was turned down, he returned to Germany a disappointed man. Not till 1890 did he receive the longedfor honourable mention for his Body of Christ (whereabouts unknown). His most forward-looking work of the period was "Othello" the Negro (p. 444), a portrait painted in Antwerp in 1884. In this picture, Corinth was free of narrative or anecdotal ballast; and the model is seen not only for painterly qualities but also with considerable empathy.

In the 1880s, Munich was the uncontested art centre of Germany, though by then its splendour as a royal city was fading. Slevogt, then aged just seventeen, moved there in 1885 to study at the Academy under Wilhelm von Diez (1839–1907). The following year, King Ludwig II, a devoted art lover, died; Slevogt drew him when the body was lying in

state. It was a moment in which one might emblematically see the changeover from one era to the next, or the co-presence of polar opposites.

The importance of the Munich Academy and its liberal approach is underlined by the impressive list of major German Impressionists who studied there before subsequently coming into their own. But the Munich Academy and its exhibition system were not at the sole service of the modern; the Piloty School was still dominant. Conflicts simmered between the various convictions and interests. Controversy over artists'

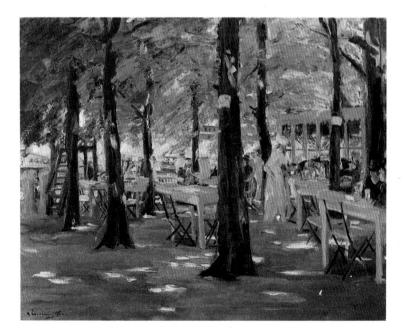

Wilhelm Trübner The Pub on Fraueninsel, 1891 Das Wirtshaus auf der Fraueninsel Oil on canvas, 48 x 65 cm Winterthur, Oskar Reinhart Collection

Max Liebermann

"De Oude Vinck" Restaurant, Leyden, 1905 Das Gartenrestaurant "De Oude Vinck" in Leiden Oil on canvas, 71.7 x 88 cm Zurich, Kunsthaus Zürich

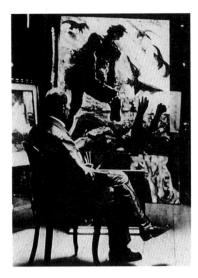

Lovis Corinth in his Berlin studio. 1917

participation in shows, and the constitution of juries, led to the first German Secession in Munich in 1892. The names of the founding members are a reminder of how various were the styles of those who felt the new group was the better home. The realists and Impressionists included Trübner, Uhde, Corinth, Slevogt, Zügel and Kuehl. Their first exhibition included works by Liebermann, and Degas and Monet too.

Berlin, the rapidly expanding new capital of a unified Germany, gradually began to outpace Munich as an art centre. In 1892, it is true, there was not vet a Secession group there; but the tensions between traditionalist and more progressive artists were unmistakable. In 1892 the Group of XI was formed there; among the members were Ludwig von Hofmann (1861-1945), Walter Leistikow (1865-1908) and Liebermann. Laforgue, a keen observer of the Berlin scene, had acutely noted in 1887 that the need for a change in the prevailing artistic climate was universally apparent. He even saw a connection between Modernist hopes and impending changes in the national leadership. Expectations of Emperor Friedrich III, who was seen as liberal, had been disappointed because he had reigned for only a short time, and his son Wilhelm II, despite his ostentatious enthusiasm for the arts, was in fact no friend of the innovatory. The foundation of the Group of XI was prompted by what became known as the Munch affair. At the recommendation of Uhde, the Norwegian artist Edvard Munch had been invited by the Association of Berlin Artists to exhibit; but when the show was opened and the members saw his work, they cancelled their invitation - an insult that prompted outrage among the moderns and liberals.

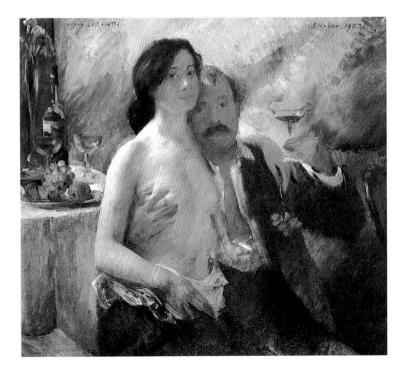

Lovis Corinth Self-Portrait with his Wife and a Glass of Champagne, 1902 Selbstbildnis mit seiner Frau und Sektglas Oil on canvas, 98.5 x 108.5 cm Berend-Corinth 234. Private collection

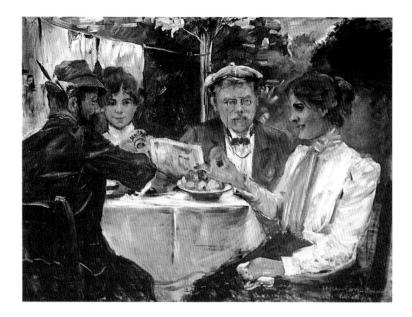

Lovis Corinth In Max Halbe's Garden, 1899 In Max Halbes Garten Oil on canvas, 75 x 100 cm Berend-Corinth 185 Munich, Städtische Galerie im Lenbachhaus

Liebermann had been awarded the small Gold Medal in 1888, his first official recognition, and from then on refused to participate in Academy exhibitions. He forfeited his chances of political patronage in Germany by taking up a doggedly cosmopolitan stance. In 1889, when the French Republic took the centenary of the Revolution as the main theme for the Paris World Fair, the German Reich declined to take part in an anti-monarchical event. In response, Liebermann organized private participation by German artists, with two aims in view: it was an opportunity for himself and fellow artists to have their work seen by an international public, and it was also a chance to bypass academic juries and put together a freely chosen selection of modern German art for viewing in France. He was subsequently awarded the Order of the Legion of Honour, but the Prussian government forbade him to accept the honour. Now the conflict was out in the open – and there were many who eagerly adopted it and made it a public issue.

It is important to bear in mind that even in the 1890s Impressionism was not yet established in Germany, and in fact never became the single dominant movement there. In France, the Impressionists were largely alone in their resistance to relatively pure academicism – and their last group show was held in 1886. The German Impressionists, however, emerged parallel with a number of modern movements. Interaction was inevitable.

The Munich Secession's umbrella for artists of very different kinds, and the triumph of Böcklin and Klinger, led to a kind of Art-Nouveaucum-Impressionism after 1892. Coming from their different points of departure, Corinth, Slevogt and Hofmann adopted formal features which did not – strictly speaking – belong together. Hofmann's lyrical reveries were expressed in an Art Nouveau idiom which used not the linear, graphic emphasis on contrast that was usual but the pastose brushwork of Impressionism. Corinth, in his 1892 *Portrait of Otto Eckmann* (Hamburg, Hamburger Kunsthalle), deliberately emphasized ornamental aspects of the picture's structure. The portrait, of one of German Art Nouveau's leading book and textile designers, uses brushwork that can only be described as decorative in its flourishes. Slevogt's *Dance of Death* (p. 447), painted in 1896 and entirely *fin de siècle* in mood, lacks any intermediate zone between foreground and background, and highlights colour contrast; art of this kind would have been inconceivable without the international poster art of the period.

In 1894, Corinth and Slevogt joined the Munich Free Association, a splinter group within the Secession that was soon dubbed the Megalomania Association. It included Trübner, Hans Olde (1855–1917), Thomas Theodor Heine (1867–1948), Otto Eckmann (1865–1902) and Peter Behrens (1868–1940), and thus both Impressionist and Art Nouveau artists. Both movements were active in "Simplicissimus", a leading periodical of the time. Böcklin's presence was great; Corinth's 1896 *Self*-

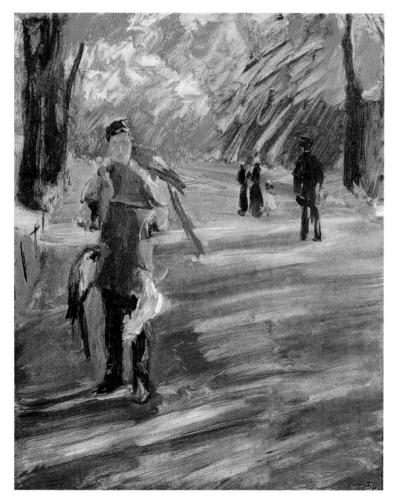

Max Slevogt Man with Parrots, 1901 Der Papageienmann Oil on canvas, 81.5 x 65.7 cm Hanover, Niedersächsisches Landesmuseum

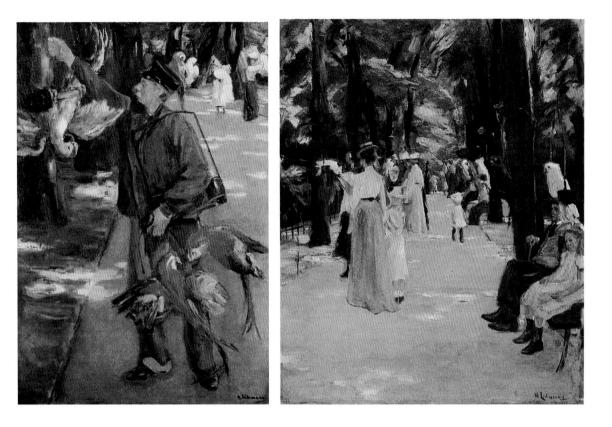

Portrait with Skeleton (p. 445) was a variation on the Swiss artist's approach to the traditional memento mori theme. The two pictures, referring to a long lineage in portrayals of life's vanity, are thematically comparable, but the differences in approach are striking: where Böcklin uses colour nuances, and the proximity, facial expressions and gestures of the protagonists, seen against an undefinable background, to create a mysterious atmosphere, Corinth deliberately avoids all unclarity whatsoever. The skeleton on its hook is plainly an anatomical model. The painter is beside it, but no relation is established between him and the skeleton. Corinth does not pressure us into any specific interpretation; rather, we are left alone to ponder dry bones and a fleshy painter. A stock in trade of Symbolist anecdote has become a sober record of things as they are.

In his study "Der Subjektivismus in der Malerei" (1892), Hugo Ernst Schmidt claimed that the triumph of Impressionism had been total: "Liebermann and Uhde are in all the state galleries. Peaceloving citizens are momentarily disquieted at this state of affairs, then they think: ah, so this is a new period in art, and they turn over and go back to sleep." But talk of an Impressionist victory was premature optimism. As late as 1895, Woldemar von Seidlitz regretfully noted that Liebermann, whom he revered, still appalled exhibition visitors. In the years before the Berlin Secession too was founded – which finally ensured a breakthrough for German Impressionism – many of the works now considered to be the

Max Liebermann Man with Parrots, 1902 *Der Papageienmann* Oil on canvas, 102.3 x 72.3 cm Essen, Museum Folkwang

Max Liebermann

The Parrot Walk, 1902 Die Papageienallee im Zoo von Amsterdam Oil on canvas, 88 x 72.5 cm Bremen, Kunsthalle Bremen

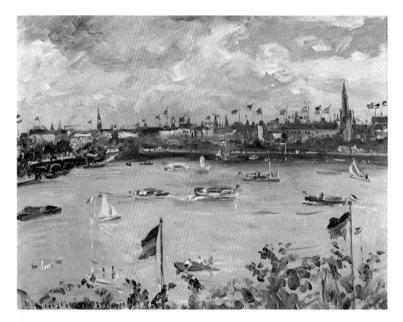

Lovis Corinth Emperor's Day in Hamburg, 1911 *Kaisertag in Hamburg* Oil on canvas, 70 x 90.5 cm Berend-Corinth 483 Cologne, Wallraf-Richartz-Museum

movement's major achievements were painted. Liebermann put dark colours and melancholy portrayals of rural toil behind him. Following the 1889 *Mending the Nets* (Hamburg, Hamburger Kunsthalle) and the 1890 *Woman with Goats*, which earned him a major Gold Medal in Munich and was bought by the Pinakothek there, he turned to lighter subject matter (and for his trouble was later deemed by art historians to have abandoned social commitment in order to pander to middle-class taste). Stylistically, the lightening of Liebermann's palette and his more rapid completion of work brought him closer to the French. Degas, who had already been struck by the controversial history painting *Christ in the Temple* (Hamburg, Hamburger Kunsthalle), praised the 1898 Boys

Max Slevogt The Alster at Hamburg, 1905 Blick auf die Alster bei Hamburg Oil on canvas, 59 x 76 cm Berlin, Staatliche Museen zu Berlin – Preußischer Kulturbesitz, Nationalgalerie

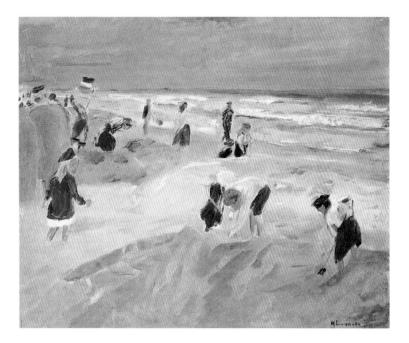

Max Liebermann The Beach at Nordwijk, 1908 Strandszene in Nordwijk Oil on canvas, 66 x 80.5 cm Hanover, Niedersächsisches Landesmuseum

Bathing (p. 443). Their respect was mutual; that same year, Liebermann published an article on Degas in the periodical "Pan". Slowly but surely, official recognition followed. In 1896 Liebermann was belatedly allowed to accept his Order of the Legion of Honour, which indicated that Franco-German détente was proceeding; and the following year a large exhibition and his appointment to a chair at the Royal Academy of Fine Art in Berlin confirmed that he had finally arrived.

Corinth differed from Liebermann, not only in temperament. He moved on from his occasionally stiff adoptions of Leibl and Art Nouveau, and in 1899 his *Reclining Nude* (p. 446) demonstrated a thoroughly natural use of Impressionist style for figure painting. German Impressionism's major works tended to be painted not in the landscape area (as with the French) but rather in nudes and portraits. While Liebermann always retained a sense of distance when approaching his models, Corinth took greater liberties and penetrated deeper into the inner soul. His 1899 portrait of Rosenhagen the critic's mother (Berlin, Nationalgalerie) anticipated his later arrestingly characterful portraits; the study goes far beyond a record of facial features and includes the relation of the figure to the surrounding space in its interpretation of personality.

The growing interest in Impressionism was connected with the shift in the art centre from Munich to Berlin. German art, previously splintered into many little schools, seemed to have found its focal base in the expanding metropolis, and in this respect was in line with political developments in the new empire. Liebermann, born in Berlin, was now the patriarch whose organizational talent was marked by a tolerance and understanding of younger artists, and soon many who had turned their backs on Munich were gathering about him. One after another quit Bavaria – from Corinth, whose *Salome* (Leipzig, Museum der bildenden Künste) had been turned down by a Munich jury in 1899, to Slevogt, who had his first solo show at Cassirer's in Berlin in 1899.

The Berlin Secession, founded relatively late, provided an umbrella for new and established, German and foreign artists. Though they espoused no single aesthetic, the group had the aura of an avant-garde. Its establishment was prompted in 1898 by a controversy over a picture by Leistikow that brings home how powerful the "enemies" (Peter Paret) of modern art were in Germany. The jury of the grand Berlin Art Show had rejected his *Sundown at Lake Grunewald* (p. 448). It is difficult now to imagine why so innocuous a painting should have

GERMANY 456

Albert Weisgerber Riding in the English Gardens, Munich, 1910 Ausritt im Englischen Garten in München Oil on canvas, 60 x 70.5 cm Saarbrücken, Saarländisches Landesmuseum

sparked a row; but the academicians' veto was felt to be particularly outrageous because Leistikow's elegiac impression combined the atmospherics of Nature with Art Nouveau characteristics and was thus squarely in line with a late Romantic tradition. Subsequently the painting was privately bought and donated to the Nationalgalerie. When the director of the gallery, Hugo von Tschudi, showed the painting to Kaiser Wilhelm II not long after, in order to show that contemporary German art was going its own way, he was brusquely informed that the picture did not record Nature as it truly was - after all, he was familiar with the Grunewald area from his hunting outings. The Kaiser's (poor) adviser and mouthpiece in questions of art was Anton von Werner (1843–1945), president of the Academy and the artist who painted the proclamation of the German Reich. The opposition of the Kaiser and von Werner had the unintended effect of encouraging the new aesthetics and consolidating Berlin's position as the centre of German Modernism. The time to cast off the yoke of academic tutelage had come. Liebermann became president of the Berlin Secession and Leistikow first secretary. Curt Herrmann (1854-1929), Ludwig Dettmann, Otto Heinrich Engel (1866–1949), Oscar Frenzel (1855–1915) and later Franz Skarbina (1849-1910) were all in the committee, which put Impressionist painters in a dominant position. Leistikow was seen as the motor behind the movement. The sixty-five members quickly prepared their first exhibition. First they demanded their own, separate, unjuried rooms at the Berlin Art Show - their main principle being the freedom to choose the work by which they were represented themselves, through an independent hanging committee.

457 GERMANY

Max Slevogt Garden at Neu-Cladow, 1912 Blumengarten in Neu-Cladow Oil on canvas, 66 x 83 cm Münster, Westfälisches Landesmuseum für Kunst und Kulturgeschichte

We should not underestimate the economic importance of the annual exhibitions. The Secessionists were primarily hoping for liberalized competition on an open and flourishing art market. No compromise could be reached, nor was it realistic to suppose that it could be. On 20 May 1899 the first Secession exhibition was opened, in purpose-built premises financed by donations. The opening was a social occasion that rippled far beyond the circumscribed circles of the connoisseurs and patrons of avant-garde art.

That first exhibition included work by Secession members and other Berlin artists, but also took as its avowed aim the presentation of a broad range of contemporary German work, including that of Böcklin, Leibl and Hans Thoma (1839–1924). In future years, the Secession vindicated its international stance by exhibiting such foreign artists as Bonnard, Cézanne, Gauguin, Ferdinand Hodler (1853–1918), Toulouse-Lautrec, van Gogh and others (without establishing any discrimination according to country of origin). Hodler, the Swiss artist, was represented by the strongly linear work characteristic of his art. His realistic, Impressionist phase, seen in such paintings as *Apple Tree in Blossom* or *Portrait of Louise-Delphine Duchosal* (p. 440), was already a thing of the past.

Twenty-seven years after Impressionism was born in the Société anonyme's exhibition in Nadar's rooms, the principle of disinterested pleasure as a criterion for assessing art now seemed established, and the arduous struggle for the freedom of art was bearing fruit. Yet the artists and their backers were as unable as ever to stay out of political controversy. Politics across the entire spectrum, from right to left, assumed it had proprietary rights in art. Whether they wished it or not, artists were drawn into politics. This process began in art criticism, which often, lacking formal arguments, vilified art of an unwelcome political persuasion through innuendo. Secessionists were seen as social democrats, revolutionaries, or even anarchists, while academic artists were considered good monarchists loyal to the Kaiser. Again, Wilhelm II was largely to blame. In a notorious speech on the opening of Berlin's Siegesallee in 1901, he accused modern art of merely presenting wretchedness in an even more miserable light than it normally appeared in. It was an art of misery and the gutter, he declared; and the terms stuck, being used in particular of the Secessionist line in Impressionism.

The first ten years following the founding of the Berlin Secession in 1899 may be considered the heyday of German Impressionism. Important works included Liebermann's *Man with Parrots* and *The Parrot Walk* (p. 453), both painted in 1902, and numerous beach scenes (p. 455); Corinth's 1902 *Peter Hille* (Bremen, Kunsthalle), his 1905 *Childhood of Zeus* (Bremen, Kunsthalle) and his 1906 *Rudolf Rittner Playing Florian Geyer* (Wuppertal, Von der Heydt-Museum); Slevogt's studies done at Frankfurt Zoo (*Man with Parrots*, p. 452) as well as his pictures of the singer Francisco d'Andrade as Don Giovanni; and the major works of the minor artists. Many of the minor artists have been unjustly forgotten, and we do well to recall some of them. Of the elder

Max Liebermann At the Races, 1909 Pferderennen in den Cascinen Oil on panel, 52.5 x 74 cm Winterthur, Kunstmuseum Winterthur

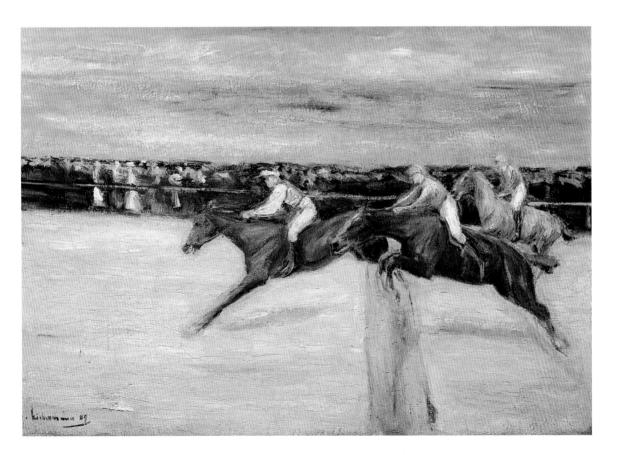

Fritz von Uhde In the Garden (The Artist's Daughters), 1906 Im Garten (Die Töchter des Künstlers) Oil on canvas, 70 x 100 cm Mannheim, Kunsthalle Mannheim

generation whose Impressionism was of a moderate kind there were Kalckreuth and Kuehl, as well as the "Salon" Impressionists Ulrich Hübner (1872–1932), Skarbina, and Karl Hagemeister (1848–1933), who emphasized effects that were easy on the eye. Ury, whose painting of streets wet after rain had made his name, was a more versatile painter than these. Paul Baum (1859–1932) and Curt Herrmann were too much under the influence of the French, and especially of the Pointillists and Post-Impressionists; Christian Rohlfs (1849–1938; p. 456) was an eclectic in whom all the styles met; and Oskar Moll (1875–1947) and Weisgerber (p. 457) were already betraying the influence of the Fauves.

The achievements of those years may tempt us to forget that Impressionism was not the sole predominant movement in Germany. A younger generation was already emerging, anxious to go beyond Impressionism. They built on the freedom that had been won in order to state aesthetic positions that expressed different, more turbulent temperaments as well as different goals. The Impressionists, who had once been the rebels fighting institutionalized, academic intransigence, were now themselves seen as the Establishment. Their mounting irritation at the Expressionists was primarily a product of a generation gap and the resulting conflict.

In 1906, when Wilhelm II had once again refused to approve an Academy exhibition in Liebermann's honour, the latter himself turned down *Young Men at the Sea* (Weimar, Schloßmuseum), which Max Beckmann (1884–1950) had submitted for the next Secession show. The grand master of German Impressionism, hitherto so generous to younger artists, was quick to see that the painting could be interpreted as a deliberately antithetical response to Liebermann's own more cultivated art.

And Corinth's uncomprehending reaction to his juniors was even crasser. His execration of Matisse was couched in language that scarcely bears quotation and is in no wise more restrained than the dismissals he himself had once had to endure.

The Berlin Secession presently hit an internal crisis. In 1908, Leistikow died. He had been the mainspring and spirit of the group; and now the differences in the members' views became irreconcilable. Among them

Wilhelm Trübner Neuburg Gates, Heidelberg, 1913 Tor zum Stift Neuburg bei Heidelberg Oil on canvas, 62 x 80 cm Mannheim, Kunsthalle Mannheim

Max Slevogt Steinbart Villa, Berlin, 1911 Der Vorgarten der Steinbartschen Villa in Berlin Oil on canvas, 85.5 x 105.5 cm Private collection now were Lyonel Feininger (1871–1956), Erich Heckel (1883–1970), Wassily Kandinsky (1866–1944), Ernst Ludwig Kirchner (1880–1938), Paul Klee (1879–1940), Emil Nolde (1867–1956), Max Pechstein (1881–1955) and Karl Schmidt-Rottluff (1884–1976) – painters who no longer had much in common with either Art Nouveau or Impressionism. The rejection of Beckmann was symptomatic. In 1910, the year before the "Brücke" Expressionist group was founded, the committee excluded 27 painters in the selection process – the younger ones whose art the elder did not understand. Nothing could prevent the Secession from falling apart now. In 1911 Liebermann resigned his presidency, and began to lead a more private life, a decision which was of course reflected in his art. From now on he mainly painted his garden or beach scenes, with the occasional commissioned portrait.

There was a caesura in Corinth's creative life too. Not long after Liebermann's resignation from the shaky Secession, he had a stroke, in December 1911, which threatened to limit his ability to paint. Corinth steeled himself to control the shaking of his hands; and his new physical state was so far from crippling his style (as was later disagreeably claimed) that a comparison of later works (p. 463) with *Emperor's Day in Hamburg* (p. 454), painted in August 1911, shows no falling off whatsoever in his sovereign command of the fleeting effect. It is true, though, that his struggle to paint did cost him a certain lightness; and it is all the more admirable that in his *Portrait of Julius Meier-Graefe* (p. 463) he

Max Liebermann Self-Portrait, 1911 Selbstbildnis Oil on canvas, 81 x 65 cm Private collection

Max Slevogt Portrait of Mrs. C., 1917 *Bildnis Frau C.* Oil on canvas, 71 x 52 cm Private collection

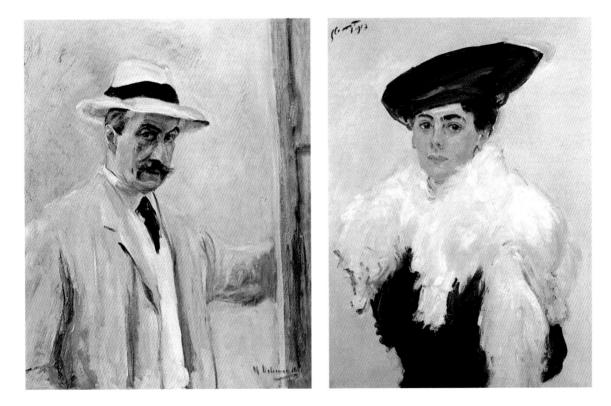

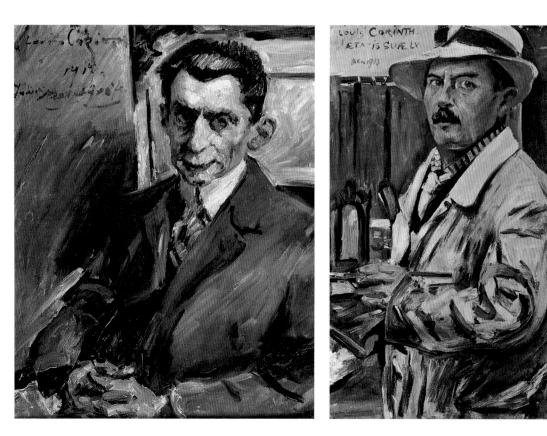

harmonized colour and form without any sense of untruthfulness to the sitter.

As a member of the Berlin Secession committee, Slevogt had never played a particularly prominent part in organizational matters. The south German Slevogt is a curiously elusive character, compared with Berlin's intellectual, disciplined Liebermann or the sanguine, melancholy East Prussian Corinth. After the disintegration of the Secession, he used the time up to the outbreak of the First World War to paint some of his finest lyrical pictures. No other German Impressionist achieved the lightness of touch that distinguishes his Neu-Cladow (1912) and Egyptian (1913/14) paintings.

If the Franco-Prussian War had clouded relations between the two peoples for some time, the renewed military conflict put an abrupt stop to the productive interchanges of younger artists. Widespread national hysteria even infected the more level-headed Impressionists, who in 1911 had defended Gustav Pauli (curator of the Bremen Kunsthalle) against charges that his buying policy neglected German art in favour of French.

Robert Sterl (1867–1932) and Slevogt became war artists. The fighting stopped the promising career of Weisgerber, who had been finding an individual path of his own between Impressionism and Expressionism, and also lost the more famous August Macke (1887–1914) and Franz Marc (1880–1916) to art. Most of the major Secession artists were too

Lovis Corinth

Portrait of Julius Meier-Graefe, 1917 Bildnis Julius Meier-Graefe Oil on canvas, 90 x 70 cm Berend-Corinth 688. Paris, Musée d'Orsay

Lovis Corinth

Self-Portrait in a Straw Hat, 1913 Selbstbildnis mit Strohhut Oil on canvas, 98 x 66 cm Berend-Corinth 576 Wuppertal, Von der Heydt-Museum

Lovis Corinth Easter at Lake Walchen, 1922 Ostern am Walchensee Oil on canvas, 60.5 x 80 cm Berend-Corinth XVI. Private collection

old to fight, but they contributed to Cassirer's "Kriegszeit", a crudely propagandist publication that used Impressionist graphics. In 1915 Liebermann painted a portrait of Field Marshal von Bülow; Corinth, failing to win Hindenburg for a sitting, made do with Admiral von Tirpitz (Berlin, Deutsches Historisches Museum). Slevogt's penchant for narrative produced a cycle of works dealing with Fernando Cortez, viewing war and conquest through the lens of history painting.

Patriotic art of this kind, together with the public's increasing familiarity with Impressionism (which now seemed almost academic beside the incomprehensible art of the younger Expressionist and Cubist painters), finally produced the long-desired recognition in the highest quarters. In 1917, on the artist's 70th birthday, Liebermann was awarded the Order of the Red Eagle, third class, by the Kaiser, and given a major exhibition at the Berlin Academy of Fine Arts. That same year, Slevogt was put in charge of a master class, and the following year, on his 60th birthday, Corinth was appointed to a chair.

In 1918 Corinth paid his first visit to the Walchensee, a lake in Upper Bavaria. In a manner comparable with Liebermann's Wannsee pictures or Monet's waterlilies, Corinth painted a series of compositions, over the next few years, in which the representation of what he actually saw became less and less important, and the autonomy of painting itself became the true subject (p. 464). The painter of the actual became a painter of the metaphysical, as the art historian Wilhelm Hausenstein (1882– 1957) noted; or, in Kirchner's words, "He began mediocre and ended great." The Expressionist's words are respectful but convey only insufficiently how much the following generation owed to Impressionism.

Lovis Corinth Self-Portrait in a Straw Hat, 1923 Selfsbildnis mit Strohhut Oil on card, 68.5 x 84 cm Berend-Corinth 925 Bern, Kunstmuseum Bern

Without the art of their predecessors, the Expressionist achievement would have been inconceivable.

The years of the Weimar Republic marked the end of German Impressionism. They had prompted a great deal of change, and now viewed the new styles with suspicion and adhered to their own. Free of financial worries, painting whatever subjects they chose, they created late masterpieces in the 1920s, even if they no longer established the image of the period. To the very end, Corinth and Slevogt tried to reconcile Impressionism and history painting. It was no coincidence that the subject of Corinth's great painting of 1925 was *Ecce Homo* (Basle, Kunstmuseum) and that Slevogt worked till his death in 1932 on the *Golgotha* fresco in the Church of Peace in Ludwigshafen.

The barbarism that clouded the arts in the years ahead, culminating in the notorious 1937 exhibition of "degenerate" art, even made posthumous attacks on Corinth, who had not failed to love the fatherland. The Nazi ideologues arrived at a medical compromise, as it were, damning the work Corinth painted after his stroke of 1911 as "degenerate". Liebermann lived to see the changes the Nazis implemented. The eldest of the three great German Impressionists, he was also the only Jew in the group. He had been given the freedom of the city of Berlin in 1927, but after the Nazis came to power he was out of favour, and there were no official regrets when he resigned from the Academy (of which he had been Honorary President since 1932). He had helped to fire "the light of freedom" (Hermann Uhde-Bernays), and now lived to see it extinguished.

Andreas Blühm

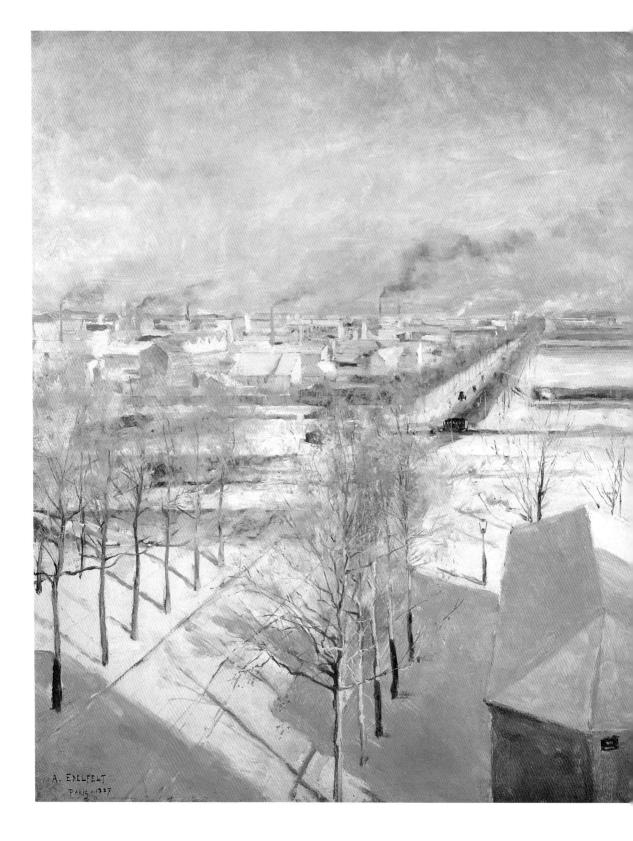

12 The New Reality: Impressionism in Scandinavia

Scandinavian Artists in Paris

Around 1870, growing numbers of Scandinavian artists took to visiting Paris, the modern metropolis with its many-sided art scene. Travel abroad had long been a tradition among artists once they graduated from the Academy, and the intense light of the south exerted its old attraction on the new generation too, not least since this was the heyday of pleinairisme (and studio work from open-air sketches). The artists who travelled in the 1870s and 1880s were not only questing for new experiences and new horizons, though; what was new about their journeyings was their wish for guidance in the private schools and studios of Paris. The artists financed their travels partly from public funds and partly through affluent private patrons. Typically, a Scandinavian artist's period abroad would last two or three years, allowing time to go to a college and to travel outside Paris, frequently to Italy or Spain. In some cases, artists remained in France for a whole decade. During the same period, numerous artists also attended German colleges of art in Berlin, Karlsruhe, Munich and Düsseldorf.

We shall be looking at about 35 Danish, Finnish, Norwegian and Swedish artists who extended their technical skills in Paris. We shall give equal attention to all four nationalities, though in fact the Swedes were somewhat in the majority, doubtless because there was a Swedish artists' colony at Grèz-sur-Loing.

A large number of northern artists attended the school of Léon Bonnat (1833–1922). Among them were Laurits Tuxen (1853–1927), Theodor Esbern Philipsen (1840–1920), Peder Severin Krøyer (1851–1909), Helene Schjerfbeck (1862–1946), Hans Olaf Heyerdahl (1857–1913), Harriet Backer (1845–1932), Edvard Munch (1863–1944) and Prince Eugene (1865–1947). Some, such as Albert Edelfelt (1854–1905), Schjerfbeck and Ernst Abraham Josephson (1851–1906), were tutored by Gérôme; others went to the Académie Julian, among them Akseli Gallen-Kallela (1865–1931) and Eero Järnefelt (1863–1937); still others, such as Richard Bergh (1858–1919), Hanna Pauli (1864–1940), Nils Kreuger (1858–1930), Anna Ancher (1859–1935) and Maria Wiik (1853–1928), attended the Académie Colarossi, where they were able to work under the guidance of various artists – the last three, for instance,

Albert Edelfelt Paris in the Snow, 1887 Paris i snö Oil on panel, 46 x 37 cm Helsinki, Ateneumin Taidemuseo taking classes with Puvis de Chavannes. Though some of the French tutors are no longer assigned an important role in art history, at the time they were well respected in the Salon milieu. Tuition at Bonnat's stressed formal aspects rather than colourism. The study of *valeurs* was important (the significance of light in the overall impact of a picture). Though the watchword was *simplicité*, artists were unlikely to learn colourist freedom at Bonnat's. Painting in the open offered a great challenge; it had been made usual around 1830 by the Barbizon painters (Rousseau, Daubigny, Corot) and was a crux for the Impressionists. The examples Scandinavian artists followed in figure painting were those of realist painters such as Bastien-Lepage, Millet and Breton, with their sentimental scenes of lower-class life. Work with a clear social message was not always conducive to the evolution of distinctively painterly qualities, but in this respect the Impressionists were able to offer new solutions in regard to both subject matter and the approach to colour and light.

The Encounter with Impressionism

None of the artists we are concerned with seems to have had any closer personal contact with any of the Impressionists; and we have only sporadic, chance information concerning the Scandinavian artists' response to the new style. In 1882, Erik Werenskiold (1855–1938) wrote a perceptive account of the new aesthetics in an article on the Impressionists in the "Nyt Tidsskrift". One thing he emphasized was the Impressionists' aim to present the visible world not only as we suppose we know it but also as it really appears. To Werenskiold's way of thinking, the movement's breakthroughs lay in the painting of movement and of daylight.

That same year, the Norwegian Lorentz Dietrichson wrote a polemical retort to Werenskiold; his article was published in 1884 in "Norsk Maanedsskrift for Literatur, Kunst og Politik". Dietrichson felt that the Impressionists did not reproduce Nature as they saw it, but rather created an abstract image of it, by dividing colours into component parts and by using colourist rather than formal means to convey motion. He drew attention to technological and scientific developments, and stressed photography's ability to record the passing moment as one of the many preconditions that had made Impressionism possible.

In 1886 Werenskiold summarized the Impressionist influence in selfassured, categorical terms in the Oslo newspaper "Aftenposten": "Many have come under their influence, but unless I am much mistaken only Krohg and myself have made Impressionism their own central artistic principle... There may be one or two others among the younger generation." Christian Krohg expressed things more diffidently in a lecture on "Art and Culture" delivered the same year to a student association. He commented: "We, the present generation of Norwegian painters that includes myself, are not Impressionists – alas! All we can do is stand on the mountain gazing into the Promised Land."

Viggo Johansen Near Skagen Østerby after a Storm, 1885 *Udkanten af Skagen Østerby efter en tordenbyge* Oil on canvas, 95 x 147 cm Skagen, Skagens Museum

Karl Frederik Nordström A Clearing in the Woods at Grèz, 1882 Skogsgläntan, motiv från Grèz Oil on canvas, 114, x92 cm Norrköping, Norrköpings Konstmuseum

Nils Edvard Kreuger Gypsy on Öland, 1885 *Tattare på Öland* Oil on panel, 32 x 41.5 cm Malmö, Malmö Museer

Erik Werenskiold Shepherds on Tåtøy, 1883 *Gjitere. Tåtøy* Oil on canvas, 59 x 65 cm Oslo, Nasjonalgalleriet

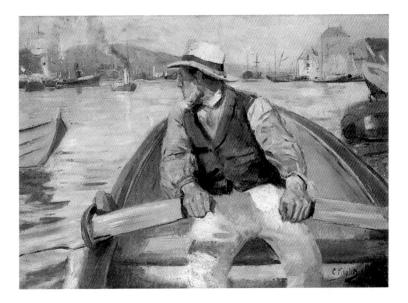

Christian Krohg Look ahead. The Harbour at Bergen, 1884 Se forut, Bergens våg Oil on canvas, 62.5 x 86 cm Oslo, Nasjonalgalleriet

Artists' Colonies

When summer arrived and tuition ceased at the private schools in Paris, the artists deserted the city. The coast of Brittany was especially popular for painting holidays. Krøyer, Schjerfbeck and Wiik worked at Concarneau, Järnefelt at Veneux-Nadon, and Munch at Saint-Cloud. In the 1880s, there was a Swedish artists' colony at Grèz-sur-Loing, by the Fontainebleau woods. Among the regular visitors were Kreuger, Bergh, Karl Nordström (1855–1923), Carl Olof Larsson (1853–1919), Bruno Liljefors (1860–1939) and Anshelm Leonhard Schultzberg (1862–1945). Krohg was there too, in 1882.

In due course they took the idea of the artists' colony back to Scandinavia with them. The most famous of the northern colonies was at Skagen. Many artists went straight there after their periods abroad, and its importance as a place where new ideas were absorbed and transmitted, helping the further development of northern art, must be stressed. Among those who used Skagen were Krøyer and Krohg, and other Danish, Norwegian and Swedish artists returned there every summer, to paint in the fine northern light in the company of friends old and new.

Plein-air Painting

Studies in Parisian academies were one thing, independent work in the summer countryside another thing altogether. The wish for Salon acceptance prompted many artists to defer to prevailing taste for four-square academic formal discipline – which ran utterly counter to attempts at a direct presentation of the real. To what extent artists were satisfied with immediate responses to Nature was a question of individual disposition, but the Impressionist example certainly exerted a strong influence on Scandinavian artists. Brief brush-strokes like commas, and a light, unmixed palette – both hallmarks of Impressionist art – made little impact on northern artists, though, even if a few of them did see the advantages of the technique.

One of these few was Johansen, as can be seen from his *Near Skagen Østerby after a Storm* (p. 473), painted with Monet's influence still fresh. Sheep are grazing in the foreground, while on the horizon, which divides the picture in two, we see Skagen with its mill, lighthouse, and the yellow-painted houses with their red tiled roofs. The

painting lacks compositional tension, but the observation of Nature is exact: the crystal clear air after the downpour seems to put a greener sheen on the grass, while a delicate rainbow still stands out against the fading blue-black storm clouds and the massive white cumulus clouds on their heels. The lighter clouds have caught a hint of pink and brown from a low sun, which is also giving the sheep a touch of gold. In *St. John's on Tisvilde Beach* (p. 481) Paulsen presents a dramatic natural scene. His unusual freedom of colour and technique introduces a dynamic feel to the fleeting moment; once again we sense the presence of Monet.

Of the Danish landscape painters, it was unquestionably Philipsen who had the soundest grasp of Impressionism and most consistently adopted its views on light, colour and brushwork. His speciality was in fact animal paintings, but his pictures of spring or autumnal landscapes Peder Severin Krøyer Hip Hip Hooray! An Artists' Party at Skagen, c. 1884–1888 Hip, hip, hurråa! Kustnerfest på Skagen Oil on canvas, 134.5 x 165.5 cm Gothenburg, Göteborgs Konstmuseum

near Copenhagen shared the distinctive mood of Pissarro and Sisley. The shadows of trees and fenceposts in *A Lane at Kastrup* (p. 486) were done in the bluish violet characteristic of Impressionism. The colours are cool, and soft, yellowish light veils the red rooftops in the background.

Nature and Civilization

In spring 1888, during his first sojourn in France, Westerholm painted *The Seine at Paris* (p. 487). The cloudy sky, the river diagonally crossing the canvas, and the tree that anchors the composition, were all in line with classic landscape art. But the picture also betrays a modern eye which makes its important, non-idyllic contribution to the visual struc-

Peder Severin Krøyer Artists at Breakfast, 1883 *Ved frokosten* Oil on canvas, 82 x 61 cm Skagen, Skagens Museum

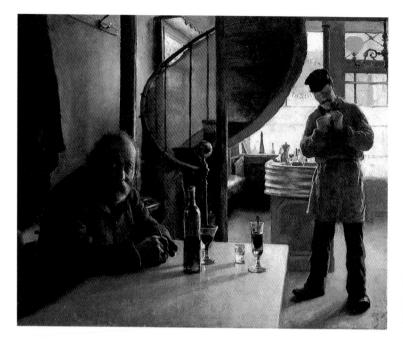

Eero Järnefelt Lefranc the Wine Merchant, Boulevard Clichy, Paris, 1888 *Fransk vinstuga* Oil on canvas, 61 x 74 cm Helsinki, Ateneumin Taidemuseo

ture. The three factory chimneys positioned as counterpoints to the tree, and the iron bridge marking the divide between water and sky, document the relentless advance of modern civilization. If Westerholm's choice of subject naturally included an awareness of the Impressionist eye for light and atmospherics, it also emphasized the collision of industrialization with unspoilt Nature – a recurring motif in Impressionism, and one which we shall encounter repeatedly in various guises.

Man and Nature

In his first summer working at Grèz, Nordström was totally under the influence of the seventh Impressionist exhibition. A Clearing in the Woods at Grèz (p. 473) does not seem fully committed to Impressionist technique, though; the filigree of the slender tree trunks retains a linear clarity. The leafage and ground, on the other hand, are a shimmering fabric of green, blue and ochre brush-strokes such as might satisfy even the most orthodox of Impressionists. The female figure near the point where the path vanishes may seem to have been positioned by chance, but in fact she has her specific spatial and narrative part to play in the overall composition.

Werenskiold too attended the Impressionist exhibition in spring 1882. Later that year, on Tåtøy, an island off Norway's Sørland coast, he painted *Shepherds on Tåtøy* (p. 474). The influence of Pissarro is again apparent; a large proportion of the 35 works the French artist exhibited in 1882 depicted farm girls and shepherdesses. His figures, seen resting,

Christian Krohg Portrait of the Artist Gerhard Munthe, 1885 Maleren Gerhard Munthe Oil on canvas, 150 x 115 cm Oslo, Nasjonalgalleriet

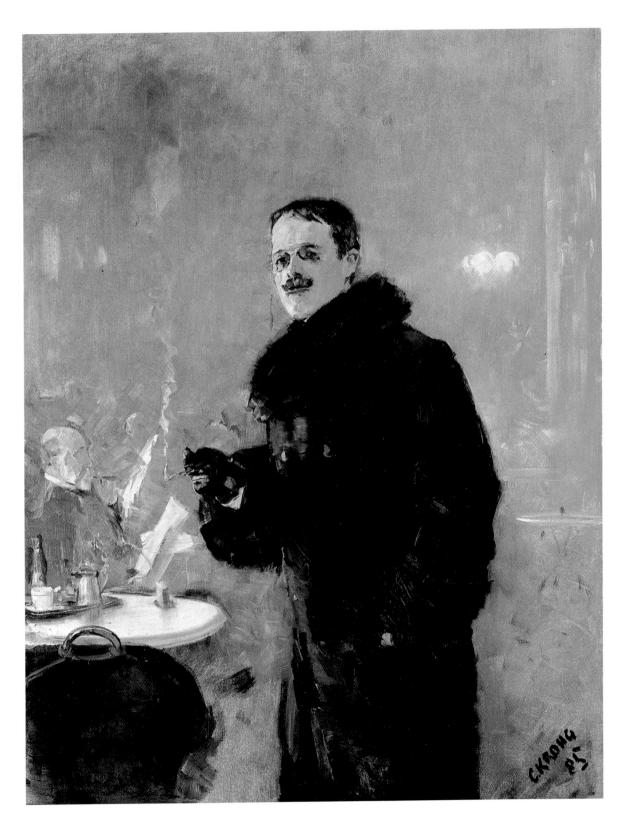

talking or knitting, typically seem organic parts of the natural setting, an impression that Pissarro emphasized through his brushwork, outlining both the figures and the landscape features in short, pastose strokes using mainly unmixed colours. The total impact was reinforced by placing the horizon very high in the picture, or eliminating it altogether, so that the landscape seems to mantle the figures. Werenskiold has adopted this approach in placing his three children, who, supposedly looking after the cattle grazing in the background, have in fact sought the shade of trees on a hot afternoon in late summer. None of the three is positioned above the horizon; rather, they seem embedded in the landscape. The brushwork is Impressionist only in part, without the determined consistency of Pissarro's. The treatment of the figures strikes us as more a result of Bonnat's tuition, which involved the detailed study of models and work on *valeurs*.

Effects of Light

The mid-1870S saw the peak of Renoir's experiments with the effect of sunlight falling through foliage and dappling figures and objects with a patchwork of shadow and light. His paintings *Nude in the Sunlight* (p. 162), *The Swing* (p. 144), and *Le Moulin de la Galette* (p. 153) provided first-rate, striking examples of this effect. For painters elsewhere, this was a novelty and a breakthrough. Pauli's *Breakfast* (p. 482) may have been inspired by Monet's 1873 *The Luncheon* (p. 119). Both pictures feature a laid table with garden seat and chairs in the shade. In Monet's, lunch has just been finished and the table left; in Pauli's, breakfast is about to begin. The central motif in both paintings is the laid table and the white cloth, while the figures – in the one, a boy playing and

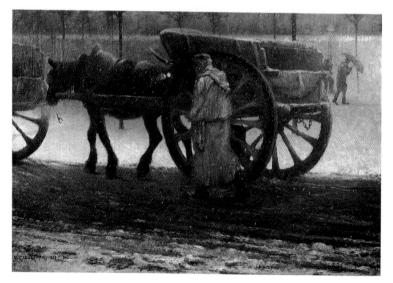

Nils Edvard Kreuger Snowy Weather, Paris, 1885 *Snöväder i Paris* Oil on canvas, 127 x 184 cm Stockholm, Prins Eugens Waldemarsudde

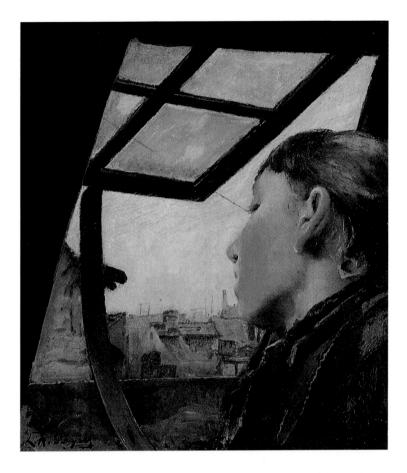

Laurits Andersen Ring Girl Looking out of a Skylight, 1885 *Ung pige, der ser ud af et tagvindue* Oil on canvas, 33 x 29 cm Oslo, Nasjonalgalleriet

Julius Paulsen St. John's on Tisvilde Beach, 1886 *Sankt Hans nat ved Tisvilde strand* Oil on canvas, 63 x 75.5 cm Copenhagen, Statens Museum for Kunst

Hanna Pauli Breakfast, 1887 *Frukostdags* Oil on canvas, 77 x 107 cm Stockholm, Nationalmuseum

ladies strolling in the background; in the other, a servant with a tray – make an incidental impression and serve merely to amplify the narrative content. Pauli's cloth is dappled with light and shadow, and the glasses, china and metal pots are catching the light that is falling through the foliage.

Krøyer tackled a similar motif in *Hip*, *Hip*, *Hooray! An Artists' Party* at Skagen (p. 476). The composition was based on a photograph taken in summer 1884. The party was in the garden of the Anchers (husband and wife were both artists) at Skagen. We see the artists raising their champagne glasses in a toast. Among those present are Johansen, Krohg, the Anchers themselves, Oscar Björck (1860–1929) and Thorvald Niss (1842–1905). The motif of movement captured in the male group is nicely complemented by the tranquillity of the seated women and the child.

Josephson pursued similar effects of light in Brittany, in a painting on a different subject, *Autumn Sunlight* (p. 489). The composition assigns equal value to the old woman in the doorway and the whitewashed wall, on which shadows of trees and pale sunlight play. The dapples are also on the woman's dark skirt and the white cloth she is holding. It is a picture that has turned away from parties, joys and feasts: here, the painter's emphasis on fleeting effects is inseparable from a perception of the transience of human life.

Plein-airisme and the Interior

There is a direct continuity from *plein-airisme* of the true outdoor kind to interiors that record the immediate effects of sunlight. The Skagen painters were particularly fond of this effect. Krøyer's *Artists at Breakfast* (p. 477), painted in 1883, was a logical development of motifs he had worked on in France, such as *Artists at Breakfast in Cerney-la-Ville* (1879) and *Passengers on a Seine Boat* (1881; both Skagen, Skagens Museum). The Skagen painting portrays Danish, Norwegian and Swedish artists at table. The objects on the table stand out in the strong sunlight in red and green against the white cloth. The light effectively glows in Krohg's bushy gingery beard and catches the sleeve of Charles Lundh's jacket. The loose brushwork and inexact outlines highlight the sense that a lively and significant moment has been captured.

Anna Ancher was a mistress of interior light and colour. Unlike Krøyer, she generally used her effects to establish a quiet, contemplative mood. The sensitivity and gifted colourism of her paintings created soulful, intimate atmospheres. In *Sunlight in the Blue Room. Helga Ancher Knitting in her Grandmother's Room* (p. 494), she uses the contrast of sunlight and the silhouettes of potted plants and window crossbars on

Hugo Birger

Scandinavian Artists Breakfasting at the Café Ledoyen, Paris, on Salon Opening Day, 1886 Skandinaviska konstnärernas frukost i Café Ledoyen, Paris, fernissnigsdagen Oil on canvas, 183.5 x 261.5 cm Gothenburg, Göteborgs Konstmuseum

the wall and floor. Her colour scheme is based on the contrasting blue of the wall and upholstery and the yellow of the curtains, an effect that is replicated in the blue smock and blonde hair of the girl sitting by the window. *The Artist's Mother, Anna Hedvig Brøndum* (p. 499) is far more of a true portrait, of course; and yet this frontal view of a seated woman with a pillow at her back, snoozing in the sun, depends on its palette of rose, violet, white, yellow and blue shades.

Järnefelt strikes a decidedly Parisian note in *Lefranc the Wine Merchant, Boulevard Clichy, Paris* (p. 478). The milieu is characteristically that of a city. But formally, too, the artist has used a compositional approach that was typical of Caillebotte and Degas, just as his gleaming brushwork recalls Manet. Considerable emphasis is placed on the various kinds of light. The backlighting and the effects that it creates in the semi-dark room are dramatic, from the foreground, where detailed attention has been paid to the play of light on the glasses and bottle with their various contents and on the features of the elderly man, via the silhouetted merchant and the brass newel head at the foot of the spiral

Akseli Gallen-Kallela Démasquée, 1888 Oil on canvas, 65 x 55 cm Helsinki, Ateneumin Taidemuseo

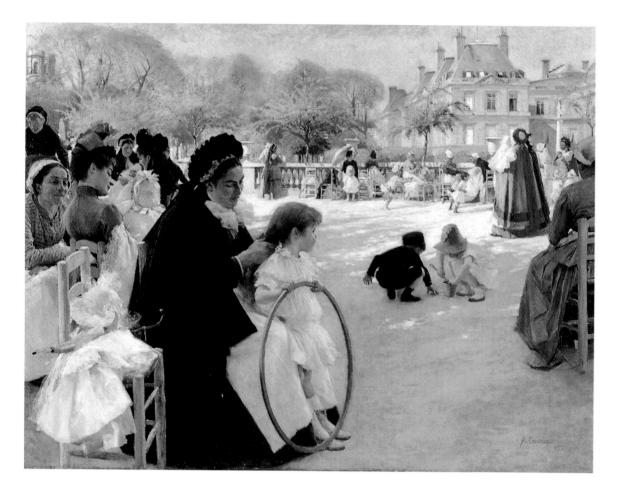

staircase, to the metal cladding of the counter. The banister of the stairs is covered in red canvas rendered translucent by a window beyond, which casts a reddish gleam on the wall and table, a gleam that is reflected by the counter cladding too. Furthermore, the merchant is lighting his pipe with a match, thus providing another source of light that illuminates his face and hands with a warm glow. The use of *contrejour* in a dark interior, and the arrested movement, reflect the experiments that Caillebotte in particular was making in the mid–1870s. We might, for instance, compare the white backlighting and the resulting reflections on the floor and elsewhere to be observed in the French artist's *The Floor Strippers* (p. 131). In Järnefelt's painting, the spatial composition is firm, with an emphasis on verticals and horizontals; however, the spiral stair is unusual, and attracts attention by virtue of the fact. The spatial tension it establishes contrasts with the simplicity of the tabletop's disappearance into the fore perimeter.

Social realism of the kind espoused by Millet, Courbet and Bastien-Lepage often entered the work of Scandinavian artists. Unlike the elder generation, who often took their subjects from farming and the life of

Albert Edelfelt

In the Luxembourg Gardens, 1887 *I Luxembourgträdgården i Paris* Oil on canvas, 144 x 188 cm Helsinki, Ateneumin Taidemuseo

Erik Werenskiold Autumn, 1891 *Høst* Oil on canvas, 120 x 151 cm Gothenburg, Göteborgs Konstmuseum

Theodor Philipsen A Lane at Kastrup, 1891 *En allé i Kastrup* Oil on canvas, 55 x 82 cm Copenhagen, Statens Museum for Kunst

craftsmen, the younger artists turned to industrial work, where large numbers of people could be seen going about their bustling business in confined spaces. This crowded and busy atmosphere accorded with the pulsating rhythm of modern life that so preoccupied the Impressionists. Anders Zorn (1860–1920) painted a series of scenes from a Stockholm brewery. *In a Brewery* (p. 488) shows a number of women sitting working in a row in a room the wet floor of which glistens with light reflected from ceiling lighting. Zorn's brushwork is broad and rapid, and his gold, brown and black provides an effective context for the strong red of one woman's blouse.

Point of View and Composition

Two crucial points of departure for compositional structure in Impressionist art were photography and Japanese art. Photographic technique called for a sense of the passing moment, for images that recorded movement in a seemingly random fashion, for points of view often dictated by chance. Abrupt cropping fragmented subjects as in a snapshot – though the effect also occurred in 18th-century Japanese woodcuts. Japonisme (as the imitation of Japanese styles was known) introduced a clear-cut and decorative sense of space and image to pictures.

One distinctive Impressionist theme was the view from a window. Just as Monet, Pissarro and Caillebotte had painted crowds on Paris boulevards as seen from high windows, Krohg in 1883 painted Von Eidsvolds Square (Impression of Karl Johan Street). In 1882 Krohg had seen the

Victor Westerholm The Seine at Paris, 1888 Seine invid Paris Oil on canvas, 60.5 x 81.5 cm Turku, Turun Taidemuseo

seventh Impressionist exhibition, and would have noticed work of a related kind by Caillebotte. His painting used a high, acute angle of vision to look down on the bustle in Christiania's most elegant street. Free of any specific narrative content, the picture simply conveys "a milieu in the great image of the age", as the artist put it in an 1886 lecture.

Munch was in close touch with Krohg and his circle in the 1880s. In 1889, and repeatedly in the Nineties, he visited Paris, where for a brief time he was much taken with Impressionism, as paintings such as *Spring on Karl Johan* (p. 492) or *Rue Lafayette* (p. 491) show.

Werenskiold transposed the Impressionist point of view to a quite different context in *Autumn* (p. 486), that of a Norwegian farm. He had visited Paris most recently in 1889, and in the autumn of that year he had participated in the Copenhagen show of Gauguin's own work and paintings from his collection of Impressionist art. The muted and somewhat melancholy colours familiar from Gauguin's Impressionist phase are here again in Werenskiold's painting. The view, which seems to have been chosen at random, admits fencing and a barn at an unusual angle (much as certain things might feature in a Paris street scene); the throng of passers-by we might expect in a city scene is replaced here by two horses at work.

Caillebotte's 1880 *Balcony, Boulevard Haussmann* (Paris, private collection) made its clearest impression on two Norwegian artists. Krohg came closest to the Frenchman's concept in his *Portrait of the Artist Karl Nordström at Grèz* (p. 470). Nordström himself left an account of how the picture came to be painted: "We had both recently studied Impressionist art at an exhibition in Paris, and our hearts were brimful of powerful new impressions. Afterwards, Krohg one day observed me standing at the open window of my room, wearing my navy suit, with the park in the background. He asked me with some eagerness to stay just as I was, ran off to fetch a canvas and the necessary

Anders Zorn In a Brewery, 1890 Stora bryggeriet Oil on canvas, 100 x 68 cm Gothenburg, Göteborgs Konstmuseum

equipment, and within moments he was already hard at work..." Despite the differences in setting and pictorial structure, there can be no doubt that Caillebotte's painting provided the direct inspiration for Krohg's. In both cases the subject is resting on an ornamental wrought-iron railing, and both are reflected in an open window. Heyerdahl too had tried his hand at a similar motif the year before, in *At the Window* (p. 469). Like Caillebotte, he presented a city scene in strong light

Ernst Josephson Autumn Sunlight, 1896 *Höstsol* Oil on canvas, 130 x 82 cm Stockholm, Thielska Galleriet viewed from a balcony, though here the main subject is a seated woman rather than a standing man, pausing for a moment in her reading to gaze ahead, lost in thought. She recalls women we often see in Manet or Morisot. The stylistic affinity to Morisot's limpid colours and freedom in brushwork is striking.

It is uncertain whether there were any direct French influences on *Girl Looking out of a Skylight* (p. 481), which Laurits Andersen Ring (1854–1933) painted in 1885. At that time, the artist had not yet visited Paris; however, the impact of Japonisme on the decorative structure is unmistakable. Ring was at that time a close friend of Madsen, who was working on his study of Japanese art. The subject and the presentation of the passing moment are rendered in a very confined space, one that permits of no narrative extras. The girl's half-averted face and the view of the city rooftops are both linked and kept separate by the play of depth and space created by the slant opening and by the angles and crossbars of the skylight.

Paulsen's *Under the Pont des Arts, Paris* (p. 495) is at once Impressionist and "Japanese". The picture is plainly related to the Impressionists' countless Seine landscapes; and the bridge arch that dominates the foreground recalls Japanese woodcuts, as well as Monet's Japanese bridge in his garden at Giverny. The very title of the painting has an Impressionists' flavour. The freshness of the colours and the intensity of the light confirm the French feel of the work.

In winter 1887, Edelfelt painted *Paris in the Snow* (p. 467) from the window of his suburban studio. The view, though it has a flavour of the fortuitous, is deliberately, tautly structured, and the subject, though scarcely oriental, is yet done *à la japonaise*. The lane crosses the image and the real space toward the horizon, its course rhythmically underpinned by trees and, further off, carriages and a tram. In the foreground, a snow-covered rooftop is cropped by the right edge. The shadows of this and the neighbouring building (from which Edelfelt is presumably viewing the scene) join the shadows of the trees to establish a contrapunctal diagonal dynamic. The smoke from the factory chimneys, blown from left to right across the horizon, adds to the effect.

Snowscapes both rural and urban were a staple of the Impressionist repertoire. They afforded an opportunity to examine the pure effect of light and shadow, reflections and colours, on the snow's gleaming surface. In *Snowy Weather, Paris* (p. 480) Kreuger tackled the motif at street level, in winter 1885. The horse-drawn wagon is seen in typical winter atmospherics. It is twilight, and the white of the snow appears blue in the glow of the streetlamps. The snowy weather is interposed like a filter between us and the things we see; but the snowfall itself is visible, especially in the orange light from the wagon lamp. The horse's breath blurs the outline of the wheel of the wagon ahead, which is abruptly cropped in a way suggestive of movement. In the background, discreetly positioned but with eloquent effect on our sense of a counter-movement, a man can be seen making his way into the falling snow, shielded by an umbrella.

Edvard Munch Rue Lafayette, 1891 Oil on canvas, 92 x 73 cm Oslo, Nasjonalgalleriet

The Sense of Movement

Light broken on waves, a swell, or the surface of water, together with reflections of the sky, plus local colour, naturally constituted a favourite Impressionist subject. In 1892, Krøyer painted a handful of modestlysized canvases of Danish beaches, paying tribute to the pleasures people took in the summer. In *Bathing Children* (p. 493) he gave his attention to light on the sea, capturing a fleeting moment as a boy runs into the water, splashing showers of spray.

Boating on the Seine was another motif that continually engaged the Impressionists. In 1877, Caillebotte painted an imaginative variation on the theme in *Canotier en chapeau haut de forme*. In this work, the cropping plays a decisive part: the boat and oars are only partly visible, as are the rower's legs. Krohg copied this approach in *Look ahead*. *The Harbour at Bergen* (p. 475), but also contrived to heighten the illusion that we are witnessing a snapshot moment: the rower is turning briefly to check his course and avoid a collision with other boats, not least the

Edvard Munch Spring on Karl Johan, 1891 *Vår på Karl Johan* Oil on canvas, 80 x 100 cm Bergen, Bergen Billedgalleriet

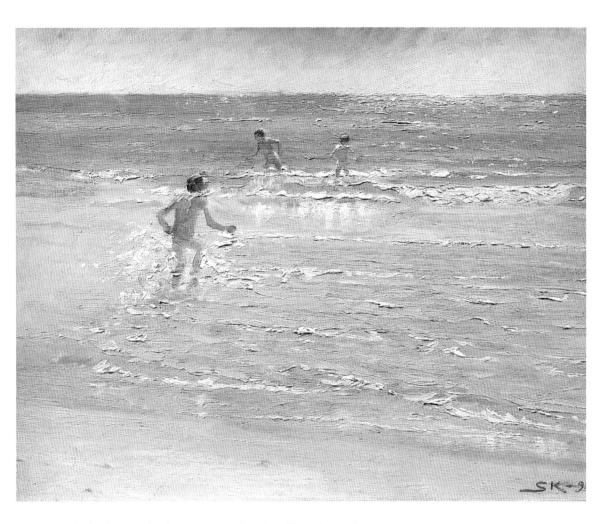

steamer in the background. This movement has the effect of transferring the energy apparent in the foreground to the horizon. The sunlight also enables Krohg to paint the reflections in the water.

Philipsen's *Street in Tunis* (p. 472) recalls a journey to Tunisia in 1882. Along a shady, cool lane between high white walls, a herd of camels are approaching us, raising dust and thus obscuring the animals to the rear. A rider on an ass, making slow progress and having to move aside, is casting a long shadow on the wall. The distinctive movement of camels is precisely captured in economical browns. The sun is gilding a white tower, and the sky is a yellowish green. Kreuger's *Gypsy on Öland* (p. 474) is an equally evocative study of motion. The horseman is riding at a gallop, leading a second horse behind him. It is raining, and the horses' hooves are splashing water from puddles. The wind is ruffling their manes and the man's clothing. Peder Severin Krøyer Bathing Children, 1892 Badende børn Oil on canvas, 33 x 40.5 cm Copenhagen, Den Hirschsprungske Samling

Anna Ancher

Sunlight in the Blue Room. Helga Ancher Knitting in her Grandmother's Room, 1891 Solskin i den blå stue. Helga Ancher ved strikketøjet i bedstemors stue Oil on canvas, 65 x 59 cm Skagen, Skagens Museum

"La Vie Moderne"

Though the new, modern, optimistically progressive style of middle-class culture associated with the new industrial heyday was apparent in other European cities too, the range of connotations implicit in the phrase "la vie moderne" is suggestive of the Paris experience. The Paris scene was often one of factory chimneys, new architecture, and busy crowds on the boulevards, on foot or in vehicles. Closer to, we witness bourgeois and bohemian lifestyles alike: the pillars of society are there, industrialists and speculators, and so are the artists, independent if financially insecure, leading their tempting life of outdoor leisure and sport and indulging in a broad variety of colourful entertainments. There were theatre shows and exhibitions, horse races and restaurants, balls, salons, and for bohemians and sempstresses alike - the grisettes, dance clubs and bars of Montmartre. By day one could take lunch in the greenery, read a paper in the park, or take a boat trip on the Seine. At night a café-chantant or café-concert offered amusement, as did the brothels. Krohg's Portrait of the Artist Gerhard Munthe (p. 479) suggested that Bohemia was alive and well in Christiania too. We have to guess at the nature of this smoky interior, the poorly lit Grand Café, with its gentlemen reading the papers and smoking cigars. In the foreground is an uncleared, deserted table. The subject has just come in from the street. He is clearly a dandy, wearing a dark coat with a voluptuous fur collar and sporting a moustache and eyeglasses. In his gloved right hand he holds a burning cigarette, the swirl of smoke drifting into the bluish haze of the room.

Bohemian ways were usual in the artists' private realms too. In *Dé*masquée (p. 484), Gallen-Kallela afforded a glimpse of his own milieu and thus of his attitude to his role as artist. The picture was painted in Paris in 1888. The model is just taking a break from posing, and the portrait has captured her at rest – in an unpretentious yet sensual relaxed position, free of attitudinizing yet also challenging, and, of course, lightly mocking. The artist has caught her weary smile, the way she is rubbing her hurting feet, the negligent gestures of her hands and arms on the sofa-top blanket, and a black half-mask she is holding in her right hand. The painting is unmistakably a homage to the odalisques of Ingres, and to Goya's Maya. But this woman is a modern contemporary, and if she

Julius Paulsen Under the Pont des Arts, Paris, 1910 *Under Pont des Arts, Paris* Oil on canvas, 46 x 55 cm Copenhagen, Statens Museum for Kunst

is *démasquée* it means she is seen stripped of literary, moral or historical veils – like Manet's *Olympia* (pp. 38/39), which drew on similar sources. A Buddha and two Japanese fans, a guitar and mask from Spain, and the colourful Finnish woven blanket, attest the importance of exotic accoutrements to Gallen-Kallela. The white lilies as a symbol of chastity, the crucifix, and the skull, suggest that the young woman has been posing as a penitent Magdalene. The present confronts the past; but the picture leaves us in no doubt as to which emerges on top.

The annual Salon provided the Scandinavian artists in Paris, too, with an occasion for festivities, especially if at least one of their number had submitted successfully. Hugo Birger (1854-1887) commemorated one such party in 1886 in Scandinavian Artists Breakfasting at the Café Ledoyen, Paris, on Salon Opening Day (p. 483). There is nothing Impressionist about the brushwork, but the subject and composition clearly owe something to Manet, Renoir or Degas. Swathes of smoke are drifting beneath the café's glass roof. The people's bodies, heads and hats provide the rhythmic spatial dynamics. No one person is highlighted; rather, the artist presents a sense of convivial bustle. First, perhaps, we notice the Swedish painter Hugo Salmson pouring champagne into a lady's glass. But our attention is also caught by Birger's Spanish wife, seated right of centre, who has turned to look straight at us. Beyond her we see a row of profiles taking us deeper into the space; the two men conversing at right perform the same function, the very direction of their gaze pointing our attention to the rear left, where some jovial toast is plainly just being offered.

Edelfelt's In the Luxembourg Gardens (p. 485), painted in 1887, uses a similar structure. Artists frequently took an interest in social life in parks. The light on the greenery, the flower beds and colourful dresses of the ladies, the children at play, all helped make park scenes interesting to painters. Manet's Music at the Tuileries (p. 43) had pointed the way, showing how a single focus of attention could be avoided. Figures stood where they happened to be; sometimes they were harshly cropped, so as to underline the impression of a chance glimpse. Edelfelt has grouped the children with their nannies along the edges, and they are looking in every direction. Spatial depth seems to open up almost by accident, yet the picture in fact features a carefully established transition from the shade beneath the trees to the sunlit promenade. As with Birger, the eye is invited to travel along a particular route: from bottom left, we follow the furled parasol across to the girl's hoop and on to the two children stooping at play, and then fetch up at the rear view of a lady in the middle distance. Beyond her, we follow the frieze of white-clad children in the background to the parasol of a woman in black, where our gaze is anchored in the replication of shape in a black article of clothing on the back of a chair, at the centre of the picture. The basic colours (as so often in Manet) are black, white, grey and ochre; the one standing lady is highlighted by the long red ribbon that falls down her cape, from her hat almost to the ground. This red is echoed in the paler red hat of a young woman at left.

Christian Krohg Paris Hackney Cab Driver, 1898 *Pariserkusk* Oil on canvas, 43 x 29 cm Oslo, Nasjonalgalleriet Krohg's portrait of a *Paris Hackney Cab Driver* (p. 497) shows another side of modern life. The city streets are briefly suggested with a few sketchy façades, and in the background are a top-hatted man and a horse-drawn carriage; but the foreground is entirely occupied by the jovial cabman, more a type than an individual. We are shown just enough of the cab to be in no doubt that he is seated on the box; and the raised whip is absolutely unambiguous. Krohg's social commitment is as palpable in this portrait of the kind of proletarian usually ignored by polite society as it is in his writings.

The examples noted here of Scandinavian art produced under the influence of French Impressionism by no means tell the whole tale of Scandinavian art of the period in question. Impressionism exerted only a brief influence, and that on only a few artists. All the artists who had contact with the Paris art scene experimented with the new aesthetics and techniques; but as soon as they were again far from the French source, their work shortly regained its native, traditional character, and was coloured by the distinctive qualities of their own countries and countrymen. Even so, there can be no doubt that the path to greater freedom in the handling of light and colour, the essentials of the painter's art, and also to a new concept of reality, led via Paris.

JENS PETER MUNK

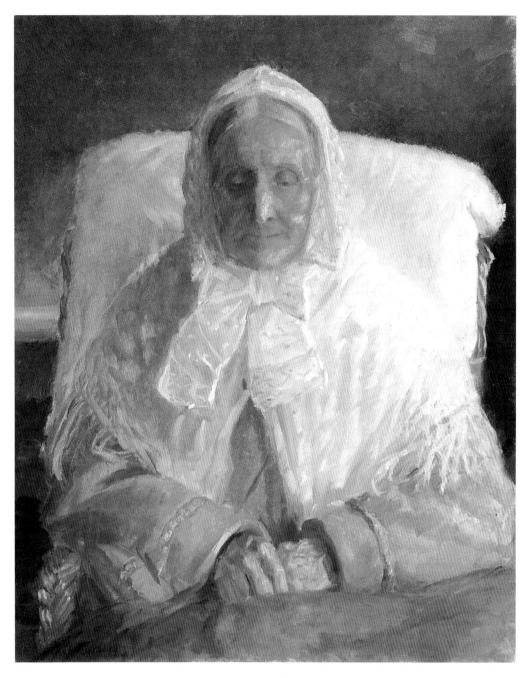

Anna Ancher The Artist's Mother, Anna Hedvig Brøndum, 1913 *Kunstnerindens moder, fru Anna Hedvig Brøndum* Oil on canvas, 79 x 63 cm Skagen, Skagens Museum

Pál Szinyei Merse A Field of Poppies, 1902 *Pipacsos mező* Oil on canvas, 88.5 x 79.7 cm Budapest, Magyar Nemzetí Galéria

I 3 Homelands and Europe: East and Southeast European Impressionists

Impressionist painting arose in eastern central Europe, eastern Europe and southeast Europe for two reasons. Artists in regions ruled by the Russian Czar or the Austro-Hungarian Dual Monarchy, or in states that had recently fought for their liberation from the Ottoman Empire, were changing their techniques in obedience to the selfsame inner logic as their counterparts in western and central Europe. At the same time, they were under the influence of France, and, because that influence was subject to a certain "time lag", it took complex forms in the East.

Two phenomena were of importance. First, the insistence of realist, Impressionist and Post-Impressionist artists on the subjective truth of their paintings, and thus on their right to individual free creativity, was linked closely and for a long time with non-artistic, social struggles and, above all, with campaigns for national liberation. Ideas of an art both committed and instructive remained vibrant longer in eastern Europe, and were more widespread than in the West. Secondly, problems that appeared purely aesthetic sometimes acquired a greater political sensitivity than was the case in, say, the French debates on the relations between Impressionism and anarchism.

Russia

The standing conflict in Russia was that between the defenders of the Slavic, orthodox culture and those who were prepared to learn and take their bearings from the West. Since Peter the Great, Russian art had been in step with west European aesthetic principles and stylistic developments. Academic training and the criteria by which artists were evaluated proceeded from the same classical base as in Paris. But in Russia, too, outside officially sanctioned art, an interest was growing in the simple life and the landscape of the homeland, as well as in outdoor light, such as we see in the limpid, poetic paintings of Alexei Gavrilovich Venezia-nov (1780–1847).

In 1863 – which happened to be the year of the first Paris Salon des Refusés – 14 St. Petersburg Academy students who favoured realism rebelled against Academy regulations. They were promptly expelled,

Ilya Yefimovich Repin Tolstoy Resting in the Woods, 1891 Lev Nikolajevitsch Tolstoj se odmara u sumi Oil on canvas, 60 x 50 cm Moscow, State Tretyakov Gallery

Ilya Yefimovich Repin

Portrait of the Artist's Daughter Vera, 1874 Portret V.I. Repine Oil on canvas, 73 x 60 cm Moscow, State Tretyakov Gallery and founded their own association. Together with members of the Moscow College of Art, which was socially and aesthetically progressive, this group became the Travelling Exhibitions Cooperative, which was established in 1870 and mounted its first public show in 1871 - in the St. Petersburg Academy, of all places, before it went on to Moscow and, in particular, provincial towns. The Peredvishniki (Wanderers), as these artists were called, mainly concentrated on realistic genre and landscape works; like the French artists grouped about Monet, there were a number of insignificant traditionalists among these Russian painters. Art by the Peredvishniki constituted the core of the most important collection of modern Russian art, that of the Moscow businessman Pavel Mikhailovich Tretyakov (1832-1898). A collector since 1856, he had opened a gallery beside his own home to the public in 1881, and in 1892, true to an idea he had had in 1860, he donated the collection to the city of Moscow for a national gallery. The Tretyakov Gallery contains the most important collection of Russian art, and has had an abiding influence on perceptions of Russian art history.

Scenes of village life, of poverty and toilsome work, or of social contrasts, were controversial both aesthetically and politically, just as Courbet's or Millet's were in France. In Russia, though, the arduous lot of the peasants, and debates on the role traditional village ways of life should play in the national identity, were of much greater importance. This factor could endow genre painting with an instructional, societal weight that verged on agitprop; and this circumstance encouraged the adoption of the "literary" qualities Manet had introduced. Landscape paintings also focussed more on people's ways of life, on society, and on the people themselves. Russian painters (and their public) inclined to Romantic or Symbolist views, rather than to sober realism or the Impressionist obsession with questions of perception such as engaged the west European mind. Ivan Nikolaievich Kramskoy (1837–1887), the intellectual leader of the Peredvishniki, put into words a polarity that was repeatedly to cause misunderstanding and alienation on both sides: "With us content, with them form. With us, the idea is the main thing, with them, the technique."

Thus Impressionist technique, often of a very high calibre, tended to be only one aspect of Russian painters' art. Ilya Yefimovich Repin (1844–1930) was a case in point. Graduating from the St. Petersburg Academy at the age of 29, he helped assure the international repute of Russian art with *Volga Boatmen* (1870–1873; St. Petersburg, State Russian Museum), which had taken him three years to complete. It was immediately exhibited at the 1873 Vienna World Fair, at a time when painters such as Monet were still being routinely turned down by the Paris Salon. Repin then spent the years from 1873 to 1876 in western Europe, including France, exhibiting at the 1875 Paris Salon. He was not taken with the sketchiness of Impressionism, and found only Manet to

Ilya Yefimovich Repin They did not expect him, 1884 Ne ždali Oil on canvas, 160.5 x 167.5 cm Moscow, State Tretyakov Gallery his taste. Even so, his technique acquired a fresh ease in private studies such as the portrait of his little daughter Vera (p. 502).

His paintings of the 1880s that were important for their focus on social problems included *They did not expect him* (p. 503), which presents the early return home of a political exile. The sensitive colouring and atmospherics of this truthful picture are convincing, as are the spatial tensions, the snapshot recording of movement, and the precise rendering of facial expressions. In 1890 Repin left the Peredvishniki, and four years later was appointed professor at the Academy, which had now been reformed. Impressionism was acquiring a weightier presence at that point; but if Repin portrayed Lev Nikolaievich Tolstoy (1828–1910) in a remarkably "unofficial" pose, reclining in the grass, reading, wearing a peasant smock, in a painting notable for its generous, sketchy brushwork and its attention to effects of light and shadow (p. 502), then the contemporary beholder was intended to concentrate more on the content than he might in the case of Manet's relaxed portrait of Mallarmé, say. From 1880 on,

Ilya Yefimovich Repin Portrait of Sofia Mikhailovna Dragomirova, 1889 Oil on canvas, 98.5 x 78.5 cm St. Petersburg, State Russian Museum

Ilya Yefimovich Repin In the Sun, 1900 *Na solnce* Oil on canvas, 94.3 x 67 cm Moscow, State Tretyakov Gallery

> Tolstoy became a sharp critic of the status quo, a social reformer for whom peasant life was the model.

> Repin's journey to France in 1873 had been made with an aristocrat of his own age, Vassili Dimitrievich Polenov (1844–1927). In 1878, Polenov's *A Yard in Moscow* (p. 507) helped ease his admission to the Peredvishniki, whose leader he became following the death of Kramskoy. The picture's emphasis lies not on the perfectly presentable home of well-todo people but on the bare grass and sandy paths in the yard and particularly the wonderful light flooding the whole scene, including the church in the background. It is an "intimate landscape" of the kind Daubigny and other Barbizon artists had established, only much brighter, its col-

Isaac Ilyich Levitan Golden Autumn, 1895 Zolotaja osen Oil on canvas, 82 x 126 cm Moscow, State Tretyakov Gallery

ours more intense. From 1892 to 1895 Polenov taught landscape painting at the Moscow College of Art, and his work of the Nineties was particularly notable for spacious, atmospheric landscapes.

One of his pupils was Isaac Ilyich Levitan (1860–1900), a Jew from a poor background. Levitan was a friend of his coeval, the writer Anton Pavlovich Chekhov (1860–1904), later to achieve world fame. He exhibited with the Peredvishniki but was not able to visit western Europe till 1890. Finally he became his own teacher's successor as head of the Moscow College of Art's landscape school. He was unequalled in his ability to evoke a veritably pantheist sense of the vastness of landscape, or the dappling of light in a *Birch Grove* (p. 506) with its rhythmic, delicately structured colour harmonies. Levitan, who rejected the Impressionism of Monet, was *par excellence* one of those who established a continuity from pre-Impressionist, lyrical responses to Nature through to Symbolist or Neo-Romantic Post-Impressionism. Nonetheless, his

Isaac Ilyich Levitan Birch Grove, c. 1885–1889 *Erezovaja rosa* Oil on paper on canvas, 28.5 x 50 cm Moscow, State Tretyakov Gallery

Vassili Dimitrievich Polenov A Yard in Moscow, II, 1878 *Moskovskij dvorik, II* Oil on canvas, 64.5 x 80.1 cm Moscow, State Tretyakov Gallery

Igor Emmanuilovich Grabar After Lunch, 1907 *Nepribrannyj stol* Oil on canvas, 100 x 96 cm Moscow, State Tretyakov Gallery

Valentin Alexandrovich Serov The Children. Sasha and Yurra Serov, 1899 Deti. Saša i Jura Serovi Oil on canvas, 71 x 54 cm St. Petersburg, State Russian Museum

paintings reveal a thoroughly Impressionist sensitivity to phenomena of light and the autonomy of pure, strong colours.

Igor Emmanuilovich Grabar (1871–1960) was a somewhat younger artist who studied under Repin and in Munich and was soon to be a signal presence as a historian of Russian art and especially as director of the Tretyakov Gallery. A more textbook Impressionist himself, he was skilful in capturing colour phenomena that accompanied surprising seasonal change, as in *Winter* (p. 509), but this spontaneous kind of Impressionism was to be only a passing phase in his own evolution as an artist.

Valentin Alexandrovich Serov (1865–1911) defies pigeon-holing too. He was one of the foremost Russian artists around the turn of the century, and as a young man he had already painted one of the loveliest pictures of the 19th century, *Girl with Peaches* (p. 511). Serov was one of the Rasnotshinz intelligentsia (non-aristocrats exempt from taxation) who were so important in intellectual life and social progress, and who

Igor Emmanuilovich Grabar Winter, 1904 Zima Oil on canvas, 75 x 54.5 cm St. Petersburg, State Russian Museum

> constituted the main public at art exhibitions in the Eighties and Nineties. His father was a composer who died young, his mother a pianist, and Serov himself was a child prodigy. Aged about nine, he was tutored in Paris by Repin, continued his studies in Moscow, and transferred to the Petersburg Academy at the age of 15. He then travelled repeatedly to western Europe. He was a regular in the illustrious circle of artists who frequented the Abramcevo estate 60 kilometres north of Moscow. The theatre-mad railway tycoon Savva I. Mamontov was the centre of the group, and it was his daughter Vera who sat for Serov's *Girl with Peaches* in 1887. The picture won a first prize in portrait painting from the Art Connoisseurs' Association. Its delight in light and colour, the ease of its brushwork and handling of outline, the ordinariness of the situation, the chance arrangement of objects in the background and the still life in the fore, are all qualities the painting shares with a Manet or Renoir of the previous decade. But Serov is also precise in his attention

Constantin Alexeievich Korovin Couple in a Boat, 1887 Para v lodke Oil on canvas, 53 x 43 cm Moscow, State Tretyakov Gallery

to facial expression, and for his sitter's character and emotional profile. That is to say, he introduces a human dimension that interested Degas alone of the French Impressionists, and in his case only in a sceptical, somewhat aloof way. Serov, who taught at the Moscow College of Art from 1897 to 1909, was later to be a high-society portrait artist, painting aristocrats and intellectuals. He had a firm grasp of the fleeting moment, and a bravura sense of colour. These qualities, and the nervous tensions or decorative zest of his outlining, made his works highly evocative.

His somewhat older friend Constantin Alexeievich Korovin (1861– 1939) was surely the purest Russian Impressionist, the closest to the French spirit, which his several visits to western Europe after 1885 familiarized him with. He too was one of the Abramcevo group, and with Serov he exhibited with the World of Art association, founded in 1900 as an offshoot of the periodical of the same name (published 1899–1904) by the editor Sergei Diaghilev (1872–1929), later famous as a ballet impresario. In the early years of the century, this periodical played a leading part in establishing links with France, Britain and Germany, and creating an international, Secessionist art that blended Impressionism, decorative Art Nouveau, and a Neo-Romantic art that stressed the values of home regions. Korovin's Paris street scenes (p. 510), lush still lifes, and pictures of holidaymakers on the Crimean coast or a young couple in a

Valentin Alexandrovich Serov Girl with Peaches, 1887 *Devočka s persikami* Oil on canvas, 91 x 85 cm Moscow, State Tretyakov Gallery

Kasimir Malevich Flower Girl, 1903 *Cvetounica* Oil on canvas, 80 x 100 cm St. Petersburg, State Russian Museum

Left: Constantin Alexeievich Korovin Café in Paris, c. 1890–1900 *Parizskoe kafe* Oil on canvas, 50 x 61 cm Moscow, State Tretyakov Gallery

Constantin Alexeievich Korovin Boulevard des Capucines, Paris, 1906 *Pariž, Bul'var Kapucinok* Oil on canvas, 73.3 x 60.2 cm Moscow, State Tretyakov Gallery

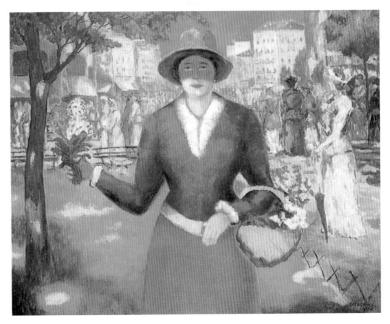

rowing boat (p. 510), all show him to have been in love with the colours and beauty of the world, with the evidence of the eye. More than any previous artist except arguably his teacher Polenov, he made the sketchy rendering of colourful impressions a viable form of finished artwork in Russian painting, too. His early works (such as those reproduced here) were nonetheless closer to the precise draughtsmanship and narrative interest of a Caillebotte or Forain than to Monet, twenty years his senior. One fact marks a difference from the French Impressionists, though: the man in the rowing boat is the artist himself, seen together with the artist Maria W. Yakunchikova. To the French way of thinking, this would not have qualified as something the artist himself had seen; they did not paint self-portraits in developed, narrative contexts.

Poland

Polish art had existed in a country that had been under the yoke of three foreign powers since the late 18th century: Prussia, Austria-Hungary and, to the largest extent, Czarist Russia. This historical condition produced a strain of patriotism that was passionate and given to sad nostalgia for past grandeur and remembrance of tragic defeats. The nation's intellectual life largely took its bearings from France, and this was reflected in the ideas and organizational structures that prevailed in Polish art. Poland's powerful interest in nationhood, the country's struggle for a culture of its own, and the time lag apparent in aesthetic developments compared with France, all meant that Impressionism in landscape, genre

Władysław Podkowiński Field of Lupins, 1891 *Pole łubinu* Oil on panel, 49.5 x 61.5 cm Cracow, Muzéum Narodówe

Władysław Podkowiński Children in the Garden, 1892 Dzieci w ogrodzie Oil on canvas, 47 x 62 cm Warsaw, Muzéum Narodówe

and portrait painting was initially a mere phase, quickly superseded by Post-Impressionist or Symbolist tendencies. On the other hand, a power-ful influence of French Impressionism was still palpable as late as 1930.²

In 1889, Władysław Podkowiński (1866–1895) and Józef Pankiewicz (1866–1940) of the Warsaw College of Art visited Paris for the World Fair. There they encountered Impressionism, and, through Theo van Gogh, the paintings of Cézanne. The exhibition of their own work in Warsaw in 1890 signalled the beginning of Impressionism there. In the few years that remained to Podkowiński in his short life, he used very bright and sometimes strongly contrastive colours, split in accordance with divisionist principles, to paint typical Impressionist landscape and garden subjects (pp. 512 and 513). Pankiewicz helped make Cracow (part of the Austro-Hungarian Empire till 1918) the leading centre of Polish Secessionism and a constant rival of Warsaw. The Sztuka (Art) Association was founded in Cracow in 1897, and in 1899 the new bearings in art earned the label Young Poland. In 1900 the Cracow College of Art was elevated to Academy status, and there Pankiewicz taught from 1906 till 1914 and again from 1919 till 1923 (though he repeatedly visited western Europe in the same periods). He too combined Impressionist and various Post-Impressionist approaches. In the Nineties he brought an equal intensity to sunlight and to nighttime scenes with the light of city streetlamps (p. 514). For Polish purposes, Pankiewicz adapted Cézanne's handling of colour, and his programmatic view that art should be "a harmony parallel to Nature", into Polish "Colourism", which was to remain influential till after 1945. From 1925 till his death he ran a Paris wing of the Cracow Academy, where a number of younger painters from Cracow constituted the Komytet Paryski (Paris Committee). Their version of late or Post-Impressionism is generally known as "Kapism" from the initials (K.P.) of the group.

Jan Stanisławski Poplars beside the River, 1900 *Topole nad woda* Oil on canvas, 145.5 x 80.5 cm Cracow, Muzéum Narodówe Polish painting in that period was polarized between pre-Impressionist traditions committed to communicating thematic messages and Post-Impressionist or Symbolist strategies. We can see this well in the Cracow professors Leon Wyczółkowski (1852–1936) and – especially – Jan Stanisławski (1860–1907). The latter lived for many years in Paris, painted pointillist work on occasion in Poland and his Ukrainian home-land, and then, as professor of landscape art and co-founder of the Sztuka, became a major figure in the Cracow art revival. He adopted Monet's poplar motif (p. 330) – a frieze-like, decorative product of the Nineties – and developed it further in the stylized, linear, melancholy manner of Art Nouveau (p. 513), reworking the same subject in lithographs and woodcuts too. Olga Boznańska (1865–1940) lived in Paris from 1895 till her death, settling for a style derived from early Impressionism, delicately painted, with atmospherics reminiscent of Manet or Whistler, while for Władysław Ślewiński (1854–1918), who lived and

Józef Pankiewicz The Old City Market, Warsaw, at Night, 1892 *Rynek Starego Miasta w Warszawie Noça* Oil on canvas, 61 x 45.5 cm Poznan, Muzéum Narodówe

worked in Paris and Brittany from 1888 to 1905 and again from 1910 on, the decisive note was set by the spatial flatness and symbolic innuendos of Gauguin and the Nabis. His art too, of course, was not without its Impressionist roots (p. 515).

For many Poles, a variety of Romanticism that aimed at psychological interpretation continued to set the tone in aesthetics, social and intellectual conduct, and attitudes to history. This cast of mind blessed Poland with close interaction between painting, literature and the theatre. There were a large number of talents with both literary and artistic gifts in the Modernist period, and artists often had a notable rapport with music and with traditional folk art.³

Władysław Ślewiński

Rough Sea at Belle-Ile, 1904 Morze (Fale nadbrzezne) Oil on canvas, 57.5 x 82 cm Jaworska 138 Cracow, Muzéum Narodówe

Bohemia and Moravia

The Czech sense of nationhood evolved in more self-assured and unproblematic ways under the Habsburgs than did Poland's under the Czars. Artistic contact with Vienna and Munich was good, and the influence of French art, apparent from the 1860s on, was indicative of the underlying logic of European cultural development rather than of politically conditioned responses. In 1863, the year of the Paris Salon des

Antonín Slavíček Walking in the Park, 1897 V parku procházce Tempera on card, 69.5 x 52.8 cm Prague, Národní Gallerv

Refusés, the Umělecká Beseda (Artists' Association) was established in Prague, for artists working in every field. In 1887 the first modern artists' organization running exhibitions of its own was founded, taking its name from Josef Mánes (1820–1871), pioneer of national art and cofounder of the Beseda, and publishing the periodical "Volné smery" (Free Directions).

In Bohemia too the struggle for a national culture and a historical tradition of one's own was so important that late Romanticism and emotional historicism (such as characterized the Prague National Theatre's opulent indulgences of the 1880s) were not perceived as being irreconcilably at odds with the new aesthetics, as they were in France in the same period. An intimate realism that discovered the landscape of the homeland in a Barbizon spirit could easily be accommodated to national his-

torical art. The Prague College of Art was the centre of this accommodation. It was an approach that enabled artists to adapt their aesthetic approaches to the task in hand – in a manner that has repeatedly baffled west European critics. An Impressionist handling of light and colour, for Czech artists, was not the statement of an aesthetic creed; rather, it was a use of available methods that had been tested for their suitability for the evolution of a national art of the homeland.

Otakar Lebeda (1877–1901), who spent a year working in France and shot himself at the age of 24 following a nervous disorder, painted landscapes now sad, now turbulent, which show him essentially locating an Impressionist style, though he also shared the fractured mood of the

Otakar Lebeda Lilac. Village Path, 1899 Šeřík. Cesta vesnicí Mixed media on card, 66 x 79 cm Prague, Národní Gallery

Antonín Hudeček Quiet Evening, 1900 *Večerní ticho* Oil on canvas, 120 x 180 cm Prague, Národní Gallery

Antonín Slavíček Elizabeth Bridge, Prague, 1906 *Eliščin most* Oil on canvas, 145 x 193 cm Prague, Národní Gallery

Symbolist Nineties (p. 517). Antonín Slavíček (1870–1910) was the closest to Impressionism of a French kind, though it was not till 1907 that he visited France. He was a pupil of Julius Mařák (1832–1899), a leading painter of patriotic landscape art. From the 1890s on, Slavíček's subject matter, relaxed brushwork, bright colours, and even structures were strongly reminiscent of Pissarro (pp. 516 and 518).

Quiet Evening (p. 517) was painted by his friend Antonín Hudeček (1872–1941), a fine talent who has regrettably remained relatively unsung. Hudeček was soon to adopt a more expressive strategy, influenced by Munch. Quiet Evening is pointillist in its handling of the grassy slope but Neo-Romantic in its atmospherics, which inform the composition

Jan Preisler Bathers, 1912 *Koupání* Oil on canvas, 104.5 x 150 cm Prague, Národní Gallery

A Stream in Sunshine, 1897 Potok ve slunečním svítu Oil on canvas, 81 x 90 cm Prague, Národní Gallery

Antonín Hudeček

and colours and insist on a rhythm of curves (as in the tree reflections in the lake, or the slender tree trunks at left) such as was characteristic of heavily stylized European art at the turn of the century. Other works by Hudeček give their full attention to effects of light (p. 519).

The art of Jan Preisler (1872–1918) was of a late Impressionist kind, and underwent change thanks first to the example of Gauguin and then to Fauvism and Expressionism. For some time this style was of greater moment than Impressionist art itself, though an Impressionist delight in Nature remained a fundamental of Czech painting. In 1902 Preisler visited Italy with Hudeček, not travelling to France (and the Low Countries) till 1906. In 1913 he became professor at the Prague Academy. Picture such as *Bathers* (p. 518) record his interest in Renoir and Cézanne.

Hungary

The proud Hungarians had been deeply humiliated by the defeat which met their revolt against the Habsburgs in 1848/49. An agricultural country where the land was parcelled into vast estates, Hungary was socially and economically far behind western Europe, and this was not without implications for art. Attempts to establish a national historical tradition culminated in the millennial celebrations of the Magyar settlements in 1896, with great festivities and artworks. The discovery and valuation of distinctive Hungarian landscapes and folk ways of life were vital sources of motivation for Hungarian artists. Like all smaller nations

Pál Szinyei Merse The Balloon, 1878 Léghajó Oil on canvas, 41.5 x 39 cm Budapest, Magyar Nemzetí Galéria

disadvantaged by history, Hungary was torn in two directions, wanting to keep up with what the leading European art centres considered modern and interesting, but at the same time wanting to preserve their own distinctive appeal.⁴

Mihály Munkácsy (i.e. Michael Lieb, 1844–1900) belonged to the generation of Monet and Liebermann. He achieved an international name in Düsseldorf and particularly Paris, where he lived from 1872 to 1896, marrying a wealthy baroness. In 1878 he was himself given a title. His own brand of realism was forceful, and contrived to retain the broad thematic range and effects beloved of the Salon. His paintings dealt with religious or philosophical material, society life in opulent interiors (comparable to similar work by the Belgian artist Stevens), and also scenes of social drama and the enduring fight for liberty. In Munkácsy's work, light and colour are not those of a pleinairist, and, as is so often the case, it was only his studies that had any impulsive spontaneity or freshness.

His friend László Páal (1846–1879) studied in Munich and then spent his short, hard life in Paris and the woods of Fontainebleau, where he introduced the Barbizon school's principles to Hungarian landscape art. He tended to paint tracks, village streets or the fringes of peaceful forests (as on p. 521), with lofty or crooked tree trunks bathed in gentle sunlight, the silvery green and sandy brown subtly nuanced, and highlighting afforded by a whitewashed house or the clothing of an old woman in the middle distance. Mildly elegiac moods mattered more to him than visual structure or the division of colours.

In Munich at about the same time, a member of Leibl's circle, Paul von Merse, likewise one of the country gentry, who had named himself Pál Szinyei Merse (1845–1920) after his home town in what is now Slovakia, undertook a valiant lone attempt at bright *plein-air* painting. His sketches make a relaxed, spontaneous impression, but in the paintings he did from them he preferred detailed precision presentation and a draughtsman's emphasis on subject matter. His strong interest in the Swiss artist Böcklin is unmistakable. In 1873 he painted his best known picture, Luncheon on the Grass (The Picnic) (p. 523). It recalls outings young artists and their girlfriends made near Munich, but was in fact painted in the studio. The subject and treatment would have been considered modern at the time. The poses of the reclining men and of the man squatting in the foreground are deliberately unconventional, conceived as snapshot records of a moment, though the group as a whole has been meticulously related to the overall composition. The scene is bathed in bright sunshine, yet the brightness does not seem the product of genuinely close observation. The colours have not been analytically split to intensify their luminous impact, nor has the problem of presenting figures at one with the natural setting in a dapple of light and shadow been tackled here. In other words, Szinyei Merse's treatment of light and

László Páal

Path in the Woods of Fontainebleau, 1876 *Ut a Fontainebleau-i erdöben* Oil on canvas, 65 x 46 cm Budapest, Magyar Nemzetí Galéria

Károly Ferenczy October, 1903 *Október* Oil on canvas, 126 x 107 cm Budapest, Magyar Nemzetí Galéria

colour is of a non-Impressionist order (such as Renoir occasionally approximated to in the late Eighties). *The Balloon* (p. 520), painted five years later, a delightful picture showing a red and yellow balloon and combining an interesting subject with an unusual visual effect, has attracted symbolic interpretation.⁵ Following failures at exhibitions in Vienna and Budapest, Merse ceased painting till 1894. He subsequently was rediscovered as a forerunner of Hungarian Modernist art and returned to painting landscapes. In 1905 he was appointed principal of the Budapest College of Art. Even when painting subjects that had always appealed to the Impressionist eye, such as poppy fields (pp. 500 and 523), he never abandoned his Böcklinesque approach, so that ultimately he lagged behind the direction art was taking in his time.

In 1896, the year of the millennial celebrations, an artists' colony was established in hilly eastern Hungary at Nagybánya (now Baia Mare in Rumania). This followed the Alföld group, artists of the Hungarian plains, who had studied peasant life and landscape at Szolnok in particular. The Nagybánya painters grouped about the colony's initiator, Simon Hollósy (1857–1918), almost all found their way there via Munich. They worked in a variety of styles, from an almost transcendent realism à la Bastien-Lepage to a Symbolist form of Art Nouveau, though always retaining an overriding interest in the homeland and its people. Károly Ferenczy (1862–1917), later professor at the Budapest Academy and tutor to a great many students, was notably consistent in his deployment of an Impressionist sense of light and of the colour harmonies between

Károly Ferenczy Summer Day, 1906 Nyári nap, Majális Oil on canvas, 100 x 103.2 cm Budapest, Magyar Nemzetí Galéria

Pál Szinyei Merse Luncheon on the Grass (The Picnic), 1873 *Majális* Oil on canvas, 123 x 161.5 cm Budapest, Magyar Nemzetí Galéria

Pál Szinyei Merse A Field of Poppies, 1896 *Pipaesos mezö* Oil on canvas, 39 x 63.2 cm Budapest, Magyar Nemzetí Galéria

József Rippl-Rónai Living on Memories, 1904 Amikor az ember visszaemlékezéseiből él Oil on card, 70.5 x 103 cm Budapest, Magyar Nemzetí Galéria

József Rippl-Rónai Lady in a Polka-Dot Dress, 1889 Nó fehérpettyes ruhában Oil on canvas, 187 x 75 cm Budapest, Magyar Nemzetí Galéria

people and their surroundings. *October* (p. 521), with its still strong autumnal light, is a fine example of his ability to simulate a spontaneous response to the fortuitous moment. It is a pleasingly unusual, asymmetrical composition including a garden table at an angle, with a breakfast still life, the sunshade of a *plein-air* painter, and a man standing and glancing through the newspaper.

József Rippl-Rónai (1861–1927) was a special case because he was involved in the evolution of Post-Impressionism in Paris.⁶ He too tended to oscillate rapidly between various techniques. After studying in Munich, he gained a Hungarian state scholarship to Paris in 1887, where he became the assistant of the overworked Munkácsy and painted pictures which the latter signed with his own name. The first work he painted in his own right, the 1889 *Lady in a Polka-Dot Dress* (p. 524), was quite different in style, suggesting the influence of Whistler. The lifesize figure is caught frontally in mid-movement, painted in a relaxed, sketchy manner but with firm, curving outlines and a decorative use of spatial areas. The whole is informed by the indefinable appeal of the woman's veiled, somewhat earnest and meditative, yet pretty face. These were very much the kind of qualities that inspired Bonnard and Vuillard too.

As Rippl-Rónai's personal style developed, he betrayed changing preferences in colourist technique, and an Art Nouveau linearity and use of larger decorative spaces was superseded by a mosaic pointillism and then by powerful Fauvist colours in what he himself called his "maize cob style". Elements of Impressionism persisted in his work, and particularly of the intimate late Impressionism of his friend Vuillard. A good example is the symbolically-titled interior *Living on Memories* (p. 524), with the old mother deep in the remoter, gloomier parts of a bright picture. The pieces of furniture, cropped by the edges, establish a compositional rhythm and, painted in a loose manner, are atmospherically comforting in the accord of their colours.

Romania

For decades Hungary and Turkey, and at times Russia, fought out a tug-of-war over Romania. About half of the country's present territory, Transylvania, was Hungarian till 1918. The Danubian principalities of Moldavia and Wallachia adopted the name "Romania" through union in 1862, attaining independence of Turkey. From 1866 this new principality was ruled by a Hohenzollern. In 1878 its sovereignty was guaranteed by the major European powers, and in 1881 Romania became a kingdom. Cultural continuity with developments elsewhere in Europe was inevitably affected by time lag. The fact that the country spoke a Romance language heightened the tendency of artists to take their bearings from France. The art colleges founded in 1860 at Jassy in Moldavia and in 1864 in the capital, Bucharest, adopted western European teaching methods and views, especially those of the French academies.

Nicolae Grigorescu (1838–1907), who started out as a painter of icons, moved on from the Bucharest College to Paris for further training from 1861 to 1869. Though he did not entirely abandon patriotic historical subject-matter, he was the first Romanian artist to break with academic tradition by adopting *plein-air* landscape styles. He made repeated visits to France, and his technique acquired an ease that places them scarcely second, in the freshness of the treatment, to the early work of Pissarro or Sisley (p. 526).

One case eloquent of eastern Europe's difficult entry into Modernism was the tragically short life of Ion Andreescu (1850–1882). The son of a brandy merchant with a great many children, he graduated from the Bucharest Art College and became a teacher of drawing and calligraphy

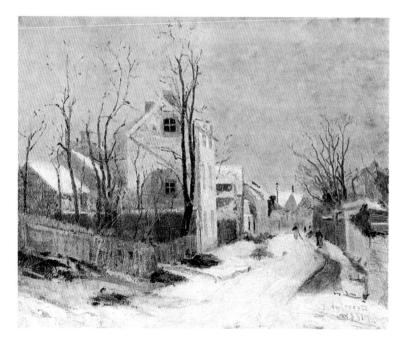

Stefan Luchian Anemones Oil on canvas, 44.5 x 35 cm Bucharest, Muzeul de Artã, Galeria Nationalã

Ion Andreescu Winter at Barbizon, 1881 Iarna da Barbizon Oil on canvas, 54 x 65 cm Bucharest, Muzeul K.H. Zambaccian

Stefan Luchian The Last Race, 1892 *Ultima cursa de toamna* Oil on canvas, 58 x 67 cm Bucharest, Muzeul de Artã, Galeria Nationalã

Stefan Luchian Anemones, 1908 Oil on canvaš, 42.5 x 43 cm Bucharest, Muzeul de Artă, Galeria Natională

Nicolae Grigorescu A Clearing, c. 1885 *Luminis* Oil on canvas, 54.5 x 81.5 cm Bucharest, Muzeul de Artă, Galeria Natională

at a provincial grammar school. In 1874, the year the Impressionists made their first joint public appearance in Paris, Andreescu exhibited a delightfully fresh still life of a few blackcurrants and nothing but, his first appearance in a Bucharest show. In 1878, already suffering from the tuberculosis that was to kill him, he was awarded a travel scholarship to France, where he spent two years at the Académie Julian. At Barbizon he was tutored by Grigorescu. He exhibited small landscapes in the 1879, 1880 and 1881 Paris Salons. He was acquainted with Georges de Bellio (1828–1894), a Romanian doctor and art collector who lived in Paris, and will presumably have shared his liking for Impressionist art. Andreescu's pictures were almost invariably small-format, designed to satisfy old-fashioned tastes, and were sold in Bucharest via Alexis Gebauer, who was in the music trade. In spring 1882 he had some 60 paintings in a rather poorly attended exhibition. Since his works had been exhibited at the Paris Salon though, he was not without purchasers in Bucharest, and one painting was acquired by the state. Only a few months later, however, he was dead.

Andreescu's pictures tend to suggest fresh delight in the beauty of Nature, relish of its colours. He was forever trying to create fresh, harmonious art out of what he saw. The rich colours of grass, foliage, rocks and sky, and the structural appearance of trees in the woods at Fontainebleau, exerted a continual attraction (p. 527), but he was also proficient at intricately nuanced whites, greys and light ochres in a village scene such as *Winter at Barbizon* (p. 525), exhibited at the 1881 Salon. If these paintings bore the signature of Pissarro, and were anywhere but in a remote gallery far from the highways of the international museum-going public and the predilections of art historians, they would long since have enjoyed a just esteem.

It was to be some time yet before Impressionist views on art made any headway in Romania. That they did so was mainly thanks to Stefan

Ion Andreescu Edge of the Forest, c. 1880 *Margine de pădure* Oil on canvas, 61 x 50.5 cm Bucharest, Muzeul de Artă, Galeria Natională

Luchian (1868–1916), who studied in Bucharest and then (1889) Munich before going to the Académie Julian in Paris (1890–1892). He then returned home, where he co-founded an independent art show in 1896 and, in 1902, the Tinerimea artistica (Artistic Youth) association. In Paris, the example of Manet and Degas had prompted him to tackle such subjects as horse races (p. 526), and he had absorbed a first influence of Post-Impressionism. He was the first Romanian artist to develop a real feel for cityscapes. For fellow Romanian artists, though, he was primarily important as a master of autonomous colour and of thick, pastose and spontaneous brushwork.

Following Grigorescu and Andreescu, it was Luchian who played a key part in establishing Impressionist choices of subject matter, ways of seeing, and techniques (albeit often modified by intense Fauvist colourism or simplified form), as a tradition that would extend well into the 20th century. It may well have been thanks to these artists that, the greatest successes achieved by Impressionism outside its native France were reached in Romania.⁷

Bosnia-Herzegovina, Croatia, Serbia, Slovenia

Among the Yugoslav peoples of the Balkans, the difficulties and tragedies of modern history long delayed the evolution of recognisably modern culture. From the Middle Ages till 1918, Slovenia, with its major city of Ljubljana, belonged to Habsburg Austria. In the same period, Croatia, with the city of Zagreb, was also under Habsburg and Hungarian control, and did not achieve any measure of autonomy till 1868. Serbia, with its capital in Belgrade, achieved independence between 1867 and 1878. after four centuries of Turkish rule. This success made Serbia a model for other southern Slavic liberation movements; but in the case of Bosnia (with Sarajevo as capital) and Herzegovina, all that could be accomplished in 1878 was to exchange the Turkish master for an Austro-Hungarian. In 1918 these and other territories became a Serbian-dominated kingdom, which adopted the name Yugoslavia in 1929. Individual endeavours to create a new, more true-to-life aesthetic as well as national cultural institutions and artistic associations inevitably went hand in hand with attempts to escape the hegemony of Vienna or Budapest, and to locate alternative examples to follow, in Munich, Paris or Russia.

In 1904, the first South Slav Art Exhibition was held (including Bulgaria). The organizers intended it as a first demonstration of the cultural unity of Yugoslavia and of the distinctive ways that culture differed from other cultures. Further exhibitions of this kind followed in Sofia in 1906, in Zagreb in 1908, and again in Belgrade in 1912. A historical assessment penned in 1968 concluded that "Impressionism was the first call to arms in modern Yugoslav art".⁸ As in all eastern Europe, Impressionism was obliged to compete with more emotional, Neo-Romantic, Symbolist renderings of Nature, which were more effective as vehicles for patriotic ideas. At the same time, Impressionism also became intermingled with other internationally disseminated, decorative forms of Post-Impressionist Modernism.

From about 1880, individual Yugoslav painters were becoming acquainted both with academic and with realistic and, above all, *plein-air* approaches in art, in Paris and, more often, in Munich. The private academy founded in Munich in 1891 by the Slovenian realist Anton Ažbè (1862–1905) played a vital part in this process. The Russian artist Grabar taught there from 1896, and the academy numbered Kandinsky among its students. In Belgrade, the Slovak Kirilo Kutlik (1847–1900) ran a school he had founded in 1895. In Croatia, an artists' organization was set up in 1897 to promote both a national school in art and Modernism in general. In these aims, though, specifically Impressionist ways of seeing and of handling colour – such as are evident in the delicate *Trees in Snow* (p. 528) by the tragic young genius Slava Raškaj (1877–1906) – constituted only one stylistic strand.

Full-blown Impressionism did eventually become apparent in a number of locations in the opening decade of the 20th century. In Slovenia, where a first national art show was held in 1900 at Ljubljana, Ivan Grohar (1867–1911), after first experimenting with other styles, took to

Slava Raškaj Trees in Snow, 1900 *Stablo u snijegu* Watercolour on paper, 43.3 x 59 cm Zagreb, Moderna Galerija

painting landscapes that combined precise atmosphere with vibrant and coherent brushwork. It is this union of mood and technique that makes *Snow in Škofja Loka* (p. 529) so appealing. On the advice of his friend Rihard Jakopić (1873–1918), Grohar had attended Ažbè's academy in Munich, and with Jakopić, Matija Jama (1872–1947) and Matej Sternen (1870–1949) – who all studied at Ažbè's, too – founded an artists' group named after the River Sava.

This Slovenia Sava group made a strong impression on young Serbian painters when they exhibited at the 1904 Belgrade show. Several of these, who were to make significant contributions to Serbian Impressionism, had been to Kutlik's school or to Ažbè's in Munich. After Kutlik died in 1900, the realist Rista Vukanović (1873–1918) and his German wife Beta (Babette Bachmayer, 1872–1927) took over his school, which became a state establishment in 1905.

The 1904 Yugoslav exhibition led Marko Murat (1864–1944), who had been trained in Munich and had received an award for an immense history painting at the 1900 Paris World Fair, to start an artists' association known as Lada (Harmony). This association survived till the Second World War. Murat, who evolved a subtle approach to open-air painting early in his career, later painted pure Impressionist work, mainly in Dubrovnik, where he worked in conservation from 1919 to 1932. On the other hand, though, in the decade after 1908 he espoused the strongly nationalist ideology of the Medulić group (so called after the Croatian Renaissance artist Andrija Medulić, called Andrea Schiavone). The leader of the Medulić group was the sculptor Ivan Meštrović (1883–1962).

Ivan Grohar Snow in Škofja Loka, 1905 Š*kofja Loka u snijegu* Oil on canvas, 87.5 x 99 cm Ljubljana, Moderna Galerija

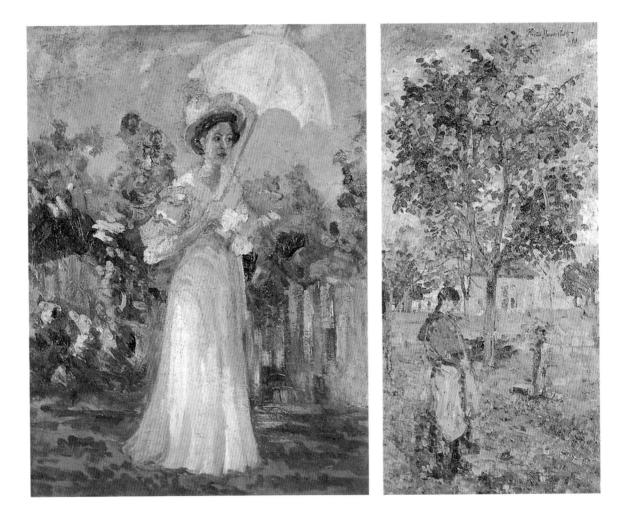

Nadežda Petrović

Lady with a White Parasol, c. 1910 *Figura sa belim šeširom* Oil on canvas, 90.2 x 65 cm Belgrade, Narodni Muzej

Kosta Miličević

Spring, 1913 Proleče Oil on canvas, 102 x 50.3 cm Belgrade, Narodni Muzej

Three Serbian painters a decade younger, born at a time when French Impressionism was already in full bloom, painted very fine work in a style influenced by Monet and his closer associates. All three studied at Kutlik's and Ažbè's academies; two of them also spent time in Paris. They were members both of Lada and of the Medulić group, and in the First World War they served against Austria-Hungary with patriotic fervour. Milan Milovanović (1876-1946) returned from Paris in 1906 a convert to Impressionism. He used the style in 1907 when he visited the Orthodox monasteries of Serbia, Macedonia, and Mount Athos. He subsequently became committed to national, historical art, and was then a war artist. In 1917, while convalescing from an injury, he was transferred to Capri, where his happiness at having survived is expressed in the visual relish with which he recorded the strong colours of his new surroundings (The Blue Door, p. 531). From 1920 on he taught at the Belgrade College of Art, although no longer painting himself. Kosta Miličević (1877–1920) taught for several years at the school run by Vukanović. His landscape works, such as Spring (p. 530), are notable for their harmony, brightness and ease; in subject matter and style they recall Pissarro.

The most arresting of the younger Serbian artists was Nadežda Petrović (1873–1915), whose practice as painter and writings as critic were alike aimed at furthering the cause of Modernism as vigorously as possible. Petrović studied under Kutlik, then under Ažbè, and then at a private summer course taught in Munich by the Secessionist Julius Exter (1863-1939). She exhibited at the 1904 Belgrade show, and was impressed by Grohar and his group. The following year she organized the first Serbian artists' colony, at Sičeva in the country. In 1906 she had work in the first Lada exhibition, and later joined Medulić. She spent the years from 1910 to 1912 in Paris, meeting the Fauves and exhibiting, like them, at the autumn Salon. Some years before, though, in Munich, Petrović had already been painting the intensely colourful and dynamically structured Trees in a Wood (1902; Belgrade, Narodni Muzej), in a manner that would reappear some years later, in the same place, in the work of Kandinsky and the Blaue Reiter Expressionists. In contrast to such excursions, pictures Petrović later painted back in Serbia, such as the bright, generously sketched, resplendent Lady with a White Parasol (p. 530), are Impressionism of a fine, pure order.

Milan Milovanović The Blue Door, 1917 *Plava vrata* Oil on canvas, 48 x 39 cm Belgrade, Narodni Muzej

Peter H. Feist

- I N.A. Dmitrieva: "Peredvishniki and Impressionists". In: Russian Art in the Second Half of the 19th Century and Early 20th-Century, Moscow, 1978, pp. 18–39 (in Russian). Cf. D.W. Sarabianov: "On the Distinctive Character of Russian Impressionism". In: Russian 19th-Century Art and the European Schools, Moscow, 1980, pp. 166–181 (in Russian). Cf. also the comparisons with French art in O.A. Liaskovskaia: Plein-airisme in Russian 19th-Century Painting, Moscow, 1960 (in Russian).
- 2 See Z. Kempiński: Impresjonizm polski, Warsaw, 1961 (with a German synopsis) and T. Dobrovolski: Malarstwo polskie ostatnich dwustu lat (Polish Art of the Last Two Hundred Years), Breslau etc., 1976.
- 3 Cf. the exhibition catalogue Romantyzm i Romantyzzność w sztuce polskiej XIX i XX wieku (Romanticism and Romantic Approaches in Polish 19th- and 20th-Century Art), Warsaw, 1975.
- 4 A recent survey is provided in J. Szabó: A XIX. század festészete Magyarországon (19th-Century Hungarian Painting), Budapest, 1985.
- 5 A. Szinyei Merse: Bildgattungen und Themen im Jugendwerk von Pål Szinyei Merse (Genres and Themes of Pål Szinyei Merse's Early Work). In: Acta Historiae Artium 27 (1981) no. 3/4, pp. 287– 361. For biographical and stylistic reasons, the date assigned varies between 1878 and 1882.
- 6 K. Keserü: József Rippl-Rónai, Budapest, Berlin and Warsaw, 1983.
- 7 M. Deac: Impresionismul în pictura românească. Precursori, maestri, influențe, Bucharest, 1976 (with a French synopsis), p. 112.
- 8 L. Trifunović, in the exhibition catalogue Serbische Malerei zwischen den Weltkriegen, 1918–1939 (Serbian Art between the World Wars, 1918–1939), National Museum, Belgrade, and Gemäldegalerie Neue Meister, Dresden, 1968, p. 8.

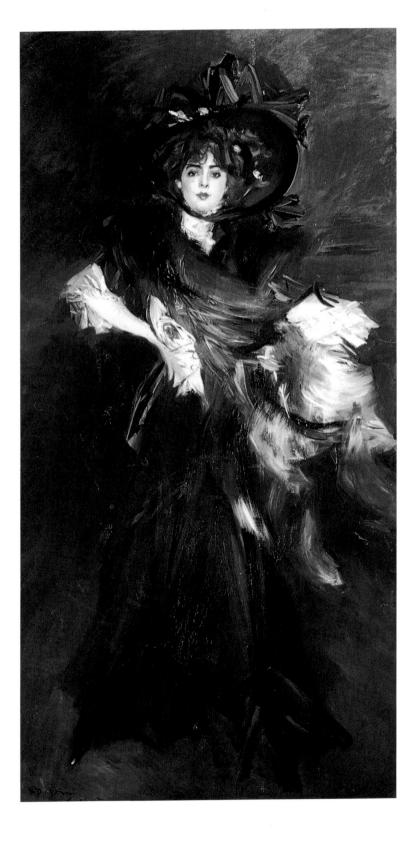

14 Impressionism and Italian Painting in the Latter Half of the 19th Century

The mid-19th century in Italy was the period of the Risorgimento, the movement that culminated in Italian unification free of Bourbon or Austrian rule. That movement provided the political and cultural backdrop for one of the most important and influential groups in Italian art in the second half of the 19th century: the Macchiaioli. This group of landscape, portrait and genre painters, flourishing from about 1850 to 1880, was based on Florence, which had become one of the most cosmopolitan cities in Italy in the 19th century thanks to liberal Habsburg/Lorraine rule. Florence was a place where revolutionaries and those who had fought in the liberation movement did not need to go in fear. Among these were many artists who had been volunteers in the 1848 and 1859 wars of liberation. In 1864 Florence became the provisional capital of the four-year-old kingdom of Italy, though in 1870, when Rome became the capital, Florence again lost its leading position and lapsed back into provincial status. These two dates mark the heyday of the Macchiaioli.

Despite the great differences between the Macchiaioli and the French Impressionists, the two groups were and still are the subject of comparison. Misleading tags such as "Italian Impressionism" merely suggest that the French movement has supplied the yardstick for assessing the Italian. This can partly be traced back to contemporary Italian critics such as Diego Martelli (1838–1896). Though the French and Italian artists shared certain ideas – such as a sketchiness in technique, modernity, and an interest in photography and Japanese woodcuts – the two schools nonetheless emerged from quite different cultural and social origins.

Unlike France with its Paris-oriented centralism, Italy had for centuries enjoyed a plural evolution in numerous regional art centres such as Florence, Rome, Milan, Naples and Turin. Moreover, the Macchiaioli movement began ten years before French Impressionism. Its openly revolutionary character constituted a signal difference from Impressionism, which occasionally made a point of avoiding political conflict; we need only recall the French artists who went into exile during the Franco-Prussian War. The Macchiaioli were working in a country predominantly agricultural, its infrastructure rural in temper. It was not till after unification that the Italian ecomomy gradually emerged from the doldrums around the turn of the century. In France, by contrast, industrialisation was already well advanced by the latter half of the 19th century.

Giovanni Boldini

Portrait of Mlle Lantelme, 1907 *Ritratto di Mlle Lantelme* Oil on canvas, 227 x 118 cm Rome, Galleria Nazionale d'Arte Moderna Most of the Impressionists were from middle-class, town backgrounds, and this affected their subject matter and approach; along with landscapes they painted the city, scenes of industrial progress, and moments in modern life. For the Macchiaioli, political and social commitment largely precluded the painting of leisure and pastimes such as the Impressionists favoured. Thus the art of the Macchiaioli did not share the cheerfulness of mood established in so many Impressionist works by the subject matter and use of colour.

In other words, their situation was altogether different from that of the French artists. Nevertheless, there were points of resemblance. The age of liberation in Italy had produced an emphasis on *il vero* in art – a truthful, realistic fidelity to what the eye saw. Painting in the open and the study of light were as essential to this endeavour as an acceptance of

modern subject-matter in art. The core of the Macchiaioli consisted of eleven painters born between 1824 and 1838 (a somewhat elder generation than the French Impressionists). The most important of them were Giovanni Fattori (1825–1908), Silvestro Lega (1826–1895), Serafino De Tivoli (1826–1892) and Vincenzo Cabianca (1827–1902), among the older painters, and Giuseppe Abbati (1836–1868), Adriano Cecioni (1836–1886), Raffaelo Sernesi (1838–1866) and Telemaco Signorini (1835–1901) of the younger. The Venetian landscape artist Guglielmo Ciardi (1842–1917) was associated with the group, as were also, to varying extents, Giuseppe De Nittis (1846–1884), Federico Zandomeneghi (1841–1917) and Giovanni Boldini (1842–1931), who con-

Giuseppe Abbati Landscape at Castiglioncello, 1863 *Campagna di Castiglioncello* Oil on panel, 10 x 30 cm Florence, Galleria d'Arte Moderna

Guglielmo Ciardi Harvest, 1883 *Messi d'oro* Oil on canvas, 132 x 275 cm Rome, Galleria Nazionale d'Arte Moderna

centrated on society-portrait art. These last-named three all took their bearings from France, and eventually moved to Paris.

The individual efforts of these artists differed so greatly that talk of a movement or group is in fact not genuinely tenable. Their backgrounds were quite different, though all were involved in various degrees in the Risorgimento. They were familiar with the liberal but romantically religious ideas of Giuseppe Mazzini (1805-1872), the leading ideologue of the Italian national movement. In 1831, while abroad, Mazzini had founded the Young Italy society to fight for the freedom, independence and unity of Italy, and he was associated with Giuseppe Garibaldi (1807-1882) in his war of independence. Though the revolts against foreign rule which Mazzini began in various parts of Italy led to nothing, his liberal ideas, influenced by French socialism and by positivism, had a real impact on the revolutionary movement. Lega painted Giuseppe Mazzini on his Death Bed (p. 536), recording the passing of a giant in one of the Macchiaioli's finest achievements. The dying man is seen almost lifesize. He is resting on two pillows and seems no longer aware of what may be going on around him. The cool colours highlight the solemnity and sadness of the mood.

Progressive ideas were aired at the Caffè Michelangiolo in Florence (cf. the photograph on p. 535). Established in 1845 in one of the city's loveliest streets, the Via Larga (now Via Cavour), it had quickly become a preferred avant-garde meeting place, comparable with the Brasserie des Martyrs, the Café Guerbois or the Nouvelles Athènes in Paris. The Florentine revolutionary nationalists under Giuseppe Dolfi met there, as did writers and critics (some of whom were directly involved in the Macchiaioli movement) and painters. "There were two rooms in the café," recalled Cecioni, "one of them decorated with frescos by the artists who frequented it. They would meet there to talk, but there were no meetings of a formal assembly kind." Doubtless political discussion was to the fore at first; but in the 1850s aesthetic debate took pride of place. This development culminated in the sessions led in the 1860s by Martelli, the most important Italian art critic of the time, in which critical assessment Giovanni Fattori The Palmieri's Bathing Rotunda, 1866 *La rotonda di Palmieri* Oil on canvas, 12 x 30 cm Florence, Galleria d'Arte Moderna

Artists at the Caffè Michelangiolo, 1856. Signorini is in the top row, fourth from left.

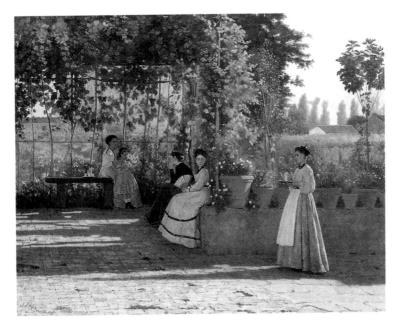

Silvestro Lega The Pergola, 1868 *Il pergolato* Oil on canvas, 75 x 93.5 cm Milan, Pinacoteca di Brera

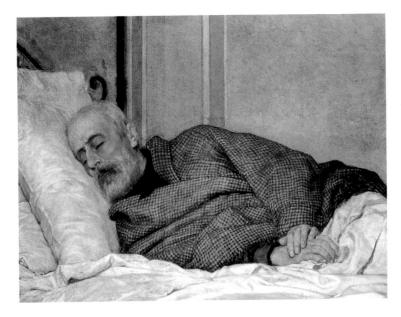

Silvestro Lega Giuseppe Mazzini on his Death Bed, 1873 *Mazzini morente* Oil on canvas, 76 x 96.9 cm Providence (RI), Museum of Art, Rhode Island School of Design, Helen M. Danforth Fund

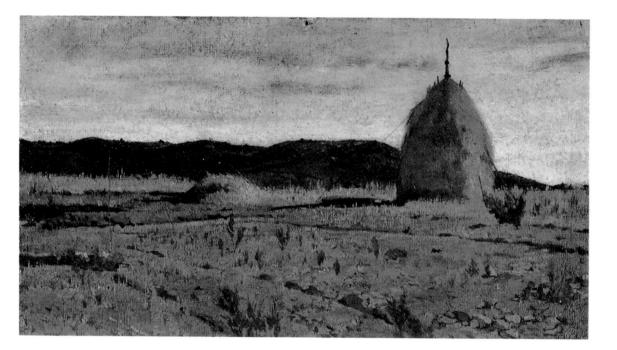

of the new French art, and thus the work of the Barbizon school, was included.

The struggle for national identity inevitably raised questions concerning the position of Italian art in relation both to the country's own history and to contemporary Europe. These questions affected the manner in which Italian culture was perceived, and also the artists' openness to developments elsewhere in Europe. In the mid-Fifties some of the Macchiaioli were already visiting the collection of Count Demidoff in the Villa San Donato in Florence. It included work by the Barbizon painters, Dutch 17th-century and English 18th-century art. Certain of the Caffè Michelangiolo artists had seen Barbizon work at the 1855 Paris World Fair, and shared their knowledge with fellow Italian artists in discussion. De Tivoli was one of them, and presently acquired the nickname papa della macchia. Chiaroscuro effects were valued, as was brushwork that involved understated colours and macchia - dabs and specks (such as might be found in other artists' preliminary sketches, but only there) rather than draughtsmanly linearity. Hence the macchia technique of sketchily juxtaposed, contrastive dabs that gave its name to the movement. The term also had a secondary connotation with the brigands of macchia country, an association that highlighted the wayward approach of these artists compared with academic tradition.

The rejection of academic tradition in Italy grew out of different premisses from that in France. In 19th-century Italy, till unification, art colleges were largely in the control of foreigners. This explains why revolutionary technique was more frequently approved in official quarters: it was seen not so much as a lack of painterly skills, as in France, but as a Giovanni Fattori The Haystack, after 1872 Pagliaio Oil on panel, 24 x 43 cm Leghorn, Museo Civico Giovanni Fattori

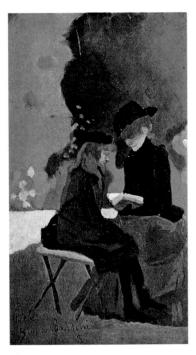

Silvestro Lega Reading, 1875 *La lettura* Oil on canvas, 38.5 x 22.5 cm Private collection

Federico Zandomeneghi Fishing on the Seine, 1878 A pesca sulla Senna (La Senna) Oil on panel, 16 x 29 cm Piceni 28 Florence, Galleria d'Arte Moderna quasi-political offshoot of the Risorgimento. Like many other artists' groups that have initially been misunderstood, the Macchiaioli (to be exact, Signorini) took their name from a tag thought up by an anonymous critic to describe their early work seen publicly for the first time at the first Italian National Exhibition in 1861. That show not only clinched the Macchiaioli's breakthrough but was also a milestone in Risorgimento history, taking as it did Italy past and present and the nation's cultural unity as its theme. Realism was felt to be the best suited strategy for a revival of national art. *Macchia* technique was at once a way of embracing present-day subject matter and of putting the melodramatic, out-of-date tradition of eclectic history painting aside. As Signorini put it: "The *macchia* was initially a way of emphasizing chiaroscuro effects in order to establish a distinction from linear academic art."

This being so, Neapolitan art of a naturalistic persuasion - which ex-students of the Naples Academy such as Domenico Morelli (1826-1901) and later De Nittis introduced to the Caffè Michelangiolo debates - met with a fruitful reception among the Macchiaioli. The Posillippo landscape school, established at Naples around 1820 but with international leanings, was one of Italy's most progressive in the first half of the 19th century. In the second half it was absorbed into the Resina School in Naples; De Nittis was one of its founder members, and he was joined by Cecioni, the main theorist of the Macchiaioli. From 1863 to 1875 the painters of the school consistently advocated plein-air work, realism, and a linking of colour and light. Their approach to colour and the curt technique using generous spaces appealed particularly to the early Macchiaioli. In both Naples and Venice, the tradition of veduta painting - topographically precise views of town and country, such as were especially popular in the 18th century and up to the invention of photography and postcards - already presupposed a high degree of realism. That tradition can be seen as one of the key antecedents of the Macchiaioli. And it was small wonder that because of this, and because of the newly awakened love of the mother country, landscape art became central. "Landscape painting is the very epitome of modern art,"

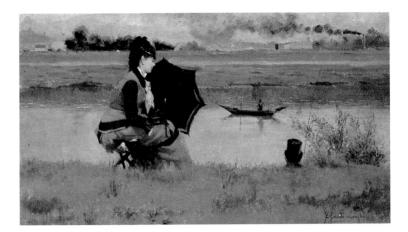

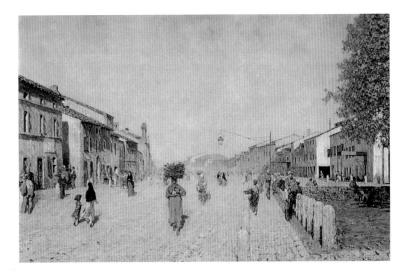

declared Signorini. "It is the form of expression that defines our century."

This is indirectly linked to responses to academic, foreign-controlled institutions. Italian artists were not able to rebel openly against them, or attack them through their own art, as long as the Austrian or Bourbon hand lay upon them. Thus it was that they turned initially to history painting, patriotically reviewing the past, in order to stimulate national pride and a resentment of foreign rule. Like many writers, artists took up subjects drawn from the greatness of the Italian Middle Ages and Renaissance. This had the effect of underlining the discontinuity between the past and the foreign-dominated present. Such art, most famously exemplified in the work of Francesco Hayez (1791–1881), together with a topographical and geographical precision in the rendering of historical locations, provided a key point of departure for *macchia* painting. In their early work, the Macchiaioli repeatedly painted historical events against the venerable backdrop of Florence, striking a note that related

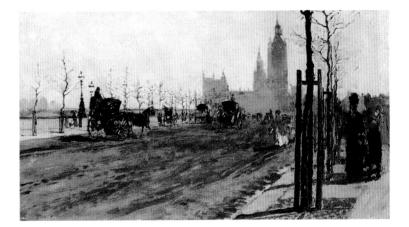

Telemaco Signorini The Suburb of Porta Adriana, Ravenna, 1875 *Borgo di Porta Adriana a Ravenna* Oil on canvas, 66 x 100 cm Rome, Galleria Nazionale d'Arte Moderna

Giuseppe De Nittis The Victoria Embankment, London, 1875 Oil on canvas, 19 x 31 cm Piceni II,796. Private collection to the present. Works by Saverio Altamura (1826–1897) were of this kind, and anticipated the ideas of younger artists by placing an emphasis on topographical details and a contemporary setting; but Abbati's paintings of the great architectural legacy of the Middle Ages were part of the same development.

Awareness of the Italian past extended to the study of the old Italian masters, and especially of the 14th- and 15th-century primitives. From 1848 to 1859, this interest was apparent in the Tuscan Purists, among them Antonio Ciseri (1821–1891). Initially adopting a decidedly anticlassical stance, they had opted for a simple, lucid formal idiom. Certain Macchiaioli painters such as Lega studied under them. Fattori too began to paint historical works in the mid–1850s, and then, with the Italian wars of liberation in mind, military pictures. Fattori's first *macchia* experiments showed him moving on from the academic history painting of his Florentine teacher, Giuseppe Bezzuoli (1784–1855), to a modern style of history painting in which the everyday routine of soldiers' lives could be portrayed shorn of its braggadocio.

Alongside history paintings, the early period of the Macchiaioli notably included the Castiglioncello School's landscape art, of significance in the 1860s in particular. Martelli, who named the school after the Tuscan coastal town of the same name where he owned an estate, invited

Giuseppe De Nittis Breakfast in the Garden, c. 1884 *Colazione in giardino* Oil on canvas, 81 x 117 cm Barletta, Galleria Giuseppe De Nittis

various artists to work in the rough, craggy bush landscape of the Maremma, at irregular intervals - among them Abbati, Odoardo Borrani (1833-1905) and Fattori. These three painters began from similar stylistic positions and constituted a homogeneous subgroup within the Macchiaioli. At first Abbati's art was to the fore, subsequently that of Fattori. Cabianca, Signorini, Cecioni, Boldini and Zandomeneghi were less frequent guests at Castiglioncello. Abbati was very taken with the clear, serene light of that part of the country, and with the colours, and he was the most regular of the visitors. From the early 1860s he was especially close to Martelli. A typical painting of that period was his Landscape at Castiglioncello (p. 534). His small-format works, generally painted on wood panels, are characteristic of early Macchiaioli art, with its larger and sometimes geometrically conceived colour zones and its contrasting darker and lighter areas. The chiaroscurist tendencies of the early phase were gradually supplanted by softer, more poetic light. At Castiglioncello, Fattori painted not only a number of highly successful portraits but also enchanting landscape studies such as The Haystack (p. 537). The simple compositional structure and his characteristically broad brushwork of the early period are particularly engaging in this painting.

About the same time, in the early 1860s, Signorini and Borrani settled in the Piagentina area east of Florence, to join Lega, who was already

Federico Zandomeneghi

Le Moulin de la Galette, 1878 *Il Moulin de la Galette* Oil on canvas, 80 x 120 cm Piceni 34 Milan, Enrico Piceni Collection

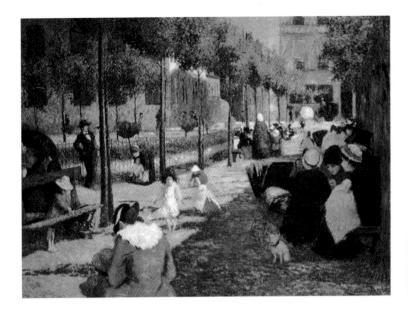

Federico Zandomeneghi Place d'Anvers, Paris, 1880 Square d'Anvers Oil on canvas, 100 x 135 cm Piceni 44 Piacenza, Galleria d'Arte Moderna Ricci Oddi

working there. Compared with the Castiglioncello group, this Piagentina school of essentially these three painters makes a more contemplative impression. After a short time at the Academy in Florence, Lega had joined the army of Tuscany in 1848. Following his return to Florence he had worked in the Purist style, influenced by the teaching of Luigi Mussini (1813-1888) and Ciseri; in the early Sixties he came under the spell of the Caffè Michelangiolo painters, and was increasingly drawn to Macchiaioli realism. He developed an overriding interest in effects of light, an interest he expressed in the *plein-air* Nature studies he painted around Piagentina after 1861. The gentle countryside, and the different temperament of the painters involved, produced a more intimate, emotional art than that of the Castiglioncello painters. Lega, a quiet man, painted simple genre idylls, perhaps influenced by Borrani, who also painted in Piagentina from 1865 on. These idylls used loving detail to record the everyday lives of ordinary rural folk. His draughtsmanship was meticulous and his compositional skill exacting, but what is also astounding is the wealth of narrative detail in the limpid, contrastively arranged zones of darker and lighter colour. At times Lega's approach could resemble the biedermeier period in southern German art. One of his finest paintings is The Pergola (p. 536), which preserves the flavour of his Purist schooling in its clarity and its compositional balance.

The most productive period for the Piagentina School was the 1860s. Lega subsequently endured a crisis in his creative life. His later work was painted with greater ease and largesse; his last landscapes, done at Gabbro near Leghorn, were darker in character, done in gloomy monochrome. From the early 1870s on Lega was afflicted with a steadily worsening eye condition; at the time of his death in 1892 he was almost blind – and, like most of the Macchiaoli, penniless. Along with Lega,

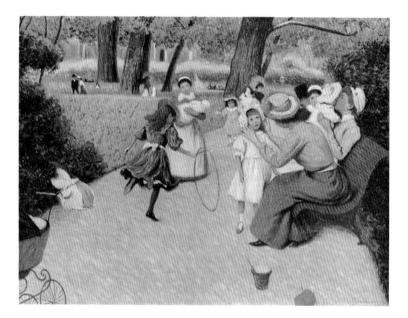

Borrani, Abbati and Sernesi, Signorini was also a founder member of the Piagentina School. In addition to being a writer of some power, he also played a leading part in the theoretical and aesthetic discussions at the Caffè Michelangiolo. His views, and the aims of the Macchiaioli, were published in periodicals such as the "Gazettino delle arti del disegno", founded by Martelli in 1867.

Signorini showed an early interest in the sociocritical writings of Pierre-Joseph Proudhon (1809-1865), and in French Positivism. This interest was also expressed in paintings that articulated his social concerns, such as the impressive Insane Ward at San Bonifacio's, Florence (p. 544). When it was exhibited in Turin in 1870, the painting sparked violent controversy. Degas, a friend of Signorini since the latter's visit to Paris, responded enthusiastically to its close observation of real conditions. Of the Macchiaioli, only Signorini consistently painted scenes of contemporary urban life. In work such as The Suburb of Porta Adriana, Ravenna (p. 539), both Signorini's choice of subject and his bright, fresh technique constituted an affinity with Impressionist paintings of a similar kind. Of all the Macchiaioli, Signorini was the most open to Impressionism. Lega and Fattori barely travelled outside Tuscany, and had no real contact with French Impressionism till after 1879, when Martelli, enthusiastic after a year in Paris, set about introducing the new aesthetics to Italy. Martelli persuaded Degas, Pissarro and others to exhibit in Florence in 1879. Italian artists responded in varying ways to the art they then saw, however. Fattori was not alone in disapproving of what was perceived as the Impressionists' too casual brushwork. Signorini, for his part, travelled widely, spending repeated periods in London and Paris, and the influences to which he was exposed made their way into his own painting.

Federico Zandomeneghi Children's Games in the Parc Monceau *Giochi al Parc Monceau* Oil on canvas, 73 x 92 cm Piceni 342. Paris, Private collection

543 ITALY

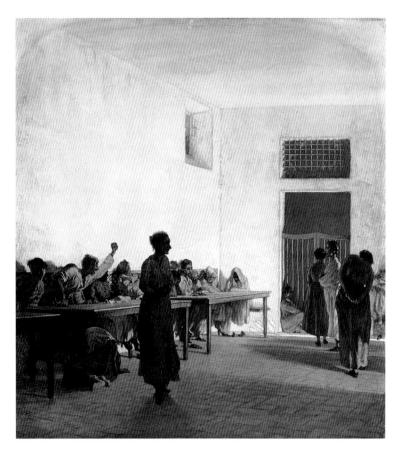

Telemaco Signorini Insane Ward at San Bonifacio's, Florence, c. 1866/67 Sala delle agitate a San Bonifacio a Firenze Oil on canvas, 63 x 95 cm Venice, Galleria d'Arte Moderna

Interestingly, the nudes and still lifes which so often occur in French Impressionism are almost entirely absent in the work of the Macchiaioli. Their art was deft in managing lighting effects and compositional structure. Unlike their French counterparts, they retained a reliance on line and outline. They created their light effects by means of colour contrasts. This fact, together with their attempts at a simpler formal idiom, and their choices of subject matter, points up the differences in the two movements' aims and concerns. The Italians were distinctly more intellectual in their approach, less interested in spontaneously conveying a sensuous impression of Nature. By the 1870s, the heyday of the Macchiaioli was already over, and developments continued in various directions. Of the early generation, only Lega, Signorini and Fattori retained their importance. From the mid-Sixties on, Italian artists increasingly responded to the pull of Paris. The work of the Macchiaioli had a strong French advocate in Degas, whose Italian family relations and numerous visits to the country had given him a keen interest in Italian art. From 1856 to 1859 he spent a number of periods in Florence, and he too went to Caffè Michelangiolo.

The names of Zandomeneghi and De Nittis are central to the active relations of France and Italy. Till 1863, De Nittis worked in Naples. His

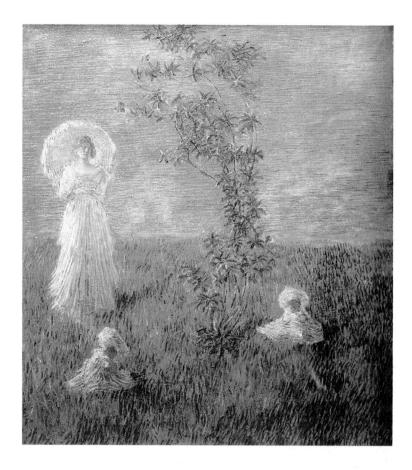

friendship with the Florentine sculptor and critic Cecioni put him in touch with the Macchiaioli in the mid-Sixties, and his style and subject matter were influenced by them. To develop his skills, he went to Paris in 1868, settled there and became established. Thanks to the support of various dealers such as Goupil he achieved a reputation and financial success. Meanwhile, he maintained his contacts with Italian friends and fellow artists via letters and visits. At first, De Nittis was under the influence of Meissonier and Fortuny, painting genre scenes that were successful and sold, or Italian street scenes in which the old Florentine chiaroscuro was still apparent. His relatively unconstrained work, such as his views of Vesuvius, met with no success. In 1873, through Degas, he met the Impressionists, and had five pictures in their first group exhibition in 1874. Though he did not participate in the exhibitions that followed, he continued a friend of Degas, Manet and Caillebotte. De Nittis also had more conventional work in the Salon, where it attracted comment, but his brushwork, composition and technique were steadily coming into line with French Impressionist practice, in paintings such as The Victoria Embankment (p. 539) or Breakfast in the Garden (p. 540). Draughtsmanship, the precise object, and narrative elements, always remained more important to him than strategies that dissolved things seen into

Gaetano Previati In the Meadow, 1889/90 *Sul prato* Oil on canvas, 62 x 56.5 cm Florence, Galleria d'Arte Moderna phenomena of light. De Nittis in part painted in obedience to prevailing public taste, and his art thus occupied a position midway between the modish and the avant-garde.

Zandomeneghi was a quite different case. He settled in Paris in 1874, living a reclusive life, and, unsuccessful in his lifetime, was obliged to earn a living doing fashion drawings. He had studied at the Venice Academy, fought under Garibaldi, and been arrested; his influential family intervened for his release. In 1862 he joined the Macchiaioli in Florence, finding their realistic studies of Nature in line with his own ideas on art. He too visited Castiglioncello. Shortly after his arrival in Paris, he wrote to Signorini of his somewhat mixed response to French Impressionism, but gradually, thanks to the advocacy of Martelli, he became more convinced. Zandomeneghi exhibited in the 1879, 1881 and 1886 Impressionist shows. In street scenes such as *Place d'Anvers, Paris* (p. 542) his brushwork was relaxed and sketchy. His portraits (p. 548) sometimes recall Monet.

Zandomeneghi's Fishing on the Seine (p. 538) focusses on the life of leisure, showing a fashionably dressed young woman with a parasol on the grassy river bank and a man fishing. Of the man, thanks to the daring composition, we see only a top hat. The painting adopts a highly unusual point of view. Its cropping or overlapping, and the spatial dependence on larger, layered zones of colour, recalls Impressionist art as well as the Japanese woodcuts which were then enjoying so warm a reception. In the background, a smoking factory chimney signals the industrial end of this idyllic world. Realistic breaches of idyllic tones such as this were inconceivable in the academic Salon art of the period, and it shows Zandomeneghi to have been squarely in line with French Impressionism's ideas of painting modern life. His major works were painted in the late 1870s and in the 1880s. Among them were Le Moulin de la Galette (p. 541), in which the poster-like figures and spatially flat, simplified forms prompt comparison with the Post-Impressionist work of a Toulouse-Lautrec.

Boldini, who also moved to Paris (in 1871), adopted only certain features of French Impressionism, notably the emphasis on *plein-air* painting. He largely remained a skilful painter of society portraits, something which had been his forte as early as in his Macchiaioli Sixties. In France he relaxed his technique considerably, though to a significant extent he retained the Italian chiaroscuro effects and broad brushwork. Boldini was an acute observer of his fellow beings, and one of his finest works is the virtuoso *Portrait of Mlle Lantelme* (p. 532), with its arrestingly bold, unconstrained brush-strokes.

In the late 1870s, the Florence Macchiaioli seemed to be running out of steam. The older views were now superseded by a more Impressionist strain, promoted by Martelli. This second generation of Macchiaioli included Francesco Gioli (1846–1922) and Armando Spadini (1883– 1925), and from the 1880s on its centre was primarily northern Italy. Piedmont had already produced a notable pre-Impressionist in Antonio Fontanesi (1818–1882). Of the Venetians, Ciardi in particular deserves

Giovanni Battista Segantini Midday in the Alps (Windy Day), 1891 Mezzogiorno sulle Alpi (Giornata di vento) Oil on canvas, 77.5 x 71.5 cm St. Gallen, Fondazione Otto Fischbacher

Giovanni Battista Segantini Ploughing, 1890 *L'aratura* Oil on canvas, 116 x 227 cm Munich, Bayerische Staatsgemäldesammlungen, Neue Pinakothek

Federico Zandomeneghi Lady in a Meadow, 1893 Signora nel prato Oil on canvas, 46 x 38 cm Piceni 289. Milan, Private collection

mention. His landscapes expressed a profound response to Nature. He had studied at the Venice Academy but had moved on at an early stage to *plein-airisme* and had evolved a style that increasingly shared features with Impressionism. At the end of the 1870s, on Zandomeneghi's advice, he moved to Florence, where he made contact with the Macchiaioli. His structural reliance on effects of light and dark, and his meticulously separated colour zones, constituted an affinity with the group; but he was also open to other aesthetics, and through the Florence debates he became acquainted with the art of the Barbizon painters, of the Neapolitan School, and on the international scene. Canvases such as *Harvest* (p. 534), flooded with light, rendered atmospheric landscapes in a style drawn from the Venetian veduta tradition. These and his views of Venice brought Ciardi great success in his own lifetime.

In the 1880s, Lombardy began to play an active part in Italian art. The movement that originated there declared its loyalty to the great Italian tradition, and was particularly interested in atmospherics of light, colour and texture. In the 1890s, such work came into its own with divisionist

Federico Zandomeneghi Portrait of a Girl, c. 1893–1895 *Ritratto di una giovanetta* Oil on canvas, 60.5 x 73.5 cm Private collection

> or pointillist paintings; the proximity of Lombardy to France and Germany was palpable. Giovanni Carnovali (1804–1873), called Il Piccio, was an important forerunner who departed from the neo-classical tradition and, taking 18th-century Venetian art and Delacroix's use of colour as his points of departure, achieved a freer treatment of light and colour that had a decisive, enabling influence on subsequent developments in art in the Lombard capital, Milan. Il Piccio was one of the many artists, writers and musicians who campaigned in Milan in the 1860s for antiacademic, anti-bourgeois aims and methods in aesthetic work. They felt the hopes which the Risorgimento had aroused had not been fulfilled, and they were opposed to the rapid spread of industrialization in northern Italy in the Nineties, and especially to the growth of Milan's industrial moneyed middle classes. The movement, initially of a mainly literary kind, aimed to liberate art and literature from formalism of any description, and was known as Scapigliatura, or unrestraint. Unlike the Macchiaioli, whose attention was primarily on formal issues, the Scapigliatura group, in close association with writers, developed a brand of ro-

Giacomo Balla The Fiancée at the Villa Borghese, 1902 *La fidanzata alla Villa Borghese* Oil on canvas, 60.5 x 90 cm Milan, Civica Galleria d'Arte Moderna

mantic idealism. They were strongly attracted to the poetry of Baudelaire. Medardo Rosso (1858–1928) was the preeminent sculptor in the group, and Daniele Ranzoni (1843–1889) was among the most gifted of the painters. His tiny, divisionist brushwork and dissolved outlines survived in the Neo-Impressionist work of Gaetano Previati (1852–1920; p. 545), Giovanni Segantini (1858–1899), and above all Giuseppe Pellizza (1868–1907).

In the work of Pellizza, the most important Lombard Neo-Impressionist, the goals of the leading French pointillist, Seurat, were most consistently pursued. This was apparent not only in his relinquishing romantic natural scenes such as Impressionism favoured, and preferring an art based upon ideas; he also dispensed with clear outlines, and used strong contrasts of juxtaposed colours. Vittore and Alberto Grubicy, art dealers in Milan, were Italy's most assertive advocates of this style; in the Eighties and Nineties they supported the Scapigliatura artists, and the

Umberto Boccioni Portrait of the Artist Adriana Bisi-Fabbri, 1907 *Ritratto della pittrice Adriana Bisi-Fabbri* Oil on canvas, 52 x 95 cm Rome, Private collection

Italian divisionists such as Pellizza and Segantini. The latter, from 1886 on, developed his own technique for splitting colours, using separate brush-strokes for complementary colour values. Segantini's art concentrated on the light in the mountains, which provided him with a preferred subject which he tended to interpret in strongly Symbolist ways (p. 547). Segantini shared Pellizza's hope that a new world was coming in which artists would play a leading role, their authority no longer derived from academies but from life and the study of Nature.

Industrialization was rapid in Italy in the Nineties, and brought in its train social unrest and strikes, some of which would be bloodily put down. The life of the new working classes provided Pellizza with subject matter for politically committed paintings. His thematic range was great, and included curiously symbolic paintings such as *Washing in the Sun* (p. 551) or work that assigned a pantheistic meaning to light. This in turn pointed forward to Futurist artists such as Giacomo Balla (1871– 1958; p. 550) and Umberto Boccioni (1882–1916; p. 550), whose antiacademic stance and visual experiments with light as a bearer of energy and dynamics owed much to the Scapigliatura and the Italian divisionists.

KARIN SAGNER-DÜCHTING

Giuseppe Pellizza da Volpedo Washing in the Sun, 1905 *Panni al sole* Oil on canvas, 87 x 131 cm Domodossola, Private collection

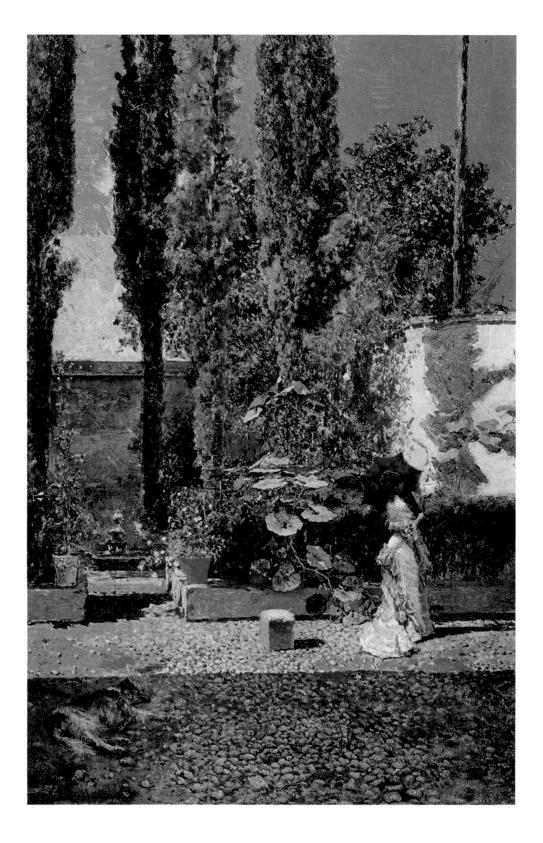

Spanish Impressionists obeyed the prevailing norms far more than their French counterparts in this respect; the French deliberately ventured aside from the straight and narrow of academic doctrine. In Rome, Pinazo took a strong interest in history painting and in landscape art. Back in Spain, he concentrated on the coast of his Valencian home parts, painting in a free and easy, sketchy style (*Luncheon*; Valencia, Museo de Bellas Artes).

Valencian art was notable for its efforts to capture the brief, passing moment by using rapid, unbroken brush-strokes and precision colourism. The vivid *plein-air* scenes, mainly Mediterranean, that the artists recorded in this style nonetheless preserved tonal unities, and might be better described as luminist than Impressionist. That is to say, the persistent survival of earthy colours, and even black, and the generally dark palette, placed them in the tradition of Spanish art.

Sorolla arrived at *plein-airisme* via years as an apprentice and journeyman in Valencia, Rome and Paris. While in Rome, he painted genre Carlos de Haes A Stream at Pont-Aven Un arroyo (Pont-Aven) Oil on canvas, 31 x 39 cm Madrid, Museo del Prado, Casón del Buen Retiro

Martín Rico y Ortega View of Venice *Vista de Venecia* Oil on canvas, 41 x 71 cm Madrid, Museo del Prado, Casón del Buen Retiro

pictures in the realist tradition of Domenico Morelli (1826–1901). During his time in Paris, he came under the spell of Bastien-Lepage. Sorolla satisfied Parisian taste by his religious mood and Parisian subject-matter. Returning to Spain in 1889, he settled in Madrid, where his art began to undergo a stylistic transformation: he attached greater importance to changing conditions of light, and now preferred scenes of Spanish folk life, especially in Mediterranean coastal areas. *The Beach at Valencia* (p. 560) is a good exampe of this kind of work. Even when Sorolla rendered effects of light in an intensified, almost unnatural way, and heightened the expressiveness of his art, his shapes and forms invariably remained identifiable.

The emphasis on form - albeit to varying degrees - constituted a point of difference between Spanish and French Impressionism. The various manifestations of light that played so vital a role in the French idiom were now to be essential in Sorolla's visual approach as well. The dramatic immediacy of Selling the Catch at Valencia (p. 561) derives from the gradation of its harmonious palette and the broad, solid forms established by its brushwork. In this painting, Sorolla has captured both the strong light of the south and the everyday life of Spanish fishing folk. In other paintings, his brushwork was often of a more modest yet vibrant order; it is as if his style altered to suit changing conditions of light. His work achieved a freedom of expression rare in Spanish art at that date, and it is small wonder that a museum in Madrid is now devoted entirely to Sorolla's paintings. In the early 20th century he enjoyed enormous international acclaim, and in 1909, for instance, had a solo exhibition in New York that included some 300 works and brought him enthusiastic recognition in the USA.

Another successful artist was the Basque painter Ignacio Zuloaga y Zabaleta (1870–1945). After 1890 he regularly spent periods in Paris, over a number of years, with the result that native Spanish influences and those of French Impressionism and Symbolism blended in his style in a quite distinctive way. His whole life long, Zuloaga was especially attached to the art of Velázquez and Goya, but above all that of El Greco. He was an ardent collector of El Greco's work, buying and renovating the latter's house in order to preserve it for posterity. Zuloaga began his own artistic career copying the old Spanish masters in the Prado, and then, after the obligatory visit to Rome, moved on to Paris, where he enrolled in the studio of Gervex, the friend of Renoir and Manet. This put him in direct touch with the contemporary French avant-garde. He travelled with his new friends Degas and Rodin, and shared a Montmartre studio with Gauguin, who introduced him to Symbolist circles and the poet Stéphane Mallarmé. Though he admired Impressionist art, he nevertheless soon returned in his own paintings to a crisper, more austere style schooled on the Spanish tradition, such as he had adopted in his early work.

Within that tradition, Zuloaga proved every inch a Spanish artist. His dynamic control of line in paintings such as *Celestina* (p. 562) reminds us of his formidable draughtsmanship skills. The emphasis on line and open space, the strong chiaroscuro tendency, and the treatment of the subject, all suggest the presence of Toulouse-Lautrec and Manet, for whom Zuloaga retained his admiration. His specifically Spanish subject-

Aureliano de Beruete y Moret The Manzanares, 1908 *El Manzanares* Oil on canvas, 57.5 x 81 cm Madrid, Museo del Prado, Casón del Buen Retiro

matter included dramatic cliffs and crags, and the sweeping Basque coastline along the Bay of Biscay, where he was frequently to be found despite periods spent in Bilbao, Seville, Granada and Paris. His studio in the little fishing village of Zumaya is now the Casa Museo Ignacio Zuloaga, open to the public.

Zuloaga's pictures, often immense in format, lacked that cheerful note peculiar to Sorolla, though. This was largely true of his scenes of Spanish folk life, too, in which he continued a native tradition of tragic realism by portraying those on the fringes of society – gypsies, beggars, cripples or witches – in distorted, grotesque ways. He also painted portraits of famous contemporaries – musicians, actors, dancers, painters and writers, as well as King Alfonso XIII and various aristocrats. After 1900, thanks mainly to his portraits, he secured a position as an internationally recognised society artist, and, as such, found himself constrained to make concessions to Salon taste, so that in this he resembled Sargent more closely than any of the great French artists.

Of the Spanish artists, Regoyos adopted first Impressionism and later Neo-Impressionism with the most persistent rigour. Born in Asturia, he studied under Haes at the San Fernando Academy in Madrid. In 1880 he went to Paris, where he was to stay a year, entering into a friendship with Luce that would have important consequences. Luce was closely connected with the Belgian art scene, with the result that Regoyos too paid repeated visits to Brussels up to 1889. There he joined the circle of the Neo-Impressionist painter van Rysselberghe, the sculptor Constantin Meunier (1831–1905), the art critic Maus, and Verhaeren the writer. With the last-named, Regoyos undertook the journey through Spain in

Joaquín Sorolla y Bastida painting on the beach

Joaquín Sorolla y Bastida The Beach at Valencia *Playa de Valencia* Oil on canvas Madrid, Museo Sorolla

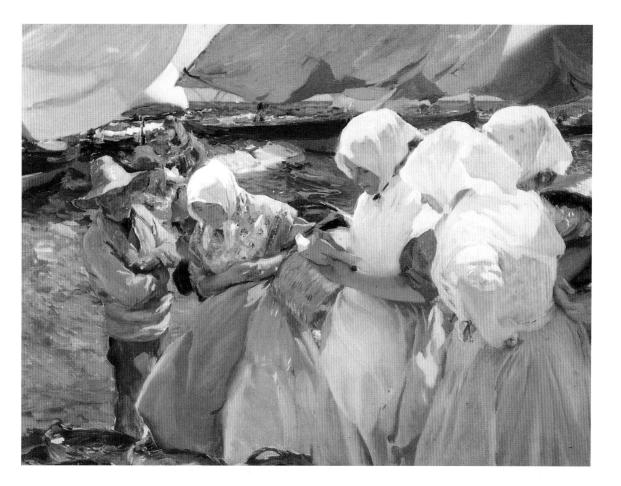

1888 which prompted Verhaeren's "La España Negra", an exploration of the country's darker sides. In 1883 Regoyos exhibited together in Brussels for the first time, and the following year was a co-founder of Les Vingt, to which group's exhibitions he regularly sent work until it was dissolved. From that time on, Impressionism began to supplant the darker hues of his work.

Regoyos was on the look-out for new modes of expression, and the Neo-Impressionism of Seurat, Signac, Pissarro and Cross aroused his interest. In 1888 he exhibited together with them in the rooms of *La Revue Blanche*, the periodical. For a short time he in fact practised a strict pointillism, as in his portrait of *Dolores Otaño* (p. 563). In 1890, 1892 and 1893 he exhibited with the Indépendants in Paris. From 1900 he was again regularly in Spain, particularly at San Sebastián on the north coast. Ill with cancer, he returned to Spain for good in 1911 and settled in Barcelona. His work met with no success in the official exhibitions there, but the younger avant-garde artists valued it highly. In his subject-matter, Regoyos ranged freely, painting scenes urban and rural, markets and streets, processions and festivals; but his finest work was in Joaquín Sorolla y Bastida Selling the Catch at Valencia, 1903 *La venta del pescado (Pescadoras valencianas)* Oil on canvas, 93 x 126 cm Valencia, Diputación Provincial landscapes. There he tackled various conditions of light and, unlike most Spanish artists, largely dispensed with the use of black. Avoiding the strong light of the south and the sharp contrasts of light and dark that it produced, he preferred the rich colours of greener northern Spain. His landscapes, painted in light, clear colours with unforced brushwork, recorded a true emotional rapport with a beloved native country which he never tired of travelling.

It was Catalan art, however, that wholeheartedly adopted Impressionism – even if the Catalan preference for greys, violets, ochres and muted greens recalls Whistler rather than a Monet or Renoir. Eliseo Meifren y Roig (1859–1940) was the leading figure here. He studied in Barcelona, then reafter living in Paris for several years, submitting regularly to the Salon and selling works through Petit's gallery (where he had a solo show). Meifren worked in France, in Italy, and throughout Spain. In 1916 he journeyed to the USA on the occasion of a solo exhibition of his works in New York. Open to new techniques and new ways of seeing,

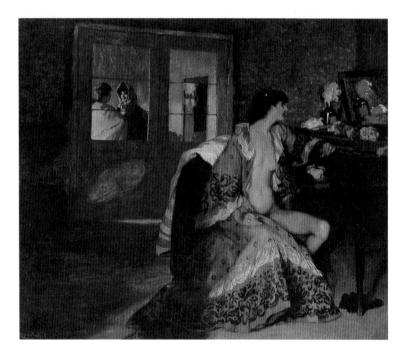

Ignacio Zuloaga y Zabaleta Celestina, 1906 Oil on canvas Madrid, Centro de Arte Reina Sofía

he painted in a relaxed, limpid manner, and his pictures have a strongly Impressionist flavour. He liked painting water, the sea and rivers, beaches and fishing ports, seen in various kinds of light. *The Marne* (p. 564) recalls Monet, not least through its view of the opposite bank and a line of poplar trees.

Various painters, such as Nicolas Raurich y Petre (1871–1945), brightened up their palettes under Meifren's influence, and adopted his more spontaneous brushwork. Raurich's taste took him to austere, for-

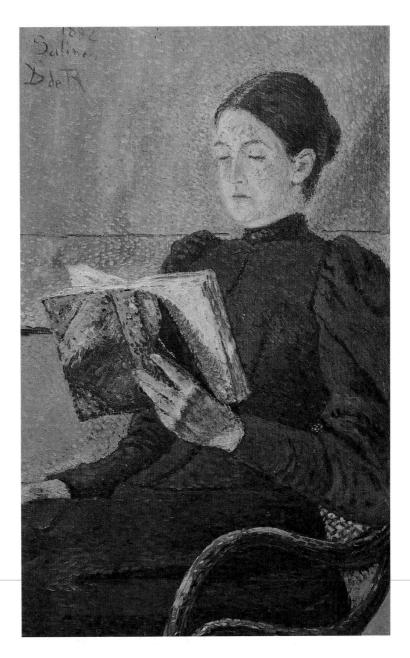

Darío de Regoyos Valdes Dolores Otaño, 1891 Oil on canvas, 55 x 35 cm Madrid, Museo del Prado, Casón del Buen Retiro

bidding landscapes such as the Pyrenees or the wild coastline of Catalonia, and he painted them in audacious swathes of colour or with pastose richness (*Solitude*, p. 566). Francisco Gimeno Arasa (1858–1927) also came from Catalonia, and his meeting with Haes in 1884 confirmed him in his own views on landscape painting. Gimeno, who had to earn a living as a house painter and decorator, developed his own turbulent style for pictures of the Spanish countryside. His manner tended to have a broad, almost violent vigour that prompts comparison with the Fauves.

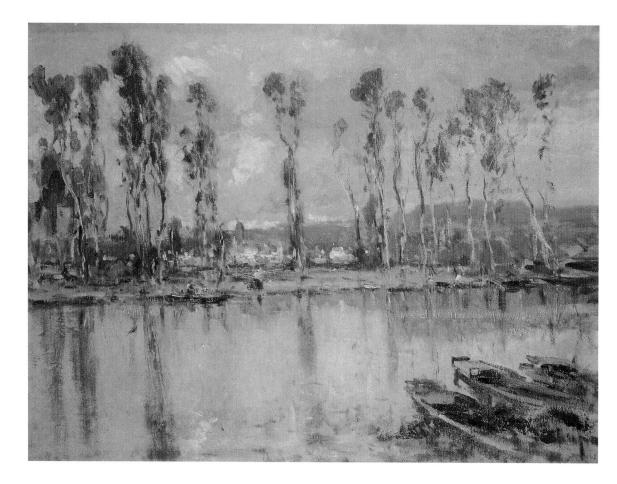

Eliseo Meifren y Roig The Marne *El Marne* Oil on canvas, 60 x 80 cm Barcelona, Museu Nacional d'Art de Catalunya Paintings in this style, such as *Blue Water* (p. 569), recorded typically savage coastlines along the Costa Verde.

Another major Catalan landscape artist who absorbed the example of Impressionism was Santiago Rusiñol y Prat (1861–1931). He was primarily active in Barcelona, where he was an art critic and dramaturgist as well as a painter. Rusiñol began his studies in Spain and continued them in Paris, where in 1891 he exhibited at the Indépendants together with the Impressionists and Symbolists. A friend of Toulouse-Lautrec, he frequented the Café Weber and met the artists who went there, in addition to composers such as Claude Debussy (1862-1918) and writers. Rusiñol paid homage to Impressionism by painting Montmartre. His palette in The Kitchen of the Moulin de la Galette (p. 567) was unusually restrained for this most exuberant of colourists, though. His paintings were notable for their precision, their diffuse lighting, and, despite the freedom of Rusiñol's brushwork, their concentration on the subject in hand. In Spain he made his name as the painter of Spanish gardens, some of which dated back to Moorish days. Minute brush-strokes conjured forth all the vibrant magnificence, life and freshness of the gardens of Valencia, Granada, Toledo or Seville; A Garden in Aranjuez (p. 565) is a beautiful example. Rusiñol was a contributor to the Barcelona avantgarde periodical "Pél y Ploma" (Brush and Pen), which also featured some of the early drawings with which Picasso first appeared before the public. The first issue of the magazine, edited by Miguel Utrillo, came out in Barcelona in 1899.

At the turn of the century, Barcelona became the capital of the Spanish avant-garde as well as a centre of the anarchist movement. The city was rocked by terrorist assassinations and bombings, its heady, stimulating atmosphere making it a vortex into which many an artist of the period was sucked. "Pél y Ploma" rapidly became the theoretical debating ground of Spanish *Modernismo*. The artists involved were vehement in their calls for Spain to join the main European current and to venture far-ranging social and cultural reform. *Modernismo*, a Spanish form of Art Nouveau, found in Rusiñol not only a committed patron but also an eloquent fellow traveller and spokesman. In 1892, 1893 and 1894 he held "modernist festivals" at Cau Ferrat, his property at Sitges on the Costa Dorada. Among the many artists who attended these festivals was his friend Ramón Casas (1866–1932). Casas similarly contributed to the

Santiago Rusiñol y Prat A Garden in Aranjuez, 1908 *Jardin de Aranjuez* Oil on canvas, 140 x 135 cm Madrid, Museo del Prado, Casón del Buen Retiro

Ramón Casas Out of Doors, c. 1890/91 *Al aire libre* Oil on canvas, 51 x 66 cm Barcelona, Museu Nacional d'Art de Catalunya

Nicolas Raurich y Petre Solitude Solitud Oil on canvas, 145 x 146 cm Barcelona, Museu Nacional d'Art de Catalunya

Santiago Rusiñol y Prat The Kitchen of the Moulin de la Galette, c. 1890 *El laboratorio de la Galette* Oil on canvas, 97 x 131 cm Barcelona, Museu Nacional d'Art de Catalunya

magazines "Pél y Ploma" and "Forma" and, like Rusiñol and many others, had been deeply influenced by a lengthy stay in Paris. The artists of this group significantly prepared the ground for Spain's later reconquest, in the new century, of an autonomous and important position in international art, a process which was decisively initiated by the vitality of the Catalan art scene.

The artistic talent of Ramón Casas was apparent at an early age. As a schoolboy he was already attending the Vincens Academy in Barcelona. In Paris he went to the studio of Carolus-Duran, whose views alternated between academic orthodoxy and Impressionism. In the case of Casas, Impressionism soon gained the upper hand over the methods of his teacher. Even so, Out of Doors (p. 566), painted on Montmartre during his Paris years, uses tonalities based on black and it squarely in the main Spanish tradition. The freedom that is reveals especially in the brushwork of the sketchy background, and the spatial flatness with which Casas sidesteps academic perspective, clearly indicate his debt to Impressionism, however. The stark contrast of black and white, and the emphasis on certain lines, give the painting a strongly graphic quality; accordingly, it is hardly surprising to learn that Casas was close to Toulouse-Lautrec and also did posters and graphic work. Of special interest in this context are some two hundred charcoal portraits of famous contemporaries which Casas did and which show him to have been an excellent portrait artist. In Spain he painted both landscapes and folk scenes, though the stress in the latter tended to be on the folklorist elements rather than on effects of colour and light.

The work of Casas, Rusiñol and their fellow artists Joaquín Sunyer (1875–1958), Isidro Nonell (1873–1911) and Joaquín Mir Trinxet

Joaquín Mir Trinxet The Waters of the Moguda, 1917 *Aguas de Moguda* Oil on canvas, 115 x 151 cm Madrid, Museo del Prado, Casón del Buen Retiro

(1873–1940) was exhibited in Barcelona in a café cabaret which went by the name of Els Quatre Gats (The Four Cats). The establishment had been opened by Pere Romeu in 1897 in imitation of the Chat-Noir in Paris. Every evening, a group of artists influenced by French Impressionism, with Casas and Rusiñol at their centre, would meet there to talk about modern art. It was these artists who were to inspire the young Picasso to strike out in new directions and find his own way of cutting loose from the conventional art and techniques he had learnt from his father, Don José. Thus, Picasso's career had its roots in Catalan Impressionism.

KARIN SAGNER-DÜCHTING

Francisco Gimeno Arasa Blue Water Aigua blava (Agua azul) Oil on canvas, 60 x 98.5 cm Madrid, Museo del Prado, Casón del Buen Retiro

George Clausen The Mowers, 1892 Oil on canvas, 97.2 x 76.2 cm Lincoln, Usher Gallery

16 The British Response to French Impressionism

Like many other French artists, Monet and Pissarro were driven into exile in London by the Franco-Prussian War of 1870/71. By their own testimony, what interested them most in English galleries was the landscape art of J. M. W. Turner (1775–1851), John Crome (1768–1821) and John Constable (1776–1837). The sensitivity of these painters toward Nature and the freedom of the artist's expressive means confirmed the French artists in their feelings about new directions in art. English landscape art, and Dutch 17th-century painting, afforded a model for a conscious departure from idealized classical landscapes. Simple rural motifs, the close study of Nature, and an eye for atmospheric phenomena, were all combined and rendered in a brushwork of considerable freedom.

Critics have always rightly stressed the influence of English landscape art on the development of Impressionism; the curious thing is that British painting as a whole did not itself build an innovatory art on the early foundations, in spite of the fact that the English landscape tradition was well represented in Royal Academy exhibitions in the second half of the 19th century. The tradition of Constable could be seen as an ideal vision of unspoilt Nature, and this gratified the wishes of the middle classes, reconciling them to an industrialized increasingly Britain. The industrial revolution had been accomplished first and fastest in Britain, and by the later 19th century the resulting urban explosions were exacerbating the traditional disaffection with the city.

It was not till the turn of the century, when Impressionism had achieved international recognition, that an English revaluation of Turner and Constable ensued, one that would consequently bear fruit with pre-Impressionist English landscape art coming to be seen as a milestone in the evolution of a new style. And it was in this spirit that, in the 1880s, as Impressionism began to catch on in Britain too, its practitioners, such as Wynford Dewhurst (1864–1941), insisted that the British variety was an altogether distinctive native strain. This distinction from French Impressionism (to which the British nonetheless owed the inspiration for their technique) depended primarily on choices of subject-matter. The thematic range was focussed on aspects of contemporary British life. No homogeneous movement evolved in Britain in the closing twenty years of the 19th century; however, an impressive diversity of talent nonetheless did emerge. The British artists often borrowed stylistic features from French Impressionism and also from contemporary Dutch and German art, but they tended to be too inclined to compromise and dilute; accordingly, their significance for English art ultimately resides in their opposition to and defeat of academic conventions, together with their establishment of ties with modern art internationally such as could put an end to British isolation.

The British Impressionists were at first less interested in French landscape art from the 1870s than in the painting of the Eighties – by which time the peak of French Impressionism was past. Most of the British artists, reacting to conditions in Britain, responded more keenly to social content, and assigned major roles in their own work to the human figure. Degas and Manet were therefore in the fore of their interest, while Monet, who had made his name primarily as a landscape artist and had

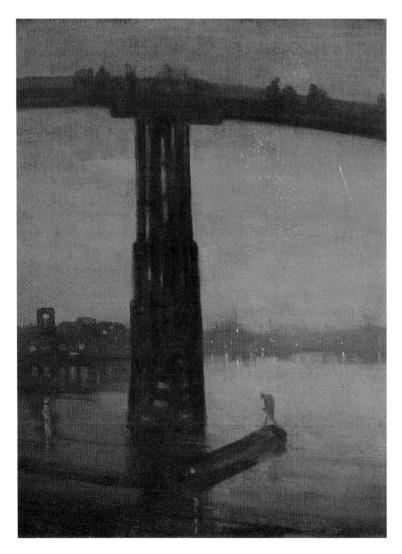

James Abbott McNeill Whistler Nocturne in Blue and Gold: Old Battersea Bridge, c. 1872–1875 Oil on canvas, 66.7 x 48.9 cm London, The Tate Gallery

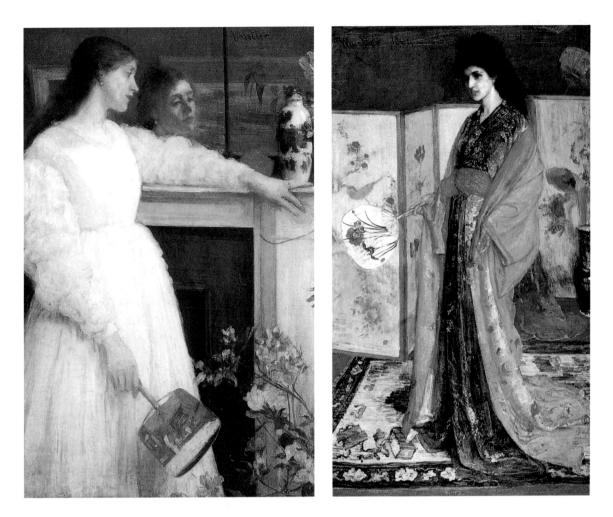

in fact largely dispensed with figures from the 1880s on, was admired for his virtuoso handling of light and colour.

When Monet and Pissarro were in London in 1870/71, their work was still as little known there as elsewhere. Though Durand-Ruel exhibited their paintings there at a relatively early date, it was not till more comprehensive Impressionist shows were mounted in the Eighties that the British reception began in earnest and English collectors started to respond with enthusiasm. At his London branch, Durand-Ruel had first exhibited the Barbizon artists in 1870. Exhibitions and publications were already making a success of the Barbizon school in Britain at that date, and Millet was particularly popular. For various younger British artists, such as George Clausen (1852–1944) or the Scot James Guthrie (1859– 1930), Barbizon art retained its allure into the Eighties. A number of British artists went to Paris to shake off the shackles of academic convention such as still prevailed at the Royal Academy and the Royal Scottish Academy. Idealistic Victorian art that glorified the aristocracy, luxury and optimism no longer had anything to say to the times, they felt; James Abbott McNeill Whistler The Little White Girl: Symphony in White, No. 2, 1864 Oil on canvas, 76 x 51 cm London, The Tate Gallery

James Abbott McNeill Whistler Rose and Silver: The Princess from the Land of Porcelain, 1864 Oil on canvas, 200 X 116 cm Washington (DC), Freer Gallery of Art, Smithsonian Institution indeed, its exclusion of contemporary reality was downright undemocratic. Furthermore, neither in England nor more particularly in London was there a cultural and social life that could rival that of Paris in particular and other great European cities in general. In the great economic centre that was London (thus John Ruskin, 1819–1900), naked materialism reigned, of an order that spelt the end of any civilization. Unlike Paris, where the vitality of the arts met with a fairly broad public response, London and its ruling classes had relatively little interest in culture. And so it had to be sought on the continent: in France, Italy, Germany and Holland.

Ironically enough, British artists in France were in closer contact with official Salon art than with the avant-garde. They tended to share the widespread enthusiasm for Bastien-Lepage, who had blended the rural subject-matter of Millet and the Barbizon school with a little social criticism and *plein-airisme* and had scored astonishing successes at the Salon with the result (p. 167). The younger generation were particularly interested in his broad brush-strokes, a new technique which he used (like the Impressionists) for his preliminary open-air sketches before adapting the final, studio product to prevailing taste. If Bastien-Lepage was nonetheless viewed as an Impressionist, it was not least because of the looseness of the criteria then applied to Impressionist art, which could include anything that used a freer technique, open-air studies, and modern subject-matter.

From the Eighties on, Britain's rural *plein-air* naturalism was tightened by the example of Bastien-Lepage and the Barbizon school. In 1883, Clausen was in Paris for several months, working under Bouguereau at the Académie Julian. He met Bastien-Lepage, and then, following a visit to Holland and acquaintances with artists there, followed his own predilection for simple, rustic scenes. Rural subjects remained to the fore in his work, and from the Nineties on he expressed them in his own version of Impressionist techniques. His post-Millet view of Nature and farm work can be seen in *The Mowers* (p. 570), which also exhibits effects of colour and light reminiscent of Monet.

Henry Herbert La Thangue (1859–1929) likewise aimed at a presentation of the simple life led by honest country people. Deeply Romantic in attitude, he had favourite areas in England, Provence and Liguria which he painted in order to establish a pre-industrial image of Nature. Like Clausen, he was strongly influenced by Bastien-Lepage in the 1880s; however, he steadily moved away from the latter's broad brushwork and social criticism alike, and established a structural style that went beyond linear precision, coupled with a more universal subject-matter. La Thangue's understanding of the natural world, as seen in his picture *In the Orchard* (p. 583), painted in the open, might best be compared with that of Pissarro. Pissarro's own art was of course communicated to the British not least by his son Lucien (1863–1944), resident in London since 1883 (p. 274).

From 1883 on, a number of painters gathered, along the lines of their colleagues in Barbizon, at Newlyn in Cornwall. The leaders of the group

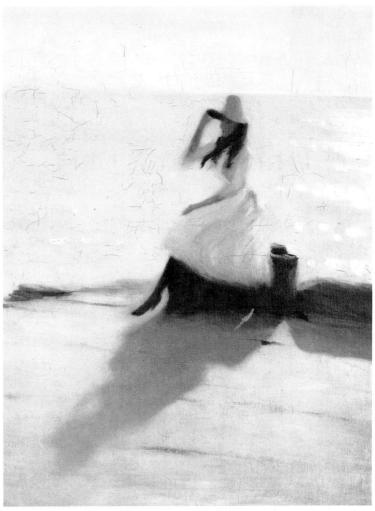

Philip Wilson Steer Young Woman on the Beach, Walberswick, c. 1886–1888 Oil on canvas, 125.5 x 91.5 cm Paris, Musée d'Orsay

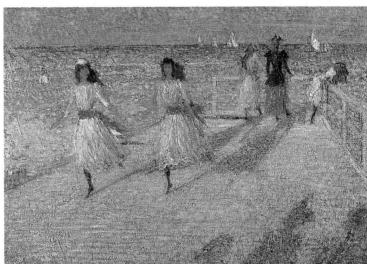

Philip Wilson Steer Girls Running, Walberswick Pier, c. 1890–1894 Oil on canvas, 69.2 x 92.7 cm London, The Tate Gallery

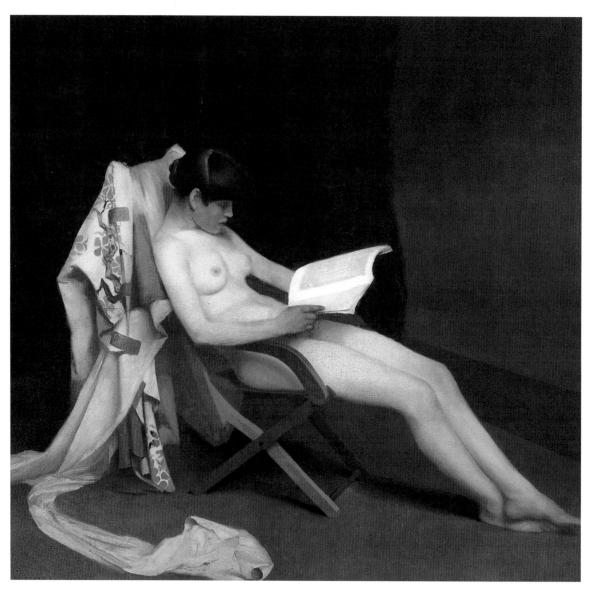

Theodore Roussel The Reading Girl, 1887 Oil on canvas, 152.4 x 161.3 cm London, The Tate Gallery were Stanhope Forbes (1857–1947) and Henry Scott Tuke (1858– 1929), and the artists' principal preoccupation was with *plein-air* naturalism, rural subjects, and fishing and coastal scenes. In 1899 Forbes established the Newlyn School of Art. Around the turn of the century, a new generation of artists gathered at the colony, taking their bearings more noticeably from the French Impressionist landscapes of the 1870s. The most striking of these artists was Laura Knight (1877–1972; pp. 586, 587).

In Scotland the 1880s also saw a lively interest in open-air painting. The Glasgow School, numbering some thirty members, was of key importance. Foremost in the group were Guthrie, his fellow Scot William MacTaggart (1835–1910), and the Irish artist John Lavery (1856–1941). They agreed in their opposition to prevailing Victorian taste and the methods of the Royal Scottish Academy. Guthrie's work brought the Glasgow School international recognition. A brief visit to Paris in 1882 left him with the lasting impact of Barbizon plein-air painting, which he would adapt to his own landscape art in the years ahead. His colours were delicate, his treatment of light and atmosphere extremely sensitive. In the mid-1880s, Guthrie entered a critical phase which resulted in his almost entirely abandoning landscapes and turning to portraits, interiors and genre work. The Morning Paper (p. 582) is one of the finest of his many portraits of middle-class women. Guthrie's pastel technique here and elsewhere seemed to him (as it did to Degas) the aptest means of expression, since it was quick and easy to use and thus ideally suited to recording impressions on the spot. There was great interest in the technique in Britain, as the sheer existence of a Pastel Society in London implies.

Guthrie was a friend of James Abbott McNeill Whistler (1834–1903). He also joined the New English Art Club in London in 1899. This independent, Secessionist movement had been founded in 1885 by Clausen, La Thangue, Forbes, Wilson Steer (1860–1942), Sidney Starr (1857– 1925) and Frederick Brown (1851–1941) to promote the new, *plein-air*, sketchy, Impressionist art. The Club was in revolt against the moralizing and anecdotal tone of Victorian art and the teaching methods of the Royal Academy. Its first annual group show was held in 1886, and revealed the members to have espoused aesthetics of various kinds, though a large number had plainly taken the principles of French Impressionism to heart.

Whistler, the friend of Monet and Renoir and, like them, in former times a student at Charles Gleyre's studio in Paris, was instrumental in communicating Impressionism to Britain. Born in America, he had been resident in England since 1863. Scandals such as the Ruskin law suit of 1877 helped make him the idol of the younger artists; more importantly, they discovered in his paintings new possibilities that pointed forward to abstract art. His nocturnes of the early 1870s were pioneering work contemporaneous with Monet's breakthrough (*Nocturne in Blue and Gold: Old Battersea Bridge*, p. 572); it was of these paintings that Ruskin had been so disparaging. In them, Whistler viewed the Thames at night

Walter Richard Sickert Lion Comique, 1887 Oil on canvas, 51 x 31 cm London, Private collection

in muted, poetic harmonies of hue. What counted was not a precise detail or outline; rather, Whistler was after large, simple, major form. The foreground, middle distance and background were treated in much the same way; conventional perspective was meaningless, given that the canvas was a single colour space. The influence of Japanese art is palpable.

Whistler's structures were of course taken from real observation, but in the studio he adapted what he had seen to an aesthetic ideal, a poetry of vision. It was, despite appearances, a different method from that of the French Impressionists in the 1870s, in other words. Whistler's interest (like that of Degas and Manet) was in the city, modern life of a Baudelairean order. During his short presidency (1886–1888) of the Royal Academy, Whistler not only expounded his aesthetic principles in his 10 o'clock lectures but also promoted French Impressionism and gave it exhibition space in 1886.

Whistler's followers included Theodore Roussel (1847-1926), Paul Maitland (1863-1909), Walter Richard Sickert (1860-1942) and the young Wilson Steer - that is, the artists widely considered the leading British Impressionists. With Starr and Brown they split off from the New English Art Club and sidelined the more rural subject-matter of the Glasgow and Newlyn Schools, or at least exerted a strong influence. Controversy resulted; and between 1886 and 1905, British Impressionism was fought out in the Club - or, by those who resigned, out of it. In 1889 Sickert organized the London Impressionist Exhibition at Goupil's London rooms; a sub-group within the club were using that label. The driving force was Sickert, who possessed a forceful literary skill too and wrote a foreword to the first catalogue in which he outlined the group's aims. He was clearly opposed to official Victorian doctrine, and warned against a decorative art that took its bearings from the Arts and Crafts movement. The task facing British Impressionism, he believed, was to record the magic and poesy that lay all around in everyday life. London, the great metropolis, provided all the stimulating subject-matter that was necessary.

Plainly this did not equally apply to all the London Impressionists, though; and contemporary critics were not slow to voice doubts concerning the unity of the group Sickert insisted existed. A concentration on London subject-matter, for instance, was apparent only in the work of Sickert (p. 588), Starr (p. 579), Roussel (p. 576) and the latter's pupil Maitland (p. 583), and to a lesser extent in that of Steer and Brown. Urban problems resulting from 19th-century expansion in the cities – such as unemployment, poverty, child labour, alcoholism and prostitution – were almost totally absent from this art. The city was being viewed as a predominantly middle-class thing. It was being aestheticized. And still Victorian taste chose to object, precisely because the work of the London Impressionists lacked a moral agenda.

In drawing people's attention to the group's peculiar subject-matter, Sickert had been aiming to pre-empt the criticism that the London Impressionists were merely copying the art of Degas, Monet and Whis-

Sidney Starr The City Atlas, c. 1888/89 Oil on canvas, 60.9 x 50.6 cm Ottawa, National Gallery of Canada, Gift of the Massey Collection of English Painting

William MacTaggart The Storm, 1890 Oil on canvas, 121.9 x 183 cm Edinburgh, National Gallery of Scotland

tler. Lucien Pissarro, however, lecturing at the Club, took a different view. He felt that very few of the English artists, who "painted flat and included black (!) in their palettes", were at all conscious of the principles of Impressionism. He had good words for Steer alone, who, he thought, was the most uncompromising in his adoption of the new style. (Despite these reservations, Lucien Pissarro was to join Sickert's circle some years later.)

Like many another English painter of his generation, Steer, who enrolled at the Académie Julian in Paris in 1882, was initially under the sway of Bastien-Lepage. Back in England, he settled in London, and from 1884 tended to paint at Walberswick on the Suffolk coast. There he painted Young Woman on the Beach (p. 575) and similar fresh, outstanding pictures, which he showed at the first London Impressionists exhibition. The fluid style echoed Whistler, while Steer's pastose brushwork (or, indeed, palette knife work) sometimes recalled Courbet or Manet. Subsequently Steer, under the growing influence of French Impressionism, lightened his colours to the point of luminosity, using a technique of visibly separate brush-strokes reminiscent of Monet's boat pictures at Argenteuil (Summer at Cowes, p. 581). The additive juxtaposition of strokes of unmixed colour already indicated how much ground brushwork was gaining in Steer's praxis at the expense of formal considerations.

Consistently enough, Steer occasionally came close to pointillism (p. 575). In his clear, simple, sometimes almost linear compositions, Steer had a predilection for backlit figures and shapes and subtly nuanced pastel colours comparable to Monet's work at Antibes and Bordighera. The Neo-Impressionist dissolution of form went unloved in Britain, and for a long time to come its unpopularity was to be a burden on Steer's standing, not only within the Club. Clear form and three-dimensionality remained fundamental in the view of British artists. Steer's approach to

a variety of avant-garde lines, from Impressionism via Neo-Impressionism to Symbolism, was reflected in the variety of his own compositional strategies and painting techniques. Thus the more spontaneous of his landscapes and coastal scenes recall Monet and Neo-Impressionism, while his interiors are more in line with Degas, Whistler and John Singer Sargent (1856–1925). It was in the 1880s that Steer painted his most important contributions to British Impressionism. In the mid-Nineties (while teaching as Brown's assistant at the Slade), his style underwent a transformation and he became a romantic eclectic, drawing his subjects increasingly from the landscape art of the 18th and early 19th centuries (Watteau, Constable, Turner), yet all the time keeping his acquired technical resources firmly to hand. In his late period he also painted outstanding watercolours.

Sargent affords an arresting example of just how readily Impressionist elements in the 1880s could be absorbed by a talent that was at heart Philip Wilson Steer Summer at Cowes, 1888 Oil on canvas, 50.9 x 61.2 cm Manchester, City Art Gallery

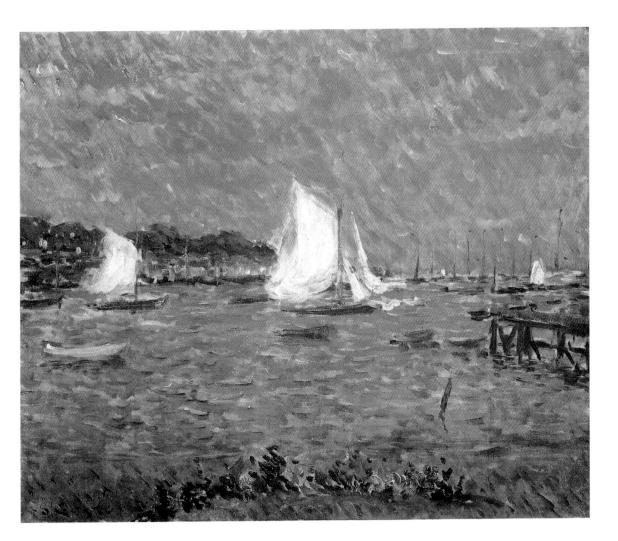

James Guthrie The Morning Paper, 1890 Pastel on paper, 52.1 x 62.2 cm London, Fine Art Society

academic. American by birth, he will be examined in greater detail in the chapter "Impressionism in North America" but he should not be forgotten here, since he played a key role in British Impressionism. He was resident in London from the mid-Eighties on, and was one of the foreign painters who repeatedly visited Giverny in order to paint near the revered Monet. Sargent in fact had been a personal friend of Monet's since 1876, and worked at his side in Giverny; and his part in communicating the French master's art to Britain was an important one. Later in his career, Sargent was to be a sought-after society portrait painter of considerable decorative resource; but in his earlier years he had a strong interest in *plein-airisme* and an easy-going technical approach to subjects. The story goes that when they were painting together, Sargent asked for black, which he felt he absolutely needed, but was refused; and the anecdote is richly suggestive of the tradition within which Sargent believed he belonged. In the 1870s in Paris he had not only studied under the academic Carolus-Duran but had also been inspired by dark-toned Spanish art. As with most of the British Impressionists, subject took precedence over form in his eyes. He never accorded the textural substance of a painting an autonomous value, as Monet did in works painted in the same period. In the Eighties, through Monet, Sargent gave more attention to natural effects of light and shadow.

Nevertheless (and this too applied to many of the British Impressionists), the chiaroscurist fundamental principles of academic art based on tonalities remained in the foreground for Sargent. To put those principles aside had been one of the revolutionary achievements of the French Impressionists. Sargent's supposedly Impressionist phase, spent painting in and near Broadway, lasted only from about 1884 to 1889. *Carnation*,

Paul Maitland Flower Walk, Kensington Gardens, c. 1897 Oil on canvas, 127 x 177.8 cm London, The Tate Gallery

Henry Herbert La Thangue In the Orchard, 1893 Oil on canvas, 82.9 x 72.4 cm Bradford, City Art Gallery and Museum, Cartwright Hall

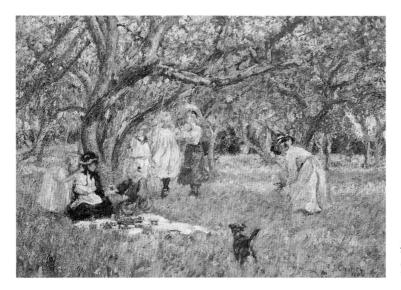

James Charles The Picnic, 1904 Oil on canvas, 37.5 x 54 cm Warrington (Cheshire), Museum and Art Gallery

Lily, Lily, Rose (p. 597) was one of his great achievements of that period. The atmosphere and lighting of the painting, exhibited in 1887 at the Royal Academy, made a powerful impact on his fellow artists; Steer was one of those who expressed their enthusiasm, urging Sargent to persuade other members of the Club, such as Clausen and La Thangue, to join the Royal Academy.

By such routes did Impressionist ideas and technical innovations begin to penetrate into the academic institutions. This may well be one reason why the Club began to lose its role as a forum for the new art in the Nineties. The fact that other artists' associations were founded, with Sickert directly involved once again, was merely one further by-product of the process.

Viewed across the entire spectrum of his work, Sickert must surely be regarded as one of the most gifted painters of his age. After studying at the Slade, he visited Degas and Manet in Paris on the recommendation of Whistler. At Dieppe in summer 1885, influenced by Degas, he did pastels and oils of beach scenes and shop fronts, pursuing ideas of pictures in series. The tendency to work in series of paintings was to remain with Sickert. The muted, soft, reticent colours of his early work strongly recalled Whistler, while the sketchiness and the patchwork, broken brush-strokes reflect his experience of France. Following his return to London, Sickert, again with Degas' example in mind, turned to the entertainment world of theatres and music-halls. The famous music-hall pictures which were so successful in England were painted from 1889 on and occupy a central position in his œuvre. Along with his works done in Dieppe (p. 588) and Venice, they constitute one of the three major thematic groups in Sickert's art. One of the first of the music-hall pictures was Lion Comique (p. 578). The understated olive green, khaki and (unusually) brownish violet have been lightened, under French influence, with cool greys and ochres. The simple tonal gradation highlights the comedian above the darkness of the orchestra pit. Unlike Degas, Sickert does not trouble with startling cropping or points of view, but, like Degas, he did work in the studio from preliminary studies. Sickert's music-hall paintings are skilful, effective exercises in using the contrast between the bright stage and dark auditorium, in which the human figures seem reduced to puppets or masks, stripped of their individuality. The chiaroscurist leanings in Sickert's work marked him out from the pure, classic Impressionists.

Sickert was active on the Club's behalf till the 1890s. In 1889, he organized a show at Goupil's in Paris at which Starr, Steer, Brown and Roussel exhibited. Durand-Ruel gave him a number of successful shows, and even Neo-Impressionists and Symbolists such as Fénéon and Signac took an interest in his paintings. In 1905 Sickert returned to London, to settle in Camden Town. Up to the First World War he painted highly individual, outstanding works. He was now experimenting more with various techniques, such as overpainting, always proceeding from meticulous draughtsmanship and composition. In this respect his technique was in a direct line of descent from the academic principle of the preliminary ébauche. He now concentrated largely on nudes, interiors and genre scenes. From 1908 on, Sickert hosted weekly gatherings of painters at his home in Fitzroy Street, where Lucien Pissarro, Spencer Gore (1878-1914) and Harold Gilman (1876–1919) were among the regulars. In 1911, under Gore's presidency, they held their first public exhibition, calling themselves the Camden Town Group. This was the seed of the influential London Group that would emerge in 1913. The foundation

Wynford Dewhurst Luncheon on the Grass (The Picnic), 1908 Oil on canvas, 82 x 100.7 cm Manchester, City Art Gallery of these groups reflected the active reception of Cézanne, van Gogh and Gauguin; Roger Eliot Fry (1866–1934) was in the vanguard of the British critical assessment of Post-Impressionism. Cubist and Futurist work was soon being received too.

Gore was one of the most important English artists in the opening years of the century (p. 590). He studied at the Slade, where he met Gilman and Wyndham Lewis (1884–1957), who were among the first members of the London Group. Gore was also a pupil of Steer, through whom he became acquainted with the work of Monet. In 1903 he met Sickert and Lucien Pissarro; the latter introduced him to the work of his father, Sickert to that of Degas. Gore quickly abandoned the New English Art Club; however, he was not only the first president of the Camden Group, but also – through his friend Lewis – injected Vorticism into the London Group. Vorticism was the British equivalent of Futurism and Cubism.

The president of the London Group was Gilman. From about 1910 on, he worked on an idiosyncratic blend of Signac, van Gogh and Gauguin's styles. He was a careful draughtsman and gave scrupulous attention to preliminaries. Gilman mainly painted landscapes, portraits and interiors with figures, but, in contrast to contemporary French avantgarde painters such as Matisse or Picasso, he always kept the observation of Nature in a firmly central position. In this sense, Gilman considered himself a realist (p. 589).

Sickert's supremely important role consisted not only in assisting the recognition of Impressionism, Whistler, and thus the tradition that lay behind his own work; he also paved the way for a new freedom in artistic

Laura Knight Flying the Kite, 1910 Oil on canvas, 150 x 180 cm Cape Town, South African National Gallery

Laura Knight Wind and Sun, c. 1913 Oil on canvas, 96.5 x 112 cm London, Pyms Gallery

expression, a freedom that ran parallel to the new sociopolitical mood of the Edwardian decade. If Impressionism in the New English Art Club had been primarily a matter of Sickert and Steer at the beginning of the Nineties, the work of Clausen, La Thangue and Lavery also served to demonstrate that familiarity with the Impressionist achievement was widespread in Britain, and that technical innovations had been adopted not only by the Club but also in the Royal Academy. New associations such as the International Society of Sculptors, Painters and Gravers, founded by Whistler in 1898, quickly outpaced the New English Art Club. Many of its members, of course, were recruited from the ranks of the Club or Sickert's friends.

Clausen, Guthrie and La Thangue now turned increasingly to a pure landscape art that was centred on atmospherics, light and motion. With the old English masters – especially Constable and Turner – in mind, they tended to foreground idylls and Arcadian views of Nature. Perhaps inevitably, *plein-air* painting was superseded once more by studio work, in the output of Clausen and La Thangue and in that of Forbes' turn-ofthe-century group at Newlyn. Knight painted curiously heroic-seeming figure compositions and idyllic country pictures, such as *Flying the Kite* (p. 586) and *Wind and Sun* (p. 587). The luminous splendour and the freshness of her work is bewitching to this day. The atmospheric vastness of her sky, and her relatively quiet colours, are reminiscent of the Hague School.

The Glasgow School always tended towards a greater emphasis upon individual personalities than was the case with the Club. In the 1890s, its interest shifted towards the decorative values of Art Nouveau, at the time a new development. The Glasgow avant-garde was fond of a modest symbolism such as linked their work to that of the Nabis and Neo-Impressionists more than to that of Manet or Monet. The preeminent Glasgow artists remained portrait painters, followers of Whistler such as Guthrie.

Monet's influence remained evident in the Edwardian years in paintings by Dewhurst such as *Luncheon on the Grass* (p. 585), which takes Monet's brushwork and some of his style without achieving his compositional unity. Dewhurst saw Monet as the finest of the Impressionists, and put his view in "Impressionist Painting: its Genesis and Development" (1904). In closing, we must mention the Aesthetic movement of the Nineties, a decadent vein parallel to realism and Impressionism. These artists included Charles Condor (1868–1909), William Rothenstein (1872–1945) and William Orpen (1878–1931). This was the second generation of the New English Art Club. They too visited France,

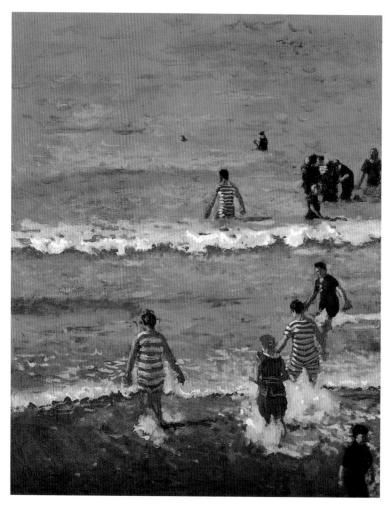

Walter Richard Sickert Bathers at Dieppe, c. 1902 Oil on canvas, 131 x 104.4 cm Liverpool, Walker Art Gallery

Harold Gilman Canal Bridge, Flekkefjord, 1912 Oil on canvas, 46 x 61 cm London, The Tate Gallery

Spencer F. Gore Mornington Crescent, 1911 Oil on canvas, 63.5 x 76.5 cm London, The Tate Gallery

and were in touch with Camille Pissarro, Gauguin, the Pont-Aven painters, and Toulouse-Lautrec. Condor and Orpen studied at the Slade, lived in Chelsea, and were friends of Steer. They kept a close eye on developments in French art such as the linear style of the Nabis, the synthetist approach of the Pont-Aven school, or the more expressionist manner of Toulouse-Lautrec.

KARIN SAGNER-DÜCHTING

17 Impressionism in North America

Origins and Principles of American Impressionism

In 1886 the French Impressionists held their eighth and last joint exhibition in Paris. It was also the year the movement achieved its American breakthrough. At the invitation of the American Art Association in New York, the Paris art dealer Paul Durand-Ruel mounted the most comprehensive exhibition of Impressionist art yet seen in North America at that date, including 23 works by Degas, 17 Manets, 48 Monets, 7 Morisots, 42 Pissarros, 38 Renoirs, and 15 Sisleys. This impressive collection of works ably represented the aims and distinctive characteristics of Impressionism. The show, which opened on 10 April, was so well received that when it closed it moved to the National Academy of Design and on 25 May was re-opened to public view.

Up till this exhibition, Durand-Ruel had contented himself with offering single works or small groups on the American market, and the US had had small opportunity to assess the new art. The first Impressionist painting to be included in an American exhibition was Degas' pastel *Ballet Rehearsal* (1874; Kansas City, MO, Nelson-Atkins Museum of

Mary Cassatt Offering the Panale to the Bullfighter, 1873 Oil on canvas, 100.6 x 85.1 cm Breeskin 22. Williamstown (MA), Sterling and Francis Clark Institute

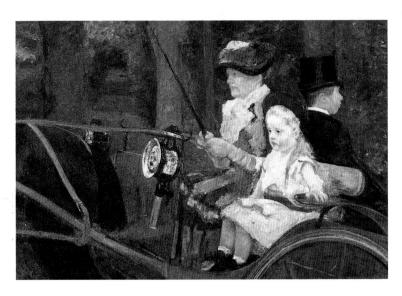

Mary Cassatt A Woman and Child in the Driving Seat, 1879 Oil on canvas, 89.9 x 130.8 cm Breeskin 69 Philadelphia (PA), Philadelphia Museum of Art Art), at the time in an American private collection, which was seen in the American Watercolor Society's annual show in New York in 1878. The following year, Manet's *Execution of Emperor Maximilian* (p. 65) was displayed at the Clarendon Hotel in New York and the Studio Building in Boston. However, another few years were still to pass before anything more than stray works by French Impressionists were seen in America. In 1883, an International Exhibition of Art and Industry (originally conceived as part of an 1881 world fair that never materialized) was held in Boston to show art and crafts from abroad. Durand-Ruel placed a fair number of Impressionist works in this exhibition – about half of all the oils displayed – including *6* Pissarros, 4 each by Renoir and Sisley, and 3 Monets.

The response to the new French aesthetics was initially reserved, and it was not till the 1886 show that a turning point was reached. Private collectors had hitherto been slow to invest; but at the Art Association show Durand-Ruel reputedly took some \$40,000. The press reaction was lively, and henceforth contemporary French art featured prominently in art magazines. One commentary in April 1886 declared that the Impressionists possessed "technical skill of a high order", and that the work on show had provided valuable new stimulus for American artists.¹

The Art Association show marked the true beginning of the reception of Impressionism by American artists. Study in Paris or in rural France became fashionable after 1886, Giverny, where Monet had moved in April 1883, proving particularly popular. In this, American painters were in line with a trend that had been established since the American Civil War (1861–1865). If art in previous decades had been primarily tied to the new sense of nationhood, in the post-war period it acquired a newly cosmopolitan cast. After the Civil War, the US developed a changed, confident view of itself, and the evolution of modern mercantile America can effectively be dated from that time. Its internal unity finally

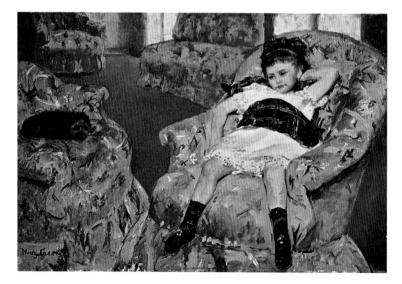

Mary Cassatt Little Girl in a Blue Armchair, 1878 Oil on canvas, 89.5 x 129.8 cm Breeskin 56 Washington (DC), National Gallery of Art, Mr. and Mrs. Paul Mellon Collection

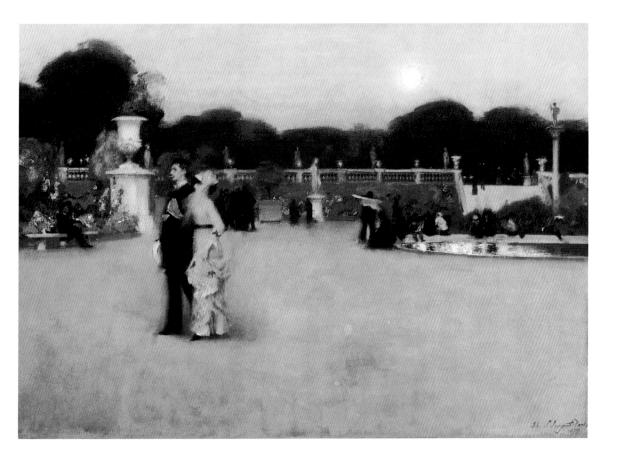

established, the US displayed a new national pride, and displayed it to all the world. Rather than closing their eyes to outside influences, the Americans now accepted the challenge to compete; and their strength in the years ahead was to lie in outdoing the old world in its own fields and by its own means.

In art, this meant two things. First, American art took to expressing the nation's achievements and self-confidence. The idealizing tendency of the American Renaissance, and its display of social status and assurance, were not unlike similar tendencies in European art, and particularly in Victorian England. Second, if American art had previously been wary of forfeiting its own identity through contact with art elsewhere, it now exhibited the sureness and independence of maturity. What mattered now was to assimilate European traditions and techniques and to transform them into something peculiarly American. American artists took to attending European academies in greater numbers than had previously been the case. Düsseldorf had already attracted Americans prior to the Civil War, and later their German goal was Munich. But it was Paris, already popular in the 1850s, that became the great magnet for American art students abroad in and after the 1860s. They matriculated at the Ecole des Beaux-Arts or at the private schools, the most frequented of

John Singer Sargent

The Luxembourg Garden at Twilight, 1879 Oil on canvas, 64.8 x 91.4 cm Philadelphia, Philadelphia Museum of Art, J.G. Johnson Collection which was the Académie Julian, where they could meet artists from all over Europe.

Paris training was based on life drawing and composition. Tutors followed the canonical wisdom of two centuries of Academy teaching, which assigned a far higher value to history painting, because of its moral dimensions and implications, than to still lifes or landscapes. But of course it was precisely landscape art that had developed a solid tradition of its own in 19th-century America. From the Hudson River School artists Thomas Cole (1801–1848) and Albert Bierstadt (1830–1902) to Luminist artists such as Fitz Hugh Lane (1804–1865) and John F. Kensett (1816–1872), the American line portrayed the specifics of the American landscape. These artists recorded the distinctiveness of Nature in the New World, its vastness, its unspoilt beauty, and its ability to consign Man to a subordinate position.

The Luminists, most active in the third quarter of the century, introduced to American landscape art its powerful atmospherics. As the group's sobriquet implied, they were interested in effects of light. Their compositions were broad in format and tended to position the horizon low in order to paint an immense veil of gauzy sky. The Luminists'

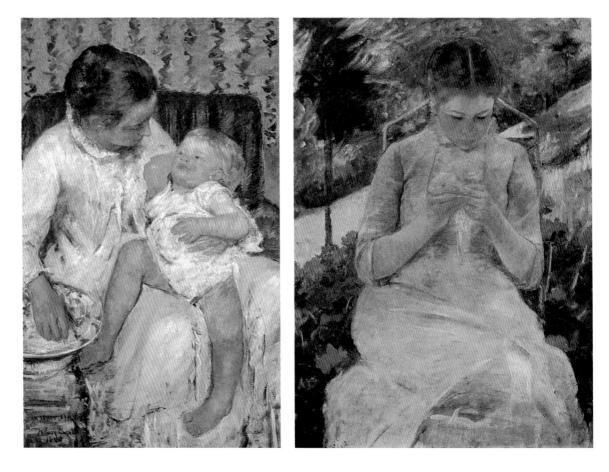

Mary Cassatt Mother about to Wash Her Sleepy Child, 1880 Oil on canvas, 100.5 x 65.4 cm Breeskin 90 Los Angeles (CA), Los Angeles County Museum of Art, Mrs. Fred Hathaway Bixby Bequest

Mary Cassatt

Young Woman Sewing in the Garden, c. 1880–1882 Oil on canvas, 92 x 63 cm Breeskin 144 Paris, Musée d'Orsay

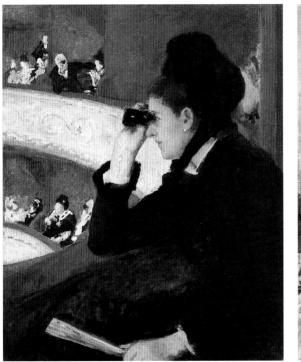

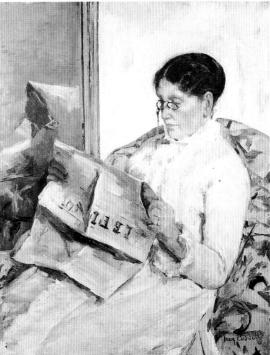

attention to light provided an invaluable seedbed for the adoption of Impressionist techniques by American artists.

Of great importance too was the fact that the new French aesthetics were only one of several artistic options with which Europe confronted the American artists. In terms of the American reception of European art, academic figure-painting and composition, Impressionist brushwork and subject-matter, along with the various principles and approaches of movements that were presently to follow, were contemporaneous and of equal validity. American artists not infrequently combined the most various of influences in their work. By far the majority of those who came to terms with Impressionism retained recognisable continuities with their academic training, preserving firm outlines and forms (especially in figure work) despite their relaxed brushwork. But their structural approaches opened and freshened thanks to landscape art, an area which academic tuition largely ignored. Small wonder, then, that American artists were particularly interested in the pictures of Bastien-Lepage (p. 167), who combined tonally modelled figure work with an unacademic approach to Nature.

Apart from their eclectic way of combining stylistic features, American artists often tended to have only a passing interest in Impressionist aesthetics, using them as a springboard to their own expressive strategies. In those strategies they could draw on the American tradition's tendency to use formats of considerable width with low horizons, for instance. The most important characteristic was the aim to present inner values rather

Mary Cassatt At the Opera, 1880

Oil on canvas, 80 x 64.8 cm Breeskin 73 Boston (MA), Museum of Fine Arts, Charles Henry Hayden Fund

Mary Cassatt

Reading "Le Figaro", 1883 Oil on canvas, 104 x 84 cm Breeskin 128 Private collection

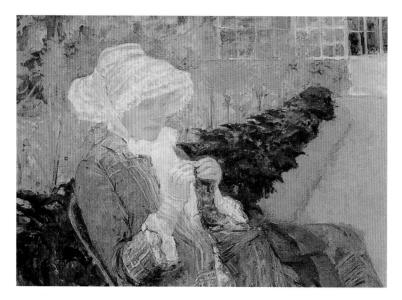

Mary Cassatt Lydia Crocheting in the Garden at Marly, 1880 Oil on canvas, 66 x 94 cm. Breeskin 98 New York, The Metropolitan Museum of Art, Gift of Mrs. Gardner Cassatt

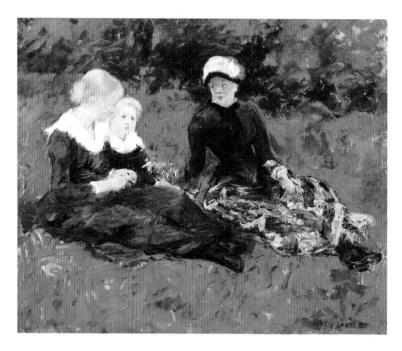

Mary Cassatt On the Meadow, 1880 Oil on canvas, 54 x 65 cm Breeskin 93. Private collection

John Singer Sargent Carnation, Lily, Lily, Rose, 1885/86 Oil on canvas, 174 x 153.7 cm London, The Tate Gallery

than merely a brief visual impression; French Impressionist technique was felt to be materialist and to neglect ideal values. Fr this reason, the French countermovements of Neo- and Post-Impressionism and Symbolism proved especially attractive to North American artists in the late 19th and early 20th century.

The changes in American responses to French art are a reminder that the Americans primarily saw Impressionism as a thing of formal, aesthetic innovation, and a revolution in brushwork and colourism. Americans did not warm to the French artists' view that their formal departures defined a position not only in the art world but indeed in society at large. Themselves trained in the Paris academic tradition, American artists could see only some secondary significance in the Impressionists' rejection of the academic annual Salon and the structural and cognitive norms that prevailed there. The French Impressionists had tackled thematic areas that had hitherto not been deemed worthy of art: as well as landscapes, they had painted motifs drawn from modern everyday life, often reflecting the societal changes that accompanied industrialization. These subjects were absent from American paintings, which emphasized cheerful rural and urban scenes flooded with light and inhabited by carefree people.

The press responses to the 1886 Art Association exhibition reflected this selective approach. Three points of criticism recurred: Impressionist figure painting was felt to be a brutal, undignified realism; Impressionist

John Singer Sargent Dr. Pozzi at Home, 1881 Oil on canvas, 204.5 x 111.5 cm

Los Angeles (CA), The Armand Hammer Collection

John Singer Sargent

Madame X (Portrait of Madame Gautreau) (Study), 1884 Oil on canvas, 206.5 x 108 cm London, The Tate Gallery

John Singer Sargent

Madame X (Portrait of Madame Gautreau), 1884 Oil on canvas, 212.1 x 109.8 cm New York, The Metropolitan Museum of Art technique was too sketchy for true works of art; and deeper qualities such as could not be registered in a first brief glance at subjects were thought to be missing from Impressionist art.

As time went by, only the vehemence with which the charge of sketchiness was levelled was to be abated. It was in fact left standing by developments in American art. In 1878 the Society of American Painters held an exhibition expressly restricted to sketches. In the winter of 1882, the Society of American Painters in Pastel, known as the Pastel Club, was founded, and in four exhibitions from 1884 to 1890 displayed work done exclusively in pastel, a technique customarily reserved for preliminary studies. By the time the Pastel Club was absorbed into the American Watercolor Society and the New York Watercolor Club in 1890, the ground had been thoroughly prepared for the formal, aesthetic innovations of Impressionism. North American artists from McNeill Whistler to Maurice Brazil Prendergast (1861–1924) were to achieve important Impressionist work in pastel and especially in watercolour.

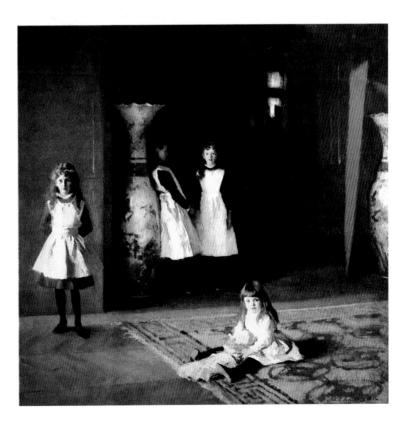

John Singer Sargent The Boit Daughters, 1882 Oil on canvas, 222.5 x 222.5 cm Boston (MA), Museum of Fine Arts

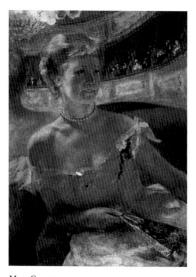

Mary Cassatt Lydia in a Loge, Wearing a Pearl Necklace, 1879 Oil on canvas, 81.3 x 58.4 cm Breeskin 64. Philadelphia, Philadelphia Museum of Art, Bequest of Charlotte Dorrance-Wright

The "European" Americans

Mary Cassatt The first two American artists to make a significant contribution to Impressionist painting were Mary Cassatt (1845–1926) and John Singer Sargent (1856–1925). Tellingly, both spent most of their lives in Europe, evolving their Impressionist styles in personal contact with the major French artists of the school.

Cassatt's work was more closely linked with French painting from the 1870s to 1980s than that of any other American. After studying at the Pennsylvania Academy of Fine Arts in Philadelphia, she was one of the first artists to leave after the Civil War, and went to Paris in 1866. There she studied privately with Jean-Léon Gérôme and probably Thomas Couture. The Franco-Prussian War interrupted her stay, but in 1871 she was again in Europe, in Parma, and in the following year in Madrid and Seville. In Spain her art made a distinct change of direction, and, impressed by Velázquez and Murillo, she painted a number of pictures on contemporary Spanish themes, albeit less in the manner of the old masters than that of Manet. The 1873 Offering the Panale to the Bullfighter (p. 591) documents this change; Cassatt has chosen a single moment, and her vigorous, contrastive brushwork creates a lively textural structure. Cassatt was subsequently to retain two features present in this composition: the cropping of figures seen close-up, and the absence of anecdotal detail.

In 1873 Cassatt moved to Paris. Degas was soon struck by her work,

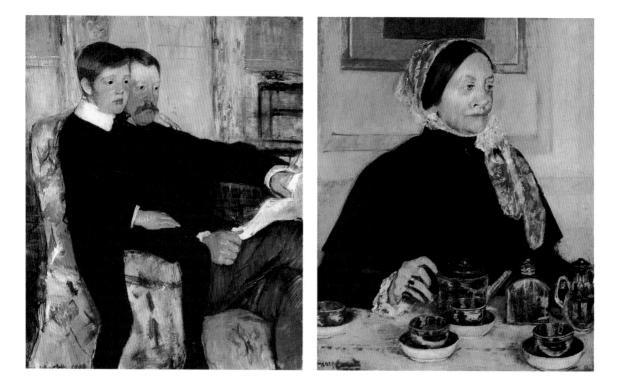

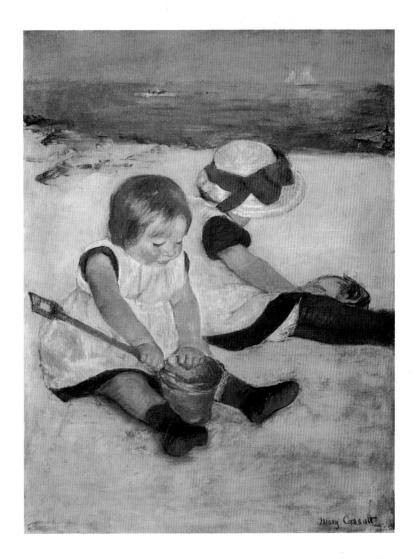

Mary Cassatt Children on the Beach, 1884 Oil on canvas, 97.6 x 74.2 cm Breeskin 131 Washington (DC), National Gallery of Art, Ailsa Mellon Bruce Collection

Left: Mary Cassatt Alexander J. Cassatt and his Son Robert Kelso, 1884 Oil on canvas, 89 x 130 cm Breeskin 136 Philadelphia, Philadelphia Museum of Art

Mary Cassatt

Lady at the Tea Table, 1885 Oil on canvas, 74 x 61 cm Breeskin 139 New York, The Metropolitan Museum of Art while Cassatt in her turn, in 1875, advised her close friend Louisine Elder – later the wife of Henry Osborne Havemeyer (1847–1907), with whom she built up the first great Impressionist collection in America – to buy Degas' 1874 *Ballet Rehearsal.* The professional and personal friendship of Cassatt and Degas was a close and fruitful one; Degas even added some touches to Cassatt's *Little Girl in a Blue Armchair* (p. 592). This painting was rejected by the American section of the Paris World Fair in the year it was painted, 1878. The girl's relaxed if unbecoming pose, and the higgledy-piggledy brushwork with which Cassatt captured the patterning of the armchairs and the divan, were presumably to blame for the rejection. The artist was visibly taking her bearings from Impressionist colourism and from Degas' treatment of the figure. Cassatt joined the circle of artists under his promotional wing and in 1879 had eleven paintings, probably co-selected by Degas, in that year's fourth Impressionist exhibition – her first showing with the group. Cassatt exhibited

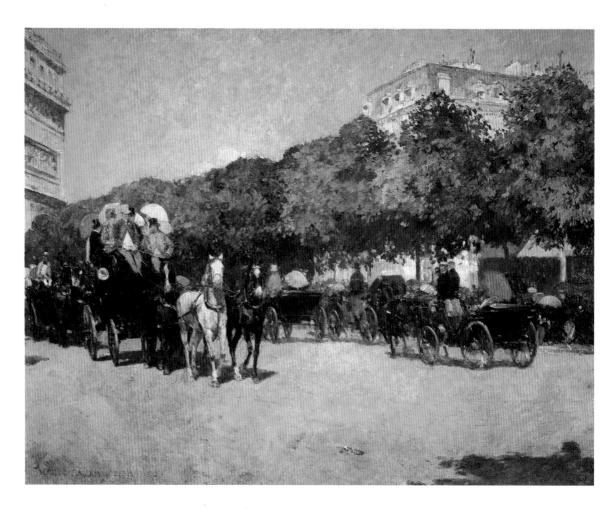

Childe Hassam Grand Prix Day, 1887 Oil on canvas, 61 x 86.3 cm Boston (MA), Museum of Fine Arts, Ernest Wadsworth Longfellow Fund

Two-wheel hackney cabs in New York, Fifth Avenue and Madison Square. About 1900 at all the group shows that were to come except the seventh, when she did not submit out of loyalty to Degas.

One of the paintings Cassatt had on show in that fourth exhibition in 1879 was Lydia in a Loge, Wearing a Pearl Necklace (p. 600) – a superlative example of Cassatt's more precisely Impressionist period. As if wishing to emphasize that the American artist was one of the French group, the Parisian press heaped the same harsh critical dismissal on her work as it did on that of the other artists. The light caught on the model's skin, for instance, was damned as a filthy, unreal nonsense. No one so unwashed would even be let into a theatre, said the critics. In fact, the painting is a delight both for its leisurely brushwork and for its spatial construction. Without defining any middle distance, Cassatt places the figure squarely up front, while the mirror in which we see her back reflected (which at first glance seems a background of gallery seats) actually shows us what Lydia herself sees before her. Beside that of Degas we may detect Manet's influence – to be exact, that of A Bar at the Folies-Bergère (p. 221).

Cassatt preferred to paint friends and acquaintances. Her sister Lydia

posed frequently. After Lydia died in 1877, Susan – probably a cousin of Cassatt's housekeeper, Mathilde Vallet – made continual appearances, posing for no fewer than nine pictures up to 1883, the last and most mature of which was *Susan on a Balcony Holding a Dog* (p. 628). Another work in this group, *Susan Outdoors in a Purple Hat* (1881; Detroit Institute of Arts, Manoogian Collection), is a good example of Cassatt's rare *plein-air* work. Like Degas, she preferred interiors. And the shrubs and trees in Cassatt's background highlighted the point at which she differed from the main Impressionist landscape painters: what interested her was chiaroscurist effects and the textural structures of brushwork, rather than the glowing effects of light in leafage.

The colouring of the figure, chair and background create flat zones, the ornamental flavour of which anticipates the artist's later style. Influenced by the two-dimensional, clearly-outlined approach and diagonal structures in Japanese woodcuts, Cassatt moved further in the decorative direction in the 1880s. She was also inspired by the mural art of Puvis de Chavannes. Alongside this formal evolution, her central concern with the role of woman also underwent a shift. If her early work had pinned subjects to specific times and situations, her later paintings

Childe Hassam Une averse. Rue Bonaparte, Paris, 1887 Oil on canvas, 102 x 196 cm New York, Hirschl and Adler Galleries

Childe Hassam

Rainy Day, Columbus Avenue, Boston, 1885 Oil on canvas, 66.4 x 121.9 cm Toledo (OH), The Toledo Museum of Art, purchased with Funds from the Florence Scott Libbey Bequest in memory of her father, Maurice A. Scott

William Merrit Chase The Open Air Breakfast, c. 1888 Oil on canvas, 95 x 144 cm Toledo (OH), The Toledo Museum of Art, purchased with Funds from the Florence Scott Libbey Bequest in memory of her father, Maurice A. Scott

John Singer Sargent Claude Monet Painting at the Edge of a Wood, 1887 Oil on canvas, 53 x 64 cm London, The Tate Gallery

tended towards a more timeless quality. In the Nineties, her portrayal of women was increasingly coloured by reflections on mutability. In this, Cassatt's development ran parallel to that of most of her French Impressionist fellows, gradually replacing an interest in momentary, fleeting impressions with a quest for more universal messages and content.

John Singer Sargent While Cassatt was acquainted with most of the French Impressionists, and was particularly close to Degas, Sargent's personal and artistic contact with Monet spanned only a brief phase in his creative life. Born in Florence of American parents, Sargent had grown up in Europe. In 1874 he began studying at the Ecole des Beaux-Arts in Paris, and entered Carolus-Duran's studio. He did not pay a first visit to the United States till 1876. Subsequent travels included Madrid, where, like Cassatt, he admired the art of Velázquez. His *Portrait of Madame Gautreau* (p. 598; later retitled *Madame X*) was so poorly received when shown at the Paris Salon that Sargent, hoping for a more favourable welcome, moved to England. There he spent the summer

William Merrit Chase End of the Season, c. 1885 Pastel on paper, 35 x 45 cm South Hadley (MA), Mount Holyoke College Art Museum

Robert William Vonnoh Poppies, 1888 Oil on canvas, 33 x 45.7 cm Indianapolis (IN), Indianapolis Museum of Art, James E. Roberts Fund

months out of London, in country places such as Broadway, Henley-on-Thames, Calcot and Fladbury.

It was in those working months that Sargent painted the works that marked his brief but intense Impressionist phase. The first composition palpably French in technique was Carnation, Lily, Lily, Rose (p. 597), painted at Broadway in the summer and autumn of 1885 and 1886. When the picture was seen at the Royal Academy in London in 1887, he was promptly dubbed the "arch-apostle of the dab and spot school"² by one critic; however, in fact, Sargent's Impressionist technique was largely restricted to his painting of the lanterns and flowers. It was not till he visited Monet at Giverny in 1887 that he embraced Impressionism more completely. Sargent's picture Claude Monet Painting at the Edge of a Wood (p. 604) records that visit. In this painting, the outlines have become blurred and the brushwork, rather than establishing a perspective three-dimensionality, embeds the figures in a dissolving fabric of colour tonalities. Sargent admired Monet deeply and bought his first of four Monet landscapes in August 1887. In summer 1888 Sargent came closest to Monet's style when painting at Calcot Mill in Oxfordshire. A Morning Walk (p. 634) prompts comparison with the paintings Monet did in 1886 of his future stepdaughter, Suzanne Hoschedé, likewise wearing white and carrying a parasol, in the open (p. 146). Sargent's composition is full of bright summer light that produces a dappled effect in the dress and grass.

In contrast to French Impressionist styles, though, the surface of the water and the shade within the parasol are rendered as areas of single colour rather than in broken mosaic fashion. Nor did Sargent sacrifice the exact portrayal of his sister Violet's facial features to an overall impression, as mainstream French tenets would have required. In this fact we are reminded of Sargent's eminence as a portraitist. His portrait skills

were the foundation of his fame, and after his Impressionist period (roughly 1884–1889) portrait art was his central concern – though in certain aspects of his work the enriching presence of freer French structural approaches remained alive.

The Evolution of a Distinct American Impressionism

Theodore Robinson When Sargent visited Giverny in 1887, the year after the Art Association Impressionist exhibition in New York, he was not the only American artist who felt the attraction of Monet. Much to Monet's disquiet, painters from various countries set up in Giverny; and the Americans constituted the most sizeable colony among them. There is not yet any agreement as to who was the first of them and can therefore claim to have established Giverny, and the closeness to Monet, in American art.

William Blair Bruce Landscape with Poppies, 1887 Oil on canvas, 27.3 x 33.8 cm Toronto, Art Gallery of Ontario, Purchased with Assistance from Wintario

But the historians do agree that in summer 1887 there were seven North American artists at Giverny: the two New Yorkers Theodore Robinson (1852–1896) and Henry Fitch Taylor (1853–1925), Louis Ritter (1854–1892) from Cincinnati, the Bostonians Williard Leroy Metcalf (1858–1925), John Leslie Breck (1860–1899) and Theodore Wendel (1857–1932), and the Canadian William Blair Bruce (1859–1906). These painters are known as the first generation of Givernists, since they initiated the procession of North American artists to the little French town, a phenomenon that lasted into the early 20th century.

This group was important in the history of North American Impressionism for two reasons. First, Breck's solo show at the St. Botolph Club in Boston in 1890 was one of the first exhibitions devoted to an American Impressionist in his home country. Unofficially, the innovatory stylistic skills Breck had acquired at Giverny had been on view to a small

John Singer Sargent Two Girls on a Lawn, c. 1889 Oil on canvas, 54 x 64 cm New York, The Metropolitan Museum of Art

public the previous year in the studio of his fellow artist Lilla Cabot Perry (1848–1933). Secondly, in the work of Robinson, North America made its own first influential contribution to Impressionism. Robinson's fellow Americans at Giverny were either slow to grasp the new aesthetics or relied too heavily on the example of Monet. The latter was the case with Breck and with Perry, who visited Giverny no fewer than ten times between 1889 and 1909. Robinson, by contrast, though a good friend of Monet from 1886 on, never became dependent on the Frenchman's style. When he moved into a house near Monet in 1888, he had already been living in France for four years, and before that period he had not been a stranger to Europe; in 1876 he had taken tuition from Carolus-Duran

and Gérôme in Paris, and, summering at Grèz, had found in Metcalf and Bruce fellow advocates of a North American espousal of the new European art.

The years Robinson spent at Giverny before finally returning to the US in 1892 fell into two stylistic periods. In the first, he painted figures in landscape settings as well as pure landscapes. These works were firmly structured and use brief, curling, heavy brush-strokes. Though Robinson was close to Monet, it is Pissarro that these paintings most strongly recall. The rural subject matter Robinson shared with another American working at Giverny, Dawson Dawson-Watson (1864–1939), as well as with Perry and Breck, also prompts comparison with Pissarro.

John Singer Sargent

The Boating Party, 1889 Oil on canvas, 87.9 x 92.4 cm Providence (RI), Museum of Art, Rhode Island School of Design, Gift of Mrs. Houghton P. Metcalf in memory of her husband, Houghton P. Metcalf

Dennis Miller Bunker The Pool, Medfield, 1889 Oil on canvas, 45.7 x 61 cm Boston (MA), Museum of Fine Arts, Emily L. Ainsley Fund

Not till the early Nineties did Robinson's work enter a second phase of lighter, feathery brushwork. The individual features in a painting were dissolved into highlights of colour that were stripped of contour or detail. *The Wedding March* (p. 615), painted in 1892 for the wedding of the American artist Theodore Earl Butler (1860–1936) and Suzanne Hoschedé-Monet, Monet's stepdaughter, is a fine example of this. At this period, Robinson adopted Monet's practice of painting variations on a theme. Breck had already painted a series of 15 haystack pictures in 1891, following Monet's example of exploring the hidden qualities of a subject by painting it in various lighting and weather, at different times of the year. In the following year, Robinson painted three variations of a view of the Seine valley, using the high vantage point that was so typical of his art. Robinson continued to work in series after he finally left Giverny.

In the US, Robinson was considered one of the pioneers of American Impressionism even before his return in 1892. He had spent every winter in New York, exhibited at the major shows, and from 1889 had displayed his Impressionist work with the Society of American Painters and the National Academy. In 1893, building on his reputation, Robinson taught a summer course at Brooklyn Art School in Napanoch (New York), and taught again the next year at Evelyn College, Princeton (New Jersey).

Robinson's work again importantly changed around 1893. Influenced by Japanese print graphics, which he debated with his friends John Twachtman (1853–1902) and Julian Alden Weir (1852–1919), he began to concentrate on bands of horizontal colour, and this introduced an element of abstraction to his work. This development was in line with his long-standing attempts to combine Impressionist technique with the presentation of values not apparent on the visual surface.

Julian Alden Weir The enthusiasm of Robinson, Twachtman and Weir for the work of Japanese artists such as Katsuschika Hokusai (1760– 1849) or Hiroshige (1797–1858) may have been prompted by the tales of their friend and fellow artist Robert Blum (1858–1903), who was in Japan from 1890 to 1892, and by exhibitions of Japanese print graphics

John Leslie Breck Garden at Giverny, c. 1890 Oil on canvas, 45.7 x 55.5 cm Chicago (IL), Terra Museum of American Art, Daniel J. Terra Collection

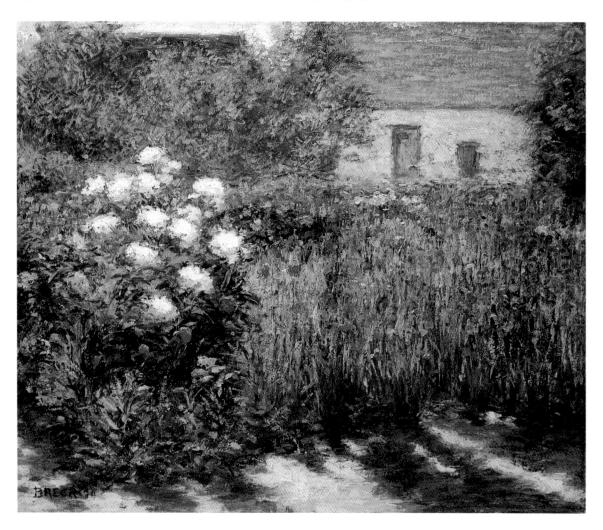

The Society of American Artists exhibition jury, 1906

"Two in a boat": photograph by Theodore Robinson, used for his painting (right), 9 x 11.4 cm. About 1890

Theodore Robinson Two in a Boat, 1891 Oil on canvas, 23.8 x 34.6 cm Washington (DC), The Phillips Collection

in America – for instance at the 1893 Chicago World Fair, or at the Museum of Fine Arts in Boston. As the development of a van Gogh or Cassatt showed, in the Eighties and Nineties Japanese art offered many painters a new direction to follow.

One of Weir's most popular works, *The Red Bridge* (p. 623), exemplifies his use of diagonal composition and zones of colour. The bridge, its colour contrasting strongly with the natural setting, opens up decorative possibilities when seen together with its reflection – the two diagonals running in at an angle to each other. The detailed brushwork, a product of Weir's study of Impressionism, loosens the composition without fragmenting it.

Weir was originally one of the few Americans to reject Impressionist technique expressly. A student with Gérôme from 1873, he wrote to his parents from Paris on the occasion of the 1876 Impressionist exhibition: "They do not observe drawing nor form but give you an impression of what they call nature. It was worse than a Chamber of Horrors."

It was not till the late Eighties and early Nineties, while painting near Branchville and Windham in rural Connecticut, that Weir was reconciled to Impressionism; and even then he restricted himself merely to certain aspects of the style. The use of brief, broken brushwork, for example, remained secondary to larger spatial gradations of a few colours. The French influence is more apparent in Weir's choice of subject-matter: in the Windham works, he frequently tackled the modern confrontation of industrial sites and open Nature. Weir's use of the contemporary American scene was in line with the Impressionist requirement of modern motifs.

John Twachtman Weir's fondness for the landscape of Connecticut was shared by his close friend Twachtman, with whom he exhibited in 1889 and 1893. Of all the American artists who absorbed Impressionism,

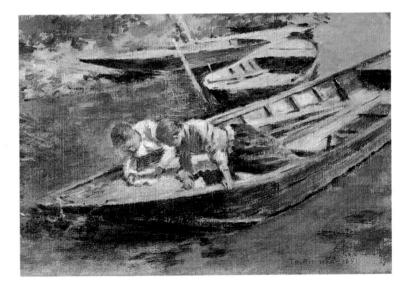

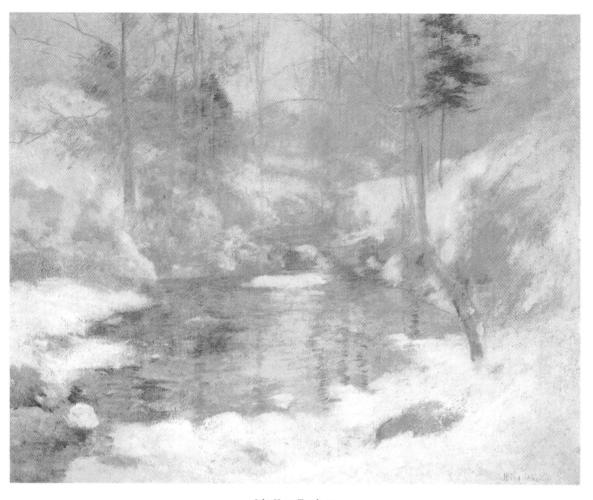

John Henry Twachtman Winter Harmony, c. 1890–1900 Oil on canvas, 65.3 x 81.2 cm Washington (DC), National Gallery of Art, Gift of the Avalon Foundation Twachtman was probably the most highly regarded both by the critics and by his fellow artists. Indeed, the press response to his work was eloquent of the American reception of Impressionism: the fact that he eschewed the perceived materialism of the French artists earned him special praise. His influence was consolidated by the summer painting school he opened in 1891 at Cos Cob (Connecticut) and by his teaching at the Art Students League in New York.

Twachtman's was the very model of an American career in art. Born in Cincinnati, he trained first at the McKicken School of Design there before studying in Munich from 1875 to 1878, like so many of his

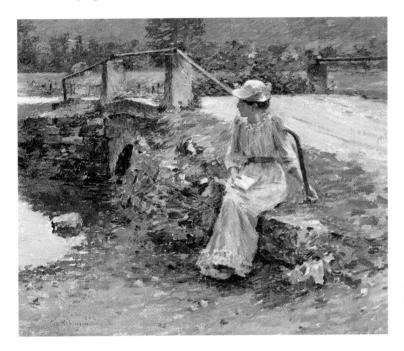

countrymen. There he joined the Duveneck Boys, a group of American artists around Frank Duveneck (1848–1919), also from Cincinnati. This group used the realist manner of the Leibl school. In 1882, having already achieved something of a name in America with realist work, Twachtman again left for Europe in search of new aesthetic ideas, this time to Paris. In place of the Munich palette with its prevalent black he now adopted the greys of the French *juste milieu*, which included artists such as Couture and Bastien-Lepage.

Twachtman returned to the US in the winter of 1885, at which time his paintings did not yet bear the traces of an encounter with Impressionism. It was not till the work he painted in Connecticut in the Nineties that the impact began to show. He moved into a Greenwich farmhouse in 1889, and from that time on his palette lightened, albeit typically with a concentration on a few related colours rather than the whole Impressionist spectrum. His softly fluid, proto-abstract forms suggested Post-Impressionist structures anticipating Art Nouveau. His brushwork deTheodore Robinson La débâcle, 1892 Oil on canvas, 45.8 x 55.9 cm Claremont (CA), Scripps College, Gift of General and Mrs. Edward Clinton Young

William Merrit Chase The Nursery, 1890 Oil on canvas, 36.5 x 40.4 cm Detroit (MI), Detroit Institute of Arts, Manoogian Collection

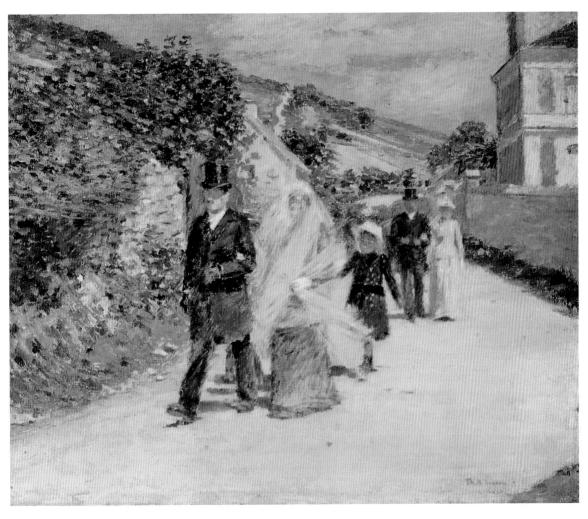

Theodore Robinson The Wedding March, 1892 Oil on canvas, 56.7 x 67.3 cm Chicago (IL), Terra Museum of American Art, Daniel J. Terra Collection

Mary Cassatt Summertime, 1894 Oil on canvas, 73.4 x 100 cm Breeskin 240 Los Angeles (CA), The Armand Hammer Collection

Edmund Charles Tarbell Three Sisters – A Study in June Sunlight, 1890 Oil on canvas, 89.2 x 102 cm Milwaukee (WI), Milwaukee Art Museum, Gift of Mrs. Montgomery Sears, Boston

veloped into a highly personal style, varying from composition to composition, fixing his subjective perceptions with an economical eye to the overall impression. The hills, rivers and lakes near his home gave him enough subject-matter for his paintings, subjects he returned to repeatedly albeit without producing any series in the manner of Monet. His intense scrutiny of Nature was comparable with Monet's, though, and resulted both in landscapes and in close-up views of plant life. His most idiosyncratic and important complex of works concerned the winter landscapes, the best known of which is *Winter Harmony* (p. 6 I 3). Painted in whites, greys and blues only, with stray highlighting, works such as this most cogently conveyed the symbolic implications of Twachtman's tendency towards abstraction.

William Merrit Chase Teaching in public or state art schools by artists associated with Impressionism was of central importance in the American dissemination of the new art and its ideas. One of its early advocates was Robert Vonnoh (1858–1933), who taught at the Pennsylvania Academy in Philadelphia from 1891 on. His interpretation of Impres-

Mary Cassatt The Boating Party, c. 1893/94 Oil on canvas, 90 x 117 cm Breeskin 230 Washington (DC), National Gallery of Art

Childe Hassam The Little Pond, Appledore, 1890 Oil on canvas, 40.6 x 55.9 cm Chicago (IL), The Art Institute of Chicago, Friends of American Art Collection, Walter H. Schulze Memorial Fund

sionism, in works such as *Poppies* (p. 606), emphasized the intensity of colour to an extent that seemingly anticipates the Fauves in France or the German Expressionists. Above all, summer schools devoted to open-air painting (we have already mentioned Robinson's courses at the Brooklyn Art School and Twachtman's at Cos Cob) became established in the 1890s as an integral part of American art teaching. These schools were a response to the need for a national artistic identity distinct from handed-down European doctrine. Surely the most popular and successful of the schools was the Shinnecock Summer School, opened on Long Island in 1891. It was founded by William Merrit Chase (1849–1916), who taught the methods and practice of *plein-airisme* there for twelve consecutive summers. Since Chase also taught at the Art Students League in New York from 1878 to 1895, he can be seen as the most important teacher of his generation.

His own work had a notable stylistic flexibility and openness. He was in Munich from 1872 to 1878, and in 1877 visited Venice with Duveneck and Twachtman; this, though, was his only period of direct contact with European art. His involvement with Impressionist aesthetics, beginning in the 1880s with admiration for Manet, did not grip till he was back in America. A first characteristic group of works were his views of Prospect Park near his Brooklyn home, and later of Central Park in Manhattan, painted from 1886 on. Here his palette was lighter than in his early work, and, with the easier brushwork, attested his conversion to *plein-air* painting. Combining the urban and the natural as they did, these paintings occupied a special position within American Impressionism. They were the first paintings of Frederick Law Olmsted's and Calvert Vaux's parks, which had used deliberately symmetrical lay-outs as a new departure in the American concept of landscape; and the press

John Henry Twachtman Horseshoe Falls, Niagara, c. 1894 Oil on canvas, 76.8 x 64.5 cm Southampton (NY), The Parrish Art Museum, Littlejohn Collection

William Merrit Chase's studio in New York. About 1895

William Merrit Chase Idle Hours, c. 1894 Oil on canvas, 64.8 x 90.2 cm Fort Worth (TX), Amon Carter Museum

responded by praising the specifically American subject matter. It was one more proof, if one were needed – declared the critic Kenyon Kox in 1889 – that what America lacked was not subjects but the eyes to see. Kox hoped America had heard the last of artists' complaints that there was no material, given that the subjects were on the doorstep – and the public too, he wrote, would do well to stop inveighing against un-American art, at least until it had seen Chase's wonderful little masterpieces.⁴

The carefree cheerfulness that Chase's canvases emanate became increasingly Impressionist in technique as the Nineties wore on. He became a master of the flickering atmospherics of light set off by blue strips of sea or sky and enlivened by women and children in bright summer dresses. The dunes and beaches of Shinnecock on Long Island provided Chase with his staple material. A particularly fine example of this period in his work is *Idle Hours* (p. 620).

Childe Hassam Despite his broad influence and high reputation, Chase was not seen as the model Impressionist in America. That role was reserved for Childe Hassam (1859–1935). His Boston and New York cityscapes represented the only American Impressionist art beside Cas-

Williard Leroy Metcalf Gloucester Harbour, 1895 Oil on canvas, 66 x 73 cm Amherst (MA), Mead Art Museum, Amherst College, Gift of George D. Pratt

Lilla Cabot Perry Monet's Garden at Giverny, c. 1897 Oil on canvas, 66 x 81 cm Mr. and Mrs. John A. Morris Collection, photo R.H. Love Galleries, Chicago (IL)

satt's to couple stylistic innovation with contemporary subject-matter. What was more, his career was longer than any other American Impressionist's, extending to a notable willingness to learn new tricks in his late work.

Hassam began in 1876 as an illustrator and engraver, then studied from 1877 to 1878 at the Boston Art Club and the Lowell Institute. By the time he settled in New York in 1884 he had visited England, Holland, Spain and Italy. He began to make a name for himself with rainy or snowy city scenes such as *Rainy Day*, *Columbus Avenue*, *Boston* (p. 603). His palette moves in subtle nuances across closely related colours, nicely catching a city atmosphere. Though the choice of colours recalls mainstream American tonalism, the subject prompts comparison with the realistic Paris street scenes of De Nittis or Béraud as well as with Caillebotte's 1877 *Paris, the Place de l'Europe on a Rainy Day* (p. 169).

In 1886, Hassam again went to Europe, this time to Paris. In this period he began to use a more Impressionist technique and colourism. *Grand Prix Day* (p. 602), painted in 1887, is generally cited as the earliest work in his changed style. His palette brighter, his accentual colour contrasts strong, Hassam has turned away from the rain to a sunny summer's day and a crowd on their way to the big June races at Long-champ in the Bois de Boulogne. The well-defined forms and contours which Hassam retained in this painting despite the shorter brush-strokes soon disappeared from the New York scenes which he was paint following his return. For Hassam, the concentration on painting New York street life, which made him famous, was an opportunity to show that American subject-matter was quite as interesting as French. Indeed, he

Julian Alden Weir

Midday Rest in New England, 1897 Oil on canvas, 100.6 x 127.9 cm Philadelphia, The Pennsylvania Academy of the Fine Arts, Gift of Isaac H. Clothier, Edward H. Coates, Francis W. Lewis, Robert C. Ogden and Joseph G. Rosengarten

Julian Alden Weir The Red Bridge, c. 1895 Oil on canvas, 61.5 x 85.5 cm New York, The Metropolitan Museum of Art, Gift of Mrs. John A. Rutherford explicitly averred that Paris boulevards were "not one whit more interesting than the streets of New York. There are days here when the sky and atmosphere are exactly those of Paris, and when the squares and parks are every bit as beautiful in colors and grouping."⁵ Hassam's attention was primarily concentrated on the movement of people and the changing of colours in changing light, as in *Fifth Avenue at Washington Square* (p. 402). His paintings exclude unpleasant details that might suggest social imperfections; this exclusion was something he had in common with his American contemporaries.

Hassam also painted landscapes. He probably first summered on Appledore, an island off the coast of New Hampshire and Maine, in 1884. He had been invited there by his pupil Celia Thaxter, poet and essayist, who ran a summer salon for painters and writers. For many years, the Appledore landscape and Thaxter's luxuriant garden provided Hassam with inspiration. From 1890 till Thaxter's death in 1894, indeed, the area prompted Hassam's finest work. After that caesura, Hassam continued to visit both Appledore and New England coastal towns

John Henry Twachtman The White Bridge, c. 1900 Oil on canvas, 76.2 x 63.5 cm Rochester (NY), Memorial Art Gallery of the University of Rochester, Gift of Emily Sibley Watson

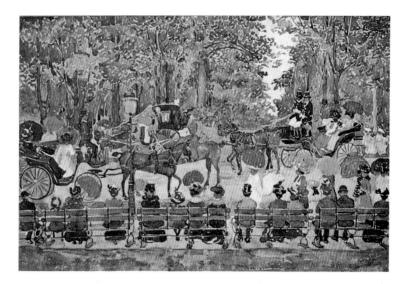

Maurice Brazil Prendergast Central Park, New York, 1901 Pencil and watercolour on paper, 36 x 55.5 cm New York, The Whitney Museum of American Art

Maurice Brazil Prendergast Ponte della Paglia, Venice, 1899 Oil on canvas, 71 x 58.5 cm Washington, The Phillips Collection

such as Newport, Gloucester and Old Lyme in the summers. The seascapes he painted on those visits in the early years of the 20th century introduced a new component into his work. In *Sunset at Sea* (p. 633), for instance, the almost monochrome bands of colour record a vision of the ocean's vastness, in a style that has Symbolist undertones and looks forward to American abstract art.

While Hassam was versatile in his thematic range, at bottom he was always expressing a love of his home country. The series he painted in the second decade of the century are best considered in these terms. They include, for instance, his window paintings – views from an upper floor of a New York building onto streets flanked by high-rise buildings. A second series, comprising the flags paintings, is still more spectacular. Documenting Hassam's patriotic feelings during the First World War, and doubtless in some degree inspired by Monet's *Rue Saint-Denis*, *Festivities of 30 June, 1878* (p. 177), these pictures transform the flagged buildings of New York into a sea of fluttering colour. Paintings like Allies Day, May 1917 (p. 639) expressed the confidence of the American war effort in Europe.

Marc-Aurèle de Foy Suzor-Coté Port-Blanc in Brittany, 1906 Port-Blanc en Bretagne Oil on canvas, 64.9 x 81 cm Ottawa, National Gallery of Canada

Right: Maurice Galbraith Cullen Winter at Moret, 1895 Oil on canvas, 60 x 92.1 cm Toronto, Art Gallery of Ontario, Gift from the J.S. McLean Canadian Fund

James Wilson Morrice Quai des Grands-Augustins, Paris, c. 1903/04 Oil on canvas, 50.4 x 61.7 cm Ottawa, National Gallery of Canada

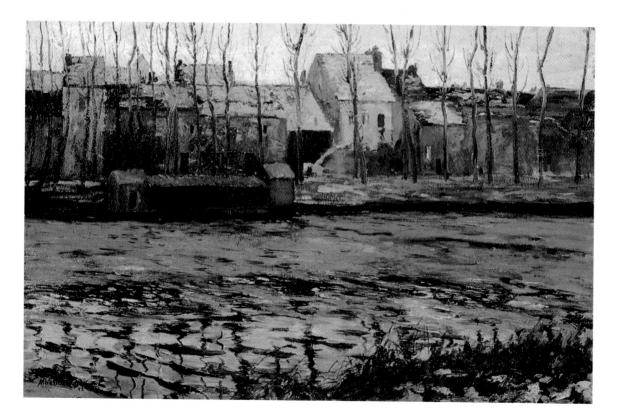

The Ten in Philadelphia in 1908. Standing from left: Chase, Benson, Tarbell, Dewing, De Camp. Seated from left: Simmons, Metcalf, Hassam, Weir, Reid

George Hitchcock The Bride, c. 1900 Oil on canvas, 76.2 x 61 cm New York, Private collection

Mary Cassatt

Susan on a Balcony Holding a Dog, 1883 Oil on canvas, 100.5 x 65 cm Breeskin 125 Washington (DC), The Corcoran Gallery of Art

Establishment and Dissemination: The Second Generation of American Impressionists

The early Impressionist wave in North America, and the major artists -Robinson, Weir, Twachtman, Chase and Hassam - paved the way for the establishment of Impressionism there. New York and Boston, where Impressionist works were regularly on view in exhibitions from the early Nineties, were the twin centres of the new style. From there it gradually spread to other American cities. Chicago first saw works by French Impressionists such as Renoir and Monet in 1888, once again thanks to the industrious Durand-Ruel. They had work at the annual Saint Louis Exposition in 1890 and at the Music Hall Association. A year later, Hassam exhibited 39 pictures there. Also in 1891, there was a French Impressionist show in San Francisco. The great Columbian Exposition at Chicago in 1893 sealed the first phase of hesitancy over the new aesthetics; though the Impressionists were not included in the official French show, there was a special exhibition - a Loan Collection of Foreign Works from Private Galleries in the United States - that afforded a comprehensive overview of their work. Impressionists from a number of countries were included, in fact. Impressionism had become a prominent feature of the American art landscape.

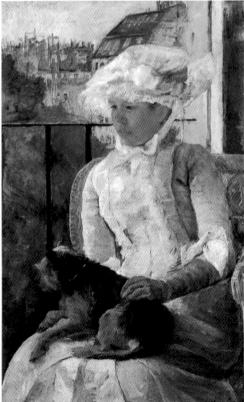

This did not mean that it was unreservedly popular, of course. Indeed, the Columbian Exhibition's emphasis on classical, idealizing work well illustrated the conservatism of the relevant powers in the art world. And the press, though interested, was by no means uniformly well-disposed. Furthermore, the American Impressionists met with resistance in artistic circles, too. Controversy over his teaching methods prompted Chase to resign his presidency of the Society of American Artists in 1895 and to abandon tuition with the Art Students League.

When a group called The Ten American Painters was founded in 1898, it was in response to this climate of rejection. To contemporaries, The Ten (as they were known) were quickly seen as the core of American Impressionism. In point of fact, they were not all equally committed to the new aesthetics; but the group was created by Hassam, Twachtman and Weir (Robinson had died in 1896) - in other words, by the foremost American Impressionists. As well as Chase, who joined in 1902 after the death of Twachtman, The Ten included Metcalf, Edmund Tarbell (1862-1938), Frank Benson (1862-1951), Joseph De Camp (1858-1923), Thomas Dewing (1851–1938), Edward Simmons (1852–1931) and Robert Reid (1862–1929). Most of the members – seven out of ten - were second-generation artists who had only adopted a French Impressionist style in the 1890s. Just as the European Secession movements separated from established institutions, The Ten split off from the Society of American Painters, where they had hitherto exhibited their work. The art shown there, they felt, was too heterogeneous. Their own interest

Mary Cassatt Young Mother Sewing, 1902 Oil on canvas, 92.4 x 73.7 cm Breeskin 415 New York, The Metropolitan Museum of Art

Mary Cassatt Reine Lefebvre and Margot, c. 1902 Pastel on paper on canvas, 83.2 x 67.5 cm. Breeskin 430

Los Angeles (CA), The Armand Hammer Collection

Durand-Ruel's Fifth Avenue gallery in New York. About 1900

was in the annual public exhibition of work that shared an aesthetic thrust. Usually their choice lighted on the New York galleries of Durand-Ruel and Montross, and the exhibitions then travelled to the St. Botolph Club in Boston, not least because a substantial number of the group – Metcalf, Tarbell, De Camp, Benson and Reid – either came from Boston or had trained there. The Ten survived for almost twenty years till the group was dissolved in 1917, and throughout that period only the members named here participated in group exhibitions.

The Boston School Of the Boston painters, Williard Metcalf was the only one who had also been one of the Givernists who painted in proximity to Monet in 1877. His own work did not turn to Impressionism till the mid–1890s, though, and his fame dated from his membership of The Ten. Metcalf's was an art that celebrated the New England landscape and architecture, familiar from trips he undertook from his New York home. The radiant colours of *Gloucester Harbour* (p. 621), painted

Williard Leroy Metcalf The Poppy Garden, 1905 Oil on canvas, 61 x 61 cm Detroit (MI), Detroit Institute of Arts, Manoogian Collection

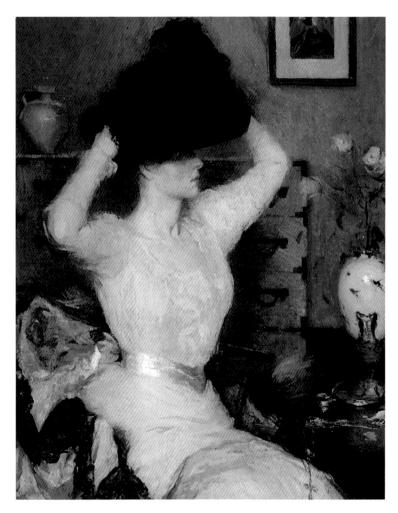

Frank Benson The Black Hat, 1904 Oil on canvas, 101.6 x 81.3 cm Providence (RI), Museum of Art, Rhode Island School of Design, Gift of Walter Callender, Henry D. Sharpe, Howard L. Chase, William Gammel, and Isaac C. Bates

Philip Leslie Hale The Crimson Rambler, 1908 Oil on canvas, 64.1 x 76.7 cm Philadelphia, The Pennsylvania Academy of the Fine Arts, Joseph E. Temple Fund

in 1895 and one of his best known works, show the influence of Impressionism on his art at that date. In style and subject matter, Metcalf was often palpably close to other American artists such as Robinson and particularly Hassam.

Metcalf's predilection for landscape was not typical of the Boston art scene. In contrast to the New York school, 1890s Impressionist art in Boston was primarily concerned with figure painting, and focussed on society ladies in appropriate settings. Tarbell was one of the first to take this direction. His compositions of the Nineties, showing stylish ladies at leisure out of doors, adopted the entire colour spectrum of French Impressionism, and indeed occasionally enhanced it, as in the glows to be seen in his subjects' faces. The choice of theme was mainly responsible for Tarbell's popularity with affluent collectors in Boston. His influence and reputation were also consolidated by years of teaching at the Boston Museum School. People even talked of Tarbellites – that is, other Bostonian figure painters whose technique and approach to their subject-matter betrayed an affinity with his presiding spirit. The foremost of these were Benson, De Camp and Reid, all of whom, like Tarbell, concentrated on portraits.

Philip Leslie Hale (1865–1931) was also seen as one of the Tarbellites. Though not one of The Ten, he was closely associated with its members. Like Tarbell and Benson, he taught at the Boston Museum School, from 1893. Hale brought to Boston figure painting an idiosyncratic variant of the genre that betrayed the influence of Neo-Impressionism. More than his American contemporaries, he tended to dissolve the outlines of whiteclad figures, merging them into their settings through a hazy mesh of delicate, pale colours, for preference yellow – as in *The Crimson Rambler* (p. 631).

Hale's art was in essence decorative; it can stand for the prevalence in the work of many a late 19th-century American artist of the oriental influence. The distance the Americans had travelled from the maxims of the French Impressionists up to 1886 can also be guessed from the renaissance of Vermeer in Boston. A monograph on the Dutch master, probably written by Hale, was published in the US in 1904; subsequently, the number of interiors painted by Tarbell, De Camp and Benson rose noticeably. By the early 20th century, *plein-airisme* had lost its stimulative function in Boston.

Impressionism in Canada The reception of Impressionism in Canada ran along broadly similar lines. It did not begin there till about a decade later than in the US: the first public exhibition of pictures by Monet, Sisley, Pissarro and Renoir was held in 1892 in the William Scott Gallery

Helen Galloway McNicoll A l'ombre de la tente, 1914 Oil on canvas, 81.3 x 101.6 cm Montreal, The Montreal Museum of Fine Arts, Gift of Mr. and Mrs. David McNicoll

in Montreal, and it was not till 1906 that a comprehensive retrospective of French Impressionism was seen, in Montreal – again featuring paintings loaned by Durand-Ruel. Though the fashion for Canadian artists after 1890 was to study in Paris at the Ecole des Beaux-Arts or the leading private academies and to summer at locations where international artists congregated, it was rare for them to grapple with the technique of Impressionism. When they did, it was either a case of direct imitation of a French model, as with Helen Galloway McNicoll (1879– 1915), or – and this applied to the majority – of briefly adopting a style as a transition to other later approaches. For Henri Beau (1863–1949),

Childe Hassam

Sunset at Sea, 1911 Oil on hessian, 86.3 x 86.3 cm Waltham (MA), Rose Art Museum, Brandeis University, Gift of Mr. and Mrs. Monroe Geller Marc-Aurèle de Foy Suzor-Coté (1869–1937) and James Wilson Morrice (1865–1924), as for the younger William Henry Clapp (1879– 1954), Clarence Alphonse Gagnon (1881–1942) and Lawren Harris (1885–1970), the decorative structures and surfaces of Neo- and Post-Impressionism were finally of greater moment than the stylistic achievements of a Monet.

Maurice Galbraith Cullen (1866–1934) was an exception to this rule. He was the first to establish the name and fame of Impressionism in Canada, and was the only one of his generation to adopt an Impressionist style rigorously and arrive at a personal manner of art by that route. Before exhibiting his landscapes for the first time in Canada in 1895, at the newly founded Société Nationale des Beaux-Arts, he studied in Paris from 1888 to 1890 at the Académie Colarossi, the Académie Julian and the Ecole des Beaux-Arts, and was close to his fellow countryman William Bruce. Cullen acquired a love of *plein-air* painting in France which remained with him his whole life long, even in harsh weather. Indeed, it was in his winter landscapes that he evolved the light effects that are unique to his art, in such paintings as *Winter at Moret* (p. 627). Cold, phosphorescent blues predominate, but reddish stray reflections of light radiate a magic warmth. This atmosphere was to become even more

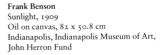

John Singer Sargent A Morning Walk, 1888 Oil on canvas, 67 x 50.2 cm The Ormond Family

Frederick Frieseke Lady in a Garden, c. 1912 Oil on canvas, 81 x 65.4 cm Chicago (IL), Terra Museum of American Art, Daniel J. Terra Collection

intense in his work after 1906. His late paintings eloquently showed that, for his generation of North American artists, French Impressionism was simply a stage along the way to their own individual, subjective response to the real.

The 20th-Century Aftermath of Impressionism

Impressionism still made its presence felt in the work of artists who did not reach maturity till the early 20th century. What the French example offered comprised first and foremost technical ideas, which could be combined with the strategies of Pointillism, Post-Impressionism and Art Nouveau. By around 1910, Impressionism and its related styles were universal in North America, and had lost their power to provoke. However, they still had significance in catalyzing the formulation by individual artists' groups of their own visual idioms. The Later Givernists In this respect, the paintings of Frederick Frieseke (1874–1939) and Richard Miller (1875–1943) were an extension of the North American tradition in Impressionist figure painting. Both artists were of the third American generation to paint at Giverny. After the painters of 1887 and shortly thereafter had spent their summers there and returned to the US, there had been a second wave of Giverny tourism in the Nineties. The Americans were drawn less by Monet's art than by the beauty of the countryside, so convenient to Paris, and by the chance of meeting artists from many other countries. The core of the American group was made up of a married couple, Mary (1858–1946) and Frederick MacMonnies (1863–1937). Garden scenes and nudes provided the circle with new motifs that were adopted and adapted by the next, third generation.

The best known of these was Frieseke. Born in Michigan, he trained at the Art Institute of Chicago and in New York before receiving a scholarship to Paris in 1898. Frieseke had begun by painting earthy interiors, but visits to Giverny in and after 1900 led him to abandon them in favour of open-air scenes, of which *Lady in a Garden* (p. 635) is typical. Of the

Henri Beau Déjeuner sur l'herbe (The Picnic), c. 1905 Oil on canvas, 72.5 x 92.5 cm Quebec, Musée du Québec

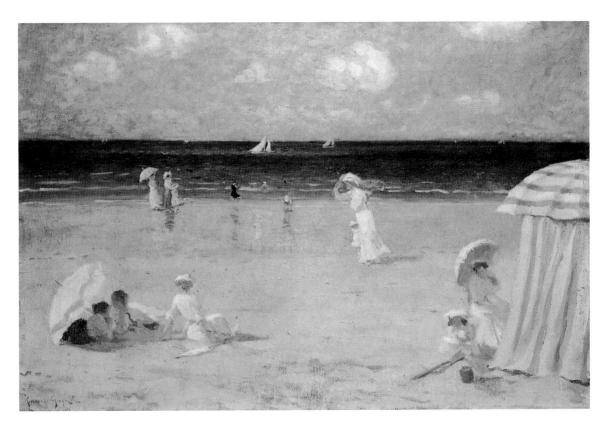

French Impressionists, Renoir in particular must surely have made an impact on him. His presence can be felt in the solidity of Frieseke's women, so different from the women of the Boston School. Effects of sunlight, by the painter's own testimony, were his central concern. His brushwork was only Impressionist in particular areas of his pictures, however – nudes, for instance, he painted in nuanced academic threedimensionality, while his handling of lush vegetation often acquired a rhythmic, decorative character. The pictures of Frieseke and Miller – whose approach to women was gentler and more intimate (*Reverie*, p. 640) – were exceptionally popular in America. At the 1909 Venice Biennale their works shared a room, representing US art. The Giverny Group (or Luminarists), to which both belonged, was the final fine achievement of Impressionism in America.

The Ash Can School By contrast, when the Ash Can School (or The Eight) came into being, it announced new bearings in 20th-century American art, and superseded the aesthetics and aims of Impressionism. Exhibiting from 1908 on at the Macbeth Gallery in New York, its members on concentrated on the unappealing sides of modern urban life. Ernest Lawson (1873–1939) and Prendergast tried to reconcile this subject matter with a lyrical use of colour derived from Impressionism. The work of these two artists can be taken as representative of the two main

Clarence Alphonse Gagnon Summer Breeze at Dinard, 1907 Brise d'été à Dinard Oil on canvas, 54 x 81 cm Quebec, Musée du Québec preoccupations in early 20th-century American art: realistic landscape, and an emphasis on formal strategies.

Lawson, born in Canada but resident in the US, brought a rough and ready brushwork to his urban scenes, the realism of which was in line with Ash Can precepts. He shared the group's taste for views of New York from the East, Harlem and the Hudson River. But he preferred landscape work to painting contemporary city life.

In 1891 Lawson was a student of Twachtman's at the Art Students League, and in summer the following year painted at Cos Cob with Twachtman and Weir. His Impressionist leanings were confirmed in 1893 when he met Sisley at Moret. The influence of Twachtman remained apparent even after Lawson's final return from Paris, where he spent most of his time from 1893 to 1896. Like the older painter, he used white for accentual highlights, and his compositions were generally fundamentally lyrical in tone (*Spring Night, Harlem River*, p. 638). Lawson's landscapes, which always betray the proximity of the city, derive their power from luminous colour and solid, pastose brushwork.

The modernity of Prendergast's art did not reside in his subject-matter; it came from the priority he assigned technique over subject. Born in Newfoundland, he grew up in Boston, where the art of Tarbell, Breck and Wendel may have laid the foundation for the colourfulness of his own future work. Studying in Paris, he readily absorbed Post-Impressionist aesthetics after 1890. His views of Paris boulevards and of the promenades at Le Treport, Dieppe, Saint-Malo and Dinard already bore the anti-naturalist hallmark of the Nabis: his figures were simple in form and flat, and the intensity of the colours was independent of spatial depth.

Ernest Lawson Harlem River, c. 1913–1915 Oil on canvas, 102 x 127 cm Detroit, Detroit Institute of Arts, Manoogian Collection

Ernest Lawson Spring Night, Harlem River, 1913 Oil on canvas on panel, 63.5 x 76.2 cm Washington (DC), The Phillips Collection

Childe Hassam Allies Day, May 1917, 1917 Oil on canvas, 93.3 x 76.8 cm Washington (DC), National Gallery of Art, Gift of Ethelyn McKinney in memory of her brother, Glenn Ford McKinney

> Prendergast's lively compositions guaranteed him success not long after his return to Boston in 1894. His financial circumstances assured, he was able to depart for Europe again in 1898; here he would spend almost two years in France but also in Italy, where he visited Rome, Capri, Siena and – above all – Venice (p. 625). His work, often executed in watercolour, remained distinctively carefree even into the 20th century, at a time when frequent stays in New York had put him in touch with the Ash Can School. The Cézanne exhibition he saw in Paris in 1907 made a profound impression on Prendergast; he was one of the first American artists to value Cézanne and transmit his principles into their own art. The work of Prendergast's maturity attests this influence in its stronger tendency to abstraction, which establishes the sole autonomous reality of the pictorial image: the anecdotal detail of his early work disappears, and spatial gradations are displaced by a single visual level on which brush-strokes are juxtaposed and superposed like solid blocks, leaving the location no longer clearly identifiable. Watercolour was superseded by pastose oil.

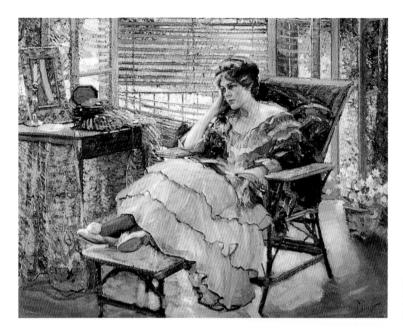

Richard Emile Miller Reverie, 1913 Oil on canvas, 114.3 x 147.3 cm Saint Louis (MO), The Saint Louis Art Museum

The artistic development of Maurice Prendergast graphically illustrates the importance of Impressionism for early 20th-century American painting. Impressionist art was now both widely held in high regard and prominent in major international exhibitions everywhere; furthermore the first historical surveys of the movement were beginning to appear, replacing the initial assessments by art critics. At one time, "The Sun" newspaper observed in 1916, Impressionism had been controversial, but now it was ancient history.6 For artists, it had come to represent a threshold, the crossing of which was a liberation that made access possible to Neo- and Post-Impressionism and more. The North American discovery of the more extreme achievements of art after Impressionism - the art of van Gogh, Gauguin and Cézanne - had barely begun but a new era dawned. At the Armory Show in New York in 1913, America had its first sighting of the Cubists, the Fauves and the German Expressionists. Twenty-seven years after America's first big Impressionist show in 1886, an exhibition of European art was again to set a milestone in the evolution of American art.

BEATRICE VON BISMARCK

- 2 Cf. Art Journal, 26 June 1887, p. 248.
- 3 Cf. Dorothy Weir Young: The Life and Letters of J. Alden Weir, New Haven (CN), 1960, p. 123.
- 4 Kenyon Kox: William Merrit Chase, Painter. In: Harper's New Monthly Magazine, March 1889, p. 556.
- A.E. Ives: Mr. Childe Hassam on Painting Street Scenes. In: Art Amateur, 27 October 1892, p. 117.
- 6 Cf. The Sun, 19 March 1916, part V, p. 8.

I Cf. Mariana van Rensselaer, In: The Independent 38, 22 April 1886, pp.491 ff., and 29 April 1886, pp. 523 ff.

Directory of Impressionism

with lists of illustrations

The "Directory of Impressionism" contains short biographies of all 236 artists whose work is illustrated in these two volumes, together with their portraits, where these can be traced; it also includes information on writers, critics, art dealers and collectors who were involved in or influenced the development of Impressionism; other entries explain important concepts and localities. Bibliographical details are intended to aid further reading on the subject. Special attention has been given to the lives and works of lesser-known painters. For exhibition catalogues (abbreviated EC), the respective editors, organisers and contributors are listed as editor (ed.), even if they only produced the catalogue or wrote the preface. Page numbers at the end of each entry refer to illustrations reproduced in this book. Many of the following articles, and all the entries on Eastern and South Eastern Europe, are the work of Peter H. Feist; I would like to express my grateful thanks to him and to my colleague, Antje Günther.

THE ANTECEDENTS OF IMPRESSIONISM

Boime, A .: The Academy and French Painting of the Nineteenth Century. New Haven (CT) and London 1971 .-Bouret, J.: L'école de Barbizon et le paysage français au XIXe siècle. Neuchâtel 1972 .- Bouret, J .: The Barbizon School. London 1972.- Bühler, H.P.: Die Schule von Barbizon. Munich 1979 .- Champa, K.S. (ed.): Barbizon - The Rise of Landscape Painting in France. Corot to Manet. Manchester, New York and Dallas 1991 (EC).- Clark, T.J.: The Absolute Bourgeois: Artists and Politics in France, 1848- 1951. Greenwich (CT) 1973.-Deuchler, F.: Die französischen Impressionisten und ihre Vorläufer: Collectors' catalogues, Vol. I. "Langmatt" Foundation, Sidney und Jenny Brown. Baden 1990.- Nochlin, L .: Realism. New York 1972 .- Picon, G .: 1863 - Naissance de la peinture moderne. Paris 1988 .- Sloane, J.: French Painting Between the Past and the Present: Artists, Critics and Traditions from 1848 to 1870. Princeton (NJ) 1973 .- Thomson, D.: The Barbizon School of Painters. London 1891

IMPRESSIONISM (GENERAL BIBLIOGRAPHY)

Adams, S.: Die Welt der Impressionisten. Weingarten 1990.- Adams, S.: The World of Impressionists. London and New York 1989 .- Adhémar, H., J. Adhémar et al.: Chronologie Impressionniste: 1863-1905. Paris 1981.- Adhémar, H. and A. Dayez-Distel (eds.): Musée du Jeu de Paume. Catalogue. Paris 1983.- Adler, K .: Wiederentdeckte Impressionisten. Oxford 1988 .- Adler, K .: Unknown Impressionists. Oxford 1988.- Bazin, G.: Die Impressionisten. Schöpfer der modernen Malerei. Gütersloh (1985).-Bazin, G.: L'époque impressionniste. Paris 1947 .- Bellony-Rewald, A .: The Lost World of the Impressionists. London 1976 .- Berger, K .: Japonismus in der westlichen Malerei. Munich 1980.- Bernard, B. (ed.): Die großen Impressionisten. Revolution der Malerei. Munich 1988.- Berson, R. (ed.): The New Painting: Impressionism 1874-1886. Documentation. 2 vols. Seattle (in preparation) .- Blunden, M. and G.: Der Impressionismus in Wort und Bild. Geneva 1979.- Blunden, M. et G.: Journal de l'impressionnisme.

Geneva 1970.- Blunden, M. and G.: Impressionists and Impressionism. New York and London 1976.- Bonafaux, P.: Les impressionnistes. Portraits et confidences. Paris 1986.-Bozo, D. and A. Marchais: Sur le motif. Les impressionnistes. Paris 1964.- Brettell, R. et al. (eds.): L'impressionnisme et le paysage français. Los Angeles County Museum of Art, Los Angeles; The Art Institute of Chicago, Chicago; Grand Palais, Paris. Paris 1984 (EC) .- Brettell, R. et al. (eds.): A Day in the Country: Impressionism and the French Landscape. Los Angeles County Museum of Art et al. Los Angeles 1984 (EC) .-Bromford, D. et al. (eds.): Art in the Making: Impressionism. National Gallery, London 1990 (EC) .- Broude, N. (ed.): Impressionismus. Eine internationale Kunstbewegung 1860- 1920. Cologne 1990 .- Broude, N. (ed.): Impressionism. The International Movement, 1860-1920. New York 1990.-Cachin, F. (ed.): Europäische Kunst im 19. Jahrhundert. Vol. 2: Realismus - Impressionismus - Jugendstil. Freiburg 1991 .- Callen, A .: Techniques of the Impressionists. London 1982.-Callen, A .: Les peintres impressionnistes et leur technique. Paris 1983.-Champa, K.S.: Studies in Early Impressionism. New Haven (CT) and London 1973, New York 1985.-Clark, T.J.: The Painting of Modern Life. Paris in the Art of Manet and his Followers. London and New York 1985 .- Cogniat, R.: French Painting at the Time of Impressionists. New York 1951 .- Cogniat, R .: Le siècle des impressionnistes. Paris 1976 .-Courthion, P.: Malerei des Impressionismus. Cologne 1976, 1981.- Crespelle, J.-P.: La vie quotidienne des impressionnistes: Du Salon des Refusés (1863) à la mort de Manet (1883). Paris 1981 .- Crespelle, J.-P.: Guide de la France impressionniste. Sites, musées, promenades. Paris 1990.- Czymmek, G. (ed.): Landschaft im Licht. Impressionistische Malerei in Europa und Nordamerika 1860-1910. Wallraf-Richartz-Museum et al. Cologne 1990 (EC) .- Damigella, A.M .: L'impressionismo fuori di Francia. Milan 1967.- Dauberville, J.: La bataille de l'impressionnisme. Paris 1967.- Denvir, B.: The Impressionists at First Hand. London and New York 1987, 1991 .- Denvir, B .: The Thames and

Hudson Encyclopaedia of Impressionism. London 1990 .- Denvir, B.: Impressionism. The Painters and the Paintings. London 1991.- Distel, A .: Impressionism: The First Collectors. New York 1990 .- Distel, A .: Les collectionneurs des impressionnistes. Amateurs et marchands. Paris 1989 .-Dukva, J.: Winds from the East. A Study in the Art of Manet, Degas, Monet and Whistler, 1856-1886. Stockholm and New York 1981.-Dunstant, B .: Painting Methods of the Impressionists. New York 1983.-Duret, T.: Die Impressionisten. Berlin 1909 .- Duret, T.: Histoire des peintres impressionnistes. Paris 1906.-Farr, D. and J. House (eds.): Impressionist and Post-Impressionist Masterpieces: The Courtauld Collection. The Cleveland Museum of Art, Cleveland: The Metropolitan Museum of Art, New York; The Kimbell Art Museum, Fort Worth; The Art Institute of Chicago, Chicago; The Nelson-Atkins Museum of Art, Kansas City. New Haven and London 1987 (EC) .-Francastel, P.: L'impressionnisme, les origines de la peinture moderne de Monet à Gauguin. Paris 1937.- Garb, T.: Women Impressionists. Oxford 1986 .- Gaunt, W .: The Impressionists. London 1970, 1990.- Harris, N. (ed.): A Treasury of Impressionism. London, New York, Sydney and Toronto 1979 (EC) .- Hartlaub, G.F.: Die Impressionisten in Frankreich. Wiesbaden 1955 .- Herbert, R.L.: impressionism. Paris - Gesellschaft und Kunst, Munich 1989.- Herbert, R.L.: Impressionism. Art, Leisure, and Parisian Society. New Haven (CT) and London 1988 .- Huyghe, R. et al. (eds.): Centenaire de l'impressionisme, Grand Palais, Paris 1974 (EC) .-Impressionism, a Centenary Exhibition. Metropolitan Museum of Art, New York 1974 (EC) .- Isaacson, J. et al. (eds.): The Crisis of Impressionism, 1878-1882. The University of Michigan Museum of Art. Ann Arbor (MI) 1980 (EC) .- Kelder, D.: Die großen Impressionisten. Munich 1981 .- Kelder, D.: The Great Book of French Impressionism. New York 1980.- Kelder, D.: Le grand livre de l'impressionnisme français. Lausanne et Paris 1981 .- Kelder, D.: L'héritage de l'impressionnisme. Les sources du XX^e siècle. Paris 1986.- Keller, H.: Die Kunst des französischen Impressionismus. Freiburg 1975.- Keller, H.: Aquarelle und Zeichnungen des französischen Impressionismus. Cologne 1980 .- Keller, H .: Aquarelles et dessins des impressionnistes français. Paris 1982 .- Lassaigne, J.: L'impressionnisme, sources et dépassement, 1850-1900, Geneva 1974.- Laux, W.S. (ed.): Salon und Secession: Zeichnungen und Aquarelle, 1880-1918. Weinheim 1989.- Lemaire, G.-G.: Esquisses en vue d'une histoire du Salon. Paris 1986 .- Lengerke, C. and I.F. Walther (eds.): Vom Jugendstil zum Impressionismus. Von Manet bis Klimt, Munich 1985 .- Le Paul, C.-G.: L'impressionnisme dans l'école de Pont-Aven. Lausanne 1983.- Le Pichon, Y .: The Real World of the Impressionists. Paintings and Photographs. 1848-1918. New York 1984 .-Les grands boulevards. Paris 1985 (EC) .- Léveque, J.-J.: Les années impressionnistes 1870-1889. Paris 1990.- Leymarie, J.: Impressionismus. Biographisch-kritische Studie. 2 vols. Geneva 1955.- Leymarie, J. and M. Melot: Les gravures des impressionnistes: Manet, Pissarro, Renoir, Cézanne, Sisley. Paris 1971.-Leymarie, J.: L'impressionnisme. 2 vols. Geneva 1955.- Martelli, D.: Les impressionnistes et l'art moderne. Paris 1979 .- McQuillan, M .: Porträtmalerei der französischen Impressionisten, Rosenheim 1986.- McQuillan, M.: Impressionist Portraits. London 1986 .- Milner, J .: The Studios of Paris. The Capital of Art in the Late Nineteenth Century. New Haven (CN) and London 1990 - Moffett, C. S.: Impressionist and Post-Impressionist Paintings in the Metropolitan Museum of Art. New York 1985 .- Moffett, C.S. et al. (eds.): The New Painting. Impressionism 1874-1886. The Fine Arts Museums of San Francisco, San Francisco; National Gallery of Art, Washington. Oxford and Geneva 1986 (EC) .- Monneret, S.: L'impressionnisme et son époque. 4 vols. Paris 1979-1981 .- Néret, G.: Les impressionnistes de la révolte à la consécration. Fribourg 1985 .- Nochlin, L. (ed.): Impressionism and Post-Impressionism 1874-1904. Sources and Documents. Englewood Cliffs (NJ) 1966 .- Oberthur, M .: Cafés and Cabarets of Montmartre. Layton 1984.-Passeron, R.: Impressionist Prints. New York 1974 .- Pool, P.: Impres-

sionism. New York and London 1967, 1988.- Reff, T. (ed.): Modern Art in Paris 1855-1900, New York and London 1981.- Reuterswärd, O .: Impressionister och purister. Stockholm 1976 .- Rewald, J .: The History of Impressionism. New York 1946, London 1980 .- Rewald, J .: Histoire de l'impressionnisme, 2 vols, Paris 1955, 1976.- Rewald J .: Die Geschichte des Impressionismus. Schicksal und Werk der Maler einer großen Epoche der Kunst. Zurich 1957, Cologne 1965, 1979.- Rewald, I.: Studies in Impressionism. London and New York 1986 .- Rosenblum, R.: Die Gemäldesammlung des Musée d'Orsay. Cologne 1989 .- Selz, J .: Kleines Lexikon des Impressionismus. Cologne 1975.- Séruillaz, M.: Les peintres impressionnistes. Paris 1959 .-Taylor, B. (ed.): The Impressionists and their World. London 1953 .- Taylor, I.R.: Impressionist Dreams, The Artists and the World they Painted. London 1990.- Venturi, L.: Les archives de l'impressionnisme. 2 vols. Paris and New York 1939, 1968.-Venturi, L.: Impressionists and Symbolists. New York 1973.- Venturi, L .: La via d'impressionismo. Turin 1970.-Wadley, N.: Impressionist and Post-Impressionist Drawing, London 1991 .- White, B.E. (ed.): Impressionism in Perspective. Englewood Cliffs (NJ) 1978 .- Wilson, M .: The Impressionists. Oxford 1983

NEO-IMPRESSIONISM, POST-IMPRESSIONISM

Amann, P.: Post-Impressionismus, Europäische Querverbindungen. Kirchdorf 1986 .- Angrand, P.: Naissance des Artistes Indépendants 1884. Paris 1965 .- Bowness, A. et al. (eds.): Post-Impressionism: Cross-Currents in European and American Painting. 1880-1906. Royal Academy of Arts, London; National Gallery of Art, Washington. London 1979 (EC) .- Cachin, F. (ed.): Félix Fénéon. Au-delà de l'impressionisme. Paris 1966 .- Cogeval, G.: Les années post-impressionnistes. Paris 1986 .- Durbe, D.: Il postimpressionismo. Milan 1967 .-Frèches-Thory, C. and A. Terrasse: The Nabis. Bonnard, Vuillard and their Circle. Paris 1990.- Gruetzner, A. (ed.): Postimpressionism: Two Reactions to French Painting in Great Britain and Ireland. Royal Academy of Painting, London 1979 (EC) - Herbert, E.W.: The Artist and Social Reform. New Haven (CT) 1961 .- Herbert, R.L. (ed.): Neo-Impressionists and Nabis in the Collection of Arthur C. Altschul. Yale University Art Gallery, New Haven (CT) 1965 (EC) .-Herbert, R.L. (ed.): Neo-Impressionism. The Solomon R. Guggenheim Museum, New York 1968 (EC) .-House, John and M.A. Stevens (eds.): Post-Impressionism. Cross-Currents in European Painting. Royal Academy of Arts, London 1979 (EC) .- Kelder, D .: The Great Book of Post-Impressionism. New York 1986 .-Lee, E.W.: The Aura of Neo-Impressionism. The W.J. Holiday Collection. Indianapolis Museum of Art, Indianapolis 1983 (EC) .- Lövgren, S.: The

Genesis of Modernism. Seurat, Gauguin, van Gogh and French Symbolism in the 1880's. Uppsala 1959, Bloomington (IN) and London 1971 .-Marert, F.: Les peintres luministes. Brussels 1944.- Parson, T. and I. Gale: Post-Impressionism. London 1992 .- Rewald, J .: Von van Gogh bis Gauguin. Die Geschichte des Nachimpressionismus. Cologne 1967, 1987.-Rewald, I.: Post-Impressionism, From van Gogh to Gauguin. New York 1956, 1978, 1986.- Rewald, J.: Le post-impressionnisme. De Van Gogh à Gauguin. Paris 1961.- Rewald, I .: Studies in Post-Impressionism. London and New York 1986 .- Roskill, M.: Van Gogh, Gauguin and the Impressionist Circle. London 1970.-Shone, R.: The Post-Impressionists. London 1979 .- Sillevis, J. et al. (eds.): A Feast of Colour. Post-Impressionists from Private Collections. Noordbrabants Museum, 's-Hertogenbosch. Zwolle 1990 (EC) .- Sutter, J .: Les Neo-impressionnistes, Neuchâtel 1970.- Sutter, J .: The Neo-Impressionists. Greenwich (CT) and London 1970.- Thomson, B.: The Post-Impressionists, Oxford 1983.- Trente ans d'art indépendant, 1884-1914. Société des Artistes Indépendants, Paris 1926 (EC) .- Vom Licht zur Farbe. Nachimpressionistische Malerei zwischen 1886 und 1912. Kunsthalle Düsseldorf, Düsseldorf 1977 (EC) .-Wardwell Lee, E. (ed.): Neo-Impressionisten. Seurat tot Struvcken. Rijksmuseum Vincent van Gogh, Amsterdam; Indianapolis Museum of Art, Indianapolis. Zwolle 1988 (EC).-Weisberg, G.P.: Beyond Impressionism. The Naturalist Impulse in European Art 1870-1905. London 1992

COLLECTIONS OF SOURCE MATERIAL

Holt, E.G. (ed.): From the Classicists to the Impressionists: Art and Architecture in the 19th Century. New York 1966.– Nochlin, L.: Impressionism and Post-Impressionism, 1874. 1904: Sources and Documents. Englewood Cliffs (NJ) 1966.– Venturi, L. (ed.): Les.archives de l'impressionisme, lettres de Renoir, Monet, Pissarro, Sisley et autres, mémoires de Paul Durand-Ruel. 2 vols. Paris 1939 (Reprint: 1969).– White, B.E.(ed.): Impressionism in Perspective. Englewood Cliffs (NJ) 1978

NETHERLANDS AND BELGIUM

Belgian Art 1880-1914. The Brooklyn Museum, New York 1980 (EC) .-Bionda, R. et al. (eds.): The Age of Van Gogh. Dutch Painting 1880-1895. Glasgow and Amsterdam 1990 (EC) .- Block, J .: Les XX and Belgian Avant-Gardism, 1868-1894. 2 vols. Doctoral thesis, University of Michigan. Ann Arbor (MI) 1980 (Microfilm) .- Canning, S.M.: A History and Critical Review of the Salons of Les Vingt, 1884-1893. Doctoral thesis, The Pennsylvania State University. MI Ann Arbor 1990 (Microfilm) .-Colin, P.: La peinture belge depuis 1830. Brussels 1930 .- Die Haager Schule. Meisterwerke der holländischen Malerei des 19. Jahrhunderts

aus Haags Gemeentemuseum, Kunsthalle Mannheim et al. Heidelberg 1987 (EC) .- Goyens de Heusch, S .: Het Impressionisme en het Fauvisme in Belgik. Antwerp 1988 .- Govens de Heusch, S.: L'impressionisme et le fauvisme en Belgique. Antwerp and Paris 1988 .- Gruyter, J. de: De Haagse School. 2 vols. Amsterdam 1972.- Haagse school: de collectie van het Haags Gemeentemuseum Haags Gemeentemuseum, 's-Gravenhage 1988 (EC) .- Hammacher, A.M .: Amsterdamsche Impressionisten en hun Kring. Amsterdam 1946.- Hammacher, A.M. and F.C. Legrand (eds.): Le groupe des XX et son temps. Musée Royale des Beaux-Arts, Brussels; Rijksmuseum Kröller-Müller, Otterlo. Brussels 1962 (EC) .- Holländische Impressionisten. Haagsche und Amsterdamsche Schule, Düsseldorf 1950 (EC) .- Lemonnier, C .: L'école belge de peinture, 1830-1905. Brussels 1906.- Licht door keur; Nederlandse luministen 1890-1910. Haags Gemeentemuseum. The Hague 1976 (EC) .- Loosjes-Terpstra, A.B.: Moderne Kunst in Nederland 1900-1914. Utrecht 1958 .- Maret, F.: Les peintures luministes. Brussels 1944.-Maus, O.: Trente années de lutte pour l'art, 1884-1914. Brussels 1926 .-Nederlands Impressionisme, Fen keuze uit de kollektie van het Rijksmuseum Kröller-Müller, Otterlo, Stadthuis Bolsward 1984 (EC) .- The Hague School: Dutch Masters of the 19th Century. Royal Academy of Arts, London 1983 (EC)

GERMANY

Deutsche Impressionisten. Aus dem Niedersächsischen Landesmuseum Hannover, Baden-Baden 1985 (EC) .-Franke, E.A.: Publikum und Malerei in Deutschland vom Biedermeier zum Impressionismus. Doctoral thesis, Heidelberg 1934 .- Hofmann, W., G. Busch and T. Barollet (eds.): Symboles et Réalités. La peinture allemande 1848-1905. Grand Palais, Paris 1984 (EC) .- Huber, J .: Zwischen Harmonie und Aufbruch. Das 19. Jahrhundert. Glattbrugg 1984 .- Niemeyer, W.: Malerische Impression und koloristischer Rhythmus. Düsseldorf 1920.- Platte, H.: Deutsche Impressionisten. Gütersloh 1971.- Römpler, K.: Der deutsche Impressionismus. Dresden 1958.-Wichmann, S.: Realismus und Impressionismus in Deutschland. Stuttgart 1964.- Wirth, I.: Berliner Maler -Menzel, Liebermann, Slevogt, Corinth in Briefen, Vorträgen und Notizen Berlin 1986

SCANDINAVIA

Andreae, R. and M. Kreutzer (ed.): Im Licht des Nordens. Skandinavische Malerei um die Jahrhundertwende. Kunstmuseum Düsseldorf 1986 (EC).– Berg, K., S. Ringbom, B. Lindwall, O. Thue et al.: 1880 – tal i nordikt maleri. Stockholm 1985 (EC).– Dreams of a Summer Night. Hayward Gallery, London 1986 (EC).– Grate, P. and N.-G. Hökby: 1880-arene i nordisk maleri. Oslo, Stockholm, Helsinki, Copenhagen 1985 (EC).– Hansen, J.O.: Dänische

Malerei 1864-1900. In: "Vor 100 Iahren. Dänemark und Deutschland 1864-1900", Kiel 1981 (EC) .- Kent, N.: The Triumph of Light and Nature. Nordic Art 1740-1940. London 1987 .- Nasgaard, R.: The Mystic North. Symbolist Landscape Painting in Northern Europe and North America 1890-1940. Toronto 1984.-Reuterswärd, O.: Impressionister och purister. Stockholm 1976.- Robbert, L. (ed.): De drogo till Paris: Nordiska Konstnärinnor pa 1880-talet. Liljvalch Konsthall Stockholm. Stockholm 1988 (EC) .- Usselmann, H .: Complexité et importance des contacts des peintres nordiques avec l'impressionnisme. Doctoral thesis, Gothenburg 1979 .- Varnedoe, K. (ed.): Northern Light. Realism and Symbolism in Scandinavian Painting 1880-1910. The Brooklyn Museum, New York et al. New York 1982 (EC) .-Varnedoe, K. (ed.): Northern Light. Nordic Art at the Turn of the Century. New Haven (CT) and London 1988 .- Voss, K .: Die Maler des Lichts. Nordische Kunst auf Skagen. Weingarten 1987.- Wichström, A.: Kvinner ved staffeliet, Kvinnelige malere i Norge for 1900. Oslo 1983

EASTERN AND SOUTH EASTERN EUROPE

Balogh, L .: Die ungarische Facette der Münchner Schule. Mainburg 1988.-Breic, T.: Slowenski impresionizem. Ljubljana 1977 .- Cevc, E. and A.: Slowenische Impressionisten und ihre Vorläufer aus der Nationalgalerie in Ljubljana. Vienna 1979 (EC) .- Cevc. E. and A.: Impressionisti sloveni della Galleria nazionale di Ljubljana. Castello sforcesco, Milan 1981 (EC) .-Fjodorow-Dawydow, A .: Russki peisach koza XIX - natschala XX weka. Moscow 1974.- Jensen, J.C. (ed.): Polnische Malerei von 1830-1914. Kunsthalle Kiel et al. Cologne 1978 (EC) .- Karabelnik-Matta, M. and G. Magnaguagno (eds.): Russische Malerei im 19. Jahrhundert. Realismus Impressionismus - Symbolismus. Aus der Sammlung der Staatlichen Tretjakow-Galerie Moskau und des Staatlichen Russischen Museums Leningrad. Kunsthalle, Zurich 1989 (EC) .-Kepinski, Z.: Impresjionizm polski. Warsaw 1961 .- Kotalik, J. et al .: Tschechische Kunst 1878-1914. Auf dem Weg in die Moderne. Darmstadt 1985.- Pleiniristi. Narodni Museum, Belgrade 1960 (EC) .- Salgo, N. et al .: Hungarian Painting. A Century 1850-1950. Washington 1990 .- Slowenische Impressionisten aus der Nationalgalerie in Ljubljana. Städtische Galerie, Regensburg 1984 (EC) .-Stele, F.: Die slowenischen Impressionisten. Ljubljana 1971.- Sternin, G.: Chudoschestwennaja schisn Rossij na rubesche XIX-XX wekow. Moscow 1970

ITALY

Bellonzi, F.: Il divisionismo della pittura italiana. Milan 1967.– Borgiotti, M.: Genio dei Macchiaioli. Milan 1964.– Borgiotti, M. (ed.): I Macchiaioli. Galleria Narciso. Turin 1965 (EC).– Broude, N.: The Macchiaioli. Italian Painters of the Nineteenth Century. New Haven (CT) and London 1987 .- Bruno, G.: La pittura in Liguria dal 1850 al divisionismo. Avengo 1982 .- Calzini, R. and A. Soffici: L'arte dei Macchiaioli. Antologia della critica, scelta di lettere dei pittori macchiaioli e bibliografia. Turin 1977 .-Dini, P.: Movimenti pittorici italiani dell'ottocento. I macchiaioli e la scuola napoletana. Milan 1967 .-Dini, P.: Dal "Caffè Michelangiolo" al Caffè Nouvelle-Athènes: I Macchiaioli tra Firenze e Parigi. Turin 1986.-Divisionismo romano. Galleria Farnese, Rome 1989 (EC) .- Durbè, D. et al. (eds.): Toskanische Impressionen. Der Beitrag der Macchiaioli zum europäischen Realismus. Bayerische Staatsgemäldesammlungen, Haus der Kunst, Munich 1975 (EC) .- Durbè, D.: I Macchiaioli, mantres de la peinture en Toscana au XIX^e siècle. Paris 1978.- Durbè, D. (ed.): I Macchiaioli - Peintres en Toscana après 1850. Galeries nationales du Grand Palais. Paris 1978 (EC) .- Durbè, D. et al. (eds.): The Macchiaioli: Painters of Italian Life, 1850-1900, 1986 (EC).-Durbè, D. and L. Titonel: The Macchiaioli. Masters of Realism in Tuscany. Manchester City Art Gallery. Rome 1982 (EC) .- Durbè, D.: La Firenze dei macchiaioli. Rome 1985.-Fiori, T. (ed.): Archivi del Divisionismo. 2 vols. Rome 1969.- Giardelli, M.: I Macchiaioli e l'epoca loro. Milan 1958 .- Grada, R. de: I Macchiaioli. Milan 1967.- Lankheit, K .: Von der napoleonischen Epoche zum Risorgimento. Studien zur italienischen Kunst des 19. Jahrhunderts. Munich 1988.- Lavagnino, E.: L'arte moderna dai neoclassici ai contemporanei. 2 vols. Turin 1961.- Matteucci, G. et al. (eds.): Three Italian Friends of the Impressionists: Boldini, De Nittis, Zandomeneghi. Stair Sainty Matthiesen Gallery, New York and Florence 1984 (EC) .- Matteucci, E. and P.B. Lande (eds.): I Macchiaioli di Renato Fucini. Florence 1985 (EC) .-Monteverdi, M.: Storia della pittura italiana dell'ottocento. 3 vols. Milan 1975.- Naujack, A.: Die Florentiner Macchiaioli. Doctoral thesis, Tübingen 1972 .- Quinsac, A.-P.: La peinture divisionniste italienne. Origines et premiers développements 1880-1895. Paris 1972 .- Tonelli, E. and K. Hart: The Macchiaioli. Painters of Italian Life, 1850-1900. Seattle 1990

SPAIN

Benet, R.: Impresionismo. [No place of publication] 1952 .- El Impresionismo en España. Salas de Exposiciónes de la Dirección General de Bellas Artes, Madrid 1974 (EC) .- Fuster, A.: Impresionismo Español. Madrid 1970.- Galvo Seraller, F. and A. González (eds.): Paisaje español entre el Realismo y el Impresionismo. Madrid 1976 .- González, C. and M. Martí: Pintores españoles en Paris (1850- 1900). Barcelona 1989 .- Pena López, C.: El paisaje español del siglo XIX: Del naturalismo al impresionismo. Doctoral thesis, Madrid 1982 .-Rodríguez Alcalde, L.: Los maestros del impresionismo español. Madrid

1987.– Soleil et ombre: l'art portugais du XIX^e siècle. Musée du Petit-Palais, Paris 1987 (EC)

GREAT BRITAIN

Baron, W. and F. Farmar: The Painters of Camden Town 1905-1920. London 1988 (EC) .- Billcliffe, R .: The Glasgow Boys. The Glasgow School of Painting 1875-1895. London 1985 .- Campbell, J .: The Irish Impressionists. Irish Artists in France and Belgium, 1850-1914. National Gallery of Ireland. Dublin 1984 (EC).- House, J. (ed.): Impressionism, its Masters, its Precursors and its Influence in Britain. Royal Academy of Arts, London 1974 (EC) .- Flint, K .: Impressionists in England: The Critical Reception. London et al. 1984 .-McConkey, K.: British Impressionism. Oxford 1989 .- Taylor, H. (ed.): British Impressionism. Castle Museum, Nottingham 1989 (EC) .- Watney, S .: English Post-Impressionism. London 1980 .- Wortley, L .: British Impressionism. A Garden of Bright Images. London 1988

USA AND CANADA

American Impressionist and Realist Paintings and Drawings from the Collection of Mr. and Mrs. Raymond J. Horowitz. Metropolitan Museum of Art, New York 1973 (EC) .- Baur, J.I.H. (ed.): Leaders of American Impressionism. The Brooklyn Museum, New York 1937 (EC) .- Bizardel, Y .: American Painters in Paris. New York 1960.- Blaugrund, A. (ed.): Paris 1889: American Artists at the Universal Exposition. Chrysler Museum, Norfolk; Pennsylvania Academy of Fine Arts, Philadelphia; New York 1989 (EC) .- Boyle, R.J. et al. (eds.): French Impressionists Influence American Impressionists. Low Art Museum, University of Miami, Miami 1971 (EC) .- Boyle, R.J.: American Impressionism. Boston 1974 .- Brown, M.W.: American Painting: From the Armory Show to the Depression. Princeton 1970.- Domit, M.M. (ed.): American Impressionist Painting. National Gallery of Art, Washington 1973 (EC) .- Fink, L.M .: American Art at the Nineteenth-Century Paris Salons. Washington and Cambridge (MA) 1990.- Gaethgens, T.W. (ed.): Bilder aus der Neuen Welt. Amerikanische Malerei des 18. und 19. Jahrhunderts. Munich 1988 (EC) .- Gerdts, W.H. (ed.): American Impressionism. The Institute of Contemporary Art, Boston et al. Seattle 1980 (EC) .- Gerdts, W.H.: American Impressionism. New York 1984.-Gerdts, W.H. (ed.): Amerikanischer Impressionismus. Meisterwerke aus öffentlichen und privaten Sammlungen der Vereinigten Staaten von Amerika. Lugano 1990 (EC) .- Hiesinger, U.W.: Impressionism in America. The Ten American Painters. Munich 1991.- Hoopes, D.F.: The American Impressionists. New York 1972 .- Impressionism and its Influence in American Art. Santa Barbara Museum of Art, Santa Barbara 1954 (EC) .- Impressionism in America. University Art Gallery Albuquerque. Albuquerque 1965 (EC) .-Lamb, R.J. (ed.): The Canadian Art Club, 1907-1915. Edmonton Art Gallery, Edmonton 1988 (EC) .- Morrin, P., J. Zilczer and W.C. Agge (eds.): The Advent of Modernism: Post-Impressionism and North American Art. High Museum of Art, Atlanta 1986 (EC) .- Murray, J. (ed.): Impressionism in Canada 1895-1935. Art Gallery of Ontario, Toronto 1973 (EC) .- Novak, B.: American Painting of the Nineteenth Century. New York 1969 .- Pierce, P.J .: The Ten. Concord (N.H.) 1976 .- Sellin, D.: Americans in Brittany and Normandy: 1860-1910. Phoenix Art Museum, Phoenix 1982 (EC) .- Spencer, H., B. Novak et al. (eds.): Impressionnistes américains. Musée du Petit Palais, Paris et al. Paris 1982 (EC) .- Weinberg, H.B.: The Lure of Paris: Nineteenth Century American Painters and their French Teachers. New York 1990 .-Wilson, R.G., D.H. Pilgrim and R.R. Murray (eds.): The American Renaissance, 1876-1917. The Brooklyn Museum, New York 1979 (EC)

ABBATI Giuseppe 1836 Naples – 1868 Florence Pupil to his father, Vincenzo Abbati. Studied under Grigoletti at the Venice Academy, where he met Signorini and Vito d'Ancona. 1859 took part in Garibaldi's movement. From 1860 in Florence; frequented the Caffe Michelangiolo; painted plein-air with his friend Martelli in Castiglioncello. Died from the bite of a rabid dog. CATALOGUE: Dini, P: A. L'opera completa. Turin 1987 ILLUSTRATION:

534 Landscape at Castiglioncello, 1863

ACADEMIE JULIAN

An art school in Paris, founded in 1868 by Rodolphe Julian (1839-1907), a pupil of Cabanel and Cogniet who himself exhibited in the "Salon des Refusés". The academy prepared pupils for entrance to the Ecole des Beaux-Arts. Once a week, Bouguereau, Boulanger, Ferrier, Fleury, Laurens, Lefebvre and others corrected the work of their pupils, who included Bonnard, Denis, Corinth, Matisse and Vuillard. In the 1880s there were approximately 600 pupils, and the monthly fee was 60 francs.

ACADEMIE SUISSE

An art school in Paris on the Quai des Orfèvres, founded by Charles Suisse, who had stood as a model for J.-L. David. The academy was attended in its early years by Delacroix, Daumier and Courbet, and later by Cézanne, Pissarro, Monet and Guillaumin, primarily for nude studies. Although it prepared pupils for the Ecole des Beaux-Arts, the school also gave avant-garde artists the chance to try out their new ideas in a relaxed environment without strict control.

AIX-EN-PROVENCE

The old capital of Provence, birthplace of Cézanne, Alexis and Zola. Its attractive countryside was often painted by Cézanne (Mont Sainte-Victoire), Renoir and others. The museums, such as the Musée Granet, galleries and art shops all contributed to make Aix into a centre for art.

ALEXIS Paul

1847 Aix-en-Provence – 1901 Triel Writer and art critic, early friend of Zola and Cézanne. Moved to Paris in 1869, where his friends introduced him into Impressionist circles. Participated in the meetings at the Café Guerbois and the Nouvelle-Athènes. Became an impassioned defender of the Impressionist view of art, which he linked to Realism in literature. He was a second at the duel between Manet and Duranty. His portrait was painted by Cézanne, Seurat and Zandomeneghi.

ANCHER Anna

1859 Skagen - 1935 Skagen Daughter of the Skagen merchant and restaurateur Erik Brøndum. First lessons with K. Madsen. 1875-1878 attended V. Kyhn's drawing school in Copenhagen. Her style influenced above all by Krohg: portraits of fishermen in Impressionist style. In 1889 she studied with Puvis de Chavannes in Paris. 1880 married Michael Ancher. The couple worked at the artists' colony in Skagen, where, since 1870, many Scandinavian artists such as Krøyer and Krohg had moved in order to paint the sea and the simple life of fishing communities. 1882 trip to Berlin and Vienna. 1885 with Krøyer and Johansen in Holland, Belgium and Paris. The most frequent motifs are simple domestic scenes,

young girls in bright, hazy colours and people in rooms filled with sunlight. Painted some very successful portraits of her husband, her old teacher, Kyhn, and her mother. Her father's former hotel is now the museum of the Skagen artists' group. WRITINGS, DOCUMENTS: Voss, K. (ed.): Letters of A.A. Copenhagen 1984

BIBLIOGRAPHY: Loerges, M.: Et solstrejf i en stue i Skagen. Portræt af A.A. 1980.– Schwartz, W.: A.A. In: "Små Kunstboger", Nr. 27, Copenhagen 1953

ILLUSTRATIONS:

494 Sunlight in the Blue Room, 1891499 The Artist's Mother, Anna Hedvig Brøndum, 1913

ANDREESCU Ion

1850 Bucharest - 1882 Bucharest 1869/70 Studied at the Bucharest School of Art. 1872-1878 Teacher of drawing and calligraphy in Buzau (Muntenia), influenced by Grigorescu. 1874 his pictures first appeared in an exhibition of contemporary artists in Bucharest. 1879/80 and 1881 with a scholarship at the Académie Julian in Paris; painted under the tutelage of Grigorescu in Barbizon, with three exhibitions. 1881 Return to Bucharest, ill with tuberculosis. 1882 successful exhibition of his smallscale Impressionist landscapes, peasant portraits and still-lifes. BIBLIOGRAPHY: Bogdan, R.: J.A. 2 vols. Bucharest 1962-1982 .- Busuioceanu, A.: A. Bucharest 1936.- Busuioceana, A.: A. Bucharest 1980.-Oprescu, G.: A. Bucharest 1932 .-Varga, V. and E. Costescu: A. Bucharest 1978

- ILLUSTRATIONS:
- 525 Winter at Barbizon, 1881
- 527 Edge of the Forest, c. 1880

ANGRAND Charles Théophile 1854 Criquetot-sur-Ouville

(Seine-Maritime) – 1926 Rouen Son of a country school teacher. First exhibition at the Ecole Municipale des Beaux-Arts in Rouen with Zacharie and Morin; admired Corot. Earned a living at first by coaching. 1875 first trip to Paris. 1882 moved to Paris. Friendly contacts with Seurat, Signac, Luce and Cross; frequented the Café l'Orient and the Café Marengo. Like his friends, he painted in the pointillist style. 1884 and 1886 participated in the "Salon des Indépendants". 1889 joint exhibition with Seurat at Les Vingt in Brussels. The death of his friend Seurat in 1891 was a great blow.

1891-1895 yearly exhibitions, at irregular intervals at the "Salon des Indépendants", too, until his death. From 1896 he led a solitary life in Saint-Laurent in the Pays de Caux. Up to 1900 his painting of form became increasingly pointillist; thereafter he returned to an almost traditional technique with simple forms. 1914 Return to Rouen. WRITINGS, DOCUMENTS: Lespinasse, F. (ed.): C.A. Correspondance 1883-1926. Lagny-sur-Marne 1988 BIBLIOGRAPHY: C.A. Galeries André Maurice, Paris 1961 (EC) .- C.A. 1854-1926. Musée de Dieppe, Dieppe 1976 (EC) .- Lespinasse, F.: C.A. 1854-1926. Rouen 1982 .- Welsh-Ovcharov, B.: The Early Work of C.A. and his Contact with Vincent van Gogh. Utrecht and The Hague 1971 ILLUSTRATIONS:

- 295 The Western Railway Leaving Paris, 1886307 Man and Woman in the Street,
- 1887

ANQUETIN Louis

1861 Etrepagny (Eure) – 1932 Paris Settled in Paris in 1882; his apartment on the Avenue de Clichy and his parents' house in Etrepagny became the rendezvous for international artists. Studied under Bonnat and Cormon in Paris, where he met Charles Laval, Toulouse-Lautrec, Bernard and van Gogh. 1883 Continuation of his studies now with Monet in Giverny. Exhibition 1886/87 with Bernard and Toulouse-Lautrec at the Café Tambourin of pictures in the style of Seurat. 1887 became interested in pointillist theories of colour; developed with Bernard the main principles of cloisonnism. He made the important discovery that certain dominant colours reveal the mood of a picture. 1888 exhibition with Les Vingt in Brussels and the "Salon des Indépendants" in Paris. 1894 travelled with Toulouse-Lautrec through Holland and Belgium. In the Nineties he confronted the realistic techniques of Courbet and Daumier. From 1896, under the influence of Rubens and Delacroix, he developed large figural compositions on ceilings, walls and wall-hangings. WRITINGS, DOCUMENTS: Anquetin, A.: De l'art. Paris 1970 BIBLIOGRAPHY: L.A. La passion d'être peintre. Galerie Brame & Lorenceau, Paris 1991 (EC) ILLUSTRATIONS:

306 Avenue de Clichy – Five O'Clock in the Evening, 1887326 Girl Reading a Newspaper, 1890

326 In the Theatre Foyer, 1890

ARGENTEUIL

Small village, seven miles from Paris on the right bank of the Seine, Accessible by two railway lines and by river boat, it was a popular destination for day-trips from Paris. Once Monet had settled here in 1873 and painted a series of his most beautiful pictures, Argenteuil became an Impressionist centre. Manet, Sisley, Caillebotte and Renoir also met there to paint. Monet set up his studio on a small boat. Argenteuil was a place where artists could work together in a relaxed atmosphere and exchange ideas. In 1878 Monet left Argenteuil and moved to Vétheuil.

ASNIERES

A favourite place with Parisians for day-trips and an important port for river traffic on the Seine. Asnières, along with the island of La Grande Jatte, the Trianon casino, and also the factories of Clichy and Saint-Ouen, offered painters, above all the Neo-Impressionists, a mixture of motifs from modern life, and it acquired the same significance for them as Argenteuil had for the first generation of Impressionists.

ASTRUC Zacharie

1835 Angers - 1907 Paris Sculptor, painter and art critic. Began as a journalist with several newspapers: 1859 founding of the journal 'Le Quart d'heure" and publication of the "14 stations du Salon". In 1855 he met Manet. In 1863, during the exhibition in the Salon, he published the journal "Le Salon feuilleton quotidien". He was also a poet and composer. Member of the Batignolles group; frequented the Café Guerbois and later the Nouvelle-Athènes. In 1874 he was co-founder of the "Société anonyme des peintres, sculpteurs et graveurs" and had six catalogue entries at the first Exhibition of Impressionists. He contributed a bust to the

Salon in both 1876 and 1881. In 1883 one of his sculptures was bought by the French state and exhibited in the Jardin du Luxembourg. In painting he developed a special technique for laying on paint using cotton wool wads instead of brushes. As a critic he was quick to recognize the importance of Courbet and praised Manet, who painted his portrait and portrayed him in "Music in the Tuileries" (p. 43).

WRITINGS, DOCUMENTS: Astruc, Z.: Le Salon des Refusés. In: "Le Salon", 20.5.1863, p. 5 BIBLIOGRAPHY: Flescher, S.: Z.A. Critic and Artist, 1833-1907. Doctoral thesis, Columbia University. New York 1978.– Flescher, S.: Manet's "Portrait of Z.A.": A Study of a Friendship and New Light on a Problematic Painting. In: "Arts Magazine" 52 (June 1978), pp.98-105 ILLUSTRATION:

92 The Chinese Gifts, c. 1873

ATELIER CORMON \rightarrow Cormon, Fernand

ATELIER GLEYRE \rightarrow Gleyre, Charles

ATTENDU Antoine-Ferdinand 1845 Paris – 1905

Details of his life are unknown. Pupil of Louis Mettling. Landscape and stilllife painter active in Neully-sur-Seine and Paris. He exhibited between 1870 and 1898 at the Salon and was represented with six works at the first Impressionist exhibition in 1874.

AURIER G. Albert

1865 Châteauroux – 1892 Paris Poet, critic and painter. Wrote many articles in journals in favour of symbolism and became friends with Bernard. From 1889 he was Chief Editor of "Le Moderniste"; in his later years he became a strong supporter of van Gogh and Gauguin.

AUVERS-SUR-OISE

Village on the Oise, about 18 miles from Paris. As early as the 1850s Daubigny, Daumier und Corot worked here. It later became an important rendezvous for the Impressionist painters. Renoir, Sisley, Cézanne and van Gogh lived there and painted views of Auvers and the surrounding countryside.

AVRIL Jane 1868–1943

Dancer at the cafés-concert and one of the celebrities of Paris night life. She was a favourite model of Toulouse-Lautrec; her most famous period was the years **1889-1894**, when she appeared at the Moulin Rouge (p. 327).

AZBE SCHOOL

The school and studio run by the Slovenian painter Anton Ažbė (1862 Ljubljana – 1905 Munich) founded in Munich in 1891, at which Slovenian painters (Ivan Grohar, Matija Jama, Rihard Jakopić, Matej Sternen), Serbian painters (Miličević, Milovanović, Nadežda Petrović, Rista and Beta Vukanović) and Russian painters (Igor Grabar, A. Javlensky, Wassily Kandinsky) all studied plein-air and Impressionist techniques. Grabar was also there as a teacher from 1896.

BAERTSOEN Albert 1866 Ghent – 1922 Ghent

Son of a rich Belgian industrialist, studied with G. den Duyts and at the Academy in Ghent with I. Delvin. After a notable success at the Paris Salon in 1887 he stayed for two years at the studio of Roll. 1898 travelled in Italy. 1900 Gold medal at the Paris World Fair. Friendship with Emile Claus. From Realism he developed a characteristic Impressionistic style using short brushstrokes. A favourite motif is his home town, Ghent. He often painted landscapes with grey skies, melancholy in mood. Member of Les Vingt. 1905 influenced by the Fauves and Impressionists. During the First World War he moved to England, where he stayed with John Singer Sargent.

BIBLIOGRAPHY: Eeckhout, P. (ed.): A.B. Ghent 1972 (EC).- Fierens-Gevaert: A.B. Brussels 1910.– Retrospective tentoonstelling A.B., 1866-1922. Museum voor Schone Kunsten, Ghent 1972 (EC) ILLUSTRATION: 431 Ghent, Evening, 1903

BALLA Giacomo 1871 Turin – 1958 Rome

An important representative of Italian Futurism. Studied at the evening School of Drawing in Turin. Thereafter he settled in Rome, where he worked successfully as a portrait painter. His first Impressionist paintings revealed his interest in colour theory. 1900 stayed in Paris; encountered pointillism and adopted its style of reducing the visible surface to coloured dots. Supported Anarchist ideas, as propounded by certain pointillists like Pissarro. Co-editor of the "Futurist Manifesto of Painting" and, until 1910, painted portraits, landscapes and social themes. 1904 took part in an international exhibition in Düsseldorf. Used pointillist technique for the subject matter of Futurism: dynamism and speed.

WRITINGS, DOCUMENTS: Balla, E.: Con B. 3 vols. Milan 1984-1986 BIBLIOGRAPHY: Barricelli, A.: B. Rome 1966. – Fagiolo dell'Arco, M.: B. pre-futurista. Rome 1968. – G.B. Galleria Civica d'Arte Moderna, Turin 1963 (EC). – G.B. Galleria Nazionale d'Arte Moderna, Rome 1971 (EC).– Robinson, S.B.: G.B. Divisionism and Futurism, 1871-1912. Ann Arbor (MI) 1981 ILLUSTRATION:

550 The Fiancée at the Villa Borghese, 1902

BARBIZON SCHOOL

Group of landscape painters who settled in the village of Barbizon near Fontainebleau, south-east of Paris, and dedicated themselves to plein-air painting. Already an artists' town in the mid-eighteenth century. Achieved its greatest importance in the midnineteenth century through its landscape painters, particularly J.-F. Millet and Rousseau, who, with their airy, light-filled pictures, were precursors of the Impressionists. In contrast to the Impressionists, however, they did not paint in the open air, but sketched from nature and then painted their pictures in the studio.

BASTIEN-LEPAGE Jules

1848 Damvillers (Meuse) - 1884 Paris Came from a country family in northeastern France, where he spent most of his life. 1867 studied at the Ecole des Beaux-Arts in Paris under Cabanel. 1870 Military service; wounded. Exhibited 1870 and 1873-1875 in the Salon. In 1875 he won 2nd place in the competition for the Rome Prize. Close friends with Zola. Painted in a Naturalist style, comparable to that of Courbet and Millet. 1878 notable success in the Salon. 1879-1882 travelled annually to London; contact with Burne-Jones and Clausen. 1881 travelled to Venice and 1884 to Algier, shortly before he died of cancer. CATALOGUE: Aubrun, M.-M.: J.B.-L. Catalogue raisonné de l'œuvre. Nantes 1985

BIBLIOGRAPHY: Fourcauls, L. de: J.B.-L. Paris 1885.– McConkey, K.: The Bouguereau of the Naturalists: B.-L. and British Art. In: "Art History" (September 1978), pp. 3-17.– Theuriet, A.: J.B.-L. Paris 1885 ILLUSTRATIONS: 167 Haymaking, 1877 214 Poor Fauvette, 1881

BATIGNOLLES

An area of Paris, which was absorbed into the city during the expansion of Paris in 1860. Many artists' studios were to be found there, especially those of the Impressionists. The Café Guerbois in Batignolles became, from 1869, a permanent rendezvous for artists, including Manet, Monet, Renoir, Sisley and Pissarro. The group later to be the Impressionists came to be called the Batignolles School by critics. One of the birthplaces of Impressionism.

BAUDELAIRE Charles 1821 Paris – 1867 Paris

French poet, a friend of painters and one of the most perceptive of art critics in the nineteenth century. Argued for a conception of modernity and subjectivity and emphasised the role of imagination and impassivity (impassibilité). In contrast to classical aesthetics he regarded the bizarre, irregular and unexpected as beautiful. **1842** after some eventful experiences at sea, he settled in Paris. Squandered his inheritance and led an irregular and extravagant life, mostly in poverty. **1845** his first critical article on the Salon; identified Romanticism with modernity and introduced the concept of the "heroism of modern life". In 1848 he became for a short period an enthusiastic supporter of the Revolution and edited a revolutionary newspaper with Champfleury. In 1855 he first wrote about Delacroix, whom he particularly admired for the musical effects of his colours and for his surnaturalisme.

In 1857 the book of poems "Les Fleurs du Mal" was published; due to its alleged immorality it was attacked in the courts. He wrote about caricatures. 1858/59 often at his mother's house in Honfleur. Met Manet, Fantin-Latour, Legros, Whistler and Stevens. Rejected Millet, and only accepted Corot's landscapes; saw photography as a danger to art. 1864-1866 in Belgium. The delayed consequences of syphilis made him lame and unable to speak.

BAZILLE Frédéric 1841 Montpellier – 1870 Beaunela-Rolande

Came from a rich middle-class Protestant family. 1849-1859 Grammar school in Montpellier. 1859 Began to study medicine in Montpellier. Acquainted with the famous art collector Bruvas, 1862 continued his medical studies in Paris, at the same time attending painting classes at Gleyre's studio, where he met Monet, Renoir and Sisley. Influenced by Manet and Courbet in his painting style. Spent his summers mostly at his parents' country house in Méric. Easter 1863 with Monet in Chailly, in order to paint plein-air in the forest of Fontainebleau. 1864 with his friend Villa he rented a studio in the Rue Vaugi-

rard. June 1864 with Monet in Honfleur, where he met Boudin and Jongkind. Supported Monet financially; gave up his medical studies. 1865 shared a studio with Monet in the Rue de Furstenberg. Exhibited 1866 at the Salon; shared a studio with Renoir in the Rue de la Visconti; shortly afterwards moved to the neighbourhood of the Café Guerbois, where he was a regular customer. Painted numerous portraits of friends and members of his family in the various studios. Exhibited yearly at the Salon. 1869 his picture "Angler with Nets" caused a fierce debate. His quiet. clear landscapes and harmonious family scenes in muted colours made him one of the most significant representatives of Early Impressionism. 1870 fought enthusiastically in the Franco-Prussian War and was killed at Beaune-la-Rolande, before Impressionism had fully developed. CATALOGUE: Daulte, F.: F.B. et les débuts de l'impressionnisme. Catalogue de l'œuvre peint. Paris 1992 BIBLIOGRAPHY: B. Galerie Wildenstein. Paris 1950 (EC) .- Daulte, F .: F.B. et son temps. Geneva 1952.- F.B. and Early Impressionism. The Art Institute of Chicago, Chicago 1978 (EC) .- Poulain, G .: B. et ses amis. Paris 1932

ILLUSTRATIONS:

- 52 The Terrace at Méric (Oleander), 1867
- 54 Family Reunion, 1867
- 55 Portrait of Pierre-Auguste Renoir, 1867
- 55 Self-Portrait with Palette, 186561 View of the Village of Castelnau-
- le-Lez, 1868
- 75 Bathers (Summer Scene), 1869
- 80 After the Bath, 1870
- 80 Louis Auriol Fishing, 1870
- 81 The Artist's Studio, Rue de la Condamine, 1870

BEAU Henri 1865 Montreal – 1949

Autumn 1907 first exhibited at the Paris Salon. His themes were landscapes, flowers, nucles and portraits. Exhibited regularly 1902-1937 at the Salon des Indépendants and at the Société Nationale des Beaux-Arts. ILLUSTRATION:

636 The Picnic, c. 1905

BELIARD Edouard

1835 Paris - 1902 Etampes Son of a Paris architect; began his career as a lawyer's assistant and secretary. First painting lessons with Hébert und Cogniet; influenced by Corot; friendly with Proudhon. Travelled to Rome. Exhibited in 1867 at the Salon. A frequent customer in the Café Guerbois. 1870 moved to London. 1872 returned to France, lived in Etampes. 1873 recommended by Alexis to the Société coopérative des peintres et graveurs. Successful participation at the 1st and 2nd Impressionist exhibitions. Mainly painted landscapes; later distanced himself from Impressionist principles. Spent his last years in Etampes. ILLUSTRATION:

155 Banks of the Oise, c. 1875

BELLIO Georges de 1828 Bucharest – 1894 Paris

A doctor of Romanian origin, patron and friend of many Impressionist painters, whom he also supported financially. He was a regular customer in their cafés and regularly attended the dinners at the Café Riche. A keen art collector, he bought pictures which otherwise would not have found a buyer. Owned important pictures by Monet ("Impression, Sunrise" p. 113) and Renoir.

BENSON Frank Weston

1862 Salem (MA) - 1951 Boston 1880-1883 pupil of Otto Grundmann at the Museum of Fine Arts School in Boston. 1883-1885 lived in Paris; studied under Boulanger and Lefèbvre at the Académie Julian. 1885 returned to the USA; lived in Salem (MA); taught art in nearby Portland. One of the first plein-air painters in America, he paved the way for American Impressionism. 1889 moved to Boston, where he taught in his studio; he soon became Professor at the Boston Museum School. Member of The Ten American Painters; annual exhibitions and numerous study trips: in 1903 he received the gold medal at Pittsburgh, in 1904 at St. Louis and in 1906 at Philadelphia. BIBLIOGRAPHY: Bedford, F.A. et al. (eds.): F.W.B. Berry-Hill Galleries. New York 1989 (EC) .- Dodge, E. (ed.): F.W.B., 1862-1951. William A. Farnsworth Library and Art Museum, Rockland (Me.) 1973 (EC) .- Morgan, C.L.: F.W.B. New York und London 1931.- Olney, S.F. (ed.): Two American Impressionists: F.W.B. and Edmund C. Tarbell. University of

New Hampshire, Art Galleries, Durham (N.H.) 1979 (EC) .- Pfaff, A.E.M.: Etchings and Drypoints by F.W.B. Boston and New York 1917 .-Price, L. (ed.): F.W.B. 1862-1951. Essex Institute and Peabody Museum, Salem (MA). 1956 (EC) .- Price, L. and F. Coburn (eds.): F.W.B., Edmand C. Tarbell. Museum of Fine Arts, Boston 1938 (EC) .- Salaman, M.C.: F.W.B. London 1925 .- Wilmerding, J. et al. (eds.): F.W.B.: The Impressionist Years. Spanierman Gallery, New York 1988 (EC) ILLUSTRATIONS: 630 The Black Hat, 1904 634 Sunlight, 1909

BERAUD Jean 1849 St. Petersburg – 1936 Paris

Born in Russia of French parents. Until 1870. he studied law in Paris. He then studied art at Bonnat's studio. Friendly with Manet; his favourite themes were people in the city, at first in an Impressionist manner. In 1873 he exhibited for the first time at the Salon. 1876 a great success at the Salon. Co-founder of the Société Nationale des Beaux-Arts, took part regularly in exhibitions there 1890-1929. From 1890 he turned to religious themes in a realistic style, which led to controversial discussions at the Salon. CATALOGUE: Offenstadt, P.: J.B. Catalogue raisonné (in preparation) BIBLIOGRAPHY: Un temoin de la Belle Epoque, J.B. (1849-1935). Musée Carnavalet, Paris 1979 (EC) ILLUSTRATIONS: 371 On the Boulevard, 1895 372 Waiting, Paris, Rue de Chateaubriand, c. 1900

BERNARD Emile 1868 Lille – 1941 Paris

Lived from 1878 in Paris. His initial artistic training was at the Ecole des Arts Décoratifs, then from 1884 at the studio of Cormon. There he met Anquetin, Toulouse-Lautrec and van Gogh. 1885 travelled in Normandy and Britanny, where he met Schuffenecker. Through van Gogh in 1886 he came to know Gauguin, whom he admired considerably. 1888-1891 he worked with Anquetin and Gauguin on the principles of Cloisonnism. After a quarrel about who was the originator of the new style, he broke off all contact with Gaugin in 1891.

Exhibition at the Salon des Indépendants. 1892 organised the first van Gogh retrospective. In 1893 he left Paris; travelled in Italy and the Middle East; lived in Cairo. 1896 travelled in Spain. 1900 and 1903 visits to Venice. From 1901 he had his own exhibitions in Paris, 1905 at Cassirer's in Berlin and 1908 at the Kunstverein (Society of Arts) in Munich. 1904 returned to Paris. His correspondence with Cézanne was important for the theory of art. 1905 founded the famous journal "La Rénovation Esthétique". His later pictures drew on the style of the Renaissance and were mostly religious themes. The large, heroically conceived figures are filled with expressive pathos.

CATALOGUE: Luthi, J.-J.: E.B. Cat. raisonné de l'œuvre peint. Paris 1982 BIBLIOGRAPHY: Cailler, P.: E.B. Geneva 1959. – Cheyron, J. and Z. El Hakim: E.B. 1868-1941. Geneva 1941. – Mornard, P.: E.B. et ses amis. Geneva 1957. – Stevens, M.A. et al. (eds.): E.B. 1868-1941. Ein Wegbereiter der Moderne. Kunsthalle Mannheim and Amsterdam 1990 (EC) ILLUSTRATION: 290 Portrait of Père Tanguy, 1887

BERNHEIM family

A family of art dealers in the 19th and 20th centuries. Alexandre Bernheim (1833-1915) opened an art shop in the Rue Lafitte in Paris in 1863 which was later run by his sons Joseph (1870-1941) and Gaston (1870-1953; ill.) The family concentrated on Impressionist paintings, especially by Renoir and Monet, who were friends of theirs. With Durand-Ruel and G. Petit they were the most important Impressionist art dealers. After 1900 the gallery became particularly interested in van Gogh, Cézanne and some of the Post-Impressionists.

BERUETE Y MORET Aureliano de 1845 Madrid - 1912 Madrid First studied law, 1867 gained his doctorate. At the same time he attended courses in painting at the studio of Carlos Múgica. 1871/72 active as a politician. 1874 decided on a career as a painter; artistic training with C. de Haes and M. Rico. Co-founder of the Institución Libre de Enseñanza. Travelled frequently in Europe and Spain. One of the most important representatives of Impressionist landscape painting in Spain. In 1878, 1884, 1901 and 1904 he received medals at the National Exhibition of Art in Madrid. 1889 and 1900 member of the international jury for the Paris World Fair. 1900 Chevalier de la Légion d'Honneur. 1898-1909 published an important monograph on the Spanish Baroque painter Velázquez. WRITINGS, DOCUMENTS: Beruete, A .: Historia de la pintura española en siglo XIX. Madrid 1926 BIBLIOGRAPHY: Lafuente Ferrari, E. et al. (eds.): A.d.B. 1845-1912. Sala de Exposiciones de la Caja de Pensiones, Madrid 1983 (EC) ILLUSTRATIONS: 556 Hawthorn in Blossom, 1911

559 The Manzanares, 1908

BESNARD Albert 1849 Paris – 1934 Paris Pupil of Brémont and Cabanel. 1868

exhibited for the first time at the Salon. 1874 winner of the Rome Prize, thereafter 1874-1878 visited Italy, staying in the Villa Medici in Rome. Marriage to the daughter of the sculptor Dubray. Two-year stay in London, where he studied Reynolds, Gainsborough, Lawrence and the Pre-Raphaelites. Return to Paris. Became very quickly an immensely successful portrait painter. Took part in international exhibitions at the gallery of G. Petit. 1893 travelled in Algeria. 1906 travelled to India. Director of the Ecole des Beaux-Arts and the Villa Medici. 1924 became the first painter accepted into the Académie Française. Successful above all in his use of pastels.

BIBLIOGRAPHY: A.B. Radierungen. Galerie zur Mühle. Moosinning/Munich 1981 (EC).- Godefroy, L.: Lœuvre gravé. Paris 1969.– Singer, H.W.: Zeichnungen von A.B. Leipzig 1913.– Coppier, A.-C.: Les Eaux-Fortes de B. Paris 1920 ILLUSTRATION:

251 Portrait of Madame Roger Jourdain, 1886

BING Siegfried (Samuel) 1838 Hamburg – 1905 Vaucresson

Gallery owner, from 1871 in Paris, where he opened a gallery for Far Eastern art, in which he was regarded as a specialist. Also gave opportunities for Impressionist, Post-Impressionist and Symbolist painters to exhibit in his gallery.

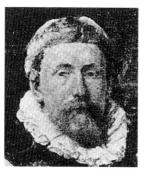

BIRGER Hugo

1854 Stockholm – 1887 Helsingborg 1871-1877 studied at the Academy of Art in Stockholm. In 1877 moved to Paris. 1879-1881 shared a studio with Josephson in the Rue Gabrielle. Exhibited from 1879 at the Salon. 1881-1885 travelled in Spain and Morocco; these experiences were transformed into the light-filled atmosphere of his paintings. Executed numerous works in a style accessible to popular taste. BIBLIOGRAPHY: Strömborn, S.: H.B. Stockholm 1944

ILLUSTRATION:

483 Scandinavian Artists Breakfasting at the Café Ledoyen, Paris, on Salon Opening Day, 1886

BLANC Charles

1813 Castres – 1882 Paris Influential art critic and art historian, brother of the Socialist historian and politician Louis Blanc. 1849-1876 wrote a "Histoire des peintres de toutes les écoles" in 14 volumes and founded, in 1859, the "Gazette des Beaux-Arts". 1848 appointed Director of the Académie des Beaux-Arts; President again 1872-1874. 1878 Professor of aesthetics at the Collège de France. His theories of colour influenced the Neo-Impressionists.

BOCCIONI Umberto 1882 Reggio di Calabria – 1916 Verona

1898-1902 studied in Rome, where he met Gino Severini and Balla. Became acquainted with the painting techniques of Divisionism but developed Neo-Impressionism further and became the leading exponent of Italian Futurism. 1902-1904 stayed in Berlin and Paris. 1907 settled in Milan. 1909 met Marinetti, with whom he composed the Futurist Manifesto in 1910.

WRITINGS, DOCUMENTS: Boccioni, U.: Gli scritti editi e inediti. Milan 1971.– Boccioni, U.: Altri inediti e apparati critici. Milan 1972

CATALOGUES: Bellini, P.: Catalogo completo dell'opera grafica di U.B. Milan 1972.– Calvesi, M. and E. Cohen: L'opera completa di B. Milan 1983.– Palzzeschi, A.: L'opera completa di B. Milan 1969.– Verzotti, G.: B., catalogo completo dei dipinti. Florence 1989

BIBLIOGRAPHY: Argan, G.C.: U.B. Rome 1953 .- Birolli, Z .: U.B. Racconto critico. Turin 1983.- B. und Mailand. Kunstmuseum Hannover. Milan 1983 (EC) .- B. a Milano. Palazzo Reale, Milan 1983 (EC).- B. prefuturista. Museo Nazionale, Reggio Calabria. Milan 1983 (EC) .- Calvesi, M. and E. Coen: B. Milan 1983 .-Coen, E. (ed.): B. A Retrospective. Metropolitan Museum of Art, New York 1988 (EC) .- Grade, R.: B., il mito del moderno. Florence 1962.-Marchiori, G.: U.B. Milan 1966 .-Schulz-Hoffmann, C.: U.B. Volumi orizzontali, Munich 1981 ILLUSTRATION:

550 Portrait of the Artist Adriana Bisi-Fabbri, 1907

BOCH Anna and Eugène

Anna (1848 Saint-Vaast – 1936 Ixelles); Eugène (1855 La Louvière – 1941 Monthyon). Belgian painters of landscapes and interiors. From a respectable manufacturing family. Painted in Provence, Brittany and Holland. Anna was influenced by van Rysselberghe and Neo-Impressionism, and supported Seurat. She bought a painting from van Gogh, "The Red Vineyard", the only picture he sold in his lifetime. Eugène studied in Paris under Cormon and was friendly with Toulouse-Lautrec, Bernard and van Gogh, for whom he also posed as a model.

BOLDINI Giovanni

1842 Ferrara - 1931 Paris First drawing lessons with his father Antonio Boldini, the history and portrait painter. 1862-1865 studied painting at the Academy in Florence with Enrico Pollastrini; became acquainted with the Macchiaioli circle in the Caffè Michelangiolo in Florence. One of the most enthusiastic exponents of plein-air painting. 1866 with Bonti, he travelled to Naples; 1867 trip to Paris. Met Degas again, who had been his neighbour in Florence. 1869 at the invitation of the Duke of Sutherland he went to London; great success as a portrait painter. 1872 moved to Paris; contacts with Goupil; notable successes in the Salon 1874/75. 1880 travelled in England, America, Austria and Germany. 1889 with Degas travelled in Spain. Took part in the international exhibitions at G. Petit's gallery. 1890 Co-founder of the Société Nationale des Beaux-Arts.

CATALOGUES: Camesasca, E. and C.L. Ragghianti: L'opera completa di B. Milan 1970 .- Prandi, D.: G.B. L'opera incisa. Reggio Emilia 1970 BIBLIOGRAPHY: B. Musée Jacquemart-André. Paris 1963 (EC) .- Cardona, C.: G.B. Genoa 1956 .- Cecchi, C.: B. Rome 1962 .- Dini, P.: B. Macchiaiolo. Turin 1989 .- Doria, V.: B. Inedito. Bologna 1982.- Doria, V.: Il genio di B. Bologna 1988.- G.B., een Italiaan in Parijs. Haags Gemeentemuseum, The Hague 1972 (EC) .- G.B. Olii, disegni, incisioni. Genoa 1987 (EC) .- G.B. Palazzo della Permanente. Milan 1989 (EC) .- Piceni, E. (ed.): B. e Parigi. I aquarelli e disegni. Florence 1959 (EC) .- Piceni, E .: B. L'uomo e l'opera. Busto Arsizio 1981.- Sari, G.: B. a Parigi (1871-1931). Alghero 1980 ILLUSTRATION: 532 Portrait of Mlle. Lantelme, 1907

BONINGTON Richard Parkes 1802 Arnold (Nottingham) – 1828 London

1817/18 moved with his family to Calais. Encouraged to take up plein-air painting by the water-colourist Louis Francia. 1818 moved to Paris, met Delacroix. 1821/22 studied at the School of Art with A. Gros and began to paint landscapes and city views on the Seine and on the coast, as well as genre and literary scenes. In 1824 he won the gold medal at the Paris Salon for paintings which, by their fresh colours and sketchy character, contributed to the influence of English painting on French art. 1825 with Delacroix in London. In 1826 went to Venice and other Italian towns, His perception of nature and his style of painting stimulated the painters of the Barbizon school and also Monet (partly through the intermediary influence of E. Isabey, Eugène Boudin and Johan B. Jongkind) to take up Impressionism.

BIBLIOGRAPHY: Cormack, M.: B. Oxford 1989. – Dubuisson, C.E.H.: R.P.B. London 1924. – Ingamells, J.: R.P.B. London 1978. – Ponton, M. (ed.): B., Francia & Wyld. London 1985 (EC). – R.P.B. (1802-1828), Paul Sandby (1730-1809): Wegbereiter der Aquarellmalerei. Städtische Galerie im Prinz-Max-Palais, Karlsruhe 1989 (EC). – R.P.B. On the Pleasure of Painting. New Haven (CT) and Paris 1991 (EC). – Shirley, A.: B. London 1940 ILLUSTRATION:

19 Water Basin at Versailles, c. 1826

BONNARD Pierre

1867 Fontenay-aux-Roses (Seine) -1947 Le Cannet (Alpes-Maritimes) 1886-1889 studied law in Paris. 1888/89 also studied painting at the Paris art college and at the private Académie Julian. Friendly with Denis, Vuillard and Sérusier, who exposed him to Gauguin's conception of art. Studied Japanese coloured woodcuts. 1889 sold a new style of poster design ("France-Champagne"). 1890 after a short period in military service, he shared a studio with Denis and Vuillard. Co-founder of the Nabis, a Symbolist group of artists. Exhibited 1891-1905 with the Indépendants. Brought out his first poster, became acquainted with Toulouse-Lautrec. 1893 lithographs in "La Revue Blanche". Became friends with its editor, T. Natanson. 1895 Vollard began to

publish his lithographs and book illustrations, which are partly influenced by Redon. He painted scenes of gardens and Paris streets, Impressionist in their composition and brushwork, and close to Degas. 1896 exhibited for the first time on his own at Durand-Ruel. Painted the stage decor for Lugné-Poe's theatre. His style developed into an independent, lightfilled Impressionism, which he used for intimate interior scenes (female nudes) and garden scenes. Exhibited 1903 for the first time at the new Autumn Salon. 1906 taught at the Académie Ranson. Used similar motifs to Renoir. 1905 travelled in Spain with Vuillard, and in the following years to Belgium, Holland, England, Italy, Algeria and Tunisia. 1909 in Southern France for the first time. 1912 bought a house in Vernonnet near Giverny. 1913 with Vuillard in Hamburg. 1914-1918 mostly in Saint-Germain-en-Laye. 1918 with Renoir Honorary President of the group "Young French Painting". In 1925 he bought a house at Le Cannet near Cannes, 1926 travelled in the USA. In later years mostly in Le Cannet; until his death he painted landscapes, views from windows, still lifes and nudes in a Fauvist-inspired Impressionist style.

WRITINGS, DOCUMENTS: Clair, J. and A. Terrasse (eds.): B.-Matisse. Correspondance. 1925-1946. Paris 1991 CATALOGUES: Bouret, F.: P.B. L'œuvre gravé. Catalogue complet. Paris and London 1981.– Bouvenne, A.: Catalogue de l'œuvre gravé et lithographié de R.P.B. Paris 1873.– Curtis, A.: Catalogue de l'œuvre lithographié et gravé de R.P.B. London and Paris 1939.– Dauberville, J. and H.: B. Catalogue raisonné de l'œuvre peint. 4 vols. Paris 1966-1974.– Roger-Marx, C.: B. lithographe. Monte Carlo 1958

BIBLIOGRAPHY: Beer, F.J.: P.B. Marseilles 1947.–Cogniat, R.: B. Paris 1989.–Ives, C. et al. (eds.): P.B. The Graphic Art. New York 1989 (EC).– Dubuisson, A. and C.E. Hughes: R.P.B. London 1924.– Gobin, M.: R.P.B. Paris 1950.– Jedlicka, G.: P.B., ein Besuch. Zurich 1949.– Mann, S.: B. Drawings. London 1991.– Natanson, T.: Le B. que je propose. Geneva 1951.– P.B. Kunstmuseum, Basle 1955 (EC).– P.B. Kunsthaus Zürich; Städtische Galerie und Städelsches Kunstinstitut, Frankfurt am Main; Zurich 1985 (EC).– Raynal, M.: Histoire de la peinture moderne. De Baudelaire à Bonnard. Geneva 1949.– Rewald, J.: P.B. New York 1948.– Rumpel, H.: B. Berne 1952.– Shirley, A.: B. London 1940.– Stokes, H.: Girtin and B. London 1922.– Terrasse, A.: P.B. Paris 1967.– Terrasse, A.: P.B. Leben und Werk. Cologne 1989.– Vaillant, A.: B. ou le Bonheur de Voir. Neuchâtel 1965 LUUSTRATION:

340 Twilight or The Game of Croquet, 1892

BOUDIN Eugène-Louis 1824 Honfleur - 1898 Deauville Settled in Le Havre in 1835, where he was an apprentice to a printer. In 1838 he opened an art framer's shop, in which he exhibited paintings by Couture, Millet, Troyon and others. Soon gave up the shop, to dedicate himself wholeheartedly to painting. 1847 travelled to Paris, 1848 visited northern France and Flansers. In 1850 he exhibited two pictures at the Société des amis des arts du Havre, after which the town gave him a scholarship to study at the Ecole des Beaux-Arts in Paris 1851-1853.1855 returned to Honfleur, travelled along the coast. Throughout his life he remained faithful to the Corot tradition and plein-air painting, especially the play of light on water and atmospheric cloud studies. His pastels - exhibited at the Salon in 1859 - were greatly admired by Baudelaire. In 1858 he met Monet and encouraged an equal enthusiasm for plein-air painting. In 1859 he met Courbet and Baudelaire. From 1862 he began to spend holidays at Trouville, where the beach life provided many models. In 1868 he was commissioned to execute a decorative painting for the Château de Bourdainville. During his stay in Brussels 1870/71, new motifs (market scenes) led to a more generous brushwork. Met Durand-Ruel there. 1874 visited Bordeaux, 1876 Rotterdam and 1884 Dordrecht. Showed in the 1st Impressionist exhibition 1874, after which he had considerable success at the Salon. 1889 received the gold medal at the General Exhibition. Based at his home in Deauville, he made various trips to Venice, the Côte d'Azur and elsewhere, which enriched his use of

colour. His pictures of the sea made him one of the forerunners of the Impressionists.

WRITINGS, DOCUMENTS: Knyff, G. de: E.B. raconté par lui-même: Sa vie, son atelier, son œuvre. Paris 1976 CATALOGUE: Schmit, R.: E.B. 1824-1898. Catalogue raisonné. 4 vols. Paris 1973-1984

BIBLIOGRAPHY: Alexandre, A .: L'œuvre d'E.B. Paris 1899 -- Benjamin, L.R.: E.B. New York 1937 .-Cahen, G.: E.B.: Sa vie, son œuvre. Paris 1900 .- Carlo, L.: E.B. Paris 1928.- E.B. Marlborough Fine Art Ltd., London 1958 (EC).- E.B. Kunsthalle, Bremen 1979 (EC) .- E.B. en Bretagne. Musée de Rennes. Rennes 1964 (EC) .- E.B. 1824-1989. Musée E.B. Honfleur 1992 (EC) .- Jean-Aubry, G.: E.B. London 1969 .- Jean-Aubry, G. and R. Schmit: E.B. La vie et l'œuvre d'après les lettres et documents inédits. Neuchâtel 1968, 1977 .-Les Boudins du Musée Municipal de Honfleur. Honfleur 1956 (EC) .-Roger-Marx, C.: E.B. Paris 1927 .-Selz, J.: B. Paris 1982

ILLUSTRATIONS:

- 35 Beach Scene, Trouville, 1863 35 Beach Scene, Trouville, 1864
- 354 Sailing Ships at Deauville,

c. 1895/96

BOUGIVAL

Village 10 miles from Paris in a valley south of the Seine, in extremely attractive and varied landscape, which attracted large numbers of artists in the mid-19th century. Monet stayed here before 1870, and Renoir, Pissarro and Sisley all worked here, Bougival, became famous for the pictures of the "Grenouillère" (Frog Island) which Monet and Renoir painted on the same day in 1869 (pp. 72, 73). Most of the pictures from this area were painted by Sisley, who lived from 1870 to 1877 in the nearby villages of Louveciennes and Marly. Between 1881 and 1884 Morisot lived in Bougival with her family.

BOUGUEREAU William-Adolphe 1825 La Rochelle – 1905 La Rochelle 1846-1850 after attending the School of Art in Bordeaux, he studied at the studio of F. Picot and at the College of Art in Paris. 1850-1854 won the Rome Prize and went to Italy. His par-

Rome Prize and went to Italy. His participation at the Paris World Fair in 1855 founded his fame and led to commissions that included wall paintings in a graphically exact but idealised late Classical or Neo-Renaissance style. 1875 Professor at the Paris College of Art, later also at the Académic Julian. 1876 member of the Academy. His Catholic faith was the main principle behind his anti-materialist traditionalism, which meant he also fought against Impressionism; he nevertheless did not flinch from using popular (or even sexual) effects to please his audience. Like Cabanel, he was despised by the Impressionists.

BIBLIOGRAPHY: Isaacson, R.: W.-A.B. Cultural Center, New York 1974 (EC).– Vachon, M.: W.-A.B. Paris 1900.– W.-A.B. Musée du Petit Palais, Paris; Musée des Beaux-Arts, Montreal; The Wadsworth Atheneum, Hartford (CT). Paris 1984 (EC) ILLUSTRATIONS: 188 The Birth of Venus, 1879

188 Bathers, 1884

BOULOGNE-SUR-MER

Resort and port at the mouth of the Liane on the Channel. **1864** and **1869** a motif for Manet ("The Departure of the Folkstone Boat", p. 77) and Degas ("At the Beach", p. 130).

BOUSSOD ET VALADON, Galerie

Etienne Boussod and Pierre Valadon owned a sumptuous gallery on the Place de l'Opéra in Paris with a branch on the Boulevard Montmartre. They mainly sold Salon paintings. In the 1880s they dealt a great deal in works of the Impressionists (Monet, Sisley, Renoir and Pissarro), after Theo van Gogh had taken over the Montmartre branch in 1879.

BRACQUEMOND Félix 1833 Paris – 1914 Paris Real name: Joseph Auguste Bracquemond. Worked first as a circus rider then in a lithographer's workshop. Gained his artistic training with the painter Joseph Guichard, 1852 exhibited for the first time at the Salon. In 1869 he married the painter Marie Bracquemond, née Quivoron. Neglected painting in favour of graphic art. One of the first to discover the artistic beauty of Japanese wood cuts. Frequented the Café Guerbois and the Café de la Nouvelle-Athènes; his friends included Degas, Manet, Fantin-Latour and Whistler. 1862 Cofounder of the Société des aquafortistes. Became known for his portraits and landscapes as well as his prints of Old Masters. 1872-1879 art manager at the Paris studio of the Limoges porcelain manufacturer Haviland. Participated in the 1st, 4th and 5th Impressionist exhibitions. 1885 published his book "Du dessin et de la couleur". In 1900 he won the Grand Prix de Gravure at the Paris World Fair. WRITINGS, DOCUMENTS: Bouillon, J.-P.: La correspondance de F.B. In: "Gazette des Beaux-Arts" 82 (December 1973), pp. 351-386.- Bracquemond, F.: Du dessin et de la couleur. Paris 1885 .- Bracquemond, F.: Etude sur la gravure et la lithographie. Paris 1897

CATALOGUE: Bouillon, J.-P.: F.B. Le réalisme absolu. Œuvre gravé 1849-1859. Catalogue raisonné. Geneva 1987

BIBLIOGRAPHY: Bouillon, J.-P.: F. et Marie Bracquemond. Mortagne and Chartres 1972 (EC).– F.B. and the etching process. The College of Wooster Art Center Museum, Wooster 1974 (EC) ILLUSTRATION: 208 Portrait of Edmond de Gon-

court, 1880

BRACQUEMOND Marie 1841 Morlaix (Finistère) – 1916 Sèvres

Née Quivoron. Grew up in Etampes. Studied at the Ingres studio. Her favourite themes were landscapes, still lifes and interiors; created wall decorations and designs for ceramics. In **1869** she married the graphic artist F. Bracquemond. Taught drawing at a school. **1874** exhibited for the first time at the Salon. **1876** participated at the Exposition de l'Union centrale des arts décoratifs. Exhibited in **1879** at the 4th and in **1880** at the 5th Impressionist exhibitions. With Morisot, Gonzalès and Cassatt she was one of the greatest female representatives of Impressionism.

BIBLIOGRAPHY: Bouillon, J.-P.: Félix et M.B. Mortagne and Chartres 1972 (EC).– Geffroy, G.: M.B. [no place or date of publication]. ILLUSTRATIONS:

194 Tea Time (Portrait of Louise Quivoron), 1880

194 On the Terrace at Sèvres, 1880 198 The Lady in White, 1880

BRANDON Edouard Emile Pereyra 1831 Paris – 1897 Paris

French painter, graphic artist and art collector. **1849** studied at the Paris College of Art, influenced by Corot. **1856-1863** lived in Rome, where he became friends with Degas. **1861** exhibited for the first time at the Salon. Painted realistic scenes from Jewish life with attentive observation of light phenomena. **1874** took part in the 1st Impressionist exhibition at the invitation of Degas (he owned several paintings by Degas).

BRECK John Leslie 1860 (at sea, near the island of Guam) – 1899 Boston

Son of a naval officer in the service of the East India Society. 1878-1881 moved first to Leipzig, then Munich. Studied there under Sträbhofer at the Academy of Art. 1882 trip to Antwerp, studied under Charles Verlat. 1883 return to America; lived until 1886 in Boston. 1887 moved back to Paris, attending the Académie Julian and painting with Metcalf, Robinson and Bruce in Giverny. Exhibited 1887-1889 in L.C. Perry's studio in Boston. 1889 successful participation at the Paris Salon. 1890 return to Boston, where he exhibited regularly at the St. Botolph Club. 1891/92 travelled in California and England (Kent), contributing to the exhibition at the New English Art Club. 1892-1899 lived in Boston. BIBLIOGRAPHY: Kimball, B. (ed.): Memorial Exhibition of Paintings by J.L.B. St. Botolph Club, Boston; National Arts Club, New York 1899 ILLUSTRATION:

611 Garden at Giverny, c. 1890

BREITNER George Hendrik

1857 Rotterdam - 1923 Amsterdam Despite his great talent for drawing, he was apprenticed to a merchant 1871-1874. 1875-1877 studied art at the Academy in The Hague under J.P. Koelman. Painted histories in the style of Charles Rochussen, but with grater emphasis on the aesthetic effects of colour. 1878/79 taught drawing at evening classes in Leyden. 1880 lessons with the landscape painter W. Maris at the Academy; improved his technique by copying Old Masters (J. Steen, F. Hals and H. Holbein). Became interested in plein-air painting. Became a member of the artists' association Pulchri Studio and worked with others at the Panorama Mesdag. Friends with the Maris brothers; worked for periods at the studio of Willem Mesdag. 1882 taught drawing in the lowest class of the Academy at Rotterdam. Met van Gogh. In 1884 he went to Paris; met Toulouse-Lautrec and Bernard at the Cormon studio. 1886 settled in Amsterdam. Taught drawing and painting at the Academy near Allebé. Painted urban life in a lively manner with naturalistic perspicacity and delicate colouring. He later reduced his palette to black, white, ochre and brown. 1903-1905 lived in Aerdenhout near Haarlem. Several trips, including Berlin, London, Ghent, Norway and in 1908 Pittsburgh. Beside van Gogh one of the most important Dutch painters of the nineteenth century.

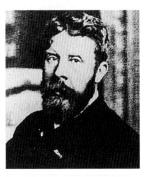

WRITINGS, DOCUMENTS: Hefting, P.H. (ed.): G.H.B. Brieven aan A.P. van Stolk. Utrecht 1970 BIBLIOGRAPHY: Baard, C.W.H.: B. Stedelijk Museum, Amsterdam 1933 (EC).- Centenaire de G.H.B. Institut Néerlandais, Paris 1957 (EC) .-G.H.B. Gemälde, Zeichnungen, Fotografien. Rheinisches Landesmuseum Bonn. Cologne 1977 (EC) .- Hammacher, A.M. (ed.): B. Museum Boymans-van Beuningen, Rotterdam 1954 (EC) .- Hefting, P.H. et al. (eds.): B. als fotograaf. Rotterdam 1956 .- Hefting, P.H.: G.H.B. Amsterdam 1968 .- Hefting, P.H.: B. in zijn Haagse tijd. Utrecht 1970.- Hefting, P.: De foto's van Breitner. The Hague 1989 .- Pit, A., W. Steenhoff, J. Veth et al.: G.H.B. Amsterdam 1908-1911.- Pols, I.V.: G.H.B. Doctoral thesis, Amsterdam 1966.- Schendel, A. v.: G.H.B. Amsterdam 1939 .-Venema, A.: G.H.B. Bussum 1981.-Veth, J.: G.H.B. 1908 ILLUSTRATIONS:

407 Portrait of Mrs. Theo Frenkel-Bouwmeester, 1887

416 The Dam, c. 1891-1893 417 The Earring, c. 1893

BRETON Jules Adolphe Aimé Louis

1827 Courrières (Pas-de-Calais) – 1906 Paris Son of a rich farmer. 1847 studied at the Ecole des Beaux-Arts in Paris, after training under G. Wappers in Autorement 1840 for the first firme at

Antwerp. 1849 for the first time at the Salon, he exhibited some paintings of urban poverty. In 1853 he began his portrayals of peasant life, which were to bring him increasing success, for in contrast to Courbet's Realism his scenes of peasant girls gleaning corn reveal, through their noble, almost Classical postures and forms, a "profound feeling for the beauty of the countryside" (Gautier). 1886 Member of the Academy. Also wrote art criticism, memoirs and poetry.

BIBLIOGRAPHY: J.B. and the French Rural Tradition. Joslyn Art Museum, Omaha (NE); Dixon Gallery, Memphis (TN); Clark Institute, Williamstown (MA). Omaha 1982 (EC)

BRUANT Aristide

1851 Courtenay – 1925 Paris Singer and poet. His cabaret "Le Mirliton" opened in Paris in 1885 and became the meeting place of painters, poets and actors. Two volumes of his chansons were published 1889-1895 with illustrations by Steinlen. Close friends with Toulouse-Lautrec. In 1895 he moved back to Courtenay.

BRUCE William Blair 1859 Hamilton (Ontario) – 1906 Stockholm

After his training at the Academy of Art in Hamilton, he studied in Paris under R. Fleury and Bouguereau. Influenced by Whistler and Cazin. As a plein-air painter, he was fond of beach and harbour motifs. **1888** married the Swedish sculptor Karoline Benedicks-Bruce. Lived in Paris. Spent his last years in Stockholm. WRITINGS, DOCUMENTS: Murray, J. (ed.): Letters Home: **1859-1906**. The Letters of W.B.B. Ontario **1982** ILLUSTRATION: **607** Landscape with Poppies, **1887**

BRUYAS Alfred

1821 Montpellier – 1877 Montpellier Art collector and mason with a remarkable influence on the Impressionists. Known mainly for his support of

Courbet. Won over Gachet to contemporary art and was friendly with the parents of Bazilles. He bequeathed his collection to the Musée Fabre in Montpellier.

BUNKER Dennis Miller

1861 New York – 1890 Boston Pupil of Chase at the National Academy of Design in New York. 1882-1885 studied with Hébert at the Académie Julian and with Gérôme at the Ecole des Beaux-Arts. Influenced by Manet. From 1880 he exhibited at the National Academy of Design. Taught at the Cowles Art School in Boston. 1887 met Sargent. In his last years he developed an increasingly Impressionistic style.

BIBLIOGRAPHY: D.M.B. A Supplementary Group of Paintings and Water Colors Including Some Early Works. Museum of Fine Arts, Boston 1945 (EC).– Ferguson, C.B. (ed.): D.M.B. (1861-1890) Rediscovered. New Britain Museum of American Art, New Britain (CT) 1978 (EC).– Gammell, R.H.L. D.M.B. Nuseum of Fine Arts, Boston 1943 (EC).– Gammell, R.H.L: D.M.B. New York 1953 ILLUSTRATION:

610 The Pool, Medfield, 1889

BUREAU Pierre-Isidor

1827 Paris – 1880 Paris Trained as a graphic artist and landscape painter with Jules Dupré. Friendly with Ribot and Boudin. 1865-1876 exhibited landscapes at the Salon. 1873 took part in the Salon des Refusés. In 1874 and 1876 he exhibited work at the 1st and 2nd Impressionist exhibitions. ILUSTRATION:

55 Moonlight at L'Isle-Adam, 1867

BÜRGER Wilhelm \rightarrow Thoré Théophile

BURTY Philippe 1830 Paris –1890 Parays-par-Astaffort

Art critic, writer and collector. A great supporter of Impressionism, which he admired as a new form of Realism and defended with sensitivity and perspicacity. He particularly favoured Manet, Degas and Renoir. As early as 1874 in his article on the 1st Impressionist exhibition for "La République Française" he recognized the epoch-making importance of the movement. In 1881 he was appointed Inspector of Fine Arts.

CABANEL Alexandre 1823 Paris – 1889 Paris

1840-1845 studied under F. Picot at the Paris Ecole des Beaux-Arts. In 1845 he won the Rome Prize and went to Italy. In 1855 at the Paris World Fair he won the first of his many decorations. 1863 member of the Academy and Professor at the College of Art with an especially large number of students. Served frequently on the Salon jury. He produced some precisely drawn, impressive mythological nudes, often in a Neo-Rococo style, and painted portraits and sentimental genre scenes; he was one of the main exponents of the mainstream of painting in the 2nd Empire and 3rd Republic. Favourite painter of Napoleon III., for paintings like "The Birth of Venus" (p. 36) he was despised by the Impressionists, as also was Bouguereau.

BIBLIOGRAPHY: Dessins d'A.C. 1823-1889. Musée Fabre, Montpellier 1989 (EC) ILLUSTRATION:

36 The Birth of Venus, 1863

CABARET DE LA MERE ANTHONY

Artists' rendezvous in Marlotte near Fontainebleau, especially in the 1860s. Courbet, Pissarro, Sisley and Monet exhibited their caricatures here. It was the subject of Renoir's painting "The Inn of Mère Anthony" (Stockholm, Nationalmuseum).

CAFE DE LA NOUVELLE-ATHENES

Situated in Montmartre near the Place Pigalle, it was a well- known meeting place for dissidents during the time of Napoleon III; Courbet and Castagnary were also customers. From about **1870**, after the Café Guerbois had become too loud for

them, it became the favourite café of the Impressionists. Customers included the artists Manet, Renoir, Degas, Gauguin, Pissarro, Desboutin, Stevens, Forain, Raffaëlli, Zandomeneghi and Caillebotte and the writers Burty, Duranty, Zola, Alexis, Moore and Duret. It was there that Degas painted his picture "The Absinth Drinker", using Desboutin and Ellen Andrée as models (p. 164).

CAFE DES AMBASSADEURS

Popular café-concert, in the gardens of the Champs-Elysées in Paris. Famous singers performed here. In several paintings and lithographs, Manet, Degas and Henri de Toulouse-Lautrec have left impressions of this café.

CAFE GUERBOIS

Situated in the Rue des Batignolles 11 (later: Avenue de Clichy), an area in which many artists owned studios. Manet first visited the café in 1866. and soon afterwards it became a favourite meeting place for his friends: Duranty, Duret, Nadar, Silvestre, Zola, Bazille, Degas, Monet, F. Bracquemond, Renoir and Stevens. They were occasionally joined by Pissarro, Cézanne and Sisley for discussion evenings that usually took place on Thursdays. Shortly after the 1st Impressionist exhibition, the artists decided it was too loud for them and changed to the Café de la Nouvelle-Athènes. Zola depicts the atmosphere very nicely in his novel "L'Œuvre".

CAFES-CONCERT

From 1830 there arose in Paris a type of café with varied entertainment. Some of these, such as the Folies-Bergère, are still famous even today. The cafés-concert were at their most popular at the end of the 19th century. For the Impressionists they were centres of that modern life which they aimed to capture in their pictures.

CAILLEBOTTE Gustave 1848 Paris – 1894 Gennevilliers Son of a middle-class family; in 1873 he inherited his father's fortune and became financially independent for the rest of his life. In 1870 he graduated in law. 1870/71 took part in the defence of Paris during the Franco-Prussian War. 1872 travelled in Italy. 1873 was accepted at the Ecole des Beaux-Arts in Paris; worked irregularly at Bonnat's studio; first contacts

with the Impressionists; met Monet;

in his style of painting he was chiefly

influenced by Degas. In 1875 he painted his famous picture "The Floor Strippers" (p. 131). His most important subjects were motifs from his immediate surroundings: family, street scenes and working life and scenes from his summer visits to Yerres, especially boat parties. In 1876 he exhibited for the first time at the (2nd) Impressionist exhibition. Helped organise and finance the 3rd, 4th, 5th and 7th exhibitions, where he also exhibited his own work. Became the patron of his artist colleagues Monet, Renoir, Sisley and Pissarro by supporting exhibitions. buying many of the paintings himself, including Renoir's "Le Moulin de la Galette" (p. 153) and "The Swing" (p. 144). In 1882 he retired from public life and only painted still lifes and landscapes. In 1883 he wrote his will, leaving his significant collection of paintings to the French state on the condition that 67 pictures be placed together in the Louvre. After his death from a stroke in 1894 the gift was scandalously hushed up, in particular because of the works by Cézanne. It was only in 1928 that the collection became a part of the Louvre and is now kept at the Musée d'Orsay

CATALOGUE: Berhaut, M.: G.C., sa vie et son œuvre. Catalogue raisonné des peintures et pastels. Paris 1978 BIBLIOGRAPHY: Berhaut, M.: G.C. Paris 1951 .- Maillet, E. (ed.): G.C., 1848-1894. Musée Pissarro, Pontoise 1984 (EC) .- Varnedoe, J.K.T.: C.'s Pont de l'Europe: A New Slant. In: "Art International" 18 (1974), No. 4, pp. 28-59 .- Varnedoe, J.K.T. and T.P. Lee (eds.): G.C. A Retrospective Exhibition. The Museum of Fine Arts, Houston; Brooklyn Museum, New York, Houston 1976 (EC) .- Varnedoe, J.K.T.: G.C. New Haven (CT) and London 1987.- Wildenstein, G. (ed.): G.C. London 1966 .- Wittmer, P.: C. au jardin. La période d'Yerres (1860-1879). Saint-Rémy-en-l'Eau 1990

- ILLUSTRATIONS:
- 131 The Floor Strippers, 1875
- 158 Riverbank in Morning Haze, 1875
- 168 Le pont de l'Europe, 1877169 Paris, the Place de l'Europe on a
- Rainy Day, 1877 182 Snow-covered Roofs in Paris,
- 1878 184 Bathers about to Dive into the
- Yerres, 1878
- 184 Canoeing, 1878
- 185 Canoeing on the Yerres, 1877 201 Square at Argenteuil, 1883
- 201 Square at Argenteuil, 1883
- 201 Farmhouse at Trouville, 1882 208 Still Life: Chickens, Pheasants
- and Hares, 1882
- 209 In a Café, 1880
- 228 The Pink Villa, Trouville, 1884
- 229 The Harbour at Argenteuil,
- 1882 244 The Bridge at Argenteuil and the Seine, 1885
- 316 Boats on the Seine at Argenteuil, 1892
- 317 Sailing Boats at Argenteuil, c. 1888

CALS Adolphe-Félix 1810 Paris - 1880 Honfleur Son of a simple labourer in Paris. 1822 was apprenticed to the engraver Anselin; 1823-1826 apprenticeship with the the engraver's firm Pons and Bosq; drawing and modelling lessons. At the same time he studied for one and a half years with Léon Cogniet at the Ecole des Beaux-Arts. Made study trips in the French countryside (Berry, Auvergne). 1835-1848 exhibited in the Salon, but without receiving attention or acclaim. Lived for ten years in various provincial towns. 1858-1869 lived on the Arrouv estate of his patron, Count Doria, and met the art dealer Martin, both of whom supported him. Had exhibitions in 1863 at the Salon des Refusés and in 1865 again at the Salon. In 1864 he painted at Saint-Valéry-en-Caux and in 1869 at Elbeuf-en-Bray. In 1873 he bought a house at Honfleur. 1874 through the intercession of Monet, he exhibited with the later Impressionists at Nadar's. 1876, 1877 and 1879 took part in the 2nd, 3rd and 4th Impressionist exhibitions. Painted melancholy landscapes with stark contrasts of dark and light, and oppressive genre scenes of poverty, fishing communities and the life of workers. BIBLIOGRAPHY: A.-F.C. 1810-1880. Musée Eugène-Boudin, Honfleur;

Musée de Vieux-Lisieux; Musée d'Art et d'Archéologie, Eté, Honfleur 1990 (EC). – Delestre, F.: C. Paris 1975

ILLUSTRATIONS:

- 124 Luncheon at Honfleur, 1875 124 Woman and Child in the Or-
- chard, 1875
- 125 Fisherman, 1874

CAMOIN Charles

1879 Marseilles – 1965 Paris 1896 moved to Paris and became the pupil of Gustave Moreau at the Ecole des Beaux-Arts. His fellow students were Rouault, Matisse and Marquet. 1902 travelled in southern France; met Paul Cézanne. 1905 exhibited at the Salon des Indépendants. 1912 travelled through Morocco with Henri Matisse and Marquet. His nudes and landscapes – especially the Côte d'Azur – are influenced less by the Fauves than by Pierre-Auguste Renoir, whom he met during the First World War.

BIBLIOGRAPHY: C.C. Musée des Beaux-Arts, Marseilles 1966 (EC),-Giraudy, D.: C., sa vie, son œuvre. Marseilles 1972 ILLUSTRATIONS: 381 Girl with a Cat, c. 1904 387 The Market Place, Toulon, c. 1908

CAROLUS-DURAN Emile-Auguste 1837 Lille – 1917 Paris

Real name: Charles-Emile Auguste Durand. Son of a hotelier, trained at the school of drawing in Lille. In 1855 he moved to Paris, assumed his pseudonym and became friendly, through Zacharie Astruc, with Gustave Courbet and Manet. Attended the Académie Suisse. 1859 first contribution to the Salon, 1862-1866 in Rome with a scholarship from his home town. 1866 first award of a medal from the Salon. Travelled in Spain, admired Velázquez. 1869 began his career as a portrait painter. 1890 co-founder of the Société Nationale des Beaux-Arts and 1899 its President, 1904 joined the Academy. 1904-1913 Director of the French Academy in Rome.

CATALOGUE: Carolus-Duran, J.: C.E. C.-D. Catalogue raisonné (in preparation)

ILLUSTRATIONS:

82 Lady with Glove (Madame Pauline Carolus-Duran), 1869

CASAS Ramón

1866 Barcelona – 1932 Paris Early training at the Vincens Academy in Barcelona. 1882 studied in Paris under Carolus-Duran. 1883 first exhibition at the Salon. Lived alternately in Paris and Barcelona. Travelled extensively in the USA, France, Belgium, Italy, Holland and Germany. Worked as an illustrator and designer of posters for the journals Pel y Ploma and Forma. His portraits and city scenes were influenced by Impressionism. He became an advocate of the avant-garde and a catalyst for the development of modern art in Spain.

BIBLIOGRAPHY: Ainaud de Lasarte, J.: R.C. Exposición Nacional de Bellas Artes. Madrid 1968 (EC).– Artís A.A.: Retrats de R.C. Barcelona 1970.– Fontebona, R.: R.C. Barcelona 1979, 1982.– Jordi, F.: R.C. pintor. Barcelona 1949.– Rafols, J.F.: R.C., dibujante. Barcelona [no date; post- 1948].– Rafols, J.F.: R.C., pintor. Barcelona 1949 ILLUSTRATIONS: 566 Out of Doors, c. 1890/91

CASSATT Mary Stevenson 1845 Allegheny City (PA) - 1926 Mesnil-Théribus (near Beauvais) Daughter of a banker; 1851 moved with the family to Paris. 1853-1855 lived in Heidelberg and Darmstadt. 1855 returned to Pennsylvania. Studied 1861-1865 at the Pennsylvania Academy of Fine Arts in Philadelphia. 1866 studied for a short period in the studio of Charles Chaplin in Paris. Self-taught; worked together with Gérôme and Charles Bellay. 1868 exhibited for the first time in the Salon. 1870 Returned because of the Franco-Prussian War, 1871 studied for a time at the Academy Raimondi in Parma; imitated Correggio and Parmigianino, admired Velázquez and Rembrandt. Exhibited 1872 and 1874 in the

Salon, 1873 travelled to Madrid, Seville, Belgium and the Netherlands; copied Velázquez and Rubens. She finally settled in Paris. In 1877 she met Degas, who advised her to join the Impressionists. Degas and Renoir greatly influenced her style of painting. Her favourite themes are portraits of women and children. From 1890 she also produced prints. Took part in the 4th, 5th, 6th and 8th Impressionist exhibitions. 1891 her first solo show at the Durand-Ruel gallery. 1892 Commissioned to do a mural for the World Fair in Chicago. Spent the summer months at the Château de Beaufresne. 1893 exhibited her work in Paris, 1895 in New York at Durand-Ruel. 1898 travelled in the USA. In 1901 she visited Italy and Spain. 1904 accepted into the Legion of Honour. 1908 last trip to the USA. 1910-1912 travelled extensively in Europe and the Middle East. 1910 became a member of the National Academy of Design in New York. 1914 own exhibition at Durand-Ruel in Paris and award of a gold medal at the Pennsylvania Academy of Art. Her failing eyesight forced her to give up painting. Improved the reception of Impressionist painting in America through her advice and influence on American collectors, including the Havemevers.

WRITINGS, DOCUMENTS: Mathews, N. (ed.): C. and her Circle: Selected Letters. New York 1984

CATALOGUES: Breeskin, A.D.: M.C. A Catalogue Raisonné of the Oils, Pastels, Watercolors, and Drawings. Washington 1970 .- Dohme-Breeskin, A.D.: The Graphic Work of M.C. New York 1948, Washington 1979 BIBLIOGRAPHY: Breeskin, A.D.: The Paintings of M.C. New York 1966 .-Breeskin, A.D. (ed.): The Art of M.C. (1844-1926). Isetan Museum of Art (Tokyo) et al., Tokyo 1981 (EC).-Bruening, M.: M.C. New York 1944 .-Bullard, E.J.: M.C., Oils and Pastels. New York 1972 .- Carson, J.M.H .: M.C. New York 1966 .- Getlein, F .: M.C.: Paintings and Pastels. New York 1980 .- Getline, F.: M.C. Paintings and Prints. New York 1980.-Hale, N.: M.C. A Biography of a Great American Painter. Garden City (NY) 1975 .- Lindsay, S.G. (ed.): M.C. and Philadelphia. Philadelphia 1985 (EC) .- Love, R.H.: M.C., The Independent. Chicago 1980 .-Mathews, N.: M.C. and the "Rude, Modern Madonna" of the Nineteenth Century. Doctoral thesis, New York University. New York 1980.-Mathews, N.: M.C. New York 1987 .-M.C. and the American Impressionists. Dixon Gallery and Gardens, Memphis (TN) 1976 (EC) .-McKown, R .: The World of M.C. New York 1972 .- Meixner, L.L. (ed.): An International Episode. Millet, Monet and their North American Counterparts. Dixon Gallery and Gardens et al., Memphis 1982 (EC) .-Myers E.P.: M.C. A Portrait. Chicago 1971.- Novak, B.: American Painting of the Nineteenth Century. London 1969 -- Pollock, G.: M.C. New York 1979.- Segard, A.: Une peintre des enfants et des mères, M.C. Paris 1913.– Sweet, F.A. (ed.): Sargent, Whistler and M.C. The Art Institute of Chicago, Chicago 1954 (EC).– Sweet, F.A.: Miss M.C. Impressionist from Pennsylvania. Norman (OK) 1961.– Valerio, E.: M.C. Paris 1930.– Watson, F.: M.C. New York 1932.– Wilmerding, J. et al. (eds.): American Light. The Luminist Movement, 1850-1875. Paintings, Drawings, Photographs. National Gallery of Art, Washington 1980 (EC) ILLUSTRATIONS:

- 591 Offering the Panale to the Bullfighter, 1873
- 591 A Woman and Child in the Driving Seat, 1879
- 592 Little Girl in a Blue Armchair, 1878
- 594 Mother about to Wash Her Sleepy Child, 1880594 Young Woman Sewing in the
- Garden, c. 1880-1882
- 595 At the Opera, 1880
- 595 Reading "Le Figaro", 1883 596 Lydia Crocheting in the Garden
- at Marly, 1880
- 596 On the Meadow, 1880
- 600 Lydia in a Loge, Wearing a Pearl Necklace, 1879
- 600 Alexander J. Cassatt and his Son Robert Kelso, 1884
- 600 Lady at the Tea Table, 1885
- 601 Children on the Beach, 1884
- 616 Summertime, 1894
- 617 The Boating Party, c. 1893/94628 Susan on a Balcony Holding a Dog, 1883
- 629 Young Mother Sewing, 1902 629 Reine Lefebvre and Margot,
- c. 1902

CASSIRER Paul 1871 Görlitz – 1926 Berlin

Art dealer and art critic. One of the first advocates of German Impressionism, he studied art history at Munich and was involved in the founding of "Simplicissimus". In Berlin he founded a publishing house and gallery and supported the artists of the Berlin Secession. From 1902 he edited the journal "Kunst und Künstler".

CASTAGNARY Jules-Antoine 1830 Saintes – 1888 Paris

Art critic and politician, actively supported Realism and Impressionism and was friends with Courbet and Baudelaire. First used the term "Naturalists" for the painters influenced by Courbet.

CEZANNE Paul

1839 Aix-en-Provence – 1906 Aix-en-Provence

1859-1860 studied law in Aix-en-Provence, began to paint "Jas de Bouffan" at his parents' home. 1861 and 1862-1865 attended the Académie Suisse in Paris and his work imitating Old Masters in the Louvre; for a time he returned to Aix as an apprentice in his father's bank; he formed friendships with Pissarro, Bazille, Guillaumin, Monet, Renoir and Sisley; he had known Zola since his school days. 1863 exhibited in the Salon des Refusés. 1865-1870 alternated between Paris and Aix; was continually

rejected at the Salon. 1866 became acquainted with Manet. 1870/71 in Aix and L'Estaque; moved from predominantly fantasy depictions in coarse, mainly dark and heavy colours to painting from nature in the open air. above all landscapes and still lifes, as well as portraits. 1871-1882 mostly in Paris, occasionally in Pontoise and Auvers, where Pissarro introduced him to the Impressionist method; met Gachet and the art dealer Tanguy. Exhibited in 1874 and 1877 with the Impressionists; continued to be rejected by the Salon. 1875 met the collector Chocquet. 1881 developed a Neo-Impressionist style, but still worked "sur le motif". 1882 succeeded in having one picture accepted at the Salon "by a pupil of Guillemet". From 1882 he lived in Aix; annual visits to Paris and its environs, numerous meetings with Zola and Renoir. 1886 guarrelled with Zola over the novel "L'Œuvre": married his mistress, Hortense Figuet; death of his despotic father, who left him his fortune and with it financial independence. 1889 at Chocquet's instigation, he exhibited a picture at the Paris World Fair and in 1890 joined the Les Vingt group in Brussels. Visit to Switzerland; contracted diabetes.

1895 the Paris art dealer Vollard gave him his first large one-man show; as part of the Caillebotte bequest, two of his paintings entered the Musée du Luxembourg. 1896 became friends with the poet Gasquet, who wrote down Cézanne's views on art; stayed at the spa in Vichy. 1897 the Berlin National Gallery was presented with one of his paintings as a gift from a collector. 1899 sale of "Jas de Bouffan"; exhibited with the Independents in Paris. 1900 exhibited in the century retrospective of French art at the Paris World Fair. 1902 built a studio at Aix; met with young artists who admired his work. 1904 his paintings were shown for the first time at the Autumn Salon in Paris; the beginning of his influence on 20th-century painting.

WRITINGS, DOCUMENTS: Bernard, E.: Souvenirs sur P.C. Paris 1921.– Bernard, E.: Sur P.C. Paris 1925.– Cézanne, P.: Correspondance. Paris 1978.– Doran, M. (ed.): Gespräche mit C. Basle 1917, Zurich 1991.– Doran, M. (ed.): Conversations avec C. Paris 1978.– Gasquet, J.: C. Paris 1921.– Gasquet, J.: C. Drei Ge-

spräche. Berlin 1948.- Gasquet, J .: Joachim Gasquet's C. A Memoir with Conversation. London 1991.-Graber, H. (ed.): P.C. Nach eigenen und fremden Zeugnissen. Basle 1942 .-Guillaud, J. and M.: C. in Provence. New York 1989 .- Hess, W. (ed.): P.C.: Über die Kunst. Gespräche mit Gasquet, Briefe. Munich 1980.- Rewald, J. (ed.): P.C. Correspondance. Paris 1937, 1978.- Rewald, J. (ed.): P.C.: Letters. London 1941, Oxford and New York 1976.- Rewald, J.: C. Correspondance. New York 1984.-Rewald, J. (ed.): P.C. Briefe, Zurich 1962, 1979 (New edition: Zurich 1988) .- Rivière, G.: Le maître P.C. Paris 1923 .- Rilke, R.M.: Briefe über C. Wiesbaden 1952, Frankfurt am Main 1983 .- Shiff, R.: C. and the End of Impressionism. Chicago 1980.- Vollard, A.: P.C. Paris 1914.-Vollard, A.: P.C. His Life and Art. New York 1926 .- Vollard, A.: En écoutant parler C., Degas et Renoir. Paris 1938 .- Vollard, A .: C. Gespräche und Erinnerungen. Zurich 1960

CATALOGUES: Bardazzi, E: C. Catalogo completo dei dipinti. Florence 1993 .- Chappuis, A .: Die Zeichnungen von P.C. 2 vols. Olten and Lausanne 1962.- Chappuis, A.: The Drawings of P.C. A Catalogue Raisonné. Greenwich (CT) and London 1973.- Dunlop, J .: The Complete Paintings of C. London 1972 .- Gatto, A. and S. Orienti: L'opera completa di C. Milan 1970.- Orienti, S.: The Complete Paintings of C. London 1972, New York 1972 .- Rewald, J .: P.C. The Watercolours. A Catalogue Raisonné. Boston and London 1984 .-Rewald, J .: Les aquarelles de C. Catalogue raisonné. Paris 1984.- Venturi, L.: C., son art, son œuvre, 2 vols. Paris 1936 (Reprint: San Francisco 1989)

BIBLIOGRAPHY: Adriani, G.: P.C.: Zeichnungen. Cologne 1978.-Adriani, G.: P.C. Der Liebeskampf. Munich 1980 .- Adriani, G .: P.C .: Aquarelle. Cologne 1981, 1982.-Badt, K.: Die Kunst C.s. Munich 1956 .- Badt, K .: The Art of C. Berkeley and Los Angeles 1965, New York 1985.- Badt, K .: Das Spätwerk C.s. Constance 1971.- Barskaja, A.: P.C. Leningrad 1983 .- Brion, M .: P.C. Paris 1979 .- Berthold, G.: C. und die alten Meister. Stuttgart 1958 .-Beucken, J. de: C., eine Bibliographie. Munich 1960 .- Brion-Guerry, L.: C. et l'expression de l'espace. Paris 1950, 1966 .- C .: Les dernières années (1895-1906). Grand Palais, Paris 1978 (EC) .- C .: The Early Years 1859-1872. Royal Academy of Arts, London; The National Gallery of Art, Washington; London 1988 (EC) .-Chappuis, A.: Album de P.C. 2 vols. Paris 1966 .- Cherpin, J .: P.C., l'œuvre gravé. Marseilles 1973.- Cogniat, R .: C. Paris 1939 .- Dorival, P.: C. Paris 1948, Hamburg 1949 .- Düchting, H.: P.C. 1839-1906. Nature into Art. Cologne 1989.- Elgar, F.: C. New York 1975 .- Feist, P.H.: P.C. Leipzig 1963 .- Fry, R .: C. A Study of his Development. London and New York 1927 .- Geist, S.: Interpreting C. Cambridge (MA) and London 1988.-Guerry, L .: C. et l'expression de l'espace. Paris 1950 .- Gowing, L .: Watercolour and Pencil Drawings by C. London 1973 .- Gowing, L.: P.C. The Basel Sketchbooks. New York 1988 .-Guerry, L .: C. et l'expression de l'espace. Paris 1950, 1966 .- Hoog, M .: L'univers de C. Paris 1971.- Hoog, M.: C. und seine Welt. Paris 1972.-Jean, R.: C., la vie, l'espace. Paris 1986.- Jedlicka, G.: C. Bern 1948.-Kendall, R. (ed.): C. by Himself. London 1988.- Kendall, R. (ed.): P.C. Leben und Werk in Bildern und Briefen, Munich 1989.- Krumring, M.L. (ed.): P.C. Die Badenden. Kunstmuseum, Basle 1989 (EC) .-Lem, F.H.: Sur le chemin de la peinture de P.C. Paris 1969.- Leonhard K.: P.C. Mit Selbstzeugnissen und Bilddokumenten. Reinbek 1966.-Lévêque, J.-J.: La vie et l'œuvre de P.C. Paris 1989 .- Lewis, M.T.: C.'s Early Imagery. Berkeley (CA) 1989.-Lindsay, J .: C., His Life and Art. New York 1972 .- Loran, E.: C.'s Compositions: Analysis of his Form with Diagrams and Photographs of his Motifs. Berkeley 1943, 1963.- Mack, G.: La vie de P.C.. Paris 1938 -- Martini, A. and R. Negri: C. et le post-impressionnisme, Paris 1976 .- McLeave, H .: A Man and his Mountain. The Life of C. London 1977 .- Meier-Graefe, J .: P.C. Munich 1910, 1923.- Meier-Graefe, J.: C. London and New York 1927 .- Meier-Graefe, J .: C. und sein Kreis. Munich 1919, 1922 .- Monneret, S.: C., Zola... La fraternité du génie. Paris 1978 .- Muller, J.-E.: C. Paris 1982 .- Neumeyer, A .: C.'s Drawings. New York and London 1958 .- Novotny, F.: C. Vienna 1937 .-Novotny, F.: C. London 1961.- Novotny, F.: C. und das Ende der wissenschaftlichen Perspektive. Vienna 1938 .- Perruchot, H.: La vie de C. Paris 1956 .- Perruchot, H.: C. Eine Biographie. Eßlingen 1957.- Ponente, N.: P.C. Bologna 1980.- Ramus, C.: C.s Formes. Lausanne 1968.- Raynal, M.: C. Geneva, Paris and New York 1954.- Rewald, J.: C., sa vie, son art, son œuvre, son amitié pour Zola. Paris 1939 .- Rewald, J .: C. et Zola. Paris 1936 .- Rewald, J .: C. New York 1948 .- Rewald, J.: C. Paris 1986 .- Rewald, J .: C. Biographie. Cologne 1986 .- Rewald, J .: C. A Biography. London and New York 1986 .- Rewald, I.: P.C. Sketchbook, 1875-1885. New York 1982.- Rewald, J .: P.C .: The Watercolours. Boston and London 1983 .- Rewald, J .: C. and America. Dealers, Collectors, Artists and Critics 1891-1912. London 1989 .- Roberts, J .: The World View of P.C. Englewood Cliffs (NJ) 1977.- Rubin, W. et al. (eds.): C. The Late Work. 1895-1906. The Museum of Modern Art, New York, 1977 (EC) .- Rubin, W. et al. (eds.): C.- les dernières années 1895-1906. Grand Palais, Paris 1978 (EC) .- Schiff, R .: Impressionist Criticism. Impressionist Color and C. Doctoral thesis, Yale University, New Haven (CT) 1973 .-Schiff, R.: C. and the End of Impressionism. Chicago and London 1984 .-Schniewind, C.O.: P.C. Sketchbook. 2 vols. New York 1951 .- Shapiro, M .: P.C. Cologne 1956, 1983.- Shapiro, M.: P.C. New York 1952, 1973.-Shapiro, M.: P.C. Paris 1937 .-Shapiro, M.: P.C. Paris 1973 .- Sherman, H.L.: C. and Visual Form. Columbus (OH) 1952.- Siblik, J.: P.C. Prague 1969 .- Taillandier, Y.: C. Paris 1977 .- Tompkins Lewis, M.: C.'s Early Imagery. Berkeley, Los Angeles and London 1989 .- Uschida, S.: C. Tokyo 1960 .- Venturi, L .: C., son art - son œuvre. I-II, Paris 1936.- Venturi, L .: C. Geneva and New York 1978.- Wadley, N.: C. and his Art. London 1975.- Wechsler, J.: C. in Perspective. Englewood Cliffs (NJ) 1975 .- Wechsler, J .: The Interpretation of C. Ann Arbor (MI) 1981 ILLUSTRATIONS:

- 85 The Railway Cutting, c. 1870
- 104 A Modern Olympia, c. 1873
- 105 Le déjeuner sur l'herbe, c. 1873-1875
- 120 View of Auvers, c. 1874
- 121 Six Women Bathing, c. 1874/75
- 196 Still Life with Fruit, 1879/80
- 224 The Bridge at Maincy, c. 1882-
- 1885 225 Mont Sainte-Victoire seen from Bellevue, c. 1882-1885
- 308 Boy in a Red Waistcoat, c. 1888-1890
- 309 Still Life with Flowers and Fruit, 1888-1890
- 347 The Smoker, 1895-1900
- 348 Still Life with Onions, 1895-
- 1900 349 Still Life with Apples and Oranges, c. 1895-1900
- 368 Mont Sainte-Victoire, 1904-1906 369 The Bathers, 1900-1905

CHAMPFLEURY Jules Husson 1821 Laon – 1889 Paris

Critic and writer belonging to the circle around Courbet and Baudelaire. Strong advocate of Realism in his theoretical writings "Le Realisme" 1857. His friend Murer introduced him to some of the Impressionists, whose works he collected.

CHARIGOT Aline

1859 Essoyes – 1915 Cagnes Renoir's favourite model and from 1890 his wife. "Dance in the Country" (p. 237).

CHARLES James 1851 Warrington (near Manchester) –

1906 London Initial training at Hatherly's School of Art in London. 1872 began his studies at the Royal Academy in London and the Académie Julian in Paris. Exponent of plein-air painting; painted atmospheric, naturalistic landscape and genre pictures. Worked mainly at his country estate of East Ashling House near Chichester; had several stays on Capri. 1875-1906 took part regularly in exhibitions at the Royal Academy; 1897-1905 exhibited occasionally at the Paris Salon.

ILLUSTRATIONS: 584 The Picnic, 1904

CHARPENTIER Georges 1846 Paris – 1905 Paris

Publisher and art collector. The publishing house he inherited from his father produced works by Flaubert, Maupassant and Zola. The Salon of Charpentier and his wife Marguerite became a meeting place for Naturalist poets, Impressionist painters and socialist politicians. He formed a close friendship with Renoir ("Madame Charpentier and her Children", (New York, The Metropolitan Museum of Art). They supported Renoir and other Impressionists through exhibitions in the rooms of Charpentier's journal, "La vie moderne".

CHASE William Merrit 1849 Williamsburg (IN) – 1916 New York

1867-1869 pupil of the portrait painter Barton S. Hays. 1869-1871 studied at the National Academy of Design in New York. Received a scholarship from business people in St. Louis to travel to Europe. 1872-1876 studied with Piloty at the Munich Academy. 1877 stayed in Venice with Twachtman and Duveneck. 1878 returned to New York. Taught at the Art Students League and the Pennsylvania Academy in Philadelphia. His studio became a rendezvous for young American artists; and he gained a great reputation as a teacher. 1881 travelled to Paris, where he met Stevens. Moved away from a tonal style and turned to brighter colours and plein-air painting. Made frequent trips to Europe. In 1885 he became friends with Whistler. 1891 founded the Shinnecock Summer Art School at his summer residence in Shinnecock.

1896 opened the Chase Art School in New York, later famous as the New York Art School. 1903 member of The Ten. 1908 Member of the Academy of Arts and Letters. BIBLIOGRAPHY: Atkinson, D.S. et al. (eds.): W.M.C.: Summers at Shinnecock, 1891-1902. National Gallery of Art, Washington 1987 (EC) .- C. Centennial Exhibition. John Herron Art Museum, Indianapolis 1949 (EC) .-Otrange-Mastai, M.L. d' et al. (eds.): W.M.C.: A Retrospective Exposition. The Parrish Museum, Southampton (NY). New York 1957 (EC) .- Pisano, R.G. (ed.): The Students of W.M.C. Heckscher Museum Huntington et al., Huntington 1973 (EC) .- Pisano, R.G. (ed.): W.M.C. M. Knoedler & Co. New York 1976 (EC) .- Pisano, R.G.: W.M.C. New York 1979, 1986 .- Pisano, R.G. (ed.): W.M.C. in the Company of Friends. Parrish Art Museum, Southampton (NY). New York 1979 (EC) .- Pisano, R.G. (ed.): A Leading Spirit in American Art: W.M.C. 1849-1916. University of Washington, Seattle 1983 (EC) .-Roof, K.M.: The Life and Art of W.M.C. New York 1917 (Reprint: New York 1975).- W.M.C. 1849-1916. The Art Gallery, University of California. Santa Barbara 1964 (EC) ILLUSTRATIONS:

604 The Open Air Breakfast, 1888

605 End of the Season, c. 1885 614 The Nursery, 1890 620 Idle Hours, c. 1894

CHATOU

Village on the Seine, 9 miles from Paris. Popular for day trips from Paris and a meeting place for anglers, boating enthusiasts and artists. Renoir worked here between 1879 and 1881 ("The Luncheon of the Boating Party", p. 220) as also did Caillebotte, Monet, Sisley and Degas.

CHESNEAU Ernest

1833 Rouen – 1890 Paris Writer and art critic. Through his friendship with Nieuwerkerke he became Inspecteur des Beaux-Arts in 1869. He was one of the first to appreciate the the artistic importance of Manet, and he compared his "Luncheon on the Grass" with the paintings of Raphael.

CHEVREUL Eugène

1786 Angers – 1889 Paris A chemist who wrote several treatises on the theory of colour, which became the theoretical basis for many 19th-century painters, from Delacroix to the Pointillists.

CHOCOUET Victor 1821 Lille - 1891 Paris

French art collector and civil servant at the Ministry of Finance in Paris. 1875 discovered the Impressionists, in particular Renoir, at the auction in the Hôtel Drouot. Also became a patron of Cézanne. 1876 became acquainted with Monet. Lent six Renoirs, a Monet and a Pissarro to the 2nd Impressionist exhibition. In 1877 retired in order to devote himself entirely to his passion for art. 1882 received an inheritance and in 1890 bought a large house in the Rue Monsigny. On the death of his widow in 1899 the collection was auctioned at G. Petit's for 450,000 francs.

CIARDI Guglielmo 1842 Venice - 1917 Venice

Studied at the Academy in Venice. On trips to France he came to know the Barbizon school. 1868 stayed in Florence; influenced by Signorini and the Macchiaioli group. Trip to Naples; met Domenico Morelli and Filippo Palizzi, whose combination of Romantic painting and Realism influenced him considerably. 1869 successful exhibition of light-filled atmospheric plein-air pictures in Venice, Milan and Vienna. Study tour through Italy, Germany and France. Gained a great reputation at home and abroad as a leading Venetian plein-air painter. 1894-1917 Professor of landscape painting at the Academy in Venice. 1909 one-man exhibition at the Biennale in Venice.

BIBLIOGRAPHY: Disegni inediti di G.C. Padua 1961 (EC) .- Menegazzi, L.: G.C. La 'Da Noal, Treviso 1977 (EC) .- Omaggio a G.C. Artisti del

'800 italiano. Galleria Narciso. Turin 1969 (EC) .- Perocco, G.: G.C. Bergamo 1958 .- Pospisil, M. and F. Pospisil: G.C. Florence 1946 ILLUSTRATION: 534 Harvest, 1883

CLAUS Emile

1849 Viive-Saint-Eloi - 1924 Astene 1870-1874 studied at the Academy in Antwerp with the history and portrait painter N. de Keyser and the landscape painter J. Jacobs. 1879 travelled in Spain, Morocco and Algeria. His style of painting is rooted in the Belgian Realist tradition, 1882 exhibited for the first time at the Salon in Paris. 1883 moved to the Villa "Sunshine" in Astene. Spent three winters in Paris. Friendly with Le Sidaner, who introduced him to French Impressionism.He began to use a brighter palette. 1894 exhibition of Impressionist pictures in the rooms of the "Libre Esthétique". Co-founder of the Impressionist artists' association Vie et Lumière. 1914- 1918 emigrated to London; his Thames pictures reveal Divisionist influence BIBLIOGRAPHY: Buysse, C.: E.C., mon frère de Flandre. Ghent 1926 - G. Vogels und E.C. Zwei belgische Impressionisten. Wallraf-Richartz-Museum, Cologne 1988 (EC) .- Maret, F.; E.C. Antwerp 1949.- Sauton, A.: Un prince du luminisme, E.C. Brussels 1946

ILLUSTRATIONS: 427 Sunshine, 1899 427 A Corner of my Garden, 1901

CLAUSEN George 1852 London - 1944 Cold Ash

(Berkshire)

Initially active in interior decoration. He then trained at the Government Art Training School in Kensington. Influenced by the painting style of Bastien-Lepage; mostly painted scenes of country life. 1883 studied under Bouguereau at the Académie Iulian in Paris. 1884 exhibited at the Royal Academy and came under severe criticism. Became an active member and co-founder of the "New English Art Club", which aimed to reform the Royal Academy, Influenced by French plein-air painting, he developed his own Impressionist-related style. 1904 Professor of art at the Royal Academy, 1902, 1904 and 1909 successful exhibitions in London.

WRITINGS, DOCUMENTS: G.C.: Six Lectures on Painting. London 1904 .-G.C.: Aims and Ideals in Art. London 1904

BIBLIOGRAPHY: McConkey, K. (ed.): Sir G.C. 1852-1944. Cartwright Hall, London 1980 (EC) ILLUSTRATIONS: 570 The Mowers, 1892

CLEMENCEAU Georges Benjamin 1841 Moulilleron-en-Pareds (Vendée) - 1929 Paris

French politician, journalist and artlover. Studied medicine. Spent time in prison as an opponent of Napoleon III. 1870 began his political career as mayor of Montmartre. 1873 became acquainted with Monet. 1881 founded the newspaper "La Justice", for which G. Geffroy was the art critic. 1895 wrote about Monet's "Cathedrals". 1906-1909 and 1917-1920 President of France, presided over the Versailles peace conference. 1918 Member of the Académie Française. Arranged with Monet the bequest of the "Water Lilies" and the construction of a building to house them.

COLIN Gustave-Henri 1828 Arras - 1910 Paris

1857 exhibited for the first time at the Salon, painted landscapes and genre pictures in the style of the Barbizon school. Knew Delacroix and Corot, travelled frequently in the Basque country. 1863 exhibited at the Salon des Refusés. 1874 took part in the 1st Impressionist exhibition, then again regularly at the Salon. Castagnary admired his attention to light effects. Frequently auctioned pictures at the Hôtel Drouot and was highly esteemed by collectors like Count Doria and Rouart. From 1890 he exhibited regularly at the Société Nationale. 1901 exhibition at the G. Petit gallery.

CONSTABLE John 1776 East Bergholt, Suffolk - 1837 Hampstead, London

1795 moved to London and worked as a topographical illustrator. 1799 studied at the Royal Academy. Influenced by his preference for landscape painting of the 17th and 18th centuries. 1802 exhibited for the first time at the Academy. 1806 visited the Lake District; adopted the principle of a close study of nature. 1811 guest of the Bishop of Salisbury for the first time. 1819 travelled to Venice and Rome, became an associate member of the Royal Academy. 1820 settled in Hampstead, in the summer mostly in Salisbury or Brighton. 1821/22 painted a series of cloud studies, 1824 gold medal at the Paris Salon; persistent influence on French painting of his view of nature and his use of simple motifs and spontaneous colours. 1827 exhibited again at the Paris Salon, 1829 member of the Royal Academy, although his nature philosophy, unliterary attitude and impressive style was fiercely debated. He made a partial concession to the Romantic search for the Sublime in his combination of landscape with important architectural monuments. 1833 first lectures on landscape painting.

WRITINGS, DOCUMENTS: Beckett, R.B. (ed.): J.C.'s Correspondence, London 1962 .- Leslie, P. (ed.): Letters from J.C., R.A., to C.R. Leslie, R.A. London 1932 .- Leslie, R.A., C.R.: Memoirs of the Life of J.C., R.A. London 1843 (revised edition, A. Shirley 1937; edited by J. Mayne 1946) CATALOGUES: Catalogue of the Constable Collection in the Victoria and Albert Museum. London 1960 .- Revnolds, G.: The Later Paintings and Drawings of J.C. 2 vols. New Haven (CT) and London 1984

BIBLIOGRAPHY: Badt, K.: J.C.'s Clouds. London 1950.- Beckett, R.B.: J.C. and the Fishers, London 1952.- Cormack, M.: C. Oxford 1986 .- Fleming-Williams, I. and L. Parris: The Discovery of C. London 1984.- Fleming-Williams, I.: C. and his Drawings. London 1990.- Hill, D.: C.'s English Landscape Scenery. London 1985 .- Holmes, C.J.: C. and his Influence on Landscape Painting. London 1902 .- J.C., R.A. New York 1988 (EC) .- Parris, L. and I. Fleming-Williams (eds.): C. Tate Gallery, London 1991 (EC) .- Reynolds, G. (ed.): J.C. Sketch-book of 1813 and 1814. 3 vols. London 1985.- Rosenthal. M.: C. London 1987 ILLUSTRATIONS:

18

- Hampstead Heath, 1824 20 The Hay Wain, 1821
- 22 Elm Trees at Old Hall Park, East Bergholt, 1817

CORDEY Frédéric-Samuel 1854 Paris - 1911 Paris Studied at the Paris College of Art, where he protested with Franc-Lamy about the teaching and called on Manet - who did not respond - to found an independent teaching studio. Financially independent, he was able to devote his time to Impressionist landscape painting. Frequented the Café de La Nouvelle-Athènes; met Gachet. 1877 took part in the 3rd Impressionist exhibition. Close friends with Murer. Painted with Cézanne and Guillaumin in Auvers, Eragny and Moret, 1881 with Renoir and others he travelled in Algeria. 1913 Memorial exhibition at the Choiseul gallery in Paris. ILLUSTRATION:

384 Track at Auvers-sur-Oise

CORINTH Lovis 1858 Tapiau (East Prussia) – 1925 Zandvoort

1876-1880 studied at the Academy of Art in Königsberg and 1880-1884 in Munich with Defregger and Löfftz. Came into contact with the Naturalism of the Leibl group. Classical and academic influences from studying in Antwerp with P.E. Gorge and 1884-1886 at the Académie Julian with Bouguereau and Robert-Fleury. 1887-1891 lived in Berlin, then moved to Munich. 1892 member of the Munich Secession and the "Freie Vereinigung" (Free Association). Painted plein-air in the countryside outside Munich. 1898 spent several months in Berlin; friends with Liebermann and Leistikow. 1901 moved to Berlin. Successful mostly as a portrait painter. Took over Leistikow's painting school.

1903 married Charlotte Berend. Through his contacts with Slevogt and Liebermann he developed his Impressionist style of painting. 1911 chairman of the Berlin Secession; in the same year he suffered a stroke. Visited South Tirol, Rome and the Riviera. From 1918 he lived mostly at his country house in Urfeld am Walchensee, 1918 President of the Berlin Secession, 1925 Honorary member of the Munich Academy. WRITINGS, DOCUMENTS: Berend-Corinth, C.: Mein Leben mit L.C. Munich 1958 .- L.C.: Das Erlernen der Malerei. Berlin 1908.- L.C.: Gesammelte Schriften, Berlin 1920.-L.C.: Selbstbiographie. Leipzig 1926 CATALOGUES: Berend-Corinth, C .: Die Gemälde von L.C. Munich 1958.-Schwarz, K.: Das graphische Werk von L.C. Berlin 1922 (Reprint: San Francisco 1985) BIBLIOGRAPHY: Berend, C.: Mein Leben mit L.C. Hamburg 1948.- Biermann, G.: L.C. Bielefeld and Leipzig 1913.- Frick, M.: L.C. Berlin 1976.-Hahn, P.: Das literarische Figurenbild bei L.C. Doctoral thesis, Tübingen 1970.- Imiela, H.J.: Die Bildnisse L.C.s. Doctoral thesis, Mainz 1956 .-Keller, H.: L.C. Walchensee. Munich and Zurich 1976 .- L.C. 1858-1925. Gemälde and Druckgraphik. Städtische Galerie im Lenbachhaus, Munich 1975 (EC) .- Müller, H.: Die späte Graphik von L.C. Hamburg 1960 .- Osten, G.v.d.: L.C. Munich 1950.- Röthel, H.K.: L.C. Zur Feier seines 100. Geburtstages. Munich 1958 (EC) .- Schröder, K.A. (ed.): L.C. Kunstforum, Vienna; Niedersächsisches Landesmuseum, Hannover. Munich 1992 (EC).- Uhr. H.: L.C. Berkeley 1990.- Zdenek, F. (ed.): L.C. (1858-1925). Museum Folkwang, Essen et al. Cologne 1985 (EC) ILLUSTRATIONS: 444 "Othello" the Negro, 1884

- 445 Self-Portrait with Skeleton, 1896
- 446 Reclining Nude, 1899
- 450 Self-Portrait with my Wife and a Glass of Champagne, 1902
- 451 In Max Halbe's Garden, 1899 454 Emperor's Day in Hamburg,
- 1911 463 Portrait of Julius Meier-Graefe,
- 1917 463 Self-Portrait with Straw Hat,
- 1913 464 Easter at Lake Walchen, 1922
- 465 Self-Portrait in a Straw Hat, 1923

CORMON Fernand 1845 Paris – 1924 Paris

Real name: Fernand-Anne Piestre. Studied in Brussels under J.F. Portaels and in Paris with Cabanel and Fromentin. 1870 exhibited a historical painting at the Salon. 1880 achieved success with his large, drastically naturalistic and bright-coloured "Cain, Fleeing with his Family" (after Victor Hugo). Professor at the College of Art and popular with students, who included Toulouse-Lautree, Anquetin, Bernard, van Gogh and many others; made them copy paintings in the Louvre and was liked because he

allowed them great freedom. Much sought after as a portrait and fresco painter in Paris and Tours. **1898** member of the Academy.

COROT Jean-Baptiste Camille

1796 Paris - 1875 Ville-d'Avray 1822-1825 after an apprenticeship with a business firm he attended a private school for landscape painting and nature studies in the open. 1825-1828 in Italy. Painted studies of landscapes and views of towns that are remarkable for their fresh vitality and harmonious composition. 1827 exhibited for the first time at the Paris Salon. 1828 lived in Paris and Ville d'Avray, later also spent periods in Arras. Travelled a great deal in France and visited Italy twice more, as well as going to Switzerland, England and the Netherlands. In allegorical and religious pictures he occasionally made concessions to contemporary taste. But through his intimate, light, poetic landscapes and quiet, gracious pictures of women reading or playing music, he paved the way for a new and realistic concept of art and nature - the Barbizon school. 1855 received awards at the Paris World Fair. A forerunner of the Impressionists. who wanted him to exhibit at their first exhibition.

CATALOGUE: Robaut, A.: L'œuvre de C. Catalogue raisonné et illustré. Paris 1965

BIBLIOGRAPHY: Baud-Bovy, D.: C. Geneva 1957.– Clarke, M.: C. and the Art of Landscape. London 1991.– Galassi, P.: C. in Italien. Munich 1991.– J.-B.C.C. The Lefevre Gallery, London 1989 (EC).– Leymarie, J.: C. Geneva 1979.– Millet, C. and the School of Barbizon. The Seibu Museum, Tokyo; Museum of Modern Art, Hyogo 1980 (EC).- Schoeller, A. and J. Dieterle: Suppléments à l'œuvre de C. Paris 1956.- Selz, J.: La vie et l'œuvre de C.C. Courbevoie 1988.- Zimmermann, A.: Studien zum Figurenbild bei C. Doctoral thesis, Cologne 1986 ILLUSTRATIONS:

Memory of Mortefontaine, 1864
The Mill at Saint-Nicolas-les-Arras, 1874

COURBET Gustave 1819 Ornans – 1877 Tour-de-Peilz (Vevev)

1831 began by drawing from nature. 1839/40 became a mostly self-taught painter in Paris. 1844 exhibited for the first time at the Salon; painted portraits, landscapes, genre scenes and animals, 1846 travelled in Holland. 1848 friendly with Corot, Daumier and Baudelaire. 1849 first received a medal at the Salon. 1850 exhibited in provincial towns, charging an entrance fee; subsequently also in Belgium and Germany. 1855 exhibited at the Paris World Fair; at the same time he organised his own oneman exhibition entitled "Realism". An opponent of the monarchy and the bourgeoisie, proponent of an anarchist form of socialism, friends with P.-J. Proudhon. 1861 for a short period he gave courses in his own studio. 1865 contacts with Whistler and Monet, controversies with Manet. 1867 once again ran his own exhibition during the Paris World Fair. Influenced and advised the future Impressionists. 1869 acclaimed at an international art exhibition in Munich. 1871 active for artistic affairs during the Paris Commune, imprisoned afterwards. 1872 Exhibition at Durand-Ruel's. 1873 held responsible for the fall of the Vendôme column: flight to Switzerland. World-wide influence as a proponent of democratic realism based on perception through the senses and dedicated to uncovering the inner contradictions of reality by means of formal structure. CATALOGUE: Courthion, P.: L'opera completa di C. Milan 1985.- Fernier, R.: La vie et l'œuvre de G.C. 2 vols. Lausanne and Paris 1977-1978 BIBLIOGRAPHY: Bazin, G.: C. Biennale. Venice 1956 (EC) .- Clark, T .: Image of the People. G.C. and the

1848 Revolution. London 1973.-Faunce, S. (ed.): C. Reconsidered. New Haven (CT) 1988 .- Fernier, J.-J., J.-L. Mayaud and P. Le Nouëne: C. and Ornans. Paris 1989 .- Fried, M .: C.'s Realism. Chicago 1990 .- G.C. Grand Palais, Paris 1977 (EC).-Léger, C.: C. et son temps. Paris 1948 .- Lemonnier, G.: G.C. et son œuvre. Paris 1968 .- Les graveurs de C. Musée Courbet 1990 (EC) .- Mac Orlan, P.: C. Paris 1951.- Nochlin, L.: G.C. A Study of Style and Society. New York and London 1976 .- Riat, G.: C. 1906

ILLUSTRATIONS:

- 26 Girls on the Bank of the Seine, 1857
- The Artist's Studio, 1854/55 The Shaded Stream, or "Le Puits 28 Noir", 1865
- 31 The Cliff at Etretat after the Storm, 1870

COUTURE Thomas

1815 Senlis – 1879 Villiers-le-Bel 1831-1839 studied at the Paris Art College with A. Gros and P. Delaroche. 1837 won only second place in the competition for the Rome Prize. 1838 exhibited for the first time at the Salon. Painted history pictures and portraits in the manner of the Venetian Renaissance, always striving to combine allegory with realism, a strict style of drawing and relatively free brushwork. 1847 gained a notable success for his huge impressive picture "The Romans in the Period of Decadence" with its moral criticism aimed at contemporary life. Young painters called on him to open his own school. 1855 despite winning a gold medal, he considered that he had not received due recognition at the World Fair in Paris and did not participate again at the Salon until 1872. 1863 taught at the College of Art emphasising academic precision, attention to brushwork and technique, but also the study of light effects in the open air. His pupils included Manet, Puvis de Chavannes, Anselm Feuerbach and various American artists. An opponent of Courbet's Realism. Wrote a text book on painting. 1869 moved to the country, where his work included genre scenes, mainly for American purchasers.

WRITINGS, DOCUMENTS: Couture, T.: Méthodes et entretiens d'atelier. Paris 1867.- T.C., sa vie, son œuvre, son caractère, ses idées, sa méthode, par luimême et son petit-fils (preface by C. Mauclair). Paris 1932 BIBLIOGRAPHY: Boime, A. et al. (eds.): T.C. 1815-1879. Musée dépar-

temental de l'Oise. Beauvais 1971 (EC) .- Boime, A .: T.C. and the Eclectic Vision. New Haven and London 1980.- Enrollment of the Volunteers: T.G. and the Painting of History. Museum of Fine Arts, Springfield (MA); Detroit Institute of Arts, Detroit; Sterling and Francine Clark Art Institute, Williamstown (MA). Springfield 1980 (EC).- L'enrôlement des volontaires de 1792: T.C. (1815-1879): Les artistes au service de la patrie et danger. Musée départemental de l'Oise, Beauvais 1989 (EC) .- T.C. 1815-1879.

Drawings and some Oil Sketches. Shepered Gallery, London 1971 (EC) .- T.C. Paintings and Drawings in American Collections. University of Maryland, Art Gallery, 1970 (EC)

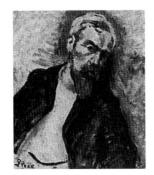

CROSS Henri-Edmond

1856 Douai - 1910 Le Lavandou Real name: Henri-Edmond Delacroix. British mother. As a child he was tutored by Carolus-Duran. Studied law and attended art school at Lille. From 1876 he was in Paris, studying art with F. Bonvin. 1881 exhibited for the first time at the Salon. Adopted an English name. Altered his style from the dark colours of realism to a brighter Impressionism, especially after his trips in 1883 to the South of France and his meetings with Monet. 1884 Co-founder of the Indépendants, contacts with Seurat and Signac; painted Paris scenes and landscapes. 1888 exhibited with Les Vingt in Brussels. 1891 Vice-President of the Indépendants, change to a pointillist style, move to southern France. 1894 first individual exhibition with Petitjean. Supported Anarchism through magazine illustrations. 1896 exhibited works of surface decoration and Symbolist expression at the art dealer Bing's Salon de l'Art Nouveau and at Durand-Ruel's, later at other galleries and at the Secessions in Berlin and Dresden. 1903 visited Venice. 1904 worked with Matisse in Saint-Tropez; became friends with Denis. 1908 travelled in Tuscany. The strong colours of his late pictures are close to Fauvism.

CATALOGUE: Compin, I.: H.-E.C. Paris 1964

BIBLIOGRAPHY: Compin, I.: H.-E.C. Paris 1964 .- Cousturier, L .: H.-E.C. Paris 1932 .- H.-E.C.: Carnet de dessins. Paris 1959.- H.-E.C.: Paysages méditeranéens d'H.-E.C. Musée de l'Amonciade, Saint-Tropez 1990 (EC) .- Rewald, J. (ed.): H.-E.C. Fine Arts Associates, New York 1951 (EC) ILLUSTRATIONS:

322 Beach on the Mediterranean, c. 1891/92

323 The Golden Isles, 1891/92 380 The Clearing, c. 1906/07 384 Undergrowth, 1906/07 389 Cypresses at Cagnes, 1908

CULLEN Maurice Galbraith 1866 Saint-Jean-de-Terre-Neuve -1934 Chambly-Quebec

Began by studying sculpture with Philippe Hébert. 1888 moved to Paris. 1889-1892 studied painting at the Ecole des Beaux-Arts. 1894/95 exhibited in Paris. Plein-air painting in Pouldu, Moret, Giverny and Venice; achieved much success with his winter landscapes. 1895 returned to Montreal. Spent the summers at Beaupré near Quebec. 1900 and 1902 travelled in Europe again. One of the most important Canadian Impressionists, with a style reminiscent of Sisley. BIBLIOGRAPHY: Antoniou, S. (ed.): M.C. 1866-1934. Agnes Etherington Art Centre, Queen's University, Kingston (Ontario) 1982 (EC) ILLUSTRATION:

627 Winter at Moret, 1895

DAGUERRE Louis-Jacques-Mandé 1787 Cormeilles (Val-d'Oise) - 1851 Bry-sur-Marne

Decorative painter and inventor. Worked with Nicéphore Niepce on the development of the first techniques of photography. 1829 experiments to perfect the heliograph. 1835 discovered how to develop a photograph by means of mercury vapour. 1837 discovered how to fix the picture in a solution of common salt. 1838 published his findings through the intercession of the physicist and politician François Arago.

DAUBIGNY Charles-Francois 1817 Paris - 1878 Auvers-sur-Oise Trained with his father. 1836 visited Italy. 1838 exhibited for the first time at the Salon. 1840 short period of

study with Delaroche. Became one of the main exponents of realistic landscape and plein-air painting ("Barbizon school"); friendship with Corot and Daumier. 1857 began to paint river landscapes from a boat. 1860 settled in Auvers-sur-Oise. 1866 visited England. Advised and supported the new Impressionist movement - also from his position on the Salon jury, 1870/71 went to London during the war, then to Holland. 1872 advised Cézanne. 1874 the Impressionists wanted him to take part in their first exhibition. WRITINGS, DOCUMENTS: Moreau-Né-

laton, E.: D. raconté par lui-même. Paris 1925

CATALOGUE: Hellebranth, R.: L'œuvre peint de D. Rolle 1976 BIBLIOGRAPHY: C.-F.D. 1817-1878. Dessins, gravures, peintures. Galerie d'exposition de l'Hôtel de Ville d'Aulnay-sous-Bois 1990 (EC) .- C. Pissarro, C.-F.D., L. Piette. Musée de Pontoise, Pontoise 1978 (EC).- Fidel-Beaufort M. and J. Bailly- Herzberg: D. Paris 1975 ILLUSTRATION:

22 The Pool at Gylieu, 1853

DEBRAS Louis

1834 Péronne (Somme) - 1917 Exhibited 1843-1866 at the Salon: genre pictures, portraits, landscapes and still lifes. Several stays in Spain. 1874 exhibited four pictures at the 1st Impressionist exhibition.

DEGAS Edgar

1834 Paris - 1917 Paris 1852 set up his studio in the house of his father, a cultured banker of aristocratic extraction. 1853-1855 studied with F. Barrias and L. Lamothe and attended the College of Art. 1854-1859 several trips to Italy, some of the time visiting relatives; studied the Old Masters, painted history pictures and realistic portraits. 1861 started his innovative choice of subject matter with his pictures of horse racing. 1862 formed friendships with Manet and Duranty. 1865 his last history picture was exhibited at the Salon; met Renoir, Monet and others; became a frequent customer at the Café Guerbois, 1868 travelled to London with Manet; began to paint scenes from music and dance theatre with unusual points of view and visual angles. 1869 exhibited at the Salon for the

last time; visited Belgium. 1870/71 soldier in Paris: during the Commune he staved with friends in Normandy; began to have problems with his eyes. 1872/73 visited relatives in New Orleans. 1874 helped organise the 1st Impressionist exhibition; attended meetings at the Café de la Nouvelle-Athènes. 1875 went to Italy. From 1876 to 1881 he took part in the Impressionist exhibitions (2nd to 6th). Led the group of socially critical Realists; became friends with Cassatt; experimented with graphic techniques and with photography. 1878 first purchase of one of his pictures by a museum. 1880 trip to Spain. 1881 exhibited a sculpture at the 6th Impressionist exhibition. 1882 refused to take part in the 7th Impressionist exhibition due to a dispute. 1883 exhibited at Durand-Ruel's in London and New York. 1886 took part in the last group exhibition by the Impressionists. 1889 travelled in Spain and Morocco. 1892 his only one-man exhibition at Durand-Ruel's. The rapid worsening of his eye condition caused him to shun all society; he drew pastels, modelled statues in wax and extended his art collection. 1900 exhibited at the Paris World Fair. 1909-1911 due to failing eyesight, he stopped work completely. WRITINGS, DOCUMENTS: Fèvre, J.: Mon oncle D. Souvenirs et documents inédits par Pierre Barel. Geneva 1949 .- Graber, H .: E.D. nach eigenen and fremden Zeugnissen. Basle 1942.-Guérin, M. (ed.): E.D. Lettres. Paris 1945.- Guérin, M. (ed.): Letters of D. Oxford 1947, New York 1948.- Guillaud, M. et al.: D.: Form and Space. Paris 1984 .- Halévy, D.: D. parle ... Paris 1960 .- Halévy, D.: My Friend D. Middletown (CT) 1964.- Reff, T .: The Notebooks of E.D. 2 vols. London 1976, New York 1985.- Reff, T.: D.: The Artist's Mind. New York 1976 .- Rivière G.: Mr. D. bourgeois de Paris. Paris 1935 .- Valéry, P.: Erinnerung an D. Zurich 1940.- Vollard, A.: D. Paris 1924 .- Vollard, A.: En écoutant parler Cézanne, D. et Renoir. Paris 1938 CATALOGUES: Adhémar, J. and F. Ca-

chin: D. Radierungen and Monotypien. Munich 1973.- Adhémar, J. et F. Cachin: E.D. Gravures et monotypes. Paris 1973 .- Adhémar, J. and J. Cachin: D. The Complete Etchings, Lithographs and Monotypes. New York 1974, London 1986.- Brame, P. and T. Reff: D. et son œuvre. A Supplement. New York 1984 .- Janis, E.P.: D. Monotypes. Catalogue Raisonné, Cambridge (MA) 1968.- Lassaigne, J .: Tout l'œuvre peint de D. Paris 1974 .- Lemoisne, P.A.: D. et son œuvre. 4 vols. Paris 1946-1949 (Reprint: New York and London 1984) .- Matt, L. v. and J. Rewald: D. Works in Sculpture, His Complete Work. London 1944 and New York 1957 .- Matt, L. v. and J. Rewald: D. Das plastische Werk. Zurich 1957.-Minervino, F. and F. Russoli: L'opera completa di D. Milan 1970.- Minervino, F.: Tout l'œuvre peint de D. Paris 1974 .- Minervino, F.: Das Gesamtwerk von D. Lucerne [no date of publication]. – Parry Janis, E.: D. Monotypes. Cambridge 1968.– Reed, S.W. and B.S. Shapiro: E.D. The Painter as Printmaker. The Complete Prints of E.D. Museum of Fine Arts, Boston 1984 (EC).– Rewald, J.: D.s Complete Sculpture. San Francisco 1944 (Reprint: San Francisco 1940).– Russoli, F.: Copera completa di D. Milan 1970

BIBLIOGRAPHY: Adriani, G. (ed.): E.D. Pastelle, Ölskizzen, Zeichnungen. Kunsthalle (Tübingen) et al., Cologne 1984 (EC) .- Adriani, G. (ed.): D. Pastels, Oil Sketches, Drawings. London and New York 1985 .-Adriani, G. (Ed.): D. Pastels, dessins, esquisses. Paris 1985 .- Armstrong, C.M.: Odd Man Out. Readings on the Work and Reputation of E.D. Chicago 1991.- studio at auctions. 2 vols. San Francisco 1989 (Reprint) .-Boggs, J.S.: Portraits by D. Berkeley 1962.- Boggs, J.S., H. Loyrette, M. Pantazzi et al. (eds.): D. Grand Palais, Paris; Musée des Beaux-Arts, Ottawa; The Metropolitan Museum, New York. Paris 1988 (EC) .- Bouret, J .: D. Paris 1965 .- Bouret, J .: D. London 1965.- Cabanne, P.: E.D. Paris 1957.-Cabanne, P.: E.D. Munich 1960.-Champigneulle: D. Dessins. Paris 1952 .- Cooper, D.: E.D. Pastelle. Basle 1952 .- Cooper, D.: Pastels by E.D. New York 1953 .- Coquiot, G .: D. Paris 1924 .- Dunlop, I.: D. London and New York 1979 .- Dunlop, I.: D. Neuchâtel 1979.- Fosca, F.: D. Etude biographique et critique. Geneva 1954 .- Gordon, R. and A. Forge: D. London and New York 1988.- Growe, B.: Zur Bildkonzeption E.D.s. Frankfurt am Main 1981.-Growe, B.: E.D. 1834-1917. Cologne 1991.- Guillaud, M. et al.: D.: Form and Space. Paris 1984 .- Hausenstein, W.: D. Bern 1948.- Huyghe, R.: E.H.D. Paris 1953 .- Kendall, R. (ed.): E.D. Leben und Werk in Bildern und Briefen. Munich 1988.- Keyser, E. de: D. Réalité et métaphore. Louvain 1981.- Lafond, P.: D. 2 vols. Paris 1918-1919.- Lassaigne, E.D. Paris 1945 .- Lefèbvre, A .: D. Paris 1981 .-Lipton, E.: Looking into D. Los Angeles 1986 .- Manson, J.B.: The Life and Work of E.D. London 1927 .-McMullen, R.: D. His Life, Time and Work, Boston 1984, London 1985.-Meier-Graefe, J.: D. Munich 1920 (Reprint: 1924) .- Meier-Graefe, J .: D. London 1923 .- Millard, C.: The Sculpture of E.D. Princeton (NJ) 1976 .- Pool, P .: D. New York 1963 .-Reff, T.: D. The Artist's Mind. New York 1976 .- Rewald, J: D. Sculpture. New York 1956 .- Rich, D.C.: D. New York 1951 .- Rich, D.C.: D. Cologne 1959 .- Rich, D.C.: D. New York 1985 .- Roberts, K .: D. Oxford and New York 1976 .- Rouart, D .: D., à la recherche de sa technique. Paris 1945 .- Rouart, D.: D. In Search of his Techniques. New York and Geneva 1988 .- Rouart, D.: D. monotypes. Paris 1948 .- Schmid, W. (ed.): Wege zu D. Munich 1988.- Sérullaz M.: L'univers de D. Paris 1979.- Shindoda, Y.: D. Der Einzug des Japanischen in die französische Malerei. Doctoral thesis. Cologne 1957 .- Sutton, D.: E.D. Life and Work. New York 1986.– Sutton, D.: D.: Vie et œuvre. Fribourg 1986.– Sutton, D.: E.D. Leben und Werk. Munich 1986.– Terrasse, A.: E.D. Milan 1972.– Terrasse, A.: E.D. Frankfurt am Main, Berlin and Vienna 1981.– Terrasse, A.: D. et la photographie. Paris 1983.– Thomson, R.: The Private D. London 1987.– Thomson, R.: D., the Nudes. London 1988.– Valéry, P.: D., Dance, Drawing. New York 1948.– Vitali, L.: E.D. Milan 1966.– Werner, A.: D. Pastels. New York 1968 ILLUSTRATIONS:

- 10 Gentlemen's Race. Before the Start, 1862
- 34 The Bellelli Family, 1858-1860
 44 Woman with Chrysanthemums, 1865
- 46 Mlle Eugénie Fiocre in the Ballet "La Source", c. 1867-68
- 67 The Opera Orchestra, c. 1868-69 70 A Carriage at the Races,
- c. 1869-1872 71 Race Horses in front of the
- Stands, c. 1869
- 79 Woman Ironing, c. 1869
- 86 The Dancing Class, c. 1872
- 87 Musicians in the Orchestra, 1870/71
- 100 Dance Studio of the Opéra, Rue Le Peletier, 1872
- 111 The Cotton Exchange at New Orleans, 1873
- 114 The Dance Class, 1874
- 115 The Races. Before the Start, before 1873
- 115 Race Horses, c.1873
- 122 Four Studies of a 14-year-old Dancer, 1879
- 129 Rehearsal of a Ballet on Stage,
- 1874 130 At the Beach, 1876
- 161 At the Café-Concert: The Song of the Dog, c. 1876/77
- 164 The Absinth Drinker, 1876
- 169 Place de la Concorde (Comte Lepic and his Daughters), 1876
- 181 Singer with a Glove, 1878
- 186 Dancer with Bouquet, c. 1878-1880
- 186 Dancer with Bouquet (curtsying), c. 1877/78
- 187 The Star or Dancer on the Stage, c. 1876-1878
- 238 Mary Cassatt at the Louvre, 1879/80
- 242 Women Ironing, c. 1884
- 248 Woman Combing her Hair, c. 1885
- 248 After the Bath. Woman Drying Herself, 1885
- 249 The Tub, 1885/86
- 262 Six Friends of the Artist, 1885

DELACROIX Eugène

1798 Charenton-St.-Maurice – 1863 Paris

1813 trained at the studio of P. Guérin. 1816 studied at the Paris College of Art. 1822 exhibited for the first time at the Salon – a picture influenced by Gericault and Rubens. Contacts with English water-colour painters. 1824 received acclaim at the Salon. Impressed by Constable, he changed to a brighter use of colour. In 1825 he moved with Bonington to London. 1830 sympathised with the July revolution. 1832 in the service of the French state in Morocco, where he was particularly impressed; the African light and the motifs were to become subjects for his paintings. 1833 commissioned to do some murals, 1855 exhibited a considerable number of pictures at the Paris World Fair. 1857 after seven attempts, he finally succeeded in gaining admittance to the Academy. In his work, passionate, sensual subjectivity in the choice of subject, composition and use of colour form a highly independent blend of Romanticism and make him one of the most powerful painters of the century. His conception of related colour and emphasis on the total colour effect were an inspiration to the Impressionists.

WRITINGS, DOCUMENTS: Delacroix, E.: Cuvres littéraires: Etudes esthétiques; Essais sur les artistes célèbres. 2 vols. Paris 1923.– Guignard, E. (ed.): E.D. Briefe und Tagebücher. Munich 1990.– Joubin, A. (ed.): D. Correspondance. I-V, Paris 1932-1936.– Mittelstädt, K. (ed.): E.D. Dem Auge ein Fest. Aus dem Journal 1847-1863. Frankfurt am Main 1988.– Moreau-Nélaton, E.: D. raconté par lui-même. 2 vols. Paris 1916

CATALOGUES: Escholier, R.: E.D., peintre, graveur, écrivain. 3 vols. Paris 1926-1929 .- Huyghe, R.: E.D. London 1963 .- Johnson, L.: The Paintings of E.D. A Critical Catalogue. 3 vols. Paris 1986 .- Lee, J .: The Paintings of E.D. 6 vols. Oxford 1980-1986 .- Robaut, A. and E. Chesneau: L'œuvre complète d'E.D. Peintures, dessins, gravures, lithographies, 1813-1863. Paris 1885 (Reprint: New York 1969).- Sérullaz, M.: E.D., dessins. 2 vols. Paris 1984 BIBLIOGRAPHY: Badt, K.: E.D. Werke und Ideale. Cologne 1976.- Bazin, G.: D. Biennale. Venice 1956 .- Christoffel, U.: D. Munich 1951.- Escholier, R.: E.D. et sa consolatrice. Paris 1932 .- Escholier, R.: E.D. Paris 1963 .- Florisonne, M.: D. Paris 1947.- Joubin, A.: Voyage de D. au Maroc. Paris 1930 .- Meier-Graefe, J .: E.D. Munich 1922 .- Mémorial de l'Exposition D. au Musée du Louvre. Paris 1964 .- Petrova, E .: D .: le dessin romantique. Paris 1990 .- Piot, R.: Les palettes de D. Paris 1931.- Rudrauf, L.: E.D. et le problème du romantisme artistique. Paris 1942.- Sérullaz, M.: Les dessins d'E.D. au Musée du

Louvre (1817-1827). Paris 1952.– Sérullaz, M.: Les peintures murales de Delacroix. Paris 1963.– Stuffmann, M. (ed.): E.D. Themen und Variationen: Arbeiten auf Papier. Städelsches Kunstinstitut und Städtische Galerie, Frankfurt am Main 1987 (EC) ILLUSTRATIONS:

16 The Massacre on Chios, 182417 The Women of Algiers, 1834

DELAVALLEE Henri

1862 Reims - 1943 Pont-Aven After university he studied at the college of art in Paris. 1881 visited Pont-Aven, where in 1886 he joined the group of artists influenced by Gauguin, especially E. Bernard. He painted Impressionist, Synthetist and occasionally pointillist paintings, but mainly worked as a graphic artist. 1890 exhibited at Durand-Ruel's. 1891-1901 visited Turkey; became a successful landscape and portrait painter. Thereafter he lived in the Oise valley and at Pont-Aven; had exhibitions at Durand-Ruel's and Vollard's.

ILLUSTRATIONS: 294 Farmyard, 1887

385 Sunny Street, c. 1887

tists "Nabis"; he shared a studio with Bonnard and Vuillard, published important articles of art criticism 1891 exhibited with the Indépendants and with the Nabis at the Le Barc de Bouttevilles gallery, 1892/93 did the decor at the Théâtre de l'Œuvre for a school friend, Lugné-Poe, Beside Impressionist portrait studies and garden scenes, he painted decorative, Art Nouveau and Symbolist works with an increasingly religious content. 1895 the first of several visits to Italy (with Sérusier). 1901 painted a group portrait "Homage to Cézanne". 1903 travelled in Germany, where he visited the former "Nabi" J. Verkade, who had become a monk at the monastery of Beuron. 1906 visited Cézanne in Aix. 1912 published his "Theories". 1919 founded workshops for religious art.

WRITINGS, DOCUMENTS: Blanche, J.-E. (ed.): Correspondance J.-E. Blanche – M.D. (1901-1939). Geneva 1989.– M.D.: Théories 1890-1910. Du symbolisme et de Gauguin vers un nouvel ordre classique. Paris 1912.– M.D.: Nouvelles théories sur l'art moderne et l'art sacré. Paris 1922.– M.D.: Journal (1884- 1943). 3 vols. Paris 1957-1959.– M.D.: Du symbolisme au classicisme: Théories, textes réunis et présentés par Olivier Revault d'Allones. Paris 1964 CATALOGUE: Cailler, P.: M.D. Geneva 1968

BIBLIOGRAPHY: Barazzetti-Demoulin, S.: M.D. Paris 1945.– Brillant, M.: Portrait de M.D. Paris 1945.– Fosca, F.: M.D. Paris 1924.– Jamot, P.: M.D. Paris 1945.– M.D. Orangeries des Tuileries, Paris 1970 (EC).– M.D. Kunsthalle, Bremen 1971 (EC).– M.D. 1870-1943. Fondation Septentrion, Marcq-en-Baroeul 1988 (EC) ILLUSTRATIONS:

341 The Muses, or In the Park, 1893

DE NITTIS \rightarrow Nittis

DENIS Maurice 1870 Granville (Manche) – 1943 Saint-Germain-en-Laye 1888 studied at the Paris college of art and at the Académie Julian. Became acquainted with Bernard, Bonnard, Vuillard and Sérusier; the latter introduced him to the Synthetism of Gauguin. 1889 took part in an exhibi-

tion at the Café Volpini. 1890 co-

founder of the Symbolist group of ar-

DESBOUTIN Marcellin 1823 Cérilly – 1902 Nice Came from a rich family; after study-

ing law at Paris he became a pupil of the sculptor Etex in **1845**. **1847/48** studied under Couture; foreign trips. **1854-1870** lived in Florence as a painter, engraver and poet. Generous host to many artists, including Degas and De Nittis. **1868** exhibited for the first time at the Salon. Ruined by financial speculation; spent several years in Geneva, 1873 settled in Paris: became acquainted with Manet and Degas at the Café Guerbois; exhibited at the Salon again. 1876 frequent customer in the Café de la Nouvelle-Athènes, sat for Degas as model for "The Absinth Drinkers" (p. 164); took part in the 2nd Impressionist exhibition, although he painted exacting character studies and genre scenes in an almost Neo-Baroque style with dark colours and close attention to details. Lived a Bohemian life without means with his wife and eight children. Portrait etchings of his many artist friends. 1881-1888 and 1895-1902 in Nice. 1889 his graphic art was exhibited at Durand-Ruel's with a foreword by Zola. 1890 co-founder of the Société Nationale. 1895 member of the Legion of Honour. 1900 won the grand prize at the Paris

World Fair. BIBLIOGRAPHY: Dupliaux, B.: M.D. Prince des bohèmes. Moulins-Yzeure 1985.– Janin, C.: La curieuse vie de M.D. Peintre, graveur, poète. Paris 1922

ILLUSTRATION:

130 Portrait of Jean-Baptiste Faure, 1874

DEVAMBEZ André-Victor-Edouard 1867 Paris – 1944 Paris

Studied at the college of art in Paris; pupil of Constant and Lefèbvre. From 1889 exhibited at the Salon. 1890-1895 in Italy as winner of the Rome prize, later professor at the college of art in Paris and member of the Institut de France. 1900 change of subject matter and style: painted Impressionist-influenced genre pictures of urban crowd scenes such as political demonstrations or theatre audiences. 1910 mural at the Sorbonne. He later painted scenes from the First World War and did illustrations. BIBLIOGRAPHY: Ménegoz, M. (ed.): A.D. (1867-1944). Musée départemental, Beauvais 1988 (EC) ILLUSTRATIONS: 373 The Charge, 1902

DEWHURST Wynford

1864 Manchester – 1941 Manchester Worked first as a journalist and illustrator. In 1892 he began to study art at the Ecole des Beaux-Arts in Paris under Gérôme, Bouguereau and Constant and at the Académie Julian. Painted Impressionist landscapes in the environs of Paris; admired Monet. In 1897 he exhibited for the first time at the Salon. 1904 and 1907 took part in the London exhibitions of the Society of British Artists and during the following years in international exhibitions at home and abroad. Published articles on Impressionism. WRITINGS, DOCUMENTS: Dewhurst, W: Impressionist Painting, its Genesis and Development. London 1904 ILLUSTRATION:

585 Luncheon on the Grass (The Picnic), 1908

DIVISIONISM \rightarrow Neo-Impressionism

DROUOT, Hôtel

State auction house in the former city residence (Hôtel) of the Napoleonic General Drouot in Paris. The art auctions held there were important indicators of the current asking prices. Whole collections and legacies came under the auctioneer's hammer after the death of an artist or collector or in cases of bankruptcy. Occasionally an artist or collector would have a series of paintings auctioned but might have to buy them back himself to avoid a disastrous fall in price. In 1875 an auction arranged by Durand-Ruel of Monets, Morisots, Renoirs and Sisleys was disrupted by a jeering audience. In 1878 the collections of Jean-Baptiste Faure and Ernest Hoschedé were sold at disastrously low prices.

DUBOIS-PILLET Albert 1846 Paris – 1890 Le Puy-en-Velay Real name: Albert Dubois. 1865 attended the cadet school at St. Cyr, after which he became an officer and amateur painter. 1880 promoted to Captain of the Republican Guard; rejected by the Salon. Spent time with artists and writers in the Café de la Nouvelle-Athènes. 1884 organizer and first president of the Société des artistes indépendants, where a Naturalist painting influenced by Manet occasioned a furious debate. Encouraged by Seurat, he subsequently began to paint pointillist landscapes, open-air genre scenes and portraits. 1888 and 1890 exhibited with Les Vingt in Brussels. In 1889 he was accused of sympathising with the Bonapartist plot of General Boulanger. He was demoted and transferred to Le Puy as a captain in the gendarmerie; he died of smallpox.

CATALOGUE: Bazalgette, L.: A.D.-P. Catalogue raisonné (in preparation) BIBLIOGRAPHY: Bazalgette, L.: A. D.-P. , sa vie et son œuvre. Villejuif and Paris 1976

ILLUSTRATION:

311 The Marne at Dawn, 1888

DURAND-RUEL Paul Marie-Joseph 1833 Paris – 1922 Paris

Son of an artist. From 1851 he worked in his parents' gallery, which patronised the painters of the Barbizon school. In 1865 he took over the business from his father. 1869 opened a new gallery in the Rue Le Peletier 11; 1871 first came into contact with Impressionist painters (Pissarro and Monet) in his London gallery. 1872 his first large exhibition of Impressionist works in London. 1871-1873 opened new branches in Brussels. In 1872 he bought all available works by Manet for 32,000 francs; also supported Monet and others. He was the first dealer to commission the total output of artists and secure their livelihood through advance payments. He found, however, that he had to give up purchases. 1876 had little success at the 2nd Impressionist exhibition. 1880 began making purchases again through credit from the banker Feder, but the latter's bankruptcy in 1882 caused renewed financial difficulties. Fierce competition with the artist G. Petit. Supported the 7th Impressionist exhibition, and organised exhibitions by individuals such as Monet; sent pictures to London, Boston, Rotterdam and Berlin (1884), and Brussels (1885). 1886/87 made a break through into new markets through a large Impressionist exhibition in New York. Founded a branch there in 1888 which was managed by his three sons. He had no interest in NeoImpressionism or Post-Impressionism; his personal favourites were the artists of the Barbizon school. **1905** large exhibitions in Berlin and London. **1911** left the firm to his sons.

DURANTY Louis Emile Edmond 1833 Paris – 1880 Paris

Founded the short-lived journal "Réalisme" and worked for the "Goncourts". In his copious publications he was a passionate advocate of Impressionist theory. 1876 publication of his book "La nouvelle peinture, à propos du groupe d'artistes qui expose dans les galeries Durand-Ruel".

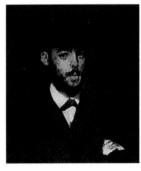

DURET Théodore 1838 Saintes – 1927 Paris

Journalist, art critic and businessman. 1863 travelled round the world for his cognac firm. 1865 met Manet in Madrid. In 1868 he founded a republican newspaper with Zola and others. In 1870 he published his first Salon report, in which he spoke about the Impressionists. 1871 deputy mayor of his region under the Paris Commune and narrowly escaped being shot. Second world trip; collected East Asian art. From 1872 he was in Paris, buying Impressionist pictures and helping with money, but against group exhibitions. 1878 published the first complete history of the movement: "The Impressionist Painters". Visited London frequently; friends with Whistler. In 1882 he wrote the preface to the posthumous exhibition of Manet's works. 1894 financial problems forced him to auction his collection at G. Petit's; nevertheless he began his collections again, which included the Post-Impressionists. **1898** actively supported Dreyfus. **1900** donated works of art to Paris museums, advised collectors and art dealers and published several books on the Impressionists.

ECOLE DES BEAUX-ARTS

College of art in Paris (today: Ecole Nationale Supérieure des Beaux-Arts), the most important art school in the country. Founded in 1796, it had its origins in the Royal Academy of 1648, which had been modelled on Italian lines and trained artists no longer tied to guilds. Until the reform of 1863 it was run by the Institut de France, which retained its influence, as the members of its art section (known as "Academy members") all taught at the Ecole. The professors, seven painters and five sculptors, changing each month, ran the strictly Classical programme of instruction, which consisted of drawing from models and making casts of Classical sculptures, with classes in anatomy, perspective and theory. In addition, the professors ran courses in their own studios. It was not until 1863 that the Ecole set up eleven teaching studios, three of which were for painting, run at first by Cabanel, Gérôme and Pils. Admittance to the Ecole was by entrance examination. There were numerous competitions during the studies, and at the end of the course the competition for the Rome Prize. The subjects given by the college were mythological, historical or Christian. The Rome Prize allowed a student to study for several years at the Académie de France in Rome and opened up interesting prospects for teaching posts and awards.

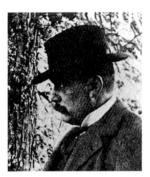

EDELFELT Albert 1854 Kiala – 1908 Haiko 1870 began his art studies at the school of the Finnish Art Society in Helsinki and with the painters B. Lindholm and B. Reinhold. 1871-1873 studied at the Academy of Art in Helsinki, 1873 at the Academy in Antwerp and 1874-1878 with interruptions at the Ecole des Beaux-Arts in Paris under Gérôme. Apart from annual visits to Finland, he lived in Paris. At first he painted history pictures; under the influence of plein-air painting and Bastien-Lepage he painted Naturalist landscapes and scenes of Finnish farm life. 1876 and 1903 travelled to Italy and 1881 to Spain. As a proponent of Finnish realism, he influenced his younger Scandinavian colleagues, especially Gallen-Kallela. Won great acclaim with the French public for his portraits. In the 1880s and 1890s he exhibited at the Paris Salon, the Salon des Champs-Elysées and the Salon du Champ de Mars. At the Paris World Fair in 1889 he received the Grand Prix d'Honneur. 1904 painted a monumental historical picture for the Academy in Helsinki (now destroyed). BIBLIOGRAPHY: Berezina, V.N.: A.E. i ego proizvedenija v Gosudarstvennon Ermitaze. Leningrad 1963.- Edelfelt. B.: Ur A.E. pariserbrev till sin mor. Stockholm 1917.- Edelfelt, B.: Ur A.E. brev. Resor och intryck. Stockholm 1921 .- Edelfelt, B.: Ur A.E. brev. Liv och arbete. Stockholm 1926.- Edelfelt, B.: Ur A.E. brev. Middagshöjd. Stockholm 1928.- Edelfelt, B.: Ur A.E. brev. Kring sekelskiftet. Stockholm 1930.- Hintze, F.: A.E. 3 vols. Helsinki 1942-1944.- Hintze, F.: A.E. 3 vols. Stockholm 1949.-Hintze, B.: A.E. Porvoo 1953 ILLUSTRATIONS: 466 Paris in the Snow, 1887 485 In the Luxembourg Gardens, 1887

ENSOR James

1860 Ostend - 1949 Ostend Learned to paint water colours as a child. 1877-1880 studied at the Academy in Ostend and Brussels. His sombre and dramatic interiors, landscapes and portraits mark a departure from traditional ways of seeing and are a deliberate reaction to the art of the academies. The landscapes owe as much to Realism as they do to Impressionism. In 1880 he returned to Ostend. 1882 joined the avant-garde group "L'Essor" and in 1883 was a founder member of Les Vingt in Brussels. There he exhibited his works, which had been rejected by the salons and which were the cause of much debate even in avantgarde circles. 1886-1900 his palette changed to lighter colours. A common motif is the masked figure, and the numerous macabre variations on this theme reveal him to be a precursor of Expressionism and Surrealism. 1926 first exhibition in Paris.

WRITINGS, DOCUMENTS: Ollinger-Zinque, G.: E. par lui-même. Brussels 1976

CATALOGUES: Croquez, A.: L'œuvre gravé de J.E. Geneva 1947.– Taevernier, A.: J.E. Catalogue illustrée de ses gravures, leur description critique et l'inventaire des plaques. Ghent 1973.– Tavernier, A.: Catalogue des gravures. Brussels 1973.– Tricot, X.: J.E. Catalogue Raisonné of the Paintings. Cologne et al. 1992

BIBLIOGRAPHY: Avermaete, R.: J.E. Antwerp 1947 .- Croquez, A .: L'œuvre gravé de J.E. Geneva 1947.-Croquez, R.: E. en son temps. Ostend 1970.- Damese, J.: L'œuvre gravé de J. E. Geneva 1967 .- Delevoy, R.L .: J.E. Antwerp 1981.- J.E. Württembergischer Kunstverein, Stuttgart 1972 (EC) .- J.E. The Art Institute, Chicago; The Solomon R. Guggenheim Museum, New York 1976 (EC).- J.E. Kunsthaus Zürich, Zurich; Koninklijk Museum voor Schone Kunsten, Antwerp 1983 (EC) .- J.E. Belgien um 1900. Kunsthalle der Hypo-Kulturstiftung, Munich 1989 .- Farmer, J.D.: E. New York 1976 .- Fels, F .: J.E. Geneva 1947 .- Fierens, P.: J.E. Paris 1943 .- Haesaerts, P.: J.E. Brussels 1957, 1973 .- Heusinger von Waldegg, J.: J.E. Legende vom Ich. Cologne 1991.- Janssens, J.: J.E. Paris 1990.- Lebeer, L.: J.E.: Aquafortiste. Antwerp 1952.- Legrand, F.-C.: E., cet inconnu. Brussels 1971.- Le Roy, G.: J.E. Brussels 1922 .- Lesko, D.: J.E. The Creative Years. Princeton 1985.- Tannenbaum, L.: J.E. New York 1951.- Vanbeselaere, W.: L'Entrée du Christ à Bruxelles. Brussels 1957 .- Verhaeren E.: J.E. Brussels 1908

ILLUSTRATION: 421 The Dejected Lady, 1881

ERAGNY-SUR-EPTE

Village on the River Epte, about 20 miles south of Dieppe. Pissarro lived there from 1884 and painted numerous pictures of the landscape there (pp. 275, 312); Monet also painted here (p. 330).

ESTAQUE (L')

Fishing village near Marseilles. 1870/71 Cézanne lived here with his model Hortense Fiquet and after his depressing stay in Paris discovered his preference for landscape painting. He returned here again and again in later life.

ETRETAT

Fishing village about 15 miles east of Le Havre. The bizarre-looking cliffs of Erretat became a popular motif for artists. Delacroix and Courbet painted here (p. 31), and it was a favourite spot for Monet, who always stayed at Faure's house (pp. 232, 233, 270). Many famous Parisians had their summer residences here, including Maupassant, who watched Monet at work in **1885**.

EVENEMENT (L')

The first newspaper to cover contemporary modern movements; founded in 1848. 1866 Zola wrote book reviews and articles on the Salons. His uncompromising defence of modernity led to a scandal. **1872-1896** under its editor Edmond Magnier the paper flourished, reporting daily on artistic events in Paris.

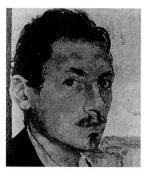

EVENEPOEL Henri 1872 Nice – 1899 Paris

Brought up by nuns after the death of his parents, he trained first in Brussels under B. Garin and then in 1892 at the art college in Paris; worked alongside Matisse and Rouault at Moreau's studio. In 1894 he left Paris to work independently without a teacher. 1897 after stays in Algeria and Blida, he died in Paris of typhoid fever, after he had finally made the decision to return to Belgium. Evenepoel worked only five years as an artist and was strongly influenced by Whistler and Manet, yet his work retains its own individual character. WRITINGS, DOCUMENTS: Hyslop, F.E.

(ed.): H.E. Lettres choisies 1892-1899. Brussels 1976 BIBLIOGRAPHY: Bollen, M. and H.

Coenen: H.E. familie. Een reeks Schetsen. Antwerp 1990.– Haesaerts, L. and P.: H.E. Brussels 1932.– Hellens, F.: H.E. Antwerp 1947.– H.E. (1872-1899). Musée d'Art Moderne, Brussels 1972 (EC).– Hyslop, F.E.: H.E. Belgian Painter in Paris 1892-1899. Pennsylvania 1985.– Lambotte, P.: E. Brussels 1908

ILLUSTRATIONS:

428 Sunday in the Bois de Boulogne, 1891

429 Veterans' Festival, 1898

EXHIBITIONS OF IMPRESSIONISTS

1874: 1st Exhibition. "Société anonyme des artistes, peintres, sculpteurs, graveurs, etc. Exposition". 35, Boulevard des Capucines. April 15 – May 15, 10 a.m. – 6 p.m. and 8 – 10 p.m. 30 participants, 167 catalogue entries.

Participants and number of catalogue entries (in brackets): Astruc (6), Attendu (6), Béliard (4), Boudin (6), F. Bracquemond (6), Brandon (5), Bureau (4), Cals (6), Cézanne (3), Colin (5), Debras (4), Degas (10), Guillaumin (3), Latouche (4), Lepic (7), Lépine (3), Levert (3), Meyer (6), Molors (4), Monet (9), Morisot (9), Mulor-Durivage (2), De Nittis (5), A.-

L.-M. Ottin (10), L.-A. Ottin (7), Pis-

sarro (5), Renoir (7), Robert (2), Rouart (11), Sisley (5).

1876: 2nd Exhibition. "Exposition de peinture". 11, Rue Le Peletier. April, 10 a.m. - 5 p.m. 19 participants, 252 catalogue entries. Béliard (8), Bureau (8), Caillebotte (8), Cals (11), Degas (24), Desboutin (13), J. François (8), Legros (12), Lepic (36), Levert (9), J.-B. Millet (10), Monet (18), Morisot (17), L.-A. Ottin (14), Pissarro (12), Renoir (18),

Rouart (10), Sisley (8), Tillot (8). 1877: 3rd Exhibition. "3^c. Exposition de peinture". 6, Rue Le Peletier. April, 10 a.m. - 5 p.m. 18 participants, 241 catalogue entries. Caillebotte (6), Cals (10), Cézanne (16), Cordey (4), Degas (25), Guillaumin (12), J. François (2), Lamy (4), Levert (6), Maureau (4), Monet (30), Morisot (12), Piette (31), Pissarro (22), Renoir (21), Rouart (5), Sisley (17), Tillot (14).

1879: 4th Exhibition. "4e Exposition de peinture". 28, Avenue de l'Opéra. April 10 - May 11, 10 a.m. - 6 p.m. 14 participants, 246 catalogue entries. F. Bracquemond (4), M. Bracquemond (2), Caillebotte (25), Cals (14), Cassatt (11), Degas (25), Forain (26), Lebourg (30), Monet (29), Pissarro (38), Rouart (23), Somm (3), Tillot (11), Zandomeneghi (5). 1880: 5th Exhibition. "5e Exposition de peinture." 10, Rue des Pyramides, on the corner of the Rue Saint-Honoré. April 1 - 30, 10 a.m. - 6 p.m. 19 participants, 232 catalogue entries. F. Bracquemond (2), M. Bracquemond (3), Caillebotte (11), Cassatt (16), Degas (12), Forain (10), Gauguin (8), Guillaumin (22), Lebourg (20), Levert (8), Morisot (15), Pissarro (16), J.-F. Raffaëlli (36), J.-M. Raffaëlli (1), Rouart (12), Tillot (14), Vidal (9), Vignon (9), Zandomeneghi (8). 1881: 6th Exhibition. "6e Exposition de peinture". 35, Boulevard des Capucines. April 2 - May 1, 10 a.m. - 6 p.m. 13 participants, 170 catalogue entries. Cassatt (11), Degas (8), Forain (10), Gauguin (10), Guillaumin (16), Morisot (7), Pissarro (28), J.-F. Raffaëlli (34), Rouart (15), Tillot (10), Vidal (1), Vignon (15), Zandomeneghi (5).

1882: 7th Exhibition. "7^e Exposition des artistes indépendants". 251, Rue Saint-Honoré (Salon du Panorama de Reichshoffen). May 15 – June 15, 10 a.m. – 6 p.m. 9 participants, 203 catalogue entries.

Caillebotte (17), Gauguin (13), Guillaumin (26), Monet (35), Morisot (9), Pissarro (36), Renoir (25), Sisley (27), Vignon (15).

1886: 8th Exhibition. "8^e Exposition de peinture". 1, Rue Laffitte. May 15 – June 15, 10 a.m. – 6 p.m. 17 participants, 249 catalogue entries. M. Bracquemond (6), Cassatt (7), Degas (15), Forain (13), Gauguin (19), Guillaumin (21), Morisot (14), C. Pissarro (20), L. Pissarro (10), Redon (15), Rouart (27), Schuffenecker (9), Seurat (9), Signac (18), Tillot (16), Vignon (18), Zandomenghi (12).

Altogether, 56 artists participated in the eight Impressionist exhibitions. Pissarro was the only artist to take

part in all eight shows. Degas, Morisot and Rouart exhibited seven times, Guillaumin and Tillot six times, Monet und Caillebotte five times. The following statistics give the number of exhibitions (1st figure) and the number of catalogue entries (2nd figure): Pissarro (8/176), Degas (7/122), Rouart (7/103), Morisot (7/83), Guillaumin (6/96), Tillot (6/73), Monet (5/121), Caillebotte (5/67), Renoir (4/71), Forain (4/59), Sisley (4/57), Vignon (4/57), Gauguin (4/49), Cassatt (4/45), Cals (4/41), Zandomeneghi (4/30), Levert (4/26), Bracquemond, F. (3/12), Bracquemond, M. (3/11), Raffaëlli, J.-F. (2/70), Lebourg (2/50), Lepic (2/43), Cézanne (2/19), Ottin, L.A. (2/21), Béliard (2/12), Bureau (2/12), François (2/10), Vidal (2/10), Piette (1/31), Signac (1/18), Redon (1/15), Desboutin (1/13), Legros (1/12), Millet (1/10), Ottin, A .-L.-M. (1/10), Pissarro, L. (1/10), Schuffenecker (1/9), Seurat (1/9), Astruc (1/6), Attendu (1/6), Boudin (1/6), Meyer (1/6), Brandon (1/5), Colin (1/5), De Nittis (1/5), Cordey (1/4), Debras (1/4), Lamy (1/4), Latouche (1/4), Maureau (1/4), Molins (1/4), Lepine (1/3), Somm (1/3), Mulot- Durivage (1/2), Robert (1/2), Raffaëlli, J.-M. (1/1).

FANTIN-LATOUR Henri

1836 Grenoble - 1904 Buré (Orne) Son of Théodore Fantin-Latour, the Italian painter and teacher of drawing and a Russian mother. 1841 moved to Paris, Trained first with his father. then 1850-1854 studied drawing at the school of Lecocq de Boisbaudran. After a short period at the Ecole des Beaux-Arts, he did temporary work at Courbet's studio. Copied drawings by Flaxman and paintings by Titian and Veronese in the Louvre. Met Flaubert and Zola in the Café Guerbois. Admired Delacroix, Corot and Courbet, and formed friendships with Manet and Whistler. 1859 rejected by the Salon. Between 1859 and 1864 he made three visits to England, where he also worked and sold pictures. 1861 exhibited for the first time at the Salon, and thereafter regularly; from 1863 he exhibited in the Salon des Refusés. 1864 after the death of Delacroix he painted his "Hommage à Delacroix", which was exhibited in the Salon in 1865. 1867 showed a portrait of Manet at the Salon. As

well as portraits of artists he painted numerous landscapes and genre scenes and a large number of still lifes with flower motifs, which established his fame in France. 1870 painted the famous picture "A Studio in Batignolles" in which he portrayed his colleagues. Despite close contacts with the Impressionists, he rejected their theories and never took part in their exhibitions. A great lover of music, he was moved by the works of Wagner to paint opera scenes.

CATALOGUES: Fantin-Latour, V.: Catalogue de l'œuvre complet (1849-1904) de F.-L. Paris 1911 (Reprint: Amsterdam and New York 1969.– Hediard, G.: F.-L. Lithographies. Geneva 1981

BIBLIOGRAPHY: Abélès, L. (ed.): F.-L. Coin de table. Musée d'Orsay, Paris 1987 (EC).– F.-L. Grand Palais, Paris 1982 (EC).– Kahn, G.: F.-L. Paris 1926.– Lucie-Smith, E.: F.-L. Oxford 1977.– Sutton, D. (ed.): H.F.-L. Wildenstein & Co, London 1984 (EC).– Verrier, M.: F.-L. Paris 1978 ULUSTRATIONS:

- 45 Still Life with Flowers and Fruit, 1865
- 81 A Studio in the Batignolles Quarter, 1870

FATTORI Giovanni

1825 Livorno - 1908 Florence Trained first with Antonio Baldini in Livorno. 1846-1848 studied at the Accadèmia di Belle Arti in Florence under Giuseppe Bezzuoli. 1848 interrupted his studies in the revolutionary years 1848/49 to work in democratic movements as courier for the Partito d'Azione. 1850 resumed his studies in Florence; a regular customer in the Caffé Michelangiolo, a focal point of political and later artistic discussion and debate. 1859 became close friends with Nino Costa, who encouraged him to paint in a Realist style. Began to study plein-air. 1861 won the Concorso Ricasoli prize for the painting "The Italian Field after the Battle of Magenta". 1861-1867 mainly in Livorno. The local peasant life became the subject of his Realist paintings. 1867 spent the summer in Castiglioncello with Diego Martelli, the supporter and theoretician of the Macchiaioli. 1869 became a teacher at the Florentine Istituto di Belle Arti. 1872 visited Rome and 1875 Paris, where he was particularly impressed

by Corot. From 1875 numerous graphic prints. 1891 wrote a fierce polemic against the Pointillists. 1900 member of the Accadèmia Albertina in Turin. One of the main representatives of the Macchiaioli, he nevertheless retained a life-long aversion to Impressionism.

WRITINGS, DOCUMENTS: Dini, P. (ed.): Inediti di G.F. Turin 1987.– Errico, F. (ed.): G.F. Scritti autobiografici editi e inediti. Rome 1980.– Fattori, G.: Ricordi autobiografici. Florence n.d. CATALOGUES: Biancaiardi, L. and B. Della-Chiesa: L'Opera completa di F. Milan 1970.– Malesci, G.: Catalogazione illustrata della pittura a olio di G.F. Novara 1961

BIBLIOGRAPHY: Baldaccini, R.: G.F. Milan 1949 .- Cecchi, E.: G.F. Rome 1933.- Cecconi, A.: G.F. Florence 1914.- Ciaranfi, F.: Incisioni di Fattori, Livorno 1953 .- Durbè D. and M. de Micheli: G.F. Busto Arsizio 1961.- Durbè D.: G.F. Livorno 1953 (EC) .- Franchi, A .: G.F. Florence 1910.- G.F. Dipinti 1854-1906. With contributions by G. Matteucci et al. Florence and Milan 1988 (EC) .- Ghiglia, O.: L'opera di G.F. Florence 1913 .- Malesci, G.: Catalogazione illustrata della pittura ad olio di G.F. Novara 1961.- Micheli, M. de: G.F. Busto Arsizio 1961.- Ojetti, U.: G.F. Milan 1921.- Ommaggio a Fattori. Artisti del '800 Italiano. Galleria Narciso. Turin 1968 (EC) .- Soffici, A .: G.F. Rome 1921 .- Somarè E .: Cento opere di G.F. nella Collezione Galli. Milan 1929 .- Tinti, M.: G.F. Rome and Milan 1926 ILLUSTRATIONS:

535 The Palmieri's Bathing Rotunda, 1866

537 The Haystack, after 1872

FAURE Jean-Baptiste 1830 Moulins – 1914 Paris

Opera singer, music teacher and composer. One of the first admirers and collectors of Impressionist paintings; friends with Durand-Ruel and with many painters, whose meetings he attended. 1873 bought some pictures by Manet for a considerable sum, including "Lola de Valence" (p. 46). Supported Degas, with whom he soon fell out because Degas failed to produce paintings he had ordered and paid for. Bought paintings by Monet, Pissarro and Sisley. 1881 became a member of the Legion of Honour.

FENEON Félix

1861 Turin - 1944 Châtenay-Malabry French writer and art critic of Symbolism. 1881 took a post in Paris at the Ministry of War. 1884 co-founder of two journals; influenced by Seurat. 1886 became the first art critic to support the Pointillist style, for which he employed the term "Neo-Impressionism". Published polemical articles of literary quality, collected under the title "The Impressionists in the Year 1886". His "Revue indépendante" organised small exhibitions. 1891 his portrait was painted by Signac (p. 321). 1894 as a supporter of Anarchism he was arrested and tried for possession of explosives; defended by T. Natanson. Until 1903, editorial secretary of Natanson's "La Revue Blanche", for which he organised exhibitions. 1906-1925 Director of the Bernheim-Jeune art gallery. Thereafter he worked on the catalogue of Seurat.

FERENCZY Károly 1862 Vienna - 1917 Budapest 1886 began to paint in Naples and Rome. 1887-1889 in Paris, under the tutelage of Bastien-Lepage and others. 1890-1892 in Szentendre on the Danube; painted Realist pictures. 1893-1896 studied at the Munich Academy under Herterich, his style becoming increasingly Impressionist. 1896-1905 mainly in Nagybánya (Baia Mare); became a strong influence on the artists' colony there. 1901 exhibited for the first time at the Munich and Berlin exhibitions. 1905-1917 Professor at the art college in Budapest. BIBLIOGRAPHY: Die Familie Ferenczy.

BIBLIOGRAPHY: Die Familie Ferencz Burgschloss Buda, Budapest 1968.– Genthon, I.: K.F. Budapest 1979.– Murádin, J.: A.F. müvészcsalád Erdélyben. Bukarest 1981.– Petrovics, E.: K.F. Budapest 1943.– Réti, I.: A Nagybányai művésztelep. Budapest 1954 ILLUSTRATIONS: 521 October, 1903 522 Summer Day, 1906

FINCH Alfred William

1854 Brussels - 1930 Helsinki Known as Willy Finch. 1878-1880 studied at the Academy in Brussels, where he became friends with Ensor. Around 1880 he painted Realist landscapes and sea views; influenced by Ensor and Whistler. Co-founder of the group Les Vingt in Brussels. Frequent trips to England, where in 1884 he met Whistler and invited him to take part the first exhibition of Les Vingt. 1887 and 1888 invited by Whistler to exhibitions in England. The first Belgian to adopt Neo-Impressionism in 1887 after he had seen Seurat's "A Sunday Afternoon at the Ile de la Grande Jatte" (pp. 260/261). 1889 exhibited for the first time with the Indépendants in Paris. From 1891 he concentrated on ceramics. 1897 in Finland, where he was appointed Director of a ceramics concern; introduced Finnish painters to the new styles of Neo-Impressionism and worked at the revival of Finnish architecture. ILLUSTRATION:

424 Havstacks, 1889

FORAIN Jean-Louis

1852 Rheims - 1931 Paris Made Paris his life-long home. As a youth he copied the paintings of the Old Masters in the Louvre. Studied first with the history painter Jacquesson de la Chevreuse and later at the Ecole des Beaux-Arts under Gérôme. Turned away from history paintings and became influenced by Manet, Degas and Japanese woodcuts. 1874 rejected by the Salon. Invited by Degas to take part in the 4th, 5th, 6th and 8th Impressionist exhibitions. 1884 and 1885 exhibited in the Salon. From 1869, influenced by the graphic art of Goya and the social criticism of Daumier, he turned almost exclusively to graphic depictions of modern urban life. From 1876 illustrator for various newspapers and journals, such as "La Cravache", "Le Monde Parisien", "Vogue", "Le Fi-garo" and "Echo de Paris". Famous

for his caricatures, he became one of the most popular artists of his day. 1889 founded the weekly magazine "Le Fifre" and 1898/99 together with Caran d'Ache the journal "Psst!". From 1892 he published his graphic work. In his later years after 1909 he produced mainly religious lithographs and etchings.

CATALOGUE: Craig-Faxon, A.: J.-L.F.: A Catalogue Raisonné of the Prints. New York and London 1982 .-Guérin, M.: J.-L.F. L'œuvre gravé. 2 vols. San Francisco 1980 BIBLIOGRAPHY: Bory, J.-F.: F. Paris 1979 .- Browse, L .: F. the Painter (1852-1931). London 1978.- Chagnaud-Forain, J. et al. (eds.): J.-L.F., 1852-1931. Musée Marmottan, Paris 1978 (EC).- Faxon, A.C. (ed.): J.-L.F., 1852-1931: Works from New England Collections. Danforth Museum, Framingham 1979 (EC) .-Faxon, A.C. and Y. Brayer: J.-L.F.: Artist, Realist, Humanist. Washington 1982 (EC) .- Guérin, M .: J.-L.F. lithographe. Paris 1910 (Reprint: San Francisco 1980) .- Guérin, M.: J.-L.F. aquafortiste. Paris 1912 .- J.-L.F., 1852-1931. Musée Toulouse-Lautrec, Albi 1982 (EC) ILLUSTRATIONS:

180 In the Wings, 1878

- 210 A Box at the Opéra, c. 1880
- 210 A box at the Opera, e. 1866 211 In the Café de la Nouvelle-Athènes, 1879

262 Ball at the Paris Opera, c. 1885 336 At the Races, c. 1890

FORTUNY Y CARBO MARSAL Mariano

1838 Reus - 1874 Rome

Brought up in the household of his grandfather, a carpenter and woodcarver. 1850 took drawing lessons at the studio of Domingo Soberanos, then with the miniature painter and silversmith Antonio Bassa. 1852 moved to Barcelona. Attended the Escuela de Artes y Oficios and studied under the sculptor Domingo Talarn. 1853 studied at the art academy of San Jorge; his teachers were Claudio Lorenzale, Milá and Gavarni. 1858-1860 Rome scholarship. 1860 sent to Morocco as a war painter; exhibited his works in Barcelona; returned to Rome via Paris. 1862 went back to Morocco. 1863 his Rome scholarship was extended. 1865 the Duke of Riánsares became his patron. 1867 married the daughter of

the painter Federico Madrazo in Madrid. As a history painter his genre pictures depicting scenes from the 18th century were highly successful, 1870 sensational sale by Goupil in Paris of the painting "At the Vicarage". 1870 lived in Andalusia. 1871 third trip to Morocco. 1872 another visit to Rome.

BIBLIOGRAPHY: Alegre Núñez, L.: F. Madrid 1958 .- A Remembrance of M.F., 1871-1949. Los Angeles County Museum of Art, Los Angeles 1968 (EC) .- F. 1838-1914, Fundación Caja de Pensiones, Madrid 1989.- Gil Fillol, L .: M.F., su vida, su obra, su arte. Barcelona 1952 .- González, C. and M. Martí: M.F.M. Barcelona 1990 .- M.F. Walters Art Gallerv, Baltimore 1970 (EC) .- M.F. et ses amis français. Musée Goya, Castres 1974 (EC) .- M.F. Museo de Arte Moderno, Barcelona 1974 (EC) .-M.F.M. (1871-1949): pinturas, grabados, fotografías, trajes, telas y objetos. Mercado Puerta de Toledo, Madrid 1988 (EC) ILLUSTRATIONS: 552 Fortuny's Garden 555 At the Vicarage, 1870

FOURNAISE, Restaurant

A restaurant popular with writers and painters in Chatou, and named after its proprietor. Maupassant, Renoir and Caillebotte were regular customers. Renoir painted "The Luncheon of the Boating Party" (p. 220), in in which the Fournaise family are pictured with his friends. Renoir painted Fournaise's portrait, and his pretty daughter Alphonsine modelled for him in several paintings, including "La Grenouillère" (p. 73).

FRANC-LAMY

1855 Clermont-Ferrand – 1919 Paris Real name: Pierre Désiré Eugène Franc. Studied at the Ecole des BeauxArts under Pils and Gérôme. Under the influence of Renoir his style moved to Impressionism. 1877 took part in the 3rd Impressionist exhibition with four works of art. Thereafter he returned to a more Classical style. Above all he painted landscapes and portraits, and was active as an illustrator. Member of the Société des Arts Français; from 1880 he exhibited in their salon. 1889 well received at the World Fair and 1900 won a medal. He is depicted in Renoir's painting "Le Moulin de la Galette" (p. 153). ILLUSTRATION:

370 An Exotic Beauty

FRANCOIS Jacques (Jacques-Francois)

Pseudonym for a woman whose real name has never been discovered. 1876 and 1877 took part in the 2nd and 3rd Impressionist exhibitions.

FRIESEKE Frederick Carl

1874 Owosso (MI) - 1939 New York Studied at the Academy in Chicago, then in Paris with Constant, Laurens and Whistler. Lived alternately in New York and Paris. Member of the Société Nationale des Beaux-Arts in Paris. From 1901 he exhibited regularly in their salon. Concentrated on painting female nudes and portraits, inspired by Whistler, in subdued, hazy colours. Painted some murals in the Wanamaker and Shelbourne hotels in Atlantic City. Exhibited in many international shows in Paris, Venice, Rome, Mannheim, Pittsburgh, Philadelphia. Several awards: 1904 silver medal at the World Fair in Saint Louis (MO) and the gold medal at the international exhibition in Munich; 1935 second Clark Prize at the Corcoran Art Gallery, Washington (DC).

BIBLIOGRAPHY: Chambers, B.W. (ed.): F.C.F. Women in Repose. Berry Hill Galleries, New York 1990 (EC).– EF. 1874-1939. Telfair Academy of Arts and Sciences, Savannah (GA) 1974 (EC).– A Retrospective Exhibition of the Work of F.F. Maxwell Galleries, San Francisco 1982 (EC).– Weller, A.S.: F.F., 1874- 1939. Hirschl and Adler Galleries, New York 1966 (EC)

ILLUSTRATION: 635 Lady in a Garden, c. 1912

GACHET Paul-Ferdinand

1828 Lille - 1909 Auvers-sur-Oise French doctor, homoeopath, socialist, art collector, painter and graphic artist. 1848-1855 studied medicine in Paris: made friends with Realist writers and artists. 1855-1859 in Montpellier. From 1859 doctor and homoeopath in Paris, met and painted with artists at such venues as the Café Guerbois and the Nouvelle-Athènes. Held socialist views. 1865-1876 taught anatomy at the state school of art. 1871 military doctor during the Commune. 1872 bought a house in Auvers, where he met and supported Daubigny, Pissarro, Guillaumin and Cézanne. 1874 lent pictures by Cézanne from his own collection to the 1st Impressionist exhibition. Formed a friendship with Renoir. 1890 took on the psychiatric treatment of van Gogh and continued until the latter's death. 1891 exhibited for the first time at the Salon des Indépendants. 1952 Gachet's extraordinary collection of paintings was bequeathed by his son to the French state - now one of the major attractions of the Musée d'Orsay.

GAGNON Clarence Alphonse 1881 Montreal – 1942 Montreal

1897-1900 studied under William Brymner at the Art Association of Montreal. Formed a friendship with W.H. Clapp and shared a studio with him in St. Lawrence. Influenced by Cullen, to whom he owed his change to a brighter-coloured palette. 1904/05 studied at the Académie Julian in Paris under Laurens. Study trips in France, Spain and Italy. 1904 received the bronze medal at an exhibition in Saint-Louis. 1906 exhibited for the first time at the Société des Arts Français in Paris and from 1911 at the salon of the Société Nationale, 1909 returned to Canada, Exhibited at the Canadian Art Club and became a member there in 1910. Stayed mostly in Baie St. Paul, where he painted the landscape of Quebec in the open air. From 1913 he received great acclaim for his winter landscapes. 1915 took part in the World Fair in San Francisco. 1922-1936 second visit to France. Travelled in Italy and Spain. BIBLIOGRAPHY: Boissay, R.: C.G. Montreal 1988 ILLUSTRATION: 637 Summer Breeze at Dinard, 1907

GALLEN-KALLELA Akseli 1865 Pori, Björneborg – 1931 Stockholm

1881-1884 studied at the Finnish Art Society in Helsinki and the private academy of A. von Becker. 1884-1889 in Paris at the Académie Julian under Bouguereau and at Cormon's studio. Began realistic plein-air painting under the influence of Bastien-Lepage. 1888 and 1889 exhibited at the Salon; 1889 first Finnish painter to become a member of the Société Nationale des Beaux-Arts. 1890 went to Karelia on the eastern border of Finland. Started the Karelian movement of Finnish artists. 1888 and 1892 came into contact with Symbolism in Paris and introduced it into Finland. 1894 designed and built a house and studio in Ruovesi and at the end of the year went to Berlin. 1895 became acquainted with the Arts and Crafts movement in London. 1897/98 studied fresco technique in Italy. 1900 painted ornamental frescoes of the Finnish national heroic epic "Kalevala" for the Finnish pavilion of the World Fair in Paris. 1902 at Kandinsky's invitation he exhibited 36 works at the "Phalanx IV" exhibition in Munich. In 1903 he was at the Vienna Secession and in 1910 showed with the "Brücke" in Dresden. 1909/10 travelled in East Africa, 1914 exhibited in San Francisco, New York and Chicago and travelled through the USA. He died while working on illustrations for a large edition of the "Kalevala".

BIBLIOGRAPHY: Juhla-Kanteletar (ed.): A.G.-K. Helsinki 1984,- Levison, A.: A.G.-K. St. Petersburg 1908,-Martin, T. and D. Sivén: A.G.-K: National Artist of Finland. Helsinki 1985,- Okkonen, O.: A.G.-K. Elämä ja taide. Helsinki 1961.- Wietek, Der finnische Maler A.G.-K. (1865-1931) als Mitglied der Brücke. In: Brücke-Archiv 2/3 (1968/69), pp. 3-26 ILLUSTRATION: 484 Démasquée, 1888

GASQUET Joachim

1873 Aix-en-Provence – 1921 Paris Provençal poet and close friend of Cézanne from 1869 to 1904; his father Henri had been a childhood friend of Cézanne. The two kept in close contact by letter and in 1912/13 Gasquet wrote a book on Cézanne that included conversations with him. Their friendship was based on deep religious feelings. Cézanne painted his portrait and gave him a picture of Mont Sainte-Victoire.

GAUGUIN Paul 1848 Paris – 1903 Atuona Hiva Oa (Marquesas Islands)

1849-1855 son of an emigré Republican journalist; grew up in Lima (Peru), then in Orléans and Paris. 1865-1871 went to sea. 1871-1883 worked as a stock-broker in Paris, painting in his spare time. 1873 married a Danish woman, Mette Gad; the couple had five children. 1874 met Pissarro and other Impressionists and studied at the Académie Colarossi. 1876 exhibited for the first time at the Salon. 1879 painted with Pissarro in Pontoise; exhibited at the 4th Impressionist exhibition. 1880-1886 exhibited at the Impressionist shows (5th-8th). 1880 at the Salon des Indépendants. 1881 painted with Pissarro and Cézanne. 1882 moved to Rouen, then Copenhagen; got into financial difficulties. 1885 returned to Paris, leaving the family in Denmark. 1886 went to Pont-Aven for the first time, met Bernard. Became acquainted with the van Gogh brothers in Paris and took part in the 8th Impressionist exhibition. 1887 travelled with the painter Laval to Panama and Martinique. 1888 with Bernard and others in Pont-Aven; in his depictions of Breton customs his style moved towards "Synthetist Symbolism". Exhibited with Theo van Gogh. A stay with Vincent van Gogh in Arles ended in disastrous personal conflict.

1889 exhibited with "The Twenty" in Brussels and during the Paris World Fair at the Café Volpini. Painted in Pont-Aven and Le Pouldu; exerted influence on Sérusier, Denis and Bonnard. 1890 once more in Le Pouldu and in the circle of Symbolists in Paris. 1891 after auctioning his paintings and breaking off with Bernard he emigrated to Tahiti, to live an alternative life to that of European city civilisation. Became ill with syphilis. 1893-1895 in Paris, Copenhagen and Brittany but had no success trying to sell his large, symbolic pictures with their areas of flat, bright colour and scenes of the South Seas, the epitome of exotic "Primitivism". 1895-1901 returned to Tahiti, where he also worked on sculptures, but his health suffered, partly through alcohol.

1897 published his autobiographical work "Noa Noa". 1898 suicide attempt and desperate poverty. 1900 commissioned by the dealer Vollard. 1901 moved to the Island of Dominique in the Marquesas Islands. 1902 protested against the policies of the colonial administration and was arrested 1903; he died, worn out, at the age of 54.

WRITINGS, DOCUMENTS: Gauguin, P.: Vorher und Nachher. Munich 1920.-Gauguin, P.: Avant et après. Paris 1923, Tahiti 1989.- Gauguin, P.: Oviri. Ecrits d'un sauvage. Paris 1974.- Gauguin, P.: Mon père P.G. Paris 1938 .- Gauguin, P.: My Father, P.G. New York 1937 .- Gauguin, P.: A ma fille Aline, ce cahier est dédié. 2 vols. Bordeaux 1989 .- Guérin, D. (ed.): P.G. The Writings of a Sauvage, P.G. New York 1977 .- Joachim Gasquet's Cézanne. A Memoir with Conversations. London 1991.- Joly-Segalen, A. (ed.): Lettres de G. à Daniel de Monfreid. Paris 1950.- Loize, J. (ed.): Noa Noa par P.G. Paris 1966 .-Malingue, M. (ed.): Lettres de G. à sa femme et à ses amis. Paris 1946.-Malingue, M. (ed.): P.G. Letters to his Wife and Friends. Cleveland 1949 .-Merlhès, V.: Correspondance de P.G. Vol. I. 1873-1888. Paris 1984 .- Mittelstädt, P. (ed.): P.G. Der Traum von einem neuen Leben. Berlin 1991.-The Intimate Journals of P.G. London 1930.- Wadley, N. (ed.): Noa Noa. G.s Tahiti. The Original Manuscript. Oxford 1985

CATALOGUES: Field, S.: P.G. Monotypes. Museum of Art, Philadelphia 1963 (EC).- Gray, C.: Sculpture and Ceramics of P.G. Baltimore 1963, New York 1980.- Guérin, M.: L'œuvre gravé de G. 2 vols. San Francisco 1980.- Kornfeld, E., H. Joachim and E. Morgan: P.G. Catalogue Raisonné of his Prints. Berne 1988,-Sugana, G.M.: L'Opera completa di G. Milan 1972.- Sugana, G.M.: Tout l'œuvre peint de G. Paris 1981.- Wildenstein, G.: G., sa vie, son œuvre. Paris 1958.- Wildenstein, G.: G., catalogue. Paris 1964

BIBLIOGRAPHY: Alexandre, A.: P.G.: Sa vie et le sens de son œuvre. Paris 1930 .- Amishai-Maisels, Z .: G.'s Religious Themes. New York and London 1985 .- Andersen, W.: G.'s Paradise Lost. New York 1971 .- Art of P.G. National Gallery, Washington; Art Institute of Chicago; Grand Palais, Paris 1988/89 (EC) .- Bismarck, B. v.: Die Gauguinlegende. Die Rezeption P.G.s in der französischen Kunstkritik 1880-1903. Doctoral thesis, Berlin 1989 .- Boudaille, G.: G. Paris 1963.- Bowness, A.: P.G. London 1971.- Boyle-Turner, C. and S. Josefowitz: G. und die Druckgraphik der Schule von Pont-Aven. Villa Stuck. Munich 1990 (EC) .- Cachin, F.: G. Paris 1988 .- Cachin, F.: G.: The Quest for Paradise. New York 1990 .-Chassé C .: G. et le groupe de Pont-Aven. Paris 1948 .- Daix, P.: G. Paris 1989 .- Danielsson, B.: G. in the South Seas. London 1964 .- Dorival, B.: P.G. Carnet de Tahiti. Paris 1954 .-Dovski, L. v.: P.G. oder die Flucht von der Zivilisation. Berne 1950.-

Dovski, L. v.: Die Wahrheit über P.G. Darmstadt 1973 .- Field, R.S.: P.G.: The Paintings of the First Voyage to Tahiti. New York 1977 .- Gauguin. The National Gallery, Washington; The Art Institute of Chicago, Chicago; Grand Palais, Paris 1988 (EC) .-Gibson, M.: P.G. Recklinghausen 1991 .- Gibson, M: P.G. Paris 1990 .-Gray, C.: Sculpture and Ceramics of P.G. Baltimore 1963, New York 1980.- Gucchi, R.: G. à la Martinique. Vaduz 1979.- Haase, A. et al. (eds.): P.G.: Das druckgraphische Werk. Stuck-Villa, Munich 1978 (EC) .- Hoog, M .: P.G. Leben und Werk. Munich 1987 .- Hoog, M .: P.G. Vie et œuvre. Fribourg 1987.- Hoog, M.: P.G. Life and Work. London and New York 1987 .- Jaworska, W.: G. et l'école de Pont-Aven. Neuchâtel 1971. (Engl. edition: London 1972).-Jirat-Wasiutynski, V.: G. in the Context of Symbolism. New York and London 1978.- Lövgren, S.: The Genesis of Modernism. Seurat, Gauguin, van Gogh and French Symbolism in the 1880's. Uppsala 1959, Bloomington (IN) and London 1971 .- Le Pichon, Y.: Sur les traces de G. Paris 1986.- Leprohon, P.: P.G. Paris 1975.- Malingue, M.: G., le peintre et son œuvre. Paris 1948 .- Malingue, M.: La vie prodigieuse de G. Paris 1987.- Mittelstädt, K.: Die Selbstbildnisse P.G.'s. Berlin 1966.- Perruchot. H.: G. Paris 1960 .- Perruchot, H.: La vie de G. Paris 1961.- Pickvance, R. (ed.): The Drawings of G. London, New York, Sydney and Toronto 1970 (EC) .- Pool, P .: P.G. New York 1978 .-Pope, K.K.R.: G. and Martinique. Doctoral thesis, The University of Texas. Austin 1981.- Prather, M. and C.F. Stuckey (eds.): G. A Retrospective. New York 1987 .- Rewald J .: G. Paris 1938 .- Rewald, J .: G. London and New York 1938.- Rewald, J .: G.'s Drawings. New York and London 1958 .- Rookmaaker, H.R.: G. and the 19th Century Art Theory. Amsterdam 1972 .- Teilhet-Fisk, J .: Paradise Reviewed: An Interpretation of G.'s Polynesian Symbolism. Ann Arbor (MI) 1983.- Thomson, B.: G. London 1987 .- Walther, I.F.: P.G. 1848-1903. The Primitive Sophisticate. Cologne 1988. - Wildenstein, G.: G. Paris 1964 .- Wildenstein, D. and R. Cogniat: G. Garden City 1974 .- Wise, S.: P.G. His Life and his Paintings. Chicago 1980 ILLUSTRATIONS:

- 207 Study of a Nude. Suzanne Sewing, 1880
- 265 The Four Breton Girls, c. 1886
 302 Night Café in Arles (Madame Ginoux), 1888
- 302 L'Arlesienne (Madame Ginoux), 1888
- 303 Vision after the Sermon: Jacob Wrestling with the Angel, 1888
- 332 Pastime ("Arearea"), 1892
- 333 We Shall Not Go to Market Today ("Ta matete"), 1892
- 334 Two Women on the Beach, 1891
- 352 The Dug-Out ("Te vaa"), 1896
- 353 "Why are you angry?" ("No te
- aha oe riri?"), 1896
- 377 Sunflowers on a Chair, 1901

GAUSSON Léo 1860 Lagny-sur-Marne (Seine-et-Marne) – 1944 Lagny-sur-Marne 1883 his interest in art was awakened at an early age in the studio of the graphic artis Eugène Froment, a friend of the family. He began as a wood sculptor, then studied graphics, finally turning to painting. At the Atelier Froment he met Maximilien Luce and Cavallo Peduzzi. Joined the Neo-Impressionists and Symobists.

Influenced by Camile Pissarro, Faul Signac, Luce, van Gogh, Gauguin and Emile Bernard. **1886** exhibited for the first time at the Salon and **1887-1900** at the Salon des Indépendants. Friends with Adolphe Retté, whose books he illustrated; published his own poems under the pseudonym Montesiste. **1899** one-man exhibition at the Théâtre Antoine in Paris. **1900-1910** lived in Africa.

CATALOGUE: Hanotelle, M.: L.G. Catalogue raisonné (in preparation) BIBLIOGRAPHY: L.G. 1860-1944, Dessins, aquarelles, gouaches, pastels, peintures. Hôtel Drouot, Paris 1979 (EC)

ILLUSTRATION: 310 Undergrowth, 1888

GAUTIER Théophile

1811 Tarbes – 1872 Neuilly-sur-Seine At first a painter, then poet and critic. Important proponent of Impressionist ideas. 1835 published his famous work "Mademoiselle de Maupin" where he first put forward the concept of "L'art pour l'art", which was to be very significant for the development of aesthetic theory.

GEFFROY Gustave 1855 Paris – 1926 Paris

Novelist, historian and art critic with radical Realist views. Began his career working at Clemenceau's journal "Justice". Frequently in the company of Impressionist painters, he wrote numerous articles about their aims and principles, as well as the introductions to exhibitions by individual artists such as Monet, Pissarro, Rodin and Morisot. 1876 visited Manet at his studio and in 1886 met Monet on Belle-Ile; he later wrote a biography of Monet. In 1894 he published a history of Impressionism in "La vie artistique", and in 1924 "Claude Monet, sa vie, son temps, son œuvre". In his later years he became director of the firm Gobelin.

GENNEVILLIERS

Idyllic spot on the right bank of the Seine near Argenteuil. Manet's family owned a house here and it became a favourite retreat for him, as also for the painter Berthe Morisot after her marriage to Eugène Manet. Caillebotte was a member of the local rowing club and also owned a small house there.

GEROME Jean-Léon 1824 Vesoul – 1904 Paris

From 1841 studied at the Atelier Delaroche. 1843 with his teacher in Rome. 1844 resumed his studies at the same studio, now under Gleyre. 1847 staged his first exhibition, with success, at the Salon. His favourite subjects were scenes drawn from Classical and Oriental mythology, which he depicted in Classical style with realistic precision, 1855 received into the Legion of Honour for his picture "The Age of Augustus". Numerous trips to Germany, 1853 on the Danube and then for five years in the Middle East. 1865 member of the Academy, where he taught for many years; from 1878 also active as a sculptor. Belonged to the conservative academic party and became a bitter opponent of the Impressionists. In 1894 he rejected Caillebotte's legacy to the French state with the words: "If the state accepts such rubbish, then the decay of morals must be already considerably advanced" CATALOGUE: Ackermann, G.M.: The Life and Work of J.-L.G., with a Catalogue Raisonné. London 1986.-Ackermann, M .: La vie et l'œuvre de J.-L.G. Paris 1986 .-BIBLIOGRAPHY: Ackerman, G.M.: J.-L.G. Courbevoie 1985

GERVEX Henri

1852 Paris - 1929 Paris

Studied under Cabanel, at whose studio he met Forain, Regnault and Bastien-Lepage. 1873 exhibited for the first time at the Salon. Long trip to Russia, appeared at the Tsar's court. Became friends with Manet and Renoir. 1874 exhibited once again at the Salon. 1878 his nude picture "Rolla" caused a sensation and was rejected by the Salon. 1883 artistic decoration of the town hall in the 19th arrondissement and of the Opéra Comique.

1884 invited to exhibit with Les Vingt in Brussels; organised a Manet retrospective. 1889 and 1900 Jury member at the World Fair; argued in favour of giving the Impressionists their due recognition. 1904 executed a cycle of frescoes for the town hall in Neuilly. A favourite Salon painter, whose range of subjects included female nudes, portraits and society scenes.

ILLUSTRATION: 250 The Salon Jury, 1885

GILMAN Harold

1876 Rode Somerset - 1919 London 1896 studied at the Hastings Art School, 1897 at the Slade School in London. 1904 stayed for a year in Spain, where he copied Velázquez. Travelled in Norway and the USA. 1906 met Sickert. His initial painting style resembled that of Pissarro and Vuillard. 1911 visited Paris. Became interested in van Gogh and Cézanne. Founded the Camden Town Group, who took Continental Impressionism as their model. 1913 the group joined with others to form the London Group, with Gilman as President. His still lifes, portraits, landscapes and interiors moved increasingly towards Post-Impressionism. 1918 commissioned by the Canadian government to paint a large picture as a war memorial in Ottawa. BIBLIOGRAPHY: Cousey, A. and R.

Thomson (eds.): H.G. 1876-1919. The Arts Council of Great Britain, London 1981 (EC).– H.G. The Arts Council of Great Britain, London 1954 (EC).–Lewis, W. and L. Fergusson: H.G. An Appreciation: London 1919 ILLUSTRATION: 589 Canal Bridge, Flekkefjord,

1912

GIMENO ARASA Francisco 1858 Tortosa (Tarragona) – 1927 Barcelona

Began in the workshop of a decorative painter in Tortosa. After military service, he settled in Barcelona. 1884 became friends with de Haes, whom he visited frequently in Madrid. Between 1888 and 1904 took part in the World Fair in Barcelona and in the Nacional de Bellas Artes in Madrid. Did not receive due acclaim until 1915. His powerful brushwork created looser forms and motifs, but without becoming abstract. ILLUSTRATION:

569 Blue Water

GIVERNY

Village at the confluence of the Epte and the Seine, about 45 miles from Paris. Monet moved here with his family in 1883. The park-like garden which he had laid out there appears in many of his pictures (pp. 362, 364, 365, 393). Artist friends, including Renoir, Sisley, Pissarro, Sargent and Rodin, and in particular foreign artists like the American Impressionists, all came to Giverny to visit Monet and to paint for themselves. (cf. p. 622).

GLEYRE Charles

1806 Chevilly (Vaud) - 1874 Paris Swiss by birth, he studied first with his uncle in Lyons. From 1825 studied with the portrait and history painter Louis Hersent and with Bonington; attended the Ecole des Beaux-Arts and the Académie Suisse in Paris. 1829-1834 lived in Rome; met the Classical painter Léopold Robert, whose painting style influenced him considerably. Travelled with an American patron in Sicily, Greece, Egypt and the Middle East. 1837 settled for a short period in Khartoum, 1838 produced some early examples of plein-air painting, 1840 exhibited for the first time at the Salon. 1843 first notable success at the Salon. 1843 took over the studio of Delaroche and opened a popular, liberal school, the Atelier Glevre, which had close contacts with the Ecole des Beaux-Arts and in which artists like Whistler. Monet, Renoir, Sisley and Bazille all worked. 1845 travelled to Venice. London and Madrid. 1864 closed the Atelier due to illness. Persuaded Sisley, Bazille and Renoir to follow him to Fontainebleau. Gleyre painted mythological, historical and religious pictures, many in large format, in a cool, Classical style but not without some Romantic emotion and feeling. BIBLIOGRAPHY: Thévoz, M.: L'accadémisme et ses fantasmes. Le réalisme imaginaire de Charles Gleyre, Paris 1980

GOENEUTTE Norbert

1854 Paris – 1894 Auvers-sur-Oise After training as a clerical assistant he studied painting at Pils's studio. Friendship with Frédéric-Samuel

Cordey. Regular customer in the Café de la Nouvelle-Athènes, where he met Renoir and Manet, who strongly influenced his style of painting. 1876 exhibited for the first time at the Salon. Helped organise the exhibition "Peintres graveurs". Moved to Auvers for health reasons, and was treated by Gachet. Through the support of his brother Charles, he was able to continue his artistic career without financial difficulties. He oftened modelled for Renoir's paintings: "The Swing" (p. 144), "Moulin de la Galette" (p. 153). Painted a famous portrait of Gachet (Paris, Musée d'Orsay; detail: see above).

CATALOGUE: Goeneutte, N.-G.: N.G. Catalogue raisonné (in preparation) BIBLIOGRAPHY: Knyff, G. d.: L'art libre au XIX^e siècle ou la vie de N.G. Paris 1978 ILLUSTRATION:

155 The Boulevard de Clichy under Snow, 1876

GOGH Theo van

1857 Groot-Zundert - 1891 Utrecht Art dealer and younger brother of Vincent van Gogh. From 1878 he worked for Goupil-Boussod-Valadon. As manager of the branch on the Boulevard Montmartre 19, where Adolphe Goupil began his career, he supported the sale of Impressionist pictures. After 1886, Vincent came to Paris and lived with him in the Rue Lepic (p. 283); his interest in Impressionism increased. He kept in close contact with his brother (from 1872 they corresponded frequently), and until Vincent's death he supported him with gifts of artistic materials

and money. Theo's sales as an art dealer include: 1 Cézanne, 23 Degas, 18 Gauguins, 5 Manets, 24 Monets, 23 Pissarros, 4 Renoirs and 7 Sisleys.

GOGH Vincent van 1853 Groot-Zundert - 1890 Auvers-sur-Oise

1869-1876 son of a parson, he worked in branches of the Paris art dealer Goupil in The Hague, Brussels and London. 1876 assistant teacher and preacher in and near London. 1877/78 trained as a lay preacher. began to draw. 1878-1880 lay preacher in the mining area of Borinage, suffered from poverty. His brother Theo, the art dealer, began to support him financially. 1880 decided on a career as an artist and studied at the academy in Brussels. 1881-1883 with the Realist painter A. Mauve in The Hague, lived with a prostitute. 1883-1885 in Drenthe (Northern Holland) and at his parent's house in Nuenen, drew and painted dark realistic scenes from the life of the poor. 1885/86 in Antwerp, for a short time at the college of art. 1886-1888 in Paris; at the Atelier Cormon he met Bernard and Toulouse-Lautrec, and through Theo the Impressionists and Neo-Impressionists; he began to employ their motifs, bright colours and style of painting. Became friends with Gauguin: impressed by the two-dimensional, decorative effects of Japanese woodcuts. 1888 in Arles; painted in a heavy style with strong colours to signify passion. A short period of artistic cooperation with Gauguin ended in a disastrous row and mental instability; in a bout of madness he cut off part of his left ear. 1889 in hospital at Arles and at the mental hospital in Saint-Rémy. Exhibited with the Indépendants in Paris. 1890 exhibited with Les Vingt in Brussels, where one of his acquaintances, the painter Anna Boch, bought the only painting he ever sold in his lifetime. Moved to Auvers-sur-Oise, where he was treated by Gachet and where, in 1890, he shot himself. His extensive later work became a basic influence on the development of Fauvism and Expressionism.

WRITINGS, DOCUMENTS: Frank, H.: V.G. in Selbstzeugnissen und Bilddokumenten. Reinbek bei Hamburg 1976.- Gogh, V. v.: Sämtliche Briefe. Ed. by F. Erpel. 6 vols. Berlin 1965-

1968.- Gogh, V. v.: The Complete Letters of V.v.G. 3 vols. London and New York 1958 .- Gogh, V. v.: Correspondance complete de V.v.G. 3 vols. Paris 1960

CATALOGUES: Faille, J.-B. de la: L'œuvre de V.v.G. Catalogue raisonné 4 vols. Paris and Brussels 1928 .-Faille, J.-B. de la: The Works of V.v.G. His Paintings and Drawings. Amsterdam and New York 1970.-Hulsker, J .: V.G. en zijn weg. Het complete werk. Amsterdam 1977 .-Hulsker, I.: The Complete v.G. Paintings, Drawings, Sketches. Oxford and New York 1980 .- Hulsker, J.: L'opera completa di v.G. Milan 1979.- Lecaldano, P.: Tout l'œuvre peint de v.G. 2 vols. Paris 1971 .- Lecaldano, P .: L'opera pittorica completa di v.G. 2 vols. Milan 1971 .- Testori, G. and L. Arrigoni: V.G. Catalogo completo dei dipinti. Florence 1990.- Walther, I.F. and R. Metzger: V.v.G. Sämtliche Gemälde, 2 vols, Cologne 1989.- Walther, I.F. and R. Metzger: V.v.G. The Complete Paintings. 2 vols. Cologne 1990.- Walther, I.F. et R. Metzger: V.v.G. L'œuvre compléte - peinture. Cologne 1990.- Walther, I.F. e R. Metzger: V.v.G. Tutti i dipinti. 2 vols. Cologne 1990

BIBLIOGRAPHY: Artaud, A .: V.G .: le suicidé de la société. Paris 1990.-Badt, K.: Die Farbenlehre V.G. Cologne 1961.- Bernard, B. (ed.): V.v.G. Leben und Werk in Bildern und Briefen, Munich 1987.- Bernard, B. (ed.): V.v.G. London 1988 .- Boime, A.: V.G.: La nuit étoilée: l'histoire de la matière et la matière de l'histoire. Paris 1990 .- Bonafoux, P.: V.v.G. Cologne 1990.- Bonafoux, P.: V.v.G. Paris 1990 .- Cabanne, P.: V.G. Gütersloh 1961.- Cabanne, P.: V.G., l'homme et son œuvre. Paris 1961.-Cachin, F. and B. Welsh-Ovcharov (eds.): V.G. à Paris. Musée d'Orsay, Paris 1988 (EC) .- Dorn, R.: Décoration, V.v.G. Werkreihe für das Gelbe Haus in Arles. Hildesheim 1990.-Elgar, F.: V.v.G. Leben und Werk. Munich and Zürich 1959.- Elgar, F .: V.v.G. Life and Work. New York 1958 .- Elgar, F.: V.v.G. Paris 1958 .-Erpel, F. (ed.): V.v.G. Lebensbilder, Lebenszeichen. Berlin and Munich 1989 .- Hammacher, A.M. and R .: V.G. Die Biographie in Fotos, Bildern und Briefen. Stuttgart 1982.- Hammacher, A.M. and R.: V.G. A Documentary Biography. London 1982 .-Lassaigne, J.: V.v.G. Munich 1973.-Lassaigne, J.: V.v.G. London 1973.-Lassaigne, J.: V.v.G. Annecy 1974.-Lassaigne, J.: V.v.G. Milan 1972.-Leymarie, J.: V.G. Paris and New York 1951.- Leymarie, I.: V.G. Geneva 1977 .- Leymarie, J .: V.G. Geneva 1977 .- Lövgren, S.: The Genesis of Modernism. Seurat, Gauguin, van Gogh and French Symbolism in the 1880's. Uppsala 1959, Bloomington (IN) and London 1971.- McQuillan, M.: V.G. London 1990 .- Mothe, A.: V.v.G. à Auvers-sur-Oise. Paris 1987.- Pickvance, R. (ed.): V.G. in Arles. Metropolitan Museum of Art, New York 1984 (EC) .- Pickvance, R .: V.G. in Saint-Rémy and Auvers. The Metropolitan Museum of Art, New

York 1986 (EC) .- Pollock, G, and F. Orton: V.v.G.: Artist of his Time. Oxford and New York 1978 .- Roskill, M.: V.G., Gauguin and the Impressionist Circle, New York 1970 .-Schapiro, M.: V.v.G. Stuttgart 1950 .-Schapiro, M.: V.v.G. New York 1950.- Schapiro, M.: V.v.G. Paris 1954 .- Schapiro, M.: V.v.G. Milan 1972.- Sweetman, D.: V.v.G. 1853 bis 1890. Düsseldorf 1990.- Stein, S.A. (ed.): V.G. A Retrospective. New York 1986 (EC) .- Tralbaut, M.E.: V.v.G. London 1974.- Tralbaut, M.E.: V.G., le mal aimé. Lausanne 1969.- Tralbaut, M.E.: V.v.G. Milan 1969 .- Tralbaut, M.E.: V.G., le mal aimé. Barcelona 1969.- Tralbaut, M.E.: V.G., le mal aimé. Amsterdam 1969 .- V.G. caris. Musée d'Orsay, Paris 1988 (EC) .- V.v.G.: Drawings. Rijksmuseum Kröller-Müller, Milan 1990 (EC) .- V.v.G .: Paintings. Rijksmuseum Vincent van Gogh, Milan 1990 (EC) .- Walther, I.F .: V.v.G. 1853-1890. Vision and Reality. Cologne 1987 .- Welsh-Ovcharov, B .: V.G. in Perspective. Englewood Cliffs (NI) 1974 .- Welsh-Ovcharov, B .: V.v.G. His Paris Period 1886-1888. Utrecht and The Hague 1976 .- Welsh-Ovcharov, B .: V.v.G. and the Birth of Cloisonism. Art Gallery of Ontario, Toronto 1981 (EC) .- Wolk, J. v.d.: The Seven Sketchbooks of V.v.G. London 1987.- Zurcher, B.: V.G. Leben und Werk. Munich 1985.- Zurcher, B.: V.G., vie et œuvre. Fribourg 1985 ILLUSTRATIONS:

- 276 Le Moulin de la Galette, 1886
- 277 Pont de la Grande Jatte, 1887 280 View of Paris from Montmartre,
- 1886 282 Restaurant Rispal at Asnières, 1887
- 283 Paris Seen from Vincent's Room in the Rue Lepic, 1887
- 284 Terrace of a Café on Montmartre, 1886
- 287 Agostina Segatori in the Café du Tambourin, 1887
- 288 Fishing in Spring, Pont de Clichy, 1887
- 289 On the Outskirts of Paris, 1887
- 289 In the Jardin du Luxembourg, 1886
- 291 Self-Portrait in a Gray Felt Hat, 1887
- 292 Portrait of Père Tanguy, 1887
- 293 Portrait of Père Tanguy, 1887
- 314 The Sower, 1888
- 315 Vincent's House in Arles (The Yellow House), 1888

GONCOURT Edmond and Jules de Edmond (1822 Nancy - 1896 Champrosay), Jules (1830 Paris -1870 Paris)

French writers and art critics. Their novels, at first written together, deal with social problems, including those of the artistic milieu, in Realist, Naturalist and finally Impressionist styles. They wrote some theoretical studies on the rediscovery of painting in the 18th century. From 1888 their diaries were published ("Journal des Gon-

courts"), and these have become an invaluable source both for their descriptions of the life of artists in Paris and for their insights into Impressionist views, particularly those of Degas.

GONZALES Eva 1849 Paris – 1883 Paris

Daughter of the writer Emmanuel Gonzalès. 1865 had lessons with C. Chaplin. 1869 met Manet and became his student and model. 1870 exhibited for the first time at the Salon. Thereafter she submitted work every year to the Salon. Until 1872 she was strongly influenced by Manet but later developed her own, more personal style. Her water colours with their bright colours and soft forms achieved great success; her work was praised by both Castagnary and Zola. During the Franco-Prussian War she stayed in Dieppe. 1879 married a brother of the graphic artist Henri Guérard. Died in childbirth, five days after Manet. 1885 memorial exhibition in the rooms of "La Vie moderne", 1924 another memorial exhibition at the autumn Salon. CATALOGUE: Sainsaulieu, M.-C. and J. de Mons: E.G. 1849-1883. Etude critique et catalogue raisonné de l'œuvre. Paris 1991 BIBLIOGRAPHY: Roger-Marx, C.: E.G.

St.-Germain-en-Laye 1950 ILLUSTRATIONS:

- 132 A Box at the Théatre des Italiens, c. 1874
- 133 Morning Awakening, 1876
- 165 The Milliner, c. 1877

GORE Spencer Frederick 1878 Epsom – 1914 Richmond His education – at Harrow and Slade

School - finished as early as 1900. A pupil of Steer. 1903 met Lucien Pissarro and Sickert. Influenced by the landscapes of Pissarro and Degas' theatre scenes. From 1907 he belonged to the group around Sickert. 1909 became a member of the New English Art Club: co-founder of the Association des artistes alliés and President of the Camden Town Group. One of the most important exponents of Post-Impressionism in England. Under the influence of Gauguin, his painting developed after 1912 from Pointillism to a style more expressive in both colour and outline. BIBLIOGRAPHY: Gore, F. and R. Shone (eds.): S.F.G. Anthony d'Offay Gallery, London 1983 (EC) .- S.F.G. The Arts Council of Great Britain, London 1955 (EC) .- S.F.G. 1878-1914. Anthony d'Offay Gallery, London 1974 (EC) ILLUSTRATION:

590 Mornington Crescent, 1911

GOULUE, La

Real name: Louise Weber (1870 – 1929). Successful Parisian cancan dancer; performed in the Moulin de la Galette, the Alcazar, the Elysée-Montmartre, the Grille-d'Egout and later above all in the Moulin Rouge, often together with Valentin le Désossé. One of Toulouse-Lautrec's favourite models; he portrayed her in various paintings and posters (pp. 324, 325).

GOUPIL Adolphe 1806 Paris – 1893

Began with a small shop selling reproduction paintings, which he produced by various techniques on his own presses. He soon began trading in contemporary (but mostly academic) paintings in his own galleries in Paris, The Hague, New York, London, Brussels and Berlin. **1869** van Gogh began his apprenticeship at the branch in The Hague. His brother Theo later worked there, but no van Gogh paintings were ever exhibited.

GRABAR Igor Emmanuilovich 1871 Budapest - 1960 Moscow 1880 the family moved to Russia. 1889-1893 studied law at St. Petersburg; drew caricatures and illustrations, was impressed by Serov. 1894-1896 studied with Repin at the St. Petersburg academy. Began to publish articles of art criticism. 1895 first visit to Western Europe. 1896-1901 in Munich as a student, then teacher at the private academy of Ažbè; from 1898 he began exhibiting. Travelled extensively. 1901-1903 in St. Petersburg, then in Moscow. Exhibited his Impressionist paintings at "World of Art" exhibitions. 1903 organised the permanent exhibition "Contemporary Art" in St. Petersburg, which encouraged a synthesis of painting and applied arts. 1904 member of the Federation of Russian Artists. Exhibited abroad. 1909-1914 active as an architect. 1909-1916 the first two-volume history of Russian art was published under his editorship. 1913-1925 Curator and Director of the Tretvakov Gallery in Moscow. 1914 trip to Egypt. 1917-1960 active in work-

shops for the restoration and preservation of monuments as well as at institutes of art and art history. At the same time he was a landscape, portrait and occasionally history painter. 1922 took part in the Russian exhibition in Berlin. 1924 visited the USA for the Russian exhibition 1929 in Germany for an exhibition of icons. 1937 at the Paris World Fair. Published a long monograph on Repin, 1943 member of the Academy of Sciences of the USSR. 1947 member of the Academy of Arts. WRITINGS, DOCUMENTS: Grabar, I.F.: My Life (Russian) Moscow and Len-

My Life (Kussian) Moscow and Leningrad 1937 BIBLIOGRAPHY: Andreeva, L. and T. Kaschdan (eds.): I.G., Pisma. Moscow 1974.– Azarkovich, W.G. and N.W. Egorova: I.G. Leningrad 1974.– Podo-

Egorova: I.G. Leningrad 1974.– Poc bedova, O.I.: I.E.G. Moscow 1965 ILLUSTRATIONS: 507 After Lunch, 1907 509 Winter, 1904

GRENOUILLERE, La

Popular place for swimming and dining on the Seine island of Croissy (Ileaux-Vaches) between Bougival and Chatou. From 1848 a popular meeting place for young Parisians, who gathered there to bathe, row and dance. A jetty led to a floating restaurant, while another led to a tiny island, known as "the Flower-Pot", with a single tree growing on it. La Grenouillère was one of the birthplaces of Impressionism. 1869 with the broad, horizontal strokes of their brushwork, Renoir and Monet were able to capture the atmosphere of summer, each painting a picture of the "Frog Island" on the same day (pp. 72, 73).

GRIGORESCU Nicolae 1838 Pitaru (near Bucharest) – 1907 Cîmpina

1848-1861 trained and worked as a religious painter of icons and churches. 1861 went to Paris on a scholarship from the principality of Moldavia. 1862 studied for a time at the Ecole des Beaux-Arts, then stayed for the first time at Barbizon. 1864 after visiting his home he returned to Barbizon and Paris. 1867 exhibited for the first time at the Paris Salon. 1869-1873 in Bucharest, received a gold medal at the "Exhibition of Living Artists", and became the first important Romanian painter of landscapes and rural life. 1873 exhibited for the ifrst time at exhibitions of the Society of Friends of the Arts in Bucharest. 1873/74 travelled to Italy, Athens, Constantinople. 1876 visited Paris; the doctor and art collector G. de Bellio became an avid supporter; visited Brittany. 1877/78 painted the war against Turkey. 1879-1887 several long trips to Paris and Brittany from Romania. 1889 member of the "Ileana" society for the propagation of art. 1889 exhibited at the Paris World Fair and for the first time at the Salon of the Romanian Atheneum. 1890 settled in Cîmpina (Carpathiars). 1899 first artist to become an honorary member of the Romanian Academy.

BIBLIOGRAPHY: Cârneci, M.: N.G. Bucharest 1989 .- Jianu, J.: G. Bucharest n.d.- N.G. Pictura, grafica. Bucharest 1984 (EC) .- Opresco, G.: G. (1838-1907). Bucharest 1961.- Popesco, M.: N.G. Bucharest 1962 .- Varga, V.: N.G. Bucharest 1973.- Vasilu, A .: Marginalii la o carte despre N.G. Bucharest 1989 .- Vlahuta, A.: N.J.G. Bucharest 1911 ILLUSTRATION:

526 A Clearing, c. 1885

GROHAR Ivan

1867 Spodnja Sorica - 1911 Ljubljana 1888 trained first with local painters in Agram. 1892-1895 attended drawing school in Graz. 1895 studied in museums in Munich. 1896-1900 after a short stay in Skofja Loka, he went on the advice of his friend Rihard Jakopić to study at the Ažbè school in Munich. Painted genre pictures and paintings in the style of Arnold Böcklin. 1900-1902 in Ljubljana, exhibited some Art Nouveaustyle, Neo-Romantic pictures at the 2nd Slovenian exhibition of art. 1904 organised with Jakopić the group "Save" and the group exhibition at Miethke's gallery in Vienna; took part in the 1st South Slavic exhibition of art in Belgrade. Influenced Serbian painters. He subsequently lived mostly in Skofja Loka; painted with Jakopić, Matija Jama and Matej Sternen. Changed to an Impressionist style influenced by Pointillism. 1907 stayed in Belgrade. 1908 exhibited with the group "Save" in Cracow and Warsaw. Died in 1911 of tuberculosis.

BIBLIOGRAPHY: Stelè, F.: I.G. Ljubljana 1960

IL LUSTRATION

529 Snow in Skofja Loka, 1905

GUERBOIS → Café Guerbois

GUILBERT Yvette

1867 Paris - 1944 Aix-en-Provence Actress in various theatres; from 1890 through her extravagant appearance and double-entendre chansons she became a famous singer at the "Eldorado". Performed also at the Moulin Rouge, Eden, Ambassadeur and Scala as well as in America and England. In Paris she became a sensation. Toulouse-Lautrec designed posters for her.

GUILLAUMIN Jean-Baptiste Armand 1841 Paris - 1927 Paris

While still at school in Moulins he met Outin and Eugène Meunier, who was to become an important collector under the name Murer. 1857 at the age of 15, he began an apprenticeship at his uncle's fashion store in Paris; at the same time, he attended evening courses at the city school of drawing with the sculptor Caillouette. 1860 employed in the administration of the Paris-Orléans railway. In his spare time he attended the Académie Suisse, where he met Pissarro and Cézanne, and began painting. 1863 exhibited at the "Salon des Refusés". A regular at the Café de Bade and later at the Café Guerbois. 1866 resigned from his position to paint with his friend Outin in the Louvre and with Pissarro in the open air. Earned his living by painting window awnings with Pissarro. He then took another administrative post in the section responsible for bridges and paths, where he only had to work at night. He painted numerous landscapes in the environs of Paris and on the Seine in lively contrasting colours and broad strokes of the paintbrush. During the Franco-Prussian War he stayed with his friend Béliard in Paris. He often visited Pissarro in Pontoise and Cézanne in Auvers, where he also saw Gachet. In 1874 he took part in the 1st Impressionist exhibition. Rented an apartment in the same house as Cézanne and worked closely with him; in 1875 he rented the Daubignys' former studio. 1877-1882 exhibited at the 3rd and 5th-7th Impressionist exhibitions; rejected by Monet and Degas but defended by Pissarro. 1884 met the young Signac, but remained aloof from the new movement of Pointillism. 1884 exhibited at the Salon des Indépendants. 1886 at the last great Impressionist exhibition. Through Durand-Ruel he became known in America. 1887 married his cousin, Joséphine Charreton. Became acquainted with the art dealer Portier. 1888 first one-man show. 1891 invited to Brussels by Les Vingt. 1892 after winning a large sum in the national lottery, he gave up his job and became financially indépendent, devoting himself solely to painting. 1893 rented a house in Crozant (Creuze); travelled in Brittany, Normandy and Dauphiné; these landscapes remained his major themes.

1904 spent two months in Holland. CATALOGUE: Serret, G. and D. Fabiani: A.G. Catalogue raisonné de l'œuvre peint. Paris 1971 BIBLIOGRAPHY: Cailler, P.: A.G. Geneva 1964 .- Centenaire de l'impressionnisme et hommage à Guillaumin. Petit Palais, Geneva 1974 (EC) .- Courières, E. des: A.G. Paris 1924 .- Gray, C .: A.G. Chester (CT) 1972 .- Gros, R.: G. à Crozant. Guéret 1982 .- Lecomte, G.: G. Paris 1926 .- Rewald, J .: Cézanne and G. in: Châtelet, A. and N. Reynaud (eds.): Etudes d'art français offerts à Charles Sterling. Paris 1975, pp. 343-353

ILLUSTRATIONS:

- 69 A Path in the Snow, 1869 92 Still Life: Flowers, Faience,
- Books, 1872
- 109 Sunset at Ivry, 1873
- 154 Quai de la Gare, Snow (Quai de Bercy), c. 1875
- 205 The Seine in Winter, 1879
- 205 Barges in the Snow, 1881
- 247 The Fishermen, c. 1885
- 310 Outskirts of Paris, c. 1890 351 Landscape in Normandy: Apple
- Trees, c. 1887 351 View of Agay, 1895

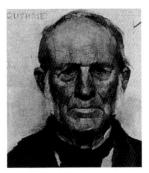

GUTHRIE James 1859 Greenock - 1930

1877 gave up his law degree to study painting at the Saint Mungo Art Club. 1879 settled in London; for a time he attended courses at the studio of John Pettie. 1882 went to Paris, where he discovered plein-air painting and changed to a freer and brighter style; influenced by Bastien-Lepage. 1884/85 decided to give up painting after plein-air studies in Berwickshire but in 1888 he was persuaded by a cousin to paint a portrait of his father; with the exception of a few landscapes in pastel, this was the start of a new and important career as a portrait painter. In his style he was influenced by his friend Whistler. 1880 member of the Glasgow Art Club; 1896-1898 President of the club. 1889 member of the New English Art Club. 1902-1919 President of the Royal Scottish Academy. BIBLIOGRAPHY: G. and the Scottish Realists. The Fine Art Society, Glasgow 1981 (EC) ILLUSTRATION: 582 The Morning Paper, 1890

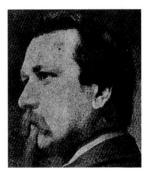

HAES Carlos de

1829 Brussels - 1898 Madrid Son of a Belgian merchant, who had emigrated to Málaga. First lessons with the painter Luis de la Cruz y Ríos in Málaga. 1850-1855 studied with Joseph Quinaux in Belgium. 1857 returned to Spain. Won the public competition for the chair of landscape painting at the Escuela de Bellas Artes de San Fernando in Madrid. His naturalistic conception of landscape exerted a strong influence on Spanish painting (Beruete, Regoyos, Morera). 1860 became a member of the Real Academía de Bellas Artes de San Fernando, 1856-1862 received a medal at the Madrid exhibition; won awards in 1864 in Bayonne, 1876 in León, 1878 in Paris and 1882 in Vienna. Numerous study trips abroad to Spain, France and the Netherlands. He bequeathed his mostly smallformat paintings to his pupils, who gave them to the Museo Nacional de Arte Moderno in Madrid. BIBLIOGRAPHY: Puente, J. de la (ed.): Los estudios de paisaje de C. de H. (1826-1898). Oleos, dibujos y grabados. Salas de Exposiciónes de la Dirección General de Bellas Artes, Madrid 1971 (EC) ILLUSTRATION: 557 A Stream at Pont-Aven

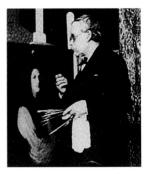

HALE Philip Leslie 1865 Boston - 1931 Boston Brother of Ellen Day and Herbert Dudley Hale. Studied with Weir at the Art Students League in New York. Travelled in Europe and studied at the Académie Julian in Paris. Returned to the USA. Taught for thirty years at the Boston Museum

School. Art critic for the Boston Herald. Married Lilian Wescott-Hale. 1913 wrote a book on Vermeer. Exponent of the more decorative style of Impressionism often seen in the work of American artists.

WRITINGS, DOCUMENTS: Hale, P.L.: Jan Vermeer of Delft. Boston 1913 BIBLIOGRAPHY: Folts, F.P. (ed.): Paintings and Drawings by P.L.H. from the Folts Collection. Voss Galleries, Boston 1966 (EC).– Hale, N.: The Life in the Studio. Boston 1969 ILLUSTRATION:

631 The Crimson Rambler, 1908

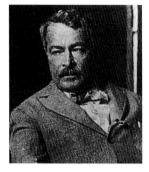

HASSAM Childe Frederick 1859 Dorchester (MA) – 1935 East Hampton (NY)

Son of a an established and wellknown Puritan family. 1876 left high school in Dorchester to train as a wood carver in Boston; 1877/78 took drawing lessons at the Boston Art Club and Lowell Institute; studied with the German painter Ignaz Gaugengigl and William Rimmer. Worked in the 1880s and 1890s as an illustrator. 1883 moved to New York; travelled in England, Spain, Italy and the Netherlands. 1886-1889 lived in Paris; attended the Académie Julian under Boulanger and Lefèbvre. Lived near the Café Guerbois and met all the important French Impressionists. Monet and Pissarro became strong influences. 1889 returned to New York: founded the New York Watercolor Club. He drew his favourite motifs from the streets of New York and captured the atmosphere of the city in a unique way. Numerous exhibitions: in New York and Boston, at the Paris Salons 1887-1890, the "Exposition internationale" at G. Petit's gallery in Paris and the international art exhibitions in Munich. Spent much of his time on Appledore Island (Maine), one of the Isles of Shoals. Painted sea and landscape pictures with Metcalf and Twachtman at various locations in the USA. Travelled extensively in Europe, Cuba and the USA. 1898 with Twachtman founded The Ten American Painters and took part regularly in their exhibitions. 1913 exhibited at the Armory Show. 1916 member of the National Academy of Design in New York and 1929 the American Academy of Arts and Letters. One of the most important American exponents of Impressionism on the French model.

WRITINGS, DOCUMENTS: Hassam, C.: Three Cities. New York 1899 BIBLIOGRAPHY: Adamo, A.: C.H. New York 1938 .- Adams, A.: C.H. New York 1938 .- Buckley, C.E. et al. (eds.): C.H. Corcoran Gallery of Art, Washington 1965 (EC) .- Catalogue of the Etchings and Drypoints of C.H. San Francisco 1989 - C.H. A Retrospective Exhibition. Corcoran Gallery of Art, Washington 1965 (EC) .- Curry, D.P. (ed.): C.H. An Island Garden Revisited. Yale University Art Museum, New Haven; The Denver Art Museum, Denver; The National Museum of American Art, New York 1990 (EC) .- Czestochowski, J.J.: 94 Prints by C.H. New York 1980.- Eliasoph, P.: Handbook of the Complete Set of Etchings and Drypoints of C.H. New York 1933 .-Fort, I.S. (ed.): The Flag Paintings of C.H. National Gallery of Art, Washington; California County Museum of Art, Los Angeles 1988 (EC) .- Griffith, F.: The Lithographs of C.H.: A Catalogue. Washington 1962 .-Hoopes, D.F.: C.H. New York 1979 .-McGuire, J.C.: C.H. New York 1929 .- Pousette-Dar, N. (ed.): C.H. New York 1922 .- Steadman, W.E. (ed.): C.H. University of Arizona Museum of Art, Tucson 1972 (EC) .-Wolfe, J. (ed.): C.H. Guild Hall Museum, East Hampton 1981 (EC) .- Zigrosser, C.: C.H. New York 1916 ILLUSTRATIONS:

- 402 Fifth Avenue at Washington Square, 1891
- 602 Grand Prix Day, 1887
- 603 Une averse. Rue Bonaparte, Paris, 1887
- 603 Rainy Day, Columbus Avenue, Boston, 1885

618 The Little Pond, Appledore, 1890 633 Sunset at Sea, 1911

639 Allies Day, May 1917, 1917

HAVEMEYER Louisine and Henry Louisine nee Waldron Elder (1848 – 1929 New York) and husband Henry (Harry) Osborne (1847 – 1907) Owners of the most famous collection of old and contemporary art in the USA. On the advice of Cassatt and Duret, they bought Impressionist paintings from Vollard, Durand-Ruel and other dealers and thus contributed enormously to the popularisation of the movement in America. Part of the collection is to be seen now at the Metropolitan Museum of Art in New York.

HAVRE (Le)

Important port in Normandy at the mouth of the Seine. Nearby towns include Saint-Adresse and Rouelles. As early as **1853** Couture went there with his pupils, who included Manet and Proust. Boudin and Monet spent their youth there; it was there that Monet painted the famous picture "Impression: Sunrise" that gave the name to the movement (p. 113). Many Impressionist sea pictures were painted there by such artists as Stevens, Pissarro and van de Velde.

HAYET Louis 1864 Pontoise – 1940 Cormeille-en-Parisis

Son of a dealer in stained glass and other decorations in Pontoise. Although his father painted, he was not in a position to give his son an artistic training. 1878 apprenticeship with a painter-decorator. Attended courses at the Ecole des Arts décoratifs; worked with various artists. 1882 met C. and L. Pissarro in Pontoise and became friends with them. 1886 met Seurat; rejected an invitation to exhibit at the 8th Impressionist exhibition. 1889 exhibited at the Salon des Indépendants. 1890 invited by Les Vingt in Brussels. 1894-1897 took part in the exhibitions of the Impressionists and Symbolists at Le Barc de Boutteville. To secure a regular income, he also worked as a theatre decor painter. Frequently went his own way; quarrelled with Pissarro and Luce; in the 1890s he gave up his Neo-Impressionism in favour of a more conservative style. Experimented with various colours and paints. 1900/01 travelled in the Alps. Provence, Auvergne and the Côte d'Azur. 1908-1910 studio in La Frette. 1924 published his autobiography and in 1925 an essay on art. CATALOGUE: Dulhon, G.: L.H. Catalogue raisonné (in preparation) ILLUSTRATION.

294 Paris, Place de la Concorde, 1888

HEYERDAHL, Hans Olaf 1857 Dalare – 1913 Oslo

1357 Dataré - 1913 Osto Born in Sweden of Norwegian parents. Studied first in Munich. 1878 went to Paris; at the Atelier Bonnat he copied Rubens, Rembrandt and Raphael. 1878 received a medal at the international exhibition in Paris. 1880 visited Florence, where he met Böcklin. Retrumed to his home country. His light and imaginative mythological scenes became extremely popular with art collectors. Showed paintings at exhibitions organised by the Société anonyme des peintres, sculpteurs, graveurs at Georges Petir's.

CATALOGUE: Aslaksby, T.: H.H., katalog. Modums Blaafarveværk 1981 BIBLIOGRAPHY: Ostby, L.: Fra naturalisme til nyromantikk. Oslo 1934.– Thiis, J.: Edvard Munch og hans samtid. Oslo 1933 ILLUSTRATION:

469 At the Window, 1881

HITCHCOCK George 1850 Providence (RI) – 1913 Marken (Netherlands)

After graduating in law, he worked from 1874 as an attorney in New York. 1879 studied at Heatherly's School of Fine Arts in London, and shortly afterwards in Paris at the Académie Julian with Lefebvre and Bouguereau. For a short period he lived in Düsseldorf, where he attended courses at the Academy. 1880 moved

HAUSSMANN Baron Georges-Eugène 1809 Paris – 1891 Paris

Civil servant from Alsace. 1853 appointed Prefect of the Seine Département by Napoleon III and until 1870 responsible for the re-modelling of the city of Paris. At enormous cost, he pushed through the process of modernisation with its straight boulevards, large squares and extensive parks. to The Hague and the studio of Hendrik Mesdag. Settled in Egmond near Amsterdam, 1885 successful exhibitions at the Paris Salon and the National Academy of Design in New York. His pictures are variations on the theme of the Dutch landscape, to which he imparted a quasi-mythical and religious depth. 1887 became an honorary member of the Salon. 1889 received the gold medal at the World Fair. 1905 returned to the USA; exhibitions in New York, Detroit and Providence. 1909 received the Austrian Order of Franz-Joseph and became a member of the National Academy of Design. ILLUSTRATION: 628 The Bride, c. 1900

HODLER Ferdinand 1853 Berne – 1918 Geneva

Came from a poor background; helped his stepfather, a decorative painter. 1867 trained with the landscape painter and souvenir maker F. Sommer-Collier in Thun. 1871-1876 studied at the art school in Geneva under B. Menn. Became interested in Corot and the French Impressionists; his style became affected by Impressionism and Realism. Became acquainted with the philosopher Carl Vogt. 1878/79 stayed in Madrid for nine months. From 1890 he developed his own monumental style with its coloured surfaces, firm outlines and symmetrical compositions with parallel forms; mainly Symbolist in content. 1891 went to Paris and joined the Rosicrucians. 1892 exhibited at the first "Salon de la Rose-Croix" in Paris. 1897 drew a design for the armoury of the Zurich Landesmuseum, for which he won first prize; it became a subject of controversy in the press. 1901-1905 took part in the Vienna Secession. Exhibited also at the Secessions in Munich and Berlin. 1905 and 1911 trips to Italy. 1907 painted a mural for the University of Jena. 1908 met Valentine Godé-Darel; drew all the stages of her illness and death in 1915. 1913 made an officer in the French Legion of Honour; executed murals for the city hall in Hannover. 1917 large retrospective in Zurich.

CATALOGUE: Loosli, C.A.: F.H. Leben, Werke und Nachlass. 4 vols. Berne 1921-1924

BIBLIOGRAPHY: Bätschmann, O.,

H.A. Lüthy and M. Baumgartner (ed.): F.H.: Sammlung Max Schmidheiny. Kunstmuseum des Kantons Thurgau, Frauenfeld 1989 (EC) .- Burger, F.: Cézanne und Hodler. Munich 1913.- Der frühe Hodler. Das Werk 1870-1890. Kunstmuseum, Berne 1981.- Eisenmann, S.F. and O. Bätschman (ed.): F.H. Landscapes. Los Angeles, New York and Chicago 1987 (EC) .- F.H. Die Mission des Künstlers. Berne 1982.- F.H. Nationalgalerie Berlin, Zurich 1983 (EC) .-Guerzoni, S.: F. H. als Mensch, Maler und Lehrer. Zurich 1952.- Hirsh, S.L.: F.H. Munich 1981 .- Hirsh. S.L.: F.H. London 1982 .- Hugelshofer, W .: F.H. Zurich 1952 .- Loosli, C.A.: F.H. Leben, Werk und Nachlass. 4 vols. Berne 1921-1924 .- Mühlestein, H .: F.H. Weimar 1914.- Müller, W.Y.: Die Kunst F.H.s. Reife und Spätwerk., 1895-1918. Zurich 1941.- Roffler, T.: F.H. Frauenfeld 1926 .- Schmidt, G .: F.H. Sein Leben und sein Werk. Erlenbach and Zurich 1942.- Selz, P.: F.H. University Art Museum, Berkeley (CA) 1972 (EC) .- Überwasser, W .: H. Köpfe und Gestalten. Zurich 1947.-Waser, M .: Wege zu Hodler. Zurich 1927.- Weese, A.: F.H. Berne 1910 ILLUSTRATIONS:

440 Apple Tree in Blossom, c. 1890440 Portrait of Louise-Delphine Duchosal, 1885

HONFLEUR

Small port in Normandy near Le Havre at the mouth of the Seine. Popular place for plein-air painting with the Impressionists and their predecessors. Among the first to paint there were Turner, Bonington, Corot, Daubigny and Dupré. In the second half of the 19th century the "school of Honfleur" was formed, which included Boudin (born in Honfleur), Cals, Jongkind and Troyon. They were followed by Monet, Bazille, Renoir, Sisley and others, who all tried to capture the mood of the sea and the effect of light on the water. The Neo-Impressionist Seurat also painted there (pp. 271-273).

the department store owner E. Hoschedé in 1863 and in 1870 inherited from her father Castle Rottenbourg in Montgeron, which became a meeting place for the artists whose pictures they collected. 1876 Monet, who the couple particularly encouraged, lived in the castle. 1874 Hoschedé organised a successful exhibition and sale of Impressionist paintings. 1878 bankruptcy and auction sale of the collection: the Hoschedé family moved in with the Monets in a house in Vétheuil. Ernest lived in Paris and in 1882 published "Impressions de mon voyage au Salon". Alice lived with Monet, moving with him to Poissy in 1881 and to Giverny in 1883. After the death of her husband she married Monet in 1892.

HUDECEK Antonín

1872 Loucká - 1941 Castolovice 1887-1890 and 1893-1895 studied at the art academy in Prague under M. Pirner and V. Brozík. 1891-1893 studied at the Academy in Munich with O. Seitz and at the private school of Ažbè. From 1897 he painted Impressionist landscapes in Bohemia, especially mountain scenery. Became friends with Slavíček. 1900 one-man exhibition in Vienna. 1901 exhibited at the Wertheim department store in Berlin. 1902 with Preisler in Italy. 1902 exhibited for the first time with the Mánes artists' federation in Prague. 1908/09 trip to Italy. 1912-1915 three exhibitions in Berlin galleries. 1916 and 1917 in the Austrian Alps. 1923 in Yugoslavia. 1927 in Italy. Bought a house in Castolovice. 1932 travelled in Italy. BIBLIOGRAPHY: A.H. Galerie vytv, umení Roudnici n. Labem 1966 (EC) - Boucková, L: A H. Oblastní galerie, Liberec 1982 (EC) .- Karlíková, L.: A.H. (Czech), Prague 1983 ILLUSTRATIONS:

517 Quiet Evening, 1900

519 A Stream in Sunshine, 1897

HOSCHEDE Alice and Ernest Alice, nec Raingo (1844 Paris – 1911 Giverny), Ernest (1837 – 1891) Collectors of Impressionist paintings (Manet, Sisley, Pissarro, Monet and others). Alice, the daughter of a rich manufacturer from Tournai, married

HUYSMANS Joris-Karl 1848 Paris – 1907 Paris Real name: Charles Marie Georges Huysmans. Symbolist writer and art critic. One of the first critics to deal positively with Impressionist concepts in his writings. Recognized Cézanne's genius as early as 1877, admired Degas and drew attention to Gauguin a his first exhibition.

L'IMPRESSIONNISTE	
danabagana".	B at the second second
TRUE MARTIN	

IMPRESSIONNISTE (L')

Art journal which appeared every Thursday during the 3rd Impressionist exhibition of **1877**; in all, there were five issues. The office was in the Galerie Legrand, and many of the articles were written by its editor, Georges Rivière, a friend of Renoir. Rivière defended the Impressionists and attempted to popularise their views on art.

INDEPENDANTS, Salon des \rightarrow Salon des Indépendants

INGRES Jean Auguste Dominique 1780 Montauban - 1867 Paris As early as 1791 he was a pupil at the academy in Toulon. 1797 pupil of J.-L. David in Paris, 1799-1801 studied at the college of art in Paris. 1802 exhibited for the first time at the Salon. 1806-1824 in Rome, then in Florence. His major influence was Raphael; he was a skilful draughtsman. His Classical "histories" and high-class, yet perceptive portraits were exhibited regularly in the Salon, and at first were often criticised as "Gothic". 1825-1834 member of the Academy and teacher in Paris. 1835-1841 as director of the French Academy in Rome, he became an internationally effective exponent of late Classicism. 1841 returned to Paris, became an influential and much acclaimed teacher. Ingres held strictly to the Classical ideal, in contrast to Eugène Delacroix and the other Romantics and also to Courbet's Realism; instead of the sensuality of colour effects he favoured a strictly linear composition, although he always worked carefully from nature studies. Ingres influenced Edgar

Degas, and was also admired by Renoir.

WRITINGS, DOCUMENTS: Schlenoff, N. (ed.): I., sources littéraires: Cahiers littéraires inédits. Paris 1956 CATALOGUES: Lapauze, H.: Les dessins de J.A.D.I. de Montauban. 8 vols. Paris 1901.- Wildenstein, G.: I. Œuvrekatalog. Paris and London 1954 .- Zanni, A.: I. Catalogo completo dei dipinti. Florence 1992 BIBLIOGRAPHY: Alain: Ingres ou le dessin contre la couleur. Paris 1949.-Alazard, J .: I. et l'Ingrisme. Paris 1950 .- Amaury-Duval, E.E.: L'atelier d'I. Paris 1878.- Cassou, J.: I. Brussels 1947.- I. Drawings from the Musée Ingres Montauban. The Arts Council of Great Britain, London 1957 (EC).- I. Zeichnungen aus dem Ingres-Museum in Montauban. Hamburger Kunsthalle, Hamburg 1961 (EC) .- Lapauze, H .: I., sa vie et son œuvre (1780-1867). Paris 1911.-Lebrot, I.: Le martyre de Saint Symphrien. Dijon 1960.- Longa, R .: I. inconnu. Paris 1942 .- Merson, O. and E. Bellier de la Chavignerie: I., sa vie et ses œuvres. Paris 1867.- Naef, H.: Schweizer Künstler in Bildnissen von I. Zurich 1963 .- Naef, H .: I. -Rome. Zurich 1962 .- Naef, H .: I. in Rome. Zurich n.d.- Picon, G.: I. Geneva 1967.- Rosenblum, R.: I. London 1985.- Toussaint, H. (ed.): Les portraits d'I. Paris 1985 (EC) .-Vedute di Roma di Ingres. Rome 1958 (EC)

- ILLUSTRATIONS:
- 14 The Bather of Valpinçon, 1808
- 15 Portrait of Madame Inès Moitessier, 1856
- 18 Angélique, 1819

INSTITUT DE FRANCE

A collective term dating from 1815 used to denote the various academies of science and arts that had existed in France since the 17th century and served as state institutions to dictate the standards and norms of cultural and scientific policy: the Académie Française, Académie des Inscriptions et Belles-Lettres, Académie des Sciences, Académie des Beaux-Arts, Académie des Sciences Morales et Politiques. The arts section had 40 members and until 1863 controlled the Paris art college (Ecole des Beaux-Arts) and the French academy in Rome. After 1863 it still had a conservative influence on the training of artists and on artistic life.

ISRAELS Isaac-Lazarus

1865 Amsterdam – 1934 The Hague Son of Jozef Israëls, the important painter of the Hague school. 1880-1882 studied at the academy in The Hague. Influenced by the Realist plein-air painting of Bastien-Lepage. 1885 moved to Amsterdam. Formed friendships with Breitner and Bauer; turned towards Impressionism. 1903-1913 lived in Paris, impressed by Degas and Toulouse-Lautrec. 1913-1915 trips to London, 1920/21 travelled in Indonesia. BIBLIOGRAPHY: LL. Stedelijk Museum, Amsterdam 1959 (EC).– Reisel,

J.H.: I.I. 1967.– Wagner, A.: I.I. 1967.– Wagner, A.: I.I. Amsterdam 1969.– Wagner, A.: I.I. Venlo 1985 ILLUSTRATION: 419 In the Dance Hall, 1893

JAPONISME

The borrowing of motifs and stylistic features from Japanese art into European and American art. A successor to the "Chinoiseries" of the 18th century, a part of the "exotisme" that followed historicism, it aimed to introduce a new aesthetic stimulation to contemporary art. Japanese artefacts such as coloured woodcuts, screens and fans had become known since 1854 when Japan was forced to begin trading with the West. The formal principles of Japanese art were gradually discovered through the Japanese sections of the World Fair from 1862, through the Paris art gallery "La Porte Chinoise", which opened in the same year, and through publications and exhibitions such as the one at G. Petit's in 1883 or the exhibition organised in 1893 by S. Bing at Durand-Ruel's. Japanese art became a catalyst and inspiration to Impressionist, Symbolist, Cloissonist and art nouveau styles, which quickly seized on such features as its use of pure, strong colours and curved lines, its fleeting movement and its asymmetry, the overstepping of frames and borders, its spatial dynamics, and its use of two-dimensional surfaces. The common motifs of Japanese art were also influential: daily life, theatre, prostitution, gardens with ponds and lilies (Monet), and the grotesque (masks and demons).

IÄRNEFELT Eero Nikolai 1863 Viborg - 1937 Helsinki 1883-1886 studied at the art academy in St. Petersburg under M.P. Clodt von Jürgensburg. Knew Repin. 1886-1891 intermittent attendance at painting classes given by Bouguereau and Robert-Fleury at the Académie Julian in Paris. Influenced by the French Realists and plein-air painters, especially Jules Bastien-Lepage. In the summer months, he painted in Finland predominantly themes of social criticism. In 1899 and 1900 he won the gold medal at the World Fair, From 1902 he worked as a teacher. 1912 appointed professor.

ILLUSTRATION: 478 Lefranc the Wine Merchant, Boulevard Clichy, Paris 1888

JIMENEZ Y ARANDA Luis

1845 Sevilla - 1928 Pontoise (France) Painter of landscapes and genre pictures. Trained with his brother José and Eduardo Cano at the art school in Seville. In 1864 he achieved some success with his pictures at the National Art Exhibition. 1867-1876 lived in Rome; made numerous trips to Paris and stayed frequently in Pontoise. Took French citizenship. 1879 and 1880 exhibited at the Salon in Paris. Exhibited at the World Fair in Paris in 1889 and in Chicago in 1893. 1864 and 1867 awards and 1893 gold medal at the Exposiciónes Nacionales de Bellas Artes in Madrid. Close observation is the key to his realistic, often highly detailed paintings. ILLUSTRATION:

553 A Lady at the Paris World Fair, 1889

JOHANSEN Viggo 1851 Copenhagen – 1935 Copenhagen

1868 studied at the art academy in Copenhagen. 1876 first exhibition. Lived in Hornback, where he painted small pictures of fishermen and scenes of ports. Trip to Paris; considerably impressed by Manet. After his marriage in 1880 he painted numerous family scenes. Experimented with various techniques. 1882-1884 trips to Holland and Paris. 1885, 1887 and 1889 exhibited at the Paris Salon and received medals. Successful exhibitions at Munich, Berlin and Chicago. 1898 and 1904 travelled in Italy. 1888-1906 professor at the women's college of art in Copenhagen. BIBLIOGRAPHY: Madsen, K .: V.J. Tilskueren 1894.- Stabell, A. (ed.): Kontrafej og Komposition. Copenhagen 1985 (EC)

ILLUSTRATION:

473 Near Skagens Østerby after a Storm, 1885

JONGKIND Johan Barthold 1819 Lattrop (Holland) – 1891 La Côte-Saint-André

Grew up in Vlaardingen near Rotterdam; worked as a solicitor's clerk. After his father's death, he studied **1836-37** at the school of drawing in The Hague as a pupil of the landscape painter A. Schelfhout. His first pictures, painted in a virtuoso but rather dry manner, reflect the traditional style of his teacher. In **1843** he received a scholarship of 200 guilders from King William II; sold a picture at the exhibition in Amsterdam. **1846-1853** settled in Paris, working at Isabey's studio and studying with Picot. Met Israëls and Chassériau and became friends with Stevens, Courbet and Troyon. In 1847, he visited Le Havre. 1848 exhibited a picture for the first time at the Salon. 1850 went to Etretat in Normandy and in 1851 accompanied Isabey a second time to Le Havre and Normandy. Influenced by French landscape painting, he developed a sketchy style and more colourful palette. By the early 1850s, his watercolours were showing Impressionist features. In 1852 he won a third medal at the Salon. Began to paint landscapes by moonlight, which later were to become very popular. 1855 returned to Holland and lived in Rotterdam until 1860. Mental problems affected his work. 1857 travelled to Paris, where he met Courbet. 1860-1870 lived a Bohemian life in Paris in great poverty. His friends organised an auction sale of work to support him financially. He made frequent trips to Nivernais, Le Havre, Honfleur, Brussels and Holland. Met Boudin, Monet and Mme Fesser, a Dutch woman with whom he managed to overcome his unstable lifestyle. 1862 painted with Monet and Boudin in Le Havre. His financial situation improved through the success and sales of his pictures, painted in powerful colours. 1870 arrested as a spy. 1873 rejected by the Salon; decided to stop exhibiting. From 1874 he lived at La Côte-Saint-André near Grenoble where, apart from short visits to Provence and Paris, he remained until his death. His palette became increasingly brighter and his style of painting simpler. Mental imbalance and persecution mania combined with alcoholism led to his death at the mental hospital in Saint-Rambert near Grenoble.

WRITINGS, DOCUMENTS: Moreau-Nélation, E.: J. raconté par lui-même. Paris 1918

CATALOGUE: Hefting, V.: J., sa vie, son œuvre, son époque. Paris 1975 BIBLIOGRAPHY: Bakker-Hefting, V .: J.B.J. Amsterdam 1964.- Boudin & J. London 1983 (EC) .- Büchler-Schild, M.: J.B.J. (1819- 1891). Seine Stellung in der Landschafts- und Aquarelltradition des 19. Jahrhunderts. Berne 1979 .- Colin, P.: J. Paris 1931 .- Hefting, V.: L'univers de J. Paris 1976 .-Hennus, M.F.: J.B.J. Amsterdam 1945.- J. and the Pre-Impressionists. Williamstown 1976 (EC).- J.B.J. 1819-1891. Dordrechts Museum et al. Tokyo 1983 (EC) .- Roger-Marx, C.: J. Paris 1932 .- Signac, P.: J. Paris n.d.

- ILLUSTRATIONS:
- 409 View of Rouen, 1865
- 410 Dutch Landscape, 1862
- 411 Rue de l'Abbé-de-l'Epée and Church of Saint James, 1872

JOSEPHSON Ernst Abraham 1851 Stockholm – 1906 Stockholm

1868-1876 studied at the art academy in Stockholm. 1873 visited Paris with his friend Hill. While a student, he also travelled in France, Spain, Italy and Holland; copied Rembrandt. 1874 studied with Gérôme in Paris. 1878 trip to Rome. 1879-1888 lived in Paris, but also painted in Sweden, Norway and Brittany. 1880 exhibited for the first time at the Salon. 1884 published two articles attacking the teaching methods at the academy in Sweden; became one of the leaders of the Swedish "Opponents". 1888 in hospital with mental illness. After his recovery he worked with greater artistic freedom and began moving towards Expressionism.

BIBLIOGRAPHY: Blomberg, E.: E.J. Gothenburg 1945.- Blomberg, E.: E.J. Stockholm 1951.- Blomberg, E.: E.J. konst. Historie-, porträtt och genremålaren. Stockholm 1956.- Blomberg, E.: E.J. konst. Från Näcken till Gåslisa. Stockholm 1959.- Hodin, J.P.: E.J. Stockholm 1942.- Jacobsson, I.: Näcken-motivet hos E. J. Gothenburg 1946 .- Mesterton, I.: Vägen till försoning. Gothenburg 1956-1957 .- Paulsson, G.: E.J.s teckningar 1888-1906. Stockholm 1918.- Zennström, P.O.: E.J. Stockholm 1946 ILLUSTRATION: 489 Autumn Sunlight, 1896

JULIAN → Académie Julian

KNIGHT Laura 1877 Long Eaton (Derbyshire) – 1972 Nottingham

Encouraged to develop her artistic talent by her mother, a teacher of drawing. 1890 studied at Nottingham Art School, where she met her future husband, Harold. 1903 trip to Holland; impressed by the pictures of the school of The Hague. 1894-1906 lived with her husband at Staithes; painted country life in muted colours.

1907 moved to Newlyn; came into contact with the circle of students around Stanhope Forbes. Her landscapes from this period are characterised by brighter, shining colours. 1918 moved to London; the new subiect matter of theatre, ballet and circus now dominated her work and she was regarded as a follower of Picasso. 1929 made Dame Laura Knight; from 1936 member of the Royal Academy, where she regularly exhibited after the Second World War. WRITINGS, DOCUMENTS: Knight, L .: Oil Paint and Grease Paint. 1936 BIBLIOGRAPHY: Dunbar, J.: L.K. Glasgow 1975 .- Fox, C .: Dame L.K. Oxford 1988 .- Grimes, T., J. Collins and O. Baddeley: Five Women Painters. Oxford 1989 ILLUSTRATIONS:

586 Flying the Kite, 1910 587 Wind and Sun, c. 1913

KOROVIN Constantin Alexeievich 1861 Moscow – 1939 Paris

1875-1886 studied at the School of Painting, Sculpture and Architecture in Moscow, mainly with Polenov; became friends with Levitan. 1881-1882 spent a year at the Academy in St. Petersburg. 1885-1919 stage designer in Moscow, at first for the private opera of S. Mamontov, at whose house in Abramcevo he was a frequent guest. 1885 the first of many trips to Paris and Spain. 1888 with Mamontov in Italy. Travelled widely within Russia, Caucasus and Central Asia. Exhibited with the "Wanderers". Painted in an Impressionist, and later an Art Nouveau style. 1894/95 visited Norway. 1896 joined the Moscow Association of Artists. Designed, to great acclaim, the pavilion at the All-Russian Exhibition of Arts and Crafts at Nishnii Novgorod. 1900 designed the decoration for the Central Asia section of the Paris World Fair; awarded with the Legion of Honour. 1901 took part in the exhibition "A Document of German Art" in Darmstadt. 1903 member of the new Federation of Russian Artists. 1905 received the title "Academic of Painting". 1909-1913 taught at the Moscow art school. Made regular visits to the Crimea. 1924 emigrated to Paris; supported by Shalyapin, he became a stage designer. He also became famous as a book illustrator.

WRITINGS, DOCUMENTS: Korowin, K.: Leben und Schaffen. Briefe, Dokumente, Erinnerungen. Ed. with an introduction by N.M. Moleva (Russian), Moscow 1963 BIBLIOGRAPHY: Basyrov, A.J.: K.A.K. 1861-1939. Leningrad 1985.- Kogan, D.S.: K.K. Moscow 1964.- Komarovskaya, N.J.: K.K. Leningrad 1961.-Moleva, N.M.: K.K. schisn i twortschestwo. Moscow 1963.- Moleva, N.M.: Zizn' mojazivopis? K.K. v Moskve. Moscow 1977 ILLUSTRATIONS: 510 Couple in a Boat, 1887 510 Café in Paris, c. 1890-1900 510 Boulevard des Capucines, Paris 1906

KREUGER Nils Edvard 1858 Kalmar - 1930 Stockholm 1874-1876 Attended the preparatory art course at the Stockholm Academy. Worked from 1876 to 1880 with E. Perséus. 1881-1887 lived in Paris, attending the Académie Colarossi; became a pupil of Laurens. Spent the summer of 1883 in Sweden and Holland. Began to paint in the French Impressionist style, mostly landscapes with animals. Active as a poster designer, did caricatures and illustrations. 1885 joined the "Opponents" the Swedish group of artists opposed to the Academy. 1886 participated in the founding of the Swedish Association of Artists and regularly contributed paintings to their exhibitions. 1887/88 painted with Bergh and Nordström in Varberg on the west coast of Sweden. 1888/89 short stay in Paris. 1889-1896 lived in Varberg, then moved to Stockholm. 1899 became one of the directors of the Swedish Association of Artists. BIBLIOGRAPHY: Boström K.: N.K. Stockholm 1948 ILLUSTRATIONS: 474 Gypsy on Öland, 1885 480 Snowy Weather, Paris, 1885

KROHG Christian 1852 Oslo – 1925 Oslo

1873 graduated in law and moved to Karlsruhe, where he studied figure painting at the Academy of Art under K. Gussow; in 1875 he followed his teacher to Berlin. Though he was impressed by Menzel and Liebermann, he preferred to paint in a Naturalist style. Formed a friendship with Max Klinger. 1878 returned to Norway.

Spent the summer months with friends (Thaulow, Ancher, Krøyer) at the small Danish fishing village of Skagen, where he painted the fishing and country life. 1881 won a state travel stipend and went to Paris. 1882 exhibited for the first time at the Paris Salon. He was strongly influenced by Manet and joined the Impressionist movement, painting mainly pictures of social criticism. 1884 began to exhibit regularly at the annual exhibitions in Oslo. He was one of the first exponents of Impressionism in his country, 1886 published the novel "Albertine" and in 1888 "A Duel". 1893 won the competition to exhibit a painting at the World Fair in Chi-

a painting at the world Fair in Chicago – the painting chosen depicts the discovery of America by Leif Erikson. 1901-1909 lived mainly in Paris, and in 1902 became a teacher at the Académie Colarossi. 1907 Chairman of the Association of Norwegian Artists. 1909-1925 Director of the newlyfounded Academy of Painting and Sculpture in Oslo.

WRITINGS, DOCUMENTS: Krohg, C.R.: Kampen for Tilværelsen. 4 vols. Oslo 1920-1921, 1989

BIBLIOGRAPHY: C.K. in "Kunstnere i Nasjonalgalleriet", IV, Oslo 1958.– Gauguin, P.: C.K. Oslo 1932.– Thue, O.: C.K. En bibliografi. Oslo 1968.– Thue, O.: C.K.s portretter. Oslo 1971

ILLUSTRATIONS:

- 470 Portrait of the Artist Karl Nordström at Grèz, 1882
- 475 Look ahead. The Harbour at Bergen, 1884
- 479 Portrait of the Artist Gerhard Munthe, 1885
- 497 Parisian Hackney Cab Driver, 1898

KRØYER Peder Severin

1851 Stavanger - 1909 Skagen Brought up by his foster-father, the famous zoologist Henrik N. Krøyer. At the early age of ten, he was already drawing illustrations for his father's books. 1864-70 studied at the academy in Copenhagen. 1871-72 exhibited portraits in Copenhagen and in 1873 received the small gold medal; commissioned by the exhibition committee to do a portrait of the flower painter Ottesen, which attracted much attention. Spent the summer in Hornbaek. 1877 travelled via Holland and Belgium to Paris, where he studied at Bonnat's studio,

learning the rigorous techniques of French Naturalism with its precise observation of surface and light effects, its purity and brightness of colour and its large forms and simplified composition. **1878** travelled in Spain and copied Velázquez. **1879** painted at Cernay-la-Ville and Concarneau. **1880/81** tour of Italy, rejected the Romantic view of Italy all too prevalent at that time in Denmark. In **1881**, he won a medal in Paris for his Naturalist picture "Italian Village Roofers".

He returned to Denmark that year, spending almost every summer from then on at his house in Skagen. With the Anchers, C. Locher and Johansen in the artists' colony there he began to paint plein-air in a style influenced by Krohg. He became a leading member of the Skagen painters. His palette also brightened considerably. In 1883 he exhibited at the Paris Salon, and later also at Georges Petit's. From 1882 to 1904 he undertook periods of teaching at the school of art in Copenhagen, but in 1890 rejected the offer of a professorship at the Copenhagen academy. 1899 became ill with severe depression and paranoia. BIBLIOGRAPHY: Bramsen, H.: P.S.K. Syv Stykker om Kunst. Copenhagen 1955 .- Christensen, H.C.: P.S.K. Fortegnelse over hans Oliemalerier. 1923.- Hannover, E.: P.S.K.: Abends am Strande. Leipzig 1907 (Meister der Farbe, No. 1).- Hornung, P.M.: P.S.K. Tølløse 1987.- Lomholt, A.: Et Møde i Videnskabernes Selskab. P.S.K.s Malerie og dets Tilblivelse. Copenhagen 1954.- Mentze, E.: P.S.K. Kunstner af stort format - med braendte vinger. Copenhagen 1980 ILLUSTRATIONS: 476 Hip, Hip, Hooray! An Artists'

Party at Skagen, c. 1884-1888 477 Artists at Breakfast, 1883 493 Bathing Children, 1892

$LAMY \rightarrow Franc\text{-}Lamy$

LA THANGUE Henry Herbert 1859 Croydon – 1929 London Studied at the Royal College of Art, the Lambeth School of Art and the Royal Academy School. From 1878 exhibited at the Royal Academy, where he won the gold medal in 1879. 1879-1882 attended Gérôme's lessons at the Ecole des Beaux-Arts in Paris. Influenced by the plein-air painting of Bastien-Lepage. Travelled in Brittany and Dauphiné. **1884** returned to England and settled in Norfolk. **1886** co-founder of the English Art Club. Tried unsuccessfully to establish an alternative exhibition to the Academy. **1891** moved to Bosham (Sussex). Trips to Italy and Provence; thereafter the Mediterranean landscape became the main subject of his paintines.

BIBLIOGRAPHY: McConkey, K. (ed.): A Painter's Harvest: Work by H.H. L.T. R.A. 1859-1929. Oldham Art Gallery, Oldham [no date of publication] (EC) ILLUSTRATION: 583 In the Orchard, 1893

LATOUCHE Louis 1829 La Ferté-sous-Jouarre – 1884 Paris

Owner of art shop on the corner of the Rue Lafitte and the Rue Lafayette. Friendly with the young Impressionist painters (Monet, Pissarro); supported them and exhibited their paintings for sale in the rooms of his shop. His customers included Gachet and Amand Gautier. At a meeting on his premises in 1867, Sisley, Bazille, Pissarro and Renoir decided to form a "Salon des Refusés". From 1866 he exhibited in the Salon. Took part in the 1st Impressionist Exhibition of 1874 with four works.

LAURENS Jean-Paul

1838 Fourquevaux (Haute-Garonne) - 1921 Paris

1854 Art school in Toulouse, then at the Paris School of Art. 1872 first success in the Salon with his history paintings – exciting compositions, faithful to detail and painted in rich colours. Numerous large murals, including those of the Paris Panthéon. 1885 Professor at the Paris School of Art. 1891 joined the Academy as successor to Meissonier.

BIBLIOGRAPHY: Guitton, J.: J.-P.L. (1875-1937). Paris 1957 ILLUSTRATION: 166 The Excommunication of Robert

the Pious, 1875

LA VIE MODERNE \rightarrow Vie Moderne

LAWSON Ernest 1873 San Francisco – 1939 Miami Beach

1889-1891 worked as a graphic designer in Mexico. 1891 studied at the Art Students League in New York under Twachtman and Weir; attended the summer courses in Cos Cob. In 1893 moved to Paris; studied at the Académic Julian. 1894 exhibited for the first time at the Salon. Influenced heavily by the Impressionist style of Sisley. 1894 returned to the USA, settled on New York's Washington Heights. Painted numerous pictures in fresh, bright colours with motifs of Manhattan and the Harlem River.

1904 met William Glackens. 1906 moved to Greenwich Village. 1907 Exhibition at the Pennsylvania Academy of the Fine Arts. In 1908 he became a member of The Eight. Exhibited in 1910 with the "Independent Artists". 1913 at the Armory Show with various Canadian groups. 1916 travelled in Spain; then in the Soviet Union and the West and South of the USA. In the 1920s he taught at Colorado Springs and Kansas City. **1936-1939** lived for health reasons in Florida.

BIBLIOGRAPHY: Anderson, D.R. (ed.): E.L. Exhibition. ACA Galleries, New York 1976 (EC).- Berry-Hill, S. and H.: E.L., American Impressionist, 1873-1939. Leigh-on Sea 1968.- E.L. Whitney Museum of American Art, New York 1932 (EC).- Karpiscak, A.L. (ed.): E.L. 1878-1939. University of Arizona Museum of Art, Tucson 1979 (EC).- O'Neal, B. (ed.): E.L., 1873-1939. National Gallery of Canada, Ottawa 1967 (EC).- Price, F.N.: E. L., Canadian American. New York 1939

ILLUSTRATIONS:

638 Harlem River, c. 1913-1915 638 Spring Night, Harlem River, 1913

LEBASQUE Henri

1865 Champigné (Maine-et-Loire) -1937 Cannet (Alpes-Maritimes) Studied at the Ecole des Beaux-Arts under Bonnat. 1896 first exhibition at the Salon. Frequently visited Pissarro, whose Impressionist style overlay Bonnat's academic influence. Commissioned by the architect Perret to supply the decoration for the Théâtre des Champs-Elysées. In 1937 he contributed a significant part of his work to the exhibition "Peintres Indépendants" in the Petit Palais. CATALOGUE: Bazetoux, D.: H.L. Catalogue raisonné (in preparation) BIBLIOGRAPHY: Banner, L.A. and P. Fairbanks: L. San Francisco 1986.- L. 1863-1937. Montgomery Gallery, San Francisco 1986 (EC) .- Vitry, P .: H.L. Paris 1928 ILLUSTRATION:

385 View of Saint-Tropez, 1906

LEBEDA Otakar

1877 Prague – 1901 Malé Chuchel 1892-1897 studied at the Prague Academy of Art under Julius Marák; painted mountain landscapes. 1896 travelled in Italy. 1897 stayed in Paris. 1898 Lebeda travelled via Munich to Paris, attended the Académie Colarossi and painted landscapes in the forest of Fontainebleau, in Brittany and Normandy. Exhibited in Prague at the Mánes art federation. 1899 in Bohemia and Brittany, became neurotic and committed suicide.

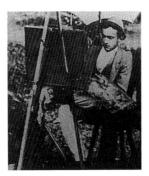

BIBLIOGRAPHY: Macková, O.: O.L. Prague 1957 ILLUSTRATION: 517 Lilac. Village Path, 1899

LEBOURG Albert-Charles 1849 Montfort-sur-Risle – 1928 Rouen

Worked first in an architect's office in Rouen. Attended the Ecole municipale de peintre et de dessin in Rouen; took drawing lessons with Victor Delamarre. In 1867 visited Paris and was captivated by the pictures of Courbet and Manet on show at the Salon. His landscapes reveal their influence. 1872-1876 Professor of graphic art at the Société des Beaux-Arts d'Alger. As Monet and Sisley were later to do, he often painted the same motif seen in different lights. In 1873 he married in Rouen. 1877 moved to Paris and worked for two years under Laurens, as preparation for the examination of the city of Paris for teachers of drawing. 1879 and 1880 took part in the 4th and 5th Impressionist Exhibitions. 1883 first admitted to the Salon. 1884 long stay in the Auvergne. 1886-1895 lived alternately in Paris and in Normandy. Travelled in 1895/96 and again in 1896/97 to Holland; 1900 visited England and 1902 Switzerland, 1905 in Bordeaux and La Rochelle. 1900 exhibited at the World Fair. 1918 large retrospective at Georges Petit's in Paris.

CATALOGUE: Bénédite, L.: A.L. Paris 1923.– Walter, R.: A.L. Catalogue raisonné (in preparation) BIBLIOGRAPHY: Bergeret, A.-M. et al. (eds.): A.L. 1849-1928. Musée Eugène-Boudin, Honfleur; Musée de la Chartreuse, Douai. Honfleur 1989 (EC). – Cartier, J.A.: A.L. Geneva 1955. – Lespinasse, F.: A.L. 1849-1928. Arras 1983. – Melki, A. (ed.): Exposition A.L. Galerie Art Melki, Paris 1976 (EC). – Schurr, G.: A.L. Galerie Art Melki, Paris 1976 (EC) ILLUSTRATIONS:

313 Road on the Banks of the Seine at Neuilly in Winter, c. 1888

383 Barges at Rouen, 1903

LEGA Silvestro 1826 Modigliana - 1895 Florence 1843 moved to Florence to study at the Accadémia under Servolino and Gazzarini; shortly afterwards he moved to the school of Luigi Mussini, an admirer of Ingres. 1848/49 volunteered for the Italian wars of liberation and unification. 1850 continued his studies in Florence. 1852 received the silver medal at the Concorso Triennale of the Accadémia for the picture "David playing before Saul". Frequented the Caffè Michelangiolo; in 1857 he took up plein-air painting under the influence of the Macchiaioli. 1857-1863 painted in the Church of Madonna del Cantone in Modigliana; developed into a Realist. 1861-1870 painted plein-air with other artists in the Piagentina area; this loose association became known as the "School of Piagentina". In 1870 received the silver medal for an exhibition in Parma. In 1872 he contracted an eye disease, which together with family affairs prevented him from painting. In 1875 with Borrani he opened a gallery for modern art in Florence, but it only survived for a short period. Through exhibitions of the Società Donatello he became acquainted with French Impressionist and Naturalist painting. In the 1880s he resumed painting under this new influence. From 1886 he was frequently a guest at the household of the Bandini family in Poggio Piana al Gabbro; he gave the two daughters painting lessons and also painted numerous landscapes himself. CATALOGUE: Matteucci, G.: L. L'opera completa. 2 vols. Florence 1987 BIBLIOGRAPHY: Daddi, G.: S.L. Spunti ed appunti. Oggiono 1978.-Dini, P.: S.L. Gli anni di Piagentina. Turin 1984.- Giardelli, M.: S.L. Milan 1965 .- Pepi, C. (ed.): S.L. in una raccolta privata. Villa di Poggio Piano, Il Gabbro. Livorno 1990 (EC) .-

Matteucci, G.: Dipinti noti e inediti di S.L. Florence 1977.- Signorini, T.: S.L. Florence 1895.- S.L. Museo Civico, Bologna 1973 (EC).- S.L. Dipinti. Palazzo della Permanente, Milan; Palazzo Strozzi, Florence 1988 (EC).- Somare, E.: S.L. Milan 1926.-Valsecchi, M.: L. Milan 1950 ILLUSTRATIONS: 536 The Pergola, 1868 536 Giuseppe Mazzini on his Death Bed, 1873 538 Reading, 1875

LEGROS Alphonse

1837 Dijon - 1911 Watford Trained with a painter of devotional art. Worked with a decorative painter in Dijon, where he attended the Ecole des Beaux-Arts, 1851 at the school of drawing of Lecocq de Boisbaudran in Paris; became friends here with Fantin-Latour and Whistler. Until 1855 he attended the Ecole des Beaux-Arts in Paris. Exhibited in 1857 for the first time in the Salon. Joined the circle around Courbet. At the invitation of Whistler, he travelled in 1860 to London. In 1861 he had some success in the Salon with an ex-voto. Often with Manet in the Café de Bade or the Café Guerbois. Had difficulty finding a market for his paintings and drawings in Paris. In 1862 he travelled in Spain. Moved in 1863 to London, where he never felt fully at home. Through the intercession of Whistler, he obtained a post as teacher of drawing at the Royal College of Art; taught with success. He exhibited in 1876 at the Royal Academy. 1870-1875 supported Durand-Ruel in the setting up of exhibitions by the Society of French Artists in London. In 1876 he took part in the 2nd Impressionist Exhibition with 25 works. 1876-1892 Professor at the Slade School. 1890 individual exhibition at the gallery of Durand-Ruel. Commissioned as a sculptor by the Duke of Portland for two monumental fountains in the park of Welbeck Abbey. BIBLIOGRAPHY: A.L. Peintre et Graveur (1837-1911). Musée des Beaux-Arts, Dijon 1957 (EC) .- Seltzer, A .: A.L.: The Development of an Archaic Visual Vocabulary in 19th-Century Art. Doctoral thesis, State University of New York. Binghampton (NY) 1980 ILLUSTRATION:

166 Communion, c. 1876

LEISTIKOW Walter 1865 Bromberg/Bydgoszcz – 1908 Berlin

Studied art at the Berlin Academy and with Eschke and Grube. 1890-1893 teacher at the Berlin School of Art. Friendly with the Naturalist writers G. Hauptmann, M. Halbe and A. Holz. 1892 co-founder of the literary group "Vereinigung der XI". His first novel "Auf der Schwelle" ("On the Threshold") appeared in 1896. 1898 rejection of his picture "Sunset over Lake Grunewald" (p. 448) by the Great Berlin Exhibition; formation of the Berlin Secession, of which he was a committee member until his death. In the 1880s he travelled to Denmark and Sweden. Painted impressionistic, atmospheric pictures of the Nordic landscape of forests and lakes. From 1890 he became influenced by Art Nouveau, Japanese wood cuts and Puvis de Chavannes. ILLUSTRATION:

448 Sunset over Lake Grunewald, 1898

LEMMEN Georges 1865 Schaerbeek – 1916 Uccle

Attended courses for a short period at the school of drawing in St. Josse-ten-Noode. Around 1880 he became influenced by Degas and Toulouse-Lautrec. 1888 joined the group Les Vingt in Brussels; became an important supporter of "Libre Esthétique". He published articles on art in the journal of Les Vingt, "L'Art moderne", against the prevailing dogma. 1890-1893, under the influence of van Rysselberghe, he moved towards Neo-Impressionism; painted numerous portraits. Exhibited at the Salon des Indépendants in Paris. He later freed himself from Pointillism and painted in a more traditional, Belgian style. Travelled in England and became interested in artefacts. His wide-ranging work includes numerous book illustrations, posters, ceramics, carpets, drawings, pastels and gouaches. WRITINGS, DOCUMENTS: Elslander, J.F.: Figures et souvenirs d'une belleépoque. Brussels 1950 CATALOGUE: Cardon, R.: G.L. (1865-1916). Monographie générale suivi du catalogue raisonné de l'œuvre gravé. Antwerp 1990, Cologne 1992 BIBLIOGRAPHY: G.L. Musée Horta, Brussels 1980 (EC) .- G.L.: dessins et estampes. Bibliothéque Royale.

Brussels 1965 (EC).- Nyns, M.: G.L. Antwerp 1954 ILLUSTRATIONS: 424 View of the Thames, 1892 425 Self-Portrait, 1890

LEPIC Vicomte Ludovic-Napoléon 1839 Paris – 1889 Paris

Son of one of the Emperor's adjutants. At first a pupil of Cabanel, Wappers and Verlat. Studied at Gleyre's studio with Bazille and Monet, with whom he became friends. A close friendship developed, through a female cousin, with Degas, and he often went riding with the latter's brothers. With Degas he went to the opera and the horse races; in the painting "Gentlemen's Race. Before the Start" (p. 10), he is depicted as one of the amateur jockeys. Worked in Paris, in Berck and at the sea. Degas persuaded him to exhibit at the 1st Impressionist exhibition in 1874. Showed 36 landscapes at the 2nd Impressionist Exhibition at Durand-Ruel's gallery in 1876. Through his private income and influence he supported his fellow painters, but nevertheless attempted to exclude Cézanne from group exhibitions. After being banned by the Impressionists from exhibiting at the same time in the Salon, Lepic refused to take part in any of their exhibitions. He achieved surprising effects through new graphic techniques. 1872 founded the Musée d'Aix-les-Bains and became its first curator, 1879 individual exhibition at the Gallery "La vie moderne". Travelled to Egypt and Pompeii, where he took part in excavations. Exhibited in 1883 at the Musée des Arts décoratifs. Caillebotte described him in a letter to Pissarro: "Lepic, Heaven knows, has no talent". Viscount Lepic is portrayed with his daughters in Degas' painting "Place de la Concorde" (p. 169).

LEPINE Stanislas Victor Edouard 1835 Caen – 1892 Paris

Grew up in an artisan family. Probably studied under Corot. Influenced in his choice of themes by Jongkind. Exhibited from 1859 at the Salon. 1873 joined the Société anonyme des peintres, sculpteurs et graveurs. In 1874 he took part in the 1st Impressionist Exhibition; he exhibited in 1886 with Durand-Ruel in the USA. Mainly painted views of Paris and its outskirts. Few people bought his pictures; organised exhibitions and sales of work at the Hôtel Drouot. Exhibited in 1889 at the World Fair. Died in poverty; friends collected money to pay the funeral costs. BIBLIOGRAPHY: Couper, J.: S.L. (1835-1892), sa vie, son œuvre. Paris 1969.– Rostrup, H.: L., La Seine vers Rouen. In: Meddelelser fra Ny Carlsberg Glyptotek 30 (1973), pp. 7-14 ULUSTRATIONS:

68 Banks of the Seine, 1869 202 The Seine near Argenteuil 202 Paris, Pont des Arts, c. 1878-83

LEROY Louis Joseph

1812 Paris - 1885 Paris Painter, graphic artist, writer and critic. Exhibited 1835-1881 at the Salon in the style of the Barbizon School; wrote several successful comedies. In his critical article on the 1st Impressionist Exhibition, which appeared in the "Charivari" of 25th April 1874 under the headline "Exposition des impressionnistes", Leroy first used the term "Impressionists", which was immediately taken up by the rest of the press and gave a name to the movement. In 1864 Leroy had already severely criticised Manet's painting "Bullfighters", which was exhibited in the Salon.

LE SIDANER Henri 1862 Port Louis (Mauritius) – 1939 Paris

In 1880 he moved to Paris and studied at the Ecole des Beaux-Arts under Cabanel. Influenced by Manet and Monet. 1882- 1887 frequently in Etaples, where he painted landscapes. He exhibited from 1887 at the Salon and in 1891 he received a medal for his picture exhibited there. Member of G. Petit's Société internationale. 1896-1900 Symbolist period; his choice of theme had literary inspiration. 1897 first individual exhibition at the Mancini gallery. 1898/99 lived in Bruges. In 1902 he settled in Gerberoy. Travelled to Holland, in 1905 to Venice and 1907/08 to London. 1929 member of the Académie Royale des Beaux-Arts in Brussels. Numerous awards: 1901 gold medal in Munich; 1908 second medal in Pittsburgh; 1914 Chevalier de la Legion d'Honneur; 1925 Carnegie award. From 1937 President of the Académie des Beaux-Arts in Paris.

CATALOGUES: Farinaux-Le-Sidaner, Y.: H.L.S. Catalogue raisonné de l'œuvre gravé et peint. Paris 1990 BIBLIOGRAPHY: H.L.S. Musée de la Ville. Dunkirk 1974 (EC).– H.L.S. Musée Marmottan. Paris 1989 (EC).– Mauclair, C.: H.L.S. Paris 1928 ILLUSTRATIONS: 386 Table beneath Lanterns, Gerberov.1924

386 14th July, Gerberoy, 1910387 House by the Sea at Dusk, 1927

LEVERT Jean-Baptiste-Léopold

Born 1828, active as landscape painter, graphic artist and designer of military clothing. Friends with the Rouart brothers, whom he visited regularly after the war of 1870, and with Degas, who persuaded him to join the Impressionists. 1874-1879 participated in the 1st-3rd and the 5th Impressionist exhibitions.

LEVITAN Isaac Ilyich 1860 Kibartai, Lithuania – 1900 Moscow

1873-1885 studied under Savrassov and Polenov at the School of Painting, Sculpture and Architecture in Moscow; as a Jew, he was from time to time refused entry to the city. He finally received a silver medal but was only given a diploma as a teacher of calligraphy. Friendship with Anton Chekhov and his brothers. Exhibited in 1884 for the first time at the "Wanderers". 1886 the first of many trips to the Crimea, mainly staying on the Volga. His poetic appreciation of the Russian landscape was highly praised. 1890-1899 trips to France, Italy, Austria, Switzerland, Finland and Germany. 1892 excluded several times from Moscow. Increasingly ill with nervous complaints and heart trouble. 1898 Teacher of landscape painting at the Moscow School of Art. In St. Petersburg he was represented for the first time at an exhibition organised by Diaghilev.

WRITINGS, DOCUMENTS: Fyodorov-Davydov, A.A. (ed.): I.I.L. Pisma, Dokumenty, vospominaniya. Moscow 1956

BIBLIOGRAPHY: Druzinin, S.N. (ed.): I.I.L. Moscow 1963.– Fyodorov-Davydov, A.A.: I.I.L. 2 vols. Moscow 1966.– Fyodorov-Davydov, A.A.: T.W. Yurova, I.I. L. Leningrad 1988.– Glagl, S. and I. Grabar: I.I.L. Moscow n.d.– Kovalenskaya, T.: I.I.L. Moscow 1938.– Paustowski, K.: I.L. Dresden 1965 ILLUSTRATIONS: 506 Golden Autumn, 1895 506 Birch Grove, c. 1885-1889

LIEBERMANN Max 1847 Berlin – 1935 Berlin

Began his studies in 1863 in the studio of Carl Steffeck. 1866 studied at the Faculty of Arts, Berlin University. 1868-1872 studied at the Weimar Academy of Art with Charles Verlat, Paul Thumann and Ferdinand Pauwels. In 1871 with the landscape painter T. Hagen he visited the Düsseldorf studio of Michael Lieb von Munkácsy; the visit made a decisive impression on him. In 1872, drawing on the tonal Realism of Leibl, he painted his first large painting "Plucking Geese", which received great acclaim, but also criticism. 1872 trip to Paris and study visit to Holland. 1873-1878 lived in Paris and followed the styles of Courbet, Millet and Ribot. Spent the summer months in Barbizon and 1876 in Amsterdam, where he imitated Franz Hals. 1878 extended visits to Berlin, Tirol and Venice; settled in Munich. At the Glaspalast in 1879 he exhibited the large painting "Christ in the Temple", which caused a scandal because of its realistic depiction of the scene. 1884 moved to Berlin. Until 1913 worked frequently in Holland. His encounter with French Impressionism in the early 1890s led to a brighter and more colourful palette. With form as his starting point, he focused on movement and rhythm as the main principle of his Impressionist style. Founded with Leistikow in 1892 the "Union of the Eleven". 1897 successful participation in a group exhibition within the Great Berlin Exhibition; awarded the gold medal and the title of Professor. 1898 appointed as member of the Academy. 1898 Co-founder of the Berlin Secession, 1899 its President. Even in old age he still painted, primarily scenes from around his country house on the Wannsee, where he lived from 1910. 1920 appointed president of the Akademie der Bildenden Künste; 1932/33 Honorary President.

WRITINGS, DOCUMENTS: Busch, G. (ed.): M.L. Die Phantasie in der Malerei. Schriften und Reden. Frankfurt am Main 1978.– Eipper, P.: Ateliergespräche mit L. und Corinth. Munich 1971.– Küster, B.: M.L. Ein Maler-Leben. Hamburg 1988.– Landsbergen, F. (ed.): M.L. Siebenzig Briefe. Berlin 1937.– Lichtwark, A.: Briefe an M.L. Hamburg 1947.– Liebermann, M.: Die Phantasie in der Malerei. Berlin 1916.– Liebermann, M.: Gesammelte Schriften. Berlin 1922.– Liebermann, M.: Künstlerbriefe über Kunst. Dresden 1957

CATALOGUE: Schiefler, G.: M.L. Sein graphisches Werk 1876-1923. 3 vols. Berlin 1907-1923 (Reprint: San Francisco 1991)

BIBLIOGRAPHY: Branner, L.: M.L. Berlin 1966.- Bunge, M.: M.L. als Künstler der Farbe. Berlin 1990.- Busch, G.: M.L. Maler, Zeichner, Graphiker. Frankfurt am Main 1986.- Eberle, M.(ed.): Max Liebermann in seiner Zeit. Haus der Kunst, Munich; Nationalgalerie, Berlin, Munich and Berlin 1979 (EC) .- Friedländer, M.J.: M.L.s grafische Kunst. Dresden 1920.- Friedländer, M.J.: M.L. Berlin 1925.- Hancke, E.: M.L. Berlin 1923.- Küster, B.: M.L. Ein Künstler-Leben. Hamburg 1988.- Meissner, G.: M.L. Leipzig 1986.- Lenz, C.: M.L., "Münchner Biergarten", Munich 1986.- M.L. Niedersächsische Landesgalerie, Hanover 1954 (EC) .-M.L. Deutsche Akademie der Künste, Berlin 1965 (EC) .- Stuttmann, F .: M.L. Hannover 1961

- ILLUSTRATIONS:
- 432 Munich Beer Garden, 1884
- 434 Plucking Geese, c. 1870/71
- 435 The Orphanage at Amsterdam, c. 1881/82
- 442 Woman with Goats, 1890442 St. Steven's Foundation, Leyden, 1889
- 443 Boys Bathing, 1898
- 449 "De Oude Vinck" Restaurant, Leyden, 1905
- 453 Man with Parrots, 1902
- 453 The Parrot Walk, 1902
- 455 The Beach at Nordwijk, 1908
- 459 At the Races, 1909
- 462 Self-Portrait, 1911

LOISEAU Gustave 1865 Paris – 1935 Paris

Son of a merchant, trained first with a decorative artist. A legacy enabled him to dedicate himself full-time to his art. 1888 attended the Ecole des Beaux-Arts and studied in 1889 with the painter Quignon. 1890 moved to Pont-Aven, where he met his friends Moret and Maufra, who shared the same Impressionist style of painting, and Gauguin and Bernard. Exhibited 1891-1895 with the Neo-Impressionists at Le Barc de Boutteville, in the gallery of Durand-Ruel and at the Salon de la Nationale. His views of Paris are famous. Travelled frequently in Normandy, along the Seine, on the cliff coast of Dieppe and in the Dordogne. 1901 large single exhibition at Durand-Ruel's. Stayed often in Pontoise, where he visited Gachet. 1927 settled on the Quai d'Anjou on the Seine.

CATALOGUE: Imbert, D.: G.L. Catalogue raisonné (in preparation) BIBLIOGRAPHY: G.L. Retrospective. Galerie des Granges, Geneva 1974 (EC).– G.L. Musée Pissarro. Pontoise 1981 (EC).– G.L. Didier Imbert Fine Arts, Paris 1985 (EC).– Melas-Kyriazi, J.: G.L. l'historiographe de la Seine. Athens 1979 ILLUSTRATIONS:

378 Orchard in Spring, c. 1899-1900
378 Banks of the Seine, 1902
379 Cap Fréhel and "La Teignouse" Cliffs, 1906

LOUVECIENNES

Village on the left bank of the Seine to the east of Paris, between Bougival and Versailles. Became popular as a place to stay and paint for many Impressionists, such as Degas, Manet, Morisot and Sisley. Renoir often went to visit his parents, who lived here. Pissarro stayed here 1869/70 and 1871/72 (pp. 82, 83, 99, 106), and Sisley lived here during the Paris Commune (pp. 84, 98, 158, 183).

LUCAS Y PADILLA Eugenio 1824 Alcalá de Henares – 1870 Madrid

Studied at the Academy in Madrid with Camarón, J. Madrazo and Tejeo. He became infamous for his copies of Spanish masters (Goya, Velázquez) although these were not forgeries, but free imitations. Considerably influenced by Goya, he painted figures, histories and portraits. He had a talent for landscapes in small format, which, despite their indebtedness to Romanticism, have a directness and spontaneity of their own.

LUCE Maximilien 1858 Paris – 1941 Paris

After an initial training as a wood carver at the Ecole des Arts décoratifs, he began to study art with Hildebrand in 1872 and took evening courses with Maillart. Up to 1885 he studied at the Académie Suisse and the studio of Carolus-Duran at the Ecole des Beaux-Arts. Earned his living as a wood carver with Eugène Froment and Auguste Lançon. In his painting, he became influenced by Impressionism. 1877 travelled with Froment to London. 1879-1883 military service. 1887 exhibited at the Salon des Indépendants. 1888 first individual exhibition on the premises of the journal "La Revue indépendante". Met Pissarro, Seurat, Signac and Angrand and joined the Neo-Impressionist group. 1889 invited to exhibit in Brussels with the Twenty; exhibited 1895 and 1897 at the Libre Esthétique in Brussels and in France at Le Barc de Boutteville and at Durand-Ruel's. 1871 came under the influence of Pissarro's Anarchist ideas and formed friendships with the Anarchist writers and journalists Jules Christophe, Jean Grave, Georges Darien and Emile Pouget; 1894 became involved in the the trial of the Thirty and served a short term of imprisonment. Until 1904 he lived in Montmartre, whose streets became a favourite subject for his paintings, 1900 exhibited at the World Fair. 1904-1924 lived in Auteuil, then moved back to Paris. Besides street scenes and motifs like factories and wharfs, he painted numerous landscape paintings on his travels through the Etampes, Normandy and Brittany. During the First World War he also painted war scenes: pictures of the wounded and homecoming soldiers. 1934 elected President of the Société des Artistes Indépendants after Signac's retirement.

CATALOGUE: Bazetoux, D. and J. Bouin-Luce: M.L. Catalogue de

l'œuvre peint. 2 vols. Paris 1986 BIBLIOGRAPHY: Cazeau, P.: M.L. Lausanne and Paris 1982.– M.L. Maison de la Pensée Française. Paris 1958 (EC).– M.L. Palais des Beaux-Arts. Charleroi 1966 (EC).– M.L., un pointilliste. Musée Toulouse-Lautrec. Albi 1977 (EC).– M.L. Musée Marmottan. Paris 1983 (EC).– Tabarant, A.: M.L. Paris 1928 ILLUSTRATIONS:

295 Paris Seen from Montmartre, 1887

374 Notre-Dame, 1900

374 Notre-Dame, 1901

375 La Sainte-Chapelle, Paris, 1901

LUCHIAN Stefan 1868 Stefanesti – 1916 Bucharest

1885-1889 studied at the school of art in Bucharest, where he also exhibited his first pictures. 1889/90 studied at the Academy in Munich under Herterich. 1890-1893 at the Académie Julian in Paris, influenced by Impressionism and Symbolism. 1893 settled in Bucharest. 1894 exhibited for the first time at the "Exhibition of Living Artists". 1896 organised with others an exhibition of independent artists. 1898 exhibited at the "Ileana" society for the encouragement of art. 1902 founder member of Tinerimea Artistica ("Artistic Youth"); despite a crippling disease, he became the leading force behind modern painting in Romania. 1920 almost totally paralvsed.

CÁTALOGUE: Jianu, I. and P. Comarnescu: S.L. (Rom.). Bucharest 1956 BIBLIOGRAPHY: Alexandru, I.: L. Bucharest 1978.– Ciuca, V.L. Bucharest 1984.– Eliasberg, N.E.: S.L. Moscow 1983.– Lassaigne, J.: S.L. Bucharest 1972

ILLUSTRATIONS:

- 525 Anemones
- 526 The Last Race, 1892

526 Anemones, 1908

MACCHIAIOLI

Group of Italian painters who gathered in and around Florence to paint plein-air with short brush strokes and their characteristic spots of paint (macchia) in reaction against the academic style. From **1853** the first members of the movement, including Signorini and Abbati, began to meet in the Caffè dell'Onore au Borgo della Croce; later the venue became the Caffè Michelangiolo, where they met to discuss political and artistic freedom. The group was influenced by the Barbizon school and later by French Impressionism; its members included Fattori, De Nittis, Boldini, Lega and Zandomeneghi.

MACTAGGART William 1835 Campbelltown - 1910 Broomiekwnowie, Edinburgh Son of a working-class family; 1852-1859 studied at the Trustee's Academy in Edinburgh under Robert Scott Lauder. 1856/57 won several prizes at the Royal Scottish Academy. His naturalistic style was influenced by the English Pre-Raphaelites, whom he met in 1857 at the Manchester Art Treasure Exhibition. Published two plays, "The Wreck of the Hesperus" (1861) and "Dora" (1868). 1870 made a member of the Royal Scottish Academy; exhibited there regularly until 1895. Made only three short trips to the Continent. His highly expressive coastal landscapes, which capture moods and dissolve forms to the point of abstraction, reveal his acquaintance with contemporary painting on the continent. He never really became known outside his native Scotland

BIBLIOGRAPHY: Caw, J.L.: W.McT. A Biography and an Appreciation. Glasgow 1917.– Errington, L. (ed.): W.McT. 1835-1910. National Gallery of Scotland, Edinburgh 1989 (EC).– Sir W.McT Scottish National Gallery of Modern Art, Glasgow 1968 (EC) ILLUSTRATION:

580 The Storm, 1890

MAITLAND Paul

1863 London – 1909 London Studied at the Government Art Training School; pupil of Roussel at the Royal College of Art. Belonged to the group of artists around Whistler. In 1888 he was made a member of the New English Art Club and 1889 of the London Impressionists. Taught drawing at the Royal College of Art. Lived in Kensington and Chelsea. ILLUSTRATION:

583 Flower Walk, Kensington Garden, c. 1897

MAITRE Edmond

1840 Bordeaux – 1898 Bordeaux Writer and musician. Art lover and friendly with most of the contempor-

ary artists. Frequently played music with Bazille at his studio in the Rue de Furstenberg; the artist painted him as the pianist in his picture "The Artist's Studio" (p. 81); he was also painted standing next to Zola in Fantin-Latour's "Studio in the Batignolles Quarter" (p. 81). Close friends also with Baudelaire, Verlaine and Renoir, with whom he shared a love of German music, particularly Wagner.

MALEVICH Kasimir 1878 Kiev – 1935 Leningrad

Began to study art in 1895 at the art school in Kiev. The Impressionism of his early period soon gave way to Fauvism and the related styles of the Russian artists Larionov and Goncharova. Rebelled against the prevailing views on art. Developed an increasingly geometric style of figure representation, akin to Cubism and abstract painting.

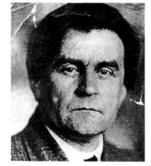

CATALOGUE: Nakov, A.: K.M. Leben und Werk. Vol. I: Œuvrekatalog, Texte und Dokumente. Landau 1992 BIBLIOGRAPHY: Nakov, A.: K.M. Leben und Werk. 3 vols. Landau 1992-1994 ILLUSTRATION: 511 Flower Girl, 1903

MALLARME Stéphane

1842 Paris – 1898 Valvins Important Symbolist poet and writer, influential critic and proponent of Impressionist ideas. His apartment in the Rue de Rome in the Batignolles Quarter of Paris became a meeting place of the avant-garde. Became close friends with Renoir, Whistler and Degas; had a special liking for Morisot. In 1874 he wrote a highly positive appraisal of Manet for the "Renaissance", which was well received by Manet himself; he defended Whistler and Morisot. Manet did the illustrations for Mallarme's translation of Poe's "The Raven" and some woodcuts for "L'Aprés-midi d'un faune". After Manet's death he became interested in Gauguin's art and formed a close friendship with Redon.

MANET Edouard 1832 Paris – 1883 Paris

1844-1848 went to school at the Collège Rollin, friendship with Antonin Proust. 1848/49 trained as a sea cadet on a voyage to Brazil. 1850-1856 pupil at Couture's studio and the Académie Suisse: liaison with Suzanne Leenhoff. 1852 birth of his son Léon Koella. 1853 visited Florence and perhaps also Austria and Germany. 1856 travelled in Belgium, Holland, Germany, Austria and Italy. 1857 met Fantin-Latour. 1858 rejected by the Salon, 1860 took an apartment in the Batignolles Quarter, frequented the Café Guerbois. 1861 exhibited for the first time at the Salon - pictures in the realistic "Spanish" style - and was awarded "special mention"; began to paint subjects from "modern life". Met Degas. 1862 met Baudelaire. 1863 caused a scandal with his pictures in the Martinet gallery and the Salon des Refusés; married Suzanne Leenhoff. 1865 met Duret in Spain. 1866 became acquainted with Monet and Zola, who corresponded with him. In 1867 he staged his own exhibition during the Paris World Fair. 1868 trip to London. 1868/69 Morisot and Gonzalès became his students and models.

1870/71 military service in the National Guard, stayed in South West France during the Commune in Paris; Durand-Ruel bought many of his paintings. 1872 visited Holland. 1873 met Mallarmé. 1874 visited Monet at Argenteuil; began to paint plein-air in an increasingly Impressionist manner. 1875 visited Venice. 1878 rejected by the Paris World Fair. 1879 murals in the city hall in Paris. 1880 exhibition at the gallery of the journal "La vie moderne" owned by the publisher Charpentier; spent the summer at Bellevue; contracted a fatal illness. 1881 received a medal 2nd class at the Salon; received into the Legion of Honour by the Gambetta government. 1882 Chevalier of the Legion of Honour; spent the summer at Rueil. 1883 last pastels; amputation of a leg, painful death. 1884 successful memorial exhibition and auction sale, 1889/90 "Olympia" bought by donations and presented to the state. WRITINGS, DOCUMENTS: Courthion, P. and P. Cailler (eds.): M. raconté par lui-même et par ses amis. 2 vols. Geneva 1953 .- Graber, H.: M. nach eigenen und fremden Zeugnissen. Basle 1941 .- Manet, E .: Lettres de jeunesse 1848-1849. Voyage à Rio. Paris 1928.- Moreau-Nélaton, E. (ed.): M. raconté par lui-même. 2 vols. Paris 1926 .- Tabarant, A. (ed.): Une correspondance inédite d'E.M.: Les lettres du siège de Paris (1870-1871). Paris 1935.- Valery, P.: Triomphe de M. Paris 1932 .- Wilson-Bareau, J .: M. by Himself. Correspondence & Conversation. Boston 1991 .- Zola, E.: M. Etude biographique et critique. Paris 1867

CATALOGUES: Guérin, M.: L'œuvre gravé de M. Paris 1944 .- Harris, J.C .: E.M. The Graphic Work. A Catalogue Raisonné. New York 1970, San Francisco 1991 .- Jamot, P., G. Wildenstein and M.-L. Bataille: M. 2 vols, Paris 1932 .- Leiris, A. de: The Drawings of E.M. Berkeley, Los Angeles 1969 .- Orienti, S.: The Complete Paintings of M. New York 1967 .- Pool, P. (ed.): The Complete Paintings of M. Harmondsworth 1985 .- Rouart, D. and D. Wildenstein: E.M. Catalogue raisonné de l'œuvre peint. 2 vols. Lausanne and Paris 1975 .- Tabarant, A.: M. et ses œuvres. Paris 1947

BIBLIOGRAPHY: Adler, K.: M. Oxford 1986.- Bataille, G.: M. Lausanne 1955, Geneva 1988 .- Cachin, F., C.S. Moffett et al. (eds.): M. 1832-1883. Grand Palais, Paris; Metropolitan Museum of Art, New York. Berlin 1984 (EC) .- Cachin, F., C.S. Moffett et al. (eds.): M. 1832-1883. Grand Palais, Paris: Metropolitan Museum of Art, New York. Paris 1983 (EC) .- Cachin, F., C.S. Moffett et al. (eds.): M. 1832-1883. Grand Palais, Paris; Metropolitan Museum of Art, New York. New York and London 1984 (EC) .- Cachin, F.: M. Cologne 1991.- Cegodaev, A.D.: E.M. Moscow 1985 .-Clark, T.J.: The Paintings of Modern Life: Paris in the Art of M. and his Followers. New York 1984.- Cogniat, R. and M. Hoog: M. Paris 1982 .- Courthion, P.: E.M. London 1962, New York 1962 .- Darragon, E.: M. Paris 1989 .- Duret, T.: Histoire d'E.M. Paris 1902 .- Florisoone, M.: M. Munich 1947.- Germer, S. and M. Fath (eds.): E.M. Augenblicke der Geschichte. Munich 1992.- Gronberg, I.A. (ed.): M. A Retrospective. New York 1988 .- Hamilton, G.H .: M. and his Critics. New Haven and Londón 1986.- Hanson, A.C. (ed.): E.M. 1832-1883. Philadelphia Museum of Art, Philadelphia 1966 (EC).-Hanson, A.C.: M. and the Modern Tradition. New Haven (CT) and London 1976.- Hofmann, W .: Nana. Mythos und Wirklichkeit. Cologne 1973 .- Hopp, G.: E.M. Farbe und Bildgestalt. Berlin 1968 .- Jamot, P.

and G. Wildenstein: M. 2 vols. Paris 1932 .- Jedlicka, G.: E.M. Zurich 1941.- Keller, H.: E.M. Munich 1989 .- Leiris, A. de: The Drawings of E.M. Berkeley (CA) 1969 .- Liebmann, K.: E.M. Dresden 1968 .-Meier-Graefe, J.: E.M. und sein Kreis. Berlin 1903 .- Meier- Graefe, J .: E.M. Munich 1912 .- Perruchot, H.: M. Eine Biographie. Berlin, Darmstadt, Vienna 1962 .- Perruchot, H.: La vie de Manet. Paris 1959 .- Proust, A .: E.M., Souvenirs. Paris 1913 .- Proust, A.: E.M. Erinnerungen. Berlin 1929 .-Reff, T.: M.: Olympia. New York 1976 .- Reff, T. (ed.): Manet and Modern Paris. The National Gallery of Art, Washington 1982 (EC) .- Rewald, J .: E.M. Pastels. Oxford 1947 .-Rey, R.: M. Paris 1938, New York 1938 .- Richardson, J .: E.M .: Paintings and Drawings, London 1958, 1982 .- Sandblad, N.G.: M. - Three Studies in Artistic Conception. Lund 1954 .- Schneider, P.: The World of M., 1832-1883. New York 1968 .-Schneider, P.: M. et son temps. Paris 1972 .- Tabarant, A .: M .: Histoire catalographique. Paris 1931 .- Tabarant, A.: M. et ses œuvres. Paris 1947.- Wilson, J. (ed.): E.M.: Das graphische Werk: Meisterwerke aus der Bibliothèque Nationale und weiteren Sammlungen. Ingelheim am Rhein 1977 (EC) .- Wivel, M., J. Wilson- Bareau and H. Finsen (eds.): Ordrupgaardsamlingen, Copenhagen 1989 (EC)

- ILLUSTRATIONS:
- 36 Le déjeuner sur l'herbe (study), 1862/63
- 37 Le déjeuner sur l'herbe, 1863
- 38 Olympia, 1863
- 42 The Races at Longchamp, c. 1865-1867
- 42 At Longchamp Racecourse, 1864
- 43 Music at the Tuileries, 1862
- 43 Horse Race, 1864
- 46 Lola de Valence, 1863
- 47 Lola de Valence, 1862 (to post 1867)
- 47 The Fifer, 1866
- 48 Reading, 1865-1873
- 48 Repose. Portrait of Berthe Morisot, 1870
- 62 Luncheon in the Studio, 1868
- 63 The Balcony, c. 1868/69
- 64 The Execution of Emperor Maximilian (Lithograph), 1868
- 65 The Execution of Emperor Maximilian (four fragments), 1867
- 65 The Execution of Emperor Maximilian, 1868
- 66 Portrait of Emile Zola, 1868
- 77 The Departure of the Folkestone Boat, 1869
- 95 The Railway, Gare Saint-Lazare, c. 1872/73
- 109 On the Beach, 1873
- 110 The Masked Ball at the Opéra, c. 1873/74
- 123 The Monet Family in the Garden, 1874
- 132 Madame Mane on a Divan, 1874
- 134 Argenteuil, 1874
- 138 Boating, 1874
- 139 Claude Monet and his Wife in his Studio Boat, 1874
- 160 Nana, 1877
- 165 Plum Brandy, c. 1877/78

- 178 Bock Drinkers, 1878 178 The Waitress, 1878/79
- 178 Man in a Round Hat (Alphonse Maureau), 1878
- 179 At the Café, 1878
- 179 The Waitress, 1879
- 179 Two Women Drinking Bocks, 1878
- 195 In the Garden Restaurant of Père Lathuille's, 1879
- 195 In the Conservatory, 1879
- 198 Bundle of Asparagus, 1880
- 200 Girl in the Garden at Bellevue, 1880
- 200 House at Rueil, 1882
- 212 Manet's Mother in the Garden at Bellevue, 1880
- 213 The Viennese: Portrait of Irma Brunner in a Black Hat, 1880
- 221 A Bar at the Folies-Bergère, c. 1881/82

MANET Eugène

1833 Paris – 1892 Paris Painter and younger brother of Edouard Manet; 1874 married Berthe Morisot. Friends with Degas and Stevens. His own artistic endeavours fall far short of those of his wife and brother. Traces of his influence can be seen in Morisot's pictures.

MANET Julie → Rouart, Madame

MANTZ Paul

and Morisot.

1821 Bordeaux – 1895 Paris Began in 1841 as a critic with the journal "L'Artiste", then became the art historian and critic for the "Gazette des Beaux-Arts". At the same time he was employed as a civil servant at the Ministry of the Interior. 1882 Director-General of the Académie des Beaux-Arts. One of the

MANZANA \rightarrow Pissarro, Georges

first to recognize the talents of Monet

MARIS Jacob Hendricus

1837 The Hague – 1899 Karlsbad The oldest of the Maris brothers. 1849 trained in the studio of Stroebel, an imitator of Pieter de Hooch. He then studied with J.-J. van den Berg and in 1855 with the Romantic painter Huib van Hove in Antwerp. Travelled up the Rhine to Switzerland. From 1865 in Paris as a pupil of Ernest Hebert. Influenced by the Barbizon school. From 1870 he lived in The Hague, painting Dutch landscapes with loose brush-strokes. BIBLIOGRAPHY: Bock, T. de: J.M. Amsterdam 1902.– Croal Thomson, D.: The Brothers M. London and Paris 1907.– Maris. Een kunstenaarfamilie. Singer Museum, Laren 1991 (EC).– Maris tentconstelling. Gemeentemuseum, The Hague, Stedelijk Museum, Amsterdam 1935 (EC).– Zilcken, P.: Les Maris: Jacob-Matthijs-Willem. Amsterdam 1896

ILLUSTRATION:

413 Allotment Gardens near The Hague, c. 1878

MARIS Matthijs

1837 The Hague - 1917 London 1858 trained with L. Meijer at the Academy in The Hague. A scholarship from the Queen of Holland allowed him to study in Antwerp with de Keyser. In 1859 he returned to The Hague, 1860 travelled up the Rhine as far as the Black Forest. Met Moritz von Schwindt and Wilhelm von Kaulbach and was impressed by their Romantic style. 1867-1873 lived in Paris and in 1877 settled London. Influenced by the English Pre-Raphaelites, he moved away from the styles of The Hague school. BIBLIOGRAPHY: Arondéus, W.: M.M. De tragiek van den droom. Amsterdam 1939 .- Croal Thomson, D.: The Brothers M. London and Paris 1907.- Croal Thomson, D. et al .: M.M. An Illustrated Souvenir. London 1918.- Gelder, H.E. van: M.M. Amsterdam 1939 .- Maris. Een kunstenaarfamilie. Singer Museum, Laren 1991 (EC) .- Maris tentoonstelling. Gemeentemuseum, The Hague; Stedelijk Museum, Amsterdam 1935 (EC) .- M.M. 1839-1939. Gemeentemuseum, The Hague 1939 (EC).- M.M. Gemeentemuseum, The Hague 1974 (EC) .- Zilcken, P.: Les Maris: Jacob-Matthijs-Willem. Amsterdam 1896 ILLUSTRATION:

413 Quarry at Montmartre, c. 1871

MARIS Willem

1844 The Hague – 1910 The Hague Became a gifted sketcher of animals as early as 1856; trained with his brothers and with P. Stortenbeker. Taught himself to paint landscapes and developed his own style in Oosterbeek and Wolfhezer, where he met Mauve in 1855. In 1863 he exhibited for the first time in The Hague. Maris travelled with Blommers in the Rhineland 1865/66. From 1869 lived in The Hague. Willem was the most realistic of the three brothers, and his landscape paintings, reminiscent of Corot, were well received, particularly in Britain and America. important critics, theorists and defenders of the Macchiaioli. 1873 founded the "Giornale Artistico"; made a considerable contribution to the spread of Impressionism in Italy.

1860 Toulouse - 1943 La Bastide-

Son of a carpenter; trained first in

croix. 1879 moved to Paris and

worked in the studio of Jean-Paul

Laurens. 1886 exhibited for the first

ship for a tour of Italy, where he de-

teristic short, divisionist brush-

medal in the Salon and became a

member of the Legion of Honour.

1895 painted some unusually large

pictures for the Neo-Impressionists

and won great acclaim when he ex-

hibited them at a one-man show at the Mancini Gallery. At the World

Fair in 1900 he won the Grand Prize.

Commissioned to paint some impor-

tant murals for the city hall in Paris

(1895), for the Capitol in Toulouse

Friendship with Rodin. Lived mostly

BIBLIOGRAPHY: H.M. Kaplan Gallery,

in Marquairol near Bastide-du-Vert

London 1971 (EC).– Martin-Ferrières, J.: H.M., sa vie, son œuvre. Paris 1967.– Valmy-Baysse, J.: H.M., sa vie, son œuvre. Paris 1910

379 The Harbour of Collioure

Art collector, journalist and critic for

and Inspector of Beaux-Arts, later In-

spector-General of the provincial mu-

seums. One of the first to admire Cé-

treatment at the World Fairs in 1900

Toulouse-Lautrec. On friendly terms

with many contemporary artists. Im-

portant proponent of the revival of

arts and crafts at the end of the 19th

and 1904. From 1892 friendship with

zanne, whom he gave preferential

numerous journals and newspapers

1859 Nancy - 1913 Paris

(1903, 1906) and in Marseilles.

(Lot).

ILLUSTRATION:

MARX Roger

century.

veloped his own style with its charac-

strokes. In 1889 he received the gold

time at the Salon. 1885 won a scholar-

Toulouse at the Ecole des Beaux-Arts

under Jules Garipuy, a pupil of Dela-

du-Vert

BIBLIOGRAPHY: Croal Thomson, D.: The Brothers M. London and Paris 1907.- Maris. Een kunstenaarfamilie. Singer Museum, Laren 1991 (EC).-Maris tentoonstelling. Gemeentemuseum, The Hague; Stedelijk Museum, Amsterdam 1935 (EC).- Zilcken, P.: Les Maris: Jacob-Matthijs-Willem. Amsterdam 1896 ILLUSTRATION: 412 Dusk, c. 1875

MARLOTTE

Town in the Forest of Fontainebleau, which had been used by the painters of the Barbizon school for plein-air painting. Its motifs became popular with Impressionist painters and writers, who frequently stayed there.

MARLY-LE-ROI

Viewing point on a hill overlooking the Seine in the park of the old château of Louis XIV, not far from the villages of Louveciennes, Port-Marly and L'Etang-la-Ville. In particular, Renoir and Sisley liked to paint in the forest here.

MARTELLI Diego 1838 Florence – 1896 Florence Studied science at the University of Pisa; from 1855 a frequent customer in the Caffè Michelangiolo in Florence. Became one of the most

1861 Nantes - 1918 Poncé (Sarthe) Worked first in a merchant's office in England; drew in his spare time and admired the Turners in the National Gallery. Back in Nantes he was encouraged to take up art by Charles Le Roux, who initiated him into the techniques of Impressionism. After a successful exhibition at the Salon in 1886, he decided to devote himself full time to his painting. He admired Monet and Sisley and was influenced by Whistler. In 1890 he met the Pont-Aven artists (Gauguin, Sérusier, Bernard and others). He spent the subsequent summers in Pont Aven or in Pouldu. 1891 and 1893 exhibited in the Salon des Indépendants and in 1894 at Le Barc de Boutteville. CATALOGUE: Durand-Ruel Godfroy, C.: M.M. Catalogue raisonné (in preparation) .- Morane, D.: M.M., catalogue de l'œuvre gravé. Published in connection with the exhibition: M.M., du dessin à la gravure. Musée de Pont-Aven; Musée départemental du Prieuré. Saint-Germain-en-Lave 1986 (EC)

BIBLIOGRAPHY: Alexandre, A.: M.M. Paris 1926. – M.M. Galerie Durand-Ruel. Paris 1961 (EC). – M.M. Galerie Art Mel. Paris 1978 (EC). – Ramade, P.: M.M. Un ami de Gauguin en Bretagne. Le Chasse-Marré 1988 ILLUSTRATION: 338 Ile de Bréhat, 1892

MAUPASSANT Guy de 1850 Tourville-sur-Arques – 1893 Paris French writer, at first also a civil servant in the Paris ministries. From

1880 Charpentier began to publish his short stories with their close observation of contemporary life, particularly the petty bourgeoise and artists. Friends with such artists as Monet, Renoir, and Degas; their subject matter, themes, motifs and point of view is mirrored in his writings. Travelled extensively in his own yacht. Became mentally unbalanced in his old age.

MAUREAU Alphonse

Exact details of his life unknown. A friend of Degas, Manet and Desboutin; a member of the artistic clientele in the Café de la Nouvelle-Athèns. 1877 invited by Degas to show four works at the 3rd Impressionist exhibition. In 1878, Manet did a pastel portrait of him wearing a round hat (p. 178). Also friends with Nina de Callias, the musician Cabaner and the writer Duranty. ILLUSTRATION: 289 Banks of the Seine, c. 1877

MAUS Octave

1856 Brussels – 1919 Brussels Barrister. 1881 co-founder of the journal "L'Art moderne". As an art critic and journalist he exerted a considerable influence on the development of art in Belgium. 1883 encouraged a rejection of the Salon and the formation of the group of artists known as Les Vingt. In 1893 he founded the progressive group "Libre Esthétique", which organised concerts, conferences and especially Impressionist and Symbolist exhibitions.

MAUVE Anton

1838 Zaandam - 1888 Arnheim 1854 trained initially as a painter of animals with P.F. van Os; 1858 a pupil of W. Verschuur for several months; in the summer he stayed at the artists' colony in Oosterbeek. where he met painters of The Hague school. Became friends with W. Maris. 1871 studio in The Hague. 1874 married the cousin of Vincent van Gogh, Ariette Sophia Jeanette Carbentus. 1873 co-founder of the "Hollandsche Teekenmaatschappij" ("Dutch Society of Draughtsmen") for the propagation of watercolour painting. 1878-1883 member of the "Pulchri studio" society of artists in The Hague. Spent the summer months of 1882 in Laren, where he moved in 1885. Painted mainly landscapes

with harmonious rich, colours and loose brushwork.

BIBLIOGRAPHY: A.M. Singer Museum, Laren 1959 (EC).– Berckenhoff, H.L.: A.M. Amsterdam 1890.– Engel, E.P.: A.M. (1838-1888). Bronnenverkenning en analyse van zijn œuvre. Utrecht 1967.– Leeman, F.: M.'s watercolours. Rijksmuseum Vincent van Gogh, Amsterdam 1988 (EC) ILLUSTRATION:

412 Laren Woman with Goat, 1885

MCNICOLL Helen Galloway 1879 Toronto (Ontario) – 1915 Swanage (England)

Studied at the Art Association in Montreal with William Brymner, then at the Slade School of Art in London and 1906 at the art school at St. Ives in Cornwall with A. Talmage. Became interested primarily in the effects of light and atmospheric mood. Later her main work became highly expressive portraits of women and children. 1908 received the Dow Prize and 1914 the Women's Art Society Prize. 1913 elected member of the Royal Society of British Artists. 1914 member of the Royal Canadian Academy. Spent most of her life in Montreal. ILLUSTRATION:

632 Under the Shadow of the Tent, 1914

MEDAN

Village on the Seine north-west of Paris, about 9 miles from Pontoise. Zola owned a house here from **1878** which became a meeting place for supporters of Realism. Other visitors included such Impressionist painters as Monet, Pissarro and Renoir. Cézanne spent several weeks here each year.

MEIER-GRAEFE Julius 1867 Resita (Romania) – 1935 Vevey (Switzerland)

German art historian, critic and writer. 1889 in Paris for the first time. 1890-1895 in Berlin, lived later in various places, predominantly in Paris, and travelled widely. At times edited the journals "Pan" and "Dekorative Kunst". 1899-1903 owned an Art Nouveau gallery in Paris. 1900 began a series of publications which helped to popularise the Impressionists and their predecessors in Germany, and established the German reputation of Cézanne. 1906 organised with H. von Tschudi the exhibition "A Century of German Art" in Berlin, a new re-appraisal of nineteenth-century art. The victory of modernity in art owes a great deal to his lively, subjective and sensitive analyses.

MEIFREN Y ROIG Eliseo 1859 Barcelona – 1940

Pupil of Antonio Caba at the art college in Barcelona. Specialised in Impressionist sea painting. Lived for several years in Paris and exhibited regularly at the Salon and at the Galerie Petit. Worked in Italy, the Canaries and the Balearic Islands. Director of the art school in Palma de Mallorca. Numerous awards and medals. **1916** one-man exhibition in New York.

BIBLIOGRAPHY: Pantorba, B. de.: E.M. Barcelona 1942 ILLUSTRATION: 564 The Marne

MEISSONIER Jean Louis Ernest 1815 Lyon – 1891 Paris

Studied with L. Cogniet. 1834 exhibited for the first time at the Salon, from which he later remained mostly aloof. 1848 officer in the National Guard, deeply shocked by the Revolution. Painted genre scenes, mostly in the costumes of the 16th and later the 18th century, also scenes from the Napoleonic Wars; his pictures were executed with extreme precision, often in tiny format, and gained the highest awards. In 1855 Napoleon III bought his painting "La rixe". A careful observer of lighting, interested in photography. Became friends with Menzel. 1870/71 officer in the National Guard, where Manet also served; a fierce opponent of the Communards and also of Courbet. 1891 president of the Société Nationale des Beaux-Arts, a break-away group from the Indépendants. After his death he was ignored and forgotten, despised by the Impressionists, ridiculed by Degas, but re-discovered by Salvador Dalí. BIBLIOGRAPHY: Greard, O.: M. Ses souvenirs, ses entretiens. Paris 1897 ILLUSTRATION: 27 The Reader, 1857

MENZEL Adolph Friedrich Erdmann von

1815 Breslau – 1905 Berlin 1830 trained as a lithographer with his father in Berlin. In 1832 he took over the firm on the death of his father. 1833 attended the plaster cast lessons at the Academy of Art in Berlin: achieved fame with his illustrations to Goethe's "Künstlers Erdenwallen". Came into contact with Schinkel, Rauch and Meyerheim. 1838-1845 did his most famous illustrations - to "Peter Schlemihls wundersame Geschichte" ("Peter Schlemihl's Marvellous Story") by Adalbert von Chamisso, Franz Theodor Kugler's "Geschichte Friedrichs des Grossen" ("History of Frederick the Great", Leipzig 1842) and the "Armeewerk" (1845-1857). From the 1840s he painted house interiors and portraits, which look ahead to the style of the Impressionists. 1849-1856 completion of the well-known Fridericus paintings of scenes from the life of Frederick the Great.

1853 member of the Prussian Academy of Arts. 1856 appointed professor. 1855, 1867 and 1868 trips to Paris, 1870 and 1873 Vienna and 1880/81 and 1883 Verona. 1875 member of the Senate at the Academy; painted his most famous picture, "The Iron Foundry". 1883 vice-chancellor of the Friedensklasse des Ordens "pour le mérite"; 1885 chancellor; 1898 received into the aristocracy: made Ritter des Schwarzen Adler-Ordens (Knight of the Order of the Black Eagle). CATALOGUES: Bock, E .: A.M. Verzeichnis seines graphischen Werkes. San Francisco 1991 BIBLIOGRAPHY: A.M. Aus Anlaß seines 50. Todestages. Museum Dahlem, Berlin 1955 (EC) .- Hochhuth, R.: M. Maler des Lichts. Frankfurt am Main 1991.- Hütt , W.: A.M. Vienna 1965 .- Jensen, J.C.: A.M. Cologne 1982.- Kaiser, K.: A.M. Berlin 1956 .- Vossberg, H .: Kirchliche Motive bei A.M. Berlin 1964.- Weinhold, R.: Menzel-Bibliographie. Leipzig 1959 ILLUSTRATION:

434 Departure of Kaiser Wilhelm I for the Front on 31 July 1870, 1871

METCALF Williard Leroy

1858 Lowell (MA) – 1925 New York 1875 studied with the landscape painter George Loring Brown and at the Lowell Institute; 1876-1878 studied at the Museum School of Fine Arts in Boston with Otto Grundmann. Travelled with the ethnologist Franz Cushing 1881-1883 in the south-west of the USA; did drawings and paintings of native Americans. 1883-1888 first stay in Europe; studied at the Académie Julian in Paris under Boulanger and Lefèbvre. 1884 went to England and Pont-Aven; 1886 the first American painter in Giverny; travelled in Algeria and Tunisia. Spent the summer of 1887/88 in Giverny once more. From 1887 member of the Society of American Artists. Successful exhibition at the Paris Salon 1888, 1888 returned to the USA. 1889 his first one-man exhibition at the St. Botolph Club, Boston. 1891 taught at the Cooper Institute. 1899 mural for the the Appelate Courthouse in Madison Square, New York. 1902 visited Havana (Cuba); studies for a mural in the Havana

Tobacco Company Store in the St. James Building, New York City. 1903 left New York and moved to the country, settling in Clark's Cove, Maine. Despite his contacts with Giverny, it was only now that he turned to Impressionist techniques in his landscapes, done in different moods and at different times of the year. Founder member of The Ten American Painters, Travelled most of the time in New England and became an important member of the artists' colony at Old Lymne, Connecticut. Influenced in technique by Lawson, his style became a more academically inspired version of Impressionism. BIBLIOGRAPHY: Bolton, T. (ed.): Memorial Exhibition of Paintings by Late W.L.M. Century Association, New York 1928 (EC) .- Duncan, W.J. (ed.): Paintings by W.L.M. Corcoran Gallery of Art, Washington 1925 .-Murphy, F. and E. de Veer (eds.): W.L.M. Museum of Fine Arts, Springfield (MA) 1976 (EC) .- Veer, E. de and R.J. Boyle: Sunlight and Shadow. The Life and Art of W.L.M. New York 1987 ILLUSTRATIONS: 621 Gloucester Harbour, 1895 630 The Poppy Garden, 1905

MEURENT Victorine Louise 1844 – c. 1885

Professional model, who posed first for the students of Couture. Became famous for sitting with the students and discussing with them. In 1862 at the age of 18 she met Manet, who spoke to her in a crowd and noted her address. For ten years she was his favourite model, achieving fame as the woman in "Le déjeuner sur l'herbe" (p. 37) and "Olympia" (pp. 38/39). She had a relationship with Stevens, for whom she also modelled; she drew her own pictures and took lessons with the genre painter Leroy. She exhibited at the Salon in 1876, when Manet's pictures were rejected, and also in 1885. She died probably an alcoholic, in poverty.

MEYER Alfred

1832 Paris – 1904 Paris Studied with F.E. Picot and E. Lévy. Teacher at the Bernard-Palissyschool in Paris. 1858-1871 worked at a porcelain manufacturer's in Sèvres and rediscoverd the long forgotten process of Limoges enamel painting. From 1864 exhibited at the Salon. 1866 awarded a medal. 1874 exhibited at the first Impressionist exhibition. 1895 published his book "L'Art de l'émail de Limoges".

MILICEVIC Kosta

1877 Vraka - 1920 Belgrade 1895-1898 studied drawing and painting at K. Kutlik's school in Belgrade. 1899-1901 at the private school of H. Strehblow in Vienna. 1902/03 studied with Ažbè in Munich. 1903-1910 attended the artsand-crafts school in Belgrade. 1907 painted the icon decoration of a church. 1908 first exhibition in Belgrade. 1910 member of the Lada group of artists; painted in an Impressionist style. 1914-1916 did military service and worked as a war artist. 1916/17 and 1918 convalescence on Corfu. 1919/20 taught drawing at evening school in Belgrade. BIBLIOGRAPHY: K.M. Muzej savremene umetnost. Belgrade 1974 (EC) .- Milan Milovanicic, K.M. Narodni Mujez. Belgrade 1960 (EC) .-Zivkovic, S.: K.M. Novi Sad 1970 ILLUSTRATION: 530 Spring, 1913

MILLER Richard

1875 St. Louis – 1943 St. Augustine (Florida)

1898 moved to Paris and studied at the Académie Julian under Constant and Laurens; he then worked as a teacher at the Académie Colarossi. Belongs with Frieseke to the 2nd generation of Giverny painters. Stayed for many years in France; each summer he lived and painted in Giverny, where he also gave courses to students of the Mary Wheeler School, Providence. 1901 and 1904 successes at the Paris Salon; 1909 had his own exhibition room at the Biennale in Venice. 1900-1915 exhibited in Paris, Buffalo, Liège and San Francisco. 1916 returned to the USA and taught in Pasadena at the Stickney Memorial School of Art. Became a specialist painter of decorative garden scenes. BIBLIOGRAPHY: Ball, R. and M.W. Gottschalk: R.E.M. An Impression and Appreciation. Saint Louis 1968 ILLUSTRATION: 640 Reverie, 1913

MILLET Jean-Baptiste

1831 Gréville – 1906 Auvers-sur-Oise Son of a Normandy peasant. Painter and graphic artist, pupil and younger brother of J.-F. Millet. The main subjects of his water colours and drawings are landscapes and peasant life. Exhibited several times at the Salon and in 1876 exhibited ten works at the 2nd Impressionist exhibition.

MILLET Jean-François 1814 Gruchy (Manche) – 1875 Barbizon

Son of a Normandy peasant; older brother of J.-B. Millet. 1837-39 after finishing his education in Cherbourg, he studied with Delaroche in Paris. 1840 exhibited for the first time in the Salon. Became acquainted with the Barbizon painters; chose to paint the daily life of the peasants and serious landscapes. With his friend C. Jacque he settled in Barbizon in 1849, living in poverty. 1867 won awards at the Paris World Fair. Millet was a precise and sympathetic observer, whose heavy-limbed figures of farmers and peasant children, depicted at times with almost religious sentiment, were the subject of much debate as to their significance. They clearly influenced the development of Realism in many countries, and especially influenced Pissarro and van Gogh. In 1899 his painting "The Angelus" was auctioned for the sensational price of 553,000 francs.

WRITINGS, DOCUMENTS: Moreau-Nélaton, E.: M. raconté par lui-même. 3 vols. Paris 1921

CATALOGUE: Moreau-Nélaton, E.: Monographie de référence. 3 vols. Paris 1921

BIBLIOGRAPHY: Bouchot, J.: Dessins de J.-E.M. Musée National du Louvre, Paris 1960 (EC).– Cain, J.: M. Paris 1913.– Fermigier, A.: J.-E.M. Geneva 1977.– Gay, P.: J.-F.M. 1814-1875. Paris 1951.– J.-E.M. Grand Palais, Paris 1955 (EC) ILLUSTRATIONS:

25 Gleaners, 1857

25 The Angelus, c. 1859/60

MILOVANOVIC Milan

1876 Krusevac – 1946 Belgrad 1895 studied at K. Kutlik's art school in Belgrade. 1897-1902 studied at the private school of Ažbè in Munich. 1902-1906 at the Academy of Art in Munich under L. Herterich and C. Marr. 1906 short period at the Académie Colarossi and the Paris art college. 1906 one-man exhibition in Belgrade. 1907 visited monasteries in Serbia, Macedonia and Mount Athos. Painted in an Impressionist style. Member of the Lada and Medulic groups. 1908 co-founder of the Serbian Association of Artists. 1914-1917 war painter with the Serbian General Staff. 1917-1937 taught at the school of art in Belgrade, but gave up painting himself.

BIBLIOGRAPHY: Duric, V.J.: M.M. Belgrade 1964.– M.M. 1876-1946. Narodni Muzej. Belgrade 1986 (EC).– M.M. Kosta Milicevic. Narodni Muzej, Belgrade 1960 (EC) ILLUSTRATION: 531 The Blue Door, 1917

MIRBEAU Octave

1848 Trévières - 1917 Paris Influential art and theatre critic and Romantic novelist. Acquainted with all the important Impressionist painters and contemporary writers; friends with Pissarro and Monet, for whom he wrote catalogue texts and discussed their pictures. 1889 wrote the catalogue for the large Monet exhibition at the Galerie Petit. 1891 published a study of Pissarro in "L'Art dans les deux mondes" and wrote an enthusiastic article on Gauguin. Long correspondence with Monet and Pissarro. A strong supporter of the Impressionists and the sculpture of Rodin.

MIR TRINXET Joaquín 1873 Barcelona – 1940 Barcelona 1889 trained with Luis Graner and

for a short time at the Academy of Art in Barcelona with Antonio Caba and Arcadio Mas y Fontdevilla. 1897 failed to gain a scholarship to Rome. Imitated works by Velázquez. 1890-1893 joined the group of artists which included Nonell, Casas, Pichot and others; further developed his colourful and emotive style of Impressionism. 1898 received the bronze medal at the exhibition of arts and crafts in Barcelona and 1899 the silver medal at the Madrid exhibition of art. 1900 stayed in Mallorca. Worked in Deya with the Belgian painter William Degouve. From 1910 took part in exhibitions in Brussels, Madrid, Barcelona and won numerous awards. BIBLIOGRAPHY: Jaürdí, E.: J.M. Barcelona 1975 ILLUSTRATION:

568 The Waters of the Maguda, 1917

MOLINS Auguste de

1821 Lausanne – 1890 Pupil of Victor Joseph Chavet in Geneva. Worked for a time in France. 1850-1870 showed in exhibitions in the Paris Salon. 1874 exhibited at the 1st Impressionist exhibition. Painted landscapes and hunting scenes. 1875 bought two pictures by Renoir. Taught drawing and painting in Lausanne.

MONDRIAN Piet

1872 Amersfort - 1944 New York Grew up in an artistic family; learnt to draw with his uncle Frits. 1892-1897 studied at the Rijksakademie in Amsterdam with A. Allebé. Impressed by Breitner and the landscape painters of the Hague and Amsterdam schools. 1904/5 in the provinces of Brabant and Overijssel; developed a more personal style, which was already beginning to move away from the idea of depiction of the visible world. 1905/6 scientific drawings for Professor Calcan in Leyden. 1908 met Toorop; became interested in Symbolism and French Pointillism. 1909 exhibited at the Stedelijk Museum in Amsterdam; his free landscape forms reminiscent of the Fauvists were heavily criticised. 1911-1914 exhibited in the Salon des Indépendants in Paris. 1912 moved to Paris. Co-founder of "De moderne kunstkring" in Amsterdam and from 1909 member of the Dutch Theosophy Society. In his philosophy and art considerably influenced by H.P.

Blavatsky's "Secret Doctrine". Gave up natural colours in favour of pure colours. From 1914 back in Holland; lived in Amsterdam, Laren, Blaricum, Scheveningen and Domburg. 1917 founded the journal "De Stijl" which gave its name to a type of art based on abstract principles.

WRITINGS, DOCUMENTS: Holtzman, H. and M.S. James (eds.): New Art, the New Life: The Collected Writings of P.M. London 1987 .- Mondrian, P .: Plastic Art and Pure Plastic Art. New York 1945 .- Schmidt, G.: Theorien und Ideen von P.M. Basle 1977 CATALOGUES: Blok, C.: P.M. Een catalogus van zijn werk in Nederlands bezit. Amsterdam 1974.- Ottolenghi, M.G.: L'opera completa di M. Mailand 1974 .- Seuphor, M .: P.M. Paris 1970, 1987 BIBLIOGRAPHY: Champa, K.S.: Mondrian Studies. Chicago 1985 .- Jaffé, H.: P.M. New York 1985 .- Jaffé, H. L.C.: P.M. Paris 1970.- Lewis, D.: M., 1872-1944. London 1957.- M. and The Hague School. Whitworth Art Gallery. Manchester 1980 (EC) .-Milner, J.: M. London 1992 .- Seuphor, M .: P.M .: sa vie, son œuvre. Paris 1956 .- Seuphor, M .: P.M .: Leben und Werk. Cologne 1957 .-Sweeney, J.J. (ed.): P.M. The Museum of Modern Art, New York 1948 (EC) .- Welsh, R.P.: M.'s early career, the naturalistic periods. New York and London 1977 ILLUSTRATION: 418 Idyll, c. 1900

MONET Camille

1847 Lyon – 1879 Vétheuil Met Monet 1865 and became his favourite model. 1867 and 1878 births of their sons Jean and Michel; the couple did not marry until 1870, against the wishes of Monet's family. Camille and their sons frequently appear in Monet's pictures (pp. 118, 146, 147, 150).

MONET Claude 1840 Paris – 1926 Giverny

1845-1859 grew up in Le Havre as the son of a minor merchant. 1858 exhibited a painting he had done under the tutelage of Boudin. 1859 moved to Paris; the Barbizon painter Troyon gave help and advice. 1860 studied at the Académie Suisse; met Pissarro and Courbet. 1861 military service in Algeria. 1862 met Jongkind in Le Havre. 1862/63 studied at Gleyre's studio in Paris; friendship with Bazille, Renoir, Sisley; impressed by Manet. 1863 began plein-air painting at Chailly near Barbizon and at Honfleur. 1865 exhibited for the first time at the Salon; friendship with Zola, Cézanne, Manet; liaison with Camille Doncieux, with whom he had two sons. In Chailly he painted a plein-air figural composition that was to excel those of Manet, 1866 success at the Salon; painted in Sainte-Adresse and other localities, becoming increasingly impressive in his use of bright colours. 1867 he and Renoir were accepted by Bazille at his studio; rejected by the Salon; first broached the idea of a group exhibition. 1868 exhibited at the Salon. Dire financial difficulties. Painted at Bennecourt and Fécamp; a frequent customer at the Café Guerbois. 1869 rejected by the Salon; with Renoir in Bougival on the Seine he worked out fully the formal techniques of the new Impressionist style. 1870 rejected once more by the Salon; married Camille; painted with Boudin in Trouville. When the Franco-Prussian War broke out, he moved to London, where he studied pictures by Turner and Constable. Through Daubigny he became acquainted with Durand-Ruel. 1871 exhibition organised by Durand-Ruel in London; trip to Holland. 1871-1878 lived in Argenteuil. 1872 painted in Le Havre ("Impression: Sunrise") and Holland. 1873 formed a friendship with Caillebotte; founding of a group of artists. 1874 first exhibition of the new group in Paris, referred to mockingly as the "Impressionists". 1876 met the department store owner and art collector Hoschedé; 2nd Impressionist exhibition. 1877 3rd Impressionist exhibition. 1878-1881 lived in Vétheuil with his family and with Alice Hoschedé and her six children.

1879 death of Camille; 4th Impressionist exhibition. 1880 exhibition of a picture at the Salon. Due to a quarrel about planning arrangements he did not take part in the next two Impressionist exhibitions. Began to concentrate more and more on landscape painting; successful oneman exhibition at Charpentier's journal, "La vie moderne". 1881-1883 in Poissy, painted also on the coast of Normandy. 1882 took part for the last time in an Impressionist exhibition. 1883 finally settled in Giverny; also painted in Etretat. Large exhibition at the Durand-Ruel gallery. Travelled with Renoir to the Mediterranean; visited Cézanne. 1884 on the Riviera and in Etretat. 1885 exhibited for the first time with Durand-Ruel's competitor, G. Petit; met Maupassant in Etretat, 1886 exhibited with Les Vingt in Brussels and in New York through Durand-Ruel. Painted in Etretat, Holland and Belle-Ile (Brittany), where he met the critic Geffroy. 1888 exhibition through Theo van Gogh at the Boussod & Valadon gallery; painted in Antibes. 1889 at the century exhibition of French art at the Paris World Fair; successful joint exhibition with Rodin at Petit's; painted

in Fresselines (Creus), 1890 collected donations enabling Manet's "Olympia" to be purchased for the state; bought a house at Giverny. 1891-1912 repeatedly successful exhibitions of series paintings at the Durand-Ruel, Petit and Bernheim-Jeune galleries; became increasingly popular abroad. 1892 married Alice Hoschedé after her husband's death. 1893 began the creation of his famous garden with lily ponds at Giverny, which became the source of his most important motifs. 1895 travelled in Norway. 1897 exhibited at the Biennale in Venice. 1898 supported Zola in the Dreyfus affair. 1899-1901 made several visits to London, painted the Thames in mist. 1904 travelled in his own car to Madrid. 1908/09 two trips to Venice; his eyesight began to fail. 1911 depression after the death of his wife Alice. 1914 idea broached by his friend Clemenceau to donate a series of paintings of water lilies to the French state; worked on these until his death. 1920 rejected the offer of membership of the Institut de France.

WRITINGS, DOCUMENTS: Brive, P. (ed.): G. Clemenceau: Lettres à une amie 1923-1929. Paris 1970.-Graber, H.: Camille Pissarro, Alfred Sisley, C.M. nach eigenen und fremden Zeugnissen. Basle 1943.- Kendall, R. (ed.): C.M. par lui-même: tableaux, dessins, pastels, correspondance. Evreux 1989 .- Proietti, M.L.: Lettere di C.M. Assisi and Rome 1974 CATALOGUES: Rossi Bortolatto, L .: L'opera completa di C.M. 1870-1889. Milan 1972 .- Rossi Bortolatto, L. and J. Bailly-Herzberg: Tout l'œuvre peint de M. 1870-1889. Paris 1981.-Wildenstein, D.: C.M.: Biographie et catalogue raisonné. 5 vols. Lausanne and Paris 1974-1991 BIBLIOGRAPHY: Adhémar, H. et al. (eds.): Hommage à C.M. Grand Palais, Paris 1981 (EC) .- Alexandre, A .: C.M. Paris 1921 .- Clemenceau, G .: C.M. Les nymphéas . Paris 1928 .-Bonnier, Louis: Avant-projet d'un pavillon d'exposition pour C.M. Paris 1920 .- Cogniat, R.: M. and his World. London 1966 .- Cogniat, R. et al. (eds.): M. et ses amis. Musée Marmottan, Paris 1971 (EC) .- Elder, M .: A Giverny, chez C.M. Paris 1924 .-Fels, F.: La vie de C.M. Paris 1929 .-Fosca, F.: C.M. Paris 1927 .- Geffroy, G.: C.M., sa vie, son temps, son œuvre. Paris 1922 .- Gordon, R. and A. Forge: M. New York 1983 .- Gordon, R. and A. Forge: M. Cologne 1985 .- Grappe, G.: C.M. Paris 1909 .-Gwynn, S.: C.M. and his Garden. London 1934 .- Hamilton, G.H .: C.M.s' Paintings of the Rouen Cathedral. London 1966.- Hommage à C.M. Grand Palais, Paris 1980 (EC) .-Hoschedé., J.-P.: C.M., ce mal connu. 2 vols. Geneva 1960.- House, J.: M. Oxford 1977 .- House, J .: M. Nature into Art. New Haven (CT) and London 1986 .- Isaacson, J .: M .: Le déjeuner sur l'herbe. New York 1972.-Isaacson, J.: C.M., Observation and

Reflection. Oxford and New York

1978.- Joyces, C. et al.: Monet at

Giverny. London 1975, 1988.- Keller,

H.: Ein Garten wird Malerei. Cologne 1982 .- Keller, H.: C.M. Munich 1985 .- Kendall, R. (ed.): M. by Himself. London 1989.- Lévêque, J.J.: M. Paris 1980.- Levine, S.Z.: M. and his Critics. New York and London 1976 .-Moffet, C.S.: M.'s Water Lilies, New York 1978 .- Mount, M .: M. New York 1966 .- Reuterswärd, O.: M. Stockholm 1948.- Rewald, J. and F. Weitzenhoffer (eds.): Aspects of M. A Symposium on the Artist's Life and Time. New York 1984.- Rouart, D.: C.M. Paris 1958 .- Rouart, D. et al .: M. Nymphéas ou les miroirs du temps. Paris 1972 (EC) .- Sagner-Düchting, K.: C.M.: A Feast for the Eyes. Cologne 1990.- Seiberling, G.: M.'s Series. New York and London 1981.- Seitz, W.C.: C.M. New York 1960, London 1984.- Seitz, W.C.: C.M. Seasons and Moments. New York 1970 .- Spate, V .: The Colour of Time. The Life and Work of C.M. London and New York 1992 .-Stucky, C.F. (ed.): M. A Retrospective. New York 1985.- Tucker, P.H.: M. at Argenteuil. New Haven (CT) and London 1982.- Tucker, P.H. (ed.): M. in the 90's. The Series Paintings. Museum of Fine Arts, Boston et al. New Haven (CT) and London 1989 (EC) .- Werth, L .: C.M. Paris 1928 .- Westheim, P.: C.M. Zurich 1953.- Wildenstein, D. et al. (eds.): M.'s Years at Giverny: Beyond Impressionism. Metropolitan Museum

of Art, New York 1978 (EC) ILLUSTRATIONS: 8 Monceau Park, 1878

- 40 The Walkers (Bazille and Camille), 1865
- 40 Le déjeuner sur l'herbe (left section), 1865
- 41 Le déjeuner sur l'herbe (study), 1865
- 41 Le déjeuner sur l'herbe (centre section), 1865
- 49 Women in the Garden, 1866
- 50 Quai du Louvre, 1867
- 51 The Garden of the Infanta, 186756 Angling in the Seine at Pontoise, 1882
- 57 The Beach at Sainte-Adresse, 1867
- 57 The Regatta at Sainte-Adresse, 1867
- 59 Terrace at Sainte-Adresse, 1867
- 73 La Grenouillère, 1869
- 76 The River, Bennecourt, 1868
- 91 Riverside Path at Argenteuil, 1872
- 91 The Harbour at Argenteuil, 1872102 The Boulevard des Capucines,
- 1873
- 112 Red Poppies at Argenteuil, 1873113 Impression: Sunrise, 1873
- 118 Monet's Garden at Argenteuil,
- 1873
- 119 The Luncheon, 1873
- 137 The Road Bridge at Argenteuil, 1874
- 137 The Bridge at Argenteuil, 1874 139 The Studio Boat, 1874
- 140 The Railway Bridge, Argenteuil,
- 1873
- 141 The Bridge at Argenteuil, 1874 146 Lady with Parasol (facing right),
- 1886
- 146 Lady with Parasol (facing left), 1886

- 147 The Walk. Lady with Parasol, 1875
- 150 Madame Monet in Japanese Costume, 1875
- 170 Gare Saint-Lazare, Paris, 1877170 Gare Saint-Lazare: the Train
- from Normandy, 1877 171 Le pont de l'Europe, Gare Saint-
- Lazare, 1877 176 Camille Monet on her Deathbed, 1879
- 177 Rue Saint-Denis, Festivities of 30 June, 1878, 1878
- 197 Still Life with Pears and Grapes, 1880
 219 Monet's Garden at Vétheuil,
- 1881
- 230 Cliffs near Dieppe, 1882
- 231 Clifftop Walk at Pourville, 1882 232 Rough sea at Etretat, 1883
- 233 The Rocks near Pourville at Ebb Tide, 1882
- 233 The Beach at Etretat, 1883
- 245 The Rocks of Belle-Ile (Rough Sea), 1886
- 270 La Manneporte near Etretat, 1886
- 296 Young Girls in a Boat, 1887
- 296 Boating on the River Epte, 1890
- 297 The Boat, 1887
- 330 Poplars on the Banks of the Epte, 1891
- 331 Haystack in the Snow, Morning, 1890
- 331 Haystack in the Snow, Overcast Weather, 1891342 Rouen Cathedral in the Morn-
- ing, 1894
- 342 Rouen Cathedral in the Morning Sun, 1894
- 342 Rouen Cathedral in the Morning, 1894
- 342 Rouen Cathedral in Bright Sunlight, 1894
- 342 Rouen Cathedral in Overcast Weather, 1894
- 342 Rouen Cathedral. Frontal view, 1894
- 343 Rouen Cathedral in Bright Sunlight, 1894
- 362 Monet's Garden, the Irises, 1900363 The Houses of Parliament,
- London, c. 1900/01
- 364 The Japanese Bridge, Harmony in Green, 1899
- 364 The Japanese Bridge, 1900
- 365 The Japanese Bridge, 1899
- 393 Waterlilies, 1914
- 394 Wistaria, 1919/20

MONFREID Georges-Daniel

1856 Paris - 1929 Saint-Clément Self-taught artist and father of the novelist Henri de Monfreid. 1874 studied at the Académie Julian in Paris; friends with Schuffenecker. 1880 rejected by the Salon. Travelled by ship to Brittany, Spain and Algeria. Met Gauguin at the Académie Colarossi. 1889 contributed to the Impressionist and Synthetist exhibition at the Café Volpini, organised by Gauguin and Bernard. Exhibited at the Salon des Indépendants, the Galerie Le Barc de Boutteville, at Durand-Ruel's, and later also at the Autumn Salon. From 1892 he shared a studio with Gauguin, whom he also admired and supported financially, and kept up an extensive correspondence with him. His painting, however, was inspired more by Pissarro or Guillaumin. **1938** large individual exhibition at the Galerie Charpentier.

MONTICELLI Adolphe Joseph Thomas

1824 Marseilles - 1886 Marseilles 1840-1842 pupil with F. Ziem; 1842-1846 studied at the school of drawing in Marseilles with Aubert and Loubon. 1846 moved to Paris and studied in the studio of Paul Delaroche. Influenced by Delacroix and Corot: painted also at Barbizon, 1848 returned to Marseilles; until 1862 he lived alternately in Marseilles and Paris, 1862-1870 moved back to Paris. 1856 met Diaz and 1858 Gachet. Frequent customer in the Café Guerbois, where he met the Batignolles painters and Manet. From 1870 he lived once more in Marseilles, leaving the city only to paint in the outlying districts. A keen patron of the theatre and opera, he depicted the atmosphere of theatre and festival in his pictures; used a brush technique akin to that of van Gogh and Cézanne

CATALOGUE: Stammegna, S.: M. 2 vols. Venice 1981-1986 BIBLIOGRAPHY: Agnel, A. d' and E. Isnard: M., sa vie, son œuvre. Paris 1926.– Alauzen, A.M. Le vrai M. Marseilles 1986.– Coquiot, G.: M. Paris 1925.– Guinaud, L.: La vie et les œuvres de M. Paris 1931

numerous artists, especially Manet, becoming knowledgeable about their work and theories. **1879** Manet painted three portraits of him. Wrote for various journals. **1880** moved back to England and became active in the New English Art Club, a group of artists working from Impressionist principles. Moore was the only Anglo-Saxon critic to write an article on the last Impressionist exhibition of **1886**.

MORET Henry

1856 Cherbourg - 1913 Paris Studied at the Ecole des Beaux-Arts with Laurens and Gérôme. Exhibited for the first time in 1880. Soon turned away from the academic style of his teachers; influenced by Monet. 1888 met Gauguin at Pont-Aven and formed a friendship with him; also met Bernard. 1889 worked at Le Pouldu with Gauguin's adherents. 1888-1892 turned to Synthetism; established his own stylistic blend of Impressionism in the manner of Guillaumin and the style of the Pont-Aven school. From 1896 lived in the small port of Doelan in Brittany. His favourite subject was the Breton landscape. 1900 travelled in Holland. BIBLIOGRAPHY: H.M. 1856-1913. Galerie Durand-Ruel. Paris 1959 (EC). -H.M. Aquarelles et Peintures. Musée de Pont-Aven, Pont-Aven 1988 (EC) ILLUSTRATIONS:

382 The Village of Paulgoazec, 1906382 Ouessant, Calm Seas, 1905

MORISOT Berthe 1841 Bourges – Paris 1895 Daughter of a top civil servant in the

Departement of Cher and a greatniece of the rococo painter Fragonard. 1857 took lessons and learned to draw. 1859 met Fantin-Latour in the Louvre, 1860-1862 a pupil of Corot with her sister Edma (later Mme Pontillon). Corot advised her to go to Auvers-sur-Oise and learn to paint plein-air. Met Daubigny there. 1864 exhibited her first landscapes in the Salon, travelled in Brittany. 1868 became friends with Manet, who gave her advice and painted her portrait ("Repose", "The Balcony", pp. 48, 63). 1872 travelled in Spain. 1874-1886 exhibited at all the Impressionist exhibitions apart from the 4th due to illness. 1874 married Manet's brother, Eugène. 1875 contributed pictures to the auction at the Hôtel Drouot. Travelled in England. 1881-1883 had a house built in Paris which became a weekly meeting place every Thursday for painters and writers such as Degas, Caillebotte, Monet, Pissarro and Whistler; Puvis de Chavannes, Duret, Renoir and Mallarmé also visited her; the latter became her closest friend and greatest admirer. 1882 exhibited at the Galerie Petit and in 1887 with Les Vingt in Brussels. 1892 widowed, bought a château in Mesnil. First single exhibition at Boussod & Valadon's. 1894 first sale of a painting to the French state. 1895 large memorial exhibition at Durand-Ruel's with 300 pictures: the catalogue introduction was written by Mallarmé. Her daughter married a son of the art collector and painter Henri Rouart; her niece Nini Gobillard married Valéry. With her fresh, bright impressions of happy domestic life, she made an important contribution to Impressionism.

WRITINGS, DOCUMENTS: Rouart, D. (ed.): B.M.'s Correspondence with Family and Friends. London 1957 (New edition: The Correspondence of B.M. Newly introduced and edited by K. Adler and T. Garb. London 1986) CATALOGUE: Bataille, M.L. and G. Wildenstein: B.M. Catalogue des peintures, pastels et aquarelles. Paris 1961 .-Clairet, Montalan and Rouart: B.M. Catalogue raisonné (in preparation) BIBLIOGRAPHY: Adler, K. and T. Garb: B.M. Oxford 1987 .- Angoulvent, B.M. Paris 1933 .- B.M. Impressionist. National Gallery of Art, Washington; The Kimbell Art Museum, Fort Worth; Mount Holyoke

MONTMARTRE

Hill in the north of Paris, originally with four windmills, from the middle of the 19th century a quiet suburb which became a centre for the art scene. From 1876 the hill was crowned with the church of Sacré Cœur. The café in a converted windmill, "Le Moulin de la Galette", the Café de la Nouvelle-Athènes on the Place Pigalle, the "Moulin Rouge" dance hall of 1889, and the Goupil art gallery (later Boussod & Valadon) became important localities in the history of Impressionism.

MOORE Georges

1852 Moorehall Ballyglass - 1933 London

Irish art critic and writer. Attempted first to train as an artist, taking drawing lessons in in London. At the age of 21, he moved to Paris and studied with Cabanel at the Ecole des Beaux-

- 88 Portrait of Madame Pontillon, 1871
- 88 The Mother and Sister of the Artist (Reading), c. 1869/70
- 89 On the Balcony, c. 1871/72
- 89 The Cradle, 1873
- 95 View of Paris from the Trocadéro, 1872
- 108 Hide and Seek, 1873
- 108 In the Grass, 1874
- 123 Chasing Butterflies, 1874
- 151 At the Ball, 1875
- 160 Young Woman Powdering Herself, 1877
- 192 Summer Day (Bois de Boulogne), 1879

MORRICE James Wilson 1865 Montreal – 1924 Tunis Studied law and trained as a barrister.

Moved to Paris and studied at the Académie Julian. Painted with his American and British colleagues Glackens, Henri, Lawson and O'Conor in Pont-Aven and Grèz-sur-Loing. Travelled in America, Russia, Venice, Tangiers and Gibraltar. His landscapes were influenced by the restrained use of colour found in Whistler and Boudin. 1912/13 met Matisse, Marquet and Camoin in Tangiers; from then on his palette brightened and became more powerful. Financially independent, he painted mainly for his own pleasure; one of the best of the Canadian Impressionists.

BIBLIOGRAPHY: Cloutier, N. et al. (eds.): J.W.M. The Montreal Museum of Fine Arts, Montreal 1985 (EC) ILLUSTRATION:

627 Quai des Grands-Augustins, Paris, c. 1903/04

MOULIN DE LA GALETTE, Le

Large barn in Montmartre on the Rue Lepic, surrounded by a large wooden fence. In the grounds itself stood two windmills, one of which served as a café while the other was still used at the time to grind lily bulbs for a perfume factory. The owners of the mill, the Debrays, had extended the café to provide a dance floor and stage for the orchestra. They also baked the famous cakes which gave the mill its name (galette = a flat, round cake).

Every Sunday from 3 p.m. till midnight, Montmartre families, whitecollar workers, students and artists gathered for the dance here or in the adjacent garden, lit in the evenings with Chinese lanterns. Entrance cost 25 centimes and gentlemen had to pay an extra 20 centimes for every dance. Between 1875 and 1883 Renoir looked for (and found) most of his models here (p. 153).

MOULIN ROUGE, Le

A dance hall, opened in October 1889 by Charles Zidler on the Boulevard de Clichy. A meeting place for Paris society high and low at the turn of the century. The red windmill at the entrance was just a façade, behind which were various sections, including a wooden elephant that transformed into a stage. The bar was decorated with mirrors, galleries and gas lamps, and brightly lit. Entrance cost 3.50 francs; the programme included various singers and artistes, plus the high point: the dancing of the quadrille and the cancan. Toulouse-Lautrec, who had reserved a table for himself from the opening night, became the artistic chronicler of the Moulin Rouge. His posters and paintings were occasionally exhibited in the foyer (see pp. 324-327).

MULOT-DURIVAGE Emilien

Mole of PDOR VGL Elmited mainly landscapes of Normandy. Member of the Société des peintres, graveurs, sculpteurs. 1874 exhibited two works at the 1st Impressionist exhibition in Nadar's rooms.

MUNCH Edvard 1863 Loten – 1944 Ekely

Came from a family of famous artists and scientists. Tragic family circumstances affected his work. 1868 death of his mother; 1877 death of his favourite sister Sophie; his father became depressive. 1880 enrolled at the technical college. 1881 studied at the Royal School of Drawing in Oslo with the sculptor Julius Middelthun. Met Krohg and under his tutelage painted light-filled, naturalistic landscapes and figural studies. 1883 attended the plein-air school of Thaulow, 1885 first visit to Paris. Development of his Persian style, in which colour and form became the expression of the mood felt, 1889 first one-man exhibition; received a state scholarship. 1889-1892 stayed in Paris. Attended Bonnat's courses on drawing; studied the Old Masters and Impressionism. The result was a series of landscapes in Pointillist style. Debate with the Pont-Aven school and the "Nabis". 1892 trip to Berlin and exhibition at the "Verein der bildenden Künstler", which caused a scandal and had to be closed; this was followed by the founding of the Berlin Secession. From 1894 he published his graphic prints; around 1900 numerous famous illustrations. In the 1890s he lived mostly abroad in France, Italy and Germany. In Berlin he came into contact with Strindberg, Meier-Graefe, Przybyszewski and others. 1896-1898 contributed to exhibitions at the Salon des Indépendants in Paris. 1902 at the Berlin Secession he exhibited the picture series "Lebensfries" ("Frieze of Life"), which he had begun in 1893. 1904 became a member of the Secession. 1905 large one-man exhibition in Prague. 1908 finally returned to Norway, after a nervous breakdown. Lived in the small fishing town of Kragerø. 1916 completed three mural decorations for the hall of Oslo University. From 1916 lived near Oslo in Ekely. 1921/22 decoration for the dining hall of the Oslo chocolate factory Freia. In the 1930s suffered from an eye affliction. CATALOGUES: Schiefler, G.: Verzeichnis des graphischen Werks E.M.s bis 1906. Berlin 1907.- Schiefler. G .: E.M. Das graphische Werk 1906-1926. Berlin 1928 BIBLIOGRAPHY: Benesch, O.: E.M. London 1960 .- Bock, H. and Busch, G.: E.M. Probleme, Forschungen, Thesen. Munich 1973 .- Boulton Smith, J.: E.M. 1863-1944. Berlin 1962 .- Carlsson, A.: E.M. Leben und Werk. Stuttgart and Zurich 1984 .-Deknatel, F.: E.M. New York 1950 .-Eggum, A.: E.M. Paintings, Sketches and Studies. London 1984 .- Eggum, A .: Munch and Photography. London 1989 .- Gauguin, P.: E.M. Oslo 1946 .-Gerlach, H.E. E.M. Sein Leben und sein Werk, Hamburg 1955.- Gierløff, C.: E.M. selv. Oslo 1953 .- Glaser, C.: E.M. Berlin 1917 .- Heller, R.: M. His Life and Work. London 1984 .-Hodin, J.P.: E.M. Stockholm 1948; Berlin and Mainz 1963.- Hodin, J.P.: E.M. London 1972 .- Langaard, J.H .: E.M. Modningsår Oslo 1960.- Langaard, J.H. and R. Revold: E.M. som tegner. Oslo 1958 .- Langaard, J.H. and R. Revold: E.M. fra år til år. Oslo 1961.- Langaard, J.H. and R. Revold.: E.M. Mesterverker i Munchmuseet. Oslo 1963.- Messer, T.: E.M. Cologne 1989.- Moen, A.: E.M. 3 vols. Oslo 1956-1958.- E.M. Haus der Kunst, Munich 1973 (EC).- E.M. 1863-1944. Museum Folkwang, Essen et al. Berne 1987 .- Sarvig, O .: E.M. Grafik. Copenhagen 1948.-Stang, R.: E.M. Oslo 1972 .- Stenersen, R.: E.M. När bild av ett geni. Stockholm 1944; Oslo 1945; Zurich 1949 .- Thiis, J .: E.M. og hans samtid. Oslo 1933 .- Væring, R. and J.H. Langaard: E.M. selvportretter. Oslo 1947.- Willoch, S.: E.M. raderinger. Oslo 1950 ILLUSTRATIONS: 491 Rue Lafayette, 1891

492 Spring on Karl Johan, 1891

MURER Eugène

1845 Moulins – 1906 Auvers-sur-Oise Real name: Hyacinthe Eugène Meunier. A writer, art collector and patron, and one of the most flamboyant of the characters in Impressionist circles. During a short period at the college in Moulins, he met Guillaumin and Outin. Moved to Paris and did an apprenticeship with

Eugène Gru, a confectioner and Socialist writer who frequented Bohemian and journalist circles and encouraged him to write. In 1870 he opened his own confectionery. Enthusiastic about Impressionism, he supported the painters in any way he could. His weekly meetings on Wednesdays at his flat on the Boulevard Voltaire became famous and most of the Impressionists and collectors went there. Murer was himself a painter and owned an important collection: Renoir and Pissarro both painted his portrait. 1878 co-organiser of the World Fair in Paris. From 1881 he lived in Auvers.

MUYBRIDGE, Eadweard 1830 Kingston (near London) - 1904 Kingston

Real name: Edward James Muggeridge. American photographer who, by placing a series of cameras side by side, was the first to photograph the actual positions of an animal in motion. On the basis of Muybridge's photographs of galloping horses, it was possible for Degas to make the discovery that the usual artistic formula for a "flying gallop" in which all four legs of the animal were depicted in the air did not correspond to reality (see p. 71).

NABIS

Post-Impressionist group of artists in France; the name is Hebrew for "prophets". Founded by pupils at the Académie Julian and the Ecole des Beaux Arts in 1888 under the influence of Gauguin's "Synthetist" style and Sérusier's "Talisman" (p. 320). From 1888 to 1893 various artists joined the group, including foreigners: Denis, Bonnard, Vuillard, Vallotton, Rippl-Rónai, Maillol and others. Taking the bright colours and asymmetry of the Impressionists, the Nabis favoured a more Symbolist and decorative view of art. They were influenced by Cézanne and Puvis de Chavannes, as well as by Japanese graphic art. The group first met at the studio of P. Ransons, which became known as the "Temple". From 1891 they organised exhibitions at Le Barc de Boutteville, contributed to the "Salon des Indépendants", and did work for the modern theatre. They also had connections with the journal "La Revue Blanche". In 1899 they gave a group exhibition at the Durand-Ruel gallery and in 1900 at Bernheim-Jeune's. Through Denis, Sérusier and Verkade, the group became a source of religious art in the 20th century.

NADAR

1820 Paris - 1910 Paris

Real name: Félix Tournachon. Began his career as a journalist and writer for various journals. From 1846 he became successful for his caricatures. The brunt of his witty but trenchant humour was often borne by members of the Academy. 1853/54 turned to photography; founded a photographic studio and became the first to take aerial photographs of Paris from

a hot-air balloon. Did the portraits of many famous personalities. Tried to raise photography to the level of a recognized art form. Supported the Impressionists and helped with the organisation of the 1st Impressionist exhibition, which took place at his studio in the Boulevard des Capucines.

NATANSON Thadée 1868 Warsaw - 1951 Paris

Important collector of Impressionist paintings; journalist and businessman. Friend of the writers Mallarmé and Anatole France and the journalists of "La Revue Blanche". In Giverny he met Monet, Pissarro and Renoir, and was acquainted with Gauguin, Redon, Rodin and Signac. He often had his portrait painted. After his death his wife donated part of his collection to the Musée National d'Art Moderne.

NEO-IMPRESSIONISM

Artistic movement started by Seurat. The application of a specific technique (Divisionism = separation of colours, or Pointillism = applying colour in small points or dashes). The result of older and contemporary physical and physiological research by Chevreul, Helmholtz, Rood and Sutter into the nature of coloured light and the processes of perception. Following this research, Seurat attempted from 1882 to find a method of rendering light in a picture as closely as possible to real perception. Thus, instead of mixing coloured paints, he juxtaposed small points or dashes of unmixed, primary colours, which at the right distance produced the desired effect on the eye of the observer. It was a kind of optical blending, using simultaneous contrasts and the heightening effect of complementary colours. This "chromoluminarism" (as Seurat called it) was seen for the first time in the picture "Bathers at Asnières" at the Salon des Indépendants in 1884. The technique was taken over by Signac, C. Pissarro and L. Pissarro, and in 1886 it was given the name Neo-Impressionism or "scientific Impressionism" by Fénéon. This Pointillist technique was given further impetus at the 8th Impressionist exhibition and the Salon des Indépendants of 1886, and in 1887 with Les Vingt in Brussels. It found a fluent proponent in Signac ("From Delacroix to Neo-Impressionism",

1899). The method gained temporary and more permanent adherents abroad and in 1904-1906 it became an important source for Fauvism (Matisse) and Expressionism, as well as for the later movements of Cubism and Futurism.

NIEUWERKERKE Alfred-Emilien de 1811 Paris - 1892 Gattaiola

Real name: Alfred Emilien O'Hara, Count of Nieuwerkerke. French politician of cultural affairs, of Dutch origin, originally a sculptor. 1849-1870 Director-General of the national museums. 1853 member of the Institut de France. 1863-1870 appointed by his friend Napoleon III as Superintendent of Fine Arts responsible for state policy on the arts. Chairman of the Salon jury. An opponent of realism, which he regarded as art for democrats. Despised the new Impressionism. In 1870 he was deposed; thereafter he lived in Italy.

NITTIS Giuseppe De 1846 Barletta - 1884 St.-Germainen-Lave

1861-1863 studied at the college of art in Naples, afterwards painting plein-air in Portici. 1866 contacts with the Macchiaioli in Florence. 1867-1870 living in Paris. 1872 finally settled there; travelled frequently to Italy and London. Pupil of Gérôme; sold work through the art dealer Goupil. 1869 exhibited at the Salon. Friendship with Manet and Degas, later with Toulouse-Lautrec. 1874 took part in the 1st Impressionist exhibition. 1878 awarded the Légion of Honour. 1879 turned to pastels. Very popular one-man exhibition at Charpentier's, "La Vie moderne". 1882 co-founder of Petit's "Expositions internationales". Nittis's bright, relaxed landscapes and city scenes, often in small format, and his anecdotal genre pictures of modern life are a successful compromise between Salon and Impressionism.

WRITINGS, DOCUMENTS: Cecioni, A. and E. Somarè (eds.): De N. Opere e scritti. Milan 1932.- De Nittis, G.: Notes et souvenirs. Paris 1895 CATALOGUE: Piceni, E.: De N. L'uomo e l'opera. Busto Arsizio 1979-1982 BIBLIOGRAPHY: Cassandro, M.: De N. Bari 1971.- Causa, R.: G. De N. Bari 1975 .- De N.: dipinti 1864-1884. Palazzo della permanente,

Milan 1990 (EC) .- Mantz, P.: Joseph De N. Paris 1886 .- Monti, R. (ed): G. De N. Dipinti 1864-1884. Palazzo della Permanente, Milan: Pinacoteca Provinciale, Bari, Florence 1990 (EC).- Mostra di G. De N. Società Salvator Rosa, Naples 1963 (EC) .-Pica, V.: G. De N. Milan 1914 .-Piceni, E.; G. De N. Milan 1955 .-Piceni, E. and M. Monteverdi: I De N. di Barletta. Barletta 1971.- Piceni, E.: De N. L'uomo e l'opera. Busto Arsizio 1979.- Pittaluga, M. and E. Piceni: De N. Milan 1963 ILLUSTRATIONS: 539 The Victoria Embankment,

London, 1875

540 Breakfast in the Garden, c. 1884

NORDSTRÖM Karl Frederik 1855 Hoga - 1923 Drottningholm (Stockholm)

1875-1878 studied at the Stockholm Royal Academy and from 1876 with E. Perséus. In 1881 moved to Paris and lived 1882-1886 mainly in Grèzsur-Loing, a centre of Impressionist plein-air painting south-east of Paris, where he met Larsson and Krohg. At first influenced by the Barbizon school and Bastien-Lepage, he then turned to Impressionism. No success at the Salon. 1886 returned to Norway and painted Swedish (winter) landscapes. Member of the group "Kunstnärsförbundet", which opposed the Academy. 1892 moved to Varberg, where 1893-1895 he founded with Bergh and Kreuger the Varberg school, an association of Swedish Symbolists. Painted landscapes in clearly defined, separate areas of colour and dark, melancholy tones. 1920-21 travelled in France. From 1910 his palette brightened and he turned increasingly to drawing. BIBLIOGRAPHY: Hedberg, T.: K.N. En studie. Stockholm 1905.- Högdahl, T.: Några kolteckningar av K.N. Stockholm 1923.- Svedfelt, T.: K.N.s konst. Stockholm 1939 ILLUSTRATION:

473 A Clearing in the Woods at Grèz, 1882

NOUVELLE-ATHENES → Café de la Nouvelle-Athènes

OTTIN Auguste Louis Marie 1811 Paris - 1890 Paris Pupil of David d'Angers. 1836 won the Rome prize. 1841 exhibited for the first time in the Salon. 1842, 1846 and 1867 won medals there. 1867 big success at the World Fair; made Chevalier de la Légion d'Honneur. Commissioned by the state to do the figures for the Medici fountain in the Parc du Luxembourg. 1874 only artist to exhibit ten sculptures at the 1st Impressionist exhibition. Nevertheless, there are no links between his work and that of the Impressionists.

OTTIN Léon-Auguste Born in Paris in 1836; date of death unkown

Son of the sculptor Auguste Ottin. Pupil of Delaroche and Lecoq de Boisbaudran, at whose studio he met Fantin-Latour. 1861-1882 exhibited regularly at the Salon. 1863 and 1873 contributed to the Salon des Refusés. With Cals, Daubigny, Lépine, Monet, Pissarro and Sisley he signed a letter to the Ministry of Arts demanding that the members of the jury be selected by the artists themselves. Contributed 7 works to the 1st Impressionist exhibition in 1874 and 22 to the 2nd exhibition in 1876.

PAAL Lázló

1846 Zám - 1879 Charenton 1864-1870 studied at the Academy in Vienna. 1870/71 stayed in Holland, London and Düsseldorf, 1872-1879 in Paris and Barbizon, friendship with Munkácsy; nervous illness. A Páal Society existed 1923-1944 in honour of his contribution to the development of Hungarian painting. BIBLIOGRAPHY: L. Bényi: L.P. 1846-1879. Budapest 1979

ILLUSTRATION:

521 Path in the Woods at Fontainebleau, 1876

PANKIEWICZ Józef

1866 Lublin - 1940 Marseilles 1884 studied with W. Gerson and A. Kaminski at the Warsaw school of drawing; friendship with Podkowinski and Stanislawski. 1885/86 studied at the Academy in St. Petersburg. 1886-1889 painted with Podkowinski in Kazimierz and Warsaw. 1889 travelled to Paris with Podkowinski; met Slewinski and Stanislawski. 1890 in Kazimierz, exhibited in Warsaw, after which he mainly painted Impressionist landscapes in Warsaw. 1894 tour of Italy. 1897-1910 member of the group "Art" (Sztuka). 1898 travelled in western Europe. 1906-1914 and 1919-1923 Professor at the Academy of Arts in Cracow, in the vacations in France. 1908 met Bonnard. 1911/12 in Giverny, met Monet. 1914-1918 in Spain, influenced by the Cubism of Picasso and Braque. 1925-1939 Director of the Paris branch of the Cracow Academy. 1927 Chevalier of the Legion of Honour. 1939 moved to Ciotat on the outbreak of war.

BIBLIOGRAPHY: Cybis, J.: J.P. Warsaw 1949.- Czapski, J.: J.P. Warsaw 1936 .- Dmochowska, J.: W kregu P. Cracow 1963.- Ligocki, A.: J.P. Warsaw 1973.- Pawla, J.: J.P. Warsaw 1979 ILLUSTRATION: 514 The Old City Market, Warsaw,

at Night, 1892

PARIS

The dominant centre of France in politics, economics and culture; for developments in these areas it gained worldwide significance ("capital of the 19th century"). During the Second Empire of Napoleon III, it was transformed by Baron Haussmann, Prefect of the Seine department, into an exemplary modern city (boulevards, covered markets, railway stations); the re-structuring of the city continued after the destructive period of the Prussian siege and the Commune in the Third Republic. Paris was the centre for the most important institutions in French artistic life (Institut de France, Ecole des Beaux-Arts, Louvre, regular art Salons). The art trade flourished here (by 1861

there were 104 galleries) as did the publishing of books and journals of art. There was a rich entertainment scene (theatre, variety shows, gastronomy). The World Fair was put on five times in Paris between 1855 and 1900, which allowed the free exchange of artistic views and ideas. The transformed city structure brought new social, cultural and visual experiences; the view of the city, the way of life and the change in communications all contributed to the motifs and pictorial concepts of the Impressionists.

PALILI Hanna

1864 Stockholm - 1940 Stockholm Began her artistic career at the the August-Malström school of painting for children in Stockholm. 1881-1885 studied at the Academy of Arts in Stockholm, 1885-1887 attended courses with Dagnan-Bouveret, Courtois and Collins at the Académie Colarossi in Paris. Influenced by Manet and Bastien-Lepage; her free brushwork owes much to her study of French plein-air technique. In 1887 she married the painter Georg Pauli; settled in Stockholm. Became famous as a portrait painter; from the 1890s she also painted genre pictures and landscapes. ILLUSTRATION: 482 Breakfast, 1887

PAULSEN Julius

1860 Odense - 1940 Copenhagen 1879-1882 studied at the Academy in Copenhagen. Protested against the old-fashioned, traditional views of art still held there. Followed Tuxen and Krøyer. 1885 travelled via Holland

and Belgium to Paris with Johansen and Krøyer; all three exhibited at the Salon. Painted portraits and landscapes.

ILLUSTRATIONS:

- 481 St. John's on Tisvilde Beach, 1886
- 495 Under the Pont des Arts in Paris, 1910

PELLERIN Auguste 1852-1929

A rich industrialist and margarine manufacturer, who became known for his interest in contemporary art and for his large collection of paintings, especially Cézannes, including "Still Life with Onions" (p. 348). In 1910 he sold his collection for the record sum of a million francs to the art dealers Durand-Ruel, Bernheim-Jeune and Paul Cassirer.

PELLIZZA DA VOLPEDO Giuseppe 1868 Volpedo - 1907 Volpedo 1883 began his studies at the Brera Academy in Milan, then at the Academies in Florence and Rome, and in 1888 at the Carrara Academy in Bergamo. Moved away from the academic style and began his inquiries into the phenomena of light, leading him to a style akin to that of the Impressionists. Friends with Segantini, Previati, Nomellini, Morbelli and Grubicy, who won him over to Divisionism. For his first Divisionist picture he received a gold medal at Genoa in 1892. 1900 exhibited at the World Fair in Paris. Lived alternately in Rome, Paris and Switzerland, 1907 committed suicide. CATALOGUE: Scotti, A.: P.d.V. Milan 1986

BIBLIOGRAPHY: P. per il "Quarto Stato". Città di Torino. Turin 1977 (EC) .- P. da V. Palazzo Cuttica, Alessandria. Milan 1980 (EC) ILLUSTRATION: 551 Washing in the Sun, 1905

PERRY Lilla Cabot

1848 Boston - 1933 Hancock (New Hampshire) Trained with the plein-air painters Vonnoh and Bunker. Studied in France in the studio of Colarossi and with Stevens. 1889 first stay in

Giverny with Monet. Bought a country house near to Monet's which became her summer residence for the next ten years. Worked under the tutelage of Monet. 1892 received a silver medal at an exhibition in Boston. 1893 exhibited with other American Impressionists at the World Columbian Exposition in Chicago, Lived for a long period in Paris, where she met Pissarro and others. Published writings on Greek, English and German literature and in 1927 a book on Monet, "Reminiscences of Claude Monet from 1889 to 1909".

WRITINGS, DOCUMENTS: Perry, L.C.: Reminiscences of Claude Monet from 1889 to 1909. In: "American Magazine of Art" 18 1927 .- Perry, L.C.: Davs to Remember. Santa Fe 1983 BIBLIOGRAPHY: Feld, S. (ed.): L.C.P. A Retrospective Exhibition. Hirschl and Adler Galleries, New York 1969 (EC) .- L.C.P. An American Impressionist. National Museum of Women in the Arts, Washington 1990 (EC) ILLUSTRATION:

622 Monet's Garden at Giverny, c. 1897

PETIT Georges 1835-1900

Owner of a Café in the Rue de Sèze in Paris, founded by his father Francis Petit: Delacroix. Corot and the painters of the Barbizon school exhibited here. From 1880 he sold Impressionist works and became with Durand-Ruel one of the most important of the gallery owners. Organised numerous exhibitions for individuals and groups. The gallery was closed in 1933.

PETITIEAN Hippolyte 1854 Mâcon - 1929 Paris Began his career as a painter-decorator.

1867-1872 attended the school of drawing in Mâcon. 1872 received a scholarship to attend the Ecole des Beaux-Arts in Paris. Studied with Cabanel, 1880-1891 exhibited regularly at the Salon. 1884 met Seurat, whose style influenced him considerably. From 1886 he painted in a Pointillist style. Up to 1898 he worked for a living as a decorator. 1898 professor of drawing at the school in the Rue de Patay and for evening courses in the Rue des Moulins-aux-près. 1892-1894 took part in several exhibitions by the Impressionists and Symbolists. 1894-1901 exhibited again in the Salon and also abroad in Brussels, Berlin and Weimar. 1903-1904 built a house in the Parc Montsouris, on the façade of which he inscribed the names of his idols, Ingres, Puvis de Chavannes and Millet. Sold very few pictures and got into financial difficulties. In 1819 he changed his style and returned to an old-fashioned type of Impressionism. CATALOGUE: Bazalgette, L .: H.P. Catalogue raisonné (in preparation) BIBLIOGRAPHY: Centenaire d'H.P. (1854-1954), Galerie de l'Institut, Paris 1955 (EC) .- H.P. Watercolours. David B. Findley Galleries, New York (EC)

ILLUSTRATION: 375 Notre-Dame, c. 1895

PETROVIC Nadež da 1873 Čačak - 1915 Valevo

1896-1898 attended K. Kutlik's school of drawing and painting in Belgrade. 1898-1900 studied at Ažbè's private school in Munich. 1900-1903 attended J. Exter's summer courses in and near Munich. Her paintings included landscapes in strong colours. 1900 first individual exhibition in Belgrade. 1900-1910 taught drawing at the women's school of arts in Belgrade. Painted in an Impressionist style and wrote articles of art criticism. 1904 helped with the organisation of the 1st South Slavic art exhibition in Belgrade. 1905 founded an artists' colony in Siceva. 1906 contributed works to the 1st exhibition of the Lada group. Later became a member of the Medulic group. 1910-1912 in Paris, painted views of the city; became influenced by the Fauves; exhibited at the autumn Salon, 1912/13 active in the Balkan wars. 1914 volunteer nurse in the First World War; died of typhoid.

1973 first retrospective in Belgrade. BIBLIOGRAPHY: Ambrozić, K.: N.P. 1873-1915. Belgrade 1973 .- Ambrozić, K. (ed.): N.P. 1873-1915. Neue Pinakothek, Munich 1985 (EC) ILLUSTRATION. 530 Lady with a White Parasol,

c. 1910

PHILIPSEN Theodor Esbern 1840 Copenhagen - 1920 Copenhagen

1862-1869 studied at the Academy in Copenhagen. 1874 trip to Paris. Helped Monet and Degas organise their first exhibition. 1875/76 worked in the studio of Bonnat in Paris. Impressed by Manet. 1877-1879 visited Italy, 1882-1884 Spain and Tunis. 1884/85 in Copenhagen: met Gauguin, who introduced him to Pissarro's techniques. 1889 received a bronze medal at the World Fair in Paris and took part in an exhibition of French and German Impressionists in Copenhagen. His light-filled, hazy landscapes introduced Denmark to Impressionism. BIBLIOGRAPHY: Leth, H.: T.P. Copenhagen 1942 .- Madsen, K .: Maleren T.P. Copenhagen 1912.- Madsen, K .: T.P. Copenhagen 1944 ILLUSTRATIONS: 472 Street in Tunis, 1882 486 A Lane at Kastrup, 1891

PHOTOGRAPHY

The invention was first published in 1839 and became an aid, a rival and a new branch of the arts. 1859 photographs first allowed at the Salon. Related to the Realist, Naturalist and Impressionist goal of faithfully reproducing the visible world. The Impressionists held their 1st exhibition in the recently vacated studio rooms of the Paris photographer F. Tournachon, known as Nadar, whom they had met in the Café Guerbois. Most of the Impressionist artists, for instance Courbet and Corot, and many of the Post-Impressionists used photographs of their own or others instead of sketches as the bases of their landscapes, city views, portraits, nudes and still lifes. The Impressionists were also influenced by certain peculiarities of the photograph, such as its representation of space, its partial lack of focus, and its occasional cutting-off of figures by the edge of the picture. Degas' depiction of movement was considerably influenced in the 1870s by the technology of the camera as developed by the British photographer E. Muybridge (q.v.) - the ability of the camera to record the individual stills in the motion of a galloping horse or a dancer

PIETTE Ludovic 1826 Niort - 1877 Paris

Pupil of Pils and Couture; met Manet in Couture's studio. Studied at the Académie Suisse, where he formed a friendship with Pissarro. Often painted with Pissarro, whose open-air technique considerably influenced him. 1864 first visit to Montfoucault in Brittany; worked frequently in Pontoise and Louveciennes. 1875 exhibited in the Salon. 1877 invited by Pissarro to exhibit at the 3rd Impressionist exhibition. After his death in 1877 his pictures were shown again at the 4th exhibition in 1879. WRITINGS, DOCUMENTS: Piette, L.: Mon cher Pissarro. Lettres de L.P. à Camille Pissarro. Paris 1985 BIBLIOGRAPHY: C. Pissarro, C.-F. Daubigny, L.P. Musée Pissarro. Pontoise 1978 (EC). ILLUSTRATION:

154 The Market outside Pontoise Town Hall, 1876

PINAZO CAMARLENCH Ignacio 1849 Valencia - 1916 Godella (Valencia)

1864 studied at the Academy of Arts in Valencia; earned a living from his hat-shop. 1873 visited Italy. 1876-1881 lived in Rome on a scholarship. 1884-1886 taught at the Escuela de Valencia. 1881-1912 awarded numerous medals. As well as landscapes he also painted history and genre pictures, and portraits. Did the decoration of various aristocrats' houses. His relaxed Impressionist style also uses dark browns and earth colours.

BIBLIOGRAPHY: González Martí, M .: I.P., su vida y su obra. Valencia 1920. ILLUSTRATION: 554 The Pond

PISSARRO Camille 1830 Charlotte-Amalie (Danish Antillas) - 1903 Paris

1842-1847 in Passy near Paris, began to draw, 1847-1852 on Saint-Thomas, went into business like his French-Jewish father; his mother was Creole. 1852-1854 with the Danish painter F. Melbye in Caracas. 1855 lived as a painter in Paris and its environs. Impressed by Corot. 1859 exhibited for the first time at the Salon. 1859-1861 attended the Académie Suisse: formed friendships with Monet, Guillaumin and Cézanne. Liaison with Julie Vellay; they had eight children. 1861 and 1863 rejected by the Salon. 1863 exhibited at the "Salon des Refusés". 1864-1868 exhibited at the Salon; financial difficulties. 1866-1868 in Pontoise, painted landscapes in which he changed from Barbizon Realism to Impressionism; frequent customer in the Café Guerbois. 1869/70 in Louveciennes, exhibited at the Salon. During the Franco-Prussian War 1870/71 in London, where he married Julie. Recommended by Daubigny to the art dealer Durand-Ruel. Many of his paintings were destroyed by German troops during the occupation of Louveciennes. 1872-1878 in Pontoise, working with Cézanne; full development of his independent style of Impressionism. 1874-1886 the only artist to exhibit at all eight Impressionist exhibitions. 1876-1879 supported by the confectioner Murer. 1879 first work with Gauguin. 1881 renewed interest in depicting peasant women. 1882-1884 lived in Osny. 1883 first of several exhibitions at Durand-Ruel's; began to be interested in Socialism. His son Lucien, a graphic artist and painter, moved to London; beginning of an extensive correspondence. 1884 settled in Eragny on the Epte. 1885 became an Anarchist. 1886-1890 painted for a time in a Pointillist style. 1886 exhibition by

Durand-Ruel in New York, 1888 began to suffer from eye problems. 1889 contributed pictures to the century exhibition of the World Fair in Paris and with Les Vingt in Brussels. 1890 in London - further visits followed. 1894 fled to Belgium from the French persecution of Anarchists. 1896 and 1898 painted views of the town and harbour of Rouen, remaining faithful to the early Impressionist style. 1897-1903 mainly painted views of Paris, also Dieppe and Le Havre. 1897 through a donation, one of his paintings reached the National Gallery in Berlin. 1900 at the century exhibition of French art at the Paris World Fair

WRITINGS, DOCUMENTS: Bailly-Herzberg, J. (ed.): Correspondance de C.P. 3 vols. Paris 1980-1988 .- Bailly-Herzberg, J. (ed.): Mon cher Pissarro: Lettres de L.P. à Camille Pissarro. Paris 1985 .- Graber, H.: C.P., Alfred Sisley, Claude Monet nach eigenen und fremden Zeugnissen. Basle 1943 .-Pissarro, L .: Notes on the Eragny Press. London 1957.- Rewald, J. (ed.): C.P.: Letters to his Son Lucien. New York 1943 Santa Barbara and Salt Lake City 1981.- Rewald, I.: C.P.

New York 1963 CATALOGUE: Pissarro, L.-R. and L. Venturi: C.P., son art, son œuvre. 2 vols. Paris 1939 (Reprint: San Francisco 1989) BIBLIOGRAPHY: Adler, K.: C.P. A Biography. New York and London 1978 .- Brettell, R., F. Cachin et al. (eds.): Pissarro 1830-1903. Hayward Gallery, London; Grand Palais, Paris; Museum of Fine Arts, Boston. Paris 1980 (EC) .- Brettell, R.P.: P. and Pontoise: The Painter in a Landscape. New Haven (CT) and London 1990.-Falla, P.S.: P. Museum of Fine Arts, Boston 1980 (EC) .- Günther, H.: C.P. Munich, Basle and Vienna 1954 .- Jedlicka, G.: P. Bern 1950.- Kunstler, C.: C.P. Paris 1974.- Kunstler, C.: The Impressionists: C.P. London 1988.-Lachenaud, J.P. et al. (eds.): P. et Pontoise. Musée Pissarro, Pontoise 1980 (EC).- Lloyd, C. et al. (eds.): C.P. 1830-1903. The Arts Council of Great Britain et al., London 1981 (EC) .- Lloyd, C .: C.P. Geneva and New York 1981.- Lloyd, C. et al. (eds.): Retrospective C.P. Isetan Museum of Fine Art (Tokyo) et al., Tokyo 1984 (EC) .- Lloyd, C. (ed.): Studies on C.P. London and New York 1986 .- Maillet, E. et al. (eds.): C.P., Charles-François Daubigny, Lucien Pissarro. Musée de Pontoise, Pontoise 1978 (EC) .- Meier, G.: C.P. Leipzig 1975.- Natanson, T.: C.P. Lausanne 1950 .- C.P.: Sa famille, ses amis. Musée de Pontoise, Pontoise 1976 (EC) .- Recchilongo, B.: C.P. Grafiche anarchica. Rome 1981.-Reid, M .: P. London 1992 .- Rewald, J. (ed.): C.P. Hayward Gallery, London; Grand Palais, Paris; Museum of Fine Arts, Boston 1981 (EC) .- Rewald, J.: C.P. New York 1963, 1989,-Rewald, J.: C.P. Cologne 1963 .-Roger-Marx, C.: C.P. graveur. Paris 1929.- Sérullaz, M.: C.P. Arcueil 1955 .- Shikes, R.H. and P. Harper: P. His Life and Work. New York 1980.-

Shikes, R.H. and P. Harper: P. Paris 1981.- Tabarant, A.: P. London and New York 1925.- Thomson, R.: C.P. Impressionism, Landscape and Rural Labour. London 1990 .- Thorold, A. (ed.): Artists, Writers, Politics: C.P. and his Friends. Ashmolean Museum, Oxford 1980 (EC)

- ILLUSTRATIONS:
- 58 Jallais Hill, Pontoise, 1867
- 82 The Mailcoach at Louveciennes, 1870
- 83 The Road from Versailles at Louveciennes, 1870
- 99 Chestnut Trees at Louveciennes, c. 1872
- 106 Orchard in Blossom, Louveciennes, 1872
- 107 The Four Seasons: Spring, 1872
- 107 The Four Seasons: Summer, 1872
- 107 The Four Seasons: Autumn, 1872
- 107 The Four Seasons: Winter, 1872
- 116 Hoarfrost, 1873
- 127 A Cowherd on the Route du Chou, Pontoise, 1874
- 127 The Hermitage at Pontoise, 1874
- 157 Harvest at Montfoucault, 1876 157 Rye Fields at Pontoise, Côte des
- Mathurins, 1877
- 173 The Mailcoach. The Road from Ennery to the Hermitage, 1877
- 174 Path at "Le Chou", 1878
- 174 La Côte des Bœufs at the Hermitage near Pontoise, 187
- 175 Vegetable Garden and Trees in Blossom, Spring, Pontoise, 1877
- 175 The Red Roofs, 1877 190 A Fair at the Hermitage near
- Pontoise, c. 1878
- 190 Vegetable Garden at the Hermitage near Pontoise, 1879
- 191 Landscape at Chaponval, 1880 191 The Woodcutter, 1879
- 204 The Cottage "La Garenne" at Pontoise, Snow, 1879
- 204 The Wheelbarow, c. 1881
- 216 The Shepherdess, 1881
- 217 Mère Larchevêque (the Washerwoman), 1880
- 217 Young Peasant Girl Wearing a Hat, 1881
- 226 Woman and Child at a Well, 1882
- 226 Poultry Market at Pontoise, 1882
- 275 Woman in an Orchard. Spring Sunshine in a Field, Eragny,
- 1887
- 275 Apple Picking, 1886
- 312 View from the Artist's Window at Eragny, c. 1886-1888
- 337 The Chat, 1892
- 355 Morning, Overcast Weather, Rouen, 1896 355 Pont Boieldieu in Rouen in a
- Drizzle, 1896
- 356 The Boulevard Montmartre on a Cloudy Morning, 1897
- 356 The Boulevard Montmartre on a Winter Morning, 1897
- 357 The Boulevard Montmartre on a Sunny Afternoon, 1897
- 357 The Boulevard Montmartre at Night, 1897
- 359 The Old Market-Place in Rouen and the Rue de l'Epicerie, 1898
- 361 The Train, Bedford Park, 1897
- 361 The Tuileries Gardens in Rain, 1899

PISSARRO Georges

1871 Louveciennes - 1961 Menton Second son of C. Pissarro, became known under the pseudonym of Manzana (the name of his grandmother on his mother's side). 1889 moved to London, where he attended the school of decoration run by the architect C.R. Ashbee. His father supported his artistic endeavours. 1891 second stay in London, where he met Sargent. After the death of his first wife he moved back to Eragny. Friendship with Luce and van Rysselberghe, with whom he worked in 1894/95 in Brussels and Hemixem. 1895 exhibited enamel works with Les Vingt in Brussels and at the Bing Gallery in Paris. Travelled in Spain and France with his brother Félix. 1898 returned to France; set up in a studio in Montmartre. Frequently worked in Moret, where he spent the holidays with Picabia. 1901 exhibited at Durand-Ruel's, 1903 for the first time at the Salon des Indépendants, and in 1906 at the autumn Salon and at the Indépendants. 1907 exhibited objets d'art and artefacts at Vollard's: from 1910 his successes grew. 1906-1936 turned to an Oriental manner influenced by Persian miniatures and Japanese painting. 1914 large one-man exhibition at the Musée d'Arts décoratifs. During the Second World War he lived in Casablanca. In his last works he returned to the techniques of plein-air painting.

BIBLIOGRAPHY: G.M.-Pissarro. Musée des Andelys 1972 (EC) .- G.M.-Pissarro. Musée Pissarro, Pontoise 1987 (EC) ILLUSTRATION:

360 The Harbour at Rouen, 1898

PISSARRO Lucien

1863 Paris - 1944 London Oldest son of C. Pissarro, with whom he studied plein-air painting. 1880-1883 various occupations. 1883/84 stayed with relatives in London, beginning of an important correspondence with his father. 1884-1890 in Paris, worked for the printer Manzi, turned to wood-cuts and wood engravings. 1886 one of the first to join the new Neo-Impressionist movement; ten catalogue entries (paintings and graphics) at the 8th Impressionist exhibition; exhibited at the first Salon des Indépendants. 1888 exhibited with Les Vingt in Brussels. 1890 finally moved to England, contacts

with the Pre-Raphaelites and open-air painters. 1892 married Esther Bensuan. 1893 settled in Epping. 1894 founded the Eragny Press (the name comes from a place near Dieppe), which played a significant role in the development of European book art. 1895 exhibited at the Art Nouveau exhibition at the Bing Gallery in Paris. 1896 left the Indépendants. 1902 worked with his father in Eragny; thereafter settled in Stamford Brook, Hammersmith, From 1904 exhibited at the New English Art Club and in 1907 with the Fitzroy Street Group. 1911 co-founder of the Camden Town Group, 1913 first one-man exhibition in London. 1916 took British citizenship, 1919 co-founder of the Monarro group, which propagated Impressionism in England. Above all a landscape painter. 1940 moved to Hewood. The correspondence with his father is an important document of the Impressionist movement.

WRITINGS, DOCUMENTS: Pissarro, L. and C. Ricketts: De la typographie et de l'harmonie de la page imprimée. Paris and London 1898.- Pissarro L .: Rossetti. London and New York 1908 CATALOGUE: Thorold, A. et al. (eds.): A Catalogue of the Oil Paintings of L.P. London 1983

BIBLIOGRAPHY: Chambers, D.: L.P.: Notes on a Selection of Wood-Blocks Held at the Ashmolean Museum. Oxford 1980 .- Fern, A.; L.P. Cambridge 1962 .- Landscape Paintings by L.P. The Leicester Galleries, London 1963 (EC).- L.P. His Watercolours. London 1990 (EC) .- Offay, A. d': L.P. 1863-1954. London 1977.- Pickvance, R. (eds.): L.P. A Centenary Exhibition. The Arts Council of Great Britain, London 1963 (EC)

ILLUSTRATIONS:

274 The Church at Gisors, 1888 274 The Deaf Woman's House, 1888

PLEIN-AIR PAINTING

The painting of landscapes and genre scenes in the open-air in order to capture the effect of light on coloration. The technique spread as part of a new striving towards naturalism and authenticity which began in Europe in the second quarter of the nineteenth century; previously, since the fifteenth century, artists working out of doors had used either water colours or the sketch pad. The development in the 1840s of portable paint in

tubes finally made it practicable to paint outside the studio. At first the technique was only used for studies. but from the middle of the century it developed as a viable method, despite opposition from academic circles. Plein-air was a preparatory stage before Impressionism, although it continued to be used by artists who did not go as far as the Impressionists in the separation of colours or the capture of the fleeting moment. It is also true to say that many Impressionist paintings were begun outside but completed in the studio.

PODKOWINSKI Władisław 1866 Warsaw - 1895 Warsaw 1880-1885 studied with W. Gerson at the school of drawing in Warsaw: became friends with Pankiewicz. 1885/86 studied at the Academy in St. Petersburg. 1886-1889 with Pankiewicz in Kazimierz and Warsaw: drew realistic genre scenes for journals. 1889 with Pankiewicz in Paris; met Theo van Gogh. 1890-1895 in Warsaw, painted in an Impressionist style and then became in his last works a pioneer of Symbolism in Poland. BIBLIOGRAPHY: Wierchowska, W .:

W.P. Warsaw 1981 ILLUSTRATIONS:

512 Field of Lupins, 1891

513 Children in the Garden, 1892

POINTILLISM → Neo-Impressionism

POLENOV Vassili Dimitrievich 1844 St. Petersburg - 1927 Gut Borok near Poleovo 1863-1871 during his law studies also

St. Petersburg, from which he graduated with a gold medal. 1872-1876 travelled on a scholarship to Italy and with Repin in France; did portraits and history paintings. 1876 awarded membership of the Russian Academy. 1876-1878 war painter in the war against Turkey. 1878 exhibited for the first time with the "Wanderers"; became one of their leading artists and a major influence in the development of "intimate" plein-air painting. Often visited Mamontov in Abramtsevo. 1881-1882 first of several trips to the Orient. 1882-1895 professor of landscape painting at the School of Art in Moscow; became interested in depictions of Christ and philosophical and religious questions. 1893 began to exhibit with the Moscow Association of Artists, as also Vrubel and Kandinsky were to do later. In 1905 he left the teaching staff of the Academy in protest against the massacre in St. Petersburg. 1910-1918 managed the first folk-theatre in Moscow and became active in the development of factory and village theatre. 1917-1927 lived in the studio house of his own design on the Oka; awarded the title of "Folk-Artist". WRITINGS, DOCUMENTS: Sacharova, J.V. (eds.): V.D.P. Letters, Diaries, Memoirs (Russian). Moscow and Leningrad 1950 BIBLIOGRAPHY: YUrova, T.V.: V.D.P.:

trained as a painter at the Academy in

V.D.P. Moscow 1961.- Sacharova E. (ed.): V.D.P. and Y.D. Polenova. Chronicle of an Artistic Family (Russian). Moscow 1964 ILLUSTRATION:

507 A Yard in Moscow, II, 1878

PONT-AVEN

Small town in Brittany which, like the neighbouring places of Le Pouldu and Concarneau, attracted painters of landscapes and country life; one of the first artist colonies in the countryside. 1886 first visit by Gauguin, Schuffenecker and Bernard, During their second visit in 1888 they developed the "Synthetist" and Symbolist style of painting, an innovation in both form and content. Through his picture "The Talisman" (p. 320), Sérusier mediated the new style to the Nabis in Paris. 1889 the Post-Impressionist "school" of Pont-Aven held its first exhibition at the Café Volpini in Paris as a fringe event during the World Fair; they exhibited landscapes with flat areas of strong colour, genre pictures of fisherman's wives in traditional costume, portraits and religious paintings. More artists joined the movement, which also found adherents from the USA, Denmark, Holland, Poland, Sweden, Switzerland

PONTILLON Edma

and Scotland

1849 Valenciennes - 1921 Paris Berthe Morisot's sister, also a painter. 1857 first lessons with Chocarne and Guichard. Studied plein-air with Corot. Until her marriage she lived with her sister and shared the same friends. 1862 travelled to the Pyrenees. 1864-1867 exhibited in the Salon. Her career finished after her marriage to Adolphe Pontillon, a naval officer and friend of Manet. Morisot often painted her portrait (p.88).

PONTOISE

Idyllic town on the Oise near Auvers, about 20 miles from Paris. Its landscape offered numerous attractive motifs for many artists, especially Pissarro with his houses built in a Roman amphitheatre. In 1866 Pissarro moved to Pontoise, where he met Cézanne in the summer of 1872 and painted with him, persuading him to join the Impressionists, Guillaumin paid him numerous visits. 1877 Cézanne again visited Pontoise while Gauguin was painting there. 1883 Pissarro moved to Osny and then to Eragny.

POST-IMPRESSIONISM

A term first used by the English painter and art critic Roger Fry and made popular by John Rewald. A loose collective idea for the various artistic movements based on Impressionism which started in the period 1884-1886: Cézanne's colour modulation (from about 1879), Pointillist Neo-Impressionism, the expressive exaggerations of van Gogh, the decorativesymbolist Synthetism of Gauguin and his disciples. The term also covers Symbolism (Redon, the Nabis, Munch and others), Art Nouveau, and Toulouse-Lautrec. To be strictly accurate, the bright palettes, sketchy style and compositional movement of many genre artists of the 1870s should also be included. It is, however, stretching the usefulness of the term to apply it to the later works of Monet and others, to the worldwide use of Impressionist technique and point of view in the art of the twentieth century, or to the direct and indirect influence of Impressionism on the early stages of modern movements such as Expressionism.

PREISLER Jan

1872 Popovice - 1918 Prague

1887-1895 studied at the School of Arts and Crafts in Prague; remained there after his studies. 1898 exhibited for the first time with the artists federation "Mánes". An influential exponent of a Symbolism based on Impressionism; also worked as an illustrator and poster designer. Painted murals, and worked with J. Kotěra, the founder of modern Czech architecture. 1900 painted decorative pictures for the Paris World Fair. 1902-1904 travelled to Italy with Hudeček; did some murals for Kotěra's Grand Hotel. 1906 staved in Paris, influenced the Fauvists. 1913-1918 professor at the Academy of Arts in Prague. BIBLIOGRAPHY: J.P. 1872-1918. Národní Galerie. Prague 1964 (EC).- Kotalík, J.: J.P. Prague 1968 .- Wittlich, P.: J.P. Prague 1988 ILLUSTRATION: 518 Bathers, 1912

PRENDERGAST Maurice Brazil 1861 Boston - 1924 New York Trained as a painter of advertisements in Boston. Attended evening courses at the Star King School and also painted watercolour landscapes. 1886/87 trip to England and possibly also France. 1891-1894 studied at the Académie Julian and the Académie Colarossi in Paris. Influenced by Whistler, Manet and Bonnard. 1895 returned to Boston. 1897 exhibited in Boston and rented a studio there. 1898-1900 trip to Europe, including a visit to Venice. In subsequent years he travelled repeatedly in Europe. His warm plein-air painting received great acclaim, with numerous exhibitions and awards. An active proponent of Impressionism and Post-Impressionism (Symbolists, Neo-Impressionists and Nabis); a pioneer of the style in the USA. In 1914, after a trip to Europe, settled in New York. CATALOGUE: Clark, C. et al. (eds.): M.B.P. & Charles Prendergast. A Catalogue Raisonné. Munich and Williamstown 1989 (EC) BIBLIOGRAPHY: Breuning, M. (ed.): M.P. Whitney Museum of American Art, New York 1931 (EC) .- Langdale, C. (ed.): The Monotypes of M.P. Davis and Long Company, New York, 1979 (EC) .- Pach, W. (ed.):

M.P. Memorial Exhibition, Whitney Museum of American Art, New York 1934 (EC) .- Rhys, H.H. (ed.) M.P. 1859-1924. Museum of Fine Arts, Boston, 1960 (EC) .- Scott, D.W .: M.P. Washington 1980.- Sims, P. (ed.): M.P. Whitney Museum of American Art, New York 1980 (EC) ILLUSTRATIONS:

625 Central Park, New York, 1901 625 Ponte della Paglia, Venice, 1899

PREVIATI Gaetano

1852 Ferrara - 1920 Lavagno Studied at the School of Art in Ferrara, in Florence and in 1877 with G. Bertini at the Brera Academy in Milan. From 1875 exhibitions, 1878

first big success. Influenced by Grubicy, he turned to Impressionism. 1887-1890 illustrations for the fairy tales of Edgar Allen Poe; through this work came into contact with Symbolist themes, 1891 exhibited at the Brera Academy. 1902 showed pictures at the exhibition of the Berlin Secession. 1907 designed the "Hall of Dreams" for the Biennale in Venice.

BIBLIOGRAPHY: G.P. Galleria Nazionale d'Arte moderna, Rome 1953 (EC) ILLUSTRATION. 545 In the Meadow, 1889/90

PROUST Antonin

1832 Niort - 1905 Paris Politician and publicist. 1864 founded "La Semaine universelle". Worked as Gambetta's secretary. 1876 Republican delegate for Niort. 1881 Minister of Education, 1889 Commissar of Fine Arts for the World Fair. Frequented all the Salons; close friends with Manet, whom he knew from school days at the Collège Rollin. Due to Proust's influence, Manet was received into the Legion of Honour; his portrait was painted by Manet in 1880. Published his reminiscences of Manet in 1897.

PUVIS DE CHAVANNES Pierre 1824 Lyon - 1898 Paris

After graduation in law and two trips to Italy he became an occasional pupil of Delacroix, H. Scheffer and Couture; especially impressed by Chassériau. 1850 exhibited for the first time at the Salon, but was rejected several times thereafter. 1854/55 executed his first monumental murals, highly decorative and difficult to interpret; this

was to remain his main type of work (it includes the murals in Amiens and the Paris Panthéon), 1887 large exhibition at Durand-Ruel's. 1890 cofounder and 1891 President of the Secessionist Société Nationale des Beaux-Arts. His style was clear and calm, and oriented towards the linear forms of the Classical and Renaissance periods. Soft but bright colours. Belonged to no particular movement, but through his pictures' content and form he considerably influenced the Symbolists (Gauguin, Denis) and also Seurat and Cézanne.

BIBLIOGRAPHY: Boucher, M.-C.: Catalogue des dessins et peintures de P. de C. Paris 1879.- Foucart, J. et al. (eds.): P. de C. 1824-1898, Grand Palais, Paris 1976 (EC) .- Foucart-Borville, J .: Le genèse des peintures murales de P. de C. au Musée de Picardie. Amiens 1976 .- Vachon, M .: P. de C. Paris 1898 .- Viéville, D.: Les peintures murales de P. de C. à Amiens. Amiens 1989.- Wattenmaker, R.J. (ed.): P. de C. and the Modern Tradition. The Art Gallery of Ontario, Toronto 1975 (EC) .- Worth, L .: P. de C. 1926 ILLUSTRATION:

189 Young Women on the Seashore, 1879

RAFFAELLI Jean-François 1850 Lyons - 1924 Paris

Lived all his life in Paris. 1868 trained initially as a singer, attending courses in the mornings at the Ecole des Beaux-Arts and studying for periods with Gérôme. 1870 exhibited for the first time at the Salon. Trips to Italy, Egypt and Spain. From 1871 rejected each time at the Salon until 1876,

when he had a big success. From the middle of the 1870s he was influenced by Monet and Sisley and changed to Impressionism. 1876 went to England. 1880 and 1881 exhibited at the 5th and 6th Impressionist exhibitions. Inventor of the Raffaëlli paint, which has the properties of both oils and watercolours. His painting is full of social criticism in his depictions of the poor areas of Paris; in their subdued tones, they are close to realism; but he also painted portraits and later above all landscapes in and around Paris. Did numerous colour illustrations, which new printing processes could reproduce cheaply. 1889 received a gold medal at the World Fair, 1891 exhibited with the Société Nationale. BIBLIOGRAPHY: Alexandre, A.: J.-F.R. Paris 1909 .- Delteil, L .: I.-F.R. Paris 1923 .- Fields, B.S.: J.-F.R. (1850-1924): The Naturalist Artist. Doctoral thesis, Ann Arbor (MI) 1979.- Lecomte, G.: R. Paris 1927 ILLUSTRATIONS:

211 The Absinth Drinkers, 1881 240 Houses on the Banks of the Oise 240 Waiting Wedding Guests, 1884 246 Fisherman on the Bank of the Seine

RAFFAELLI Jean-Marius

Probably a graphic artist; further facts about his life unknown. 1880 exhibited six etchings at the 5th Impressionist exhibition.

RAŠKAJ Slava

1877 Ozalj - 1906 Stenjevec 1885-1893 grew up in a home for the deaf and dumb in Vienna. 1896 taught to paint by B. Čikoš in Ozalj (Croatia), 1898 exhibited at the 1st exhibition of the Society of Croatian Artists in Zagreb. 1899-1901 lived in Ozalj, Zlatar and Orahovice. 1900 showed some watercolours at the Paris World Fair. Also painted Impressionist pictures. 1901 showed 12 works at the Society of Croatian Artists; became a member. Signs of mental illness. 1902- 1906 at the mental hospital in Stenjevec. BIBLIOGRAPHY: Peić, M.: S.R. Zagreb 1985 ILLUSTRATION:

528 Trees in Snow, 1900

RAURICH Y PETRE Nicolas 1871 Barcelona - 1945 Barcelona After training in a merchant's office, he studied art in Barcelona; travelled to Madrid, Rome, Paris, Munich and London. 1897 received a medal; began a career as a landscape and stilllife painter. Had a big success at the Paris Salon in 1899, as well as in Vienna, Venice, Karlsruhe, Rome, Athens and Mexico. ILLUSTRATION: 566 Solitude

REDON Odilon

1840 Bordeaux - 1916 Paris Mainly self-taught in Bordeaux and Paris. 1867 exhibited an etching at the Salon. Admired Delacroix. Later met Corot, Courbet, Fantin-Latour. 1881 exhibited for the first time at the gallery of the journal "La Vie

moderne". 1884 co-founder of the Indépendants. For years he only did copper engravings. 1886 exhibited at the 8th Impressionist exhibition and with Les Vingt in Brussels. 1890 friendship with Gauguin. 1891 close contact with the poet Mallarmé; began to do Symbolist work. 1899 exhibition in his honour by Symbolist painters at Durand-Ruel's. Began to work again with pastels and oils in a relaxed style with intensive colours. Given a prominent place in Denis' group-portrait "Hommage à Cézanne", 1909-1916 lived a life of withdrawal and meditation at Bièvres near Paris.

WRITINGS, DOCUMENTS: Redon, O.: Lettres d'O.R. Brussels/Paris 1923.– Redon, O.: A soi-même: Journal (1867-1915). Paris 1961.– Redon, O.: Selbstgespräch. Tagebücher und Aufzeichnungen 1867-1915. Munich 1971 CATALOGUES: Mellerio, A.: O.R. Catalogue raisonné of the Lithographs and the Etchings. New York 1968.– Wildenstein, A.: O.R. Catalogue raisonné (in preparation)

BIBLIOGRAPHY: Bacou, R.: O.R. 2 vols. Geneva 1956.– Bacou, R. (ed.): O.R. Pastels. London 1987.– Berger, K.: O.R.: Phantasie und Farbe. Cologne 1964.– Cassou, J.: O.R. Munich 1974.– Hobbs, R. O.R. London and New York 1977.– Mellerio, A.: O.R.: Peintre, dessinateur et graveur. Paris 1923.– O.R.: collección Ian Woodner. Barcelona 1990 (EC).– Roger-Marx, C.: O.R. Paris 1925.– Sandstrom, S.: Le monde imaginaire d'O.R. Lund 1955.– Selz, J.: O.R. Paris, 1971

- ILLUSTRATIONS:
- 350 Pevrelebade, c. 1896/97
- 376 Beatrice, c. 1905
- 376 Paul Gauguin, c. 1903-1905

REGOYOS VALDES Darío de

1857 Ribadesella – 1913 Barcelona 1877 studied with de Haes at the Academy of Arts in San Fernando, Madrid. 1880 travelled to Paris, where he met Luce, and 1881 to Brussels, where he met van Rysselberghe. 1881-1889 lived mostly in Brussels. 1882 showed work at the exhibitions of the group "L'Essor" in Brussels. 1882 travelled to Spain with Maus, Luce, Meunier and van Rysselberghe. 1883 co-founder of Les Vingt, 1884 first of their exhibitions, at which he was to exhibit regularly. Visited Whistler, Pissarro, Degas, Seu-

rat and Signac, 1888 travelled to Spain with Verhaeren. 1888 exhibited with Pissarro, Seurat, Signac, Cross, Anguetin and Raffaëlli in the rooms of the "Revue Blanche". His landscapes, which had a certain gloom to them despite their Impressionist style, began to be influenced by Neo-Impressionism. Exhibited in Paris at the Salon des Indépendants, 1890 exhibited for the first time but without success at the Madrid Art Exhibition. Above all he painted landscapes in which he combined an Impressionist observation of nature with a Pontillist style of painting. 1898 stayed in London, thereafter settling in San Sebastián in Spain. 1899 published his book "La España Negra". 1903 and 1906 exhibited in Paris. Became ill with cancer and in 1907 moved to

Arenas (Bizcaya), then in 1910 to Gra-

nada, in 1911 to Barcelona and fi-

BIBLIOGRAPHY: Benet, R.: D. de R. Barcelona 1946. – D.d.R. 1837-1913. Fundación Caja de Pensiones, Madrid 1986 (EC).– Encina, J. de la : Guiard y R. Bilbao 1921.– García Minor, A.: El pintor D. de R. y su época. Oviedo 1958

ILLUSTRATION: 563 Dolores Otaño, 1891

RENOIR Pierre-Auguste

1841 Limoges - 1919 Cagnes Son of a poor tailor; 1844 moved to Paris. 1854-1858 trained as a porcelain painter. 1859/60 worked at a firm producing painted curtains. 1860-64 became a pupil of Gleyre; studied at the Ecole des Beaux-Arts, together with Monet, Sisley and Bazille. 1863 began painting plein-air near Barbizon, under the tutelage of N. Diaz; met Pissarro and Cézanne. 1864 and 1865 exhibited at the Salon. 1865 1872 Lise Tréhot became his model and lover. 1866 and 1867 rejected by the Salon, painted portraits in the open-air. 1867 lived at Bazille's house with Monet. 1868-1870 shared a studio with Bazille in the Batignolles quarter, frequented the Café Guerbois; met Manet; exhibited at the Salon. 1869 with Monet at Bougival on the Seine; together they worked out the main tenets of the Impressionist method, 1870/71 military service in the war. 1872 rejected by the Salon, he called for a Salon des Refusés; Durand-Ruel exhibited one of his pictures for

the first time in London, 1873 met the critic Duret; painted with Monet at Argenteuil; a frequent customer in this period at the Café de la Nouvelle-Athènes. 1874 exhibited at the 1st Impressionist exhibition. 1875 had some pictures auctioned at the Hôtel Drouot; met the art collector Choquet. 1876 exhibited at the 2nd Impressionist exhibition: visited A. Daudet at Chaprosay; received commissions from the publisher Charpentier; his favourite themes became pictures of the middle-class at leisure and portraits. 1877 exhibited at the 3rd Impressionist exhibition; again had some pictures auctioned. 1878-1881 exhibited at the Salon but not at Impressionist exhibitions. 1879 one-man exhibition at the gallery of Charpentier's journal "La Vie moderne"; first visit to the Berard family in Wargemont (Normandy). 1880 met his future wife, Aline Charigot; broke his right arm and painted with his left hand. 1881 travelled to Algeria, later to Italy; impressed by Raphael and the Pompeii frescoes. 1882 painted a portrait of the composer Wagner at Palermo; visited Cézanne at L'Estaque. Durand-Ruel exhibited pictures by him at the 7th Impressionist exhibition and in London. 1883 one-man exhibition at the Galerie Durand-Ruel; exhibited also at the Salon and in London, Boston and Berlin. Visited Jersey, Guernsey and the Côte d'Azur. Formal characteristics of his work at this time include clearly delineated, three- dimensional human figures. 1884 formed a friendship with Morisot. 1885 exhibited for the first time at Essoyes, Aline's home village. 1886 exhibitions with the group Les Vingt in Brussels, in New York through Durand-Ruel, and in Paris through G. Petit; he did not exhibit at the last Impressionist exhibition. 1889 refused to exhibit at the World Fair in Paris. 1890 married Aline; they had three sons. Rejected the award of the Legion of Honour; exhibited for the last time at the Salon. Returned to the rich colours and free brushwork of his earlier days and painted mainly nudes and landscapes. 1892 first sale of a painting to the French state made possible by Mallarmé; large single exhibition at Durand-Ruel's; travelled in Spain and Pont-Aven. 1894 became the executor of Caillebotte's bequest of Impressionist paintings to the French state. 1896 tour of Germany; visited Bayreuth and Dresden. 1897 broke his arm after falling from a bicycle. 1898 visited Holland. 1899 due to rheumatism, moved to the South of France. 1900 exhibited at the century exhibition of French art at the World Fair in Paris; became Chevalier of the Legion of Honour. Increasing numbers of exhibitions abroad, 1902 his health deteriorated - at the end his hands were almost paralysed with arthritis. 1904 exhibited for the first time at the Autumn Salon. 1907 bought the house "Les Colettes" in Cagnes. 1910 retrospective at the 9th Biennale in Venice:

"Les Colettes" in Cagnes. 1910 retrospective at the 9th Biennale in Venice; visit to Munich. 1911 Officer of the Legion of Honour. 1913 began to do sculptures with the help of R. Guino.

1915 death of his wife, 1919 Commander of the Legion of Honour; honoured with the hanging of one of his pictures in the Louvre. WRITINGS, DOCUMENTS: Renoir, I.: Mein Vater A.R. Munich 1962. - Rivière, G.: R. et ses amis. Paris 1921. -Vollard, A.: A.R. Paris 1920 CATALOGUES: Daulte, F.: A.R.: Catalogue raisonné de l'œuvre peint. Vol. I: Figures 1860-1890, Lausanne 1971 (sole volume published). - Fezzi, E .: Das gemalte Gesamtwerk von R. aus der impressionistischen Periode 1869-1883. Lucerne 1973. - Tancock: The Sculpture of R. Philadelphia 1976. -Vollard, A.: P.-A.R. Paintings, Pastels and Drawings. San Francisco 1989

BIBLIOGRAPHY: André, A.: L'atelier de R. 2 vols. Paris 1931 (Reprint: San Francisco 1989). - André, A.: R. Dessins. Paris 1950. - Bacou, R.: P.R. 2 vols. Genova 1956. - Baudot, I.: R.: Ses amis, ses modèles. Paris 1949. -Daulte, F.: P.-A.R. Basle 1958. -Daulte, F.: P.-A.R. Watercolours, Pastels and Drawings in Colour, London 1959. - Daulte, F.: A.R. Paris 1974. -Distel, A. J. House et al. (eds.): R. Hayward Gallery, London; Grand Palais, Paris; Museum of Fine Arts, Boston. Paris 1985, London 1985 (EC). -Feist, P.H.: P.-A.R. 1841-1919. A Dream of Harmony. Cologne 1991. -Fezzi, E.: R. Paris 1972. - Florisoone, M.: R. Paris 1937. - Fosca, F.: R. London and Paris 1961. - Gaunt, W.: R. Oxford 1982. - Gowing, L.: R., Paintings. London 1947. - Haesaerts, P .: R. sculpteur. Brussels 1947. - Hoog, M. and N. Wadley: R.: un peintre. une vie, une œvre. Paris 1989. -Meier-Graefe, J .: R. Paris 1912. -Monneret, S.: R. Cologne 1990. -Pach, W.: P.-A.R. Cologne 1958. -Perruchot, H .: La vie de R. Paris 1964. - Rewald, J. (ed.): R. Drawings. New York 1946. - Rouart, D.: R. Geneva 1954, London 1985. - White, B.E.: R. His Life, Art, and Letters. New York 1984

- ILLUSTRATIONS:
- 2 By the Seashore, 1883
- 6 Mademoiselle Romaine Lacaux, 1864
- 11 Oarsmen at Chatou, 1879
- 13 The Walk, 1870
- 32 Alfred Sisley and his Wife, 1868
- 53 The Pont des Arts, Paris, 1867
- 73 La Grenouillère, 1869
- 93 Madame Monet Reading "Le Figaro", 1872

- 128 The Theatre Box, 1874
- 144 The Swing, 1876
- 145 Lise with a Parasol, 1867
- 148 Conversation with the Gardener, c. 1875
- 149 Country Footpath in the Summer, c. 1875
- 153 Le Moulin de la Galette, 1876
- 153 Le Moulin de la Galette, 1876
- 162 Nude in the Sunlight, c. 1875/76
- 163 Female Nude (Anna), 1876
- 193 The Seine at Asnières, c. 1879
- 215 On the Terrace, 1881
- 220 The Luncheon of the Boating Party, 1881
- 223 Two Girls, c. 1881
- 234 Young Girl with a Parasol (Aline Nunès), 1883
- 236 Dance at Bougival (Suzanne Valadon and Paul Lhote), c. 1882/83 237 Dance in the Country (Aline
- Charigot and Paul Lhote), c 1882/83 237 Dance in the City (Suzanne Vala-
- don and E.-P. Lestringuez), 1882 239 Les Parapluies, 1883
- 304 The Bathers, 1887
- 305 After the Bath, 1888
- 346 Portrait of Paul Cézanne, 1880
- 390 Gabrielle with Jewels, c. 1910
- 391 Study for "Bathers", c. 1884

REPIN Ilya Yefimovich 1844 Chuguyevo – 1930 Kuokkala (Finland)

1864-1871 studied at the Academy in St. Petersburg, where he was awarded the distinction of a gold medal. 1871 met the art critic V. Stassov. 1873 exhibited the picture "The Volga Boatmen" at the World Fair in Vienna. 1873-1876 on a scholarship in Italy and France; met Zola. 1876/77 in Chuguyevo. Received the title of Academician of Art. 1877-82 in Moscow. 1878-1891 and again from 1897 member of the "Wanderers"; visited S. Mamontov in Abramtsevo; painted by preference portraits and genre pictures with a social theme. 1880 went with Serov to the Ukraine. 1882 moved to St. Petersburg; met Tolstoy. 1883 travelled in western Europe with Stassov; Impressionist features became increasingly apparent in his work. 1887 in Italy and Germany. 1889 went to the World Fair in Paris, and with Stassov to England, Germany and Switzerland. 1892-1907 professor at the college of art of the Academy in St. Petersburg. 1893/94 travelled in western Europe. 1898

travelled to Constantinople and Jerusalem. 1899 at the international exhibition of the journal "World of Art". Bought "Penaten" a country house in Kuokkala. 1900 jury member of the Paris World Fair, awarded the Legion of Honour. Exhibited in Prague. 1902 member of the Academy in Prague, 1917 moved back to Kuokkala, now part of Finland. WRITINGS, DOCUMENTS: Repin, I.: Daljokoje bliskoje (1937), Moscow 1953. - Repin, I.: Fernes und Nahes. Erinnerungen. Berlin 1970 BIBLIOGRAPHY: Brodsky, I.: R., Pisma. Moscow 1969. - Efimowitsch, I. (ed.): I.R. Malerei. - Grabar, I.E.: I.E.R. 2 vols. Moscow 1937, 1963. -Ljaskowskaja, O.: I.E.R. Moscow 1962, 1982. - Sternin, G. et al.: I.R. Leningrad 1985. - Valkenier, E.R .: I.R. and the World of Russian Art. New York 1990 ILLUSTRATIONS:

- 502 Tolstoy Resting in a Wood, 1891 502 Portrait of the Artist's Daughter Vera, 1874
- 503 They did not expect him, 1884 504 Portrait of Sophia Mikhailovna
- Dragomirova, 1889
- 505 In the Sun, 1900

REVUE BLANCHE, La

Journal for avant-garde literature and art and an important mouthpiece for Impressionism. Founded in 1889 by Paul Leclercq and Auguste Jeunehomme. 1891 taken over by the Natanson brothers, who organised exhibitions of modern art in the rooms of the journal. Appeared for the last time in 1903.

REVUE INDEPENDANTE, La

Most important journal of the Naturalists, Symbolists and Impressionists in the last quarter of the 19th century. 1884 founded by Georges Chevier and Félix Fénéon. There were 24 issues in the period 1884-1885. After a break in publication, it resumed under Edouard Dujardin. Included on its staff Mallarmé, who wrote theatre reviews. Exhibitions of Impressionist work were held on the premises. The journal did not appear between 1893 and 1895 and in 1895 after a few issues it was discontinued.

RICO Y ORTEGA Martín 1833 Madrid - 1908 Venice Worked as an illustrator with his

brother, a copperplate engraver. Studied at the San Fernando Academy of Arts in Madrid under Genaro Pèrez Villaamil. Extremely successful at the exhibitions in Madrid. Received medals at the World Fair in Paris in 1878 and 1888. Influenced by the painters of the Barbizon school. He was friends with Fortuny, whose light-filled style influenced him and brightened up the colours of his more Realist style as seen in his depictions of motifs and scenes from Venice, Rome and Toledo. BIBLIOGRAPHY: Paysages d'Espagne, Aquarelles inédites de M.R. Musée Goya, Castres 1979 (EC) ILLUSTRATION: 558 View of Venice

RING Laurits Andersen

1854 Zeeland - 1933 Roskilde Initial training as a painter in Præstø; attended the technical school in Copenhagen; 1874 admitted to the Academy in Copenhagen, where he studied 1875-1877 and 1884. His landscapes and genre pictures frequently deal with social themes. 1889 travelled via Hamburg to Paris. Impressed by Millet and Raffaëlli. The clear composition of his pictures reveals his interest in Japanese art. ILLUSTRATION:

481 Girl Looking out of a Skylight, 1885

RIPPL-RONAI József 1861 Kaposvár - 1927 Kaposvár 1881-1883 trained as a pharmacist, then worked as a home tutor. 1884-1887 studied with Herterich and Diez at the Academy in Munich. 1887 went to Paris on a state scholarship; worked

initially with Munkácsy. 1889 visited Pont-Aven. 1890 studied at the Académie Julian; became friends with Maillol and Vuillard, later with Bonnard, 1893 travelled in England. 1894 exhibited at the Salon of the Société Nationale. Visited Gauguin; joined the Symbolist group the Nabis and the group around the "Revue Blanche". 1895 visited Cézanne; exhibited in Budapest. 1896 some of his pictures were exhibited by Gurlitt for the first time in Berlin. 1897 did an Art Nouveau design for the dining room of Count Andrássy. 1899 visited Maillol in Banyuls. 1900 silver medal for some embroidery designs at the Paris World Fair. 1900-1902 in Hungary, large one-man exhibition. 1902 travelled in Belgium and Russia; settled in Kaposvár. 1904 and 1905 trips to Italy. 1906 successful exhibition in Budapest. 1907 member of the committee of the new "Group of Hungarian Impressionists and Naturalists"; turned to decorative and Fauvist styles of painting. 1911 and 1914 stayed in Paris. 1918 on the Council for Art and Literature of the Republic. Began to have problems with his sight; drew mainly pastels. 1925 a self-portrait was commissioned in Florence. WRITINGS, DOCUMENTS: Rippl-Rónai, J.: Emlékezései. Budapest 1957 BIBLIOGRAPHY: Fülep, L.: R.- R. Csontváry, Derkovits. Budapest 1975. - Genthon, I.: R.-R.: The Hungarian "Nabi". Budapest 1958. - Keserü, K .: J.R.-R. Berlin 1983. - R.-R. 1861-1927. Pittore, grafico, decoratore. Pinacoteca capitolina, Rome 1983 (EC). - Szabadi, J.: J.R.-R. Budapest 1978 **ILLUSTRATIONS:**

524 Living on Memories, 1904 524 Lady in a Polka-Dot Dress, 1889

RIVIERE Georges 1855-1943

Writer and critic. A close friend of Renoir, who painted him in his picture "Le Moulin de la Galette" (p. 153). Followed the development of Impressionism with interest and in 1877, at Renoir's prompting, founded the journal "L'Impressioniste" to defend the movement; only five issues appeared (in April). Rivière wrote almost all of the contributions himself; for many painters these were the only articles that viewed their work in a positive light. After 1920 he published books on Renoir, Cézanne and Degas.

ROBERT Léon-Paul

Born in Bagneux in 1849 Genre painter, pupil of Bonnat and Puvis de Chavannes. Founder member of the "Société des peintres, sculpteurs, graveurs". Showed two watercolours at the 1st Impressionist exhibition in 1874. 1879-1883 exhibited at the Salon

ROBINSON Theodore

1852 Irasburg (VT) - 1896 New York 1869-1874 studied at the Art Institute in Chicago and 1874-1876 at the National Academy of Design and the Art Students League in New York. 1876-1879 tour of Europe. Studied under Carolus-Duran and Gérôme at the

Ecole des Beaux-Arts and in 1877 exhibited at the Paris Salon. In 1879 he met Whistler in Venice. 1880-1883 worked on a decorative mural for John LaFarge in Tarrytown (New York) and a mural at the Metropolitan Opera, 1884 lived at Barbizon during the summer months, 1884-1887 travelled through France, Belgium and the Netherlands. From 1888 he formed a close friendship with Monet, and was considerably influenced by his Impressionism. It is possible that his interest in photography and its relation to painting may have encouraged Monet to try similar experiments. Until 1892 he spent the winter months in New York and the summers at Giverny, 1895 became a teacher at the Pennsylvania Academy of Fine Arts.

WRITINGS, DOCUMENTS: LOW, W.H.: A Chronicle of Friendship, New York, 1908.- Robinson, T.: Claude Monet. In: "The Century Magazine" 44 (September 1892), pp. 696-701. BIBLIOGRAPHY: Baur, J.I.H. (ed.): T.R. 1852-1896. Brooklyn Museum, New York 1946 (EC) .- Byrd, D.G. (ed.): Paintings and Drawings by T.R. University of Wisconsin, Madison, 1964 (EC) .- Clark, E.: T.R. His Life and Art. Chicago 1979.- Johnston, S. (ed.): T.R. Baltimore Museum of Art, Baltimore 1973 (EC) .- Lewison, F .: T.R. and Claude Monet. In: "Apollo" 78 (September 1963), pp. 208-211.– T.R. 1852-1896. The Baltimore Museum of Art, Baltimore 1973 (EC) ILLUSTRATIONS: 612 Two in a Boat, 1891

614 Le débâcle, 1892

615 The Wedding March, 1892

ROCHEFORT Henri de

1831 Paris - 1913 Aix-les-Bains Civil servant and critic, Sub-Inspector of the Paris Beaux-Arts. Founded and worked for several journals. One of the most famous authors of polemical articles for "Le Figaro". Defended Gambetta in 1870 after the capitulation of Paris; supported the Commune and was accordingly deported to New Caledonia in 1873. He was much admired by the Impressionists.

ROELOFS Willem

1822 Amsterdam - 1897 Antwerp Son of the owner of a brickworks. Pupil of E.J. van de Sande Bakhuizen in The Hague. 1848-1887 lived in

Brussels. His conception of landscape is comparable to that of Daubigny or Rousseau. Important predecessor of the Impressionists in Holland. BIBLIOGRAPHY: Bremmer, H.P.: W.R. Amsterdam 1909.- Eere-teentoonstelling W.R. Pulchri-Studio, The Hague 1907 (EC) .- Jeltes, H.F.W .: W.R. Amsterdam 1911 ILLUSTRATION:

408 Summertime, 1862

ROHLFS Christian 1849 Niendorf - 1938 Hagen

1864 a severe knee injury led later to the amputation of his leg. Began to draw and through the support of the writer Theodor Storm he was able to begin his art studies at Weimar in 1870. 1869 moved to Berlin. 1870/71 and 1874-1884 studied at the Weimar School of Art with F. Schaus, A. Struys and M. Thedy. Independently of the French Impressionists, he developed his own method of painting which was indebted to Naturalism but reminiscent of the French style; it was greeted with bitter hostility in Weimar. 1895 stayed in Berlin. 1901 given a post in Hagen at the Folkwang school planned by K.E. Osthaus, but the scheme failed and no lessons were ever taught. Met Renoir, Signac, Seurat, Cézanne and van Gogh, who influenced him. From 1900 member of the Berlin Secession. 1905/06 painted in the summer months at Soest and met Nolde. From 1910 turned to Expressionism. In 1911 he joined the New Secession and in 1914 the Free Secession. 1924 became a member of the Prussian Academy of Arts in Berlin. 1927 travelled to Ascona. 1937 all his

works were confiscated and he was dismissed from the Berlin Academy. CATALOGUE: Vogt, P.: C.R. Œuvrekatalog der Druckgraphik. Göttingen 1950.- Vogt, P.: C.R. Aquarelle und Zeichnungen. Recklinghausen 1958 (with catalogue) .- Vogt, P.: C.R. Das grafische Werk. Recklinghausen 1960.- Vogt, P.: C.R. Œuvrekatalog der Gemälde. Recklinghausen 1978 BIBLIOGRAPHY: C.R. 1849-1938. Gemälde zwischen 1877 und 1935. Museum Folkwang, Essen 1978 (EC).-C.R. Das Spätwerk. Museum Folkwang, Essen 1967 (EC) .- C.R. Aquarelle und Zeichnungen. Landesmuseum Münster 1974 (EC).- Scheidig, W.: C.R. Dresden 1965 .- Vogt, P.: C.R., 1849-1938: Aquarelle, Wassertemperablätter, Zeichnungen, Recklinghausen 1988 (EC) ILLUSTRATION: 456 Birch Wood, 1907

ROLL Alfred

1846 Paris - 1919 Paris After training as an ornamental draughtsman, he became the pupil of Gérôme, L. Bonnat and H. Harpignies at the Ecole des Beaux-Arts in Paris. Travelled in Belgium, Holland and Germany, 1870 exhibited for the first time at the Salon. Painted realistic pictures of everyday life, sometimes with a social message, and Impressionist-inspired plein-air portraits of workers. 1886 exhibited by Durand-Ruel with the Impressionists in the USA. 1890 Co-founder of the Secession group Société Nationale des Beaux-Arts; in 1905 became their president, 1895 assisted with the painting of the town hall in Paris.

ROUART Henri 1833 Paris - 1912 Paris

Successful industrialist, art collector and painter; his achievements deserve wider recognition. Like his brother Alexis he was a school friend of Degas, with whom he kept in touch all his life; they fought together in the war of 1870/71. Painted under the tutelage of Millet and Corot. Friendship with Tillot. 1868-1872 exhibited at the Salon. 1874-1886 exhibited at all the Impressionist exhibitions except for the 7th, mostly watercolour landscapes from his many trips abroad. Took part in the discussions of the Impressionists and supported them financially. Lived in Paris and La-Queueen-Brie. He was a regular host and patron to the Impressionists, 1912 memorial exhibition at Durand-Ruel's. 1912 auction sale of his rich collection, which beside the Impressionists contained works by El Greco, Gova, Poussin and Breughel. His correspondence with Degas is important. ILLUSTRATION:

203 Terrace on the Banks of the Seine at Melun, c. 1880

ROUART Iulie

1879 Paris - 1967 Paris Nee Manet. Daughter of Morisot and Eugène Manet. All her life she frequented Impressionist circles. After the deaths of her parents, Mallarmé became her guardian. In 1900 she married Ernest Rouart, the son of Henri Rouart. She was a model for Manet, Degas, Renoir, and her mother.

ROUEN

The capital of the Seine valley with an imposing Gothic cathedral. Many of the most important Impressionist pictures were painted in this city or its environs. The picturesque narrow streets had been popular motifs with the predecessors of the Impressionists (Bonington, Turner, Corot, Boudin, Jongkind and others). The Impressionists were particularly attracted to the effects of light and the changing moods and atmosphere of the town. Artists who worked here include Renoir, Sisley, Degas, van Gogh, Pissarro, Gauguin and above all Monet, who painted the famous series of paintings of the cathedral (pp. 342 and 343).

ROUSSEAU Pierre Etienne Théodore 1812 Paris - 1867 Barbizon Studied initially with his cousin, the landscape painter Alexandre Pau, and then in 1829 with Remond, Lethière and others at the Ecole des Beaux-Arts in Paris. Completed his artistic education with open-air painting - he was probably the first to paint pleinair in the woods at Fontainebleau. 1830 painted in the Auvergne. Travelled in France and Switzerland. 1831 exhibited at the Salon but thereafter went through a period of constant rejections. 1836 in Barbizon for the first time; became the main exponent of the realistic, atmospheric landscape painting that came to be known as the "Barbizon school". 1849 received an award from the Salon. 1866 advised Monet. Durant-Ruel bought 70 pictures. **1867** president of the painting jury for the World Fair in Paris. His rather melancholy, powerful pictures reveal a very precise observation of light.

BIBLIOGRAPHY: Forges, M.T. de and H. Toussaint (eds.): T.R. Musée National du Louvre, Paris 1967 (EC).– Terrasse, A.: L'univers de T.R. Paris 1976

ILLUSTRATION:

23 Clump of Oaks, Apremont, 1852

ROUSSEL Theodore

1847 Lorient – 1926 Hastings Born in France, lived from 1874 in London. A self-taught artist. In the 1880s he was influenced by Whistler. 1887 exhibited at the Society of British Artists; joined the New English Art Club. One of the main exponents of Impressionism in England. Taught Maitland. Worked mostly in and around Chelsea.

BIBLIOGRAPHY: Rutter, F.: T.R. 1926 ILLUSTRATION:

576 The Reading Girl, 1887

RUSINOL Y PRAT Santiago

1861 Barcelona – 1931 Aranjuez Painter, dramatist, poet and critic. Trained initially as an artist with T. Moraga. Studied in France. Exhibited at the Salon des Indépendants with the Impressionists and Symbolists. The most important Catalan landscape painter of the period. Responsible with Casas for the introduction of Western European influences into painting in Spain.

BIBLIOGRAPHY: Frances, J.: S.R. y su obra. Gerona 1945.– Pla, J.: S.R. i el

seu temps. Barcelona 1955.– Roch, H.J.: S.R. (1861-1931). Ein Beitrag zur Kunst des ausgehenden 19. Jahrhunderts in Katalonien. Doctoral thesis, Frankfurt am Main and Berlin 1983.– Rusiñol, M.: S.R. visto por su hija. Barcelona 1963 ILLUSTRATIONS:

565 A Garden in Araniuez, 1908

567 The Kitchen of the Moulin de la Galette, c. 1890

RYSSELBERGHE Théo van

1862 Ghent - 1926 St. Clair (Var) Studied at the Academies in Ghent and Brussels. 1881 exhibited for the first time at the Salon in Brussels. Influenced by Manet and Degas. 1883 co-founder of the group Les Vingt. Organised the exhibition with Maus and after 1893 also those of the "Libre Esthétique". 1886 travelled with the poet Emile Verhaeren to Paris. Met Seurat, admired his painting "A Sunday Afternoon at the Ile de la Grande Jatte" (pp. 260/261), and from 1887/88 turned to Pointillism. becoming the main exponent of the style in Belgium. Travelled in Spain, North Africa, the Near East and Europe. From 1897 lived in Paris. His Pointillism relaxed into a more Impressionist style of brushwork.

WRITINGS, DOCUMENTS: Lettres de T.v.R. à Octave Maus. In: "Bulletin des Musées Royaux de Belgique" 15 (1966), No. 1-2, pp. 55-112 BIBLIOGRAPHY: Eeckhout, P. and G. Chabot (eds): T.v.R. Museum voor Schone Kunsten, Ghent 1962 (EC).– Fierens, P.: T.v.R. Brussels 1937.– Maret, F.: T.v.R. Brussels 1937.– Maret, F.: T.v.R. Antwerp 1948.– Pogu, G.: T.v.R. Sa vie. (no place of publication; about 1963) ILLUSTRATIONS:

- 423 Heavy Clouds, Christiania Fjord, 1893
- 425 Portrait of Auguste Descamps, the Painter's Uncle, 1894
- 426 Family in an Orchard, 1890

SAINTE-ADRESSE

Village in Normandy at the mouth of the Seine, four kilometres from Le Havre. Visited by Corot, Isabey and Jongkind. 1862 Jongkind did numerous sketches here which were to have a decisive effect on the development of Monet as an artist. 1866-1868 Monet lived here, painting the "The Beach at Sainte-Adresse" (p. 56) and the famous "Terrace at SainteAdresse (p. 59). Van de Velde, Dufy and Marquet later painted beach scenes here and landscapes in the surrounding countryside.

SAINT-TROPEZ

At the end of the nineteenth century this small fishing port on the Côte d'Azur became a popular resort for sailing enthusiasts and a meeting place for writers and painters (Duran, Signac, Luce, Cross, Matisse, and others), who liked to paint in the bright light of the Mediterranean.

SALON

A regular exhibition of contemporary art, named after the Salon carré (rectangular hall) at the Royal Palace of the Louvre in Paris, where since 1667 the members of the Academy had given an annual exhibition to the king of their latest work. In 19th-century France this was the most important state-organised event for the encouragement and regularisation of artistic activity; it was imitated in other countries. The organisation and selection of the artists and their works, and the appointment or election of the jury, varied considerably. Foreign artists were also allowed to submit work.

Medals and other prizes were awarded. Winners of medals were permitted to exhibit the next year without undergoing the selection process. The huge numbers of exhibits (1865: 3559, 1880: about 6000) were mostly shown in a haphazard manner, from 1857 at the Palais de l'Industrie. It was nevertheless popular with the general public (1876: c. 519,000 visitors) and was well covered in the press, for the Salon set the latest standards of artistic activity and influenced public sales and commissions, as well as the art market and the careers of individual artists. For avant-garde artists and critics the idea of "Salon painting" became a term of abuse (one still used today). 1881 the Salon was changed into the Société des artistes français. 1884 beginning of the era of Secessions in Europe, with the founding of the Indépendants with their own Salon without a jury. 1890 this movement split, with the foundation of a new Salon with jury, the Société Nationale des Beaux-Arts. 1903 founding of the Autumn Salon, which favoured the Post-Impressionists, and later the Fauves and Cubists.

SALON DES INDEPENDANTS

A French society of independent artists (Société des artistes indépendants) founded in 1884 in Paris under the

presidency of Redon; organised by A. Dubois-Pillet, after an initial, chaotic exhibition without a jury. In the same year he arranged the first Salon "without a jury or prize-giving". In 1886, shortly after the 8th Impressionist exhibition, the 2nd Salon des Indépendants was a resounding success; the Symbolists also exhibited. From then on, Salons took place every year, with increasing acclaim. The salon was opened in 1889 by the President of the city council, and in 1890 by the President of the Republic. From 1891 there were retrospectives of deceased members; foreign artists began to take part. It became an important forum for the Post-Impressionists, and later for the Fauves and Cubists etc.; imitated in other countries. Presidents: up to 1909 Valton, 1909-1934 Signac, 1934-1941 Luce.

SALON DES REFUSES

The "Salon of Rejected Artists". An exhibition set up in 1863 by Napoleon III as a liberal gesture for those artists whose work had been rejected by the Salon jury under their chairman, Count Nieuwerkerke, 1200 out of the 2300 rejected artists exhibited their work, mostly of mediocre quality, although it included pictures by Bracquemond, Cals, Cézanne, Colin, Fantin-Latour, Jongkind, Laurens, Legros, Manet, Pissarro and Whistler. Manet's "Le déjeuner sur l'herbe" (p. 36) was seen by about 40,000 visitors and caused a scandal. which Zola later described in his novel "L'œuvre". 1864 and 1873 this Salon was repeated, but in general it was replaced by private initiatives and group exhibitions.

SARGENT John Singer

1856 Florence - 1925 London Son of a doctor who had emigrated from America. First studied drawing with the painter Carl Welsch in Rome. 1870-1874 studied at the Accadèmia delle Belle Arti in Florence. Continued his studies in 1874 at the studio of Carolus-Duran in Paris. 1878 first big success at the Salon. 1879 travels in Spain, where he studied the work of Diego Velázquez. 1880-1882 lived in Holland, studied Frans Hals. 1884 his painting "Madame Gautreau" (p. 598) caused a scandal at the Salon. Moved to London. Formed a friendship with Whistler, whose studio he took over in 1885. 1886 co-founder of the Impressionist New English Art Club. 1888 large exhibition at the St. Botolph Club in Boston; began in this period to be known for his portaits. 1893-1906 active exclusively as a portrait painter in England and America. His portraits have a characteristic realism, but also follow the canons of contemporary bourgeois taste. Member in 1890 of the Legion of Honour, 1894 of the National Academy of Design in New York and 1897 of the Royal Academy in London. In 1907 turned to landscape painting in water colours and until 1914 painted plein-air on the Continent. 1890-1916 series of murals for the Boston Public Library. 1918 active as a war painter in Northern France. Drew sketches for his monumental war painting "Gassed". In the 1920s he executed the murals for the Boston Museum of Fine Arts and the Widener Library at Harvard University,

BIBLIOGRAPHY: Birnbaum, M.: I.S.S. A Conversation Piece. New York 1941.- Charteris, E .: J.S. New York 1927.- Downes, W.H.: J.S.S. His Life and Work. Boston 1925 .- Fairbrother, T.J.: J.S.S. and America. Doctoral thesis, Boston 1981.- Hills, P. (ed.): J.S.S. Whitney Museum of American Art, New York 1986 (EC) .-Lomax, J. and R. Ormond (eds.): J.S.S. and the Edwardian Age. Leeds Art Galleries, London 1979 (EC) .-McKibbin, D.: S.'s Boston. Boston 1956 .- Meynell, A .: The Work of J.S.S. London 1903 .- Meynell, A .: L'œuvre de J.S.S. Paris 1904.- Mount, C.M.: J.S.S. A Biography. New York 1955, London 1957.- Olson, S. et al.: S. at Broadway. The Impressionist

Years. New York and London 1986.– Olson, S.: J.S.S. His Portrait. London 1986.– Ormond, R.: J.S.S. Oxford 1970.– Ormond, R.: J.S.S.: Paintings, Drawings, Watercolors. New York 1970.– Ormond, R.: J.S.S. His Portraits. London 1986.– Ratcliff, C.: J.S.S. New York 1982.– Sweet, F.A. (ed.): S., Whistler and Mary Cassatt. The Art Institute of Chicago, Chicago 1954 (EC)

- ILLUSTRATIONS:
- 593 The Luxembourg Garden at Twilight, 1879
- 597 Carnation, Lily, Lily, Rose, 1885/86
- 598 Dr. Pozzi at Home, 1881 598 Portrait of Madame Gautreau
- (Study), 1884
- 598 Madame X (Portrait of Madame Gautreau), 1884
- 599 The Boit Daughters, 1882604 Claude Monet Painting at the
- Edge of a Wood, 1887
- 608 Two Girls on a Lawn, c. 1889
- 609 The Boating Party, 1889 634 A Morning Walk, 1888

SCHEFFLER Karl

1869 Eppendorf – 1951 Überlingen German art critic. Began his career as a decorator and designer of wallpaper. 1894 started writing about the movement for art reform as envisaged by Ruskin and Morris; encouraged by Meier-Graefe. 1906-1933 editor of the journal "Kunst und Künstler" (Art and Artists) published by B. Cassirer. One of the most energetic proponents of Impressionism and Secession art in Germany. Rejected Expressionism. 1944 received an honorary doctorate from the University of Zurich.

SCHUFFENECKER Claude-Emile 1851 Fresne-Saint-Mamès (Haute-Saône) – 1934 Paris

1871 a colleague of Gauguin's – both with the stock-broker Bertin. Attended evening courses in drawing and took lessons with Grellet, Paul Baudry and Carolus-Duran. Decided to become a painter in the late 1870s. Earned a secure living as a teacher of art at the Lycée Michelet de Vanves. Supported his friend Gauguin (until **1891** also financially) and introduced him to other Impressionist painters (Guillaumin, Pissarro). His style is similar to that of Sisley and did not gain the admiration of Gauguin. 1880 exhibited for the first time at the Salon. 1883 rejected by the Salon. 1884 co-founder of the Salon des Indépendants. Friendship with Bernard. 1886 contributed to the 8th Impressionist exhibition. 1889 organised the alternative exhibition of the Impressionists at the Café Volpini during the World Fair. His apartment in Paris became a meeting place for the Pont-Aven school of artists, to which his work also belongs.

ATALOGUE: POT, R.: C.-E.S. Catalogue raisonné (in preparation) BIBLIOGRAPHY: C.-E.S. and the School of Pont-Aven. Norman Mackenzie Art Gallery, Regina (Saskatchewan) 1977 (EC).- E.S. Hirschl and Adler Galleries, New York 1958 (EC).- E.S. Galerie des Deux-Iles, Paris 1963 (EC).- Grossvogel, J.E. (ed): C.-E.S. 1851-1934. State University of New York Art Gallery. Binghamton (NY) 1980 (EC) ILLUSTRATIONS:

- 416 A Cove at Concarneau, 1887 421 Female Nude, Seated on a Bed,
- 1885 1885

SEGANTINI Giovanni Battista 1850 Arco - 1899 Pontresina Grew up in poverty. Trained with a painter-decorator; 1875-1879 attended evening courses at the Brera Academy in Milan. 1878 met Grubicy, who introduced him to Pointillism. Gave up his dark, academic style of painting. Travelled in northern Italy. 1886 settled in Savognin. From 1894 lived in Maloja. His favourite subjects were landscapes with peasants, in which he combined the close observation of nature with the new techniques of painting. His pictures have been assigned to both Symbolism and Art Nouveau. Exhibited in Paris, England, Germany and Austria. 1898 member of the Vienna Secession.

CATALOGUE: Arcangeli, F. and M.C. Gozzoli: L'opera completa di G.S. Milan 1973.– Quinsac, A.-P.: S. Catalogo generale. 2 vols. Milan 1982 BIBLIOGRAPHY: Arcangeli, F. and M.C. Gozzoli: S. Milan 1973.– Belli, G. (ed.): S. Palazzo delle Albere, Milan 1987 (EC).– Budinga, L.: G.S. Milan 1964.– Calzini, R.: S. Geneva 1947.– Nicodemi, G.: G.S. Milan 1956.– Quinsac, A.-P.: G.S.: Trent' anni di vita artistica europea nei carteggi inediti dell'artista e dei suoi mecenati. Oggiono 1985.– Quinsac, A.-P. S. Milan 1982.– Segantini, G.: G.S. Zurich 1949.– Servaes, F.: G.S., sein Leben und seine Werke. Vienna 1902.– Tobler, D. and G. Magnaguagno (eds.): G.S. Kunsthaus Zürich, Zurich 1990 (EC).– Zbinden, H.: G.S. Berne 1951 ILLUSTRATIONS:

- 547 Midday in the Alps (Windy Day), 1891
- 547 Ploughing, 1890

SEROV Valentin Alexandrovich 1865 St. Petersburg - 1911 Moscow 1872-1875 lived with his mother in Munich and Paris, took art lessons with Karl Köpping und Repin. 1875-1880 stayed for the first time with the Mamontow family in Abramtsevo, went to school in Kiev and Moscow. 1880 visited and studied in Ukraine with Repin. 1880-1885 studied at the Academy in St. Petersburg; friendship with Vrubel. 1885 trip to Munich and Holland. 1886 exhibited for the first time at an exhibition in Moscow; staved for the first time with his student friend Dervis in Domotkanovo. 1887 visited Vienna and Italy. 1888 received an award for the first time from the Moscow Society for Friends of Art. 1889 visited the World Fair in Paris and Germany; friendship with Korovin. 1890-1899 exhibited with the "Wanderers" and became a member in 1894. Painted lively portraits and landscape studies, partly pleinair, and occasional histories; drew illustrations, 1896 exhibited for the first time at the Munich Secession, 1898 became a member, 1897-1909 influential teacher at the Moscow School of Art; called for the development of the "modern" in Russia. 1898 became a member of the Russian Academy. 1900-1904 worked for the journal "World of Art" and contributed to its exhibitions. 1900 won a distinguished award at the World Fair in Paris for a portrait of Grand Duke Paul. 1902 met Gorky. 1903 member of the Academy of Arts in St. Petersburg, but refused the offer of a teaching position; became a member of the new Russian federation of Artists. 1904-1911 several trips to Italy, France, Spain, England and Germany. 1905 left the Academy in St. Petersburg in protest against the shooting of demonstrators in St. Petersburg; drew political caricatures. 1907 visited Greece with L. Bakst; turned

to mythological themes. 1907-1911 designed theatre sets, also in Western Europe. 1910/11 met Matisse in Paris and Moscow.

BIBLIOGRAPHY: Kopschitser, M.: V.S. Moscow 1967.– Sarabyanov, D.: V.S. Leningrad and New York 1977.– Sarabyanov, D. and G. Arbusov: V.S., Painting, Graphics and Designs of Stage Sets. Leningrad 1982.– Silberstein, E. and V. Samkov: V.S. v vospominaniyakh, dnevnikakh, i perepiske sovremennikov. Leningrad 1971

ILLUSTRATIONS:

508 The Children. Sasha and Yurra Serov, 1899

511 Girl with Peaches, 1887

SERUSIER Paul 1864 Paris - 1927 Morlaix 1888 assistant at the private Académie Julian in Paris. At Pont-Aven, met Gauguin and the adherents of Synthetism, and mediated it to Denis, Bonnard, Vuillard. 1889 organised the Symbolist Nabis; visited Gauguin, whose depictions of Breton landscapes and peasant women influenced him considerably. 1891 under the influence of his Nabi colleague J. Verkade he began to move towards a religious and mystical conception of art. 1892 visited Pont-Aven again. 1893 with Bernard, visited Italy for the first time. 1893-1896 worked at the Lugné-Poe theatre. 1897 visited Verkade, now a monk, for the first time at Beuron monastery. 1914-1927 lived a secluded life in Brittany. CATALOGUE: Guicheteau, M. and H. Boutaric: P.S. 2 vols. Paris 1976-1989 BIBLIOGRAPHY: Boyle-Turner, C.: P.S. Doctoral thesis, Ann Arbor (MI) 1983.- Guicheteau, M.: P.S. Pontoise 1989

ILLUSTRATION:

320 The River Aven at Bois d'Amour (The Talisman), 1888

SEURAT Georges

1859 Paris – 1891 Paris From a peasant family; had drawing lessons in 1875; later copied in museums. 1878/1979 studied at the Ecole des Beaux-Arts; read widely on colour theory. 1880 military service; settled afterwards in Paris; concentrated for two years on dark and light drawings in chalk. 1883 accepted at the Salon; started his first large painting, an open-air scene in a new, Divisionist and Pointillist technique. 1884 rejected by the Salon; met Signac; founded with him and others the Society of Independent Artists (Indépendants), which organised its own Salon. 1885 painted on Grand Jatte, an island in the Seine in Paris, and at Grancamp on the Normandy coast; met Pissarro, who adopted his technique of painting. 1886 won great acclaim at the 8th Impressionist exhibition: painted at Honfleur; through Durand-Ruel exhibited in New York; exhibited with Pissarro and Signac in Nantes: met the art theorist C. Henry: contacts with Symbolists and Anarchists. 1886 and subsequent years: exhibited with the Independents. 1887 exhibited with Les Vingt in Brussels, travelling there for the opening. Drew illustrations for Charpentier's journal, "La Vie moderne"; exhibited at the Théâtre Libre. 1888 painted at Port-en-Bessin, and 1889 at Crotoy beach; exhibited with Les Vingt in Brussels. 1890 painted at Gravelines; worked out his theories in writing. His arrogance threatened to split the Impressionists. 1891 exhibited once again with Les Vingt; died of diptheria. His attempt to establish a theoretical basis for painting and his strict formal discipline influenced many artists in the 20th century

WRITINGS, DOCUMENTS: Seurat, P.: Notes sur Delacroix. Caen 1987 CATALOGUES: Chastel, A.: L'opera completa di S. Milan 1972.- Chastel, A.: Tout l'œuvre peint de S. Paris 1973.- Dorra, H. and J. Rewald: S. L'œuvre peint, biographie et catalogue critique. Paris 1959.- Grenier, C.: S. Catalogo completo dei dipinti. Florence 1990.- Grenier, C.: S. Catalogue complet des peintures. Paris 1991.- Haucke, C.-M. de: S. et son œuvre. 2 vols. Paris 1961.- Kahn, G .: Dessins. 2 vols. Paris 1920.- Minervino, F.: Das Gesamtwerk des S. Lucerne 1972 .- Minervino, F.: Tout l'œuvre peint de S. Paris 1973.- Minervino, F.: L'opera completa di S. Milan 1971 .- Zimmermann, M.F.: S. Sein Werk und die kunsthistorische Debatte seiner Zeit. Weinheim 1991.-Zimmermann, F.S.: S. Antwerp and London 1992 .- Zimmermann, M.F.: Les mondes de S. Paris 1991 BIBLIOGRAPHY: Alexandrian, S.: G.S. New York 1980.- Bernadini, C.: S. Madrid 1982 .- Broude, N. (ed.): S. in Perspective. Englewood Cliffs (NJ) 1978 .- Cachin, F., R.L. Herbert et al. (eds): G.S. 1859-1891. Grand Palais, Paris; The Metropolitan Museum of Art, New York. Paris and New York 1991 (EC) .- Courthion, P.: S. Cologne 1969, 1991.- Courthion, P.: S. London and New York 1969, New York 1988 .- Cousturier, L .: G.S. Paris 1969.- Cousturier, L.: G.S. Milan 1969.- Franz, E. and B. Growe (eds.): G.S. Zeichnungen. Kunsthalle Bielefeld, Munich 1983 (EC) .- Fry, R. and A. Blunt: S. London 1965 .- Fry, R.: S. Basle 1965.- Gould, C.: S.'s "Bathers Asnières" and the Crisis of Impressionism. London 1976.- Hautecoeur, L.: G.S. Paris 1974 .- Hautecoeur, L.: G.S. Milan 1974.- Herbert, R.L.: S.'s

Drawings, New York 1962, London 1965 .- Homer, W.I .: S. and the Science of Painting. Cambridge (MA) 1964, New York 1988.- Kahn, G.: The drawings of G.S. New York 1971.- Laprade, J. de: S. Paris 1951.-Lhote, A.: S. Paris 1948 .- Lövgren, S.: The Genesis of Modernism. Seurat, Gauguin, van Gogh and French Symbolism in the 1880's, Uppsala 1959, Bloomington (IN) and London 1971 .- Madeleine-Perdrillat, A .: S. Geneva and New York 1990.-Morris, J .: A Sunday Afternoon on the Island of La Grande latte, G.S. London 1979 .- Perruchot, H.: La vie de S. Paris 1966 .- Petránsky, L.: S. a neoimpresionizmus. Bratislava 1978 .-Rewald, J.: S. New York 1943.- Rewald, J .: S. New York 1946 .- Rewald, J.: S. Paris 1948 .- Rewald, J.: S. A Biography. New York and London 1990.- Rich, D.C.: S. and the Evolution of "La Grande Jatte". Chicago 1935, 1969.- Rich, D.C. (ed.): S., Paintings and Drawings. The Art Institute of Chicago, Chicago 1958 (EC) .- Russel, J .: S. Berlin, Darmstadt and Vienna 1968 .- Russel, J.: S. London and New York 1965, 1991.-Russel, J.: S. Paris 1967 .- Seligmann, G.: The Drawings of G.S. New York 1947.- Stuckey, C.F.: S. Mount Vernon and New York 1984.- Terrasse, A.: L'univers de S. Paris 1976.- Thomson, R.: S. Oxford 1985.- Wotte, H.: G.S. Wesen, Werk, Wirkung. Dresden 1988 .- Zahn, L.: S. Cologne and Vienna 1967

ILLUSTRATIONS:

- 254 Horses in the Seine (Study for "Bathers at Asnières"), c. 1883/84
- 254 Bather (Study for "Bathers at Asnières"), c. 1883/84
- 254 Bathers at Asnières, c. 1883/84
- 255 Echo (Study for "Bathers at Asnières"), 1883/84
- 255 Seated Youth with Straw Hat (Study for "Bathers at Asnières"), 1883/84
- 255 The Leg (Study for "Bathers at Asnières"), 1883/84
- 256 Watering Can, 1883
- 256 Houses at Le Raincy, c. 1882
- 258 L'Ile de la Grande Jatte, 1884
- 259 A Sunday Afternoon at the Ile de la Grande Jatte, 1885259 Angler (Study for "Ile de la
- Grande Jatte"), 1884-1886
- 259 Couple (Study for "Ile de la Grande Jatte"), 1884–1886

- 259 Woman with Parasol (Study for "Ile de la Grande Jatte"), 1884/85
- 260 A Sunday Afternoon at the Ile de la Grande Jatte, 1884-1886
- 271 The Beach at Bas-Butin near Honfleur, 1886
- 271 Bec du Hoc, Grandcamp, 1885 272 The Lighthouse at Honfleur,
- 1886 273 The "Maria", Honfleur, 1886
- 273 The Harbour at Honfleur, 1886
- 298 Seated Female Nude (Study for "The Models"), c. 1886/87
- 298 Model from Behind (Study for "The Models"), c. 1886/87
- 299 Standing Female Nude (Study for "The Models"), 1887
- 299 Standing Female Nude (Study for "The Models"), 1887
- 300 The Circus Parade, c. 1887/88
- 301 The Models, 1888
- 318 Le Chahut, c. 1889/90318 Dancers on Stage (Study for "Le Chahut"), 1889
- 319 Young Woman Powdering Herself, c. 1889/90
- 320 Portrait of Paul Signac, 1890
- 328 Study for "The Circus", 1891
- 329 The Circus, 1891

SECESSION

Term used for groups of artists that broke away from the established organisations to hold their own exhibitions. 1884 in France the Société des artistes indépendants broke away from the Société des artistes français and organised its own Salon. In Germany and Austria (Munich 1892, Vienna 1897, Berlin 1898), the term Secession was used. Similar exhibition organisations were set up in England, Scandinavia, Belgium, Eastern and South-eastern Europe. Secession art or Secession style is an imprecise collective term for Impressionist and Post-Impressionist art in the period before Expressionism and Fauvism; it also includes architecture and arts and crafts.

SICKERT Walter Richard 1860 Munich – 1942 Bathampton

1868 the family emigrated to London. Earned his living initially as an actor. 1881 won a scholarship to attend the Slade School of Fine Art in London. 1882 at Whistler's studio. 1883 met Degas in Paris; in Dieppe 1885 they became close friends. Influenced by Manet and Degas, who encouraged him to be meticulous in his draughtsmanship. 1888 joined the "New English Art Club" and soon became the leading exponent of Impressionism in London. From 1885 he spent every summer in Dieppe. 1898-1905 lived permanently in Dieppe. In this period he painted almost exclusively views of either Dieppe or Venice. 1903/04 last stay in Venice. Began to paint genre scenes, which dominated his work until 1914. From 1904 he taught at the Slade School of Fine Arts and at the Westminster Technical Institute. With Lucien Pissarro and Gore 1907-1909, he developed a technique of painting with small, bright spots of paint applied very close to each other. 1910 rejected this method and 1913/14 developed a new technique, involving a base of two layers of paint on a coarse canvas on which areas of clear colours are then applied in layers. 1906-1914 began once again to spend regular periods in Dieppe. From 1922 he stopped travelling and stayed in England. 1934 member of the Royal Academy, His own private school developed into the "Camden Town Group", active 1911-1913. WRITINGS, DOCUMENTS: Stitwell, O. (ed.): A Free House: Being the Writings of W.R.S. London 1947 BIBLIOGRAPHY: Baron, W.: S. London 1973.- Bertram, A.: S. London 1955.-Browse, L.: S. London 1960.- Emmaus, R.: The Life and Opinions of W.R.S. London 1941.- Lilly, M.: S. The Painter and his Circle. London 1971.- Paintings, Drawings and Prints of W.R.S. 1860-1942. The Arts Council of Great Britain, London 1977 (EC) .- Rothenstein, J.: S. London 1961.- Shone, R.: W.S. Oxford 1988 .- W.R.S. Fine Art Society Ltd, London 1973 (EC) .- W.R.S. Drawings and paintings 1890-1942. Liverpool 1989 (EC) ILLUSTRATIONS:

578 Lion Comique, 1887 588 Bathers at Dieppe, c. 1902

SIGNAC Paul 1863 Paris – 1935 Paris

Son of a master harness-maker, he began to paint under the influence of Monet and Guillaumin in 1880, instead of becoming an architect. 1883 studied at the free academy of Bing. 1884 co-founder of the Society of Independent Artists (Indépendants); friendship with Seurat, whose Divisionist, Pointillist style influenced his town and river landscapes, as well as his figural painting. Painted at Porten-Bessin. 1886 exhibited at the 8th Impressionist exhibition, and through Durand-Ruel in New York; exhibited with Seurat and Pissarro in Nantes. He subsequently formed many new friendships, helped organise exhibitions, and wrote articles of art criticism. 1887 travelled with Seurat to Brussels and also to the Mediterranean for the first time (Collioure); drew for Charpentier's journal, "La Vie moderne", and exhibited at the Théâtre Libre. 1888 exhibited for the first time with Les Vingt in Brussels. 1889 visited van Gogh at Arles, illustrated theoretical writings by C.

Henry; politically an Anarchist. 1890 first of several trips to Italy; became the first foreign artist to join Les Vingt. 1892 married Berthe Roblès, a relative of Pissarro; sailed from Brittany to Marseilles, remaining all his life an enthusiastic sailor. His style (including watercolours), is characterised by square daubs of paint in pure, bright colours; he painted mainly views of harbours and seascapes. 1893 bought a house at Saint-Tropez, which was to become a resort and favourite of modern artists. 1896 first trip to Holland. 1899 published a book on the theory of Neo-Impressionism. 1907 trip to Constantinople. 1908 president of the Société des artistes indépendants. WRITINGS, DOCUMENTS: Rewald, J.

(ed.): P.S. Extraits du journal inédit. In: "Gazette des Beaux-Arts" 36 (1949), pp.97-128, 166-174, 39 (1952), 42 (1953).– Signac, P.: D'Eugène Delacroix au néo-impressionnisme. Paris 1899 (Reprint: Paris 1964, 1987)

CATALOGUE: Kornfeld, E.W. and P.A. Wick: Catalogue raisonné de l'œuvre gravé et lithographié de P.S. Berne 1974

BIBLIOGRAPHY: Besson, G.: P.S. Paris 1935.– Besson, G.: P.S. Paris 1950.– Cachin, F.: P.S. Greenwich (CT) 1971.– Cachin, F.: P.S. Paris 1971.– Cachin, F.: P.S. Milan 1970.– Cousturier, L.: P.S. Paris 1922.– Lemoyne de Forges, M.T. (ed.): Catalogue de l'exposition du centenaire de P.S. Musée du Louvre, Paris 1963 (EC).– P.S. Musée National d'Art Moderne, Paris 1951 (EC)

ILLUSTRATIONS:

- 252 Rue Caulaincourt: Mills on Montmartre, 1884
- 257 Outskirts of Paris: The Road to Gennevilliers, 1883
- 266 Two Milliners, Rue du Caire, c. 1885/86
- 267 The Breakfast (The Dining Room), c. 1886/87
- 269 The Railway at Bois-Colombes, 1886
- 269 Gasometers at Clichy, 1886
- 272 The River Bank, Petit-Andely, 1886
- 281 The Boulevard de Clichy under Snow, 1886
- 319 Woman Taking up Her Hair, 1892
- 321 Portrait of Félix Fénéon in Front of an Enamel of a Rhythmic

Background of Measures and Angles, Shades and Colours, 1890 366 The Papal Palace at Avignon, 1900

388 Pine Tree at Saint-Tropez, 1909

SIGNORINI Telemaco 1835 Florence - 1901 Florence Son of the court painter to the Grand Duke of Tuscany. 1848-1852 attended the "Scuola Pié di San Giovanni degli Scolopi"; school friends included Diego Martelli and the future poet Giosué Carducci. His literary talents began to flourish in this period, and he remained active all his life as a critic, art theoretician and poet. 1852 pressurised by his father, he trained as an artist; learned to draw nudes at the Academy. 1853 be came interested in landscapes and from 1854 painted plein-air with Borrani. Frequented the Caffè Michelangiolo. 1856 visited Venice, where he met Abbati. 1858 first experiments with the Macchia technique. 1859 military service in the Second War of Independence. Spent the summer of 1860 painting in the open-air at La Spezia. 1861 travelled to Paris; visited the Salon. Became very interested in the work of Corot, Décamps and Daubigny. In Florence; joined with Lega, Abbati, Borrani and Sernesi to form the Piagentina school. In the early 1870s he became friends with Degas and was influenced by him. Travelled in 1869 to Paris, 1873/74 to France, 1881 to England and Scotland, 1884 again to Paris and London. 1892 appointed professor at the "Istituto Superiore di Magistero Femminile" in Florence.

WRITINGS, DOCUMENTS: Signorini, T.: Silvestro Lega. Florence 1895 BIBLIOGRAPHY: Franchi, A.: G. Fattori, S. Lega, T.S. Milan 1953.- Masini, L.-V.: T.S. Florence 1983.-Ojetti, U.: T.S. Milan 1911, Rome 1930.- Somarè E.: T.S. Milan 1926, Bergamo 1931 ULUSTRATIONS:

- 539 The Suburb of Porta Adriana, Ravenna, 1875
- 544 Insane Ward at San Bonifacio's, Florence, c. 1866/67

SILVESTRE Armand

1837 Paris – 1901 Toulouse Civil servant at the Ministry of Finance, technologist, writer and journalist. On completion of his technical

studies joined the writers in Montparnasse. Frequented the Café Guerbois and the Café de la Nouvelle-Athènes and in his journals and catalogue articles became one of the first proponents of Impressionism.

SISLEY Alfred

1839 Paris - 1899 Moret-sur-Loing Son of well-to-do English parents in London; intended to make a career in business; 1857-1862 began to draw. 1862/63 studied at the Atelier Gleyre in Paris with Monet, Renoir and Bazille. 1863 early attempts at plein-air painting with his friends at Chailly-en-Bière near Barbizon. 1865 worked with Renoir, Monet and Pissarro at Marlotte and with Renoir on a boat on the Seine. 1866 exhibited for the first time at the Salon, married Marie Lescouezec; the couple had two children. 1867 rejected by the Salon; with others called for the founding of a "Salon des Refusés"; painted at Honfleur. 1868 spent periods with Renoir at Chailly and exhibited at the Salon. 1869 rejected by the Salon; frequented the Café Guerbois. 1870 showed some Impressionist pictures at the Salon. 1871 stayed at Voisins-Louveciennes during the Commune; Durand-Ruel exhibited one of his pictures in London. 1872 Durand-Ruel began to buy regularly from him. In the following period, he painted Impressionist river landscapes and village scenes (also in the snow) at Argenteuil, Bougival and Louveciennes. 1874 exhibited at the first Impressionist exhibition; travelled to England at the expense of J.-B. Faure, the singer and art collector. 1875-1877 lived at Mary-le-Roi. 1875 a disastrous auction sale of pictures at

the Hôtel Drouot with Renoir and others. 1876 and 1877 exhibited at the 2nd and 3rd Impressionist exhibitions; auctioned more pictures. Moved to Sèvres, supported by the hotelier Murer and the publisher Charpentier. 1878/79 dire poverty; a few purchases arranged by Duret. 1879 rejected by the Salon; did not exhibit at the 4th -6th Impressionist exhibitions. 1880-1882 lived at Veneux-Nadon with Moret, 1881 first one-man exhibition at Charpentier's journal, "La Vie moderne". 1882 exhibited at the 7th Impressionist exhibition; settled in Moret-sur-Loing. 1883 one-man exhibition without success at Durand-Ruel's; moved to Sablons. 1885 exhibited at Durand-Ruel's in London, Boston, Rotterdam and Berlin. 1887 contributed to an exhibition at G. Petit's. 1888 exhibited with Renoir and Pissarro at Durand-Ruel's, 1889 individual exhibition by Durand-Ruel in New York; moved for the last time to Moret, remaining to the end an exponent of pure Impressionist landscape painting. 1890 elected a member of the "Nationale"; subsequently exhibited in their Salon. 1893/94 painted some of his best picture series (the idea was borrowed from Monet). 1894 painted in Normandy as a guest of the art collectors Murer and Depeaux. 1897 large retrospective at G. Petit's met with little success with the critics and collectors; painted on the English coast. 1898 seriously ill with cancer; had no money to apply for French citizenship. At the posthumous auction of his work in 1899 the prices for his pictures began to rise drastically. 1911 the first memorial for an Impressionist was built for him at Moret.

WRITINGS, DOCUMENTS: Graber, H.: Camille Pissarro, A.S., Claude Monet nach eigenen und fremden Zeugnissen. Basle 1943

CATALOGUE: Daulte, F.: A.S. Catalogue raisonné de l'œuvre peint. Lausanne 1959

BIBLIOGRAPHY: Cogniat, R.: A.S. Paris 1978, 1981.- Cogniat, R.: A.S. New York 1978.- Couldrey, V.: A.S. The English Impressionist. London 1992.- Daulte, F.: Les paysages de Sisley. Lausanne 1961.- Daulte, F.: S., paysage. Paris 1961 .- Daulte, F.: A.S. Munich 1975 .- Daulte, F .: The Impressionists: A.S. London 1988.-Francastel, P.: Monet, S., Pissarro. Geneva 1947 .- Gache-Patin, S. and J. Lassaigne: S. Paris 1983.- Gale, I.: S. London 1992.- Jedlicka, G.: S. Berne 1949.- Jedlicka, G.: S. Lausanne 1950.- Jedlicka, G.: S. Milan 1950.-Lloyd, C. et al. (eds): A.S. Isetan Museum of Art (Tokyo) et al., Tokyo 1985 (EC) .- Nathason, R. (ed.): A.S. London 1981 (EC) .- Scharf, A.: A.S. London 1966 .- Shone, R.: S. London 1992 .- Stevens, M.-A. (ed.): A.S. Royal Academy of Arts, London; Musée d'Orsay, Paris; The Walters Art Gallery, Baltimore; London 1992 (EC) ILLUSTRATIONS:

- 84 First Snow at Louveciennes, c. 1870/71
- 84 The Saint Martin Canal in Paris, 1870

- 96 The Saint Martin Canal, 1872
- 96 The Island of Saint-Denis, 187297 The Bridge at Villeneuve-la-
- Garenne, 1872 98 The Saint Martin Canal in Paris,
- 187098 Landscape at Louveciennes, 1873
- 99 Villeneuve-la-Garenne on the River Seine, 1872
- 142 The Regatta at Molesey, 1874 158 Louveciennes, 1876
- 158 Louveciennes, 1876 159 Flood at Port-Marly, 1876
- 159 Market Place at Marly, 1876
- 172 The Seine at Suresnes, 1877
- 183 Snow at Louveciennes, 1878
- 313 Moret-sur-Loing in Morning
- Sun, 1888 339 The Bridge at Moret, 1893

SLAVICEK Antonín 1870 Prague – 1910 Prague

1886/87 study trip to Munich. 1887-1889 studied with J. Mařák at the Academy of Arts in Prague. 1899 stayed at the Benedictine monastery of Gross Raigern (Moravia). 1890-1893 painted landscapes near Altbunzlau. 1891 exhibited with other pupils of Mařák in Prague. 1892-1897 joined the Association of Artists. 1894-1899 studied once again with Mařák at the Academy; painted in an Impressionist style. 1897 exhibited for the first time at the Prague Society of Fine Arts and in Vienna. 1898 began to exhibit regularly with the Mánes group of artists. 1899 became the successor of Mařák at the Academy. 1905 views of Prague became his favourite theme. 1907/08 travelled on a stipend to Paris. Became ill in 1909, went for treatment to Dubrovnik. BIBLIOGRAPHY: A.S. 1870-1910. Varech 1980 (EC) .- Kotalík, J.: A.S., 1870-1910. Soupis díla (Czech), Prague 1965 (with catalogue) .-Tomes, J.: A.S. Prague 1973 ILLUSTRATIONS:

516 Walking in the Park, 1897518 Elizabeth Bridge, Prague, 1906

SLEVOGT Max

1868 Landshut – 1932 Neukastel 1884-1890 studied at the Academy of Fine Arts in Munich with Johann Herterich and Wilhelm Diez. Influenced by Wilhelm Leibl and Trübner. 1889 travelled to Paris and studied French Impressionism at the Académie Julian. 1890 tour of ftaly. 1893 member

of the Munich Secession and the "Freie Vereinigung" (Free Association); 1896 worked for the journal "Simplicissimus". Through Leistikow, came into contact with the Berlin Secession. 1900 travelled to the World Fair in Paris. 1901 stayed in Frankfurt am Main, where he painted his famous brightly coloured zoo pictures. From 1901 in Berlin, working mainly as a portrait painter. Held a master class at the Academy. 1914 visited Egypt and painted landscapes in the bright sunlight. 1915 went to Belgium as a war artist. After 1918 lived in Neukastel in the Palatinate. In the 1920s returned to religious themes with his graphic cycle "Passion". Did 500 illustrations for an edition of Goethe's "Faust". 1924 murals for the concert hall at Neukastel and in Berlin, 1927 in Bremen and 1932 in the Friedenskirche Church at Ludwigshafen. 1924 did the stage design for "Don Giovanni" at the Dresden Opera.

CATALOGUE: Waldmann, E. and J. Sievers: M.S. Das druckgraphische Werk 1890-1914. Heidelberg and Berlin 1962 (Reprint: San Francisco 1992)

BIBLIOGRAPHY: Imiela, H.-J.: M.S. Karlsruhe 1967.– M.S. Saarland Museum, Saarbrücken; Rheinisches Landesmuseum, Mainz; Saarbrücken 1992 (EC).– Roland, B.: M.S. Pfälzische Landschaften. Munich 1991.– Scheffler, K.: M.S. Berlin 1940.– Voll, K.: M.S. Munich and Leipzig 1912.– Waldmann, E.: M.S. Berlin 1923.– Weber, W.: Die religiösen Werke von M.S. Kaiserslautern 1966 ILLUSTRATIONS: 447 Dance of Death, 1896

- 452 Man with Parrots, 1901 454 The Alster at Hamburg, 1905 458 Garden at Neu-Cladow, 1912
- 461 Steinbart Villa, Berlin, 1911 462 Portrait of Mrs. C., 1917

SLEWINSKI Władysław

1854 Bialynin a.d. Pilica – 1918 Paris 1888-1905 after a short period of lessons with W. Gerson at the Warsaw School of Drawing, he studied in Paris at the Académie Julian and the Académie Colarossi. 1889 with Gauguin for the first time at Pont-Aven; began to exhibit Impressionist-inspired and Synthetist landscapes and pictures of poor and simple people at Paris and Warsaw. 1905-1910 in Cracow and Poronin (Carpathians).

Travelled extensively, including Munich. 1910-1918 in Paris and Brittany. CATALOGUE: JAWORSKA, W.: W.S., Warsaw 1983 BIBLIOGRAPHY: W.S. Museum narodowe, Warsaw 1983 (EC) ILLUSTRATION: 515 Rough Sea at Belle-Ile, 1904

SOCIETE ANONYME DES ARTISTES

Otherwise known as Société anonyme coopérative des artistes- peintres, sculpteurs, graveurs etc. Founded on 27 December, 1873 in Paris, an officially registered society with about 30 members and a statute on the model of the Association of Bakers at Pontoise. The society was publicised in Durand-Ruel's gallery journal and in other periodicals. Its aim was to hold a group exhibition, financed by the membership fee (at least 60 francs annually) and 10% of the takings from the sale of work. It organised an exhibition, which began on 15th April 1874; this is now regarded as the first Impressionist exhibition. A financial failure, the society soon split into factions and folded on 17 December 1874.

SOMM Henry

1844 Rouen – 1907 Paris Real name: François Clément Sommier. Pupil at the School of Drawing in Rouen with Gustave Morin and Pils. Active as a cartoonist, graphic artist and caricaturist for several journals. 1879 exhibited at the 4th Impressionist exhibition. 1890 met Toulouse-Lautrec, very impressed by his sketches of daily life. Worked for the Haviland d'Auteuil studio of which Bracquemond was artistic director. ILLUSTRATIONS: 263 The Red Overcoat

263 Stylish Ladies in the Street

SOROLLA Y BASTIDA Joaquín 1863 Valencia – 1923 Cercedilla (Madrid)

Trained initially as a smith, then became the pupil of one of his uncles. 1875 studied at the San Carlos Academy in Valencia. 1878 and 1882 received awards. 1884 married the daughter of his patron, García, a photographer. Studied the art of Diego Velázquez. 1884/85 travelled on a stipend to Rome, Assisi and Paris. Influenced by the Realism of Morelli. In Spain in 1887 his pictures

caused a scandal. Later exhibited with great success in Madrid, Berlin, Munich, Vienna and Paris. 1906 exhibited at the Galerie Petit in Paris. 1909 an exhibition in New York led to several portrait commissions in America.

BIBLIOGRAPHY: Anderson, R.M.: Costumes Painted by S. in his Provinces of Spain. Hispanic Society of America. New York 1957 .- Eight Essays on J.S. y B. Hispanic Society of America. 2 vols. New York 1909.-Pantorba, B. de: La vida y la obra de J.S. Madrid 1953 .- Peel, E. (ed.): The Painter J.S. y B. Instituto Valenciano de Arte Moderno, Centro Julio González, Valencia; San Diego Museum of Art, San Diego; London 1989 (EC) ILLUSTRATIONS:

560 The Beach at Valencia

561 Selling the Catch at Valencia, 1903

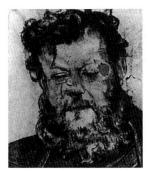

STANISLAWSKI Jan 1860 Olszany (Ukraine) - 1907 Cracow

1884/85 studied at the School of Art in Cracow, after studying mathematics and technology and attending the School of Drawing under W. Gerson in Warsaw. 1885-1888 in Paris, studied at the Academy with Carolus-Duran. 1890 at the Salon of the Société Nationale. 1896-1898 helped with the work on some panorama pictures in Russia and Germany. 1897 co-founder of the association "Art" (Sztuka). Professor of landscape painting at the College of Art in Cracow, a leading figure in the artistic life of the city and in the "Young Poland" movement. Numerous trips to Paris, Vienna, Berlin, Munich, Kiev; exhibited at numerous exhibitions at home and abroad. BIBLIOGRAPHY: W. Juszczak: J.S.,

Warsaw 1972 .- Stepnowska, T.: J.S. Warsaw 1976 ILLUSTRATION:

513 Poplars beside the River, 1900

STARR Sidney

1857 Kingston upon Hull (Yorkshire) - 1925 New York

Studied at the Slade School of Fine Arts in London with Povnter and Legros. 1874 won a scholarship. 1882 met Whistler, whose style influenced him. From the middle of the 1870s. he exhibited at the Society of British Artists. 1882-1886 exhibitions at the Royal Academy. 1886 founder member of the New English Art Club. In the same year, elected a member of the Royal Academy. 1889 exhibited at the English Impressionist exhibition, Galerie Goupil, and at the World Fair in Paris, where he won a medal. 1892 left England due to a scandal and settled in New York. 1896 did the decorative painting for the Grace Chapel in New York and the Library of Congress, Washington. ILLUSTRATION:

579 The City Atlas, c. 1888/89

STEER Philip Wilson

1860 Birkenhead - 1942 London Son of a landscape and portrait painter. 1878-1881 studied at the College of Art in Gloucester and at the Art Training School. 1882/83 studied at the Académie Julian in Paris with Bouguereau and 1883/84 at the Ecole des Beaux-Arts with Cabanel. Influenced by French Impressionism (Monet, Whistler) and Pointillism. 1884 returned to England. 1886 founder member of the New English Art Club. 1889 exhibited with the English Impressionists and 1889-1894 with Les Vingt in Brussels. 1893-1930 professor at the Slade School of Fine Arts. 1894 individual exhibition at the Galerie Goupil. 1895 returned to the tradition of the English landscape painters of the early 19th century (Turner, Constable). 1918 official war painter. In the last years of the War turned to water colours.

CATALOGUE: Yockney, A.: S. Catalogue Raisonné. London 1945 BIBLIOGRAPHY: Ironside, R.: W.S. London 1943.- Laughton, B.: P.W.S.

1860-1942. Oxford 1971.- MacColl, D.S.: Life, Work and Setting of P.W.S. London 1945.- Munro, J. (ed.): P.W.S. 1860-1942 .- P.W.S. The Arts Council of Great Britain, London 1960 (EC) ILLUSTRATIONS:

575 Young Woman on the Beach. Walberswick, c. 1886-1888

575 Girl Running, Walberswick Pier, c. 1890-1894

581 Summer at Cowes, 1888

STEVENS Alfred

1823 Blandford - 1906 London Lived and worked most of his life in Paris. 1844 after an initial training in his home town with Navez, a pupil of David, he studied with Ingres at the Ecole des Beaux-Arts. 1849-1852 in Brussels, where he first exhibited in 1851. 1852 settled in Paris. Influenced by Courbet, he formed friendships with Delacroix, Baudelaire and above all Manet, in whose studio he met Bazille; frequent customer at the Café Guerbois. Had contacts at the court of Napoleon III. A successful painter of the daily life of the well-to-do bourgeoisie. Inspired compositions with a sensitive feeling for colour tone and subject matter. One of the first, with Bracquemond, to become interested in East Asian art. 1870/71 with Manet and Degas in the National Guard. Close friendship with Morisot. Gave courses in painting for ladies. 1882 co-founder of the international art exhibitions of the Petit Gallery. 1886 rejected Poin-

tillism; published the book "Impressions sur la peinture". 1889 with H. Gervex painted the "Panorama of the 19th century" for the Paris World Fair. 1895/96 in Belgium. 1900 large retrospective in Paris. Linked to the Impressionist movement not through the treatment of light or his style of painting but rather through the unique sense of movement in his composition and his feeling for the everyday, fleeting moment.

BIBLIOGRAPHY: A.S. Centenary Exhibition. Victoria and Albert Museum, London 1975 (EC) .- Coles, W.A. (ed.): A.S. The University of Michigan, Museum of Art. Ann Arbor 1977 (EC) .- Towndrow, K.R.: The Works of A.S., Sculptor, Painter, Designer. Tate Gallery, London 1950 (EC) ILLUSTRATION: 199 Family Scene, c. 1880

STRYDONCK Guillaume van 1861 Namsos (Norway) - 1937 Saint-Gilles (near Brussels) Studied at the Academy in Brussels and with E. Agneessens. Co-founder of Les Vingt. 1886 trip to Florida. His realistic style, characterised by its large brush-strokes, increasingly acquired aspects of Impressionist painting as he began to tackle the effects of light. 1887-1890 painted in Machelen und Blankenberge. 1891-1895 lived in India. 1895 settled in Weert sur l'Escaut, where the Flemish landscape became his major theme. From 1900 he taught at the Academy in Brussels. ILLUSTRATION.

420 The Oarsmen, 1889

SUISSE → Académie Suisse

SUZOR-COTE Marc-Aurèle de Foy 1869 Arthabaska (Québec) - 1937 Initial training as a church painter. 1891 began his studies in Paris at the Ecole des Beaux-Arts under Bonnat. At first he painted mainly still lifes in the academic tradition. From 1893 came under the influence of Impressionism. His compact treatment of figures belongs in the Millet tradition. 1897-1907 second stay in Paris. Attended the Académies Colarossi and Iulian, 1907 returned to Canada. Thereafter his painting remained heavily indebted to French Impressionism. Often painted the same landscape scene in varying qualities of light and at different times of the day, particularly scenes of rivers in winter, 1913 exhibited at the Canadian Art Club, where he became a member in 1914. BIBLIOGRAPHY: Jouvancourt, H. de: S.-C. Montreal 1978 .- Ostiguy, J.-R .: M.-A.d.F.S.-C. Winter Landscape. Ottawa 1978 ILLUSTRATION:

626 Port-Blanc in Brittany, 1906

SYMBOLISM

A literary (Mallarmé) and artistic movement of the last years of the nineteenth century ("Fin de siècle"), first publicised in a manifesto of 1886 by the poet J. Moréas. The movement was more a philosophical approach than a stylistic unity, a sense of crisis and a deep-felt distrust of the worship of progress and the belief in the ability of materialistic science to understand and control the natural world and human society. It led to a reaction against the realistic, naturalistic and Impressionist depiction of the visible world and to a halting, subjective concern to grasp the ineffable meaning and purpose "behind" things. There was a strong religious and mystical component to this Neo-Idealism, which included a revival of Romantic conceptions. In France, there was a simultaneous movement to combine Symbolism with decorative and primitive art. Initiated by A. Aurier in 1891, it was developed by Gauguin and the Pont-Aven school, and the Nabis; it is also seen in certain features of van Gogh's style. The movement attracted remarkable individualists such as Moreau, Puvis de Chavannes, Rops,

699

Redon, the English Pre-Raphaelites and Böcklin. It found a following in Belgium, Holland, Italy, Scandinavia, and German-speaking and Eastern European countries. It had a significant influence on the form and critical appreciation of Neo-Impressionism and of Monet's later works.

SZINYEI MERSE Pál

1845 Szinye-Ujfalu (Svina, Slovakia) - 1920 Jernye (Jarovnice, Slovakia) Began to paint in 1862. 1864-1869 studied at the Munich Academy with A. Wagner and above all with Piloty; had contact with Leibl and G. Max. Regular stays at Jernye; finally turned to plein-air figural painting. 1869 met Courbet in Munich. From 1870 lived mostly on the family estate at Jernye. 1872/73 lived in Munich, making an independent contribution to European Impressionism. 1882/83 lived in Vienna; he then became disappointed with his lack of success and gave up painting for ten years, living as a landowner, and for a time as a parliamentary delegate. 1896 his contribution to plein-air painting was rediscovered and he was celebrated as a national hero; he began to paint again, mainly landscapes. Exhibited at the World Fair in Paris in 1900 and in St. Louis in 1904, 1905 Rector of the School of Art in Budapest. 1907 member of the committee of the new "Group of Hungarian Impressionists and Naturalists".

CATALOGUE: P.S.M. Budapest 1943 BIBLIOGRAPHY: Bernáth, M.: P.S.M. Budapest 1981.- Kampis, A.: P.S.M. Budapest 1975.- Kontha, S.: Páal Mészöly, Szinyei. Budapest 1975.- Pataky, D.: P.S.M. Budapest 1963.-Szinyei Merse, A.: Bildgattungen und Themen im Jugendwerk von P.S.M. In: "Acta Historiae Artium" 27 (1981), No. 3-4, pp. 287-361.- Végvári, L.: P.S.M. Budapest 1986 ILLUSTRATIONS: 500 A Field of Poppies, 1902 520 The Balloon, 1878

- 520 The Balloon, 1878 523 Luncheon on the Grass
- (The Picnic), 1873
- 523 A Field of Poppies, 1896

TANGUY Julien-François 1825 Plédran – 1894 Paris

Known as "Père Tanguy". At first a plasterer, then a butcher. **1870** moved to Paris, where he initially sold paint

and then worked from 1870 as an art dealer. Took his paints to the painters, including Monet, Renoir and Pissarro, visiting them in the open-air and advising them as they painted. Anarchist and Communarde. Condemned and deported to Brest. 1873 returned to Paris and opened a shop in the Rue Clauzel, where he also exhibited. Took pictures from the Impressionist artists in exchange for supplies of paints and canvas. Particularly supported Cézanne; exhibited the less accesible work of young Post-Impressionists. 1886 became friends with van Gogh, who painted his portrait (p. 293). His shop became a meeting place for young artists, who could exchange ideas with older colleagues: Cézanne, Gauguin, Pissarro, Guillaumin, van Gogh, Seurat. He died of cancer. To raise money for his widow, the remaining paintings and other presents given him by the artists were auctioned at the Hôtel Drouot in 1894, although with only moderate results.

TARBELL Edmund Charles 1862 West Groton (MA) – 1938 New Castle

1877-1879 trained as a graphic artist with Forbes Lithographic Co. 1879 studied at the Boston Museum School under Otto Grundmann. Became friends with Hale; admired Fortuny. In the 1880s he travelled extensively in Europe, including Germany and Italy; stayed for a long period in Venice. 1884/85 studied at the Académie Julian in Paris. 1886 exhibited at the Salon. 1886 joined the Society of American Artists. 1888 returned to America. 1889-1912 professor at the school of the Museum of Fine Arts in Boston. 1891 first one-man show at the St. Botolph Club in Boston. 1893 exhibited at the World Fair in Chicago. 1897 member of "The Ten American Painters". 1900 a big success at the World Fair in Paris. 1906 member of the National Academy. 1918-1926 Director of the Corcoran School of Art in Washington. BIBLIOGRAPHY: Olney, S.F. (ed.): Two American Impressionists: Frank W. Benson and E.C.T. University Art Galleries, University of New Hampshire, Durham (NH) 1979 (EC) .- Pierce, P.J.: E.C.T. and The Boston School of Painting 1889-1980. Hingham (MA) 1980.- Price, L. and F. Coburn (eds):

Frank W. Benson, E.C. T. Museum of Fine Arts, Boston 1938 (EC) ILLUSTRATION:

616 Three Sisters – A Study in June Sunlight, 1890

THORE Théophile 1824 La Flèche – 1869 Paris

Known as Wilhelm Bürger. French art critic and art historian. With views based on Romanticism, and as an admirer of Delacroix, he believed in a strong social role for art. **1848** active participant in the revolution; until **1860** in exile in Germany and Holland, writing under the pseudonym of Wilhelm Bürger. Placed the Dutch painters of the 17th century higher than Raphael and the Classicists; a proponent of the realism of the Barbizon school, of Courbet and of the young Renoir.

TILLOT Charles Victor 1825 Rouen – 1895 Rouen

1839 studied at the Ecole des Beaux-Arts in Paris. 1846 exhibited for the first time at the Salon. From 1851 also an art critic. 1860 bought a house in Barbizon; studied with Millet and Th. Rousseau. Friendship with Degas and the Rouart brothers; collected Japanese prints. 1876-1886 exhibited at all the Impressionist exhibitions except the 1st and 7th, mainly landscapes and sea scenes in the style of the Barbizon school. 1895 retrospective at the Durand-Ruel gallery. ILLUSTRATION:

264 Still Life with Flowers

TISSOT James 1836 Nantes – 1902 Château-de-Buillon (Doubs)

1857 studied at the Ecole des Beaux-Arts in Paris; made friends with Degas, Whistler, and the writer Daudet. 1858 visited the history painter Leys in Antwerp. 1859 exhibited for the first time at the Salon some Late Romantic-style history pictures. 1862 influenced by Japanese prints. Tour of Italy. 1863 went for a time to London, where he exhibited from 1864 at the Royal Academy. Influenced by Manet, he began to use Impressionist techniques of colour and composition. A great success with his anecdotal and detailed pictures; also influenced by the Japanese style. 1871 service in the National Guard and participation in the Commune; emigrated to England. Refused to take part in Impressionist exhibitions. 1875 travelled with Manet to Venice. 1882 returned to Paris. 1883 successful exhibition, which included arts and crafts. 1883-1885 a series of 15 pictures of typical Parisian women. 1886 began to paint biblical themes. 1886/87 and 1889 travelled in Palestine. 1889 received a gold medal at the World Fair in Paris. BIBLIOGRAPHY: J.T. Etchings, Drypoints and Mezzotints. Bury Street Gallery, London 1981 (EC) .- J.T. Biblical Paintings. The Jewish Museum, New York 1982 (EC) .- Matyjyszkiewicz, K. (ed.): J.T. London 1984 (EC) .- Wentworth, M .: J.T. Oxford 1984.- Wood, C.: T. London 1988 ILLUSTRATIONS:

- 241 Berthe, 1883
- 241 The Newspaper, 1883
- 251 The Painters and their Wives, c. 1885

TOOROP Jan Theodorus 1858 Porworedjo (Java) – 1928 The Hague

Son of a Dutch official stationed on Java and the painter Charley Toorop. 1871 first lessons in drawing at The Hague. 1876-1878 studied at the technical college in Delft, 1878-1880 at the Academy in Amsterdam with A. Allébé, and 1880-1882 at the Academy in Brussels. Influenced by Courbet and Ensor. 1884 met Whistler and Matthijs Maris in London and joined the Belgian group of artists, Les Vingt; exhibited there regularly. 1885 stay in Paris; impressed by Seurat, he began to paint in the Pointillist manner. 1886 moved to The Hague. From 1891 active for the "Kunstkring" at The Hague. 1892 organised the first large van Gogh exhibition in Holland. In the 1890s he mainly painted in a Symbolist style. The most important exponent of Dutch Luminism, a technique that uses the juxtaposition of wide daubs of paint to give the effect of a mosaic. 1911 president of the "Moderne Kunstkring". Converted to Catholicism in 1905, after which he painted religious and mythical pictures. WRITINGS, DOCUMENTS: Janssen, M.:

Herinnerungen aan J.T. Amsterdam 1933

BIBLIOGRAPHY: Hefting, V: J.T. Een kennismaking. Amsterdam 1989.– Hefting, V. (ed.): J.T. 1858-1928. Haags Gemeentemuseum 1989. The Hague 1989 (EC).– Janssen, M.: J.T. Amsterdam 1915.– J.T. 1858-1928. Impressionniste, Symboliste, Pointilliste. Institut Néerlandais. Paris 1977 (EC).– J.T. 1858-1928. Haags Gemeentemuseum. The Hague 1989 (EC).– J.T.T. De jaren 1885 tot 1919. Rijksmuseum Kröller-Müller. Otterlo 1978 (EC).– Siebelhoff, R.: The Early Development of J.T., 1879-1892. Doctoral thesis, Toronto 1973 ILLUSTRATIONS:

414 Shell Gathering on the Beach, 1891

- 414 The Dunes and Sea at Zoutlande, 1907
- 415 Three Women with Flowers, c. 1885/86

TOULOUSE-LAUTREC Henri de 1864 Albi – 1901 Castle Malromé (Gironde)

Born at Albi into an old southern French aristocratic family; already physically weak, he broke both his legs in 1878 and 1879, after which he was crippled and remained a dwarf; already active artistically. 1882-1886 studied with F. Cormon, at whose studio he met Bernard and van Gogh; painted realistic pictures of social criticism in bright Impressionist colours, and began to frequent the bars and dance halls of Montmartre and to exhibit pictures there. All his life he spent every summer by the sea. 1886 temporary liaison with the model Suzanne Valadon; first publication of his drawings in journals. 1887 contributed pictures to an exhibition at Toulouse. 1888 exhibited for the first time with Les Vingt in Brussels. Theo van Gogh from the Galerie Goupil bought a picture. 1889 exhibited for the first time at the Salon des Indépendants. Became a regular at the "Moulin Rouge". 1890 with Signac in Brussels for an exhibition of Les Vingt and then in Spain. 1891 exhibited with Impressionists and Symbolists at the art dealer's Le Barc de Boutteville; began to paint a new style of poster for bars, cabarets and publishing houses with a stylised, flat treatment of forms. 1892 visited Brussels and London. 1893 first large exhibition at the Galerie Goupil; also other exhibitions. Began to live for a time in a brothel in order to paint and draw. 1894-1897 travelled in France, Belgium, Holland, Spain, London, Lisbon. Exhibited at the Salon of the "Libre Esthétique" in Brussels, mixed with the circle of artists around the Nabis and the journal "La Revue Blanche"; became increasingly alcoholic. 1899 after collapsing he was taken to the the mental hospital at Neuilly, despite the protests of friends; continued to paint and to drink. 1901 became partly paralysed; died at his mother's castle.

WRITINGS, DOCUMENTS: Rodat, C. de: T.-L.; Album de famille. Fribourg 1985.- Schimmel, H.D. (ed.): The Letters of H. de T.-L. Oxford 1991 CATALOGUES: Adhémar, J.: T.-L. Lithographies. Paris 1965.- Adriani, G.: T.-L. Das graphische Werk. Cologne 1976 .- Adriani, G.: T.-L. The Complete Graphic Works. London 1988.-Dortu, M.-G.: T.-L. et son œuvre. 6 vols. Paris 1971 .- Sugana, G.M. and G. Caproni: The Complete Paintings of T.-L. New York 1973, Harmondsworth 1987.- Wittrock, W.: T.-L. The Complete Prints. 2 vols. London 1985

BIBLIOGRAPHY: Adriani, G.: T.-L., Gemälde und Bildstudien. Cologne 1986.- Barbier, L. (ed.): T.-L. Album de jeunesse. Berne 1985.- Bouret, J .: T.-L. London 1964.- Castleman, R. and W. Wittrock (eds): H. de T.-L. Bilder der Belle Epoque. Munich 1985 (EC) .- Castleman, R. and W. Wittrock (Ed.): H. de T.-L. Images of the 1890s. The Museum of Modern Art. New York 1985 (EC) .- Cooper, D.: H. de T.-L. New York 1966 .-Denvir, B.: T.-L. London 1991.-Dortu, G. and P. Huisman: L. par L. Lausanne 1964 .- Jourdain, F. and J. Adhémar: T.-L. Paris 1952 .- Jovant, M.: T.-L. 2 vols. Paris 1926-27 .- Keller, H.: H. de T.-L. Cologne 1968 .-Lassaigne, J.: T.-L. Paris 1939 .- Le Targat, F.: T.-L. Paris 1988 .- Natanson, Th.: Un Henri de Toulouse-Lautrec. Geneva 1951.- Perruchot, H .: La vie de T.-L. Paris 1958 .- Roger-Marx, C.: T.-L. Paris 1957 .- Thompson, R. et al. (eds): T.-L. Havward Gallery, London 1991; Grand Palais, Paris 1992 (EC) ILLUSTRATIONS:

- ILLUSTRATIONS:
- 227 Young Routy, c. 1882
- 243 The Laundress, 1884-1886278 Portrait of Vincent van Gogh, 1887
- 324 La Goulue Entering the Moulin Rouge, 1892
- 325 A Dance at the Moulin Rouge, 1889/90
- 327 Jane Avril at the Jardin de Paris, 1893
- 327 Aristide Bruant at his Cabaret, 1892
- 344 Women in a Brothel, c. 1893/94 345 The Sofa, 1895

TROUVILLE

Town on the coast of Normandy; beside Deauville, one of the most popular resorts with the French aristocracy and rich bourgeoisie. Meeting place for writers and artists (Courbet, Jongkind, Manet, Monet etc.). The beach and the sea became favourite motifs.

TRÜBNER Wilhelm 1851 Heidelberg - 1917 Karlsruhe 1867/68 studied with K.F. Schick at the Academy of Arts in Karlsruhe and from 1868 with A. v. Wagner at the Academy in Munich. Became acquainted with the work of the French Impressionists at the large international exhibition at the Glaspalast. 1869 became a private pupil of Hans Canon for a short time in Stuttgart. 1870 returned to Munich and studied with Wilhelm von Diez at the Academy in Munich. 1871 met Leibl, who advised him to leave the Academy; he joined the circle of Realist painters in Munich. 1872/73 travelled with Carl Schuch in Italy. 1873 went to Brussels and then to the Chiemsee; from 1890 frequently spent the summer months there, 1875-1884 lived in Munich and painted in 1876 with Schuch in Weßling and Bernried. Travelled to Paris in 1879 and to London in 1884. In the 1890s the dark tones of his palette were replaced by the brighter colours of a more Impressionist-orientated style. 1894 member of the Munich Secession. 1896 became a teacher at the Städelsches Kunstinstitut in Frankfurt. 1903-1907 professor at the Academy in Karlsruhe. WRITINGS, DOCUMENTS: Trübner, W.: Personalien und Prinzipien. Berlin

1918 CATALOGUE: Rohrandt, K.: W.T. Kritischer und beschreibender Katalog sämtlicher Gemälde, Zeichnungen und Druckgraphik, Biographie und Studien zum Werk. Vol. 1. Doctoral thesis, Kiel 1974

BIBLIOGRAPHY: Beringer, J.A.: W.T. Stuttgart and Berlin 1917. – Geissler, J.: Die Kunstheorien von Adolf Hildebrand, W.T. and Max Liebermann. Doctoral thesis, Berlin 1963. – T. Gemälde und Zeichnungen. Berlin 1962 (EC). – T. in Heidelberg. Heidelberger Kunstverein 1967 (EC). – W.T. Gedächtnisausstellung. Kurpfälzisches Museum. Heidelberg 1951 (EC) ILLUSTRATIONS:

- 449 The Pub on the Fraueninsel, 1891
- 461 Neuburg Gates, Heidelberg, 1913

TSCHUDI Hugo von

1851 Jakobsdorf (Austria) – 1911 Cannstadt

Swiss art historian. After graduation in law and a period of travel he be-

came an assistant at the Museum of Art and Industry in Vienna and in 1884 assistant at the museums in Berlin. 1894 professor. 1896-1907 Director of the National Gallery. 1896 with Liebermann in Paris, exhibited at Durand-Ruel's. Arranged significant donations of Impressionist pictures to the national Gallery, but this caused a difference of opinion with Kaiser Wilhelm II and he was forced to resign. 1909-1911 Director of the Pinakothek in Munich.

TURNER Joseph Mallard William 1775 London – 1851 London

1789 studied at the Royal Academy. 1790 exhibited there for the first time. 1792 study tours through Wales, England, Scotland. Painted landscapes and sea scenes, at first in watercolour; influenced by painters of the 17th and 18th centuries; later did works based on events from world history in imaginatively idyllic landscapes. 1802 made a study of Old Masters in the Louvre. 1804 first private exhibition at his own gallery. 1807 painted views of the Thames from his own boat; became professor of perspective at the Academy. 1817 second tour of the continent; many others followed. Despite his Romantic preference for literary, idealist subject matter, he influenced the Impressionists in his sensitive use of colour tone and mood, his "informal" painting style and his special feel for the optical effects of modern reality.

CATALOGUE: Butlin, M. and E. Joll: The Paintings of J.M.W.T. 2 vols. London 1984.– Wilton, A.: T. in his time. London 1987

BIBLIOGRAPHY: Chumbley, A. and I. Warrell (eds.): T. and the Human Figure: Studies of Contemporary Life. Tate Gallery, London 1989 (EC) .-Gage, J .: J.M.W.T. A Wonderful Range of Mind. New Haven (CT) and London 1991 .- Herrmann, L .: T. Paintings, Watercolours, Prints and Drawings. Oxford 1986 .- Powell, C .: Turner in the South: Rome, Naples, Florence. London 1987 .- Reynolds, G.: T. London 1969, 1986.- Shanes, E.: T.'s Human Landscape. London 1985 .- Upstone, R. (ed.): T., The Second Decade: Watercolours and Drawings from the Turner Bequest, 1800-1810. Tate Gallery, London 1989 (EC) ILLUSTRATIONS:

20 Cathedral Church, Lincoln, 1795

- 21 Yacht Approaching the Coast, c. 1838-1840
- 21 Rain, Steam and Speed The Great Western Railway, 1844

619 Horseshoe Falls, Niagara, c. 1894

624 The White Bridge, c. 1900

TWACHTMAN John Henry 1853 Cincinnati – 1902 Gloucester (MA)

1871-1875 studied at the Micken School of Design in Cincinnati and at Frank Duveneck's studio. 1875-1877 continued his studies in Munich with Ludwig von Löfftz. Influenced by Leibl. 1877 travelled with Duveneck and William Merrit Chase to Venice. 1878 returned to America and exhibited at the Society of American Artists; 1879 became a member there. Painted in various coastal towns of America, in New York and Cincinnati. 1880 travelled to Florence, where he gave courses at the Duveneck School. 1881 honeymoon in England, Belgium and Germany; painted with Weir in Holland; met Anton Mauve, who strongly influenced his Impressionist style. 1883-1885 lived in Paris and studied at the Académie Julian. 1885 moved to Connecticut near Weir. 1886 rented Holly House Farm in Cos Cob, which became a meeting place of American Impressionists. Preferred to paint snow landscapes and tried to capture their atmosphere. 1893 exhibited with Weir and Monet in New York but without much success. 1897 cofounder of The Ten American Painters. 1901 large one-man show at the Art Institute in Chicago. 1901/02 taught at summer courses in Gloucester, Massachusetts.

BIBLIOGRAPHY: Boyle, R.J.: J.T. New York 1979 .- Boyle, R.J. and M.W. Baskett, (eds): A Retrospective Exhibition: J.H.T. Cincinnati Art Museum, Cincinnati 1966 (EC) .- Chotner, D. et al. (eds): J.T.: Connecticut Landscapes. National Gallery of Art, Washington 1989 (EC) .- Clark, E.C.: J.H.T. New York 1924 (private printing) .- Hale, J.D.: The Life and Creative Development of J.H.T. 2 vols. Doctoral thesis, Ohio State University. Columbus 1957.- J.T. Connecticut Landscapes. National Gallery of Art, Washington 1989 (EC) .- Tucker, A.: J.H.T. New York 1931.- Wickenden, R.J.: The Art and Etchings of J.H.T. New York 1921 ILLUSTRATIONS:

613 Winter Harmony, c. 1890-1900

UHDE Fritz von

1848 Wolkenburg - 1911 Munich First drawing lessons while still at school; encouraged by his parents, both amateur painters. 1866 studied for three months at the Academy of Arts in Dresden. 1867-1871 military career; painted battle scenes - influenced by the war painter Ludwig Albrecht Schuster. 1876 went to Vienna, where he met Makart and was influenced by his dark, emotional style. 1879 visited Paris; pupil of M. Munkácsy. 1880 settled in Munich; became friends with Liebermann, through whose influence he discovered plein-air painting. 1882 travelled in Holland. His frequent religious themes are done in a realistic medium and reveal the influence of light-filled plein-air painting. 1892 cofounder of the Munich Secession; 1899 elected to their committee. 1907 successful showing of his pictures at the winter exhibition of the Secession.

BIBLIOGRAPHY: Brand, B.: E.v.U. Das religiöse Werk zwischen künstlerischer Intention und Öffentlichkeit. Doctoral thesis, Mainz 1983.– Keyssner, G.: U. Stuttgart and Berlin 1922.– Ostini, F. v.: F.v.U. Bielefeld and Leipzig 1902.– Rosenberger, H.: U. Stuttgart and Berlin 1908 ILLUSTRATIONS:

- 436 Fisher Children in Zandvoort, 1882
- 437 Two Daughters in the Garden, 1892
- 437 Big Sister, 1885
- 438 Walking to Bethlehem, c. 1890
- 439 Bavarian Drummers, 1883
- 460 In the Garden (The Artist's
- Daughters), 1906

UNION ARTISTIQUE (L')

Society for the encouragement of the arts founded in 1860 by various historians, writers, painters (including Degas and Lepic), composers and influential people. It organised literary talks, art exhibitions and concerts. Few of the Impressionists showed work at the exhibitions, which were dominated by the fashionable artists of the time such as Bastien-Lepage, Duran, Sargent, Blanche etc.

VALADON Suzanne 1867 Bourg de Bessines (near Limoges) - 1938 Paris Real name: Marie Clémentine Valadon. Illegitimate child; had a neglected childhood in Montmartre. At age eighteen she herself had an illegitimate child; her son Maurice Valadon later became the artist Utrillo. Earned a living as a model; became the model and lover of Puvis de Chavannes and Renoir. Began to do her own painting; encouraged and instructed by the artists there (Toulouse-Lautrec, Degas and Renoir). Her favourite themes included drawings of female nudes and portraits, decorative still lifes, interiors and landscapes. CATALOGUE: Petrides, P.: L'œuvre com-

plet de S.V. Paris 1971

VALERY Paul 1871 Sète – 1945 Paris

Prose writer and poet. Friends with Rouart's sons; joined the circles around Degas and Morisot. **1889** began to study law at the University of Montpellier. **1894** moved to Paris and worked from **1895** as an editor at the Ministry of War. **1900** married Nini Gobillard, one of Morisot's nieces. **1900-1922** active as a private secretary. **1925** elected to the Académie Francaise.

VAN GOGH \rightarrow Gogh

VELDE Henry van de 1863 Antwerp – 1957 Zurich 1880-1884 studied at the Academy of Arts in Antwerp and 1884/85 with Bastien-Lepage and Carolus-Duran in Paris. Influenced by J.-F. Millet and Manet. Member of "L'Art Indépendant", a Belgian group of painters akin to the Barbizon school. 1888 influenced by Seurat's painting "A Sunday Afternoon at the Ile de la Grande Jatte" (pp. 260/261), he followed van Rysselberghe's advice and turned to Pointillism. Member of Les Vingt. 1894 discovered the writings of William Morris and developed the decorative, linear Art Nouveau style for which he is famous. From 1895 active as an architect. 1898 founded the "workshops for applied art" at Ixelles in Brussels, which concentrated on utilitarian art. 1902 moved to Weimar; Director of the School of Arts and Crafts until 1915 and 1926-1935 Director of the "Institut supérieur des Arts décoratifs" in Brussels. 1925-1936 professor of architecture at Ghent. From 1947 lived in Switzerland.

WRITINGS, DOCUMENTS: Velde, H. v. d.: Zum neuen Stil. Munich 1955.-Velde, H. v. d.: Geschichte meines Lebens. Munich 1962 BIBLIOGRAPHY: Curjel, H. (ed.): H.v.d.V. Kunsthaus Zürich, Zurich 1958 (EC) .- Hammacher, A.M.: Die Welt H.v.d.V.s Cologne 1967 .- Hammacher, A.M.: Le monde de H.v.d.V. Antwerp 1967.- H.v.d.V. 1863-1957. Palais des Beaux-Arts, Brussels; Rijksmuseum Kröller-Müller, Otterlo 1963.- H.v.d.V. (1863-1957): Schilderijen en tekeningen. Koninklijk Museum voor Schone Kunsten, Antwerp; Rijksmuseum Kröller-Müller, Otterlo; Otterlo 1988 (EC). -Hüter, K.-H.: H.v.d.V. Berlin 1967 .- Sembach, K .-J.: H.v.d.V. New York 1989 .- Sembach, K.-J. (ed.): H.v.d.V. Ein europäischer Künstler in seiner Zeit. Cologne 1992 (EC) .- Teirlinck: H.v.d.V. Brussels 1959 .- Voort, J. v.: Gedenkboek H.v.d.V. Ghent 1933 ILLUSTRATIONS:

422 Bathing Huts at Blankenberge, 1888

422 Woman at the Window, 1889

VIDAL Eugène

1847 Paris – 1907 Cagnes Studied with Gérôme in Paris, but linked with the Impressionists. 1873 exhibited for the first time at the Salon. Travelled in Algeria. 1880 exhibited at the 5th and in 1881 at the 6th Impressionist exhibitions. 1900 a big success at the World Fair in Paris. ILLUSTRATION:

133 Girl Resting on her Arms

VIE MODERNE, La

Illustrated weekly with large arts section, founded in 1879 by Georges Charpentier, the editor, and Emile Bergerat, the director. Silvestre and Edmond Renoir were in charge of the arts column. Exhibitions of works by the Impressionists were held in the editorial offices, while the magazine contained in-depth discussions of contemporary art, together with the latest graphics.

VIGNON Paul-Victor

1847 Villers-Cotterêts – 1909 Meulan Pupil of Corot, who heavily influenced his style of painting. Further guidance and advice from Cals. Painted in Pontoise, Auvers-sur-Oise and many other locations alongside Pissarro - with whom he was on friendly terms - Guillaumin and Cézanne. 1880 participation in the 5th and 1881 in the 6th Impressionist exhibitions. Despite Monet's opposition, he also exhibited 1882 in the 7th and 1886 in the 8th Impressionist exhibitions. Friends with Gachet, Murer and van Gogh's brothers. 1894 large one-man exhibition at Bernheim-Jeune's. ILLUSTRATIONS:

202 The Crossroads 203 The Hills at Triel, c. 1881

VILLE D'AVRAY

Village near Saint-Cloud. Corot frequently stayed there; Courbet painted in the woods nearby. Monet lived there in 1860, while Renoir spent the summer of 1868 in the village.

VOLLARD Ambroise 1867 Saint Denis (Réunion) - 1939 Paris

Son of a notary. One of the most important art dealers to succeed Theo van Gogh. Initially completing legal studies in Montpellier and receiving his doctorate in Paris, he then devoted himself to his hobby, art, first of all purchasing art prints from the Bouquinistes on the banks of the Seine. Thereafter, studies in the gallery of the Union Artistique, Opened his first gallery in 1893 at 41 Rue Laffitte, with an exhibition of sketches by Manet. Through Denis and Bernard, he came to know and appreciate Cézanne, organizing in 1895 the first Cézanne exhibition. Also sold pictures by Renoir, Degas and Pissarro. Moved with his gallery in 1899 to 6 Rue Laffitte. As the most important art dealer for the avant-garde, he organized the first exhibitions of works by van Gogh, Picasso (1901) and Matisse (1904). In addition, he represented unknown artists. In his role as publisher, he printed lithographs and books illustrated by artists. Published monographs on Cézanne, Degas and Renoir and, in 1937, his "Memoirs of an Art Dealer".

VONNOH Robert William 1858 Hartford (CT) - 1933 Nice Initial artistic studies at the Massachusetts Normal Art School. 1881-1883

studies at the Académie Julian, Paris, under Boulanger and Lefèbvre. Influenced by Bastien-Lepage. 1883-1887 studies continued at the Boston Museum School and the Cowles Art School under L.C. Perry. 1887-1891 second period of residence in France. Journey to Grèz-sur-Loing; interested in Impressionism, above all in the works of Sisley and Monet. Participation in the Paris World Fair. 1891 return to America. 1891-1896 and 1918-1920 professor at the Pennsylvania Academy of the Fine Arts. 1990 member of the National Academy.

Typical representative of American Impressionism, revealing a fresh quality if with less atmosphere. His second wife, Bessie Potter Vonnoh, was also a successful painter. WRITINGS, DOCUMENTS: Vonnoh, R.: Increasing Values in American Paintings. In: "Arts and Decoration" 2 (May 1912), pp. 254-256 .- Vonnoh, R.: The Relation of Art to Existence. In: "Arts and Decoration" 17 (September 1922), p. 328f. BIBLIOGRAPHY: Clark, E .: The Art of R.V. In: "Art in America" 16 (August 1928), pp. 223-232 ILLUSTRATION:

606 Poppies, 1888

VUILLARD Edouard

1868 Cuiseaux - 1940 La Baule 1886-1889 studies at the Paris Art High School, under Gérôme among others. Attended the free Académie Julian in 1888; friendship with Bonnard, Denis, Sérusier. 1889 one-off participation in the Salon. 1890 cofounder of the "Nabis", the Symbolist group of artists; sharing a studio

with Bonnard and Denis, 1891 oneman show at the magazine "La Revue Blanche"; long-term friendship with its editor, T. Natanson, and the latter's wife, Misia. Contact with Toulouse-Lautrec and Mallarmé, among others. Exhibition by the "Nabis" in Le Barc de Boutteville's gallery. Impressed by Japanese colour woodcuts, he began his impressive, extensively decorative, "intimate" interior scenes. 1892 first of numerous wall creations depicting decorative scenes. Contact with J. Hessel, the art dealer, the two frequently holidaying together thereafter. 1893 stage sets for the "Théâtre de l'Œuvre" of his schoolfriend Lugné-Poe. 1900 Swiss journey with F. Vallotton. Works exhibited at the Berlin Secession for the first time. 1901 exhibited with the "Indépendants". 1902 journey to Holland. 1903 co-founder of the Autumn Salon; regularly exhibiting at Bernheim-Jeune's. 1909 teaching for a time at the Académie Ranson, 1913 with Bonnard in Hamburg. 1914-1916 active military service and army painter. Later, numerous traditional portraits, interiors and urban landscapes. Died while fleeing from German troops.

CATALOGUES: Roger-Marx, C.: E.V. L'œuvre gravé. Paris 1948 (Reprint: San Francisco 1990) BIBLIOGRAPHY: Preston, S.: V. New York 1985 .- Roger-Marx, C.: V. Paris 1945.- Salomon, J.: Auprès de V. Paris 1945.- Salomon, J.: V. Paris 1968.- Thomson, B.: V. Oxford 1988 ILLUSTRATION:

340 After the Meal, c. 1890-1898

WEIR Julian Alden

1852 West Point - 1919 New York Son of a history painter and drawing teacher at the U.S. Military Academy, West Point. Initial training from his father; later, in the 1860s, in the New York studio of his brother, John Ferguson. 1870-1872 studies at the National Academy of Design under L. Wilmarth. 1873 studies continued in Paris under Gérôme. Practising openair painting in summer in Pont-Aven (Brittany) and Cernay-la-Ville, southwest of Paris. 1874/75 journeys to England, Spain and Holland. Friendly with Bastien-Lepage and Sargent. 1875 first work exhibited in the Paris Salon and the New York National Academy of Design. Regular partici-

pation in the Salons of the following years. 1877 return to New York; member of the Society of American Artists, engaged in the organization of exhibitions and exhibiting there himself. 1882 president of the Society. Renewed travel in Europe in the 1870s and 1880s. Close friendship with Twachtman. From 1878 teaching at the Cooper Institute. From 1885 to 1889, he took over the portrait class at the Art Students League, and conducted summer courses in Branchville in 1897-1901. 1886 member of the National Academy. Founding his career as an artist primarily on portraits and still lifes, he also painted successful history works and family scenes.

WRITINGS, DOCUMENTS: Weir, J.A.: Jules Bastien-Lepage. In: "Studio" 13 (January 1885), pp. 145-151 .- Young, D.W. (ed.): The Life and Letters of J.A.W. New Haven (CT) 1960 BIBLIOGRAPHY: Blashfield, E.H.: A Commemorative Tribute to J.A.W. New York 1922 .- Burke, D.B .: J.A.W. An American Impressionist. Newark (DE) 1983 .- Coffin, W.A. (ed.): A Memorial Exhibition of the Works of J.A.W. Metropolitan Museum of Art, New York 1924 (EC) .-Flint, J.A. (ed.): J.A.W.: American Impressionist 1852-1919. National Collection of Fine Arts, Washington 1972 (EC) .- Phillips, D. et al .: J.A.W .: An Appreciation of his Life and Works. New York 1922 .- Young, M.S. (ed.): J.A.W., 1852-1919: Centennial Exhibition. American Academy of Arts and Letters. New York 1952 (EC) .- Young, M.S. (ed.): Paintings by J.A.W. Phillips Collection, Washington 1972 (EC) ILLUSTRATIONS:

623 Midday Rest in New England, 1897

623 The Red Bridge, c. 1895

WEISGERBER Albert 1878 St. Ingbert - 1915 Fromelles (Belgium)

Attended the arts-and-crafts school in Munich. 1897-1901 studies at the Munich Academy under Franz von Stuck. 1905-1907 residing in Paris; impressed by Cézanne. From 1897 working as an illustrator for the Munich magazine "Jugend". Contact with the Matisse circle around Hans Purrmann. Experimenting with Fauvism, which replaces the pastose darkcoloured application of paint with bright colours and a harmonious manner of painting; a preference for religious subjects. 1909 member of the Munich Artists' Association. 1913 president of the New Secession. CATALOGUE: Ishikawa-Franke, S .: A.W. Leben und Werk. Saarbrücken 1978

BIBLIOGRAPHY: Christoffel, U.: A.W. St. Ingbert 1950 .- Heuss, T.: Erinnerungen an A.W. Heidelberg 1962 .-Weber, W .: Zum Werk A.W.s und Œuvreverzeichnis der Gemälde. Heidelberg 1962 ILLUSTRATION:

457 Riding in the English Gardens, in Munich, 1910

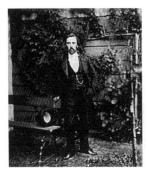

WEISSENBRUCH Johannes Hendrik 1824 The Hague - 1903 The Hague 1830-1846 drawing studies under J.J. Löw and evening classes at the Academy in The Hague under B.J. van Hove, the interior decorator. Copied the works of the 17th-century Flemish artists. Painting in the area surrounding The Hague, Haarlem and Arnheim. Significant open-air and watercolour painter of the "Hague School". 1866 member of the "Société Belge des Aquarellistes". Acquaintance with Roelofs. Sole journey abroad undertaken. 1900 move to Barbizon. 1901 large one-man exhibition, organized by the members of the "Pulchri Studio" and Buffa, the Amsterdam art dealer's. BIBLIOGRAPHY: Gelder, H.E. van: J.H.W. Amsterdam 1940.- J.H.W. Schilderijen, aquarellen, grafiek. Singer Museum, Laren 1960 (EC) .-Laanstra, W .: J.W., schildergraficus, 1822-1880. Amsterdam 1986 ILLUSTRATION: 408 View of Haarlem

WERENSKIOLD Frik

1855 Eidskog - 1938 Oslo 1872-1876 pupil of J. Middelthun, the sculptor, and A. Ender at the Kristiania drawing school in Oslo. 1876-1880 studies at the Munich Art Academy under Löfftz and Lindenschmit. His style of painting was orientated towards the realist works of the circle around Leibl. Impressed by the exhibition of Realist works by French painters seen in Munich in 1879. Following his return to Norway, he joined Krohg, Munthe and Thaulow, travelling to Paris with his

Norwegian colleagues in 1881, 1883 and 1885. Worked during 1888/89 in Bonnat's studio. Admired Manet and van Gogh. Wrote a critique in 1889 of the Copenhagen exhibition of works by French Impressionists, in which he characterized Cézanne, Guillaumin and Manet as the true Impressionists.

BIBLIOGRAPHY: Norske malere. E.W. Kristiania 1913 .- Østby, L.: E.W. Tegninger og akvareller. Oslo 1977. Svedfelt, T.: E.W. konst. Stockholm 1947 ILLUSTRATIONS:

474 Shepherds on Tåtøy, 1883 486 Autumn, 1891

WESTERHOLM Victor 1860 Åbo - 1919 Åbo

1869 start of artistic training under R.W. Ekman. 1871 with T. Waenerberg. 1878-1886 studies at the Düsseldorf Academy under E. Dücker. Work exhibited at the 1882 Paris Salon. Occupied in the summer with open-air painting in Åland. 1886 foundation of a painters' colony in Önningeby, its programme devoted to open-air painting. 1887 abandonment of idealizing style of painting, beginning of Impressionist manner. From 1888 teacher in Åba. Influenced in the 1890s by Symbolism. ILLUSTRATION:

487 The Seine at Paris, 1888

WHISTLER James Abbott McNeill 1834 Lowell (MA) - 1903 London 1843 family emigrated to Russia. 1845 initial lessons in drawing at the St. Petersburg Academy. 1849 return to America following death of his father. 1851 entered West Point Military Academy. 1855 training as painter in Paris. 1856 studies in Glyre's studio. Of greater significance for his artistic development were his encounters with Fantin-Latour, Courbet and Legros. 1858 journey to Luxembourg, northern France and the Rhine; series of 13 etchings, the "French Series". 1859 move to London following rejection by the Salon. 1864 exhibited the critically acclaimed picture "The Little White Girl: Symphony in White No.2" (p. 573) in the Salon des Refusés. Influenced in the 1860s by Japanism. 1866 journey to Chile. Around 1870 first "Nocturnes" with the Thames landscape as subject; these works served to clearly reveal the reproduction of a poetic mood and the correspondence of pictorial and musical harmony. The subject was to occupy him all through the following decade. From the 1870s on, an increase in portraiture, which would represent his principal source of income until into the 1890s. 1874 decoration of the Peacock Room (now in the Freer Gallery of Art, Washington) for his patron, F.R. Leyland. 1878 libel action against Ruskin, which bankrupted him despite his moral victory. 1892 successful one-man exhibition in the Goupil Gallery, London. Whistler's style of painting should be compared not so much with the analytical technique of Impressionism as rather with colour impressionism, something already developed in the 17th century, the effect of which is based upon aesthetic quality. President of the Society of British Artists and the International Society of Sculptors, Painters and Gravers.

WRITINGS, DOCUMENTS: Menpes, M.: W. as I Knew Him. London 1904.-Pennell, E.R. (ed.): The W. Journal. Philadelphia 1921.- Whistler, J.A.M .: The Gentle Art of Making Enemies. New York 1953

CATALOGUES: Kennedy, E.G.: The Etched Work of W. San Francisco 1978 .- Levy, M. and A. Staley: W. Lithographs. A Catalogue Raisonné. London 1975.- Lochnan, K.A.: The Etchings of J.M.W. New Haven (CT) and London 1984 .- Young, A.M. et al.: The Paintings of J.M.W. 2 vols. New Haven (CT) and London 1980 BIBLIOGRAPHY: Cabanne, P.: W. Munich 1988 .- Curry, D.P.: J.M.W. at the Freer Gallery of Art. Washington, New York and London 1984. Fine, R.E. (ed.): J.M.W. A Reexamination. Washington 1987 .- Fleming, G.: The Young W., 1834-1866. London and Boston 1978.- Gregory, H.: The World of J.M.W. New York 1959 .-J.M.W. Nationalgalerie, Berlin 1969 (EC) .- Laver, J .: Paintings by J.M.W. London 1938 .- McMullen, R.: Victorian Outsider. A Biography of J.M.W. New York 1973 .- Pearson, H.: The Man W. London 1952, New York 1978.- Pennell, E.R. and J. Pennell: The Life of J.M.W. 2 vols. Philadelphia and London 1908 .- Prideaux, T.: The World of W. New York 1970.-Spalding, F.: W. Oxford 1979 .- Sutton, D.: Nocturne: The Art of J.M.W. London 1964.- Sutton, D.: J.M.W.:

Paintings, Etchings, Pastels and Watercolours. London 1966.- Sweet, F.A. (ed.): Sargent, W. and Mary Cassatt. The Art Institute of Chicago, Chicago 1954 (EC) .- Taylor, H .: J.M.W. New York 1978.- Walker, J.: J.M.W. New York 1987 .- Weintraub, S.: W. A Biography. New York 1974 ILLUSTRATIONS:

- 572 Nocturne in Blue and Gold: Old Battersea Bridge, c. 1872-1875
- 573 The Little White Girl: Symphony in White, No. 2, 1864
- 573 Rose and Silver: The Princess from the Land of Porcelain, 1864

WORLD FAIRS

These representative exhibitions, organized on a country basis and embracing the latest in science, technology and culture, were intended as a means of promoting exports. They were always linked to the interests of domestic and foreign policy, for example the 100th anniversary of the French Revolution. 1851 the first in London, in the technically innovative Crystal Palace. 1855 in Paris, art for the first time given its own section, later also to encompass national retrospectives. The most important "Expositions universelles" were those of 1862 (London), 1867 (Paris), 1873 (Vienna), 1876 (Philadelphia), 1878, 1889 and 1900 (Paris), 1893 (Chicago), and 1904 (Saint Louis), the years between seeing events of a more limited nature. The competition between the nations, the possibility of international comparisons in a compressed space, and a viewing public running into millions gave the World Fairs considerable significance for artistic development, and especially for Impressionism with its interest in "modern life". In addition to the official exhibitions, excluded artists organized private one-man or group shows (Courbet in 1855 and 1867, Manet in 1867, the Pont-Aven group in 1889, Impressionist pictures belonging to American private collections in 1893). Not until 1889 and especially - 1900 did France publicly acknowledge her Impressionists in a World Fair.

ZANDOMENEGHI Federico 1841 Venice - 1917 Paris

Scion of a well-known artistic family, his father and grandfather sculptors. 1856-1859 studies at the Venice Art Academy; training continued in Pavia. 1860-1862 participation in the national movement, following Garibaldi to Sicily. 1862-1866 residence in Florence; member of the circle around Macchiaioli. Friendly with

Martelli, visiting him in Castiglioncello. Living during 1866-1874 primarily in Venice, with visits to Rome and Florence; frequently earning his living through fashion drawings. 1874 move to Paris, where he encountered the French Impressionists. Acquaintance with Toulouse-Lautrec. Subject-matter comparable with Degas' café and street scenes, nudes and portraits. Exhibited in 1879-1881 and 1886 at the 4th, 5th, 6th and 8th Impressionism shows. Increased pastel paintings from the 1880s on. Went unacknowledged in Italy until long after his death. CATALOGUE: Piceni, E.: Z. L'uomo e l'opera. Milan 1979

BIBLIOGRAPHY: Cinotti, M.: Z. Busto Arsizio 1960.– Dini, F.: F.Z., la vita e le opere. Florence 1989.– Dini, F.Z.: Un veneziano a Parigi. Ca' Pesaro, Venice. Milan 1988 (EC).– Piceni, E.: Z. Milan 1932, 1952, 1967 ILLUSTRATIONS:

- 538 Fishing on the Seine, 1878
- 541 Le Moulin de la Galette, 1878
- 542 Place d'Anvers, Paris, 1880
- 543 Children's Games in the Park
- Monceau
- 548 Lady in a Meadow, 1893
- 549 Portait of a Girl, c. 1893-1895

ZOLA Emile

1840 Paris – 1902 Paris French writer and art critic; schoolfriend of Cézanne in Aix-en-Provence. Went in 1858 to Paris. 1862-1866 publicity manager for the Hachette publishing house; thereafter freelance author. 1866/67 critical defence of Manet's art. Began in 1870 to write his novel series – partly socially critical – about the Rougon-Macquart family, utilizing the naturalistic method of the "experimental novel"; it was published in the course of 1871-1903, including 1880 "Nana" (cf. Manet, p. 160) and 1886 "The Masterpiece", in part a critical characterization of Impressionism. From 1877 on, second residence in Médan. Wrote art critiques, his clients including a Russian newspaper in St. Petersburg. 1896 last Salon report in "Le Figaro". 1898 journalistic involvement against antisemitism and reaction (Dreyfus Affair).

ZORN Anders Leonard 1860 Utmeland – 1920 Mora

Already studying in 1875 at the Stockholm Academy. 1881 move to Paris; thereafter leading a restless, unsettled life, 1881/82 journey to Spain; 1884 in Spain again and also in Portugal. 1882-1885 living in London, working in England exclusively as a painter of watercolours. 1885/86 journeys to Hungary, Greece and Turkey, 1887 to Spain and Algeria. 1887/88 winter spent in the international painters' colony in St. Ives, Cornwall. Thereafter living until 1896 predominantly in Paris. Preoccupation with Nordic motifs, in his early work also with those of the Orient. 1896 settled down in Mora. Founded an open-air and local-history museum, in which he also exhibited his own works (since 1939, the public "Zornmuseet"). Well-known and successful everywhere on account of his nudes and portraits.

CATALOGUES: Asplund, K.: A.L.Z. The Engraved Work. A Descriptive Catalogue. 2 vols. San Francisco 1990.– Hjert, S. and B.: A.Z. A Complete Catalogue of the Engravings. Uppsala 1980

BIBLIOGRAPHY: Asplund, K.: A.Z. His Life and Work. London 1921.– Boëthius, G.: Z. Tecknaren, målaren, ersaren, skulptören. Stockholm 1949.– Boëthius, G.: A.Z. Stockholm 1954.– Engström, A.: Z. Stockholm 1928.– Forssmann, E.: Tecknaren A.Z. Stockholm 1959.– Forssmann, E.: Z. i Mora. Stockholm 1960.– Friedrich, P.: A.Z. Berlin 1924.– Hedberg, T.: A.Z. 2 vols. Stockholm 1923/24.– Jensen, J.C. (ed.): A.Z. Gemälde, Aquarelle, Zeichnungen. Kunsthalle der Hypo-Kulturstiftung et al. Munich 1990 (EC) ILLUSTRATION: 488 In a Brewery, 1890

ZULOAGA Y ZABALETA Ignacio 1870 Eibar – 1945 Madrid

Son of a metal engraver, receiving his artistic training from his father. Copied works by Velázquez, Goya and El Greco in the Prado, Madrid. Exhibited at the 1887 national art exhibition for painting. 1888 residence in Rome. 1889 studies in the Paris studio of Gervex. Temporary abandonment of his austere Spanish style, painting in the manner of Monet, but also that of Renoir, Pissarro and Sisley. Friendly with Rusiñol. Exhibited in 1894 at Le Barc de Boutteville's. Regular participation in the Salon of the "Société Nationale des Beaux-Arts". Occasional residence in Bilbao, Seville and Granada. Journeys through Italy, Belgium and many European cities, where he participated in exhibitions. 1916 and 1925 journeys in the USA.

BIBLIOGRAPHY: Alonso, M.D.: Z. Madrid 1979.- Arozamena, J.M. de: I.Z. El pintor, el hombre. San Sebastián 1970.- I.Z. in America, 1909-1925. Spanish Institute, New York 1989 (ÊC) .- Lafuente Ferrari, E .: Los retratos de Z. Pamplona 1950.- Lafuente Ferrari, E.: La vida y el arte de I.Z. Madrid 1950.- Lafuente Ferrari, E.: I.Z. y Segovia. Segovia 1950.- Lafuente Ferrari, E.: I.Z. Barcelona 1980.- Milhou, M.: I.Z. et la France. Bordeaux 1979.- Pantorba, B. de: I.Z. Madrid 1944 .- Plessier, G .: Etude critique de la correspondance échangée entre Z. et Rodin de 1903 à 1917. Paris 1983 ILLUSTRATION. 562 Celestina, 1906

Acknowledgements and Picture Credits

The editor and the publisher would like to thank the museums and public collections, the galleries and private collectors, the archives and photographers, and all others who have assisted in the preparation of this two-volume monograph. Particular gratitude is due Mrs. Claudia Brigg, Christie's Colour Library, London, and Mrs. Eve Boustedt, Impressionist and Modern Art Department, Sotheby's, London, for varied and diverse supportive cooperation. Thomas Jaworek, Durham, prepared numerous photographic reproductions especially for this publication, and we owe him special thanks, as we do the editor's assistants, Antje Günther and Matthias Feldbaum, both Munich.

The editor and the publisher have made an intensive effort to obtain and provide compensation for the copyright to the photos on which the reproductions are based in accordance with legal provisions. Given the total of 236 artists whose works have been reproduced herein, however, this was not possible in every case despite intensive efforts on our part. Persons who may nevertheless still have claims are requested to contact the publisher.

Unless otherwise individually indicated, the copyright for the reproduced works is held by the heirs of the respective artist or their legal successors: Angrand: © VG Bild-Kunst, Bonn, 1992. Anquetin: © VG Bild-Kunst, Bonn, 1992. Beraud: © VG Bild-Kunst, Bonn, 1992. Bernard: © VG Bild-Kunst, Bonn, 1992. Besnard: © VG Bild-Kunst, Bonn, 1992. Boldini: © VG Bild-Kunst, Bonn, 1992. Bonnard: © VG Bild-Kunst, Bonn, 1992. Camoin: © VG Bild-Kunst, Bonn, 1992. Corinth: © VG Bild-Kunst, Bonn, 1992. Denis: © VG Bild-Kunst, Bonn, 1992. Devambez: © VG Bild-Kunst, Bonn, 1992. Ensor: © VG Bild-Kunst, Bonn, 1992. Forain: © VG Bild-Kunst, Bonn, 1992. Gagnon: © Estate of Clarence A. Gagnon, VIS-ART Copyright, Inc., 1992. Gallen-Kallela: © Pirkko Gallen-Kallela, Helsinki, 1992. Gervex: © VG Bild-Kunst, Bonn, 1992. Grabar: © VG Bild-Kunst, Bonn, 1992. Hayet: © VG Bild-Kunst, Bonn, 1992. Knight: © John Farquharson Ltd., London, 1992. Lebasque: © VG Bild-Kunst, Bonn, 1992. Lebourg: © VG Bild-Kunst, Bonn, 1992. Lemmen: © VG Bild-Kunst, Bonn, 1992. Le Sidaner: © VG Bild-Kunst, Bonn, 1992. Liebermann: © Marianne Feilchenfeldt, Zurich, 1992. Loiseau: © VG Bild-Kunst, Bonn, 1992. Luce: O VG Bild-Kunst, Bonn, 1992. Martin: O VG Bild-Kunst, Bonn, 1992. Mondrian: © VG Bild-Kunst, Bonn, 1992. Munch: © Munch-Museet, Oslo, 1992. Pissarro, Georges (Manzana): © VG Bild-Kunst, Bonn, 1992. Raffaëlli: © VG Bild-Kunst, Bonn, 1992. Regoyos: © VG Bild-Kunst, Bonn, 1992. Rohlfs: © Helene-Rohlfs-Stiftung, Essen, 1992. Schuffenecker: © VG Bild-Kunst, Bonn, 1992. Signac: © VG Bild-Kunst, Bonn, 1992. Slevogt: © VG Bild-Kunst, Bonn, 1992. Sorolla: © VG Bild-Kunst, Bonn, 1992. Trübner: © Henry Trubner, Seattle, 1992. Vuillard: © VG Bild-Kunst, Bonn, 1992. The locations and owners of the works are listed in the captions to the illustrations, except for those cases where they wished to remain anonymous or were not known to the editor. The editor and the publishers would greatly appreciate any information regarding incomplete or incorrect details. Key to the abbreviations: l = left, t = top, r = right, b = bottom.

AMHERST, Massachusetts, Mead Art Museum: 621.- ANTELLA, Scala, Istituto Fotografico Editoriale: 533, 540, 544.- BARCELONA, Museu Nacional d'Art de Catalunya: 555, 564, 566 b, 567.- BELGRADE, Narodni Muzej: 530 l, 530 r, 531.- BERLIN, Archiv für Kunst und Geschichte: 434 t.- BER-LIN, Bildarchiv Preußischer Kulturbesitz: 434 b, 448.- BEVERLY HILLS, California, Louis Stern Galleries: 202, 203.- BOSTON, Museum of Fine Arts: 602 t, 610.- BRUSSELS, Musée d'Ixelles: 424 t.- BRUSSELS, Musées Royaux des Beaux-Arts: 431.- BUDAPEST, Magyar Nemzeti Galéria (Photo: Mester Tibor): 500, 520, 521 l, 521 r, 523 t, 524 t, 524 b.- CAMBRIDGE, Fogg Art Museum, Harvard University: 210.- CAPE TOWN, South African National Gallery: 586.- CHICAGO, The Art Institute of Chicago: 618.- CHICAGO, R.H. Love Galleries: 622.- CHICAGO, Terra Museum of American Art, Daniel J. Terra Collection: 611, 615, 635.- COPENHAGEN, Den Hirschsprungske Samling (Photo: Hans Petersen): 493.- COPENHAGEN, Statens Museum for Kunst (Photo: Hans Petersen): 472, 481 b, 486 b, 495.- CRACOW, Muzéum Narodówe Krakowie (Photo: Tadeusz Szklarczyk): 512, 513 b, 515.- DE-TROIT, Detroit Institute of Art, Manoogian Collection (Courtesy Richard A. Manoogian): 614 b, 630 t, 638 t.- DRESDEN, Staatliche Kunstsammlungen, Gemäldegalerie Neue Meister: 439.- ECUBLENS, Archiv André Held: 35 t, 58,

69, 83, 92 t, 96 t, 96 b, 97, 127 t, 127 b, 132 t, 156 t, 158 b, 159 b, 160 r, 211 b, 300, 301, 329, 337, 355 t, 356 b, 359, 378 b, 459, 599.- ETAMPES, Musée d'Etampes: 155 b.- EUERBACH, Schloß Obbach, Sammlung Georg Schäfer: 447.- FORT WORTH, Amon Carter Museum: 620.- GOTHENBURG, Göteborgs Konstmuseum: 476, 483, 486 t, 488.- THE HAGUE, Haags Gemeentemuseum: 408 t, 413 l, 413 r.- HELSINKI, Valtion Taidemuseo (Photo: Matti Routsalainen): 466, 478, 484.- INDIANAPOLIS, Indianapolis Museum of Arts: 634 l.- LAREN, Singer Museum: 416 b.- LINCOLN, Usher Art Gallery: 570.- LINZ, Neue Galerie der Stadt, Wolfgang-Gurlitt-Museum: 444.- LI-VORNO, Museo Civico Giovanni Fattori: 537.- LONDON, The Bridgeman Art Library: 580, 583 b, 584.- LONDON, Christie's Colour Library: 133 b, 180, 246, 263 r, 370, 375 b, 387 b, 416 t, 427 b, 549.- LONDON, Fine Art Society: 582.- LONDON, Pyms Gallery: 587.- LONDON, Richard Green Gallery: 316.- LONDON, Sotheby's: 202 b, 203 b, 316, 338, 360, 375 t, 378 t, 379, 381, 382, 384 t, 385 t, 539.- LONDON, The Tate Gallery: 572, 576, 583 t, 589, 590, 597.- LONDON, University of London, Courtauld Institute Galleries: 221.- LUGANO, Fondazione Thyssen-Bornemisza: 402.- MADRID, Centro de Arte Reina Sofía: 562 .- MADRID, Museo del Prado, Casón del Buen Retiro: 552, 556, 557, 558, 559, 563, 565, 568, 569.- MALMÖ, Malmö Museer: 474 t.- MANCHESTER, Manchester City Art Gallery: 581, 585.- MIL-WAUKEE, Milwaukee Art Museum: 616 b.- MONTREAL, The Montreal Museum of Fine Arts (Photo: Brian Merrett): 632.- MUNICH, Archiv Alexander Koch: 61, 212.- NEW YORK, Coe Kerr Gallery: 634.- NORRKÖPING, Norrköpings Konstmuseum: 473 b.- OSLO, Nasjonalgalleriet (Photo: Jacques Lathion): 469, 470, 474 b, 475, 479, 481 t, 497.- OTTAWA, The National Gallery of Canada: 579, 626, 627 t.- OTTERLO, Rijksmuseum Kröller-Möller: 419.- PARIS, Galerie Bruno Meissner: 382 t.- PARIS, Galerie Etienne Sassi: 360.- PARIS, Gilles Néret: 202 t, 205 t.- PARIS, Guy Loudmer: 386 b.- PARIS, Photographie Giraudon: 134, 151, 174 t, 209, 252, 371.- PARIS, Réunion des Musées Nationaux: 10, 14, 16 t, 17, 19, 23, 27 t, 28, 29 t, 30 t, 31, 34 t, 36 t, 37, 38/39, 45, 54 t, 63, 66, 67, 68, 71, 81 t, 82 t, 82 b, 89 r, 100/101, 109 t, 114, 116/117, 123 b, 124 t, 124 b, 125, 129, 131, 142/143, 166 t, 167, 172, 173, 175 t, 182, 183, 189, 190 b, 199, 203 t, 204 b, 213, 216, 240 t, 240 b, 247, 257 t, 274 t, 275 t, 298 l, 298 r, 299 r, 307, 311, 313 t, 317, 320 t, 323, 334/335, 339, 340 t, 340 b, 341, 350, 351 t, 351 b, 366/367, 372, 373, 376 r, 383, 389, 411, 427 t.- PEISSENBERG, Artothek: 260/261, 432, 435, 438, 442 t, 443, 445, 457, 561.- PHILADELPHIA, The Pennsylvania Academy of the Fine Arts: 623 t, 631.- PONTOISE, Musée Pissarro: 154 t.- POZNAN, Muzéum Naródowe (Photo: Pietraszak): 514.- PRAGUE, Národní Galerie (Photo: Milan Posselt, Oto Palán): 516, 517 t, 517 b, 518 t, 518 b, 519.-PROVIDENCE, Museum of Art, Rhode Island School of Design (Photo: Cathy Carver): 536 b, 609, 630 b .- QUEBEC, Musée du Québec (Photo: Patrick Altman): 636, 637 .- ROCHESTER, New York, Memorial Art Gallery of the University of Rochester: 624.- ROTTERDAM, Museum Boymans-Van Beuningen: 417.- SAINT LOUIS, The Saint Louis Art Museum: 640.- SAN FRAN-CISCO, Montgomery Gallery: 375 t.- SKAGEN, Skagens Museum (Photo: Svend Thomsen): 473 t, 477, 494, 499.- SOUTH HADLEY, Massachusetts, Mount Holyoke College Art Museum: 605.- SOUTHAMPTON, New York, The Parrish Art Museum (Photo: Noel Rowe): 619.- STOCKHOLM, Nationalmuseum: 482.- STOCKHOLM, Prins Eugens Waldemarsudde: 480.- STOCK-HOLM, Thielska Galleriet: 489.- TOLEDO, The Toledo Museum of Art: 603 b, 604 t.- TORONTO, Art Gallery of Ontario: 607 (Photo: Larry Ostrom), 627 b (Photo: Carlo Catenazzi).- TOURNAI, Musée des Beaux-Arts: 195 t.- TURKU, Turun Taidemuseo: 487.- UTRECHT, Centraal Museum Utrecht, Stichting Van Baaren Museum: 408 b, 412 t.- WALTHAM, Massachusetts, Rose Art Museum, Brandeis University: 633.- WASHINGTON, National Gallery of Art: 613.- WASHINGTON, The Phillips Collection: 612 b.-ZAGREB, Moderna Gallerija (Photo: Fedor Vucemilovic): 528.- Documentation Wildenstein Institute: 52, 80 l, 80 r, 158 t, 184 t, 208 t, 228, 229 b, 379 t, 387 t. All other master copies may be found in the collections cited in the captions; the archives of the editor or of the former Walther & Walther Verlag, Alling, or the archives of Benedikt Taschen Verlag, Cologne; or else were specially photographed by Thomas Jaworek for this work.

Index of Names

The Index of Names does not include picture titles; nor does it make reference to the "Directory of Impressionism" (pp. 642-706)

ABBATI, GIUSEPPE (1836-1868) 534, 540, 541, 542 Alexis, Paul (1847-1901) 112, 268 Alfons XII., King (1857-1885) 553 Alfons XIII., King (1886-1941) 560 Altamura, Saverio (1826-1897) 540 Ancher, Anna (1859-1935) 467, 483 André, Albert (1869-1954) 376 Andrée, Ellen (1857-c. 1915) 167, 179 Andreescou, Ion (1850-1882) 525, 526, 527 Angrand, Charles (1854-1926) 233, 291,471 Anguetin, Louis (1861-1932) 262, 276, 291, 302, 320 Arosa, Gustave (c. 1835-c. 1900) 218 Astruc, Zacharie (1835-1907) 78, 90, 136 Attendu, Antoine (1845-1905) 136 Aurier, G.-Albert (1865-1892) 300, 309 Auriol, Louis 80 Avril, Jane (1868-1943) 325 Ažbè, Anton (1862-1905) 528, 529, 530, 531 BACHMAYER, BABETTE (1872-1927) 529 Backer, Harriet (1845-1932) 467 Baertsoen, Albert (1866-1922) 423 Bakunin, Mikhail (1814-1876) 268 Balla, Giacomo (1871-1958) 551 Balleroy, Albert de (1828-1873) 40 Barbier, André (1883-1970) 159, 162 Bastien-Lepage, Jules (1848-1884) 207, 212, 423, 468, 485, 522, 558, 574, 580, 595, 614 Baudelaire, Charles (1821-1867) 40, 43, 550 Baum, Paul (1859-1932) 460 Bazille, Frédéric (1841-1870) 12, 53, 68, 70, 78, 85, 86, 90, 93, 94, 103 Beau, Henri (1863-1949) 632 Bécat, Emilie 187 Beckmann, Max (1884-1950) 460, 462 Beethoven, Ludwig van (1770-1827) 373 Behrens, Peter (1868-1940) 452 Béliard, Edouard (1835-1902) 125, 138 Bellelli, Gennaro 46, 48 Bellelli, Giovanna 46 Bellelli, Laura 46 Bellio, Georges de (1828-1894) 197, 526 Bénédite, Léonce (1859-1925) 332 Benjamin, Walter (1892-1940) 40 Benson, Frank Weston (1862-1951) 629, 630, 631, 632 Bérard, Paul (1833-1905) 214 Béraud, Jean (1849-1936) 212, 220, 622 Bergh, Richard (1858-1919) 467, 475 Bernard, Emile (1868-1941) 262, 276, 291, 304, 311, 336 Bernheim, Galerie 349 Bernstein, Carl und Felicie 435, 436 Beruete y Moret, Aureliano de (1845-1912) 555

Besnard, Albert (1849-1934) 255, 337 Bezzuoli, Giuseppe (1784-1855) 540 Bierstadt, Albert (1830-1902) 594 Bilders, Johannes Warnardus (1811-1890) 409 Birger, Hugo (1854-1887) 496 Björck, Oscar (1860-1929) 482 Bjørnson, Bjørnstjerne (1832-1910) 472 Blanc, Charles (1813-1882) 553 Blechen, Karl (1798-1840) 433, 443 Blum, Robert (1858-1903) 611 Boccioni, Umberto (1882-1916) 551 Boch, Anna (1848-1936) 420, 425 Böcklin, Arnold (1827-1901) 281, 439, 451, 452, 453, 458, 521 Boime, Albert 10 Boldini, Giovanni (1842-1931) 534, 541, 546 Bonaparte, Charles Louis Napoléon (1803-1873) → Napoleon III Bonington, Richard Parkes (1802-1828) 20, 23, 53 Bonnard, Pierre (1867-1947) 12, 325, 391, 392, 429, 458, 524 Bonnat, Léon (1833-1922) 263, 467, 468, 471, 480 Borrani, Odoardo (1833-1905) 541, 542 Bosch, Hieronymus (1450-1516) 430 Boucher, François (1703-1770) 154 Boudin, Eugène-Louis (1824-1898) 50, 52, 70, 136, 198, 212, 255, 407, 408 Bouguereau, William-Adolphe (1825-1905) 207, 212, 223, 435, 448, 574 Boussod & Valadon, gallery 338, 341 Boznanska, Olga (1865-1940) 514 Bracquemond, Félix (1833-1914) 55, 74, 103, 257 Bracquemond, Marie (1841-1916) 216, 257 Braque, Georges (1882-1963) 370 Breck, John Leslie (1860-1899) 608, 609.610.638 Breitner, George Hendrik (1857-1923) 413, 415, 418 Bremmer, Hendrik Pieter (1871-1956) 418 Breton, Jules (1827-1906) 212, 217, 276, 301, 468 Brettell, Richard 199 Breughel the Elder, Pieter (1525/30-1569) 419, 430 Broglie, Jacques-Victor-Albert de (1821-1901) 111 Broude, Norma 12 Brouwer, Adriaen (1605/06-1638) 419 Brown, Frederic (1851-1941) 577, 578, 581, 585 Bruant, Aristide (1851-1925) 325 Bruce, William Blair (1859-1906) 608, 609, 634 Brunner, Irma 213 Burckhardt, Jacob (1818-1897) 206 Bürger, Wilhelm (1824-1869) → Thoré, Théophile Burty, Philippe (1830-1890) 190 Busch, Günter 445 Butler, Theodore Earl (1860-1936) 610 CABANEL, ALEXANDRE (1823-1889) 60, 64

Cabianca, Vincenzo (1827-1902) 534, 541 Caillebotte, Gustave (1848-1894) 12, 156, 176, 177, 191, 199, 216, 220, 223, 233, 257, 332, 333, 346, 484, 485, 487, 488, 489, 492, 512, 545, 622 Cals, Adolphe-Félix (1810-1880) 136, 198 Cardon, Emile 140 Carnot, Sadi (1837-1894) 332 Carnovali, Giovanni, called Il Piccio (1804-1873) 549 Carolus-Duran, Emile-Auguste (1837-1917) 92, 103, 226, 429, 569, 584, 606.610 Carolus-Duran, Pauline 92 Carrand, Louis-Hilaire (1821-1899) 336 Carus, Carl Gustav (1789-1869) 433 Casas, Ramón (1866-1932) 565, 567, 569 Cassatt, Alexander and Robert 601 Cassatt, Mary (1845-1926) 188, 217, 224, 229, 257, 370, 471, 600, 601, 602, 603, 605, 612, 620 Cassirer, Paul (1871-1926) 436, 456, 464 Castagnary, Jules-Antoine (1830-1888) 26, 68, 135, 141, 221 Cazin, Jean-Charles (1841-1901) 226, 255 Cecioni, Adriano (1836-1886) 534, 535, 538, 541, 545 Céleyran, Gabriel Tapié de (1869-1930) 326 Cézanne, Paul (1839-1906) 12, 33, 54, 55, 60, 64, 68, 89, 105, 106, 108, 109, 112, 125, 126, 138, 141, 146, 147, 148, 191, 199, 200, 207, 214, 230, 233, 234, 237, 239, 240, 253, 262, 263, 264, 268, 283, 301, 304, 332, 358, 360, 361, 362, 363, 368, 369, 370, 372, 373, 383, 385, 458, 471, 513, 519, 585, 639, 640 Chaplin, Charles (1825-1891) 170 Charigot, Aline → Renoir, Aline Charpentier, Georges (1846-1905) 214, 215, 253, 255 Charpentier, Marguerite 215 Chase, William Merrit (1849-1916) 617, 618, 620, 628, 629 Chekhov, Anton Pavlovich (1860-1904) 506 Chéret, Jules (1836-1933) 325, 336 Chevreul, Eugène (1786-1889) 279 Chialiva, Luigi (1842-1914) 182 Chocquet, Victor (1821-1891) 156, 158, 191, 193, 200 Ciardi, Giuglielmo (1842-1917) 534, 546, 548 Ciseri, Antonio (1821-1891) 540, 542 Clapp, William Henry (1879-1954) 634 Claretie, Jules (1840-1913) 187, 206, 219 Clark, Timothy J. 10 Claus, Emile (1849-1924) 423, 424, 425, 429 Claus, Fanny 78 Clausen, George (1852-1944) 573, 574, 577, 584, 587 Clemenceau, Georges (1841-1929) 216, 230, 267, 358, 381 Cole, Thomas (1801-1848) 594

Colin, Gustave (1828-1910) 136

590 Constable, John (1776-1837) 19, 20, 22, 23, 105, 571, 581, 587 Cordey, Frédéric-Samuel (1854-1911) 198 Corinth, Lovis (1858-1925) 433, 435, 436, 437, 438, 439, 448, 450, 451, 452, 453, 455, 456, 459, 460, 462, 463, 464, 465 Cormon (= Fernand-Anne Piestre) (1845-1924) 262, 263, 318, 320, 321, 413 Corot, Jean-Baptiste Camille (1796-1875) 23, 27, 30, 33, 52, 55, 56, 60, 70, 84, 103, 113, 136, 217, 231, 233, 234, 253, 468 Courbet, Gustave (1819-1877) 28, 29, 30, 31, 33, 34, 43, 60, 68, 74, 90, 93, 103, 113, 136, 176, 206, 212, 268, 277, 321, 350, 360, 410, 420, 435, 447, 485, 502, 580 Couture, Thomas (1815-1879) 34, 36, 37, 600, 614 Crome, John (1768-1821) 571 Cross, Henri-Edmond (1856-1910) 291, 292, 561 Cullen, Maurice Galbraith (1866-1934) 634 DAUBIGNY, CHARLES-FRANCOIS (1817-1878) 27, 56, 105, 198, 410, 468, 505 Daudet, Alphonse (1840-1897) 214 Daulte, François 85 Daumier, Honoré (1808-1879) 141, 217 David, Jacques-Louis (1748-1825) 279, 554 Dawson-Watson, Dawson (1864-1939) 609 Debussy, Claude (1862-1918) 564 De Camp, Joseph (1858-1923) 629, 630, 631, 632 Defregger, Franz (1835-1921) 435, 448 Degas, Edgar (1834-1917) 12, 40, 43, 44, 46, 47, 48, 50, 55, 68, 73, 78, 80, 82, 104, 105, 113, 119, 120, 121, 122, 124, 129, 136, 138, 141, 164, 172, 173, 176, 177, 178, 179, 182, 187, 188, 189, 191, 194, 196, 199, 206, 207, 212, 213, 214, 216, 217, 218, 220, 224, 225, 226, 229, 230, 232, 233, 257, 258, 263, 267, 268, 294, 320, 321, 325, 326, 332, 333, 336, 338, 370, 372, 373, 374, 391, 394, 413, 420, 426, 441, 447, 450, 454, 455, 471, 484, 496, 510, 527, 543, 544, 545, 559, 572, 577, 578, 581, 584, 585, 586, 591, 601, 602, 603, 605 Delacroix, Eugène (1798-1863) 18, 19, 23, 24, 30, 34, 37, 44, 78, 113, 191, 234, 279, 291, 337, 372, 377, 549 Denis, Maurice (1870-1943) 309, 358, 436 Depeaux, Félix-François (1853-1920) 341, 354 Desboutin, Marcellin (1823-1902) 179, 191, 193 Dettmann, Ludwig (1865-1944) 441, 457 Devambez, André-Victor-Edouard (1867-1944) 391

Condor, Charles (1868-1909) 588.

Dewhurst, Wynford (1864-1941) \$71, 588 Dewing, Thomas (1851-1938) 629 Diaghilev, Sergei (1872-1929) 510 Diaz de la Peña, Narcisse (1807-535, 546 1876) 27 Diez, Wilhelm von (1839-1907) 448 Dihau, Désiré 82 Dillis, Johann Georg (1759-1841) 433 360 Dolfi, Giuseppe 535 Doncieux, Camille → Monet, Camille Dreyfus, Alfred (1859-1935) 332, 333 Dubois-Pillet, Albert (1846-1890) 253.291 Dujardin, Eduard (1861-1949) 277 Dupré, Jules (1811-1889) 27 Durand, Charles → Carolus-Duran 640 Durand-Ruel, Paul (1833-1922) 105, 113, 135, 140, 178, 192, 197, 198, 43, 56 223, 224, 225, 237, 255, 256, 279, 336, 341, 345, 348, 349, 350, 370, 380, 381, 391, 573, 585, 591, 592, 628, 630, 632 Duranty, Louis Emile Edmond (1833-1880) 11, 194, 196, 219 Duret, Théodore (1838-1927) 135, 163, 191, 206, 339 612 Duveneck, Frank (1848-1919) 614, ECKMANN, OTTO (1865-1902) 4522 Edelfelt, Albert (1854-1908) 467, 471, 490, 496 586 Engel, Otto Heinrich (1866-1949) 1927) 563 Ensor, James (1860-1949) 417, 421, 423, 425, 428, 430 Evenepoel, Henri (1872-1899) 423, Exter, Julius (1863-1939) 531 70. 57 FANTIN-LATOUR, HENRI (1836-1904) 55, 60, 78, 191, 253 Fattori, Giovanni (1825-1908) 534, 540, 541, 543, 544 212, 220 Faure, Jean-Baptiste (1830-1914) 118, 191, 193 326, 513 Feininger, Lyonel (1871-1956) 462 Fénéon, Félix (1861-1944) 267, 280, 290, 332, 421, 585 Ferenczy, Károly (1862-1917) 522 Finch, Alfred William (1854-1930) 612, 614 421, 428 Fiocre, Eugénie 80 82 Fiquet, Hortense (1850-1918) 105, 239, 358 Flaubert, Gustave (1821-1880) 168 Fontanesi, Antonio (1818-1882) 546 586 Forain, Jean-Louis (1852-1931) 216, 217, 220, 257, 263, 320, 336, 471, Forbes, Stanhope (1857-1947) 577, dealer's 256 Fortuny y Carbó Marsal, Mariano (1838-1874) 545, 554, 555 Fournaise, Alphonse 152, 159 Fragonard, Jean-Honoré (1732-1806) 82, 154 Franc-Lamy, Pierre (1855-1919) 198 Frenzel, Oscar (1855-1915) 457 Friedrich III, Emperor (1831-1888) 525, 526, 527 Frieseke, Frederick (1874-1939) 636, 531 Fromentin, Eugène (1820-1876) 445 23 Fry, Roger Eliot (1866-1934) 586 GACHET, PAUL (1828-1909) 126, 148, Guichard, Joseph (1830-1877) 138 197, 318 Guillaumin, Jean-Baptiste Armand

618

457

425

512

587

450

637

Gagnon, Clarence Alphonse (1881-1942) 634

Gallait, Louis (1810-1887) 419 Gallen-Kallela, Akseli (1865-1931) 467, 495, 496 Garibaldi, Giuseppe (1807-1882) 226 Garniers, Charles (1825-1898) 198 Gas, Don Ilario de 43, 46, 119 Gasquet, Joachim (1873-1921) 358, Gaudin, Carmen 321 Gauguin, Paul (1848-1903) 12, 217, 218, 219, 225, 232, 242, 258, 263, 268, 276, 277, 279, 300, 301, 302, 303, 304, 309, 311, 315, 320, 336, 632 346, 370, 372, 420, 436, 458, 471, 472, 488, 515, 519, 559, 586, 588, 372 Gautier, Théophile (1811-1872) 40, 426, 445 Gautreau, Madame 605 44I Gebauer, Alexis 526 Geffroy, Gustave (1855-1926) 267, 338, 358, 381 Géricault, Théodore (1791-1824) 48 Gérôme, Jean-Léon (1824-1904) 140, 464 155, 256, 333, 467, 471, 600, 609, Gerstenberg, Oskar 179 Gervex, Henri (1852-1929) 156, 220, 223, 226, 255, 559 1907) 601 Gide, André (1869-1951) 358 Gilman, Harold (1876-1919) 585, Gimeno Arasa, Francisco (1858-452 Ginoux, Marie 302, 303 Gioli, Francesco (1846-1922) 546 Giorgone (c. 1478-1510) 64 Gleyre, Charles (1806-1874) 53, 54, 460 Gobedska, Marie → Vuillard, Marie 467, 489 Gobillard, Jeanne (Nini) 82, 339 Gobillard, Yves → Morisot, Yves 420, 429 Goeneutte, Norbert (1854-1894) Gogh, Theo van (1857-1891) 321, Gogh, Vincent van (1853-1890) 12, 458 256, 262, 263, 303, 311, 314, 315, 318, 320, 321, 370, 372, 410, 412, 450, 451 413, 418, 420, 458, 472, 585, 586, Goncourt, Edmond de (1822-1896) 611 Gonzalès, Eva (1849-1883) 12, 68, 1543) 46 85, 167, 168, 171 Gore, Spencer F. (1878-1914) 585, 230 Goulue, La (1870-1929) 322, 326 Goupil, Adolphe (1806-1893) 138, 140, 256, 326, 545, 578, 585 Goupil, Boussod et Valadon, art 606 Goupil & Cie., art dealer's 262 Goya, Francisco de (1746-1828) 78, 217, 495, 553, 558 519 Grabar, Igor (1871-1960) 508, 528 Grave, Jean (1854-1939) 268, 292 Greco, El (1541-1614) 553, 558, 559 Grigorescu, Nicolae (1838-1907) Grohar, Ivan (1867-1911) 528, 529, Gros Antoine-Jean (1771-1835) 19, Grubicy, Vittore and Alberto 550 Guérard, Henri (1846-1897) 167, 171 445

(1841-1927) 12; 33, 55, 60, 89,

103, 125, 126, 138, 146, 147, 148,

200, 214, 218, 225, 233, 242, 253, 258, 288, 344, 345, 370, 471 Guillemet, Antoine (1843-1918) 78, Guino, Richard (1890-1973) 374 Gurlitt, Fritz 255, 435, 436 Guthrie, James (1859-1930) 573, 577, 587, 588 HAES, CARLOS DE (1829-1898) 555, 556, 560, 563 Hagemeister, Karl (1848-1933) 460 Hale, Philip Leslie (1865-1931) 631, 338 Halévy, Ludovic (1834-1908) 179, Hals, Frans (c. 1583-1666) 407, 409, Hamann, Richard (1879-1961) 9, 10, Harris, Lawren (1885-1970) 634 Hassam, Childe (1859-1935) 620, 622, 624, 626, 628, 629, 631 Hausenstein, Wilhelm (1882-1957) 430 Hauser, Henriette 166 Haussmann, Georges-Eugène (1809-1891) 29, 130, 488 Havemeyer, Henry Osborn (1847-Hayez, Francesco (1791-1881) 539 Hebrard, Adrien (1883-1914) 374 Heckel, Erich (1883-1970) 462 Heine, Thomas Theodor (1867-1948) 510 Henry, Charles (1859-1926) 279, 290 Herbert, Robert L. 10 Herrmann, Curt (1854-1929) 457, Heyerdahl, Hans Olaf (1857-1913) Heymans, Josph Adrien (1839-1921) Hill, Henry 182 Hiroshige (1797-1858) 611 Hirsch, Alphonse (1843-1884) 119 Hodler, Ferdinand (1853-1918) 290, Hofmann, Ludwig von (1861-1945) Hofmann, Werner 60, 164, 370, 395 Hokusai, Katsushika (1760-1849) Holbein the Younger, Hans (1497/98-594 Hollósy, Simon (1857-1918) 522 Hoschedé, Alice (1844-1911) 197, Hoschedé, Blanche (1865-1947) 381 Hoschedé, Ernest (1837-1891) 197 Hoschedé, Jacques 472 Hoschedé, Suzanne (1868-1899) 350, Hübner, Ulrich (1872-1932) 460 Hudeček, Antonín (1872-1941) 518, 225 Huysmans, Joris-Karl (1848-1907) 122, 218, 220, 268 INGRES, JEAN AUGUSTE DOMINIQUE (1780-1867) 17, 18, 19, 30, 44, 141, 234, 279, 495 Isabey, Eugène (1803-1886) 407 36 Israëls, Isaac Lazarus (1865-1934) 413, 415, 416 Israëls, Jozef (1824-1911) 409, 410, JACOBSEN, CARL 472 Jacque, Charles (1813-1894) 27 Jakopić, Rihard (1869-1943) 529 521, 614

Jama, Matija (1872-1947) 529 James, Henry (1843-1916) 206 Jamot, Paul 246 Järnefelt, Eero Nikolai (1863-1937) 467, 475, 484, 485 Jeffery, Marcel (1872-1924) 423 Johansen, Viggo (1851-1935) 471, 472, 476, 482 Jongkind, Johan Barthold (1819-1891) 52, 60, 70, 94, 407, 408, 410 Josephson, Ernst Abraham (1851-1906) 467, 482 Joyant, Maurice (1864-1930) 326, KAHN, GUSTAVE (1859-1936) 267, 380 Kahn, Maurice 380 Kalckreuth, Leopold von (1855-1928) 438, 460 Kandinsky, Wassily (1866-1944) 352, 462, 528, 531 Kensett, John F. (1816-1872) 594 Keyser, Narcisse de (1813-1887) 423 Khnopff, Fernand (1858-1921) 421, Kirchner, Ernst Ludwig (1880-1938) 462, 464 Klee, Paul (1879-1940) 462 Klimt, Gustav (1862-1918) 292 Klinger, Max (1857-1920) 439, 451 Knight, Laura (1877-1972) 577, 587 Knobloch, Madeleine 286 König, Leo von (1871-1944) 433 Korovin, Constantin (1861-1939) Kox, Kenyon 620 Kramskoy, Ivan Nikolaievich (1837-1887) 503, 505 Kreuger, Nils Edvard (1858-1930) 467, 475, 490, 493 Krohg, Christian (1852-1925) 468, 471, 472, 475, 482, 483, 487, 488, 489, 492, 493, 494, 498 Kropotkin, Peotr (1842-1921) 268 Krøyer, Peder Severin (1851-1909) 467, 471, 472, 475, 482, 483, 492 Kuehl, Gotthardt (1850-1915) 433, 450, 460 Kutlik, Kirilo (1847-1900) 528, 529, 530, 531 LAFORGUE, JULES (1860-1887) 435. 436, 450 Lane, Fritz Hugh (1804-1865) 477, Larousse, Pierre (1817-1875) 206 Larsson, Carl Olof (1853-1919) 475 Lassalles, Ferdinand (1825-1864) 444 La Thangue, Henry Herbert (1859-1929) 574, 577, 584, 587 Latouche, Louis (1829-1884) 136 Lavery, John (1856-1941) 577, 587 Laurens, Jean-Paul (1838-1921) 206 Lavrov, Pyotr Lavrovich (1823-1900) Lawson, Ernest (1873-1939) 637, 638 Lebeda, Otakar (1877-1901) \$17 Lebourg, Albert-Charles (1849-1928) 217, 336 Le Coeur, Jules 90 Leenhoff, Ferdinand (1841-1914) 62 Leenhoff, Léon-Edouard (1852-1925) Leenhoff, Rodolphe 162 Leenhoff, Suzanne (1830-1906) 36 Lefèbvre, Reine 629 Lega, Silvestro (1826-1895) 534, 535, 540, 541, 542, 543, 544 Leibl, Wilhelm (1844-1900) 31, 433, 434, 435, 443, 447, 448, 455, 458,

Leistikow, Walter (1865-1908) 450, 456, 457, 461 Lemmen, Georges (1865-1916) 421, 425, 428, 429 Lemonnier, Camille (1844-1913) 419 Lenbach, Franz von (1836-1904) 448 Lepic, Ludovic-Napoléon Vicomte (1839-1889) 138, 179 Lépine, Stanislas (1835-1892) 136 Leroy, Louis (1812-1885) 141 Lescouezec, Marie 90 Lestringuez, Eugène-Pierre 237 Levitan, Isaac Ilyich (1860-1910) 506 Lewis, Wyndham (1884-1957) 587 Lhote, Paul 237 Lieb, Michael (1844-1900) 520 Liebermann, Max (1847-1935) 220, 228, 255, 410, 416, 433, 434, 435, 436, 437, 438, 439, 441, 443, 444, 445, 446, 447, 450, 451, 453, 454, 455, 457, 459, 460, 462, 463, 464, 465, 471, 520 Liljefors, Bruno (1860-1939) 475 Löfftz, Ludwig von (1845-1910) 448 Loiseau, Gustave (1865-1935) 336 Louis XIV (1643-1715) 15 Louis Philippe, King (1773-1850) 26 Lucas y Padilla, Eugenio (1824-1870) 554 Luce, Maximilien (1858-1941) 292, 332, 560 Luchian, Stefan (1868-1916) 527 Lundh, Charles 483 MACH, ERNST (1838-1916) 356 Macke, August (1887-1914) 463 Mac-Mahon, Patrice Graf von (1808-1893) 111, 194 MacMonnies, Frederick (1863-1937) 636 MacMonnies, Mary (1858-1946) 636 MacTaggart, William (1835-1910) Madrazo, Cecilia de 554 Madrazo, José de (1781-1859) 554 Madrazo, Frederico de (1815-1894) Madsen, Karl (died 1938) 490 Magritte, René (1898-1967) 78 Maillol, Aristide (1861-1944) 374 Maitland, Paul (1863-1909) 578 Maître, Edmond (1840-1898) 78, 86 Mallarmé, Stéphane (1842-1898) 172, 264, 338, 339, 504, 559 Mamontov, Savva I. 509 Mánes, Josef (1820-1871) 516 Manet, Berthe → Morisot, Berthe Manet, Edouard (1832-1883) 12, 34, 36, 37, 40, 43, 44, 55, 56, 62, 64, 68, 70, 71, 72, 73, 74, 76, 77, 78, 80, 82, 84, 86, 88, 90, 92, 103, 104, 105, 106, 113, 118, 119, 126, 135, 136, 145, 156, 160, 162, 163, 165, 167, 168, 170, 171, 173, 176, 177, 179, 191, 196, 197, 199, 206, 213, 215, 216, 217, 218, 220, 222, 223, 225, 227, 228, 229, 263, 264, 277, 286, 298, 330, 332, 338, 339, 383, 391, 395, 413, 418, 420, 426, 435, 441, 471, 472, 484, 490, 496, 503, 504, 509, 514, 527, 545, 553, 559, 572, 578, 580, 584, 588, 592, 600, 602, 618 Manet, Eugène (1833-1892) 43 Manet, Gustave (1835-1884) 62 Manet, husband and wife 217 Manet, Julie → Morisot, Julie Manson, James Bolivar 292 Manzana (1871-1961) → Pissarro, Georges Marák, Julius (1832-1899) 517

Marc, Franz (1880-1916) 463 Marées, Hans von (1837-1887) 286 Maris, Jacob Hendricus (1837-1899) 409,410 Maris, Mathijs (1837-1917) 409, 410 Maris, Willem (1844-1910) 409, 410, 413 Marquéz, Francisco Domingo y (1842-1920) 556 Martelli, Diego (1838-1896) 533, 535, 540, 541, 543, 546 Martin, "Père" (c. 1810-c. 1880) 138, 193, 196 Martinet, Louis 40, 56, 64 Marx, Roger (1859-1913) 267, 336, 358 Masson, André (1896-1987) 383 Matisse, Henri (1869-1954) 369, 370, 377, 426, 461, 586 Maupassant, Guy de (1850-1893) 214, 349 Maureau, Alphonse 199 Maus, Octave (1856-1919) 286, 421. 426, 560 Mauve, Anton (1838-1888) 409, 410, 412, 445 Maximilian, Emperor of Mexico (1832-1867) 71, 105, 592 Mazzini, Giuseppe (1805-1872) 535 McNicoll, Helen (1879-1915) 632 Medulić, Andrija (after 1500-1563) 529, 530, 531 Meier-Graefe, Julius (1867-1935) 227, 462 Meifren y Roig, Eliseo (1859-1940) 562 Meilhacs, Henri (1831-1897) 179 Meissonier, Ernest (1815-1891) 24, 104, 225, 332, 545, 554 Melbye, Fritz (1826-1896) 33 Menzel, Adolph (1815-1905) 220, 255, 433, 436, 437, 443, 446 Messina, Antonello da (1430-1479) 88 Meštrović, Ivan (1883-1962) 529 Metcalf, Williard Leroy (1858-1925) 608, 609, 629, 630, 631 Meunier, Constantin (1831-1905) 420, 560 Meurent, Victorine (1844-c. 1885) 62 Meyer, Alfred (1832-1904) 136 Miličević, Kosta (1877-1920) 530 Miller, Richard Edward (1875-1943) 636, 637 Millet, Jean-François (1814-1875) 27, 28, 30, 60, 113, 176, 212, 217, 221, 315, 420, 429, 468, 485, 502, 573. 574 Milovanović, Milan (1876-1946) 530 Mirbeau, Octave (1848-1917) 267, 291 Mir Trinxet, Joaquín (1873-1940) 567 Moffett, Charles 11 Moitessier, Ines 18 Molins, Auguste de (1821-1890) 136 Moll, Oskar (1875-1947) 460 Mondrian, Piet (1872-1944) 418 Monet, Alice \rightarrow Hoschedé, Alice Monet, Blanche → Hoschedé, Blanche Monet, Camille (1847-1879) 92, 93, 160, 198, 230 Monet, Claude (1840-1926) 12, 33, 50, 52, 53, 54, 64, 68, 70, 74, 78, 86, 88, 89, 90, 92, 93, 94, 105, 106, 113, 122, 126, 129, 130, 131, 135, 136, 138, 141, 148, 152, 160, 162, 163, 172, 173, 190, 191, 193, 194, 196, 197, 198, 199, 206, 214, 215, 220, 223, 224, 225, 230, 233, 239, 255, 257, 263, 264, 268, 276,

277, 292, 294, 298, 314, 330, 332, 337, 338, 341, 344, 346, 348, 349, 350, 352, 353, 354, 356, 358, 360, 370, 372, 373, 378, 379, 380, 381, 383, 384, 385, 388, 389, 391, 395, 407, 408, 413, 423, 424, 438, 441, 448, 450, 464, 471, 472, 476, 480, 487, 490, 502, 503, 506, 512, 514, 520, 530, 546, 562, 571, 572, 573, 574, 577, 578, 580, 581, 582, 586, 588, 592, 605, 606, 607, 608, 609, 610, 616, 626, 630, 632, 634, 636 Monet, Jean (1867-1914) 160, 225, 380, 381 Monet, Michel (1878-1966) 354 Moréas, Jean (Papadiamantopoulos) (1856-1910) 264 Moreau, Gustave (1826-1898) 425 Morelli, Domenico (1826-1901) 538, 558 Moret, Henry (1856-1913) 344 Morgenstern, Christian (1805-1867) 443 Morisot, Berthe (1841-1895) 12, 55, 68, 70, 77, 78, 82, 104, 105, 118, 126, 135, 138, 141, 171, 172, 190, 214, 217, 224, 225, 233, 255, 265, 332, 338, 341, 490 Morisot, Edma (died 1873) 55, 82 Morisot, Julie (1878) 34 Morisot, Yves (1838-1893) 82, 339 Morren, Georges (1868-1941) 425 Morrice, James Wilson (1865-1924) 634 Motijo, Duchess Eugenie de 553 Mulot-Durivage (1838-1944) 136 Munch, Edvard (1863-1944) 450, 467, 475, 488, 518 Munkácsy, Mihály von (1844-1900) 444, 446, 520, 524 Murat, Marko (1864-1944) 529 Murer, Eugène (1845-1906) 148, 232, 344 Murillo, Bartolomé Esteban (1618-1682) 553, 600 Mussini, Luigi (1813-1888) 542 Musson, Michel 122 Muybridge, Eadweard (1830-1904) 48 NADAR (1820-1910) 136, 145, 458 Napoleon I (1769-1821) 16 Napoleon III (1803-1873) 29, 36, 60, 71, 74, 103, 553 Natanson, Thadée (1868-1951) 392 Neuhuys, Albert (1844-1914) 412 Nieuwerkerke, Alfred-Emilien de (1811-1892) 60, 112, 227 Niss, Thorvald (1842-1905) 482 Nittis, Giuseppe de (1846-1884) 138, 212, 215, 215, 220, 255, 534, 538, 544, 545, 546, 622 Nonell, Isidro (1873-1911) 567 Nordström, Karl Frederik (1855-1923) 475, 478, 488 Novotny, Fritz 12 Nunès, Aline 235 OFFENBACH, JACQUES (1819-1880) Olde, Hans (1855-1917) 452 Olmsted, Frederick Law (1822-1903) 618 Orpen, William (1878-1931) 588, 590 Osborn, Max 60 Otaño, Dolores 561 Ottin, Louis-Marie (1811-1890) 136 PAAL, LASZLO (1846-1879) 520 Pach, Walter 376 Pankiewicz, Józef (1866-1940) 513 Papadiamantopoulos → Jean Moréas

Pauli, Gustav 463 Pauli, Hanna (1864-1940) 467, 480, 482 Paulsen, Julius (1860-1940) 471, 476, 490 Pauwels, Ferdinand (1830-1904) 419 Pechstein, Max (1881-1955) 462 Pelizza da Volpedo, Giuseppe (1868-1907) 550, 551 Pere Romeu 569 Perry, Lilla Cabot (1848-1933) 608, 609 Peter the Great, Tsar (1672-1725) 501 Petit, Francis 56 Petit, Georges (c. 1835-1900) 223, 255, 256, 341, 349, 471, 562 Petrović, Nadežda (1873-1915) 531 Phidias (5. Jhd. v. Chr.) 283 Philipsen, Theodor Esbern (1840-1920) 467, 471, 476, 493 Picard, Edmond (1836-1924) 421 Picasso, Pablo (1881-1973) 321, 369, 565, 569, 586 Piestre, Fernand-Anne → Cormon Piette, Ludovic (1826-1877) 146, 199 Piloty, Karl Theodor (1826-1886) 449 Pinazo Camarlench, Ignacio (1849-1916) 556, 557 Pissarro, Camille (1830-1903) 12, 33, 34, 50, 52, 54, 55, 60, 64, 68, 70, 88, 89, 104, 105, 106, 113, 124, 125, 126, 135, 138, 141, 146, 147, 148, 173, 191, 196, 199, 200, 216, 217, 218, 219, 220, 223, 224, 225, 232, 233, 239, 253, 255, 257, 258, 262, 263, 268, 279, 292, 294, 301, 328, 332, 333, 337, 345, 346, 348, 360, 391, 395, 413, 428, 429, 441, 448, 471, 477, 478, 480, 487, 518, 525, 526, 531, 543, 561, 571, 573, 574, 588, 609, 632 Pissarro, Lucien (1863-1944) 33, 258, 292, 574, 578, 580, 585, 586 Podkowiński, Władisław (1866-1896) 513 Polenov, Vassilv (1844-1927) 505, 512 Poussin, Nicolas (1593-1665) 26 Preisler, Jan (1872-1918) 519 Prendergast, Maurice Brazil (1861-1924) 599, 637, 638, 639 Previati, Gaetano (1852-1920) 550 Prinz Eugen (1865-1947) 467, 472 Proudhon, Pierre-Joseph (1809-1865) 268, 543 Proust, Antonin (1832-1905) 40, 64, 222, 226, 229 Puvis de Chavannes, Pierre (1824-1898) 103, 104, 172, 221, 268, 283, 286, 304, 468, 603 **OUIVORON, LOUISE 194** RAFFAELLI, JEAN-FRANÇOIS (1850-1924) 217, 220, 230, 255 Raimondi, Marcantonio (c. 1480-c. 1530) 64 Ranzoni, Daniele (1843-1889) 550 Raphael (1483-1520) 64, 234 Raškaj, Slava (1877-1906) 528 Raurich y Petre, Nicolas (1871-1945) 562 Redon, Odilon (1840-1916) 253, 258, 265, 268, 304 Regovos Valdes, Darío de (1857-1913) 555, 560, 561 Reid, Robert (1862-1929) 629, 630, 631 Rembrandt (1606-1669) 206, 218, 352, 409, 410, 413, 445 Renard, Gabrielle (1879-1959) 377